university college
for the creative arts

Modern Sculpture Reader

Edited by

Jon Wood, David Hulks and Alex Potts

HENRY MOORE INSTITUTE

Modern Sculpture Reader

Edited by Jon Wood, David Hulks and Alex Potts

Editorial Assistance and Permissions Research: Ellen Tait
Scanning and Editorial Assistance: Michael Calderbank
Copy Typing: Jackie Howson
Proofreading: Elizabeth Teague
Indexing: Ellen Tait

Design + Production: Groundwork, Skipton
Print: Henry Ling Limited, Dorchester

Published in 2007 by
Henry Moore Institute
74 The Headrow
Leeds LS1 3AH

The Henry Moore Institute is part
of The Henry Moore Foundation

www.henry-moore-fdn.co.uk

Short introductions:
Jon Wood: 2, 3, 5, 6, 7, 9, 10, 11, 12, 15, 17, 18, 19, 21, 22,
24, 31, 32, 34, 35, 36, 38, 41, 45, 47, 48, 49, 50, 51, 52, 55,
57, 59, 60, 61, 64, 66, 67, 70.
David Hulks: 1, 4, 8, 13, 14, 16, 20, 23, 25, 26, 27, 28, 29,
30, 33, 39, 40, 42, 43, 53, 54, 56, 58, 62, 63, 68, 69.
Alex Potts: 37, 44, 46, 65.

ISBN 978 1 905462 00 1

Contents

Contents

Contents

Post-modernity and the negation and persistence of the sculptural

Contents

Foreword

The Henry Moore Institute (est. 1993) is a centre dedicated to the study of sculpture. It is unique in the United Kingdom and unusual in the world more broadly. Central to the study of any subject is its literature. One of the very first projects we talked about was a 'sculpture reader'. Early discussions (which go back to a proposal from Anthony Hughes and Erich Ranfft) touched on the possibility of producing a two-volume historical compilation, from medieval sculpture to the 1990s. The editors of what is now the *Modern Sculpture Reader* reconceived the project, deciding to create a volume that focused on dealing with the twentieth century. I am gratified that it has been possible to realise this important addition to the literature on modern sculpture under the auspices of the Institute, representing as it does the fruits of a collaboration that successfully brought together the expertise we have here with that of scholars working elsewhere in the UK and the USA. I am most grateful to the Foundation's trustees for supporting my bid for this book to go into our annual budget as a special project and to the many copyright holders who have made it possible for us to work within this budget by waiving or reducing their fees.

The project was developed jointly between Jon Wood, of the Henry Moore Institute, David Hulks, himself a former Henry Moore Post-Doctoral Fellow at the University of East Anglia, and Alex Potts, of the University of Michigan, with Jon acting as overall coordinating editor, assisted by Ellen Tait. Starting in the summer of 2002, the initial source-work was carried out by David, with small enabling grants from the Institute. The final choice of texts was arrived at collaboratively by the three editors, who also wrote introductory material on the individual texts, while Alex wrote the essay that serves as an introduction. We all know that anthologies are judged as much by what they exclude as by what they include, but we hope that the *Modern Sculpture Reader* will accompany and enrich the study of a subject which continues to be the focus of vital creative activity, despite the various proclamations of its demise over the last century, and which enjoys a particularly active relationship with its own description.

Penelope Curtis
Curator, Henry Moore Institute

Preface

Since the 1960s, with the publication of books such as Herschel Chipp's *Theories of Modern Art* (1968) and Prentice Hall's series *Sources and Documents in the History of Art* (1965–1972, 1980), there has been a steady increase in the publication of anthologies on art. What is striking about many such collections is how sculpture so often gets short shrift or is squeezed out, either stuck in the shadow of painting and architecture, subsumed within intermedia studies or sometimes displaced altogether. It is also striking that a book presenting the literature on sculpture as an active site of debate and as a subject raising very important and ongoing art-theoretical issues has not been made available before. The *Modern Sculpture Reader* is an attempt to rectify this situation. It is an anthology dedicated solely to sculpture as a rich and contested medium across the twentieth century. Faced with the *paragone* of modern times that is so emphatically biased towards painting, it aims at redressing the balance by making available a variegated body of texts on sculpture, many of which were highly influential and widely circulated in their time, but were soon forgotten and remain neglected today. It also presents some rare and little-known texts that elucidate the nature of sculpture and its potential in extraordinary and sometimes highly experimental ways.

The *Modern Sculpture Reader* is not in any way exhaustive or comprehensive and was envisaged from the outset as a book that would always lead readers elsewhere and generate new interest and fresh thinking on the subject. Like any anthology of this kind, the *Modern Sculpture Reader*, as well as being a serious attempt to chart the changing intellectual history and trajectory of its subject, is also a volume intended to raise issues about sculpture in ways that a more official history of sculpture cannot do. In keeping with this, the three editors all arrived at the study of sculpture from different perspectives and came together on this project at an interesting time when the reappraisal of art of the last century more generally was (and still is) undergoing much discussion. Alex Potts had recently published his book *The Sculptural Imagination: Figurative, Modernist, Minimalist* (2000) and was keen to take the opportunity to re-engage in the story of twentieth-century sculpture through an anthology of texts that extended beyond those discussed in his book. David Hulks is a teacher and researcher in world art studies, with an interest in psychoanalytic theory and in the conceptual aspects of three-dimensional art from the post-war period onwards. Jon Wood's interests in the studio as a site of artistic self-fashioning, making, display and encounter, in the relationships between sculpture, photography and film, and in the artist interview, furthered awareness of the sub-themes and contexts of much of the writing on sculpture reprinted here.

From what started off as a collection of writings by the 'critical historians of sculpture' for whom sculpture and its history was a specialist area of academic enquiry (such as Rudolf Wittkower and Albert Elsen), we soon shifted our attention to a more open representation of the ways ideas about sculpture have been expressed and developed in written discourse. We also decided that we wanted to include a wider range of material by a greater variety of contributors across the twentieth century – all of whom offer critical interventions into the understanding of sculpture and its accompanying debates.

Our original plan had been to end our selection in the late 1970s, the moment when the opening up of medium categories and the critique of high modernist conceptions of the art object were becoming accepted wisdom. This post-minimalist moment seemed to mark a natural ending to a period of intensive engagement with, and radical critique of, sculpture and the sculptural. However, we decided against this strategy for several reasons. Given that many of the texts here engage with issues relating to contemporary artistic practice at the time they were written, we came to the conclusion that the volume needed to attend to discussions of sculpture up to the present day. It also became apparent, when we were surveying our choices of texts, that there had been a significant critical engagement with notions of sculpture throughout the later twentieth century up until the present. Consideration of sculpture also brings into focus a number of issues that persist in a 'post-medium age'. As many of the texts in this volume demonstrate, sculpture's object-based characteristic highlights the materiality of art works and the viewer's more embodied, potentially tactile engagement with them. If broadly conceived as an art having to do with objects and environments realized in three dimensions, sculpture also raises important questions about the kinaesthetic dimensions to viewing works of art and about the role of siting and environment.

Reproducing a collection of twentieth-century writings on sculpture has been a very challenging undertaking. From the outset, we knew that we wanted to include writings that not only made important and intriguing contributions to our understanding of what sculpture may have been in the past, but which were also imaginative, poetic and well written. Owing to the nature of our expertise, we have had to limit ourselves to texts from a predominantly European and American context. Over the last couple of years, we have tried to locate as many instances as possible where a writer decided to write about sculpture or used the words 'sculpture', 'sculptor' or 'sculptural' in ways that marked a new usage, a new definition, or a new contribution to the discussion of sculpture. As a result of this, it soon became very clear that the *Modern Sculpture Reader* would for the most part be a collection of writings by critics, artists, poets and other creative writers. This is because we thought that, as the first book of its kind on sculpture, it should be one that provided texts

from commentators who were in one way or another intimately engaged with sculpture and who had ongoing and often direct experiences of its production, dissemination and reception.

Such a 'primary source' collection allows valuable access and insight into the development of the critical language of sculpture across the twentieth century. It also reveals how discussion about sculpture has been played out across a range of different kinds of texts. This is demonstrated by the wide variety of genres that appear in our anthology, including: manifestos, poems, prose poems, newspaper articles, chapters of books, lectures, seminar papers, transcribed and edited interviews, magazine reviews, journal articles, anecdotal recollections, artists' notes, exhibition catalogue essays, and artist statements. The order is chronological, rather than organised by theme, issue or nationality, with the anthology comprising four sections: 'Nineteenth-century inheritance', 'Modernism and anti-modernism', 'The new sculpture and the anti-sculptural', and 'Post-modernity: the negation and persistence of the sculptural'. The thinking behind these sections is discussed in detail in Alex Potts's introduction. As well as tracing the changing definitions of the medium and the critical positions that both responded to and were marshalled in support of particular sculptors and kinds of practice, the *Modern Sculpture Reader* also offers access to a number of sculpture's key ongoing concerns across a hundred-year period, from materials and techniques to the monument and conditions of display. This collection also points to twentieth-century sculpture's connections and affiliations with other media, such as architecture, painting, drawing, photography, film and design. Indeed one or two texts included here approach sculpture obliquely in unexpected ways, providing some surprising insights on what we mean by 'sculpture' and the 'sculptural' and what functions these terms might serve.

Wherever possible we have tried to reproduce each text in its entirety, rather than as excerpted passages, in order to provide the reader with a sense of the full scope and address of each text. Where it has not been possible to do this, we have indicated where the complete version of the text can be found. At times, the original text will be one that has been re-published (and even anthologised) elsewhere; at other times, it will be appearing for the first time in English translation. The *Modern Sculpture Reader* contains texts that were originally published in a range of languages (German, Russian, French, Italian, Spanish, Polish and English). Each text comes with its original footnotes, editorial comments and with a short introduction to its author and concerns.

The Editors

Alex Potts

Introduction: The Idea of Modern Sculpture

The sculptures in the monuments and exhibitions of every single city of Europe offers such a pitiable spectacle of barbarism, stupid clumsinesses, and monotonous imitation that my Futurist eye turns away with profound disgust.
Umberto Boccioni, 1912

In concrete terms, in order to feel that I am a sculptor, I'm almost obliged to make feigned sculptures.
Pino Pascali, 1967

Sculpture is the step beyond painting. It is what you resort to when your obsession with things goes beyond an illusion of something on canvas.
Edward Allington, 1997

Sculpture, in the various texts collected together in this anthology, exists both as a distinct art form and as a set of ideas or phantasies about sculpture. The ideas and phantasies involved are negative as much as positive. Well before the beginning of the twentieth century, writers on art had begun to feel that sculpture was somewhat at odds with conditions of modernity. In the twentieth century, such an attitude of mind gave rise to phantasies about new forms of sculpture that would no longer quite be sculpture in the accepted sense of the word, and might even negate its very essence. This resulted in some incredibly rich and suggestive writing about the nature and status of the art object in the modern world.[1] What is being addressed by many of the writers in this volume, then, is not modern sculpture as such, but the radical ambiguities of a modern sculptural imaginary. Many were seeking an alternative to the traditional sculptural object, an art existing as material phenomenon in real space that would not be reducible to the status of a statue, any more than to that of a two-dimensional image.

In the past few decades, this anti-sculptural turn has become particularly marked, resulting in a situation where contemporary work is only relatively rarely specifically designated as sculpture. The traditional categorisation of the fine arts as painting or sculpture has ceased to have much currency and the assumptions about medium specificity that gave a theoretical framing to this distinction have come to seem largely irrelevant in what many consider to be a post-medium world.[2] Something of a watershed can be identified in the late

1970s, the moment when the opening up of medium categories and the critique of high modernist conceptions of the art object first became accepted wisdom in the contemporary art world. One might be prompted to see this post-minimalist moment as marking the end to a period of intensive interrogation and radical critique of sculpture.[3] However, as the texts in this anthology indicate, a vital engagement with the idea of sculpture and the qualities associated with it has nevertheless persisted in writing on art right up to the present day.

There are several reasons for this. Issues that come to the fore in discussions of sculpture still play an important role in present-day conceptions of art. A consideration of sculpture gives particular prominence to the materiality of the art work and to the viewer's more embodied, potentially tactile engagement with things and environments.[4] Even traditional sculptural concerns persist today, if often as points of reference for practices that actively negate qualities conventionally associated with sculpture. Sculpture is generally thought of as being made of solid, durable materials (if casts are often hollow, their surfaces are not just surfaces, but thick, rigid and substantial). It has stood as the non-ephemeral art par excellence. By contrast, the more radical forms of three-dimensional art in the mid and later twentieth century have negated monumentality and permanence, in the interests of highlighting the vivid ephemerality of the living moment or of escaping the reifying logic of the collectible artifact. What gives to such striving for the ephemeral and informal a lot of its urgency, though, is precisely the continuing presence of the monumental, permanent object in the modern artistic imaginary, whether seen as a perversion, perhaps annihilation, of a truly living art, or as a curious, even archaic phantasy that exerts considerable fascination.

The obdurate-seeming materiality of sculpture also exposes an underlying tension in modern conceptions of the art work between the imagined and the literally object-like qualities attributed to it. No matter how conceptual a work might be, in the process of being realized it has to acquire material substance. Equally, even the most matter-bound art object must retain a degree of ostensiveness if it is to distinguish itself from the surrounding environment of ordinary fabricated things. More than a painting, a sculpture evidently has a curiously ambiguous status as both object and as the projection of something – mental, psychic and cultural or ideological – that cannot literally be objectified. Its evidently materialising qualities bring out into the open anxieties haunting the modern production and consumption of art that any work when released into the world might just become another mundane commodity.

In the 1960s and 1970s, the more experimental three-dimensional work took on radically anti-sculptural forms that actively resisted immediate reification – with work that was ephemeral and time based, such as a performance or happening, or context specific and conceived as an intervention in a space

rather than as a thing in its own right, or conceptual, so that any permanent, materially realized elements of the work would be meaningless in themselves and only gain validity as the support for an idea. Once the work concerned gained widespread acceptance, however, new forms of commodification were developed to accommodate and give it a certain permanence: the copyrighting of an idea, the marketing of authenticated images and documentation relating to a work, the videotaping of a performance, or the publicising of temporary non-object-based art as a way of promoting more readily saleable work.[5] As a result, it is now less possible than before to make clear-cut ideological distinctions between work that resists being appropriated as commodifiable object, and work that is evidently object-like.

Other factors have reinforced anti-sculptural attitudes, beyond the attempt to resist any too obvious-seeming commodification of the art object that was particularly marked in the experimental work of the 1960s and 1970s. Most significant are the major changes that have taken place in recent times in modes of display in galleries and museums. Exhibitions have become increasingly installation orientated, offering viewers experiences that are enveloping and more immediately accessible than the contemplation of isolated or semi-autonomous objects.[6] At the same time, artistic taste now favours work that, while it may be materially elaborate, looks provisional and dispersed, and divested of qualities associated with traditional plastic form. If most three-dimensional work shown nowadays at major international exhibitions is no longer sculpture in any readily recognizable sense, does this mean the demise of sculpture? An end of sculpture, however, would be particularly hard to define given that sculpture has attracted as much disquiet as it has fascination over the entire period surveyed in this volume. Even at those moments when medium specificity and formalist values were taken seriously, sculpture had a decidedly problematic status, and was often conceived as existing in an indeterminate space between painting, the two-dimensional art, and architecture, the truly spatial and three-dimensional art.

The first three sections of this anthology correspond to three moments of intensive engagement with sculpture: the fin de siècle and very early twentieth century, the subsequent period of early modernist formalism and avant-garde anti-formalism, and the post Second World War period extending through to the countercultural 1960s and early 1970s, when attempts to imagine a new sculpture vied with polemic against the sculptural object. A final fourth section brings the collection to the end of the twentieth century. In the earlier three moments, the engagement with sculpture had a double dynamic. On the one hand there was the drive to define sculpture in new, more systematically conceived ways as radically different from painting. On the other, there was the seemingly opposing compulsion to imagine an art that actively negated the

qualities traditionally associated with the sculptural object. Such contradictory imperatives operating on ideas of what a modern sculpture might be make discussions of sculpture particularly suggestive for understanding the anxieties as well as the aspirations associated with the work of art in the modern world. Thus, for example, the Italian artist Pino Pascali's commitment to producing 'feigned sculptures' ('*finte sculture*') as a way of continuing to make compelling work articulates an ironic attachment to the idea of sculpture that is very telling for general attitudes to the art object in the 1960s. [Pascali, p. 244].

Nineteenth-century inheritance

At the fin de siècle and in the early years of the twentieth century, sculpture came into the purview of critical debate about art as a result of what was generally recognized as a major revival of sculpture, following a period when sculpture tended to be dismissed as a classical art form out of tune with the spirit of modernity – its flux and change and its dissolution of established forms and ways of thinking. Work such as Auguste Rodin's and Medardo Rosso's represented in extreme form a broader move away from the classicising white marble figure that previously had dominated the sculpture that had ambitions to be taken seriously as art. In this new discussion of sculpture, certain paradigms persisted that had informed critical commentary on sculpture ever since medium specificity became a concern in the wake of Lessing's publication *Laocoon* (1766) on the structural distinctions to be made between the visual and literary arts. Sculpture had been envisioned as the art form whose essence lay in plastic form, painting in changing visual appearance. If painting was the medium seen to correspond more fully to the mind-set and sensibility of modern times, sculpture was considered the more primitive, basic art, embodying values that lay at the foundation of a sound artistic practice, but that in Baudelaire's famous formulation were in their modern manifestations boring.[7] Sculpture as an evidently material art was also disadvantaged by the anti-positivism that had characterized critical attitudes towards the visual arts ever since the Romantic period. Anxiety over its status as object as distinct from visual representation was heightened by the fact that the boundaries between sculpture and the decorative *objet d'art* were not always that clear.[8]

There are two principal ways in which this inheritance crystallized in the discussion of sculpture that took place at the turn of the nineteenth century, whether in critical commentary on the new sculpture represented by artists such as Rodin and Rosso, or in formalist theories about the distinctive constitution of different art forms being formulated at the time, particularly by German writers. On the one hand, a distinctively modern sculpture was being conceived that escaped the confines of the traditionally sculptural object and

took on some of the modern qualities of painting; on the other, the distinction between the sculptural and the painterly was being defined in new, more systematically formal terms. Formalist writers such as Adolf von Hildebrand and Wilhelm Worringer considered compact plastic form to be the distinctive domain of sculpture, a tendency taken to extremes in Worringer's case where the abstract block-likeness was conceived in anti-classical terms. The 'primitiveness' ascribed to sculpture as an art form soon came to be associated with what was literally seen at the time as the primitive or archaic in art, as Carl Einstein's slightly later discussion of African sculpture makes clear. Hildebrand's influential analysis of sculptural form was more complex and contradictory than Worringer's, and exposed the extent to which plastic form was being conceived by theorists of the period in terms of two-dimensional image rather than three-dimensional shape. The compact form he and Worringer saw as the foundation for a successful sculpture was the clearly defined stable image the sculpture presented when seen head-on from a reasonable distance. This, Hildebrand explained, anchored the destabilizing kinaesthetic experience of the shifting, partial views to be had of a work when moving around and up close to it.

Hildebrand's quest for an art that embodied stability and wholeness led him to favour a conception of the sculptural object as akin to sculptural relief, leading later theorists of sculpture such as Carl Einstein, Daniel-Henry Kahnweiler and Herbert Read to criticise his theory as being anti-sculptural and failing to take on board the distinctive tactile or cubic qualities of the free-standing sculptural object. By contrast with these critics who singularly failed to consider how a free-standing sculpture might be viewed differently from a painting, however, Hildebrand at least recognized the tensions between a formalist conception of sculpture as stable plastic form and a kinaesthetic experience of it as object in the round.[9] Indeed, his theory might even be seen as suggesting ways of thinking about distinctive features of the new sculpture, particularly Rodin's, where plastic form opens up to a play of shifting surface and optical effects.

The poet Rainer Maria Rilke's characterization of Rodin's sculpture can be read almost as an inversion of Hildebrand's conception of sculptural form. Here is sculpture that privileges movement over stability, as well as painterly play of light on surface and spatial effects extending out into the work's surrounding environment over compact plasticity. It would appear that with Rodin, sculpture found a way of entering into a domain previously seen as the exclusive preserve of painting, thereby claiming for itself a status as a truly modern art.[10] At the same time there is also in Rilke a view of sculpture as a primordial phenomenon, akin to the dim remembrance of things prized in earliest childhood. The essence of a true sculptural sensibility, Rilke seems to

be saying, lies deeply embedded in our psyche – his sculptural thing is almost analogous to the part object of a later psychoanalytic imaginary.[11] Like Worringer's primitive, abstract cubic shape or Hildebrand's plastic form, it is more imagined than real, an intangible subjective phenomenon rather than an actual object. Rilke here formulates something that was to haunt the sculptural imaginary through much of the twentieth century – the new sculpture as impossible object, whose imaginative power was at odds with the ordinary positivity and reified aesthetic qualities to which an actual sculpture, realized as a material object set in some degraded, typically modern physical environment, was subject. This has close affinities with the image of a true sculpture that emerges from Medardo Rosso's short essay. For Rosso it would represent the negation of qualities traditionally associated with sculpture – the dissolution of literal thingness in vividly immediate optical effect, and the transformation of a lump of inert matter into an intuition of life.[12]

Modernism and anti-modernism

Umberto Boccioni's 'Technical Manifesto of Futurist Sculpture' marks the beginnings of a rather different modernist reconceptualising of sculpture – how could sculpture be reconstituted so that it would not just imbue itself with the modernity of the painterly, but would actively confound the values associated with traditional sculpture and the museumified art object? Boccioni's vision is a bit of a ragbag, but it energetically proposes an approach to conceiving sculptural form that radically deconstructs classicising and monumentalizing norms. At the same time his notion of a new sculpture, like Rosso's non-sculptural sculpture to which it is clearly indebted, and like the futuristic phantasies projected by slightly later artists and critics such as the dadaist Raoul Hausmann, imagines a work that would no longer be subject to ordinary material constraint and would somehow penetrate into the surrounding environment, ceasing to be a free-standing, self-supporting and bounded sculptural object. Subsequent thinking about the new forms to be taken by a truly modern sculpture could often be as fascinatingly wayward as Boccioni's speculations. Imagining how modern sculpture might free itself from its outmoded fixation on the human figure, André Salmon saw the sculptor taking inspiration instead from the industrially produced tools and domestic fittings of the modern world, at the same time creating entities that would no longer be the trinkets and functional objects they might seem to be but 'absolutely new objects...liberated from the tyranny of the real' [Salmon, p. 69].

In the period after the First World War, most attempts to conceive a distinctively modern equivalent to traditional sculpture fall roughly into two categories: on the one hand there was to be a new sculpture, but still defined

within the larger parameters of sculpture as an art form, and on the other a radically different kind of three-dimensional art that would no longer be recognisable as sculpture or even perhaps as art. Daniel-Henry Kahnweiler, Eric Gill, Carl Einstein and Ezra Pound each had in mind an art that would be more truly sculptural than traditional classicising figurative work. Pound is particularly interesting because he so directly addresses the new object-like status of sculpture. The idea of sculpture as object, associated at the time with Brancusi, particularly appealed to Pound's Imagist sensibility and spoke to his commitment to achieving an objectivity cleansed of Romantic and subjective expressiveness in his poetry. But the sculptural object was also in his view no ordinary object. It was an essential, pared-down form that could transcend its objecthood to become 'aerial', 'free from all terrestrial gravitation' [Pound, p. 83].

What we encounter here is a projection of sculpture as dramatizing a paradox pervading almost any modernist conception of the work of art – on the one hand a keen awareness of the concrete materiality of a work, and on the other an insistence that it somehow negate and perhaps momentarily transcend, in the viewer's projection of it, palpable physical qualities, such as mass, or clearly delimited and bounded form, ordinarily seen as characterizing a work of sculpture. In Adrian Stokes's writing on Renaissance sculpture, we find such a modern problematic articulated in a peculiarly vivid way. The true, carving conception of sculpture for him is at one level very much about truth to sculptural materials, to the shape and substance of the lump of stone in which a work is rendered. Yet the essence of sculpture for him lies in the final analysis in the subtle modulations of its surface and the visual effects this produces, rather than in its substantive shape as three-dimensional thing.[13] His is a sculpturalness that in many respects is unsculptural. Such paradoxes in Stokes should alert us to the complexities of the aesthetic of truth to materials that enjoyed such a vogue in the 1920s and 1930s. The imperatives behind it lay not so much in the privileging of a particular way of working as in a more pervasive preference for the given, found qualities of things, a broader truth to materials that a present-day artist such as Susan Hiller can still see as relevant to her very different conceptual deployment of anthropological materials. In Stokes's case this preference was grounded in a deep unease over the arbitrary creation of freely invented shapes made possible by modern methods of fabrication and readily malleable synthetic materials.[14]

Amongst the more radical attempts to conceptualise the parameters of a new sculpture that would negate the crass positivity and outdated 'bourgeois' classicism of traditional figure sculpture are to be found writings by artists who saw themselves as realizing a spatial art situated somewhere on the boundary between sculpture and architecture. Naum Gabo's, Lázló Moholy-Nagy's and

Katarzyna Kobro's conceptions of a new sculpture based on the articulation of space rather than the shaping of solid masses clearly echo thinking about modernist architecture going on at the time. These artists, though, were still committed to a spatially oriented reconfiguring of the sculptural object, by contrast with other, polemically anti-aesthetic initiatives that negated the very constitution of the sculptural object.

Such attempts to get beyond the sculptural object are represented here in texts written by Russian constructivists seeking to forge a revolutionary art practice that would participate in the making of a new communist world, and by surrealists whose anti-bourgeois and anti-positivist ideology prompted them to imagine an object that would be completely at one with their inner promptings and would thus escape the condition of the reified, aestheticised art work. In both there was an imperative to break down the boundaries seen to separate art from life in the modern bourgeois world and get beyond the hierarchical values and social exclusivity shaping its conception of art. In viewing their practice as that of 'working on the organization of new objects in the new collective way of life' and 'creating a concrete everyday object with determined functions', artists such as Tatlin were hardly producing art any more, even if much of their work has in retrospect been canonized as such [Tatlin, pp. 94–95]. Their work was situated on a boundary between art and non-art, both imagined, one might say utopian, and also thoroughly imbricated in practical contingencies of everyday life.

The surrealist engagement with the object, which came to public notice with 'The Surrealist Exhibition of Objects' organized by André Breton in Paris in 1936, was, for all its anti-aesthetic compulsions, still largely directed at the art world and framed within the critical parameters of art making. Even Breton's experimentation with the found object, the special yet ordinary object singled out on the basis of a momentary but pressing inner psychic need from objects encountered in everyday life, is in his account interwoven with a story about Giacometti's making a sculpture. Both Michel Leiris and Maurice Raynal are quite explicit that they are talking about a radical reconfiguring of sculpture. At the same time, like a number of a writers in this volume, they imagine a sculptural object that somehow explodes its confines, becoming, as Raynal put it so eloquently, something projecting one beyond the 'pusillanimity' inspired by the conventional art work and stimulating one to immerse oneself in 'inevitably ephemeral, great gregarious impulses' [Raynal, p. 112]. The compulsion to get away from the dead weight of traditional sculpture here prompted the imagining of a radically transfigured materiality emerging from the reified dross of the modern bourgeois, consumerist world.

The texts by Carola Giedion-Welcker and Arturo Martini nicely round out the preoccupations with the sculptural object that came to a head in this

period. Welcker's 1937 text is the foundational survey of the modern tradition in sculpture. It brings together the various radical aspirations seen at the time to have informed the experimental reconceptualising of sculpture over the previous thirty years – breaking down the boundaries between art and life and the exclusiveness associated with the traditional art object; transforming what had been static into dynamic, living values; and positing a new sculpture as a simple, unadorned, very concrete object on the one hand, and as a more immaterial art of volume and space, that related closely to modernist architecture's new architectonics, on the other. Welcker was championing what she saw as various productive new formations of sculpture, which at that point were making their transition from radical gestures enacted on the margins of the art scene to mainstream, institutionalized practices. Martini by contrast dwells on the dark side of the modern sculptural imaginary, as well he might in the wake of his experience as one of the Italian sculptors who had worked for the newly deposed Fascist regime. His bleak assessment of the situation of sculpture has a reach that goes well beyond his own circumstances, however, and speaks to persistent unease that the formal conventions of sculpture were exhausted and could neither be renewed nor radicalized. Painters and architects may have succeeded in becoming poets of the modern world, according to Martini, but not sculptors: 'Sculpture has remained what it is, a dead language which has not found the vernacular'. Still, at the end of his essay there is a typical modernist leap into the void as Martini imagines a radically new 'art of the blind' that, on emerging into visibility, would be the very antithesis of the conventional statue [Martini, p. 179].

The new sculpture and the anti-sculptural

During the post-war period, and well into the 1970s, the radical negation of the sculptural and the constitution of new, non-sculptural forms of three-dimensional art existed alongside a productive and widely promoted tradition of modern sculpture. Painting may have been the dominant art form, but sculpture, specifically in its modern formations, was attracting widespread attention.[15] Even public sculpture enjoyed something of a vogue in the 1960s and early 1970s, with a number of artists such as Jean Dubuffet and Claes Oldenburg enthusiastically putting forward wildly ironic proposals for new kinds of large-scale public sculpture. The period's most influential theorist of the post-industrial urban environment, Henri Lefebvre, still took the idea of the monument seriously as 'the only conceivable or imaginable site of collective (social) life' in the modern world, while also being sharply critical of the 'essentially repressive' nature of the actual monuments that punctuated the urban landscape [Lefebvre, p. 298].

Henry Moore reached the apogee of his fame in the 1950s and 1960s, his work functioning for Herbert Read as a model for envisioning what a modern sculptural imaginary might be, at the same time that Moore's rendering of the erotic and tactile potential of sculptural mass precipitated some richly invested responses from critics such as David Sylvester. Such writing may seem rearguard, but it did have convictions that may be easier to recognize now that the Moore phenomenon is well in the past. Sylvester's account in his 1968 article of the tactile and motor sensations that a close examination of the surfaces of a sculpture by Moore provoke in a viewer seems in retrospect not that far removed from Michael Fried's characterization, dating from the previous year, of the primordial bodily sense of physical being that emerges from attending closely to the spatial architectonics of Anthony Caro's sculpture. Caro was seen at the time to have effected a radical break with the massiveness and biomorphism of Moore's art, realizing a new, purely abstract, optical sculpture that had a lot in common with contemporary painting. Paradoxically, now that this formal revolution is well in the past, Moore's appears the more considerable and resonant achievement.

Possibly the most influential attempt in the postwar period to rethink the parameters of a truly modern sculpture was Clement Greenberg's essay 'The New Sculpture'. This first came out in 1949, and then underwent radical revision to become a lead essay in his *Art and Culture* (1961), the publication that established him as the proponent of a new, high modernist doctrine of art. For Greenberg, the new sculpture was to be entirely abstract and to appear weightless and thereby negate the mass and solidity of traditional monolithic sculpture. He conceived it almost as if it were painting that had achieved the minimal material substance needed to exist in three dimensions. In later formulations, he explicitly represented this new sculpture as a pre-eminently optical art, as a painting or drawing in space. In the first version of the essay, however, such ideas exist in interesting tension with an insistence on the literal materiality that distinguished sculpture from painting. Greenberg projected a vision, and it is important to realize that this was more vision than reality in 1949, of a radically new sculptural art practice: 'objects that seem to have a denser, more literal reality than those created by painting', and disposing of 'a potential wealth of forms … as palpable and independent and present as the houses we live in and the furniture we use' - terms that echo early modernist utopian phantasies of a thoroughly reconfigured world made out of the new forms invented by modern artists [Greenberg, p. 193].

Greenberg subsequently beat a hasty retreat from such quasi-utopian implications of his thinking, as he did from his earlier Marxism. We need to turn to a statement Eva Hesse made in 1969 for an impassioned rearticulation of the modernist vision of a radically reconstituted art object that had erupted

from time to time in earlier engagements with sculpture. The kind of work to which she aspired, and that would emerge from the radical negations she had in mind, was hardly even identifiable as art: 'I remember I wanted to get to non art, non connotive,/non anthropomorphic, non geometric, non, nothing,/everything, but of another kind, vision, sort, from a total other reference point...' [Hesse, p. 283]. Her formulation 'Not painting, not sculpture' was a leitmotif in a lot of thinking about art at the time. Donald Judd's specific objects were in a sense paintings that had descended from the wall to become three-dimensional things, and that abjured the plastic conventions of sculpture as much as they did the framing of painting.[16] David Smith's earlier conception of a 'new sculpture' constantly weaved between painting or drawing and sculpture, for in his view its 'aesthetic process relates closer to the mode of painting than to the historic making of sculpture' [Smith, p. 198]. It was as if he was uneasy about the exclusiveness of the category of sculpture, and could only imagine a truly modern sculpture existing in the gap between painting and sculpture, while at the same time being fascinated by the properties of welded steel; its hard, heavy, and at times brutal materiality, as well as the spaciousness it made possible.

A significantly new perspective on sculptural aesthetics emerged when sculpture came to be envisaged as a phenomenon existing in the same space as the viewer rather than as a self-sufficient modernist object. As a result of this development, closely associated with minimalism, the focus of interest shifted from the constitution or negation of the object to its placing in and effect on its environment and to the interactions being activated between it and the viewer. The seminal text was the artist Robert Morris's 1966 'Notes on Sculpture'.[17] Carl Andre's slightly later reconceptualising of his sculpture as no longer a plastic form or a construction but a place was equally influential. This new perspective is very evident in later texts by Richard Serra and Robert Irwin where they discuss the site-specific and phenomenal aspects of their sculptural work. The consequences of such a shift were potentially dramatic. Not only did the sculptural object as such become less significant, but it could be marginalized to the point where a work was best seen as an environment or installation rather than a sculpture. This potentially anti-sculptural turn gained momentum later on from changes that began to take place in ways of displaying works of art in museums and galleries in the late 1970s and early 1980s. Both artists and curators experimented with installations that created ever more vivid, immediate, enveloping and in some cases spectacular experiences for the viewer. By contrast, early three-dimensional minimalist work that foregrounded issues of placement, environment and interaction with the viewer, that often was not specifically categorized as sculpture – Morris in the end, for example, did not conceive of himself as a sculptor – was for the most part quite spare and austere.[18]

Initially, the interest in context and placement produced more a reorientation of sculpture than an outright rejection of it. There were other developments at the time, however, that sought more radical negations both of sculpture and of the art object in general. In a book that carried the prescient title, *Beyond Modern Sculpture*, Jack Burnham followed the logic of the techno obsessions that gripped sectors of the art world in the 1960s to propose a form of self-activating work that went well beyond the art object as traditionally conceived. However, in the end the vision he offered of an art world invaded by robots held more significance for the imaginary of science fiction film than it did for art. Other radical initiatives sought, not just to move beyond the art object, but to create a non art that either blurred almost completely into life or radically ironised any specialness the art work could claim for itself. Marcel Duchamp, as the inventor of the ready-made, became the hero of the moment, and his 1961 statement 'Apropos of "Readymades"' became a locus classicus for a new notion of a non-aesthetic art object. The thought experiment of setting in an artistic context an object that in itself was uninteresting and not in any way rendered aesthetic, even by some surrealistic story of psychically charged discovery, became a key precedent for the conceptual turn of the later 1960s and early 1970s discussed by Lucy Lippard and John Chandler in their essay on 'The Dematerialization of Art'. Yet several of the objects singled out by Duchamp have acquired a status as masterpieces, even as erotically charged sculptures that have invited as rich an array of viewer responses as any traditional sculpture.[19] With Robert Smithson, the sculptural in a sense returns through his refusing the terms of Lippard's dematerialization and instead focusing on the brute physicality of the matter deployed in his art work. What fascinated him was an art that could simultaneously be conceptual and 'clogged with matter … a quiet catastrophe of mind and matter' [Smithson, p. 293]. This articulated a paradox deeply lodged in the imaginary of the modern art world – the aspiration to create work that would be both embedded in the material fabric of things and exist as an idea in the mind.

Whether such concerns are specifically sculptural is a moot point. The same is true of the radically non-art, anti-art object aspirations of artists such as David Medalla and Allan Kaprow. We are possibly dealing here with a more general category of work than sculpture – phenomena of very different kinds that are realized in a 'real' rather than a depicted environment. Kaprow's general aspiration to get beyond the reified art object to a living, dynamic experience of things had long been considered by theorists of art as integral to a truly compelling aesthetic experience,[20] as is evident in the writings on sculpture by Medardo Rosso and Jean-Paul Sartre reproduced here. The difference in Kaprow's case is the extremity of the compulsion to do away with the art object and get outside the environments created by art institutions. He

had in mind an art that would be an ephemeral action or performance, or what he called a happening, enacted in a non-art setting where, in theory at least, the boundary between viewing subject and viewed work, and between art and life, would be abolished. At the same time, he made it clear that such practices, working directly with spaces and things and people, developed logically out of his earlier gallery work assembled out of bits and pieces of junk and the environments he created there that viewers could enter inside.

Art forms such as happenings only continue to exist in the public imaginary if they are not entirely ephemeral, or not exclusively constituted at their moment of realization in one particular place. Such performance-based work gains an afterlife though its material traces – photographs and videos, verbal records, scripts, recounted memories, and in some cases left-over objects. In Bruce Nauman's case, video recordings of performances, often accompanied by sound effects, were deployed in three-dimensional arrays that involved viewers in a spatial and kinaesthetic as well as image-based experience. With Joseph Beuys, the material remnants from a performance became works in their own right – existing not solely as objects, but also as evocations of an idea or impulse or living action made manifest through an often hybrid concatenation of objects, texts and photographic images. Beuys envisaged such work as realizing an expanded notion of sculpture that, as he became increasingly political, he designated as social sculpture. Such developments could be seen to mark both a new beginning and an end for sculpture, with sculpture now embracing almost any materialized phenomenon, ephemeral or relatively permanent, often subsisting as trace or representation rather than palpable reality – but in the end still sharing with traditional sculpture the necessity of negotiating, and at times defying, the reifying logic of the art work as realized in a gallery setting or in an art-world publication.

Post-modernity: the negation and persistence of the sculptural

The period from the late 1970s through to the present day has not witnessed any wholesale radical rethinkings of sculpture; nor has sculpture been the contentious focus of concern it was for experimental artists and critics in the 1960s. The latter decades of the twentieth century can perhaps best be seen as a period of aftermath and persistence as far as thinking about sculpture is concerned. However, if medium specificity, particularly in its high modernist, formalist guise, has come to seem increasingly irrelevant to contemporary practice, this does not mean that speculation about sculpture and the sculptural became irrelevant to a critical understanding of modern and contemporary art. A number of texts in this anthology, such as those by John Lechte and Gareth Jones, give evidence of a fruitful engagement with sculpture and the

distinctive qualities that might define a sculptural object. Artists with a high profile in the contemporary art world have continued to practise as sculptors, and have felt compelled to write about their fascination with issues specific to sculpture as an art form – as is evident from the texts here by Louise Bourgeois, Tony Cragg, Rachel Whiteread, Georg Baselitz, Edward Allington and Susan Hiller.

There has been a flurry of new thinking on practices bordering on sculpture where siting and context rather than a singular object are of primary importance. The artistic imaginary of the period seems to have been particularly gripped by issues relating to the environment and site specificity.[21] These issues had already emerged as key areas of concern in the late 1960s and early 1970s, generating a new movement of land or environmental art that Rosalind Krauss theorized in her 1978 article 'Sculpture in the Expanded Field' as a negation of the sculptural situated somewhere between landscape, sculpture and architecture. Discussion of these issues was reinvigorated in the 1980s and 1990s by a growing interest in work located, not like land art in marginal or out-of-the-way places where the artist could frame the viewer's perception of the intervention being made in the environment, but in publicly accessible urban spaces. Such public projects, of the kind discussed by Walter Grasskamp in his account of the well-known Münster projects in Germany, usually rejected the terms of traditional public sculpture as aesthetic supplement to an urban space or as public monument, and often took the form of temporary interventions rather than permanent works. At the same time, this work re-engaged with issues relating to the public sphere and to the symbolic significance of place that had been more or less eliminated from critical analysis of art at a time when sitelessness was assumed to be the condition of art in the modern world, and modernist ideas of autonomy as a protest against bourgeois and state-sponsored appropriation of art prevailed. Issues relating to sculpture in the public sphere are addressed here in the texts by Richard Serra and Rachel Whiteread, both of whom have made a name for themselves with more or less controversial works that had a visible impact on densely populated urban spaces.

Some of the more inventive site-specific initiatives of the past few decades involve work that is not necessarily substantively sculptural or even visual. Max Neuhaus's text discusses how sound on its own has been deployed to reshape and create a sharpened awareness of a particular environment. He proposes a very different rhetoric from the one usually associated with public art: creating 'works in public spaces', 'accessible to people' but 'not imposing them on people', that may not even particularly strike passers-by but have to be found by them [Neuhaus, p. 442]. Neuhaus here re-engages with issues that had been central to public sculpture, but in a new register that rejects a dis-

tinctively sculptural monumentality designed to draw attention to a work that has to compete in a busy, visually dense environment. His concern to devise compelling interventions in public spaces that abjure the assertiveness of traditional public art is also evident in Acconci's meditation on how he might approach making a site-specific work he had been invited to realize in Vienna. His text echoes several concerns that have preoccupied artists seeking to make work that gets beyond token packaging as public or site-specific art and offers a genuinely engaged response to a place. At the same time he raises some very topical, politically charged questions about the modern media spectacle of interventions in heavily populated urban environments: 'How can I remain a traveler and still act in public? One way is: I can travel from place to place, like a guerilla fighter, setting a bomb in place and then traveling on. But there are no places I want to bomb. No, I don't want to get rid of places; let them stay.' [Acconci, p. 390]

The complexities of context and place have also been addressed in thinking about the siting of work in a gallery setting, where the focus is not just on the physical parameters of such spaces but also on their ideological inflections as arenas for the consumption and display of art. O'Doherty's analysis of the supposedly value-free white cube spaces devised for the display of modernist art dates from 1976, but the issues had if anything become more pertinent for contemporary art practice when he republished his critique with the postscript from 1986 reproduced here. In this he addresses how an artist might be able to intervene critically with work that is radically anti-autonomous, and posited against the self-sufficient, site-less paintings and sculptural objects for which such spaces were custom designed. This extension of site specificity to a preoccupation with the cultural politics of a work's context, a significant concern for art that occupies or intervenes in real space, and that for lack of an alternative term we might still designate as sculpture, is taken up in Benjamin Buchloh's meditation on 'The Conclusion of Modern Sculpture'.

A telling dialectic, central to an understanding of what sculpture might be at the end of the twentieth century and beginning of the twenty-first, is set up between the texts reproduced here by Tony Cragg and Benjamin Buchloh. For Cragg, a practising sculptor, sculpture is a particular kind of object that can interrupt and activate an alternative to the ready-made interactions we have with the artificially fabricated objects and environments that surround us. In encountering a sculpture, in his view, we become aware of something about the basic materiality of the world and of the bodies we inhabit that is blocked by the spectacle of expendable, merely functional objects and objects of consumption that constitute so much of our everyday world. Buchloh on the other hand underlines the fact that art galleries and the work they contain are also part of this spectacle, and that any viewer's phenomenal experience of a work of art

will be mediated by the commodified context framing it – undermining the possibility of an aesthetic experience of the kind Cragg envisions. Such a situation is highlighted in the case of sculptural work because of its evidently object-like quality and its literal imbrication in the fabric of the gallery environment. The continuing engagement with sculpture as an issue might partly be explained by its capacity to activate this tension.

The tension is given a typically contemporary inflection in Guy Brett's discussion of art such as Gabriel Orozco's that seeks to capture some vividly felt, ephemeral response to a phenomenon occurring in everyday life, but that, when displayed as a relatively permanent art work in a gallery, becomes subject to a stultifying logic. Once fully absorbed into an art-world context, there is the danger, as Brett puts it, that the image of 'the light touch which captures an instant of perception out of the flux of life… becomes emptied and exhausted by consumption' [Brett, p. 488]. If no work of art can permanently lay claim to the status of found object, an art work that compels attention from a viewer has in some way to be found by her or him. Any art work of significance, regardless of whether it embraces qualities that we see as sculptural or actively negates these, is caught up in a very basic contradiction, momentarily bringing to life alternatives to the pervasive reifications shaping the world of art and the world of everyday experience while also being embedded in these reifications. For artist and viewer, art involves a process in which material substance is given to impulses, ideas and apprehensions of things. As such, it is inevitably caught up in the forces that shape the artificially fabricated environments viewer and artist inhabit, forces permeated by the imperatives of modern capitalism. Like other imaginatively charged materializing processes in which people engage from time to time, art can momentarily project them beyond and perhaps even enable them to resist these imperatives, but it cannot do so on a permanent basis. An artistic phenomenon that is seen to have achieved stable significance or value, like any other phenomenon that has become a fixed feature of the world we inhabit, is inevitably absorbed back into the indifferent, ready-made environments from which it once briefly stood out.

1 The complex status of the sculptural in modern theories and critical commentaries on art is discussed in detail in my book *The Sculptural Imagination: Figurative, Modernist, Minimalist*, New Haven and London, Yale University Press, 2000.

2 On medium, see Rosalind Krauss, '*A Voyage on the North Sea': Art in the Age of the Post-Medium Condition*, London, 1999; T. J. Clark, 'Modernism, Postmodernism, and Steam', *October 100*, Spring 2002, p. 161; and Alex Potts, 'Tactility: the interrogation of medium in art of the 1960s', *Art History*, Vol. 27, No. 2, 2004, pp. 283–304.

3 This moment was marked by the publication of two texts that continue to function as key points of reference for discussions of the aesthetics of modern sculpture in the English-speaking world: Rosalind Krauss's *Passages in Modern Sculpture* (New York, 1977) and William Tucker's *The Language of Sculpture* (London, 1974), books that encapsulated much of the rethinking of sculpture that had taken place over the previous few decades. Symptomatic of later ambivalence about sculpture are two more recent publications: Thomas McEvilley's *Sculpture in the Age of Doubt* (1999) and Richard Williams's *After Modern Sculpture: Art in the United States and Europe 1965–70* (2000).

4 For a fuller discussion of these bodily aspects of the materiality of sculpture, see Anne Wagner, *Mother Stone: The Vitality of Modern British Sculpture*, New Haven and London, 2005, particularly pp. 19–24, 69–70, 245–9.

5 See Thomas Crow, *Modern Art in the Common Culture*, New Haven and London, 1996, particularly pp. 82–4, 215–6, and Blake Stimson, 'The promise of conceptual art' in Alexander Alberro and Blake Stimson (eds.), *Conceptual Art: A Critical Anthology*, Cambridge, Mass., 1999.

6 See the special issue *On Installation*, *Oxford Art Journal*, Volume 24, Number 2, 2001.

7 Potts, *The Sculptural Imagination*, pp. 61–77.

8 Martina Droth, 'Small sculpture c. 1900: the "New Statuette" in English sculptural aesthetics', in David Getsy (ed.), *Sculpture and the Pursuit of a Modern Ideal in Britain, c.1889–1930*, Aldershot, 2004, pp. 141–166.

9 Potts, *The Sculptural Imagination*, pp. 124–31.

10 The distinctive modernity of Rodin's conception of sculpture was also discussed at length by Georg Simmel in an essay published in 1902, 'Rodin's sculpture and the contemporary spirit' (Simmel, *Vom Wesen der Moderne: Essays zur Philosophie and Ästhetik*, Hamburg, 1990, pp. 265–71).

11 Helen Molesworth (ed.), *Part Object Part Sculpture*, University Park, Pennsylvania State Press, 2005.

12 Harry Cooper and Sharon Hecker, *Medardo Ross: Second Impressions*, New Haven and London, Yale University Press, 2003.

13 Potts, *The Sculptural Imagination*, pp. 148–56.

14 On the cult of truth to materials and direct carving in the 1920s, see Penelope Curtis, *Barbara Hepworth: A Retrospective*, London, 1994, pp. 19–25. Adrian Stokes's later essay 'Collages' (*Reflections on the Nude*, London, 1967, pp. 19–33) discusses the enlarged understanding of truth to materials in post-war art.

15 In the post-war period there was a spate of publications in English analyzing the modern 'tradition' of sculpture and its origins and history, including Wilhelm Reinhold Valentiner, *Origins of Modern Sculpture* (New York, 1946), Andrew Carnduff Ritchie, *Sculpture of the Twentieth Century* (New York, 1952), Carola Giedion-Welcker, *Contemporary Sculpture: an Evolution in Volume and Space* (New York, 1955; an updated edition of *Modern Plastic Art*, Zürich, 1937), Michel Seuphor, *The Sculpture of this Century: Dictionary of Modern Sculpture* (London, 1959 and New York, 1960) and Eduard Trier, *Form and Space: The Sculpture of the Twentieth Century* (London, 1961 and New York, 1968), Jean Selz, *Modern Sculpture: Origins and Evolution* (New York, 1963 and London, 1963), Herbert Read *A Concise History of Modern Sculpture* (London and New York, 1964) and Robert Goldwater, *What is Modern Sculpture?* (New York, 1969). Albert Elsen's *Origins of Modern Sculpture: Pioneers and Premises* (New York and London, 1974) might be seen as marking the end of this preoccupation with the idea of a distinctively modern sculptural tradition.

16 On Judd's hugely influential discussions of a three-dimensional art that would be neither quite painting nor sculpture, see Alex Potts, 'Objects and Spaces' in *Sculptural Imagination*, pp. 269–310.

17 Morris's view of sculpture as an object situated in relation to the viewer was the subject of an extended critique in Michael Fried's essay 'Art and Objecthood', first published in *Artforum* in 1967 (*Art and Objecthood: Essays and Reviews*, Chicago and London, 1998, pp. 148–72), the most widely cited defence of the autonomy of the object and the formal logic of medium specificity from the period. Rosalind Krauss's *Passages in Modern Sculpture* (New York, 1977) established the phenomenological approach pioneered by Morris as central for discussion of the aesthetics of modern sculpture. On the phenomenological turn in later twentieth-century sculpture, see Alex Potts, *The Sculptural Imagination*, pp. 207–68.

18 Alex Potts, 'Installation and Sculpture', *Oxford Art Journal*, Vol. 24, No. 2, 2001, pp. 5–24.

19 See Molesworth (ed.), *Part Object Part Sculpture*.

20 See Jacques Rancière's discussion of the modern conception of the aesthetic as a form of living in *The Politics of Aesthetics*, London and New York, 2004, pp. 23–30.

21 Miwon Kwon, *One Place after Another: Site Specific Art and Locational Identity*, Cambridge, Mass., MIT, 2002.

1 Adolf von Hildebrand

from *The Problem of Form in the Fine Arts* 1893

The Problem of Form in the Fine Arts, written by the sculptor Adolf von Hildebrand (1847–1921) and first published in German in 1893, was immediately popular amongst artists and art writers. Its influence increased still further when in 1907 it was revised and translated into English – at which point 30 illustrations were added, and the title changed to *The Problem of Form in Painting and Sculpture*.

Hildebrand's theoretical understanding of sculpture was developed in collaboration with the aesthetic philosopher Conrad Fiedler. Fiedler was concerned that art historians too readily assumed that the determining impulses for an artist's work came from the society and culture within which it originated, whereas in Fiedler's view the artist was largely isolated from society and was involved in a profound and importantly visual engagement; the artist's concern was with 'form'. While agreeing with this, Hildebrand also extends the argument considerably. Drawing on scientific theories of visual perception, he not only notes the artist's optical activity, but also considers the mental response, which should be focused, he argues, on extracting the formal values intrinsic to the object perceived. This emphasis on the 'purely visual' means that Hildebrand is sceptical about any linguistic processes that in his view would interfere with the all-important optical engagement – a view that ultimately leads to Clive Bell's 'significant form', or later Clement Greenberg's 'opticality'. For Hildebrand, conceptual thought is extraneous to the primary artistic activity involving the 'purely visual'; although for sculptors, optical scrutiny also involves them in the absorption of multiple appearances so that in the end appearance is superseded by the truer perception of the object's form, embodied in a two-dimensional gestalt. It was this radically optical, extra-linguistic model of artistic scrutiny that for Worringer and others suggested a move beyond representational art which would follow an 'urge to abstraction'. For Hildebrand, however, wrestling with appearance is fundamental to the artistic aim, so that in order to understand him correctly, it is crucial to remember the extent to which his own work remained representational and based on, even if not determined by, narrative conventions.

Hildebrand's optical, anti-kinaesthetic and relief-based conception of sculpture elicited criticism from later writers, such as Carl Einstein, D-H Kahnweiler and Herbert Read, who saw it as denying the essentially 'cubic', three-dimensional nature of sculpture.

Adolf von Hildebrand, *Das Problem der Form in der bildenden Kunst* (1893), translated by Harry Francis Mallgrave and Eleftherios Ikonomou (eds), *Empathy, Form and Space: Problems in German Aesthetics 1877–1893*, Getty/University of Chicago Press, 1994, pp. 229–32, 271–78. Two sections from the beginning and end of the book are extracted. (Complete text: pp. 227–79.)

I. VISUAL AND KINESTHETIC IDEAS

In order to understand the relation between form and appearance, we must first of all get a clear understanding of a distinction in the mode of perception. For this purpose, let us take an object with its surroundings and background as given and with the line of sight of an observer likewise given. Let us further assume that the observer can move but only toward or away from the object. If his vantage point is distant, the eyes no longer converge at an angle but view the object in parallel lines. Then the overall image is two-dimensional, for the third dimension (all closer and more distant parts within the object's appearance) or the modeled object can be perceived only by surface contrasts: that is, as surface features indicating distance or nearness. If the observer steps closer to the object, he will need a different visual accommodation to see the given object; he will cease taking in the overall appearance at one glance and can compose the image only by moving the eyes back and forth and making various accommodations. He will therefore divide the overall appearance into several visual impressions that are connected by the movements of his eyes. The closer the observer comes to the object, the more eye movements he will need, and the less coherent will be the visual impression. Finally the field of vision becomes so confined that he will be able to focus only on one point at a time, and he will experience the spatial relationships between different points by moving his eyes. Now seeing becomes scanning, and the resulting ideas are not visual [*Gesichtsvorstellungen*] but kinesthetic [*Bewegungsvorstellungen*]; they supply the material for an abstract vision and idea of form.

These two extremes of visual activity are actually two different modes of seeing. The image received by the viewing eye at rest expresses three-dimensionality only by surface signs, through which coexisting elements are simultaneously apprehended.[1] At the other extreme, the eye's mobility enables it to scan a three-dimensional object directly from a close vantage point and to transform the perception into a temporal sequence of images.

All modes of perception between these extremes combine visual impressions and kinesthetic activity; they are impure with regard to their experiential components. Foremost is stereoscopic vision, in which we actually see the object from two vantage points at the same time. The movement from one to the other has been condensed into a single moment, for the difference in vantage points coincides with the distance between the simultaneously viewing eyes. This is basically a combination of a visual impression and a kinesthetic process; we can separate the two by closing one eye at a time to resolve the common image back into two separate images. In doing so, we push the object away from us, as it were, and receive a completely coherent surface image [*Flächenbild*].

For the sake of simplicity let us call this pure surface image the distant image [*Fernbild*].

Having separated perception into pure scanning and purely kinesthetic eye activity, let us now examine more closely the relation between visual and kinesthetic ideas.

Let us take the appearance of something three-dimensional. Its distant image presents a visual impression of kinesthetic ideas; they are, so to speak, latent in the visual impression or surface image. If we direct our attention exclusively to this latent three-dimensional content, we find that all visual impressions suggest this content but by developing into kinesthetic ideas. Visual impressions in a distant image indicate only the object's two-dimensional extent; but if we exclude from the overall impression all lines devoid of perspective and all surface elements lying parallel to the picture plane, then these stimuli to eye movements present the direct geometric image of those movements. Yet everything in the distant image that works toward the third dimension and stimulates movement into depth [*Tiefenbewegung*] is not a geometric image of movement but only a suggestion of it. The foreshortened line of a perspective is not as long as the line traced by the movement into depth.

If, on the other hand, we proceed from the kinesthetic activity of the eye, visual ideas automatically develop with each movement insofar as they present a direct equivalent of motion in two dimensions, that is to say, of a line or simple surface. By changing our vantage point, we view the relative positions of the surfaces to each other as a line and are thus able to create profile views for all these relative positions. The visual ideas of the form thus acquired are actually abstract in nature; they illustrate movement abstracted from the actual visual impression. Accordingly, the three-dimensional imagination derives visual ideas from lines and simple surfaces and only thus acquires distinct kinesthetic ideas. It therefore knows only a coherent form, corresponding to the two-dimensional content; the three-dimensional imagination itself executes geometric images – the third dimension – by shifting its vantage point.

We therefore possess a coherent image of the *three-dimensional complex* only in the distant image, which constitutes the only coherent apprehension of the form as perceived and imagined.

Since the visual impression partly depends on the changing conditions for the idea of depth and is therefore itself variable, and since we also read and acquire the object's form from its appearance as a kinesthetic idea, we never retain a clear image for the idea of depth. Indeed, everyone can imagine a sphere as a form but not how the sphere communicates its roundness as a visual impression. What we all recall is the two-dimensional circular line and the kinesthetic idea with which we repeat that circular line in every direction.

Thus we see that apart from very different degrees of clarity in people's ability to imagine form, this ability itself bears a very unclear relationship to visual ideas. The *perceiver* sees or spatially reads the appearance quite unconsciously, and he receives the visual impression in order to form a spatial idea. In *imagining* it he has to piece the object together, partly from visual and partly from kinesthetic ideas, that is, he imagines a rough visual image and fills it out three-dimensionally with the help of a kinesthetic idea. The visual impression and the kinesthetic idea relate to the same object, but they bear no specific, intrinsic relation to each other.

This lack of clarity with regard to the visual clues that facilitate our idea of form is natural because the only control for this relation between our visual and kinesthetic ideas lies in the artistic representation itself. Only there do our ideas become perceptible; only there can we test whether we react immediately to the impression received from the representation. All other mental disciplines leave us entirely naive, caught in a wholly unconscious contact with nature and in possession of a wholly unclear idea of form. The visual arts alone reflect the active operation of consciousness: the activity that seeks to bridge the gap between ideas of form and visual impressions and to fashion both into a unity. The true enjoyment of a work of art and its spontaneous blessing lies in the perception of this unity.

From this perspective, let us now consider the creative work of the sculptor and of the painter. The sculptor mentally works with kinesthetic ideas, which he gains in part directly from the kinesthetic activity of the eye, in part from visual impressions. By working with his hands in a solid material he represents these impressions directly. These represented kinesthetic notions in turn yield visual impressions and acquire their coherent form as a distant image. The question is whether or not this distant image or pure appearance yields a clear, expressive image of the form. The sculptor therefore indirectly creates a visual impression or coherent appearance. He judges the represented form, the result of his kinesthetic imagination, by the visual impression he receives when he steps sufficiently far back to view the distant image of the form. As long as no coherent image appears, the real form has not yet achieved its true unity; for this to happen, the emerging image must possess the form's full expressive strength. This is the sculptor's three-dimensional problem.

The painter mentally works with visual ideas that he expresses directly on a surface, thereby creating a whole in the sense of a distant image. Insofar as these impressions are intended to stimulate ideas of form, the painter has the task of depicting a surface image in such a way that we fully comprehend the object's form. He does this by testing the visual impressions for the suggestive force of their three-dimensional clues, which he in fact employs and shapes for this purpose. This is the painter's problem. Both painter and sculptor thus

deal with the reciprocal relation of image and form, but the painter creates an image in relation to the idea of form, and the sculptor realizes an idea of form in relation to the impression of the image.

Our idea of form in nature, which is a product of the coherent surface image or distant image, is based on a constant exchange between the experience of visual and kinesthetic ideas. This has unconsciously led to stronger regularity insofar as all viewers will obtain a specific idea of form as a necessary consequence of a specific surface impression. Connecting the visual and kinesthetic modes of representation is thus equivalent to seeking or applying the law that governs the relationship between them. This law exists only for the visual imagination and manifests itself there. We simply discover whether or not our idea of form is a spontaneous reaction. The law affects every viewer, not consciously but as an independent vital activity.

Thus the artist's task in viewing a specific object in nature is to understand and present this general law. Every individual appearance in nature must be translated into a general case or visual image whose general meaning expresses an idea of form.

By understanding nature in this way, the artist confronts the specific appearance in nature with an image in which the application of law has processed and clarified the natural appearance and that thereby satisfies a need of our imagination.

The specific factors that the artist captures from the changing appearance of nature and applies to this lawful construction, as well as the visual means that he uses in processing natural appearances for the purpose of creating an idea of form subject to its own inner law – these will be determined by his subjective needs and his personal way of viewing things. Yet even with this individual latitude, the true work of art always presents an image governed by an intrinsic law, and this alone endows it with artistic meaning.

[…]

VII. STONE SCULPTURE

One can imagine that the material the artist uses in his presentation must influence his technique and that it cannot be insignificant whether this technical approach is analogous to or incompatible with this imaginative process. In the latter case, the mechanical execution runs counter to the mental image; either the hindrance must be overcome or the natural need of the idea will suffer and degenerate under the influence of the representational process.

Yet when the material is such that the artist can carry on his work in accordance with his imaginative needs, and when the material conditions

correspond to the conditions of the imaginative development, then the representational process will have a salutary and beneficial effect on the unified idea; it will gain strength and in a natural way always draw attention to the basic artistic problems.

The free cutting in stone offers such a representational process, and it therefore seems appropriate to me to examine it more closely.

Sculpture undoubtedly arose from drawing, for giving depth to a drawing leads to the idea of relief. We must view it as an animation of the surface. Even the first rounded sculptures describe a coherent space. Thus the ancient Egyptians chiseled crouching figures out of simple cubes of stone, thereby keeping the stone walls intact but transforming them into the limbs of a crouching figure. In the same way that we might at a distance mistake a stone cube for a crouching man, the stone cube has actually turned into a figure. The stone thereby loses its objective quality in our imagination but tacitly continues to exist as the general form of the figure. The eye experiences this spatial unity as it does a coherent image or visual surface in a drawing. And just as our fancy creates a figure out of a simple stone cube, so the figure leads the observer back again to the simplest visual sensation. To create such three-dimensional images, the stone is first hewn into a simple general form and then modified according to the figurative form required.

Architecture creates simple geometric solids as building members, and these then spring to life as sculptures; the same process has led to many other sculptural creations whose simple general form indicates that they were first cut out of stone. This type of sculpture is important not only as a component of the architecture but also from a purely sculptural viewpoint. The plastic representation has remained bound to a simple, understandable spatial unity, thus assuring a visual unity and repose. Architecture therefore has had a very healthy influence on the sculptural imagination.

It is now easy to understand that over time sculpture freed itself from this direct architectural purpose, but at the same time it also lost the discipline of a closed, regular general form. It lost the general form that had objective meaning in and of itself and that could accordingly be cut first. Thus it now became impossible to determine beforehand how and where, from every view, the figure should appear in stone, even if the liberated figure were conceived as part of a total space, for the three-dimensional relationship of the different views to each other cannot be defined in advance. A preliminary cutting of the overall form was no longer possible.

The artist has only one recourse, namely, to start with one view in mind and let the others arise logically from it. This forces the sculptor to base his cubic or kinesthetic idea on a visual idea or ideal image and to proceed from there.

To do this it is necessary first to draw the image on the principal surface of the stone. I always choose as flat a surface as possible, for it will give the feeling of an ideal plane and not something already formed. As I project the image onto the surface, I am able to fill this surface at will with my image of the form. The depth or volume of the stone concerns me only insofar as I allow sufficient room for my figure. I am now in the same position as when I want to begin a relief, and since there is a natural need to fix the image even now and not to postpone its clarification to later stages of the work, my imagination will trace a figure whose principal masses are already present on this surface. If it is already there, then I have laid a firm basis for the entire work and for all other vantage points. In this way I succeed in envisioning a figure that might also exist in relief: that is, one that would fully express its nature. Along with this, I must envision what will appear in the first layer and what will come in the following layers. In order to be able to bring the high points of the first layer into a clear pictorial or two-dimensional relation from the start, I must conceive the image in such a way that several principal parts appear in this first layer: for example, a head, a hand, a knee, and so on, depending on the position of the figure. As I carve this image into the stone, removing from the surface what lies outside the contour and graduating the form within, I begin at the same time to pay attention to the real depth dimension of the figure in the round. This is possible only if my visual sense is assisted by side views of the emerging forms by which I can control the dimensions of depth as surface dimensions. Since it is initially impossible to do this satisfactorily, my work will increasingly bear the character of a relief and will proceed according to the eye's need for movement into depth or for light and shadow. Thus the hard-to-verify depth of the material will emerge only gradually as the form develops. One can say that all the dimensions of depth of the material form tend to exist, at first, only as relief. The extraction of the form always takes place according to visual need; and the active imagination involved is invariably visual in nature, like a view from a distant vantage point. The result is that the image is coherent at each stage, in the sense that it has a common surface and a common visual unity from a single vantage point – even though its real unity as a material form for different vantage points has not yet been achieved.

In these first stages of the work, the artist's experience and skill will determine whether he will proceed in many or in a few stages to achieve the dimensions of depth of the material form. If many, he will gradually proceed through successive layers of the marble, creating one surface image after another. If few, the dimensions of depth will approach their actual relations from the start, and then the artist from the outset assumes a larger *scale* for the movement into depth.

What is important in this process and what we must not lose sight of is that I *must* imagine and carve simultaneously all that appears to the eye on a single plane. Only after I work out the first representational layer can I proceed to the next layer. For it is in the nature of the technical conditions that I must free the image uniformly from the front before I can go any deeper. Otherwise I would have nothing but holes in the stone, which would hinder the chiseling and produce no clear image.

Michelangelo characteristically described this process of working in marble when he said that one must think of the work as an image submerged in water, which gradually recedes so that the figure emerges above the surface little by little until it is completely free.

What results for the eye is a form defined by the notion in the artist's mind, such that the individual forms are conceived in terms of the surface layers that they share. The individual forms thereby acquire a relationship or unity that exists only for the eye and has no organic basis. This *tacit cohesion* is of the greatest importance for the observer's natural process of perception, for it supplies him with the image in stages and within a definite arrangement, that is, as large and simple surface masses. This tacit cohesion, as we know, is the artistic idea of form or of space, for it makes the image into a form suited to the eye and structured for the imagination.

This discipline will become clearer if we contrast it with the process of modeling in clay.

There I build an armature and dress it with clay until it corresponds more and more to the figure. I therefore proceed out from the object and gradually develop the exterior toward me. Since I initially have no spatial body but only gradually compose one, insofar as the figure occupies it, I base myself not on a general but on the spatial idea of an object. Moreover, since I work the clay up around the armature, I always see myself as moving around the object in my mind, that is, I am neither given nor forced by my manner of working into a defined vantage point vis-à-vis the object. On the contrary, the use of clay suspends this necessity.

The imaginative act accompanying this technical process is based and insists on the objective reality of the image, the given natural form, which is presented fully in the round. Yet it leads to no articulation or idea of space beyond the natural object.

When we consider that our imagination is shaped by the representational process, we can easily see how differently the imagination must work in the free cutting in stone, compared with modeling in clay. Obviously I am speaking only of the discipline that the manner of working exerts, not of the *impossibility* of forming a general idea of space through illusion when one models in clay.

However, illusion is essential in modeling, whereas stone puts the idea of space before us in a very real way.

Because stone makes it necessary that the structuring of the large masses on the surface precede the working out of details, I am naturally forced to read the figure into these masses in a recognizable way; or rather, I work toward an image that already presents itself forcefully and expressively in the large masses. The work thus demands an image in general terms. It is therefore important that the rest of the image still be present in the mass of stone, that is, in a positive space, as if still immersed in a universal element or in darkness. In this way the imagination always feels the possibility that more form is available. The idea of form remains in a natural state as it does in nature, where, for instance, one part of the image is illuminated while another is plunged in darkness and unrecognizable.

Modeling in clay is very different. There is no positive space that has not been modeled, and there is no general clay space beyond what is modeled. The modeled object, moreover, appears in contrast to the air and the truly real space, so that the unfinished clay image thereby appears more positive than the finished image. The imagination is thus offered the unfinished as if it were finished. The unfinished image in stone sculpture contrasts with the stone itself, that is, with an unformed element out of which the unfinished form emerges like a growing thing. This is why we naturally expect that it will continue to grow. The image evolves further out of the space and always appears incomplete in relation to its stone background.

In order to maintain the imagination in this condition while the work proceeds, it is important when cutting stone to retain the background as long as possible.

The more masterly the treatment of the stone, the more decisive and the more definite will be the form that emerges onto the surface. Our instinct demands that a positive form step forth from the general spatial fog as quickly as possible, for this then sets clear conditions for later forms, and the image quickly emerges in its full clarity. Herein lies the necessity for a very clear and positive idea of the objective form.

The general forms that I initially convey in the stone must be imagined, as already pointed out, in such a way that they contain the particular forms. To the extent that these details influence the general form, they should be apparent from the beginning. We have earlier seen that from a certain vantage point there are some particular forms that merely enrich the general form, while there are others that themselves play an expressive role within that form. This means, in other words, that at a distance the former blend together while the latter remain distinct. In the design of the general form, the role of the particular forms must be clear in the artist's imagination, as defined by their

visual effect as a distant image. Only in this way will the idea of the image as an object relate to the visual idea that I can gain of the image from my vantage point. The progress of the work forces me into this mode of visualization, for I must begin with what is simple and cannot do everything at the same time. The more highly developed this activity is, the more precisely will the idea of the object be translated into a simple or complicated visual idea. If the ability to do this is highly pronounced, the image will from the very beginning have ever simpler but more precise forms; or rather, the ideal image will already consist of *nothing* but simple and precise visual ideas.

As the figure, grasped as a visual impression, proceeds in this way into depth, the side views and eventually the rear view develop as necessary consequences.

One sees from this account of working in stone that the sculptor must proceed from an ideal image and translate its idea of form into a real kinesthetic idea.

In modeling of clay, by contrast, the kinesthetic ideas are rendered first; only then does it emerge how they work as a visual impression. The visual impression thus plays only the role of a critic: it has no influence over the initial idea of form. Once it is presented it becomes hostile to the initial idea. To alter this reality in order to form a clear visual idea is more difficult than to represent a fully matured idea.

Modeling in clay is of value in the study of nature, in the acquisition of kinesthetic ideas, and in furthering one's knowledge of form in general, but it does not develop the artistic unity of the whole as an image. For this a reverse process is preferable, one that starts from the visual and proceeds to the kinesthetic, or, in other words, starts from the idea evoked in the observer by the sculpture. The more developed and complete the visual idea is, the easier and simpler the work of representation becomes.

Sound artistic development clarifies the visual imagination so much that the process of representation and its material obstacles increasingly dwindle away. The imagination strives to reduce the image to its simplest factors so that the artistic representation has only these factors to offer. Therefore, a clear and simple method of presentation is proof of extensive practical experience. Such a method, once established, forces every beginner to compose and clarify his idea of the work accordingly and to reduce it to its simplest means of representation. His imagination necessarily develops *artistically* as he masters the presentational process; it *must* undergo the artistic metamorphosis. Herein lies the great significance of cutting directly in stone.

On the other hand, a purely technical facility with the chisel and the resulting ability to rework the stone in the so-called finishing stages of execution and treatment have nothing whatever to do with the intrinsic value of *free cutting* as discussed above.

We have seen that this method of cutting stone frees a figure from the block of stone in such a way that we still sense the block as a unity even though it has materially disappeared, for the high points combine in the exterior surfaces and still represent those surfaces. This method is therefore closely associated with the artistic metamorphosis of the idea of the sculpture as an object. The general law or the indispensable requirement of the artist's idea of the work is spatial unity. What is changing is the idea of the object. The wealth of objects that nature offers to the artist's idea of the object is endless, and the choice of an idea of an object depends on how suitable it is for a spatial unity. A work of art is therefore always a combination of these two elements, and artistic individuality is characterized by the way they are combined.

Michelangelo was the artist who, next to the Greeks, most relentlessly and logically developed his artistic imagination in relation to his representational process. In his work, imagination and representation are one and the same.

His work is characterized by the greatest possible utilization of the block of stone, within the most self-contained general appearance. His idea of the work as object constitutes the most compact spatial unity possible. He concentrates life as much as he can and avoids unanimated space whenever possible. The less of the stone block there is to cut away, the more concise, rich, and – one might say – imaginatively nourishing does the representational process become. All sweeping gestures and projecting limbs are avoided as rambling, and body movements arise in his compressed imagination that occupy as little space as possible without losing their force or energy: nothing but turning and bending in the joints, the body movements penetrate the torso as much as possible and compactly fill the space of the stone.

Thus Michelangelo's strongly pronounced feeling for a kind of spatial unity distanced him from all ordinary gestures because they could not be the most succinct expression of his needs; his idea of the work of art was explained and conditioned solely by artistic need.

He subjugated his corporeal imagination to this need with passionate consistency and thus created a new corporeal world. He extracted from nature a wealth of movements that previously had been given little or no attention. An endless vitality is poured into these, and his postures display the greatest variety within the smallest possible space. Thus we must see them as a lasting enrichment of the artistic imagination, directly related to a lasting simplification of the representational method and unification of space.

So crucial was this artistic viewpoint in the making of his figures that their gestures are inexplicable from any other perspective. The isolation and solitude of his consistent artistic conception distance his figures from every human tie and give them an unapproachable grandeur, even while they are

brought infinitely closer to the observer by the uncanny directness of their process of creation.

The artistic coherence of the appearance is so effective that the observer no longer thinks of movement in terms of inward motivation or expression of a narrative. The feeling for the natural gesture thereby disappears; and Michelangelo's successors, seeking to exploit these new possibilities of movement in dramatic terms, fell into highly affected and exaggerated gestures.

That Michelangelo and his predecessors could pursue this principle so single-mindedly and to such lengths is explained by the fact that their works were not intended for the open air but for enclosed spaces. Michelangelo's figures were neither silhouetted against the sky nor intended to be viewed from any great distance. Thus the clarity of his figures was not dependent upon the clarity of their silhouettes.

The open air and distant views were important to the Greeks, forcing them to a freer and looser arrangement of the parts.

Although their figures are always conceived and captured in a clear spatial unity, this unity never appears to be materially present because of the freer arrangement of the figures but is felt as a sense of unity in the act of perception. The idea of the work of art as object comes to life effortlessly in the spatial unity, and its perceived naturalness acquires a transfigured unity, in which neither of the two elements – object and unity – encumbers the other.

If we think of a work such as Michelangelo's *Madonna* in the Medici chapel, we here again find the entire cubic content as a material form in the most effortless way completely dissolved into a pure image so that all distinctions of time, circumstances, and individuality are reduced to nothing before the universal and eternal laws that govern and always will govern artistic creation.

1 Translator's note: to avoid misunderstandings, I shall stay with customary artistic usage and throughout use the word 'surface' [*Fläche*] to signify the mathematical term 'plane' [*Ebene*].

2 Rainer Maria Rilke

'Rodin – Book Two' 1907

As the German poet Rainer Maria Rilke (1875–1926) explains in his prefatory remark to this text, 'Rodin – Book Two' was originally delivered as a lecture. As such, he states, it is not only in keeping with a general contemporary interest in making art accessible to a new, willing and participatory public, but also directly reflects the voice, urgency and expressive character of his own ideas about Rodin's sculpture. Having met in 1902 and worked as a secretary to the sculptor until 1906, Rilke had acquired a good knowledge of the sculptor's work and career and, commissioned to write a monograph on Rodin's sculpture, was in an unusually good position to do so. Rilke's eloquent lecture/essay calls compellingly upon the visual and auditory imagination of his audience/readers from beginning to end, asking them to ruminate on the sound, memory and meaning of the word 'thing' and (in the absence of immediate visual illustration) to draw upon their mental image of Rodin's sculptures. Seven years after his exhibition at the 'Paris 1900 Exposition', Rodin had gained a reputation as possibly the most important artist of his time.

Things, in their most simple being, Rilke writes, still haunt the adult imagination, adding: 'you are seldom aware that you still need things, which like the things of your childhood, expect your confidence, your affection, your devotion'. This first section sets out Rilke's sculptural aesthetic and his understanding of the revolutionary aspects of Rodin's approach to sculpture through a highly personal invitation to the reader to imagine the inner workings of Rodin's creative process. He achieves this by subtly conducting, through his lecture, a form of journey in which the visual focus is gradually opened up and amplified from object to space – from thing to surfaces, to light, to space, and then from space to place, finally settling in what he casts as the ever-growing, ever-changing, self-generating and seemingly timeless environment of Rodin's sculpture studio. It is here that Rilke stops to ask himself: 'Why is this immense work continually growing and where will it end?... where are Rodin's things to go'? This question leads Rilke to tackle the issue of the destination of sculpture in the modern world. Rodin, he states, had to struggle against the essential homelessness of sculpture in an environment of impermanence and instability that made the monumental redundant. Thus he had to make sculpture regardless of any site: 'He long foresaw their homelessness... He raised the immense arc of his world above us and made it a part of Nature.'

Rainer Maria Rilke, 'Rodin – Book Two', in *Where Silence Reigns: Selected Prose*, New York: A New Directions Book, 1978, pp. 45–54 and 66–69 (full text: pp. 44–69). Translated by G. Craig Houston.

There are some great names which, if they were pronounced at this moment, would establish a friendship between us, a cordiality, a unanimity, which would make it seem as if I – only apparently isolated – were speaking from amongst you, my voice sounding from your midst as one of your voices. But the name which shines like a great five-starred constellation high above us this evening, cannot be spoken. Not now. It would bring unrest amongst you, would set in motion currents of sympathy and of hostility, whereas I need your tranquillity and the unruffled surface of your friendly expectation.

I beg those who are still able to do so to forget the name in question, and I require of all a still wider forgetting. You are accustomed to hear art spoken about, and who would conceal the fact that you give an ever readier reception to words which speak to you on that subject? A certain beautiful and vigorous movement, which could not be hidden any longer, has arrested your gaze like the flight of a great bird: and now you are asked to lower your eyes for the space of an evening. For it is not in that direction, not towards the firmament of uncertain developments, that I would turn your attention, not from the bird flight of the new art that I would prophesy to you. I am as one who would remind you of your childhood. No, not only of your own childhood, but of everything that ever was childhood. For my purpose is to awaken memories in you which are not yours, which are older than you; to restore connexions and renew relationships which lie in the distant past.

If my subject were personalities, I could begin where you have just left off on entering this room; breaking in upon your conversation, I would, without effort, share your thoughts – borne and swept along by this stirring age, on the shores of which all human interests seem to lie, washed by its waters and strangely reflected in them. But when I attempt to visualize my task, it becomes clear to me that it is not people about whom I have to speak, but things.

Things.

When I say that word (do you hear?), there is a silence; the silence which surrounds things. All movement subsides and becomes contour, and out of past and future time something permanent is formed: space, the great calm of objects which know no urge.

But no, you do not yet feel the silence falling. The word 'things' passes you by, it has no meaning for you: it means too much, all of which lacks significance. And so I am glad I have appealed to childhood; perhaps it will help me to bring home to you this word, as something precious linked with many memories.

If possible, out of practice and grown-up as your feelings are, bring them back to any one of your childhood's possessions, with which you were familiar. Think whether there was ever anything nearer to you, more familiar, more indispensable than such a thing. Whether everything else – except it – was not

capable of acting unkindly or unjustly towards you, of frightening you with pain, or confusing you with uncertainty? If, amongst your early experiences, you knew kindness, confidence and the sense of not being alone – do you not owe it to that thing? The first time you shared your little heart, as one shares a piece of bread which must suffice for two, was it not with a thing?

Later, in the legends of the saints, you found a holy joyfulness, a blessed humility, a readiness to be all things, qualities which were already familiar to you because some small piece of wood had once shown you them all, assuming and illustrating them for you. That small, forgotten object, willing as it was to represent any and every thing, made you familiar with thousands of things by filling a thousand roles, by being animal and tree, and king and child; and when it ceased to play its part, all these things were there. That something, worthless as it was, prepared the way for your first contacts with the world, introduced you to life and to people; and, more than that, its existence, its outward appearance, whatever it was, its final destruction or mysterious withdrawal from the scene caused you to know the whole of human experience, even to death itself.

You scarcely remember it, and you are seldom aware that you still need things which, like the things of your childhood, expect your confidence, your affection, your devotion. How does this happen? How does it come about at all that things are related to us? What is their history?

Things were made very early, with difficulty, after the pattern of natural things already existing; utensils and vessels were made, and it must have been a strange experience to see the made object as a recognized existence, with the same rights and the same reality as the thing already there. Something came into existence blindly, through the fierce throes of work, bearing upon it the marks of exposed and threatened life, still warm with it – but no sooner was it finished and put aside than it took its place amongst the other things, assumed their indifference, their quiet dignity, and looked on, as it were, from a distance and from out its own permanence with melancholy consent. This experience was so remarkable and so great that we can understand how things soon came to be made solely for its sake. For the earliest images were possibly nothing but practical applications of this experience, attempts to form out of the visible human and animal world something immortal and permanent, belonging to an order immediately above that world: a thing.

What kind of a thing? A beautiful thing? No. Who would have known what beauty was? A similar thing. A thing in which one recognized again what one liked, and what one feared, and what remained incomprehensible.

Do you remember such things? Perhaps there is one which for a long time seemed to you simply ridiculous. But one day you were struck by its urgency, the peculiar, almost desperate earnestness which all things possess; and did

you not notice how a beauty such as you would not have thought possible came over this thing almost against its will?

If you have experienced such a moment, I would now call it to my aid. It is the moment which restores things to their real life. For no object can affect you if you do not allow it to surprise you with an unimagined beauty. Beauty is always something added to that which is already there, and what that something is we do not know.

The fact that there existed aesthetic opinion, which believed itself capable of understanding beauty, has misled you and has produced artists who considered their vocation to be the creating of beauty. And it has not yet become superfluous to repeat that beauty cannot be 'made'. No one has ever made beauty. One can only create kindly or sublime conditions for that which sometimes dwells amongst us, an altar and fruits and a flame. The other is not in our power. And the thing itself which goes forth indestructible from human hands is like Socrates' Eros, is a daemon, is something between a god and a man, not in itself beautiful, but expressing pure love of and pure longing for beauty.

And now imagine how completely this idea must transform everything when it dawns upon a creative artist. The artist, guided by this knowledge, has no need to think of beauty; he knows as little as anyone else wherein it consists. Directed by his urge towards the realization of purposes far beyond him, he only knows that there are certain conditions under which beauty may consent to come to the things he makes. And his vocation is to learn to know those conditions and to acquire the power of producing them.

But whoever studies these conditions thoroughly learns that they do not pass beyond the surface and nowhere penetrate within; that all that one can do is to produce a definitely self-contained surface which is in no part accidental, a surface which, like that of natural objects, is surrounded by the atmosphere from which it receives its shadows and its lights, simply this surface, nothing else. Dissociated from all big-sounding, pretentious and capricious phraseology, art suddenly appears to take its place in the sober and inconsiderable life of every day, amongst the crafts. For what does it mean, to produce a surface?

But let us for a moment consider whether everything before us, everything we observe, explain, and interpret, does not consist simply of surfaces? And what we call mind and spirit and love: are these things not only a slight change seen on the small surface of our neighbour's face? And must not the artist, who would give us these in plastic form, keep to the tangible element which is in keeping with his medium, to the form which he can lay hold of and imitate? And whoever had the power of seeing and producing all forms, would he not (almost unconsciously) give us all spiritual emotion? Everything that has ever been called longing or pain or bliss or which, by reason of its inexpressible spirituality, cannot even be given a name?

For all happiness that has ever thrilled the heart; all greatness, even to think of which almost destroys us; every spacious, world-transforming idea: there was a moment when these were nothing but a pursing of the lips, the lifting of the eyebrows or the shadow on a brow: and this contour of the mouth, this line above the eyelids, this shadow on a face – perhaps they have previously existed in exactly similar form: as a marking on an animal, a fissure in a rock, a hollow in a fruit…

There is only one single surface which suffers a thousand changes and transformations. It was possible to think of the whole world for a moment under this conception, so that it became simple, and was placed as a task to be accomplished in the hands of the man who so thought of it. For the endowment of an object with life of its own does not depend on great ideas but upon whether out of such ideas one can create a *métier*, a daily labour, something that remains with one to the end.

And now I venture to say to you the name which cannot be withheld any longer: Rodin. You know it is the name of countless objects. You ask to see them, and I am confused because I cannot show you any of them.

But I seem to see one and another in your memory, and feel as if I could lift them out and place them here in our midst:

that man with the broken nose, unforgettable as a suddenly raised fist;

that youth, whose upward stretching is as near to you as your own awakening;

that walking figure, which stands like a new word for the action of walking in the vocabulary of your feeling;

and the man sitting, thinking with his whole body, withdrawing into himself;

and the burgher with the key, like some great receptacle containing only pain.

And Eve bending down as if from the distance into the embrace of her own arms, whose outward turning hands would ward off all things, even her own changing body.

And the sweet, soft, Inner Voice, armless as life within, and separated, like some member apart, from the rhythm of the group.

And some small thing whose name you have forgotten, made out of a white shining embrace which holds together like a knot; and that other thing, called, perhaps, Paolo and Francesca, and still smaller ones which you find within you like thin-skinned fruits.

and: now your eyes, like the lenses of a magic lantern, throw over and past me on to the wall a gigantic Balzac. The figure of a creator in his arrogance, erect in the midst of his own motion as in a vortex which catches the whole world up into this seething head.

And now that these things, taken from your memory, are present with us, shall I put beside them others from the many hundred things? That Orpheus, that Ugolino, that St. Theresa receiving the stigmata, that Victor Hugo with his commanding gesture, oblique and massive, and that other figure oblivious to all but the whispering voices, and still a third, to whom three maidens' voices from below are singing, like some source springing forth from the earth to greet him? And I feel the name vanishing in my mouth and feel that all this is simply the Poet, the same Poet who is called Orpheus when his arm, with a wide sweep embracing all things, is lifted to the strings, the same who, with convulsive anguish, clings to the feet of the fleeing Muse as she escapes; the same who, finally, dies, his face upright in the shadow of his voices which cease not to fill the world with song, and so dies that this little group is often known as *Resurrection*.

But who can keep back the surge of lovers which rises out beyond on the ocean of this man's work? With these figures relentlessly linked together there come destinies and sweet and comfortless names: but suddenly they vanish like a passing radiance – and we understand why. We see men and women, men and women, and again men and women. And the longer one looks, the more does even this content become simplified, and one sees: Things.

At this point my words lose their power of expression and revert to the great discovery for which I have already prepared you, the knowledge of the one surface, knowledge which placed the whole world at the disposal of this art. Placed it at its disposal, but did not yet bestow it. Infinite labour was necessary (is still necessary) before it could be appropriated.

Consider the labour entailed when the goal was to gain the mastery of all surfaces; for no one thing is like another. When the artists did not merely aim at knowing the body in general, the face, the hand (these things do not exist); but all bodies, all faces, all hands. What a task is this! And how simple and serious it is; devoid of fascination or promise; entirely unpretentious.

It implies a craft, but, as it seems, a craft for one who is more than mortal, so immense is it, so endless and without limit and so dependent upon a never-ceasing apprenticeship. And where was to be found a patience which should be equal to such a labour?

It was found in the love of this incessant worker, in which it was constantly renewed. For that is, perhaps, the secret of this master, namely, that he was a lover whom nothing could withstand. His desire was so lasting and passionate and uninterrupted that all things capitulated: the things of nature and the enigmatic things of all ages, in which human feeling sought to be a part of Nature. He was not satisfied with those which commanded ready admiration. He wanted to learn admiration in all its phases. He appropriated the difficult, reticent things, carrying them like a burden, the weight of which forced him

further and further into his craft. Under their pressure it must have become clear to him that with objects of art, just as with a weapon or a balance, what matters is not the outward appearance and the 'effect' thereby produced, but that far more important is good workmanship.

This quality of workmanship, this conscientiousness of execution, was everything. To reproduce a thing meant to have made oneself familiar with every part, to have hidden nothing, overlooked nothing, nowhere to have used deceit; to know all the hundred profiles, to be familiar with it from every angle, from above and from below. Only then did the thing exist, only then did it become an island separated on all sides from the continent of the uncertain.

This work (the work of the *modelé*) was the same in everything one made, and had to be carried out so humbly, so obediently, so devotedly, so impartially on face and hand and body that no specified parts remained and the artist worked at the form without knowing what exactly would result, like a worm working its way from point to point in the dark. For who remains uninfluenced when confronted with forms which have definite names? Who does not exercise power of selection when he calls something face? But the creative artist has no right to select. His work must be permeated by a spirit of unvarying obedience. The forms must pass through his fingers untampered with, like something entrusted to his keeping, if they are to appear pure and intact in his work.

And that the forms in Rodin's work are: pure and intact; without questioning he transmitted them to his works, which, when he leaves them, seem never to have known human touch. Light and shadow grow soft about them as about fresh fruit, and more alive with movement, as if brought hither by the morning wind.

Here we must speak of movement; not, indeed, in the sense in which it has so often been mentioned with reproach; for the mobility of the gestures, which has attracted much attention in this sculpture, takes place within the things, like the circulation of an inner current, never disturbing the architectural calm and stability. The introduction of movement into plastic art would have been nothing new. What is new is the kind of movement which light has been made to impart by means of the peculiar treatment of the surfaces, the inclines of which are so manifoldly varied that light flows from them now slowly, now in a cascade, appearing now shallow and now deep, gleaming or dull. The light which falls on one of these things is no longer any light, is no longer accidental in any of its effects; the thing takes possession of it and uses it as something of its own. This acquisition and appropriation of light, as the result of a quite clearly defined surface, was recognized by Rodin to be an essential characteristic of plastic objects. The antique and the Gothic had, each in its own way, sought a solution of this problem of plastic art, and he placed himself in line

with the most ancient traditions when, at this stage in his development, he strove to master the problem of light.

There actually exist marbles which have their own light, such as the bowed countenance resting on the block in the Luxembourg Museum, *La Pensée*. It leans so far forward as to become shadowy, and the white shimmer of the marble above which it rests is such that under its influence the shadows melt and pass into a transparent *clair-obscur*. And who does not remember with delight one of the smaller groups in which two bodies create a twilight, in the veiled softness of which they meet? And is it not remarkable to see the light passing over the recumbent back of the Danaïde, slowly, as if the hours scarcely caused it to advance? And did anyone know of that complete gamut of shadows reaching to the shy transparent darkness which we see sometimes about the navel in certain small antiques, and which we now only find in the hollow of curved rose-leaves?

Such developments – difficult to express in words – mark the advance in Rodin's work. With the conquest of light began the next great achievement, to which his things owe their appearance of largeness, a largeness independent of all measurement. I refer to the conquest of space.

Once again things came to his aid, as so often before, things outside in nature and isolated things in art of noble origin, to which he returned constantly to question them. Their answer was invariably a conformity to law, with which they were filled and which he gradually came to understand. They revealed to him a mysterious geometry of space from which he learnt that if an object was really to take its place in space, to be recognized there, as it were, in its cosmic independence, its contours must be arranged in the direction of certain planes inclining towards each other.

It is difficult to express precisely what this knowledge was. But in Rodin's work we can see how he applied it. With ever increasing decisiveness and assurance the given details are brought together in strongly marked surface-units, until finally they adjust themselves, as if under the influence of rotating forces, in a number of great planes, and we get the impression that these planes are part of the universe and could be continued into infinity.

There is the *Youth of Primitive Times*, standing as if in an enclosed space; about *John* this space widens in all directions; *Balzac* is surrounded by the whole atmosphere, but a number of headless figures, in particular the tremendous new version of the *Man walking*, seem to pass into a sphere far beyond us, into infinite space, amongst the stars, into a vast, unerring rhythm of the spheres.

[...]

I was passing through the vast workshops, lost in thought, and I noticed that

everything was in a state of growth and nothing was in a hurry. There stood the *Thinker*, in bronze, mightily concentrated within himself, completed; but he was part of the still growing complexity of the *Gate of Hell*. There was one of the monuments of Victor Hugo, advancing slowly towards completion, still under observation, still liable perhaps to alteration, and further off stood the other versions still incomplete. There lay the Ugolino group, like the unearthed roots of an ancient oak, waiting. There was waiting the remarkable monument for Puvis de Chavannes with the table, the apple-tree, and the glorious spirit of eternal peace. And over yonder was what I took to be a monument for Whistler, and this recumbent figure here will, perhaps, some day make famous the grave of some unknown person. One can scarcely make one's way through it all, but finally I arrived back at the small plaster cast of the *Tour de Travail*, which, now that its design has reached its final form, only awaits a patron who will help to set up the immense lesson of its imagery in the midst of men. But here beside me is another work, a quiet face to which belongs a hand expressive of suffering, and the plaster has that transparent whiteness which only Rodin's instrument can impart. On the stand has been written, and already crossed out, the provisional legend: *Convalescente*. And now I find myself amongst objects all of which are new and nameless and still in the process of growth; they were begun yesterday or the day before or years ago; but they show the same unconcern as the others. They keep no count of time.

And then I asked myself for the first time: how is it possible they are indifferent to time? Why is this immense work continually growing and where will it end? Does it think no more of its master? Does it really believe itself to be in the hands of Nature, like the rocks over which a thousand years pass as one day?

And it seemed to me in my amazement that all the finished works would have to be cleared out of the workshops, so what remained to be done in the ensuing years might be seen. But while I was counting the many finished works, the shimmering stones, the bronzes, all these busts, my eye was caught by the lofty *Balzac*, which had returned to the studio, rejected, and now stood there proudly, as if refusing to leave it again.

And since that day I see the tragedy of the immensity of this work. I feel more clearly than ever before that in these works sculpture has developed continuously to such power as has not been known since the ancients. But this plastic art has been born into an age which possesses no things, no houses, no external objects. For the inner life of which this age consists is still without form, intangible: it is fluid.

This man had to lay hold of it; he was at heart a giver of form. He has seized upon all that was vague, ever-changing, developing, which was also within himself; and enclosed it in form and set it up like a god; for change has its god

also. As if one had stopped the flow of molten metal and let it harden in one's hand.

Perhaps the opposition which his work everywhere encountered is, in part, explained by his use of force. Genius is always a cause of alarm to its own age; but here, where genius outstrips our age not merely in things spiritual but also in its powers of concrete realization, its effect is terrible, like a sign in the heavens.

One might almost be persuaded that there is nowhere any place for these things. Who will venture to receive them? And are they not themselves the confession of their own tragedy, these radiant things which, in their loneliness, have drawn the heavens about them? And which now stand there beyond the power of any building to control? They stand in space. What have they to do with us?

Imagine a mountain rising up within an encampment of nomads. They would leave it and depart on account of their flocks. And we are a nomad people, all of us; not because we have, individually, no home, beside which we stay and at which we work, but because we have no longer a common home. Because we must always carry what we have of greatness about with us, instead of setting it up from time to time where greatness is.

And yet, wherever there is real human greatness, it desires to shelter within universal nameless greatness. When once again, after the ancients, greatness at last burst forth from men in sculptured figures, from men who were also nomads in spirit and filled with change – how it flung itself upon the cathedrals, taking refuge in the vestibules and climbing doorways and towers, as at a time of inundation.

But where are Rodin's things to go?

Eugène Carrière once wrote of him, 'Il n'a pas pu collaborer à la cathedrale absente.' There was no place where he could collaborate and nobody worked with him.

In the houses of the eighteenth century and in its well-ordered parks he saw sorrowfully the last outward appearance of the inner life of an age. And patiently he discovered in it the marks of that union with nature which has since been lost. With ever increasing insistence he drew attention to it, counselling us to return 'à l'œuvre même de Dieu, œuvre immortelle et redevenue inconnue'. And he was referring to those who would come after him when, looking at the landscape, he said: 'Voilà tous les styles futurs.'

His works could not wait; they had to be made. He long foresaw their homelessness. The only choice he had was to destroy them while yet within him, or to win for them the sky which is about the mountains.

And that was his work.

He raised the immense arc of his world above us and made it a part of Nature.

3 Medardo Rosso

'Impressionism in Sculpture – an explanation' 1907

In this *Daily Mail* newspaper article the Italian sculptor Medardo Rosso (1858–1928) sets out his case for 'impressionism in sculpture', referring at once to his working practice and to a more general phenomenon of the period. He explains his conception of impressionist sculpture, firstly from the position of the artist or viewer encountering his work, and secondly from a historical point of view, providing a brief list of precedents that support his account of sculpture's aims. Nothing, Rosso states, is separated from its surroundings. The human eye takes in what it sees all at once, in one rich and surprising first impression. Impressionist sculpture thus aims to re-enact this initial moment, recreating its suggestive momentary life. In theory, spontaneity is everything for him and there is no need whatsoever for dry measurements and calculations that merely take the life out of what is an experience rather than a physical thing. In practice, Rosso's sculptural endeavours involved an elaborate engagement with sculptural materials and with the processes of casting.

Rosso espouses the creation of a sculpture of visual and emotional impact, and stresses that the impact of such sculpture on the viewer is similarly immediate and two-dimensional. He argues that there is no need to walk around his sculpture, since there are actually no artificially constructed 'in-the-round' viewpoints to take in. Rosso's sculpture is thus for the eye, not the hand: it does not need to be touched to be appreciated, but to be looked at and sympathetically pondered standing directly in front of it. Rosso begins his article by stressing the centrality of light in the envisioning of sculpture and concludes with a discussion of how early examples of coloured and painted sculpture failed to account for and harness this crucial sculptural element: 'When the artist applied himself to the painting of his statue, at this very moment he recognised his impotence and the weakness of his work.'

Medardo Rosso, 'Impressionism in Sculpture – an explanation', *Daily Mail*, London, 17 Oct. 1907. Reprinted in *Mostra di Medardo Rosso 1858–1928*, Milan: Palazzo della Permanente, 1979, pp. 68–70, and *Medardo Rosso 1858–1928*, Frankfurt: Frankfurter Kunstverein, Steinernes Haus am Römerberg, 1984, pp. 56–58.

Light being of the very essence of our existence, a work of art that is not concerned with light has no right to exist. Without light it must lack unity and spaciousness – it is bound to be small, paltry, wrongly conceived, based necessarily upon matter.

Nothing in this world can detach itself from its surroundings, and our vision – our impressions, if you prefer the term – can only be the result of mutual relations or values given by light, and must have the dominating tonality seized at a glance.

There is another point which has never yet been spoken of, and which, nevertheless, is of enormous importance; it is that at the first moment of looking spontaneously at any object in nature, we experience a displacement of tonalities, a broadening of the thing before our eyes; before our spirit – an effect that changes after this first moment. The reason is that after this first flash our eyes, our mind, take back their habits of laziness and thus destroy that first moment of real life, of the complete vision, during which we experience a transposition of the values which, though materially in front, seem to be forced back, and vice versa. But though all this is sharply accentuated at the first moment, it is none the less true that it is still visible at any later moment.

The colour of sculpture.

The real visual truth of anything that meets our eye in nature can only strike us with full force in that short moment when the vision breaks upon us, as it were, as a surprise – that is to say, before our intellect, our knowledge of the material form of objects, have had time to come into play and to counteract and destroy that first impression. Is not the truth of the first impression, charged as it is with poetry and suggestiveness, infinitely more significant than that other truth, which is based on our accumulated knowledge of dry facts? Art is an emotional language; and mathematical accuracy does not lend itself to the expression of our emotions.

Thus we have before us a colour perspective wholly different from the other traditional and material perspective; and I claim that we need not and should not follow the method of the catalogued celebrities who have measured, and are still measuring, the first plan and second plan, and follow the material facts of form.

There is no more need to walk around a work in clay, or wood, or bronze, or marble, than there is to walk around a work on canvas; and thus conceived, a work of sculpture will be infinitely suggestive, intimately alive, homogeneous and grand.

On the other hand, every work that is built up of different parts, composed, and invented, becomes small, paltry, untrue, and material. How could it be otherwise when it is known that even to-day such and such a celebrity enlists the collaboration of mechanical workers to manufacture here one portion, there another, of a material mass which is in this case so justly described as a 'statue' – the expression of the negation of life. Is it possible that a work of art is not the property of an idea, and that any hand but that whose owner has conceived this idea should be able to express it?

A work of sculpture is not made to be touched, but to be seen at such or such a distance, according to the effect intended by the artist. Our hand does

not permit us to bring to our consciousness the values, the tones, the colours – in a word, the life of the thing. For seizing the inner significance of a work of art, we should rely entirely on the visual impression and on all the sympathetic echoes it awakens in our memory and consciousness, and not on the touch of our fingers.

Where the Greeks failed.

And note how the preoccupation with colour asserts itself even at a very remote epoch – how in the later Greek and Roman days works of sculpture are composed of marbles in different colours, and how the statues themselves are coloured! What does this signify, unless it means that the artist realised that his work did not produce the effect he had intended. And do you think he would have had to resort to such means if, before executing his work, he had painted it in his mind, with due consideration of the relations of tone values and of light? When the artist applied himself to the painting of his statue, at this very moment he recognised his impotence and the weakness of his work.

Further back still, the Egyptians were far greater. They needed not to have recourse to such small means, because they aimed above all at a certain harmony, at a general effect, and because they considered the play of light. Thus they succeeded in giving their works a grand unity and made them dominate the space. Even in their intentionally decorative spirit they make us forget matter.

Of the Macedonians, in the first Greek period, I will only mention one example: the tomb in the gallery of the casts by the brothers Keller at the Louvre – you will be forced to recognise in it the preoccupation with the impression, the intuition of life, and the neglect of matter. And much nearer to us, it is the same with the German Gothics, as opposed to the works of the Italian Renaissance, which by comparison become material. And this is only natural, since the Renaissance was but the outcome of the late Greek and Roman periods. And finally, if I may extend the argument to works upon canvas, those of you who, like myself, have seen Velázquez's *Infanta* in the Salon Carré of the Louvre, cannot have failed to notice how all the works by which it is surrounded become to a certain extent mere pictures, while it alone seems to enter into the very spirit of creation.

4 Wilhelm Worringer

from *Abstraction and Empathy* 1908

The critic and cultural theorist Wilhelm Worringer (1881–1965) begins *Abstraction and Empathy* by asserting that the popular theory of empathy, as advanced by Theodor Lipps and others, fails to account for 'wide tracts of art history' due to its having missed the non-empathetic force that he calls 'the urge to abstraction'. He radically questions the way that a non-western or pre-Renaissance art is criticised for being 'inorganic' and therefore 'lifeless' because of a lack of interest in mimesis. Inorganic art, Worringer argues, should not be so readily dismissed. Borrowing from the Austrian art historian, Alois Riegl, he argues instead that styles that seem based on inorganic, 'crystalline' formations and therefore not on life processes (Byzantine art, for example, or Egyptian monumental sculpture) are as they are, not because they are lacking in sophistication, but rather because they are based on an entirely different but equally valid 'abstract artistic volition'.

Worringer's argument struck a strong chord with contemporary artists and critics who were advocating an abstract or anti-naturalistic modern art, and became an important point of reference for the early modernist aesthetic forming at the time. Not only were his ideas very much in accord with a widespread investment in non-western, so-called primitive art; they were also, as the following extract shows, especially applicable to sculpture – the art form where Worringer felt that the negative take on 'eradication of depth' particularly needed to be challenged. In the extract below (from the 'Practical Section' of *Abstraction and Empathy*), Worringer seems to be speaking to contemporary sculptors as much as passing historical comment. He suggests, for example, that the 'original' abstract volition with its 'laws of the inorganic', might be called upon to raise the organic 'into a timeless sphere, to eternalise it'. His example is Adolf Hildebrand who, while impressed by principles of empathy, also emphasized flatness over roundness and thereby energized his still traditional reliance on organic form. Worringer's 'urge to abstraction', however, seems more directly pertinent to the work of later artists such as Henri Gaudier-Brzeska, Jacob Epstein and Eric Gill, whose work clearly departed from the 'bourgeois naturalness' targeted by Worringer's argument. The 'unnaturalness' lost in the wake of the Renaissance is for Worringer a matter of 'deep regret', suggesting that for a new generation of sculptors and sculpture theorists the urge to abstraction would be something to resurrect and develop.

This excerpt is taken from Chapter Four of Worringer's book, entitled 'Selected examples from Architecture and Sculpture from the viewpoints of Abstraction and Empathy'. Wilhelm Worringer, *Abstraction and Empathy: A Contribution to the Psychology of Style* (1908), (trans. Michael Bullock), London: Routledge & Kegan Paul, 1948, rpt. 1963, pp. 81–90.

Before we now turn to sculpture, we must remind the reader of the principle which we sought to lay bare in the theoretical section. In agreement with Riegl we made the assertion that the artistic volition of the ancient cultural peoples impelled them to approximate the artistic representation to a plane, because in the plane the tactile nexus was most strictly preserved and because, for this reason, the sought after depiction of external things in their closed material individuality was most readily given expression within the plane. The way in which this surface principle dominates art is shown pre-eminently by Egyptian art, especially Egyptian relief. But the history of Greek relief, whose significance and decisive role have been grossly underestimated, because sculpture in the round has received exclusive attention, also shows how representation in the plane was chosen not in answer to dictates from without, but for its own sake, because it was in the closest conformity with the artistic volition. Indeed, it may be said that the original and most immediately appropriate mode of expression for the Greek artistic volition was the relief. It is true that consistent pursuit of this representation in the plane was relaxed simultaneously with the naturalistic animation of archaic rigidity; shadows and foreshortening were admitted, but this tendency to relaxation never went so far as to deprive the single form of its material individuality by the introduction of free space and, in conjunction with it, of perspective. This development is reserved rather for the Post-Christian epoch. This is not what concerns us here however. Rather let us seek, under these premises, to do justice to Antique, and especially archaic and archaicising Greek sculpture from a fresh point of view. We shall here advocate the standpoint, which may appear paradoxical, but which follows clearly from the presuppositions, that round-sculptural representation is a type of art which is due to external conditions and runs counter to the original abstract artistic volition, whereas the kind of art that arises out of the original abstract artistic volition is precisely representation in the plane.

And here it is only monumental sculpture that comes under consideration. Miniature sculpture naturally serves better for the satisfaction of an imitative play impulse that rejoices in symbols and upon whose productions other demands are made than upon a work of art. Nevertheless, the stylistic elements of monumental sculpture can also be demonstrated in miniature sculpture, even though they do not find there an equally forceful expression.

In the great monumental art then, the demand for round-sculptural representation appears as an inhibitive factor for the authentic artistic volition. That is to say: where external circumstances and conditions demanded round-sculptural representation, the problem was one of overcoming the resistances arising out of this demand; in other words, of carrying out the principles of the artistic volition, despite this resistance. We shall discuss in a moment the

way in which this will was able to force its way through. It may however be noted in anticipation that it is in this original incompatibility of round-sculptural representation with the dictates of an artistic volition directed toward the abstract, toward eternalisation, that the reason must be sought for the phenomenon that all sculpture in the round bears most strongly the marks of a so-called stylisation. Because, with its three-dimensionality, which at once draws it into relativity and the unclarity of appearances, it threatens to escape from that urge to eternalisation which is contained at varying degrees of strength in every artistic volition, it has to be eternalised with all the more vigorous external means. It is relatively simple to wrest the things of the outer world from the flux of happening and to render them perceptible *per se* in their material individuality and closed unity by projecting them onto a plane surface; but the means of sculpture in the round are ill-adapted to this aim, for in truth a free-sculptural representation occupies just as lost and arbitrary a position in the world-picture as its natural model, which the artist has simply tried to eternalise in stone. Naturally he seeks to achieve this eternalisation along another route than by simply translating the model into an indestructible material. Where he contents himself with this latter procedure he ends up with a lump of stone, but no work of art.

The means that were found of bridging or suppressing the inevitable contradiction between round-sculptural representation and abstract tendencies to eternalisation, constitute the history of the evolution of the idea of sculptural style. Two main factors in this process can be most easily picked out. There arose the postulate to give a different form of expression to the notion of material individuality, which had otherwise been attained only through the tactile nexus of the plane surface. This came about through the attempt to preserve this impression of unity and the tactile nexus as far as possible by the compactness of the material and its undivided corporeality. This fundamental law of sculpture has remained unchanged from the earliest archaic statues to Michelangelo, Rodin and Hildebrand. For there is, in principle, no difference between an archaic statue and one of Michelangelo's tomb-figures. In the former the figure seems to grow laboriously out of a column, the arms adhere closely to the body, as far as possible all division of the surface is avoided and divisions that are unavoidable are either intimated in a general way only or else merely painted on, in order to achieve the maximum impression of material compactness. In contradistinction to this, with Michelangelo the compactness of matter is rendered perceptible not from without, but from within. In his case the strictly terminal limits of matter are not factual but imaginary, yet we are nonetheless clearly conscious of them. We cannot touch them, but we feel them with their cubic compactness. For it is only under the invisible pressure of this cubic compactness that the dynamism of Michelangelo's formal language

acquires its superhuman grandeur. Within a closed cubic space a maximum of movement; here we have one of the formulas of Michelangelo's art. This formula comes alive for us when we recall the incubus, the oppressive dream, that lies over all these figures, the tormented, impotent desire to tear oneself free, which lifts every creation of Michelangelo's spirit into a realm of profound and gigantic tragedy. Thus whereas the compactness of matter is physically tangible in the archaic figure, with Michelangelo we feel only the invisible cubic form in which his figures pursue their existence. The goal is the same in both, however, namely to approximate the representation to material individuality and closed unity.

The artistic materialists naturally failed to see these deeper causes of the genesis of sculptural style; they explained all constraint by the resistance of the material. They were never struck by the absurdity of the idea that the chisel which exactly hacked out the face of an archaic figure, or the minute decorations of its vestments, should not have possessed the ability to separate the arms or the legs from the body and give these limbs some sort of support. Why put such a simple explanation, which is so illuminating to sound commonsense, to the test? To be sure, a fleeting glance at Egyptian sculptures would already have revealed the untenability of such a thesis. That the Egyptians had acquired an easy mastery over material is shown by the statues of the secular art of the Old Empire, which have been sufficiently admired for their realism – the village mayor, the brewer etc. And at the same time the statues in the court style, that is the authentic monumental art, exhibit an undividedness of form and a severity of style as great as any archaic statue. Something else must, therefore, have contributed to this style than technical incompetence, as the artistic materialists would have us believe. Riegl says: 'We have no wish to deny the fact that a progressive development has taken place since Egyptian art, but a protest must be raised against the belief that this development was one of technical ability. In pure technical ability, i.e. in the mastery of raw materials, the Egyptians were superior to their successors right up to the present day' (*Spätrömische Kunstindustrie*).

After this digression we will repeat the first postulate of sculptural artistic volition: tactile compactness of material. We shall acquaint ourselves with the second postulate at once. It is entirely in concord with the course of development which we formulated theoretically in Part One when Collignon says in his history of Greek sculpture: 'The first symbols of the Godhead, the so-called aniconic images, irrespective of whether they were carved out of wood or stone, were purely geometrical in form; they can be reduced to a few very simple types. Such were the basic elements from which, in the course of development, the first Greek statues proceeded. They still make their presence felt in the archaic statue and in the homely votive offering modelled out of clay.' According to

this then, the first symbols of the Godhead were pure abstractions, without any resemblance to life. It was clear that as soon as a real natural model was found worthy of being rendered in monumental sculpture, the attempt was made to approximate this rendering to the former pure abstraction. Let the reader recall how, in Part One, we sought to define the work of art of early epochs, in so far as a natural model underlay it, as a compromise between the urge to abstraction and the very necessity of reproducing the natural model. And let him compare with this definition Schmarsow's statements in his chapter on monumental sculpture: 'Every inflection of the strictly geometric figure, every approximation to the forms of the plant or animal world softens and weakens the ruthless clarity of the monumental tectonic and carries the figures involved over into the conditions of growth and life, i.e. of temporality. The representation of organic creatures seems to stand in incompatible contradiction to this abstract eternalisation of existence in the crystalline body. The figure of an organic growth already proclaims manifold relationship, betrays in every member the conditionality of growing and withering. The mobility of organisms opposes all interpretation as fixed form. How far removed is the living individual from the absolute closedness of the regular body, and yet the project is undertaken of separating the values of existence from those of life and eternalising that element in the organic growth which can be rendered as a permanent component in rigid material. Forcible accommodation to the framework of cubic forms is the first maxim of this monumental endeavour, once the artist has become conscious that it is a matter not of imitating reality, not of representing the living creature in its actions and activities, in its relation to nature, but, on the contrary, of abstracting the constant, of transcribing the living into the immobile, rigid, cold and impenetrable – of recreating it in another, an inorganic nature' (*Grundbegriffe der Kunstwissenschaft*, Chapter XVI). Here too then the compromise character of the sculptural work of art is clearly underlined.

To call for aid upon the laws of the inorganic in order to raise the organic into a timeless sphere, to eternalise it, is a law of all art, but exceptionally so of sculpture. This embellishment of the organic with the inorganic may take place in a variety of ways. The one that lies closest to hand is forcibly to press the forms into tectonic values, to enclose them as it were in a tectonic regularity, within which their authentic life is suppressed. Heinrich Brunn, in his *Kleine Schriften*, undertook a highly remarkable initial attempt to make tectonic style in Greek sculpture and painting the object of a detailed investigation. He characterises the evolution of Greek monumental sculpture as a conquest of the schematico-mechanical (i.e. the abstract-regular) by the organico-rhythmic 'and if, in the process, the tectonic principle does not lose the regulating influence which it previously exercised as an educating medium, it nevertheless

withdraws, outwardly, further and further into the background, and continues to operate only more or less unconsciously and in secret' (*Kleine Schriften*, Munich, 1905). Thus the Greeks soon abandoned this forcible accommodation to the framework of cubic forms, and sought to overcome the abstract-regular by the organic-regular, dead geometric form by the rhythm of the organic. Their happy natural endowment, the joyousness that characterised their feeling for life, pointed out this route to them. The sculpture of other peoples recoiled from such enlivenment and an Egyptian would certainly have been incapable of appraising the organic beauty and harmony of a Classical statue, and would perhaps have turned away in arrogant disdain from such trifling.

In forcible accommodation to regular cubic forms, in the tectonic constraint of the figures, organic values were outwardly transposed into the world of the inorganic. This takes place in a more subtle and inward manner through the incorporation of sculpture into architecture. Here tectonic constraint is not direct, but indirect. The same principle has come to be employed in a diverse fashion. Sculpture is totally absorbed in another organism of the highest regularity. Now if this architectonic regularity is of an organic kind, as in Greek architecture, the constraint within which sculpture lives also has an organic effect, as for instance in the figures of a pediment; if, on the contrary, it is of an inorganic kind, as in Gothic, the figures are drawn into the same inorganic sphere. In the latter as in the former case, however, they lose the arbitrariness and lack of clarity which adheres to round-sculptural representation, in that, as though conscious of their relativity, they fasten onto a system of regular structure extraneous to themselves. Maximum compactness of material, forcible compression of the object into geometrical or cubic regularity: these two laws of sculptural style are to be found at the inception of all sculptural art and remain more or less determinant throughout the whole course of its evolution; because sculpture, as already stated, is, through its three-dimensionality, least able to dispense with so-called stylisation and therefore, of all the arts, bears the most distinct marks of the need for abstraction.

A third postulate, which is closely bound up with the first and is in reality merely a consistent development of it, was fulfilled only by those peoples whose artistic volition was entirely subject to the principle of abstraction. This postulate was to cause the cubic construction to give the effect of a plane surface, i.e. to work over the sculptural construct in such a way that the visual image created in the spectator the illusion of a surface representation, instead of three-dimensional reality. This tendency found expression in an outward, direct manner with the Egyptians, in an internalised, indirect one for example with Hildebrand.

We will call to mind the principles propounded in Hildebrand's *Problem der Form*. There he states: 'As long as a sculptural figure makes itself felt

primarily as cubic it is still in the initial stage of configuration; only when it creates an impression of flatness, although it is cubic, does it acquire artistic form. Only through the consistent implementation of this relief interpretation of our cubic impressions does the representation gain its sacred fire, and the mysterious benison that we receive from the work of art rests upon it alone.'

5 Umberto Boccioni

'Technical Manifesto of Futurist Sculpture' 1912

This manifesto, written by Umberto Boccioni (1882–1916), represents one of the most energetic, imaginative and articulate calls for the renewal of sculpture published in the first decades of the twentieth century. Boccioni was a painter as well as a sculptor, deeply preoccupied with the legacy of impressionism, and with how futurist sculpture might be made to supersede the achievements of Rosso, Meunier, Rodin and Bourdelle. As an Italian, he also felt the oppressive and 'anachronistic' weight of the classical tradition, arguing (like many of his contemporaries) that modern sculpture could only develop if it turned its back on Greco-Roman and Renaissance norms. In this manifesto, Boccioni targets sculpture's traditional privileging of the female nude, the heroic monumental statue and the 'nobility' of marble and bronze in particular. Sculpture, he argues, should have a subject matter that is subtly and sensitively in tune with the spirit and ideas of modern times, and not be imbued with the rhetoric and storytelling of yesteryear. It should employ whatever means and materials necessary to articulate this close relationship with the real world, and open up the sculpted figure to create a 'sculpture of environment'. Describing his vision as 'physical transcendentalism', Boccioni espouses a sculpture that simultaneously projects itself into space and into surrounding objects, so that it acts as a medium of intersection, a nodal point of connection that both absorbs and penetrates the world around it. He imagines that in such sculpture 'the sidewalk can climb up on your table and that your head can cross the street while your table lamp suspends its spider web of plaster rays of light between one house and another'. The linear and architectonic character of this description, with its collapse of scale, distance and perspective, coupled with its articulation of an enigmatic urban moment, are very telling. Together these features show Boccioni's interest in combining the complicated psychology and flux of modern urban life with a contemporary sculptural rendition.

Boccioni was killed in battle in 1916 at the age of thirty four, leaving behind a relatively small body of work and writing. Seen alongside the writings of Marinetti, Balla and Carrà, Boccioni's work demonstrates the central role he played in articulating the movement's radical ambitions. Futurist manifestos, defiantly setting out their positions not only in regard to art but also lust, noises and smells, appeared in exhibition catalogues, in the press, in journals (such as *Lacerba*, based in Florence) and in leaflets, as was the case here.

Umberto Boccioni, 'Technical Manifesto of Futurist Sculpture', *Poesia*, Milan, 11 April 1912. Translated by Robert Erich Wolf. This translation first appeared in: Ester Coen, *Umberto Boccioni*, New York: The Metropolitan Museum of Art, Harry N. Abrams, 1988, pp. 240–43.

The sculpture in the monuments and exhibitions of every single city of Europe offers such a pitiable spectacle of barbarisms, stupid clumsinesses, and monotonous imitation that my Futurist eye turns away with profound disgust!

What dominates in every country's sculpture is the blind and dull-witted imitation of the formulas inherited from the past, an imitation encouraged by the double cowardice of slavish submission to tradition and of getting by with the least effort. In the Latin countries we have the infamous heavy hand of Greece and Michelangelo, something endured with a certain seriousness of mind in France and Belgium but with grotesque imbecilism in Italy. In the Germanic countries we have an insipid Hellenizing, pseudo-Gothic ragbag, cranked out on an industrial scale in Berlin or sapped of all backbone by the effeminate finicking of the German professorial lot in Munich. In the Slavic countries, on the other hand, one finds a confused collision between the creatures of archaic Greece and monsters spawned in the Nordic lands and the East: a formless accumulation of influences that range from the excess of abstruse details typical of Asia to the infantile and grotesque inventiveness of Laplanders and Eskimos.

In all these manifestations of sculpture, but also in those with a somewhat greater breath of innovative daring, the same ambiguity is perpetuated: The artist copies the nude and studies classical statuary with the naive conviction that he will be able to light on a style that somehow fits the way people feel nowadays, yet without straying ever so little from the traditional conception of sculptural form: a conception, with its famous 'ideal of beauty' that everyone speaks of on bended knee, and that simply never breaks away from the period of Phidias and its subsequent decadence.

And it is all but inexplicable that the thousands of sculptors who continue from generation to generation to turn out their silly puppets have, so far, not asked themselves why the sculpture halls are visited with boredom and even revulsion (when they are not simply deserted), and why monuments are inaugurated in all the public squares of the world amid either incomprehension or general hilarity.

Nothing of the sort happens with painting. Thanks to its continual renewal, slow as it may be, painting stands as the most crystal-clear condemnation of the plagiaristic and sterile work of every single sculptor of our epoch!

Somehow the sculptors simply must convince themselves of this absolute verity: To go on constructing and trying to create with Egyptian, Greek, or Michelangelesque elements is like trying to draw water with a bottomless bucket from a dried-up well!

There can be no renewal whatsoever in art if its very essence is not renewed, that is, the vision and conception of the line and of the masses that give form to the arabesque. It is not merely by reproducing the outward aspects of contem-

porary life that art can become the expression of its own time. Yet sculpture, as it has been understood so far by the artists of the last and present centuries, is a monstrous anachronism!

Sculpture has not progressed because of the very limited field allotted to it by the academic concept of the nude. An art that has to undress a man or woman to the buff in order even to begin to act on our feelings is a dead art! Painting, however, has been given a transfusion of fresh blood, has deepened and broadened itself by letting the landscape and surroundings act simultaneously on the human figure or on objects, arriving by those means at our Futurist *compenetration of planes* (*Technical Manifesto of Futurist Painting*, April 11, 1910). Sculpture likewise will find a new fountainhead of emotion, and therefore of style, but only when it extends its plasticity to what our barbarous primitiveness has made us consider, up to our day, as subdivided, impalpable, and consequently not expressible through three-dimensional means.

As point of departure we must proceed from the central nucleus of the object we wish to create, and from that basis discover the new laws – that is, the new forms – that link it invisibly but mathematically to the *visible plastic infinite* and to the *inner plastic infinite*. That new plastic art will therefore involve translating the atmospheric planes that link and intersect things into plaster, bronze, glass, wood, and any other material one may wish. This vision, which I have called *physical transcendentalism* (lecture on Futurist painting at the Circolo Artistico in Rome, May 1911), is capable of rendering in three-dimensional forms the attractions and mysterious affinities that create the reciprocal influences that give form to the planes of the objects represented.

Sculpture must therefore make objects come to life by rendering their prolongation into space perceivable, systematic, and three-dimensional: No one can still doubt that one object leaves off where another begins and that there is nothing that surrounds our own body – bottle, automobile, house, tree, street – that does not cut through it and slice it into cross-sections with an arabesque of curves and straight lines.

There have been two attempts at a modern renewal of sculpture: one decorative and concerned with style, the other simply plastic – sculptural – and having to do with material as such. The first remained anonymous and disorganised. It lacked any overall technical and coordinating spirit, and overly bound up as it was with the economic demands of the building trades, it produced no more than pieces of traditional sculpture more or less decoratively synthesized and framed within architectural or decorative motifs or moldings. All the buildings and houses constructed with a claim to modernity provide examples of such efforts carried out in marble, cement, or metal plaques.

The second attempt was more inventive, less commercially restricted, and more poetic, but it was also too isolated and piecemeal. It lacked the synthesiz-

ing thinking behind it that could impose an overall principle. And this because, when embarking on a process of renewal, it is not enough to believe with all one's heart: one needs to set up and champion some norm that will mark out clearly the path to be taken. I am alluding to the genius of Medardo Rosso, to an Italian, to the only great modern sculptor who has sought to open a vaster field to sculpture by rendering in three-dimensional art the influences of an environment and the atmospheric links that bind it to the subject.

Of the three other great contemporary sculptors, Constantin Meunier has brought absolutely nothing new to the sculptural sensibility. His statues are almost always masterly fusions of Greek heroics with the athletic humbleness of the longshoreman, sailor, miner. His plastic and constructional approach to sculpture in the round or in low relief is still tied to the Parthenon or the classical hero, though he did attempt for the very first time to create and impart an air of divinity to subjects that had been disdained or left to the cheap sort of realistic reproduction.

Bourdelle brings to the sculptural block a virtually irascible severity of feeling for abstractly architectonic masses. A passionate, stern, sincere, creative temperament, he is unfortunately incapable of liberating himself from a certain archaic influence and from that other, anonymous influence of the swarm of stonecarvers of the Gothic cathedrals.

Rodin is possessed of a vaster spiritual and intellectual agility which permits him to move from the Impressionism of his Balzac to the irresolute expressions of his Burghers of Calais and to all his other sins committed in the name of Michelangelo. He brings to his sculpture a wayward inspiration, a grandiose lyrical impetus, and these would be well and truly modern had Michelangelo and Donatello not had them, in virtually identical forms, four hundred years ago, and if Rodin himself had used them to put life into a reality conceived in entirely new fashion.

Thus in the work of these three great geniuses we have influences from different periods: Greek in Meunier, Gothic in Bourdelle, Italian Renaissance in Rodin.

Medardo Rosso's work, on the contrary, is revolutionary, utterly modern, more profound though, necessarily, limited. No heroes or symbols stir his works, but the plane of a woman's or child's forehead suggests a liberation into space that, when the history of the human spirit comes to be written, will be understood as of greater importance than has been recognized in our time. Unfortunately the Impressionistic approach he has been trying out has limited Rosso's efforts to a kind of high or low relief, which shows that he is still conceiving the figure as a world in itself, on a traditional basis and with storytelling intentions.

Medardo Rosso's revolution, for all its great importance, is rooted in an

outwardly pictorial concept and neglects the problem of a new construction of planes. The sensual modeling with the thumb is meant to imitate the lightness of Impressionist brushwork and does convey a feeling of lively intimacy. Unfortunately, however, it requires a rapid execution working directly from life, and this deprives a work of art of a feeling of universal creation. Which means that it has the same merits and defects of pictorial Impressionism, and if our own aesthetic revolution grew out of that movement's efforts and explorations, it has carried them further and is moving, instead, to the opposite pole.

In sculpture as in painting there can be no renewal except through seeking the style of movement, that is, through rendering systematic and definitive – thus, synthesizing – what Impressionism offered as fragmentary, accidental, and consequently analytical. And it is out of precisely that systematization of the vibrations of lights and of the interpenetration of planes that Futurist sculpture will come into being. The basis of that new sculpture will be architectonic, not only as regards construction of masses but also because the sculptural block will contain within itself the architectonic elements of the sculptural environment in which the subject has its existence.

The natural result will be a *sculpture of environment*.

A Futurist sculptural composition will contain within itself the kind of marvelous mathematical and geometric elements that make up the objects of our time. And these objects will not be disposed alongside the statue as explanatory attributes or separate decorative elements but, in accord with the laws of a new conception of harmony, will be embedded in the muscular lines of a human body. Thus the wheel of some piece of machinery might project from a mechanic's armpit; thus the line of a table could cut right through the head of a man reading; thus the book with its fan of pages could slice the reader's stomach into cross-sections.

Traditionally the statue is clearly cut out and its form stands out against the atmospheric background of the setting in which it is displayed. Futurist painting, for its part, has gone beyond that conception of the rhythmical continuity of lines in a figure and of the figure as something isolated from the background and from the *invisible enveloping space*. 'Futurist poetry,' according to the poet Marinetti, 'after having destroyed traditional meter and created free verse, is now destroying syntax and phrases and sentences constructed in the Latin manner. Futurist poetry is an uninterrupted spontaneous flow of analogies, each summed up intuitively in the essential noun.' Whence, 'unfettered imagination and words in liberty.' Balilla Pratella's Futurist music shatters the tyrannical regular succession of rhythmic beats.

Why should sculpture have to lag behind, fettered by laws no one has the right to impose on it? Let us overturn the whole lot of them, then, and proclaim *the absolute and total abolition of the finite line and of the statue complete in*

itself. Let us fling open the figure and let it incorporate within itself whatever may surround it. We proclaim that the environment must become part of the sculptural block conceived as a world in itself and with its own laws; that the sidewalk can climb up on your table and that your head can cross the street while your table lamp suspends its spider web of plaster rays of light between one house and another.

We proclaim that the entire visible world must come sweeping down on us, become one with us, and thereby create a harmony whose only guiding principle will be creative intuition; that a leg, an arm, or an object – in themselves unimportant except as elements of the sculptural rhythm – can be abolished altogether, not in imitation of a Greek or Roman fragment but so as to fit the harmony the author himself aims to create. A sculptural entity, in the same way as a painting, can only resemble itself, because figures and things must have their existence in art over and beyond the logic of what objects look like.

Which means that a figure can have one arm clothed and the other bare, and the various lines of a vase of flowers can play a nimble game of tag between the lines of a hat and a neck.

And it means that transparent planes, panes of glass, sheets of metal, wires, street lamps, or indoor electric lights can indicate the planes, tendencies, tones, semitones of a new reality.

And it means too that a new intuitive coloring of white, gray, black can intensify the emotional force of the planes, while the introduction of a colored plane can violently accentuate the abstract significance of the sculpture itself.

What we have said about *force-lines* in painting (preface – manifesto to the catalogue of the First Futurist Exhibition in Paris, October 1911) is no less pertinent to sculpture where the dynamic force-line can bring life to the static line of a muscle. In that line of muscle, however, the straight line will predominate because it is the only one that matches the inner simplicity of the synthesis we counterpose to the outward baroque effect that results from analysis.

But the straight line will not induce us to imitate the Egyptians, primitives, and savages, as an occasional modern sculptor has done in a desperate attempt to free himself from the Greeks. Our straight line will be alive and palpitating, will lend itself to all the necessities of the infinite expressions of matter, and its fundamental naked severity will symbolize the severity of steel in the lines of modern machinery.

We can, to end with, affirm that in sculpture the artist should not shrink from any or every means that might help achieve a *reality*. No fear is more stupid than that which makes us afraid of straying even ever so little from the strict confines of the art we practice. There is no such thing as painting,

as sculpture, as music, as poetry: There is only one creation! And so if a sculptural composition suggests the need for a special rhythmic movement that might reinforce or contrast with the rhythm fixed within the *sculptural whole* (something indispensable in any work of art), one can attach to it some sort of contrivance that could impart an appropriate rhythmic movement to the planes or lines.

We should not forget that the pendulum and rotating spheres in a clock, that the movement of a piston in and out of a cylinder, that the meshing and unmeshing of two cogwheels with the continuous appearing and disappearing of their little steel rectangles, that the fury of a flywheel, or the whirling of a propeller are all plastic and pictorial elements that a Futurist work of sculpture should exploit to the full. The opening and closing of a valve creates a rhythm no less beautiful but infinitely newer than that of an animal's eyelid!

CONCLUSIONS:

1. To proclaim that sculpture aims at the abstract reconstruction of planes and volumes that determine forms and not at what they may be meant to represent figuratively

2. To abolish in sculpture, as in every other art, the traditional 'sublimity' of the subject matter

3. To deny that sculpture should in any way aim at reconstructing real-life episodes, while affirming instead the absolute necessity of utilizing any and every element of reality itself as means to return to the essential factors that account for plastic sensibility. Thus, by thinking of bodies and their parts as plastic zones, we will introduce into a Futurist sculptural composition planes made of wood or metal, immobile or set into motion mechanically, as means of characterizing an object: hairy spherical forms to stand for heads of hair; semi-circles of glass for a vase; iron wires and netting for an atmospheric plane; etc., etc.

4. To destroy the merely literary and traditional 'nobility' attributed to marble and bronze. To deny that a single material has to suffice for the entire construction of a sculptural ensemble. To assert that even twenty different materials can be used together in a single work where the purpose is to arouse plastic emotion. We enumerate a few of these: glass, wood, cardboard, iron, cement, horsehair, leather, cloth, mirrors, electric lights, etc., etc.

5. To proclaim that in the intersection of the planes of a book with the corners of a table, in the straight lines of a match, in a window frame, there is more truth than in all the tangles of muscles, in all the full breasts and bulging buttocks of the heroes or Venuses that inspire our present-day sculptural idiocy

[39]

6. That it is only out of an utterly modern choice of subjects that we can arrive at the discovery of new plastic ideas

7. That the straight line is the only means that can lead to the primitive virginity of a new architectonic structuring of sculptural masses or zones

8. That no renewal can be looked for except through the sculpture of environment, because that is the only approach through which sculpture will develop, prolonging itself into space so as to shape and model space itself. Which means that, from today on, even clay can be used to model the atmosphere that surrounds all things

9. The thing as we create it is nothing less than the bridge between the external plastic infinite and the internal plastic infinite, and so objects never come to an end in themselves but intersect with infinite combinations arising out of either attraction or collisions

10. The urgent task is to destroy the systematic recourse to the nude, the traditional concept of the statue and the monument!

11. And therefore we must refuse, courageously, any and every commission, no matter how lucrative, which does not by its nature involve a pure construction of sculptural elements that have been completely rethought and renewed.

6 Guillaume Apollinaire

'Duchamp-Villon' 1913

Guillaume Apollinaire (1880–1918) was a hugely influential supporter of modern art in Paris in the first two decades of the twentieth century, and a leading figure in cubist circles. Although he had a strong interest in non-western and particularly African art, the majority of his writings focused on recent developments in painting, rather than on sculpture. The work of contemporary sculptors (including Rosso, Archipenko, Laurens, Modigliani, Brancusi, Boccioni and Lipchitz) did get a brief mention in his writings, but this article on the work of Raymond Duchamp-Villon represents his most sustained and thoughtful consideration of modern sculpture.

What excited Apollinaire about the sculpture of Duchamp-Villon (one of Marcel Duchamp's brothers) was its intriguing relationship to architecture. Apollinaire sees in his work the potential for re-envisioning a lost, large-scale, functionless architecture. This new kind of architectural sculpture would not employ sculptors as decorators, but as formulators of new monumental, sculptural projects. What matters, and has always mattered to sculptors and architects, he concludes characteristically, is light, 'incorruptible light'. Apollinaire's idea here has much in common with Adolf Loos's anti-decorative notion of the 'Denkmal' (discussed in his essay 'Architektur', 1909) as an abstract, sculptural and architectural monument. Apollinaire's article was published at the end of his 1913 book, *Méditations esthétiques: les peintres cubistes*. It came out in the same year that Duchamp-Villon's sculpture was exhibited in the Armory Show in New York, and that he took part in the 'Maison Cubiste' project exhibited at the *Salon d'Automne* in Paris. The 'Maison Cubiste' project was a collaborative endeavour, co-ordinated by André Mare, to create a cubist house. Duchamp-Villon made a plaster model of the house and designed some of the architectural reliefs inside. His work for this project provided the immediate, sculptural context for Apollinaire's article.

Guillaume Apollinaire, 'Duchamp-Villon', *Méditations esthétiques: les peintres cubistes*, Paris: Eugène Figuière, 1913. Translated and introduced by Peter Read, and republished in Guillaume Apollinaire, *The Cubist Painters*, London: Artists Bookworks, 2002, pp. 81–84.

As soon as sculpture departs from nature it becomes architecture. The study of nature is more important for sculptors than for painters, as one can easily imagine a painter who has abandoned nature entirely. Indeed, however committedly they may study nature and even copy it, the new painters no longer consider appearances to be in any way sacred. Only certain conventions, freely accepted by viewers, have made it possible to establish the relationship

between particular paintings and real objects. The new painters have rejected those conventions and some of them, rather than going back to observing the conventions, have deliberately included real elements, completely foreign to painting, in their pictures. For them, as for the writer, nature is a pure spring from which they can drink without any fear of being poisoned. It saves them from the decadent intellectualism which is art's greatest enemy.

Sculptors, on the other hand, can stay faithful to natural appearances (and there are many who have done so). By applying colour, they can make their works completely lifelike. They can, however, obtain more than surface appearances from nature and, like the Assyrians, the Egyptians or African and Oceanian sculptors, they can imagine, magnify or reduce forms which, though instilled with powerful aesthetic life, must always be legitimised by nature itself. Respect for this essential condition of sculpture is what legitimises Duchamp-Villon's works. He has only ever chosen to leave this position in order to work directly on architecture.

* * *

Whenever its elements are not legitimised by nature, sculpture becomes architecture. Whereas pure sculpture must necessarily have a practical end in view, one can perfectly easily conceive of architecture being as removed from practical considerations as music, the art which it most closely resembles. The Tower of Babel, the Colossus of Rhodes, the statue of Memnon, the Sphinx, the Pyramids, the Mausoleum, the Labyrinth, Mexico's sculpted blocks of stone, obelisks, menhirs etc., triumphal or commemorative columns, triumphal arches, the Eiffel Tower – the whole world is covered with monuments more or less devoid of any practical purpose, or at least quite disproportionate to any purpose they were originally intended for. The Mausoleum and the Pyramids are indeed too big to be tombs and so have no practical justification. Columns, even if, like Trajan's Column or the Place Vendôme column, they are meant to commemorate historic events, are just as impractical because as your eye travels up towards the top you can hardly see the details of the historic scenes they represent. Could anything be more useless than a triumphal arch? And the use the Eiffel Tower has been put to was only thought of after it had been built for no practical purpose.

* * *

Nowadays, however, our sense of architecture has been lost to such an extent that the idea of a monument with no useful purpose appears extraordinary, and almost monstrous.

On the other hand, people happily accept a sculptor making a work without any practical justification, this despite the fact that when sculpture lacks a function it becomes ridiculous.

Whether it be the statue of a hero, or a sacred beast, or a divine being, the practical purpose of sculpture is to represent illusory appearances. This artistic imperative has been understood since time immemorial and explains the anthropomorphic nature of the gods, for the human form is what can be most easily legitimised from nature while allowing the greatest scope to the artist's imagination.

As soon as sculpture stops being portraiture, it becomes no more than a decorative technique for intensifying architecture (with lamps, allegorical garden statues, balustrades, etc.).

* * *

The utilitarian ambitions of most contemporary architects explain why architecture has fallen behind the other arts. The architect and the engineer should aim to build sublimely – to raise the highest tower, to prepare for ivy and passing time a ruin more beautiful than any other, to span a port or a river with an arch more daring than the rainbow, ultimately to compose a lasting harmony, the most powerful that man has ever imagined.

* * *

Duchamp-Villon has this titanic view of architecture. To him, as a sculptor and architect, nothing matters but light, and for all the other arts too, nothing matters but light, incorruptible light.

7 Carl Einstein

from *African Sculpture* 1915

The German writer and art critic Carl Einstein (1888–1940) started visiting Paris regularly from about 1910 onwards. There he met cubist artists through an old school friend, the dealer Daniel-Henry Kahnweiler, and pursued his growing interest in African art, collecting images for book plates. Einstein's reputation, built on his 1912 novella *Bebuquin* and on lectures about modern art given to the circle around the journal *Die Aktion*, was consolidated by the impact of *African Sculpture* (*Negerplastik*), with its radical subject matter and strident aesthetic argument. Einstein's was the first European account to place African objects within the framework of 'high' art, particularly striking given the classical resonances of the German term 'Plastik'. His use of illustrations (with no information about the sculptures reproduced) reinforced this radical approach to his subject, distancing it from the existing anthropological treatments of such material.

As African art in this period largely lacked detailed supporting information about its production, Einstein's strategy was to view it mainly in terms of form and spatial articulation, using ideas derived from the sculptural theories of Hildebrand and also Heinrich Wölfflin, some of whose lectures he had attended at university. By implicitly referring to cubism (via the 'cubic'), Einstein also connected the striking handling of form and apparent bodily distortions in African figures and masks to the work of European sculptors, pre-empting Kahnweiler's own emphases on modern sculpture's use of space and volume, as well as his rejection of classical proportions in depicting the human figure. Both African and modern western art, in this respect, could break free from sculpture's traditional reliance on a viewing audience to complete its effects, having their own autonomous presence. But Einstein's study did also include some quasi-anthropological insights to support his argument, pointing for example to the worship of 'idols' in the dark, where any visual sculptural effect would be rendered irrelevant, and thus implying a potentially equivalent cult-like status for modern, especially cubist, art. Einstein is sometimes exclusively thought of as proto-modernist theorist *par excellence* through this text, but this is a little misleading: a second book on African sculpture published in 1921 included much more anthropological information and called for a more stringent art-historical engagement with it. He was also to have close involvement with the surrealists and would later write a polemic against a purely abstract art.

Carl Einstein, *Negerplastik*, Verlag der weißen Bücher, Leipzig, 1915. Translated by Joachim Neugroschel. This translation is also printed in Jack Flam and Miriam Deutch (eds), *Primitivism and Twentieth-Century Art: A Documentary History*, Berkeley: University of California Press, 2003, pp. 79–89 (complete text: pp. 77–91.)

THE PAINTERLY

The European's usual failure to appreciate African art parallels its stylistic power; after all, this art constitutes a significant instance of three-dimensional viewing.

We may state that European sculpture is filled with painterly surrogates. In Hildebrand's *Problem der Form* (Problem of Form) we have the ideal balance of painterly and sculptural. Before Rodin, French sculpture, remarkable as it may be, seems to aim at wiping out the sculptural. Even frontality, normally regarded as a strict 'primitive' purification of form, has to be taken as a painterly treatment of the cubic [i.e., solid, three-dimensional]; for frontality sums up the three-dimensional on multiple levels, which suppress the cubic. After all, the parts closest to the viewer are accentuated and arranged in surface planes, while the more distant parts are seen as an incidental modulation of the front surface which is dynamically weakened. Here, the artist emphasizes the motifs that are concretely placed in front.

In other cases, the artist replaced the cubic with an objective equivalent of motion; or else, using a drawn or modeled motion of form, he whisked away the decisive component, the immediate expression of the third dimension. Even perspective efforts are harmful to the process of sculptural viewing. Thus we easily understand why the necessary and determined borderline between relief and free-standing sculpture has been fading since the Renaissance, and the painterly excitement, playing around the cubic material (the mass), has transcended any three-dimensional formal structure. As a result, it was painters and not sculptors who delved into crucial issues of three-dimensionality.

Given these formal tendencies, it is clear why our art had to undergo a thorough blending of painterly and sculptural (Baroque). This development could end only with the total defeat of sculpture, which, attempting at least to preserve the maker's excitement and convey it to the viewer, had to be entirely impressionistic and painterly. The three-dimensional was eliminated; the personal 'script' carried the day. This history of form was necessarily beholden to a psychological process. Artistic conventions seemed paradoxical; harmony was embodied in an utterly intense creator and, accordingly, in an utterly stimulated viewer; the dynamics of individual processes won out; they became essential and were dwelled on and strongly highlighted. The decision was placed in the prelude and afterward, the work turned increasingly into a guide for psychological excitement; the individual flow, cause, and effect were fixated. These sculptures were more like confessions of a genetic development as objectified forms, more like the lightning-fast contact of two individuals; the dramatics of the judgment passed on works was often considered more

important than the art itself. Every precise canon of form and viewing had to be resolved.

A more and more intense development of the sculptural was striven for, a later multiplication of the methods. The actual lack of the sculptural could not be made up for by that 'realistic' legend of the 'palpated' model; instead this very legend confirmed the absence of a thorough and uniform conception of space.

Such action destroys the distance of things and allows only for the functional meaning that they preserve for the individual. This kind of art signifies the potential accumulation of as great a functional effect as possible.

In several recent artistic efforts, we have seen that this potential component, the viewer, was made virtual and visible. A very few European styles diverged from this – especially the Romanesque–Byzantine, but its Oriental origin has been demonstrated; and equally well known is the rather swift transformation into movement (Gothic).

The viewer was woven into the sculpture, becoming an inseparable function (e.g., perspective sculpture); he united with the predominantly psychological reevaluation of the maker's person if he did not contradict that person by judging him. Sculpture was the subject of a conversation between two people. A sculptor oriented along those lines had to be interested mainly in predetermining the effect and the viewer; in order to anticipate and test the effect, he obviously had to turn himself into the viewer (Futurist sculpture), and the sculptures have to be seen as a 'transliteration' of the effect. The spiritual and temporal components fully outweighed the spatial determinant. In order to achieve the – albeit often unconscious – goal, the artist would establish the identification of viewer and maker, for this was the only way to obtain an unrestricted effect.

This state of affairs is marked by the fact that the artist usually sees the effect on the viewer as a reversal of the creative process even though the effect is characterized as nonintense. The sculptor submitted to the majority of spiritual processes and transformed himself into the viewer. While working he would always maintain the detachment of the future viewer and he would model the effect; he emphasized the viewer's visual activity and modeled in touches, so that the viewer himself would shape the actual form. Spatial construction was sacrificed to a secondary, indeed alien feature: material motion. Cubic space, the premise of all sculpture, was forgotten.

Just a few years ago we experienced the impact of a new crisis in France. Through a tremendous exertion of consciousness we realized how nonfunctional and dubious this process was. Several painters had enough strength to avoid a handiwork that slid mechanically further; detached from the usual means and methods, they investigated the elements of viewing space, the

things that this viewing produces and dictates. The results of this important effort are sufficiently well known. At the same time, Europeans logically discovered African sculpture and realized that this art, in isolation, had cultivated the pure sculptural forms.

Normally the efforts of these painters are described as 'abstraction,' though we cannot deny that it was only through a rigorous critique of the muddled terminology that Europeans managed to approach a direct grasp of space. Yet we must approach this direct grasp, which powerfully separates African sculpture from the art that it affects and which gives it an awareness: what looks like abstraction in Europe is an immediate and natural given in Africa. In formal terms African sculpture will prove to be the most powerful realism.

Today's artist not only seeks pure form, he also regards it as the opposition to his prehistory, and he weaves extreme reactiveness into his striving; his necessary criticism intensifies the analytical component.

RELIGION AND AFRICAN ART

African Art is, above all, religious. The Africans, like any ancient people, worship their sculptures. The African sculptor treats his work as a deity or as the deity's custodian: from the very outset, he maintains a distance from his work because this work either is or contains a specific god. The sculptor's work is adoration from a distance, so that the work is, *a priori*, autonomous and more powerful than its maker, especially since the latter devotes his utmost intensity to the sculpture; thus, as the weaker being, he sacrifices himself to it. His labor must be described as religious worship. The resulting piece, as a deity, is free and independent of everything else: both worker and worshiper are at an immeasurable distance from the work. The latter will never be involved in human events except as something powerful and distanced. The transcendence of the work is both determined by and presumed in religiosity. It is created in adoration, in terror of the god, and terror is also its effect. Maker and worshipper are *a priori* spiritual, that is, essentially identical: the effect lies not in the artwork but in presumed and undisputed godliness. The artist will not dare to vie with the god by striving for an effect; the effect is certainly given and predetermined. It makes no sense to treat such an artwork as striving for an effect since the idols are often worshipped in darkness.

The artist produces a work that is autonomous, transcendent, and not interwoven with anything else. This transcendence is manifested in a spatial perception that excludes any possible action by the viewer; a completely drained, total, and unfragmentary space must be given and guaranteed. Spatial self-containment does not signify abstraction here; it is an immediate sensation. This is guaranteed only if the cubic is achieved totally – that is,

if nothing can be added to it. Any activity by the viewer is entirely omitted. (To achieve something similar, religious painting is confined to the pictorial surface; thus, it cannot be approached in decorative or ornamental terms, which are secondary consequences.)

I have said that the three-dimensional must be complete and undiminished. The contemplation is determined by religion and fortified by the religious canon. This determination of the viewing leads to a style that, rather than submitting to any arbitrary individualism, is dictated by the canon and may be altered only by religious upheavals. The viewer often worships the works in darkness; while praying he is entirely absorbed in and devoted to the god, so that he can scarcely affect, much less even notice, what sort of artwork this is. The situation is the same when a king or chieftain is depicted; indeed, a divinity is contemplated, even venerated in a common man's artwork; this too determines the work. An individual model or portrait has no place in such an art – or at most as a profane subsidiary art that can barely elude the religious practice of art, or that contrasts with it as less essential and unprestigious. The work is treasured as the prototypical embodiment of the worshipped power.

A feature of African sculpture is the strong autonomy of its parts; this too is determined by religion. An African sculpture is oriented not toward the viewer but in terms of itself; the parts are perceived in terms of the compact mass, not at a weakening distance. Hence, they and their limits are reinforced.

It also strikes us that most of these works have no pedestal or similar support. This absence might come as a surprise since the statues are, by our norms, extremely decorative. However, the god is never pictured as anything but a self-sufficient being, requiring no aid of any kind. And he has no lack of pious, adoring hands when he is carried about by the worshipper.

Such an art will seldom reify the metaphysical, which is taken for granted here. The metaphysical will have to be manifested entirely in the complete form, concentrated in it with amazing intensity. That is to say, the form is treated thoroughly in terms of extreme self-containment. The result is a great formal realism; for nothing else can release the forces that exist as immediate form rather than becoming form through abstraction or reactive polemics. (The metaphysical in today's European artists still hints at the previous critique of the painterly and is involved in representation as an objective and formal essence; this completely challenged the absoluteness of religion and art and their rigorously staked-off correlation.) Formal realism, not construed as imitative, mimetic naturalism, has an inherent transcendence, for imitation is impossible: whom could a god imitate, to whom could he submit? The result is a consistent realism of transcendent form. The artwork is viewed not as an arbitrary and artificial creation, but rather as a mythical reality, more powerful

than natural reality. The artwork is real because of its closed form; since it is autonomous and extremely powerful, the sense of distance is bound to produce an art of enormous intensity.

The European artwork is subject to emotional and even formal interpretation, in that the viewer is required to perform an active visual function, whereas the African artwork has a clear-cut goal, for religious reasons beyond the formal ones. The African artwork signifies nothing, it symbolizes nothing. It is the god, and he maintains his closed mythical reality, taking in the worshipper, transforming him into a mythical being, annulling his human existence.

Formal and religious self-containment correspond to one another – as do formal and religious realism. The European artwork became the metaphor of the effect that challenges the viewer to indulge in casual freedom. The religious artwork in Africa is categorical and has a precise existence that defies restriction.

For the artwork to have a delimited existence, every time-function must be omitted; that is, one cannot move around or touch the artwork. The god has no genetic evolution; this would contradict his valid existence. Hence, without using relief (which shows a nonporous and nonindividual hand), the African has to find a representation that instantly expresses itself in solid material. The spatial viewing in such an artwork must totally absorb the cubic space and express it as something unified; perspective or normal frontality is prohibited here – they would be impious. The artwork must offer the full spatial equivalent. For it is timeless only if it excludes any time-interpretation based on ideas of movement. The artwork absorbs time by integrating into its form that which we experience as motions.

VIEWING CUBIC SPACE

Any conceptual debate, no matter how deeply rooted in the act of viewing, becomes autonomous and refrains from expressing all divergences of artistic events in order to maintain its specific structure.

First of all, we have to examine the formal visual quality on which African sculpture is based. We can fully ignore the metaphysical correlative since we have pinpointed it as an autonomous factor, and we know that an abstracted form must have resulted from religion.

We then have to clarify the formal viewing process expressed in this art. We will avoid the mistake of ruining African art by unconsciously recalling any European art form, since for formal reasons African art presents itself as a sharply defined area.

African sculpture presents a clear-cut establishment of pure sculptural vision. Sculpture that is meant to render the three-dimensional is taken for

granted by the naive viewer, since it operates with a mass that is determined as a mass in three dimensions. This task appears to be difficult, indeed almost impossible, for instance, when we realize that not just any spatiality, but rather the three-dimensional, must be viewed as *form*. When we think about it, we are overwhelmed with almost indescribable excitement; this three-dimensionality, which is not taken in at one glance, is to be formed not as a vague optical suggestion, but rather as a closed, actual expression. European solutions, which seem makeshift when tested on African sculpture, are familiar to the eye, they convince us mechanically, we are accustomed to them. Frontality, multiple views, overall relief, and sculptural silhouette are the most common devices.

Frontality almost cheats us of the third dimension by intensifying all power on one side. The front parts are arranged in terms of a single viewpoint and are given a certain plasticity. The simplest naturalist view is chosen: the side closest to the viewer, orienting him, with the aid of habit, in terms of both the object and the psychological dynamics. The other views, the subordinate ones, with their disrupted rhythms, suggest the sensation that corresponds to the idea of three-dimensional motion. The abrupt movements, tied together mainly by the object, produce a conception of spatial coherence, which is not formally justified.

The same holds true for the silhouette, which, perhaps supported by perspective tricks, hints at the cubic. At closer inspection, we see that the silhouette comes from drawing, which is never a sculptural element.

In all these cases, we find painting or drawing; depth is suggested, but it is seldom given immediate form. These procedures are based on the prejudice that the cubic is more or less guaranteed by the material mass and that an inner excitement circumscribing the material mass or a unilateral indication of form would suffice to produce the cubic as a form. These methods aim at suggesting and signifying the sculptural rather than actually carrying it out. Yet this cannot be accomplished in this way, since the cubic is presented as a mass here and not immediately as a form. Mass, however, is not identical with form; for mass cannot be perceived as a unity; these approaches always involve psychological acts of motion, which dissolve form into something genetically evolved and entirely destroy it. Hence the difficulty of fixing the third dimension in a single act of optical presentation and viewing it as a totality; it has to be grasped in a single process of integration. Which, however, is form in the cubic.

Clearly, form must be grasped at one glance, but not as a suggestion of the objective; anything that is an act of motion must be fixed as absolute. The parts situated in three dimensions must be depicted as simultaneous; that is, the dispersed space must be integrated in a single field of vision. The three-dimensional can be neither interpreted nor simply given as a mass. Instead, it

has to be concentrated as specific existence, which is achieved as follows: the thing that lets us see in three-dimensional terms and that is felt normally and naturalistically to be movement is shaped as a formally fixed expression.

Every three-dimensional point in a mass is open to endless interpretation. This alone makes it almost impossible to achieve an unequivocal goal, and any totality seems out of the question. The very continuity of the relationships of that point merely dashes any hopes of a specific solution – even though we may like to think that we can suggest a unified impression in the gradual, slowly guided process of the functioning of that point. No rhythmic arrangement, no relationship based on drawing, no multiplicity – however rich – of movement can delude us into thinking that the cubic is not immediate and not gathered into a unified form here.

The African seems to have found a pure and valid solution to this problem. He has hit on something that may initially strike us as paradoxical: a formal dimension.

The conception of the cubic as a form (sculpture must contend with that alone and not with a material mass) compels us to define just what that is. It is the parts that are not simultaneously visible; they have to be gathered with the visible parts into a total form, which places the viewer in a visual act and corresponds to a fixed three-dimensional contemplation, producing the normally irrational cubic as something visibly formed. The optical naturalism of Western art is not an imitation of external nature. Nature, passively copied here, is the viewer's standpoint. This is how we understand the genetic evolution, the unusual relativism of most of our art. European art was adjusted to the viewer (frontality, perspective); and the creation of the final optical form was left more and more to the actively participating viewer.

Like our conceptual ability, form is an equation; this equation is considered artistic when it is grasped as absolute, as unrelated to anything outside it. For form is the complete identity of the visual process with individual realization; in terms of their structure, these two fully coincide and do not relate to one another as a general concept and an individual instance. Viewing may cover multiple cases of realization, but it does not have a greater reality than those instances. It therefore follows that art constitutes a special case of unconditional intensity, and that the quality must be created in it as undiminished.

The task of sculpture is to bring forth an equivalent absorbing the naturalist sensations of movement – and thus the mass – in their entirety and transforming their successive differences into a formal order. This equivalent has to be total, so that the artwork may be felt not as an equivalent of human tendencies directed elsewhere, but rather as something unconditionally self-contained and self-sufficient.

The dimensions of usual space are counted as three, whereby the third, a dimension of movement, is merely counted but not investigated as to its nature. Since the artwork gives form to that which has a specific nature, this third dimension is split in two. We think of motion as a continuum that, while changing space, encloses it. Since fine art fixates, this unity is divided, that is, conceived of in opposite directions; it thereby contains two entirely different directions, which, say, in the mathematician's infinite space, remain quite insignificant. In sculpture, the depth direction and the forward tendency are completely separate ways of creating space. Their disparity is not linear; rather, these are excellent formal distinctions, if they are not melded impressionistically – that is, under the influence of naturalistic concepts of movement. It follows from this that sculpture, in a certain sense, is discontinuous, especially since it cannot do without contrasts as an essential device for fully creating space. The cubic should not be veiled as a secondary suggestive relief and therefore should not be introduced as a materialized relationship; instead, it has to be highlighted as intrinsic.

The viewer of a sculpture readily believes that his impression combines viewing with a conception of the deeper-lying parts; because of its ambiguity this effect has nothing to do with art.

We have stressed that sculpture is a matter not of naturalistic mass, but only of formal clarification. Hence, the nonvisible parts, in their formal function, have to be depicted as form; the cubic, the depth quotient (as I would like to call it), has to be depicted on the visible parts as form; to be sure, only as form, never blending with the objective, the mass. Hence, the depiction of the parts cannot be material or painterly; instead, they must be presented in such a way as to become sculptural – a way that is naturalistically rooted in the act of motion, fixed as a unity and visible simultaneously. That is to say: every part must become sculpturally independent and be deformed in such a way as to absorb depth, because the conception, appearing from the opposite side, is worked into the front, which, however, functions in three dimensions. Thus, every part is a result of the formal presentation, which creates space as a totality and as a complete identity of individual optics and viewing, and also rejects a makeshift surrogate that weakens space, turning it into a mass.

Such a sculpture is firmly centered on one side, since the latter undistortedly offers the cubic as a totality, as a resultant, while frontality sums up only the front plane. This integration of the sculptural is bound to create functional centers, in terms of which it is arranged. These cubic *points centraux* [central points] instantly produce a necessary and powerful subdivision, which may be called a strong autonomy of the parts. This is understandable. For the naturalist, mass plays no part; the famous, unbroken, compact mass of earlier artworks is meaningless; furthermore, the shape is grasped not as an effect,

but in its immediate spatiality. The body of the god, as dominant, eludes the restrictive hands of the worker; the body is functionally grasped in its own terms. Europeans often criticize African sculpture for alleged mistakes in proportion. We must realize that the optical discontinuity of the space is translated into clarification of form, into an order of the parts, which, since the goal is plasticity, are evaluated differently, according to their plastic expression. Their size is not crucial; the decisive feature is the cubic expression that is assigned to them and that they must present no matter what.

However, there is one thing that the African eschews, but to which the European is misled by his own compromise: the modeling interpolated as a basic element; for there is one thing this purely sculptural procedure requires: definite subdivisions. The parts are virtually subordinate functions, since the form has to be concentratedly and intensely elicited in order to be form; for the cubic, as a resultant and as an expression, is independent of the mass. And that alone is permissible. Art as a qualitative phenomenon is a matter of intensity; the cubic, in the subordination of views, must be presented as tectonic intensity.

In this context we have to touch on the notion of the monumental. This concept probably belongs to periods that, lacking any contemplation, measured all their works by the same yardstick. Since art deals with intensity, monumentalism is not an issue. There are other things that must also be eliminated. In approaching these sculptural arrangements we can never rely on linear interpolations; they merely show a viewing weakened by conceptual memories – and that is all. But we are sure to understand the African's untwisted realism if we learn to see by looking – see how the restricted space of the artwork can be immediately fixated. The depth function expresses itself not through proportions but through the directional result of the welded and not objectively added-up spatial contrasts, which can never be viewed as a unity in the dynamic conception of the mass. For the cubic resides not in the variously placed individual parts, but in their three-dimensional resultant, which is always grasped as a unity and which has nothing to do with mass or the geometric line. The latter presents cubic existence as the nongenetic, unconditional outcome, since the motion is absorbed.

After the assessment of the sculptural concentration, the consequences can be easily explained. Many Europeans have condemned African sculptures as disproportionate; others have tried to glean from them the anatomical structures of the various tribes. Both critiques can be dispensed with; for the organic has no special meaning in art since it only indicates the real possibility of movement. By equating reflections on art with the making of art, albeit in a reverse chronology, Europeans constructed with the aid of abrupt notions, as if art were somehow based on and abstracted from a model. It is quite obvious

that the premise of such a procedure would already be art. When examining, we must never leave the level of the object; otherwise we will be talking about many things – but not the object before us. Both 'abstract' and 'organic' are (either conceptual or naturalistic) criteria alien to art and therefore completely extra-territorial. And we can also ignore vitalistic or mechanistic explanations of art forms. Broad feet, for instance, are broad not because they carry, but because our eyes often move down or because the artist seeks an equilibrium that contrasts with the pelvis. Since the form is tied neither to the organic nor to the mass (now and then the so-called organic needs a pedestal as a geometric and compact contrast), most African sculptures have no pedestal. Or if a pedestal is present, it is sculpturally emphasized by points, and so on.

But back to the issue of proportions. These depend on the extent to which depth is to be expressed in terms of the decisive depth quotient, by which I mean the sculptural resultant. The interrelations of the parts hinge purely on the degree of their cubic functions. Important parts require a corresponding cubic resultant. That is also how we should understand the so-called twisted joints or limbs in African sculptures; a rolled twist makes visible and concentrates that which constitutes the cubic nature of two otherwise abrupt directional contrasts. Parts that are set back and normally only guessed at become active and, in a focused uniform expression, they become functional: they thereby become form and are absolutely crucial to the representation of the immediately cubic. In a rare unification the other sides have to be subordinated to these integrated forms, yet they do not remain unprocessed, suggestive material; they become formally active.

On the other hand, depth becomes visible as a totality. This form, identical with unified viewing, is expressed in constants and contrasts. Yet these are no longer open to infinite interpretations; rather, the twofold depth direction – the forward and the backward movement – is bound in a cubic expression. Each cubic point can be interpreted in terms of two directions; here, it is involved and secured in the cubic product, and it therefore contains both the forward and the backward movement, but not within a relationship that is interpolated from the outside.

In African sculpture as in some other so-called primitive art, we are struck by the fact that some statues are uncommonly long and slender, while the cubic resultants are not especially emphasized. These factors may express an uncontrolled determination to encompass the cubic naked in the lank form. We believe that we cannot get at these thin, plain, compressed forms by means of the surrounding space.

I would like to add something about the group. The group visibly confirms previously stated opinion that the cubic is expressed not in mass but in form. Otherwise, the group, like any perforated sculpture, would be a paradox and a

monstrosity. The group constitutes the extreme case of what I wish to call the remote sculptural effect: at closer inspection, two parts of a group relate no differently to one another than two remote parts of a figure. Their coherence is expressed in their subordination to sculptural integration – assuming that we are not dealing simply with a contrasting or additive repetition of the formal theme. Contrasting repetition has the advantage of reversing directional values and thus also the meaning of sculptural orientation. On the other hand, juxtaposition shows the variation of a sculptural system within a visual field. Both are grasped totally, since the given system is unified.

8 Eric Gill

Sculpture: An Essay 1918

Eric Gill (1882–1940) was a practising sculptor with strong religious convictions and utopian beliefs. He became an enthusiast for direct stone cutting during his period in London, at which time he associated with the vorticist circle, particularly Jacob Epstein. He also made links at this time with Roger Fry, who from 1912 to 1913 included eight of his carved-stone sculptures in the 'Second Post-Impressionist Exhibition' at the Grafton Galleries in London. Gill moved to Ditchling, Sussex in 1907 and formed an artists' community there based on a revival of medieval guild practices as articulated by the Arts and Crafts movement and the theoretical writings of William Morris. In the early 1930s, his practical and theoretical ideas began influencing a new generation of artists and critics closely involved with modern sculptural practice, especially Henry Moore and Herbert Read. Gill's 'truth to materials' principle became inextricably linked to modern abstraction in sculpture, with 'direct carving' influencing sculpture training for several generations afterwards. This influence continued up to and even after the war; but with the introduction of new synthetic and industrial materials, as well as new ideas and methods, Gill's version of what was more widely known as 'truth to materials' eventually lost its purchase.

Gill's 'Sculpture' essay first appeared in a magazine called *The Highway*, but was subsequently reproduced in book form as a publication for The Guild of St. Joseph and St. Dominic at Ditchling. Consistent with the guild's core principles, it was presented in typography designed by Gill and printed on hand-manufactured paper. *Sculpture: An Essay* was published again at Ditchling in 1924, in the same year that Gill departed with his family to form a new guild practice at Capel-y-Ffin in Wales. For the 1924 edition of the essay, the author added a lengthy argument in favour of religiosity in art, so that the text – now called 'Sculpture: an essay on stone-cutting: with a preface about God' – became the second half of an extended discussion based on Catholic and Hindu revelation.

Eric Gill, *Sculpture: An Essay*, Ditchling: St. Dominic's Press, 1918; first published as 'Sculpture: an essay' in *The Highway* (1917).

I shall assume that the word sculpture is the name given to that craft and art by which things are cut out of a solid material, whether in relief or in the round. I shall not use the word as applying to the craft and art of modelling. I oppose the word 'cut' to the word 'model' and assume that a sculptor is one who shapes his material by cutting and not by pressing. The cutting of stone is the type of the craft of the sculptor and the modelling of clay, if he practises it at all, is, for him, merely a means of making preliminary sketches. The modelling of clay or wax whether the thing modelled is to be rendered permanent by firing in an

oven or by casting in metal or plaster, is a craft and art of the greatest impor-tance, but facility in it is no sort of necessity for the carver.

By the word 'thing' I mean that which is its own justification, as opposed to (1) that of which the justification is the success with which it imitates the appearance of something else and (2) that of which the justification is the success with which it conveys a criticism or appreciation – e.g. the work of Cimabue as opposed to (1) that of a photographer and (2) that of Rembrandt.

A work of art may resemble another thing or it may not, but such resem-blance as it may have must be thought of as accidental and not substantive.

Representations can and may, undoubtedly, be made by cutting and modelling, but such is not primarily the sculptor's job. The sculptor's job is primarily that of making *things*, not representations or criticisms of things.

It is commonly supposed that the study of nature is a prime necessity and that realism, which is thought to be the close imitation of appearances, is the object of the artist. Now in the first place the study of nature is *not* a prime necessity, though the love of nature may be such, and in the second place realism is not the imitation of appearances but is an expression of the reality underlying appearances.

That kind of sculpture which is dependent upon a close study and imitation of appearance is only very little removed from the craft of the photographer – an admirable craft but not primarily the sculptor's.

The sculptor, as any other artist, is primarily a herald, and his work heraldic. His business is to achieve in the things he makes the discovery of Beauty and to proclaim it. By the word 'Beauty' I do not mean merely the loveliness of the earth or of living things, but that absolute entity which, like Goodness and Truth is apprehended by conscience.[1]

The analysis of this matter is the business of the aesthetician, to whom the artist would do well to leave it. Let the artist mind his own business, remem-bering that the study of heraldry is the study proper to him as artist – that is the study, not merely of coats of arms, but of all those means by which Beauty has been and may be discovered or revealed – and that nature is for him simply a dictionary, however well-beloved and however inspiring, to which he may go for reference when necessary or when he chooses.

Now there are two ways of regarding works of art. Such works may be thought of as having existed only incompletely in the mind or imagination of the artist and as having awaited completion in, and as having been dependent upon the material of which they are made, so that the artist and the material are jointly and not severally responsible for the finished work, or such works may be thought of as having existed completely in the mind of the artist and as having a merely accidental relation to such stuff as he has chosen for their material embodiment.

Thus we may say that there are two kinds of works of art: first, those which owe part of their quality as works of art to the material of which they are made and of which the material inspires the artist and is freely accepted by him, and, second, those which owe nothing of their quality except by accident, to their material and, indeed, of which the material is even a hindrance to the free expression of the artist and is patronised rather than beloved by him.

Of the first kind are all primitive works and the works of barbarians. Of this kind, also, are the works of all those craftsmen and artists who are not merely designers and who are accustomed to translate their own ideas or designs into the natural terms of material and are free to do so.

Of the second kind are the works of artists and designers who are only executants in the material of which the design or model and not the finished work is made. Thus all works designed in clay by the artist and translated into stone by an artisan are of this kind.

Now I do not suppose myself to be addressing those who are engaged in designing things for other people to make or those who are engaged in the job of modelling clay for casting in bronze or firing in kilns. I am addressing the ordinary workman who, like myself, has in hand the job of carving-stone.

There are two chief kinds of stone-carving. Just as a tailor may cut his coat according to his cloth or his cloth according to his coat, so a stone-carver may make his carving according to his stone or he may cut his stone according to the preconception of his carving which is in his mind or which is necessitated by the building or other place where his carving is to go.

Thus if you have a piece of stone you may, if you are free to do so, carve it into what shape you will; but if your carving is to fit a certain place, either in size or manner, you will have to be very sure before you begin to work, as to your measurements and as to your subject and its treatment. Therefore the two kinds of stone-carving may be called 'unconditioned' and the 'conditioned'. Now for either of these two kinds it may be useful or necessary to make a model, but if such be made it should be made in soft stone and to some simple scale, such as 'one inch to the foot' or 'quarter full size', so that measurements may be easily calculated from it. It is not desirable to make it to the full size because a full-size model is not worth the labour unless the proposed carving is to be no more than a few inches high, and then a model is generally unnecessary and often undesirable.

It is not desirable to make the model in clay, because the sort of thing which can be easily and suitably constructed in clay may not be, and generally is not, suitable for carving in stone.

The armature, that is the skeleton of iron or wood which is necessary for the support of the clay for a model of a large size, is not merely difficult to make, but has the effect of giving a quite different character to the work from

that which *is* the natural character of carved stone. The armature, in fact, *is* the model – the model reduced to its simplest terms of movement and attitude.

Modelling in clay is properly not (except for such very small things as can be held and turned about in the hand) the mere pressing and squeezing of the clay into a desired or approved shape. It is rather the clothing or giving of body to a skeleton. It is a process of addition; whereas carving is a process of subtraction.

The proper modelling of clay results, and should so result, in a certain spareness and tenseness of form and any desired amount of 'freedom' or detachment of parts. The proper carving of stone, upon the other hand, results, and should so result, in a certain roundness and solidity of form with no detachment of parts. Consequently a model made to the full size of the proposed carving would be, if modelled in a manner natural to clay, more of a hindrance than a help to the carver, and would be labour, and long labour, in vain.

Further, it must be remembered that enthusiasm is not cheap and lightly to be expended. If a man has really devoted himself to the making of a full-size model of clay or any other material, it is hardly possible for him to face the copying of his own model in stone. He cannot do the same thing twice with the same feeling of propulsion. For that reason, if for no other, it is usual for the work of translation into stone from a full-size model of clay or plaster to be given over to an artisan who proceeds by measurements and various mechanical contrivances to produce an imitation in stone of a thing of which the nature is clay.[2] The modeller then reappears and gives the finishing touches. The finished work is not a piece of carving, but a stone imitation of a clay model. If the model be good it is possible that the stone imitation may retain some of its goodness.

But why, indeed, should a process so elaborate and so unnatural be followed? It cannot be only because the making of a full-size model has used up the energy of the artist. That might happen once. But an artist who found his energy thus 'used up' would say: 'No, a full-size model is too much of a good thing. I will make only a small model, or none at all, and save myself for the stone.' Why, then, is this process pointing not exceptional nowadays but usual? The answer is simple. It is because artists are not trained in workshops to be stone-carvers, but in art schools to be modellers. There is just this excuse for them: stone-carving is not only very like hard work, especially in its preliminary stages, but it is apparently much slower. If the artist has an idea, that idea is much more quickly materialised in clay than in stone. It is not exactly that he is in a hurry, it is rather that he is feverish, that he is impatient, that he is afraid of losing the idea in the slow process of stone-cutting.

The later stages of the making of a model in clay are, I think, considerably more irksome and 'nervous', and certainly slower, than the later stages

of stone-carving. But in the early stages clay is certainly the easier and more expeditious material.

So it is that clay modelling is so much in vogue: because in the preliminary stages it produces quick results and because clay is the material in which the artist is as a student taught to work.[3]

Now we have divided works of art into two kinds: those owing their nature in part to their material and those of which the material is accidental. And we have divided stone-carvings into two classes: the unconditioned and the conditioned. It is obvious that if you are an idealist and do not care in what material your idea takes shape, you might just as well or better, be a modeller as anything else. It therefore follows that if I am, as I say, addressing stone-carvers I am not addressing idealists. I am addressing that kind of artist who finds in his material a complement to himself, and that material being stone, it follows that modelling in clay must for him be kept on a wholly subordinate position and be the means, merely, of making such preliminary and experimental sketches as cannot be done on paper.

But the making of models is not absolutely essential. Some stone-carvers may find a model desirable, some may not, or a model may be desirable in one case and not in another. There is, however, little doubt that the use of models is very much overdone at the present time. In the case of carvings in low relief, for instance, a model is generally unnecessary, a drawing to scale being all that is required, and even that may sometimes be dispensed with.

The cause of this over-reliance on models is, as I have said, simple enough: The artist is not trained to be a stone-carver, the stone-carver is not, or is not thought to be, an artist. The artist therefore, becomes a mere designer, the stone-carver a mere executant – the one losing himself in idealism, the other in technical dexterity.

Truly it would be better were 'artist' and 'craftsman' interchangeable terms. But such a consummation is, except in the case of individuals, not possible under modern conditions. The very nature of modern civilization is such as to preclude it.

Our modern civilization, admirable as it may appear to be in many of its manifestations of power and goodwill, is, essentially, built upon the employment of the many by the few. It is a complicated system in which world-markets have taken the place of local markets, and factories the place of small workshops, the manufacturer that of the craftsman, the contractor that of the builder, and in which commerce is paramount and men of commerce our rulers.

Altogether apart from the question as to whether it is good or bad is the fact that the combination of craftsman and artist in one individual is foreign to such a civilization and impossible in it. It is impossible because in such a

civilization men are not commonly their own masters any more than they are commonly their own landlords.

But the question of 'good or bad' cannot be escaped, and our answer to it must be such as is natural to our own point of view as stone-carvers. We cannot make decisions for others. We can, and must, decide for ourselves.

If we are going to be stone-carvers, then we must be both craftsmen and artists. If that combination is impossible, then stone-carving is, as an occupation worthy of free men, non-existent and we must find another trade.

Now I am not looking at this matter from the point of view of the 'artist'. From his point of view there is little of which to complain – he is what he chooses to be. I am looking at the matter from the point of view of the workman, the hired stone-carver. Reform must come at *his* demand. He is the victim, his must be the revolution.

Men do not eat because other people kindly give them bread. They eat because they are hungry and they would bake bread whether other people were benevolent or not. Even so material organization and betterment must be the product of appetite and not of theory, of the men and not of their masters, of the players and not of the spectators.

The modern movements of reform fail for this very reason: that they make their appeal to irresponsible persons, to manufacturers and distributors, to shopkeepers and their customers, to anyone but the person responsible for the doing of the work.

Therefore, as men have revolted and have organized with the object of gaining economic independence, so must they revolt and organize to obtain intellectual independence. The trade union must be not merely the guardian of the just price, it must become, as it did in the mediæval fraternities, the guardian of good quality. The control of industry is valueless unless it includes the control of design and workmanship.

But where all are agreed that the price of labour must be 'fair', very few workmen are concerned to assume or demand responsibility for the work done. It cannot be said that there is, at the present time, any widespread and articulate demand upon the part of stone-carvers that they shall be the executants of their own ideas. They are, as a rule, perfectly willing to execute any design that is put before them. They have ceased to think of themselves as artists, or, rather, for they never did so think of themselves, as freemen, they accept without demur the tyranny of the architect and modeller. They either do not profess to have any ideas of their own at all, or such ideas as they have are merely those of copyists and imitators of bygone 'styles', and technical accomplishment is their only criterion of excellence.

In the absence then of any articulate demand for freedom and responsibility there is nothing to be done but to create such a demand. The individual

must be converted that the mass may be leavened. And in the forefront of our propaganda must be proclaimed the fact that we, the workmen, the men who do the work, are the persons responsible and not the architect and designer, not the contractor the shopkeeper or the customer.

We will not talk about art. We will demand responsibility, saying that, as we do the work, we will do it as we choose.[4] The designer can go. The contractor can go. We will sell things at our own workshops and deal directly with our own customers. We shall demand protection from the importation of cheaper and inferior foreign work and we shall abolish the factory and contracting system.

But meanwhile, before these demands, natural to the craftsman but at present inarticulate, can be enforced, what is to be said of existing efforts at reform from above, that is reforms made at the instance of educational theorists, artists, architects and cultured contractors? For the most part nothing need be said, being reforms from above they may be neglected by the persons below. Coming from above they naturally subserve the interests of the employer and buyer rather than those of the craftsman.

Art cannot be taught, and it is best not talked about. It must be spontaneous. It cannot be imposed. But its enemies can be destroyed. Its enemies are irreligion and the offspring of irreligion – commercialism and the rule of the trader. The trader should be subordinate – he has become the head of the State. *Vade Satanas, Laus Deo*.

I say Art cannot be taught. Art education is therefore impossible. The art school is no good to anyone except as a springboard for revolutionists. Learning about art, reading about it, museums and exhibitions, all alike are of no value to the workman. They are the occupation and invention of well-meaning theorists and dealers. Technical institutes are a different matter. They are both valuable and dangerous. They are valuable in as much as they supplement workshop training though they can not supplant it. They are a danger in as much as they tend to make us content with the present inadequacy of the workshop. They supply a superior workman to our employers without doing anything to hinder the development of a system which destroys workmanship. They give our employers a better quality workman without making any demands upon them which jeopardise the system.

But though technical institutes cannot supplant the workshop, they can and do supplant apprenticeship. The general decay of apprenticeship, due solely to the introduction of the factory system and quantitative as opposed to qualitative production, is more to be deplored than almost every other thing which labour has suffered, and its revival should be one of the first endeavours of revolutionists. No system of state-aided or benevolent technical training in schools can take its place.

The matter must here be left at this bald statement of essentials, without

its proper support of argument and reference. Sculpture is both a craft and an art. The combination of craft with art must be revived. The revolution must come at the instance of the craftsman and not of the artist. The need is religion and the subordination of the trader. Again: *Laus Deo: vade Satanas!*

1 Beauty is not to be confused with loveliness. Beauty is Absolute, loveliness Relative. The lovely is that which is or represents the lovable. The lovely is lovable relatively to our love of it. Beauty is Absolute and independent of our love. God is Beautiful whether we love Him or do not, but the taste of an apple is lovely only if we taste it and love the taste. The Madonna of Cimabue is beautiful with an Absolute Beauty. The Madonna Sassoferato is lovely because it portrays that kind of woman who is lovable to those who love that kind of woman and in that kind of attitude which is charming to those who are charmed by it.

2 This work of translation is called 'pointing', and the artisan a 'pointer', because the instrument chiefly used is called a 'pointing machine'. This instrument is one by the aid of which innumerable holes of various depths are drilled in the stone block so that eventually nothing remains to be done but knock off the stone between the holes.

3 I think all that is vital in modelling can be written in one paragraph. The model should be seen as a number of contours joined by planes. The best modelling is done by pressing with a tool, and not by squeezing with the fingers. Modelling is the addition of clay to clay, each additional piece of clay being pressed into place with the tool. The use of the fingers is to be avoided as being too facile and as productive of accidental contours and planes. The workman may take advantage of accidents, but his method should not be provocative of such. Hardness and firmness both of intention and execution should be the aim of the modeller as of all workmen, but more particularly of the modeller because of the pliability of his material and the ease with which it may seduce him.

4 Though we claim the right of choice, yet, the reader will note, we admit responsibility. The responsibilities of the workman to his customer and to the community are even more obvious and natural than those of the trader – the trader being out merely to sell things, the workman to make them. Men do not naturally make things which please only themselves. But a shopkeeper will sell anything, whatever he thinks of it. *He is irresponsible.*

9 Raoul Hausmann

'Material of Painting Sculpture and Architecture' 1918

This short text by Raoul Hausmann (1886–1971), founder member of Berlin dada in 1917, might seem inaccessible at first because of the near absence of punctuation and lack of grammatical structure, but its message regarding a dadaist articulation of sculpture is nevertheless clear and expressed with experimental confidence. Classical figurative sculpture, for many dadaists, was an object of hatred and ridicule, offering a tangible icon of bourgeois culture and a retainer of classical beauty and ideal norms of anatomical proportion. The corporeal integrity of classical sculpture was frequently attacked in dadaist works (in their collages and photomontages), but rather than follow in this somewhat rhetorical line, Hausmann offers a poetic and imaginative re-envisioning of what sculpture might be and how it might manifest itself. This is also in keeping with his own work and practice, for which photomontage was central – so much so that he claimed to have invented it. His short prose-poem-like text owes much to cubist and futurist thinking on 'simultaneity', as well as to techniques of collage and photomontage for which Hausmann's work on paper was much noted at the time. 'Sculpture which crams itself into space, changes it inciting conformance jubilation or dismal sorrow', Hausmann states, casting sculpture as a constructive living force, a happening that dynamically creates and destroys, rupturing its urban surroundings like a cluster of fireworks, and becoming a real, vital, created form. Hausmann's short text was published in the *Third Dada Almanac*, a small-circulation publication illustrated with woodcuts prints.

Raoul Hausmann, 'Material der Malerei Plastik und Architektur', in *Dritte Veröffentlichung Dada*, October 1918. Translated by Deborah Shannon.

Painting dynamism of colours of form conceived in the plane which one will make as pure as possible a created form organically analogous to the seen moments neither imitative nor descriptive. In the brilliant cleanness of the paper pictures momentary instants electric prisms of the fragile happening from a right-angled jubilation of layers applied simultaneously or wrung twisting out of the inner reality of the creator. Creating form the moving the living force seeing one makes the constructive-dynamic in the purity of a material. Sculpture which crams itself into space, changes it reposes inciting conformance jubilation or dismal sorrow one will extricate from the atmosphere the plastic-dynamic momentary instant in the transparency of the glass black velvet iron sky of the city above it trembles electric blue blue green red spectral concatenation of some happening that is good consoling and full of utter reality the nature of the created form. The norm. Architecture spatial

dynamics or so it should be, as yet only in Bohemia by Gocar and Janak why not creatively form the light and integration into the darkness seclusion of the space. The movement of the wall the window no symmetry as a chance incision one will let it reach from floor to ceiling in assorted forms stained glass that delights and affects the people with its transmission of light. Regularity is a measure of bourgeois spatial comfort a door will be an entrance or outburst of solidity into the ambience atmosphere that surrounds or is left behind. The roof is not the poundcake and avoids formlessness. Architecture will find its lightness without mere purposiveness. Everything in flux the spaces the con-strainednesses of the new human who devotes himself to it.

10 André Salmon

'The Fable of the Little Tin Fish' 1919

André Salmon (1881–1969) was a novelist and poet, as well as a writer on contemporary art in Paris. He was a friend and early supporter of Picasso, and closely associated with cubist circles and Apollinaire. He was also the author of a number of collections of art writings. These included *Histoire anecdotique du cubisme* (1912), *La Jeune Peinture Française* (1912), *L'Art Vivant* (1920), *Propos d'atelier* (1922) and *La Jeune Sculpture Française* (1919), part of which was written five years earlier in 1914.

'The Fable of the Little Tin Fish' is the first essay in this last collection and precedes texts that discuss the work of Rodin, Picasso, Bourdelle, Nadelman, Derain, Despiau, Maillol, Manolo, Gauguin and Duchamp-Villon. Salmon begins by setting up a compelling juxtaposition between the worthy images of muscular workers made by Constantin Meunier in his studio to celebrate proletarian labour and craftsmanship, and the extraordinary, sculptural metalwork made by workers nearby on the rue des Italiens. This disconnection between indoors and outdoors, between the represented and the real, between memorialised subject matter and actual *métier*, leads to Salmon's main point: that modern sculpture can only develop and liberate itself from inherited academic formulae if it successfully takes on board the material processes and conceptual possibilities of contemporary industry and engineering. By the same token, he states, we must ask if sculpture might today be 'condemned to extinction by the skill of the worker in small or major industry'. By imagining sculpture as an art of object-making, Salmon begins to raise questions about how and whether a sculptural object might distinguish itself from a decorative or functional object. He toys with the possible conflation of the two, in ambivalent ways that suggest a playful quasi-dadaist outlook, incorporating an elevation of invention and an evaluation of the sculptural object as animated by a new technical and intellectual kind of artistic skill. Salmon argues that the sculptor can learn from the 'beauties of the trademan's work' through the example of two objects: the steel comb that Braque and Picasso used to 'paint' hair with and the recent phenomenon of the little tin fish. This popular toy is praised by Salmon for its plastic values, well-designed look, scientific logic and meditative potential. He in turn laments the fact that such a revolutionary sculptural achievement soon becomes an outmoded fad, quickly trivialised by bourgeois taste and overtaken by other random playthings.

André Salmon, 'Apologue du petit poisson de fer blanc', in *La Jeune Sculpture Française*, Paris: Société des Trente, 1919, pp. 8–19. 'The Fable of the Little Tin Fish' was translated by Beth S. Gersh-Nešić and is also reproduced in: Beth S. Gersh-Nešić, *André Salmon on French Modern Art*, Cambridge and New York: Cambridge University Press, 2005, pp. 99–104.

Profoundly struck by the majesty of manual labor, the sculptor Constantin Meunier descended into the mine, into the hell of puddlers, [and] took out his sketchbook. Faithful to the anatomical ideal as much as to his social consciousness, [he] drew the positions of the labourer at work: a handsome, almost nude model (even more beautiful than an academic Antinous), ravaged by the pain that formed him [and] the effort that tears [him] apart, like the cries of raised and dripping flesh.

Familiar with an already ancient mechanism, Constantin Meunier recognized in the mine [and] in the studio a traditional picturesque, a quasi-romantic disorder: torn and dirty clothes hanging here and there, open bottles, torn posters, spiders' webs, and naïve prints [that are] tender or violent, glued or tacked to the wall, clear signs of the fetishes of the simpleminded.

Thus, Constantin Meunier assembled in this moral tranquility this absolute respect for a common cause (proletarian virtue and its suffering) [in] the substance of a strong and fine work that glorifies the worker.

The idea of assimilating the worker with his tool, to sculpt [only] the pick of a miner [or] the power hammer of the blast furnace's serf, did not occur to him.

But when the Boulevard was disemboweled, demolishing the Theatre of Novelties – that temple of laughter that unleashed the exhibition of boxer shorts and garters (nudity being strictly hidden) – they made this beautiful hole before [erecting those] pitiful buildings [that are] more strictly *passé* than all the tumbledown past. Once set up, the construction site on the rue des Italiens [sent] powerful waves emanating like d'Arsonval's calories in five hundred thousand directions per second, piercing the watertight compartments of the Parisian studios.

All the artists worthy of being called young hastened to the construction site on the rue des Italiens.

There, they knew the wonderful days of salutary fever. I do not believe that any other exhibition would have thrilled them in this way.

They paid only moderate attention to the workers; those workers who prevented Constantin Meunier from seeing the factory and machine. They considered them, and were in that regard rational, as the humblest accessories of new instruments.

The elegance of ironwork, the logical beauty of deep wells delivered to them the secret of the present.

They knew what eluded the artists contemporary to the building of the Eiffel Tower. Those of 1889 suffered nothing more than the moderate worry of artists [set] in their Byzantine and Mandarin ways, threatened by practical reality.

Those of 1911 were not afraid of Science.

Having accepted it for a while, they had, as a result, mastered it.

They did not make a single sketch at the construction site on the rue des Italiens – at most they took some notes. But they did not behave like men of letters; they resisted the engineers while surpassing them, while going beyond their calculations, limited by the average needs of those who domesticate science for mercantile ends.

The fruit of their meditations was this bold desire to give birth to works of art that were no longer sculpted objects, but objects to which it would become impossible to give another appearance. No longer simulations (more or less touching for reasons most often external to the material), but authentically new objects, [these works are] capable of provoking a surprise equal to what the meditating onlookers of the construction site on the rue des Italiens joyously endured: objects for which practice alone determined an intelligent implementation.

I am not claiming that all recent sculptors have limited [themselves] to this purpose, but I am pointing out that the goal for several [sculptors] went that far.

We can say that such objects may not be to our taste, but [they are] the taste from circumstances we find ourselves in: [whether at the] table or washbasin.

One thing was definite: they would no longer be gods.

So many gods whom we questioned in vain, or in vain questioned us, clutter up our dwellings [and our] temples of contradictory cults.

[But] such an art has its dangers.

[Therefore], let us agree that these are the immediate dangers.

However, let's not overemphasize our concern about the attraction that civil engineers, industry, and its processes exert on modern artists.

What appears to superficial minds as just a disastrous constraint, to the contrary, is only the sign of the most extreme freedom.

An anecdote will explain [what I mean] better, and besides, an anecdote in this kind of work is icing on the cake.

Because of his family's background, the painter Georges Braque (a fervent disciple of Picasso) belongs to that class of rich artisans and great entrepreneurs. His family painted, or had [others] paint for them, almost all the interior walls erected in Le Havre at the end of the last century. I am convinced that Georges Braque owes to this ancestry some of his most brilliant qualities.

One day he was discussing with Picasso the inimitable in painting, a favourite theme of modern artists. If one paints a gazette in the hands of a personage, should one take pains to reproduce the words PETIT JOURNAL or reduce the enterprise to neatly gluing the gazette onto the canvas? They went on to praise the skillfulness of housepainters who extract so much precious marble and wood from imaginary quarries and forests.

Naturally, Georges Braque provided useful explanations, not sparing the juicy details of the craft.

He went on to say that a certain steel comb that helps housepainters create false marble and false wood can be run along a painted surface to achieve a simulation of veins and persillage.

We might smile at the seriousness brought to this type of discussion, because we might harbour the faintest prejudice and would not want to heed certain benefits that the artist finds, [as he] leans toward the beauties of the artisan's work. Malherbe was listening to the conversation of laborers from Port du Foin to enrich his language.

Finally, those who laugh at us do not cease corrupting their understanding by listening to the most wretched academic recipes. "Dull, my dear sir, dull!"

In short, Picasso and his guests agreed on the use of the housepainter's comb, but note that no one intended, however, to imitate these skillful artisans.

This is of extreme importance. An artist grows thinking about many things. He may even desire equipment that seduces him, but that's enough. He does not have to appropriate either the tool or the process. It is better [to do] what one of their own did (the painter Marcoussis) – imitate the imitation.

But a patron, who was there, did not think like that.

He went down to the closest café to consult the phone directory, jumped into a taxi, and was driven to an edge-tool maker in the Marais who manufactured the famous comb for painting wood and marble.

Shivering [with excitement], as if he were carrying the radium of new art, the patron had himself driven back to Picasso's to put into able hands his purchase.

The eyes of the painter then glowed with that flash of childlike joy that his intimates know so well.

For one who only aspires to create and retain new forms, [he was] happy to possess a new toy. He promised to get to work and made an appointment with the art lover for the next day.

He would spend the night making false wood and false marble.

But when the morning had come, the patron saw nothing but a portrait of a well-groomed sapper.

With the comb for faking wood and marble, Picasso had painted [and] waved the hair and the beard of his subject.

This anecdote proves nothing except that we should never despair of an art that absorbs everything.

As soon as we arrive at the [kind of] sculpture liberated from the tyranny of the real, from anatomical verity, which no longer tends to create *perfect objects* ([made] precious by virtue of their sole plastic form and the richness of material), we are forced to wonder whether such an art is valid or whether it is

not condemned by the skill of the worker, in small and large industries, capable of creating objects (toys or machines) that have an absolute mechanical and plastic perfection without embellishments borrowed from art.

Already a sense of decency makes us reluctant to decorate our homes with canvases and statuettes. The Museum is a school, and we are loath to scholarize our homes in this way.

[Today's] most revolutionary art will be accepted by tomorrow's ultra-middle class. The middle class does not bend, it accepts in order to destroy or vilify, [and] in order to lead the principle of beauty back to a degree of triviality.

Two years ago, a small businessman made a toy of rare beauty that seemed [to be] the result of a collaboration between a Mallarmé and an Edison: [someone who is] always curious about correct deductions but more aware of the relativity of things. Everyone amused himself with this little tin fish balanced on a brass wire, a prisoner of a wide-open cell – a simple ribbon of crude metal bent into a circle, which [was] animated by a rotating movement, giving the perfect illusion of an aquarium filled with water in which the little tin fish revolved. Indeed, [some] considered it amusing, but how many found it beautiful, perfectly beautiful?

Thus, here was an object whose plastic virtues were evident, an object of rational creation, although it relied on the principles of a carefully mastered science. Moreover, this toy prompted the most intense meditation. All these qualities were underrated, and yet [this] object was universally adopted.

[Then] what happened? What was the consequence of this miracle, the choice of the disbelievers in this prayer wheel?

The little tin fish is a rare piece today, almost impossible to find.

What the crowd clamors for now is the same amusement deformed by its [own demands]. The same illusory glass cage no longer encloses the tin goldfish, but [instead] a yellow plush chick, which is the height of stupidity, because little chicks are not put into aquariums. This is the kind of prank that bad artists call fantasy. Fantasy is only for the pleasure of the creator; it can emanate from the absurd in one detail that the whole will justify. This [is] nothing of the sort.

Clodion's art could not fail to lead to the art of the obscene and sad statuette with no sculptural value: *Woman Looking for Her Flea* or *The Dive*.

To what nonsensical [end] will the profound and sometimes temerarious investigations of today lead?

It would be instructive to find out what likeable aesthetic decision was the source for a series of touching creations from which the colored-glass [gazing] ball in suburban gardens is the infuriating result.

11 Daniel-Henry Kahnweiler

'The Essence of Sculpture' 1920

Daniel-Henry Kahnweiler (1884–1979) was a highly influential gallery owner, dealing in and writing on the work of artists such as Pablo Picasso, Georges Braque, Fernand Léger and Juan Gris. His writings on art included important texts such as *The Rise of Cubism* (written in 1914) and the well-illustrated *The Sculpture of Picasso* published in 1949 with photographs by Brassaï and translations by David Sylvester. Although his essay 'The Essence of Sculpture', published in the journal *Feuer* in 1919–20, makes reference to Picasso's collages, it stands as a more generalised attempt to stake a claim at a particular historical moment for sculpture's autonomy in relation to painting, relief and architecture. The text was well illustrated with photographs of sculptures by Georges Minne and also by Aristide Maillol, Bernhard Hoetger, Fritz Claus, Hermann Haller, Auguste Rodin and Josef Enseling.

Written in the aftermath of the First World War and in response to the writing of Hildebrand, whose view of sculpture (as grounded in the logic of relief) he opposed, Kahnweiler conceived sculpture as autonomous and unframed, able to sustain itself internally without being set off by a surrounding environment. He argues that the 'essence' of sculpture is to be found in its independence, its 'in-the-round' character that enabled it to stand apart from ordinary objects in its immediate surroundings while also coexisting with them. 'Sculpture', he argues, 'should rise up proudly in space' and dissociate itself from 'other bodies that appear behind it.' Abstract, geometric sculpture is for Kahnweiler 'the highest manifestation of sculpture' because it encourages the 'viewers' objectification of the represented object' while successfully inhabiting any setting. Kahnweiler concludes his essay by criticising the sculpture of Rodin, Rosso and Boccioni, which he sees as trapped in a 'space-phobic' illusory tradition and with the sculptural object being envisaged as grounded in its immediate surroundings.

Daniel-Henry Kahnweiler, 'Das Wesen der Bildhaueri', *Feuer,* Herausgegeben von Dr. Bagier, Düsseldorf, Band 1, Oktober 1919 – März 1920, 1920, pp. 145–56. Translated by Deborah Shannon.

As an art form which displays its works directly to our sight, sculpture is indubitably, manifestly, a 'visual art'. Less definite, indeed far more dubitable, is its relationship to the other visual arts. If we examine works of the different visual arts to determine their intention, we discover important dissimilarities among them. Architecture and architectonics carry their intention in their own nature, whereas painting and sculpture point beyond their own nature to something else, which they 'depict'. The painting is not a mere surface covered with lines and colours, it is also a 'landscape' or a 'portrait'; the sculpture is not a mere

block of stone or metal, but also a 'bust' or a 'nude'. We will therefore call architecture and architectonics *applied* visual arts, in contrast to the *representational* visual arts, painting and sculpture. Let us immediately stress, this is not to be understood as implying an antithesis between 'applied' and 'pure' arts. One should not be misled by the popular hedonistic aesthetics, which says that the end of a work of 'pure' art is aesthetic pleasure: that pleasure is the work's effect on the aesthetically receptive viewer, but not the end its creation served. On the contrary, the work of *representational* art fulfils its end in *representation*, the *applied* work of art in *utilisation*. This is the sole antithesis between the two. The question now is whether this antithesis might not be traced back further. The germ of every work of art is an experience of the artist. Does the experience which brings forth a work of applied art bear any characteristic differentiating it from the visual artist's experience? Might we say, recording an external visual experience, a 'real' encounter experienced in the corporeal world, is the work of the representational arts, while expressing an inner 'unreal' vision is that of the applied? Up to a point, yes. Admittedly, only naturalistic representational art strives to convey real visual experience directly; all other tendencies in the representational arts depict only fragments of their real visual experiences, worked over and unified into new forms. But the origins of the representational work of art are always visual stimuli, and a representational artist is one whom visual reality intrudes upon, with the impetuous cry to be recorded, immortalised. Not that the architect or the interior designer is unaffected – as well we know – by buildings or furnishings he has seen. Without his conscious knowledge, these seen objects will certainly have a hand in the work he will invent. His true experience, however, is a purely inner vision; without an optical stimulus from outside, his imagination fashions the house which, first by drawing and then by building, he accomplishes as a work of art for all to see. With that, this border line we have traced from the work of art's origin to its realisation may reasonably be deemed accurately drawn and valid. It leaves no outward, obvious, material trace; on the contrary, it resides in the work's inner determinateness, in the intention with which its author created it.

In contrast, a very striking material difference seems to separate the two representational arts from one another. Without agonizing unduly, the popular perception grasps it intuitively. Painting is commonly seen as the representation of the physical world expressed in two dimensions while sculpture is expressed three-dimensionally. Now the question is whether we can content ourselves with this definition. What is the true significance of this difference between two- and three-dimensionality? Possibly illusion and reality? Certainly not: this block of marble in relation to the object it represents is no more a 'real' man than this canvas. In material terms, the canvas is as real as the marble; as the 'man' they portray, however, both are illusions, objects of art, which only *represent* a man.

Both aim solely to evoke the image of a man in the viewer. So the true difference is not found there either. What is a reality in one instance and an illusion in the other is not the object portrayed, but only the *light*. The *light is real* in the three-dimensional art work, illusory in the two-dimensional. The former is a physical object which the real light plays upon. The work of the 'sculptor' thus consists in creating an object on which the real light objectifies itself, such that this reciprocal realisation of form and light gives substance to the artist's experience, as immortalised in the work of art. Not so with the 'painter'. He is forced to 'paint' the light, to create the illusion of it, by varying the degree of lightness of his colours. 'Chiaroscuro' is his only means of conveying the 'real' physical world to the viewer, because real light simply makes the picture visible in a plane, but without lending any three-dimensional physicality. Unless he were to dispense completely with depicting the illusion of corporeality and turn to flat pictures, as in Egyptian art, Byzantine painting of the 9th century, etc.

Here we would appear to have a sharp division between sculpture and painting which seems to correspond to each art form's visible material idiom. To determine this, we have examined the means used by both art forms to arrive at their end, i.e. 'representation'. But are we right to accord such importance to the means that we make them fundamental to this distinction? What ought to cause us particular disquiet here is the subject of *relief*. Strictly speaking, this art form shows us a surface with certain projections upon which the light is forced to objectify. This surface with projections, for its part, is designed to be viewed up against another surface, whether as a permanent fixture or a smaller, movable work. The relief, we might say, makes use of sculptural means for its own design which approaches that of painting. It is utterly distinct from sculpture in the round. We wish to make this clear by calling the relief three-sided but the sculpture four-sided. What this means will be clear to anyone. We think of the viewer and note that he can observe the relief mounted on the wall from three sides only – from the front and from either side – but the sculpture he can also view from behind. In other words, only sculpture in the round possesses the characteristic of true three-dimensionality, the cubic quality inherent to all bodies in space, which makes it possible for us to walk around them. With that, we have arrived at a wholly new border line, drawn right through what was hitherto the field of sculpture itself, which we assumed to be characterised by the use of real light. If we take four-sidedness, the genuinely cubic, as the characteristic of sculpture, then relief, despite its sculptural means, falls outside the field of sculpture, because only sculpture in the round is intrinsically cubic. Which of the two boundaries is right, which corresponds to the true essence of both art forms?

Earlier, when we separated the representational arts from the applied, we found our way to the origin of the work of art, to the artist's experience. Here

too, this route would bring us certainty if at the very moment of the artist's visual experience, some particular hallmark of the painterly or the sculptural could be discerned. For example, Hildebrand has attempted this.[1] Essentially he identifies the definitive feature of sculpture as the 'kinaesthetic ideas' of objects which the sculptor gains by scanning with the hands and eyes, while the painter contents himself with the two-dimensional view, much as the object presents itself to his gaze. First of all, I consider these supposed 'kinaesthetic ideas' a psychological heresy. When scanning the object, the viewer takes in hundreds upon hundreds of images; but any transition from one image to another, any 'kinaesthetic idea' simply does not occur. In psychological terms they are individual retinal impressions and no more, each of which we process into the supposed three-dimensional image. Then these wholly separate images are combined to a single object by our mind, which fleshes out the first 'seen' image with the help of those that follow. The sentence should probably be rephrased to the effect that the painter contents himself with a single visual impression of the object, and strives to record it, whilst the sculptor strives to obtain a large number of visual impressions of the object, and uses all of them in his pictorial work. This wording sounds quite convincing to begin with. Upon reflection, however, it is unsound. The whole distinction between one and several visual impressions is untenable: given that every visual impression, as soon as it is processed to an image in the mind, is already composed of many elements, notably including older visual impressions.

If truth be told, Hildebrand's apprehension of visual perception is derived entirely from his definition of sculpture. His definition, concurring with the 'two- and three-dimensional' distinction, intimates that sculpture holds a large number of visual impressions ('flat pictures' in Hildebrand's terms) ready for the viewer, whereas painting holds only one. Out of the difference between the viewer's two-dimensional 'distant picture' and three-dimensional 'close picture', which has since, quite rightly, been challenged in many quarters, Hildebrand constructs an interpretation of painting as the art form which need only bring the ready-made two-dimensional 'distant picture' onto canvas, whereas sculpture must shape its three-dimensional creation so as to evoke the many two-dimensional images in the viewer in just the way intended. We shall have cause to revisit this theory; for now, suffice it to say that it, too, leaves a border line between relief and sculpture, since of course the flatter the relief, the fewer visual impressions it holds for the viewer than a sculpture in the round. But returning to visual experience, these attempts to determine a *difference in visual perception* in different artists are a regrettable matter indeed. In the extreme, they lead down the absurdly misguided paths of Nordau or psychoanalysis. Every healthy person 'sees' the external world in the same way. His very humanity compels him to see it in that way. To see differently is a sign of

physiological or psychological abnormality: colour blindness, mind blindness, etc. That is not to deny that the object finally constituted as the content of a viewer's mind can exhibit certain differences in different viewers, or in the same viewer at different times. However, these are not *obligatory*, but *deliberate*. *To see is always to judge*, which means collecting the important, leaving out the unimportant. What I demand of my vision is information for my impending action; I collect the necessary details for this action. So, too, the sculptor or painter will often view the external world in that capacity, relating it to his artistic activity, the work he is about to execute. There is no attendant compulsion, however, to 'see' artistically; with his customary visual practice the world will appear to him exactly as it does to his fellow men in the same position, and just like him, with a little guidance his fellow men could easily achieve brief spells of 'sculptural' or 'painterly' vision. Extraordinary experiences – visual or other experiences – do not an artist make; an artist, in truth, is one to whom quite a commonplace experience suddenly appears so precious that he desires to convey it to everyone, and who possesses the power to do so. Even we non-artists often happen to record an experience. But only for ourselves, in our memory. The artist, however, is compelled to save his experience from the transience it would succumb to within his 'memory', and to 'immortalise' it in the work of art.

Now both representational art forms stem from a visual experience, yet as we have seen, any difference in this visual experience could be a pragmatic one at most, a deliberate difference adopted in preparation for the subsequent artistic work. Therefore the real distinction must now be sought in the next stage of the creation of the work of art, in the transformation of the visual experience into an art work. How is this accomplished? Our eyes glance around us perpetually. One optical impression constantly follows another, our imagination constantly reworks them into objective spatial images for our mind. Suppose that one spatial image contains some particular thing which intrudes suddenly upon the artist, clamouring for permanence. In the artist's memory the corresponding spatial image connects up with other spatial images 'seen' beforehand and afterwards; the object of interest itself is just one part of a spatial image. It must be plucked out of this context if it is to stand as an art work for all to see. Here, we find ourselves once again at the dividing line between painting and relief, on the one hand, and sculpture in the round, on the other. For painting and relief portray their object together with part of its 'seen' surroundings, whereas sculpture in the round engages with an object wholly removed from its surroundings. For our purposes, this yields yet another dividing line for the finished works of art. Painting and relief depict different objects grouped together. Their portrayal of this coexistence, an explicitly signalled illusion, which inhabits its own space – that is, having no relationship whatsoever with 'real' bodies in

'real' space – is thus clearly separate from the rest of the corporeal world, and achieves the prerequisite for an independent existence. Not so the sculpture in the round: it stands in ordinary space with the other bodies, a body like them. We must hold fast to this outcome; it will allow us to explain the true essence of sculpture, the designation we confer on sculpture in the round alone. *Painting and relief create their own space.* They seemingly evade ordinary space, suspending it for their viewer by displaying themselves on a wall. On a wall: this is how they delimit ordinary space, obliterate depth, only allowing the existence of the surface. In this plane, they carefully edge their work with a frame, within which they summon up an illusion of space, whether by creating the illusion of receding depth or jutting protrusion. The represented objects inhabit this illusion of space alone, disregarding 'real' space, not engaging with it.

With true sculpture – sculpture in the round – it is quite the opposite. It stands in ordinary space, not separated from other bodies, always in relationship to them, a body like them. One must not – as Hildebrand did in the book cited earlier – characterise sculpture by means of the multiplicity of images it conveys to the viewer who circumnavigates it. That is not of prime importance; that the sculptor predetermines each of these images at will is ultimately just a question of technique, of patient work. Rather, the critical thing is that every one of these images is shown to the observer in association with other bodies, whereas painting and relief, by virtue of their choice of location, display themselves to the observer's eye alone. Thus true sculpture in the round, the true sculptor's work, will have to be such that it can be placed anywhere, can enter into relation with any other bodies; otherwise it will not earn the designation 'sculpture in the round'. We have already noted that relief creates an illusion of space, exactly the same as painting. Hence we have categorised it with painting, and determined that creating an illusion of space was a characteristic of both. The terms forged in the past for classifying art also denote certain vocations: 'painter' contains the idea of applying paint, and 'sculptor' [German *Bildhauer*, literally: picture hewer] is palpably redolent of the chiselling of stone. But no-one has taken offence at artists being called 'sculptors' though they never chiselled stone but only modelled in wax or clay. Picasso will always be called a painter, even if he should create nothing but collages out of paper and other materials. So I hope I shall be forgiven if, for want of a more appropriate word, I refer to all those who create an illusion of space in their works of art as 'painters'. But painting and relief are not alone in creating an illusion of space: an illusion of space is always present where interaction with other bodies in the room is forcibly suspended. Any limitation of the field of vision to the rear cancels out true depth, creates an illusion of space, though the boundaries to either side may be determined by the outer limits of human eyesight and not clearly predefined as in painting and relief. Our definition of the illusion of

space prompts a new narrowing down of the field of true sculpture. Now we see: though ostensibly 'in the round', some sculpture is created in permanent, deliberate reliance on a firm spatial confine (any exterior or interior wall that limits the observer's gaze, for example, whether the sculpture stands in a niche, near a wall or far from one). In truth this is not true sculpture or the work of a true sculptor. Even this degree of reliance creates an illusion of space; the confine to the rear produces detachment from the other objects in the room.

Sculpture, though, should rise up proudly in space. It must not be afraid of the association, in the observer's field of vision, with other bodies that appear behind it. Its independent existence must be so robust that it stands out victoriously in spite of everything. *Independent existence* is what it will have to strive for. Above all it will have to endeavour to mark itself out, conspicuously, as a 'work of art', an illusion, to differentiate itself clearly from the surrounding corporeal world. It has invented a whole range of means of cultivating an 'unnatural', an illusory appearance. They include monochrome colour, unusually large or small dimensions, limitation to the bust, or elevation above other bodies on a pedestal. All this prevents the sculpture in the round from being taken for a 'real' man (for example), stamping it unmistakably as a work of art. At the same time, however, it is ironic that monochrome, the most effective of these means, will deny the possibility of conveying colour for sculpture's own end, namely representation. Yet one of sculpture's means, the loftiest and noblest to my mind, endures in order to identify it as a human artefact. Thus far we have only touched upon sculpture's relation to painting as representational art. Now, having recognised it as art inhabiting ordinary space, we can and must determine its relation to architecture and architectonics, which, like sculpture, stand in ordinary space, without creating an illusion of space.[2] How are the works of these art forms shaped to foster their independent existence, their contrast with the other bodies in the room? We see it at first glance: what distinguishes human artefacts from creations of nature is their regularity. Houses, furnishings, devices have primarily vertical and horizontal lines; then straight lines of all kinds, regular curves, shapes like the cube, the sphere, the cylinder; works of nature, on the other hand, are random, erratic, vary one thousand-fold, exhibit none of those 'regular' shapes. In human works, these always appear as soon as no attempt is made to represent or depict natural forms. How can that be? Because these *'regular' lines and forms are fundamental to our very sense of space*; we build all space upon them. We approach every body with these standards, and it measures up to a greater or lesser degree; referring to it, we outline its image for ourselves. If we ourselves enrich the corporeal world, if we set out to create a new object in it, then – provided we are not hindered by what we are trying to represent – we realise these lines and forms, which we yearn for to no avail in the natural world. Sculpture, too, has trodden this path before and

will tread it again in the present day. It too, in its works, can satisfy humanity's yearning for regularity of forms, can produce strong, rigid statues in strict 'geometrical' style. More than any other means, this confers independent existence on the works. Every work of art requires deformation; the new entity that it is craves different conditions from those of the object 'experienced' and represented. All that varies is the degree of deformation, depending on the purpose served by sculpture in the intellectual life of the times. If it attains geometrical severity, on the other hand, the artist will be able to introduce the intrinsic colours of the represented object, or even realistic details[3] which act as stimuli to encourage the viewer's objectification of the represented object.[4] Then his work will be 'more real', 'more compelling' than superficially mimetic pictorial work, yet still clearly done by human hand. It will be able to inhabit any setting, always dominating magnificently: because it does not exhibit arbitrary forms, but the primal forms themselves which define all our spatial experience. To me, such art seems the highest manifestation of sculpture. But even the mimetic sculpture in the round is still sculpture, if it is capable of residing in ordinary space. Instead of the primal forms themselves, however, it will have to use the petty means of monochrome in order to identify itself as a human artefact.

No work can be called sculpture which is incapable of living in ordinary space, which creates an illusion of space around itself. Then it is painting. It is clear to anyone what a restriction of the field of sculpture this entails. But this observation may also provide us with an explanation. What actually remains of Christian European sculpture, if we measure it by this standard? Almost nothing! *It is painting…* The Christian church, in its hostility to idols, destroyed the figurative style of sculpture which produced real idols, and protected only the painting that was impotent to do so. With logical consistency, the 'sculpture' of the Middle Ages is affixed to the building, never leaving the protective wall. It conceives of itself as relief. The Renaissance comes: it also wants to create sculpture in the round, although this is completely unsuited to its scientific mode of representation or its dramatic-narrative representational ends. Instinctively, here again the best remain close to the wall, shield their work in the illusion of space. Meanwhile, those who boldly placed their statues in ordinary space failed in their efforts. Their attempt was misguided, their work incapable of occupying the space. It was not sculpture in the round, but relief; plucked from the confines that created its illusion of space, now vaguely cast adrift in ordinary space. However, the work of the few great sculptors, from Nicolá Pisano to the present day, should be called to mind: almost all are associated with some spatial confine, inhabit an illusion of space. Up to the present day, the age of Christianity has brought forth no true sculpture, only relief: painting. Never has its perception been cubic or sculptural, but always silhouette-like and painterly. Hence, also, its low tally of great masters of 'sculpture': driven by the

spirit of society, the best visual artists devoted themselves to painting proper. But even those who persisted with 'sculpture in the round' developed more and more in the direction of pure painting: from Michelangelo via the Baroque, to Barye, to Rodin, until finally Medardo Rosso no longer contents himself with showing the objects themselves but, like the painter, wants to harness pieces of the surrounding atmospheric layer. Thus came the ultimate conclusion of a kind of art which dreaded 'real' space, which it dared not inhabit. This art was 'space phobic', not sculpture but painting. Hildebrand concedes as much when he refers constantly to the 'torment of the cubic' and devotes his attention, the whole weight of his work, to the 'flat images' to be evoked in the viewer. One sees: he is ruled by the morbid fear of his work coming into contact with the other bodies in the room; he wants to anticipate and predetermine all the possibilities of such contact. Hence, even with Hildebrand, a preference for relief, an abhorrence of statues in the middle of a public place. It need hardly be mentioned, given the preceding discussion, that an artist like Rodin was no sculptor but a painter. Works like the *The Burghers of Calais* can only inhabit an illusory space, they need to be confined; anyone can see as much. It is equally obvious that Medardo Rosso's example encouraged Rodin to stop short of fully separating the object he was representing from its surroundings. He likewise – ever the Impressionist – wanted to endow it with 'its own atmosphere'.

Thus the pseudo-sculpture of Christian Europe reached the furthest extent of its aberration. Even today, many do not recognise the misguided nature of those exertions. In their sculptural works, the Futurists, whose sympathies tend very much towards Impressionism, have taken Rosso's principle of not detaching the object from its surroundings even further than Rosso himself (according to the late Umberto Boccioni), thereby revealing themselves trapped in long-outmoded trains of thought, despite their resistance to 'Passeism'. As for popular 'sculpture', the least said, the better. A renewal of true sculpture will come, we feel sure. Many signs presage it. How will it be? Will it show itself openly, disintegrating the outer surface of bodies, hollowed throughout? Probably. For certain, though, if it wants to merit the designation of sculpture, it will have to satisfy the requirement we postulated for every true sculptural work: even as it coexists with other bodies in space, marking itself out at all times and in all places as a work of art, it will stand as a visible attestation in space to the human spirit's mastery over the world born of its imagination.

1 *Das Problem der Form*, 7th and 8th eds., Strasbourg, 1910, p. 5 ff.
2 One would wish to exclude from the field of interior design those furnishings that hang on a wall: cupboards etc. That, it seems to me, would be tiresome pedantry.
3 Such as hair, beards, drapery, necklaces etc. in negro sculpture, a real 'grille' (the flat perforated spoon) of Picasso's *Glass of Absinthe*.
4 See my text *Weg zum Kubismus*.

12 Ezra Pound

'Brancusi' 1921

Ezra Pound (1885–1972) was an American poet and essayist whose active involvement with T. E. Hulme, Wyndham Lewis and the Vorticist movement in London before and during the First World War brought him into contact with modern sculpture, as represented by the direct carving of Henri Gaudier-Brzeska and Jacob Epstein. After the war, Pound settled in Paris, and the close relationship he had established with Gaudier-Brzeska and his subsequent writing on his work provided an important conduit for Pound's later appreciation of Brancusi's sculpture, as the poet acknowledges at the beginning of this 1921 article.

Pound's account of Brancusi's radically pared-down, abstract stone carvings is conducted through a celebration of the sculpture's deep sensitivity to its material constitution and through praise for the subtle and complex compression of forms and multiple viewpoints within a single free-standing work. Such is the inner and outer power of Brancusi's sculptures for Pound that he sees them as 'master keys to the world of form', and reads this sculptor as being atavistically in touch with the structural and symbolic language of the ancients. The fact that Brancusi works in series and that changes occurred subtly and slowly over time from piece to piece serves to reinforce such sympathies. For Pound, Brancusi's work is not easy, 'off-the-peg' modern sculpture. Pound raises the question of how we look at the sculpture and introduces the idea of 'levitation' as a crucial part of the encounter and sculptural situation at stake for the viewer. Such an appreciation, he admits, might run the risk of being seen as a form of 'crystal-gazing' and 'self-hypnosis' – mystifying self-projection and solipsism that overloads the seductive surfaces of these simplified sculptures with imagined and 'divine' meaning. What, however, prevents this from being the case, he concludes, is the fact that these sculptures materially *demonstrate* such associations, rather than refer to or illustrate them, since with Brancusi 'the ideal form in marble is an approach to the infinite *by form*'.

This was one of the first extensive articles written on Brancusi's sculpture, and though highly influential, was not greeted with much enthusiasm by the sculptor himself. It was published in the Paris-based but American-owned magazine *The Little Review*. As well as providing an important early reading of the Romanian sculptor's work, introducing it to a wider audience, *The Little Review* also printed a number of Brancusi's own photographs of his sculpture to accompany the article.

Ezra Pound, 'Brancusi', *The Little Review*, Paris, Autumn, 1921, pp. 3–7.

'I carve a thesis in logic of the eternal beauty,' writes Remy de Gourmont in his *Sonnets à l'Amazone*. A man hurls himself toward the infinite and the works of art are his vestiges, his trace in the manifest.

It is perhaps no more impossible to give a vague idea of Brancusi's sculpture in words than to give it in photographs, but it is equally impossible to give an exact sculptural idea in either words or photography. T. J. Everets has made the best summary of our contemporary aesthetics that I know, in his sentence 'A work of art has in it no idea which is separable from the form.' I believe this conviction can be found in either vorticist explanations, and in a world where so few people have yet dissociated form from representation, one may, or at least I may as well approach Brancusi via the formulations by Gaudier-Brzeska, or by myself in my study of Gaudier:

'Sculptural feeling is the appreciation of masses in relation.'
'Sculptural ability is the defining of these masses by planes.'
'Every concept, every emotion presents itself to the vivid consciousness in some primary form. It belongs to the art of that form.'

I don't mean to imply that vorticist formulae will 'satisfy' Brancusi, or that any formula need ever satisfy any artist, simply the formulae give me certain axes (plural of *axis*, not of *ax*) for discrimination.

I have found, to date, nothing in vorticist formulae which contradicts the work of Brancusi, the formulae left every man fairly free. Gaudier had long since revolted from the Rodin–Maillol mixture; no one who understood Gaudier was fooled by the cheap Viennese Michaelangelism and rhetoric of Meštrović. One understood that 'Works of art attract by a resembling unlikeness'; that 'The beauty of form in the still stone can not be the same beauty of form as that in the living animal.' One even understood that, as in Gaudier's brown stone dancer, the pure or unadulterated motifs of the circle and triangle have a right to build up their own fugue or sonata in form; as a theme in music has its right to express itself.

No critic has a right to pretend that he fully understands any artist; least of all do I pretend, in this note, to understand Brancusi (after a few weeks' acquaintance) even as well as I understood Gaudier (after several years' friendship); anything I say here effaces anything I may have said before on the subject, and anything I say the week after next effaces what I say here – a pale reflection of Brancusi's general wish that people would wait until he has finished (i.e., in the cemetery) before they talk aesthetics with or about him.

At best one could but clear away a few grosser misconceptions. Gaudier had discriminated against beefy statues, he had given us a very definite appreciation of stone as stone; he had taught us to feel that the beauty of sculpture is inseparable from its material and that it inheres in the material. Brancusi was giving up the facile success of representative sculpture about the time Gaudier

was giving up his baby-bottle; in many ways his difference from Gaudier is a difference merely of degree, he has had time to make statues where Gaudier had time only to make sketches; Gaudier had purged himself of every kind of rhetoric he had noticed; Brancusi has detected more kinds of rhetoric and continued the process of purgation.

When verbally intelligible he is quite definite in the statement that whatever else art is, it is not *'crise des nerfs'*; that beauty is not grimaces and fortuitous gestures; that starting with an ideal of form one arrives at a mathematical exactitude of proportion, but *not by* mathematics.

Above all he is a man in love with perfection. Dante believed in the 'melody which most in-centres the soul'; in the preface to my Guido I have tried to express the idea of an absolute rhythm, or the possibility of it. Perhaps every artist at one time or another believes in a sort of elixir or philosopher's stone produced by the sheer perfection of his art; by the alchemical sublimation of the medium; the elimination of accidentals and imperfections.

Where Gaudier had developed a sort of form-fugue or form-sonata by a combination of forms, Brancusi has set out on the maddeningly more difficult exploration toward getting all the forms into one form; this is as long as any Buddhist's contemplation of the universe or as any mediaeval saint's contemplation of the divine love, – as long and even as paradoxical as the final remarks in the *Divina Commedia*. It is a search easily begun, and wholly unending, and the vestiges are let us say Brancusi's 'Bird', and there is perhaps six months' work and twenty years' knowledge between one model of the erect bird and another, though they appear identical in photography. Therein consisting the difference between sculpture and sketches. Plate No. 5 shows what looks like an egg; I give more photos of the bust than of this egg because in the photos the egg comes to nothing; in Plate No. 12 there is at the base of the chimaera an egg with a plane and a groove cut into it, an egg having infantile rotundities and repose.

I don't know by what metaphorical periphrase I am to convey the relation of these ovoids to Brancusi's other sculpture. As an interim label, one might consider them as master-keys to the world of form – not 'his' world of form, but as much as he has found of 'the' world of form. They contain or imply, or should, the triangle and the circle.

Or putting it another way, every one of the thousand angles of approach to a statue ought to be interesting, it ought to have a life (Brancusi might perhaps permit me to say a 'divine' life) of its own. 'Any prentice' can supposedly make a statue that will catch the eye and be interesting from some angle. This last statement is not strictly true, the present condition of sculptural sense leaving us with a vastly lower level both of prentices and 'great sculptors'; but even the strictest worshipper of bad art will admit that it is infinitely easier to make a

statue which can please from one side than to make one which gives satisfaction from no matter what angle of vision.

It is also conceivably more difficult to give this formal-satisfaction by a single mass, or let us say to sustain the formal-interest by a single mass, than to excite transient visual interests by more monumental and melodramatic combinations.

Brancusi's revolt against the rhetorical and the kolossal has carried him into revolt against the monumental, or at least what appears to be, for the instant, a revolt against one sort of solidity. The research for the aerial has produced his bird which stands unsupported upon its diminished base (the best of jade carvers and netsuke makers produce tiny objects which also maintain themselves on extremely minute foundations). If I say that Brancusi's ideal form should be equally interesting from all angles, this does not quite imply that one should stand the ideal temple on its head, but it probably implies a discontent with any combination of proportions which can't be conceived as beautiful even if, in the case of a temple, some earthquake should stand it up intact and end-ways or turned-turtle. Here I think the concept differs from Gaudier's, as indubitably the metaphysic of Brancusi is outside and unrelated to vorticist manners of thinking.

The great black-stone Egyptian patera in the British museum is perhaps more formally interesting than the statues of Memnon.

In the case of the ovoid, I take it Brancusi is meditating upon pure form free from all terrestrial gravitation; form as free in its own life as the form of the analytic geometers; and the measure of his success in this experiment (unfinished and probably unfinishable) is that from some angles at least the ovoid does come to life and appear ready to levitate. (Or this is perhaps merely a fortuitous anecdote, like any other expression.)

Crystal-gazing?? No. Admitting the possibility of self-hypnosis by means of highly polished brass surfaces, the polish, from the sculptural point of view, results merely from a desire for greater precision of the form, it is also a transient glory. But the contemplation of form or of formal-beauty leading into the infinite must be dissociated from the dazzle of crystal; there is a sort of relation, but there is the more important divergence; with the crystal it is a hypnosis, or a contemplative fixation of thought, or an excitement of the 'subconscious' or unconscious (whatever the devil they may be), and with the ideal form in marble it is an approach to the infinite *by form*, by precisely the highest possible degree of consciousness of formal perfection; as free of accident as any of the philosophical demands of a 'Paradiso' can make it.

This is not a suggestion that all sculpture should end in the making of abstract ovoids; indeed no one but a genius wholly centred in his art, and more or less 'oriental' could endure the strain of such effort.

But if we are ever to have a bearable sculpture or architecture it might be well for young sculptors to start with some such effort at perfection, rather than with the idea of a new Laocoon, or a 'Triumph of Labour over Commerce.' (This suggestion is mine, and I hope it will never fall under the eye of Brancusi. But then Brancusi can spend most of his time in his own studio, surrounded by the calm of his own creations, whereas the author of this imperfect exposure is compelled to move about in a world full of junk-shops, a world full of more than idiotic ornamentations, a world where pictures are made for museums, where no man has a front-door that he can bear to look at, let alone one he can contemplate with reasonable pleasure, where the average house is each year made more hideous, and where the sense of form which ought to be as general as the sense of refreshment after a bath, or the pleasure of liquid in time of drouth or any other clear animal pleasure, is the rare possession of an 'intellectual' (heaven help us) 'aristocracy.')

13 Osip Brik

'Into Production!' 1923

The critic Osip Brik (1888–1945) was an active proponent of Russian Constructivism, within which the term 'production' had a privileged meaning. In a collection of constructivist articles he published under the title *Art in Production* in Moscow in 1921, Brik explained how the production he had in mind meant rejecting 'the beautifully decorated object' and instead producing an object that is 'consciously made'. By 1923 Brik and other productivists felt the need to modify their earlier utopian aspirations, finding that actual cultural production was not fulfilling what genuine revolutionary artists ought to expect. As part of a new 'call to arms', Brik's 'Into Production!' essay singles out one artist, Aleksandr Rodchenko (1891–1956), as an exemplary figure who demonstrates how productivism should work in practice. At the time of writing, Rodchenko was director of teaching in the metalwork faculty, *Metfak*, at the Moscow School of the Technical Arts, *Vkhutemas*. His students were taught 'composition' and 'formation of objects', based on his own pedagogical, sculptural work – most famously the *Spatial Constructions* of 1921.

'Into Production!' originally appeared in the first issue of the journal *Lef. Lef* was produced by Brik and others, including Rodchenko, from his Moscow apartment under the senior editorship of the poet, Vladimir Mayakovsky. In the editorial of the first issue, constructivists were advised to guard against becoming 'just another aesthetic school', while production artists were told not to become 'applied-art handicraftsmen'. Brik amplifies this message, insisting that 'material culture' should pit itself against 'the abstract apprehension of colour and form', while also refuting any suggestion that it is therefore simply applied art. An 'organizing talent' is needed in order to dispel 'aesthetic considerations', he adds. But Rodchenko is a production artist rather than an artist in the traditional sense: he spits on artists, and is intent on proving to industrialists that 'only the productional-constructive approach to the object gives the highest proficiency to production'. His mission is to meet the needs of a new communist consumer: 'a consumer who does not need pictures and ornaments, and who is not afraid of iron and steel'.

Osip Brik's text was first published in *Lef*, (Moscow, no. 1, March 1923). It was translated and reprinted in Stephen Bann (ed.), *The Tradition of Constructivism*, New York: Da Capo, 1974, pp. 83–5. Translated by Richard Sherwood.

Rodchenko was an abstract artist. He has become a constructivist and production artist. Not just in name, but in practice.

There are artists who have rapidly adopted the fashionable jargon of constructivism. Instead of 'composition' they say 'construction'; instead of 'to

write' they say 'to shape'; instead of 'to create' – 'to construct.' But they are all doing the same old thing: little pictures, landscapes, portraits. There are others who do not paint pictures but work in production, who also talk about material, texture, construction, but once again out come the very same age-old ornamental and applied types of art – little cockerels and flowers or circles and dashes. And there are still others who do not paint pictures and do not work in production – they 'creatively apprehend' the 'eternal laws' of color and form. For them the real world of things does not exist; they wash their hands of it. From the heights of their mystical insights they contemptuously gaze upon anyone who profanes the 'holy dogmas' of art through work in production, or any other sphere of material culture.

Rodchenko is no such artist. Rodchenko sees that the problem of the artist is not the abstract apprehension of color and form, but the practical ability to resolve any task of shaping a concrete object. Rodchenko knows that there aren't immutable laws of construction, but that every new task must be resolved afresh, starting from the conditions set by the individual case.

Rodchenko knows that you won't do anything by sitting in your own studio, that you must go into real work, carry your own organizing talent where it is needed – into production. Many who have glanced at Rodchenko's work will say: 'Where's the constructivism in this? Where's he any different from applied art?' To them I say: The applied artist embellishes the object; Rodchenko shapes it. The applied artist looks at the object as a place for applying his own ornamental composition, while Rodchenko sees in the object the material that underlies the design. The applied artist has nothing to do if he can't embellish an object; for Rodchenko a complete lack of embellishment is a necessary condition for the proper construction of the object.

It is not aesthetic considerations but the purpose of the object that defines the organization of its color and form.

At the moment things are hard for the constructivist production artist. Artists turn their backs on him. Industrialists wave him away in annoyance. The man in the street goggles and, frightened, whispers: 'Futurist!' It needs tenacity and will power not to lapse into the peaceful bosom of canonized art, to avoid starting to 'create' like the 'fair copy' artists, or to concoct ornaments for cups and handkerchiefs, or daub pictures for cozy dining rooms and bedrooms.

Rodchenko will not go astray. He can spit on the artists and philistines, and as for the industrialists, he will break through and prove to them that only the productional-constructive approach to the object gives the highest proficiency to production. Of course, this will not happen quickly. It will come when the question of 'quality' moves to the forefront; but now, when everything is concentrated on 'quantity', what talk can there be of proficiency!

Rodchenko is patient. He will wait; meanwhile he is doing what he can – he

is revolutionizing taste, clearing the ground for the future nonaesthetic, but useful, material culture.

Rodchenko is right. It is evident to anyone with his eyes open that there is no other road for art than into production.

Let the company of 'fair copyists' laugh as they foist their daubings onto the philistine aesthetes.

Let the 'applied artists' delight in dumping their 'stylish ornaments' on the factories and workshops.

Let the man in the street spit with disgust at the iron constructive power of Rodchenko's construction. There is a consumer who does not need pictures and ornaments, and who is not afraid of iron and steel. This consumer is the proletariat. With the victory of the proletariat will come the victory of constructivism.

14 Katarzyna Kobro

'Sculpture and Solid' 1929

Katarzyna Kobro (1898–1951) trained in Moscow in the former Soviet Union, but from 1924 onwards lived and worked at Łódz in Poland. She came to prominence initially in connection with the *Blok* group, a collection of Polish cubists, suprematists and constructivists, although from 1925 to the time of writing 'Sculpture and Solid' she was more closely associated with the Polish quarterly, *Praesens*. 'Sculpture and Solid' is one of Kobro's first attempts at theoretical writing. It was submitted to the journal *Europa*, in response to an editorial call for answers to the questions: 'What do you think of the current state of modern art?' and 'What tendency in the efforts and explorations of modern art do you regard as the most promising and productive?' This gave Kobro an opportunity to advance her long-held views about the potential for sculpture to move away from a now-redundant monumentality and instead to embrace 'spatial manipulation' and 'the organization of the rhythm of proportions'. From 1928 onwards, the proportions in question were specifically those of Pythagoras' 'golden section'. By restricting herself to these ratios, Kobro appears to have been attempting to make her practice more systematic, perhaps in response to accusations of 'looseness' in a generally hostile critical response to her work. In its connection to architecture, Kobro saw sculpture as 'laboratory work'. She regarded it as 'the most advanced artistic endeavour' of all the disciplines, nevertheless blurred the boundaries between media. In the period 1926–29, her usual practice was not to exhibit sculpture alone, but rather to mix it with painting, architectural models and furniture design. As a result, critics often mistook her sculpture for something else – a fact bemoaned by her husband, Władyslaw Strzemiński, who once asked in desperation: 'was it so difficult to read in the catalogue that it [Kobro's sculpture] was not furniture but spatial sculpture?'

Katarzyna Kobro, 'Rzeźba i bryła', *Europa*, no. 2, 1929, p. 60; translated and reproduced in *Katarzyna Kobro 1898–1951*, Leeds: Henry Moore Institute, and Łódz: Muzeum Sztuki, 1999, p. 155. Translated by Jerzy Jarniewicz.

There are very few modern sculptors. Are there any material reasons for this? Or does this result from the fact that today sculpture is too directly involved with architecture, so that every truly modern architect should be a good modern sculptor?

In his Futurist sculptures Boccioni showed us how to free sculpture from the weight of the solid. Archipenko opened up the interior of the solid, preserving, however, the closure of its volume. Vantongerloo feels the need for the harmony of dimensions and for modern classicism; he builds up the sculpture out of several inter-related cubes, enclosed within the overall cubic volume.

In his few experiments with painting and architecture, Van Doesburg promised some spatial solutions in the construction of sculpture out of planes and solids, but what he promised was neither painting, nor sculpture, nor architecture. It only gave an idea of what could be achieved. In his dynamic-spatial constructions and his theoretical writings, Malevich raises the issues of balance in the distribution of weight and mass in space. He was the prophet of abstract painting; now he introduces through his architectonic sculptures a new era of architecture, growing out of contemporary sculpture.

Sculpture is the shaping of space. If one wishes to see the true tendencies in the development of sculpture, one should compare the highest achievements of the present. One should not care about the work of the majority of minor sculptors, but consider only the achievements of the trend-setters. Secondly, one should realize, once and for all, that sculpture is neither literature, nor symbolism, nor individual psychological emotion.

Sculpture is nothing but the shaping of form in space. Sculpture addresses all people and speaks to them in the same language. Its language is form and space. Hence the objectivism of the most economical expression of form. There are no multiple solutions – there is only one – the simplest and the most appropriate.

A sculpture is part of its ambient space. That is why it should not be separated from space. A sculpture enters space, and space enters it in turn. The spatiality of the construction, the bond between the sculpture and space, brings out of the sculpture the sheer truth of its existence. That is why there should be no accidental shapes, only those shapes that relate and bind it to space. A solid is a lie about the essence of the sculpture. It closes up the sculpture and separates it from space; it exists for itself and it treats its interior space as something completely different from the exterior space. In reality, however, space is always the same. Nowadays the solid already belongs to history and is just a pretty tale from the past.

As it becomes united with space, the new sculpture should be its most condensed and essential part. It achieves this because its shapes, through their mutual interdependence, create a rhythm of dimension and division. The unity of rhythm is achieved by means of the uniform scale of its calculations. The harmony of units is the external manifestation of number.

15 Michel Leiris

'Alberto Giacometti' 1929

Before aligning himself with the 'dissident surrealists' grouped around Georges Bataille and the periodical *Documents*, Michel Leiris (1901–90) had moved in surrealist circles in the mid-1920s, associating with the painter André Masson. After his experiments with poetic texts on painting and drawing, Leiris wrote an essay on Giacometti, his first piece of writing on a sculptor. It fused an imaginative engagement with Giacometti's work, which, Leiris suggested, he had encountered in Giacometti's studio, with a more laconic presentation of the young artist's career to date. This essay was also the first extended commentary to be published on Giacometti's work, and as such served to present him as a new 'discovery' of the *Documents* group, before others (such as André Breton) could appropriate him for themselves. The journal *Documents* aimed to challenge disciplinary boundaries and artistic hierarchies by presenting diverse materials, ranging from new archaeological finds to reviews of the latest jazz releases. Giacometti's work in this context implicitly participated in an assault on established cultural values, where definitions of sculpture were opened up to new and potentially subversive models.

Leiris's article fused references to anthropological and psychoanalytical concepts with extraordinary images of sculptural petrifaction and dissolution, as well as stressing the ways in which the sculptures he had seen and touched himself had set off chains of personal associations. Within surrealism more broadly, sculpture had a problematic status, as it was not easily aligned with 'automatic' practices, and Leiris's essay reflected this by not discussing sculpture directly, as its author admits. Despite this, Leiris's text does evoke the material processes and forms of Giacometti's work (often in plaster), comparing these to tools and utensils in a way that complicates distinctions between art and artefact and evokes the close implication of the sculptural object in the activities of its viewers and users (to the point of *eating* sculpture, in the account's striking conclusion). The studio-home setting – where art and life, art viewing and hospitality overlap – is an important dynamic in such considerations. In 1931, two years after writing this text, Leiris would take part in a major state-sponsored ethnographic expedition crossing Africa. He would subsequently pursue a multiple career as the author of poetry, art writings and autobiography, and as a practising anthropologist.

Michel Leiris, 'Alberto Giacometti', *Documents*, yr. 1, no. 4, September 1929, pp. 209–10. Translated by Julia Kelly.

We are living in a very dull-witted age by all accounts, and the fetishism upon which our human existence is grounded, as in the most ancient times, only rarely finds the opportunity for undisguised fulfilment. Worshipping the scanty

phantoms of our moral, logical and social imperatives, we end up clinging to a transposed fetishism, a poor apology for one of our deepest motivations, and this sorry fetishism takes up the greater part of our activities, leaving virtually no room for real fetishism – the only worthwhile kind, due to its complete self-awareness and consequent lack of any deception.

In the realm of artworks, we hardly ever find any objects (paintings or sculptures) that are able to live up to the demands of this true fetishism – that is to say to live up to the love (the truly loving love) of our own selves, projected from inside to outside and clad with a solid shell, confining it to the bounds of a precise thing and placing it, like a piece of furniture to be used, in the vast unfamiliar chamber of space.

In most cases, these objects, despite being made by human hands, remain still more distant from us than the products of nature, since they are at once merely their servile reflection as well as their very feeble, wan and mocking shadow, unable to provide us with a pole to line up with the internal pole of our love.

It is due to this lack of stability, this absence of autonomy, that almost all works of art are appallingly boring, *more boring than rain*, as they are after all much less close to us than droplets of water – those pretty little liquid spheres liable at least to remind us of the shape, if not the taste, of our tears, their humidity and fluidity matching the sweet feeling that flows in our limbs when we love someone or even when someone touches us.

At present, there are few artists whose work eludes this terrible boredom. In the past, their works were fewer still. But amongst those contemporaries exempted from that rule by special privilege, we can name Giacometti.

There are moments we can call *crises* and which are the only ones that matter in our lives. These are moments when the outside world seems suddenly to answer the summons that we issue from inside ourselves, when it seems to open up so that between it and our hearts an unexpected communication takes place. I have several memories of this kind in my life, all of which involve apparently trifling events, stripped too of symbolic value and thus *gratuitous*, if you will: in a bright Montmartre street, a negress from the Black Birds troupe holding a bouquet of wet roses in both hands, a liner with me on board slowly parting from a quayside, some snatches of song murmured by chance, coming across a strange animal which must have been a sort of giant lizard in a Greek ruin…Poetry can only emerge from such 'crises,' and the only artworks that count are those which provide equivalents of them for us.

I like Giacometti's sculptures because everything he does is like the petrifaction of one of these crises, the intensity of a love affair swiftly caught by surprise and immediately fixed in time, the stone marker that attests to it. Nevertheless there is nothing dead in this sculpture: instead everything there

is prodigiously alive, as it is in the true fetishes we can idolise (that is to say the true fetishes that resemble us and are the objectivised form of our desires) – alive with a life that is full of grace and strongly marked by humour, a fine expression of that sentimental ambivalence – a kind of tender sphinx that we continue to nurture, more or less secretly, inside ourselves.

Don't expect me to actually talk *sculpture*. I prefer to WANDER in my mind, as these lovely objects that I've been able to see and touch stir up so many memories in me…

Some of these sculptures are hollow like spatulas or emptied-out fruits. Others are perforated with air passing through them, poignant lattices placed between interior and exterior worlds, sifting screens eroded by the wind – a hidden wind that envelops us with its vast black swirls, at those unheard-of moments of delirium.

Giacometti was born on the 10th October 1901 in Stampa, Switzerland (in the Grisons district). He is the son of a painter.

Up to the age of 14, he stayed in his native village, then in 1915 he went to a secondary school, which he left four years later to paint and sculpt, something he had already wanted to do for several years. For six months, he studied at the School of Arts and Crafts in Geneva, but didn't like it there. For all of 1921 he was in Italy, travelling widely. Nine months were spent in Rome. In 1922 he came for the first time to Paris. For three years he would never stay there very long; but since 1925 he has settled there, except for two or three months spent every year in his country of birth. At first, he went regularly to an academy to work from nature, but for several years now he has worked alone.

So Giacometti is a very young sculptor. It is always stupid to make predictions, and prophets most often are no different from doom-mongers. But how can we not give him credit when we see those figures born from his fingers which are so concrete, so clear, absolute like creatures we love, shaped in the fleeting and sweet salt of snow, the dust that falls from our nails when we file them – intangible cinders that a lover should preserve like a relic – the wondrous salt that so many ancient researchers thought they could extract from the belly of the earth, the salinity of waves and of stars that also have their own tides, then the salt of tears, tears of laughter, despair or madness, light and vaguely wicked tears, fantastic tears or heavy tears loaded with the salt of frozen skeletons and carcasses, ever drops of water that fall unceasingly, sometimes piercing a dazzling well in the mute rock of existence, concrete drops of water resembling the salt that will always stir up our hunger, sea salt, briny salt, salt of cracking joints, tooth salt, salt of sweat, the salt of a glance… Here, finally, are stone dishes, bronze foodstuffs that are marvellously alive, able to arouse and revive our great hunger for a long time to come!

16 Vladimir Tatlin

'The Problem of the Relationship between Man and Object: Let us declare War on Chests of Drawers and Sideboards' 1930

Vladimir Tatlin (1885–1953) was famously inspired by Picasso to move from painting into sculptural relief work. In this essay, however, he shows the extent to which his ideas respond more importantly to the revolutionary atmosphere of Soviet Russia and specifically to the innovation known as 'material culture'.

Tatlin claims in this article to have had the idea for material culture as early as 1914, although its origins are developed more clearly and substantially in the later movement known as 'productivism'. Productivism was elaborated by Osip Brik and others via journals such as *Lef*. However, the essential ideas of productivism and material culture were realized simultaneously and in more practical terms by Tatlin at the State Institute of Artistic Culture in Moscow, known as *Ginkhuk*. In later years, Tatlin's material culture concept became established both as a term and as an ideal practice, especially at the Higher Artistic and Technical Studios of the Moscow School of the Technical Arts, *Vkhutemas*, where from 1927–30 Tatlin taught as Associate Professor. He was also at this time head of 'The Experimental Laboratory for Material Culture', a construction project based in the bell tower of a Moscow convent, supported by The People's Commissariat of Education, *Narkompros*. It was from here that he worked with students on the famous experimental one-person glider, *Letatlin* (first exhibited in 1932), based on the close anatomical study of birds and flying insects.

With the *Letatlin* project probably uppermost in his mind at the time of writing, Tatlin appears in this essay to be reining in modernist experimentation so as to drive a more rigorous, observation-based art education mindful not only of new industrial design and technology but also of the existing designs and technologies of nature. His new recommendation is that productivists, in their eagerness to focus on *faktura*, should not neglect the study of 'organic form' – advice that might be seen as critical of the overly mechanical or abstract design methodologies that modernism and later on Stalinism tended to encourage.

The essay originally appeared in the Moscow-based journal of the Union of Art Workers, *Rabis* (April 1930, p. 9), the text lifted almost intact from an earlier *Rabis* essay, 'The Artist as an Organizer of Everyday Life' (1929). The new title seems to be an attempt at pinpointing a problem rather than just championing the artist's organizational skills, while the subtitle introduces an even clearer, characteristically revolutionary rallying cry.

Vladimir Tatlin, 'The Problem of the Relationship between Man and Object: Let us Declare War on Chests of Drawers and Sideboards' (1930), in Larissa Alekseevna Zhadova (ed.), *Tatlin*, Thames and Hudson, 1984, pp. 267–68 (trans: Colin Wright et al). Originally published in Рабис, no. 15, 14 April 1930, p. 9.

We are now waging war for a collective way of life.[1]

Socialist cities, 'green cities', communal residences, palaces of culture are being built. In this construction there arises before us in all its breadth the problem of *man and object*.

The object in our conception must become not a sign of social distinction but that unit which is called on to realize specific functions allotted to it. At moments this object may disintegrate, become only a part of the whole, but continue to fulfil some functions.

Against the old artistic thinking it is necessary to set the new form: material culture.

Working in this area since 1914, first alone and then with a group of students, I became convinced that our industry will be able to produce objects of high quality only when the artist-production worker takes a direct part in the organization of the object.

A way of thinking based on the culture of material makes it possible to take account both of the properties of individual materials and of the most advantageous features of their interrelationships. In such a way the artist, in creating an object, furnishes himself with a palette of different materials which he uses on the basis of their properties. Taken into account here are colour, texture, density, elasticity, weight, strength, etc., etc.

With the task of creating a concrete everyday object with determined functions, the artist of material culture takes account of all properties of suitable materials and their interrelationships, the organic form (man) for which a given object is created, and finally the social side: this man is a worker and will use the object in question in the working life he leads.

Here must be considered the maximum functionality of the object which can be achieved when there is a great understanding of the properties of materials. This factor creates the possibility for an intelligent selection of materials for a functional object, and for the introduction of completely new and hitherto unexplored materials. This in turn gives a completely exceptional result: an object which is original and radically different from objects in the West or in America. This last fact is very important inasmuch as our everyday life is being built on completely new principles.

The demands we make of an object which has to serve us are considerably greater given the conditions of everyday life here than the demands made in capitalist countries.

Our everyday life is built on healthy and natural principles and an object from the West cannot satisfy us. We must search for completely different points of departure for creating our object. It is for this reason that I show such a great interest in organic form as a point of departure for the creation of the

new object. I came to the unalterable view that studying organic form will give the richest material for the creation of a new object.

All our life, and production too, is overburdened by objects, and mainly things which contain other objects. We have to strive to eliminate these, to take from them only certain parts and introduce those parts into a building's architecture (shelves into the recess of a wall and so on). What do we use in constructing one object or another? Modern technology is working on those questions first and foremost. But that is not enough. Besides 'what', 'how' is very important, the organic form is important. For this we take and analyse existing objects, we use technical constructions as models for the forms of everyday objects, and finally, we also use as models the phenomena of living nature. Such are our principal tasks in working on the organization of new objects in the new collective way of life.

1 Translator's note: The headings over the article – 'Let us live in a new way!', 'The force of habit of millions is the most terrible force', 'Let us blow up the Bastille of stagnation, backwardness, darkness! Let us break up a decayed way of life!' – are not Tatlin's: his article was printed in a regular, recurring section of the journal. As illustrations, under the heading 'Woodmetal [*Dermet*] of VKhUTEIN. Diploma works', three photographs are printed showing the furniture made by P. Galaktionov (directed by Rodchenko) and a wooden trans- formable table.

17 Salvador Dalí

'The Object as Revealed in Surrealist Experiment' 1932

Through his 1932 article 'Surrealist Objects', Salvador Dalí (1904–89) became the most prominent spokesperson for the functions and properties of this new genre-defying surrealist activity, pursued most assiduously in the 1930s. In this essay he had defined the object as distinctly 'extra-sculptural', to be produced by those with no artistic training, such as André Breton or his soon-to-be wife Gala. 'The Object as Revealed in Surrealist Experiment' was one of a series of texts in which Dalí elaborated upon aspects of object production as a communal and potentially 'automatic' activity, but in which he also provided a brief history of surrealist objects to date. To this end, he created a mini-inventory, including Marcel Duchamp's *Why Not Sneeze?* (1921) and Man Ray's *Enigma of Isidore Ducasse* (1920), and cited a passage from Breton's then unpublished 'Introduction to the Discourse on the Paucity of Reality' of 1924, in which the author had called for the production of objects seen in dreams.

Dalí's text, though, is notable too for its consideration of what he terms 'automatic sculpture', where participants in group meetings would be invited to mould shapes in their hands as unthinkingly as possible. In 1933, the year after this article was published, Dalí provided the captions for a series of photographs by Brassaï entitled *Involuntary Sculptures*, which included close-up shots of a rolled-up metro ticket (unknowingly fingered in a bank worker's pocket) and a piece of bread roll. In 'The Object as Revealed in Surrealist Experiment', Dalí also emphasised the edible nature of certain surrealist objects, their ability to be ingested, and to become part of those involved with them, as well as making a series of suggestive connections between wax as a sculptural and occult material, honey, candles and the senses of taste and smell. Behind the pseudo-scientific tone of Dalí's text, as he outlines the 'experiments' embodied in the surrealist object, lies a striking intimation of sculpture as a performative practice, taking on shifting material forms and closely involving and implicating its instigators in ways that require extensive documentation and analysis, both textual and photographic.

Dalí's text was first published in English, and translated by the poet David Gascoyne, the author of *A Short Survey of Surrealism* (1935), and amongst the earliest champions of surrealism in Britain. The original French version no longer exists.

Salvador Dalí, 'The Object as Revealed in Surrealist Experiment', *This Quarter*, Paris, yr. 5, no. 1, September 1932 (Surrealist number), pp. 197–207. Translated by David Gascoyne. It was reprinted in Lucy Lippard (ed.), *Surrealists on Art*, New Jersey, Prentice Hall, 1970, pp. 87–97.

In my fancies, I like to take as the point of departure for surrealist experiments the title of a Max Ernst picture, *Revolution by Night.* If in addition to how nearly quite dream-like and almost overwhelming these experiments were originally, one considers the nocturnal, the splendidly blinding, power of the word more or less summing up our future, the word 'Revolution,' nothing could be less subjective than this phrase, *Revolution by Night.* After all, that the review which for several years recorded the experiments should have been called *The Surrealist Revolution* must be significant.

The years have modified the surrealist concept of the object most instructively, showing as it were in image how the surrealist view of the possibilities of action on the external world have been and may still be subject to change. In the early experiments with poetic solicitation, automatic writing and accounts of dreams, real or imaginary articles appeared to be endowed with a real life of their own. Every object was regarded as a disturbing and arbitrary 'being' and was credited with having an existence entirely independent of the experimenters' activity. Thanks to the images obtained at 'The Exquisite Corpse,'[1] this anthropomorphic stage confirmed the haunting notion of the metamorphoses – inanimate life, continuous presence of human images, &c.– while also displaying the regressive characters determining infantile stages. According to Feuerbach, 'primitively the concept of the object is no other than the concept of a second self; thus in childhood every object is conceived as a being acting freely and arbitrarily.' As will be seen in the sequel, the objects come gradually to shed this arbitrary character as the surrealist experiments proceed; when produced in dreams, they grow adapted to the most contradictory forms of our wishes, and finally are subordinated – quite relatively, it is true – to the demands of our own action. But it must be insisted that before the object yields to this necessity, it undergoes a nocturnal and indeed subterranean phase.

<p style="text-align:center">* * *</p>

The early surrealist experimenters found themselves plunged into the subterranean passages of *Revolution by Night,* the passages where *The Mysteries of New York* must have just been enacted; in fact, dream passages still identifiable today. They found themselves plunged in the post-mechanical open street, where the most beautiful and hallucinating iron vegetation sprouts those electric blooms still decorating in the 'Modern Style' the entrances to the Paris Métro. There they were stricken with oblivion and, owing to the threat of unintended cataclysms, became highly developed automatic puppets such as men now risk becoming. All night long a few surrealists would gather round the big table used for experiments, their eyes protected and masked by thin though opaque mechanical slats on which the blinding curve of the convulsive graphs would appear intermittently in fleeting luminous signals, a delicate nickel apparatus like an astrolabe being fixed to their necks and fitted with

animal membranes to record by interpenetration the apparition of each fresh poetic streak, their bodies being bound to their chairs by an ingenious system of straps, so that they could only move a hand in a certain way and the sinuous line was allowed to inscribe the appropriate white cylinders. Meanwhile their friends, holding their breath and biting their lower lips in concentrated attention, would lean over the recording apparatus and with dilated pupils await the expected but unknown movement, sentence or image.

On the table, a few scientific instruments employed in a system of physics now forgotten or still to be elaborated, endowed the night with their different temperatures and the different smells of their delicate mechanisms, having been made a little feverish by the fresh and cool taste of the electricity. There was also a woman's bronze glove and several other perverted articles such as 'that kind of white, irregular, varnished half-cylinder with apparently meaningless bulges and hollows,' which is mentioned in *Nadja*,[2] and further the cage Breton describes in *Wandering Footsteps*: 'I have in mind the occasion when Marcel Duchamp got hold of some friends to show them a cage which seemed to have no birds in it, but to be half-full of lumps of sugar. He asked them to lift the cage and they were surprised at its heaviness. What they had taken for lumps of sugar were really small lumps of marble which at great expense Duchamp had had sawn up specially for the purpose. The trick in my opinion is no worse than any other, and I would even say that it is worth nearly all the tricks of art put together.'[3]

The semi-darkness of the first phase of surrealist experiment would disclose some headless dummies and a shape wrapped up and tied with string, the latter, being unidentifiable, having seemed very disturbing in one of Man Ray's photographs (already then this suggested other wrapped-up objects which one wanted to identify by touch but finally found could not be identified; their invention, however, came later).[4] But how can one give the feel of the darkness which for us shrouded the whole business? Only by mentioning the way the surrealists were strongly attracted by articles shining with their own light – in short, phosphorescent articles, in the proper or improper meaning of that word. These were a paper-cutter decorated with ears of wheat, casts of naked women hung on the walls, and T squares and biscuits forming a Chirico 'metaphysical interior.' It is of no importance that some of these things had been covered with the luminous paint used on watch faces to make the hands and figures shine in the dark. What matters is the way in which the experiments revealed the desire for the object, the tangible object. This desire was to get the object at all costs out of the dark and into the light, to bear it all winking and flickering into the full daylight. That is how the *dream objects* Breton called for in his *Introduction to a Speech on the Poverty of Reality* were first met with.

He then said:

It should be realized that only our belief in a certain necessity prevents us from granting to poetic testimony the same credence we give, for example, to an explorer's story. Human fetishism is ready to try on the white topee or stroke the fur cap, but it displays quite another attitude when we come back full of our adventures. It absolutely requires to believe that what it is told about has *actually happened*. That is why I recently suggested that as far as is feasible one should manufacture some of the articles one meets only in dreams, articles which are as hard to justify on the ground of utility as on that of pleasure. Thus the other night during sleep, I found myself at an open-air market in the neighbourhood of Saint-Malo and came upon a rather unusual book. Its back consisted of a wooden gnome whose white Assyrian beard reached to his feet. Although the statuette was of a normal thickness, there was no difficulty in turning the book's pages of thick black wool. I hastened to buy it, and when I woke up I was sorry not to find it beside me. It would be comparatively easy to manufacture it. I want to have a few articles of the same kind made, as their effect would be distinctly puzzling and disturbing. Each time I present one of my books to some selected person, I shall add some such object to my gift.

For thereby I may assist in demolishing the thoroughly hateful trophies of the concrete and add to the discredit of 'rational' people and things. I might include ingeniously constructed machines of no possible use, and also maps of immense towns such as can never arise while human beings remain as they are, but which nevertheless would put in their place the great capitals now extant and to be. We could also have ridiculous but perfectly articulated automatons, which, though not doing anything in a human way, would yet give us proper ideas of action.

It is at least possible that the poet's creations are destined very soon to assume such tangibility and so most queerly to displace the limits of the so-called real. I certainly think that one must no longer underrate the hallucinatory power of some images or the imaginative gift some men possess independently of their ability to recollect.

** * **

In the second phase of surrealist experiment, the experimenters displayed a desire to interfere. This intentional element tended more and more to tangible verification and emphasized the possibilities of a growing relation to everydayness.

It was in the light of this that the inquiry concerning the day-dream which love is pre-eminently (*The Surrrealist Revolution*, No. 12) took place. It is significant that the inquiry was undertaken at the very moment when surrealism was bestowing an ever more concrete meaning on the word 'Revolution'.

In the circumstances, it cannot be denied that there is a dialectical potentiality in the fancy whereby the title of Max Ernst's picture, *Revolution by Night* is converted into 'Revolution by Day' (such an apt motto for the second phase of surrealist experiment), it being understood and emphasized that the day meant must be the exclusive day of dialectical materialism.

The proof of the existence of the desire to interfere and of the (ill intentioned) intentional element just mentioned is provided in the overwhelming assertions which André Breton makes in the *Second Manifesto* with the assurance natural to those who have become fully conscious of their mission to corrupt wickedly the foundations of the illegitimate, assertions which have necessarily had their effect on art and literature.

<p style="text-align:center">* * *</p>

The awareness I was given in *The Visible Woman* that certain fulfilments were imminent led me to write, quite individually and personally, however: 'I think the time is rapidly coming when it will be possible (simultaneously with automatism and other passive states) to systematize confusion thanks to a paranoiac and active process of thought, and so assist in discrediting completely the world of reality.' This has led me in the course of things to manufacture quite recently some articles still undefined which, in the realm of action, provide the same conflicting opportunities as the most remote mediumistic messages provide in the realm of receptivity.

But the new phase of surrealist experiment is given a really vital character and as it were defined by the *simulations of mental diseases* which in *The Immaculate Conception*, André Breton and Paul Eluard have contrasted with the various poetic styles. Thanks to simulation in particular and images in general, we have been enabled, not only to establish communication between automatism and the road to the object, but also to regulate the system of interferences between them, automatism being thereby far from diminished but, as it were, liberated. Through the new relation thus established our eyes see the light of things in the external world.

Thereupon, however, we are seized with a new fear. Deprived of the company of our former habitual phantoms, which only too well ensured our peace of mind, we are led to regard the world of objects, the objective world, as the true and manifested content of a new dream.

The poet's drama as expressed by surrealism has been greatly aggravated. Here again we have an entirely new fear. At the limit of the emerging cultivation of desire, we seem to be attracted by a new body, we perceive the existence of a thousand bodies of objects we feel we have forgotten. That the probable splitting of the personality is due to loss of memory is suggested by Feuerbach's conception of the object as being primitively only the concept of second self, all the more so that Feuerbach adds, 'The concept of the object is usually produced

with the help of the 'you' which is the 'objective self'. Accordingly it must be the 'you' which acts as 'medium of communication', and it may be asked if what at the present moment haunts surrealism is not the possible body which can be incarnated in this communication. The way in which the new surrealist *fear* assumes the shape, the light and the appearance of the terrifying body the 'objective self' should be compels us to think so. This view is further supported by the fact that André Breton's next book, amounting to a third surrealist manifesto, will be entitled with the clarity of a magnetized meteor, a talisman-meteor, *The Communicating Vessels*.

<p style="text-align:center">* * *</p>

I have recently invited the surrealists to consider an experimental scheme of which the definite development would have to be undertaken collectively. As it is still individual, unsystematized, and merely suggestive, it is only put forward at present as a starting-point.

1. *The Transcription of Reveries*

2. *Experiment Regarding the Irrational Acquaintance of Things*: Intuitive and very quick answers have to be given to a single and very complex series of questions about known and unknown articles such as a rocking-chair, a piece of soap, &c. One must say concerning one of these articles whether it is:

> Of day or night,
> Paternal or maternal,
> Incestuous or not incestuous,
> Favourable to love,
> Subject to transformation,

Where it lies when we shut our eyes (in front or behind us, or on our left or our right, far off or near, &c.). What happens to it if it is put in urine, vinegar, &c., &c.

3. *Experiment Concerning Objective Perception*: Each of the experimenters is given an alarm-watch which will go off at a time he must not know. Having this watch in his pocket, he carries on as usual and at the very instant the alarm goes off he must note where he is and what most strikingly impinges on his senses (of sight, hearing, smell and touch). From an analysis of the various notes so made, it can be seen to what extent objective perception depends upon imaginative representation (the causal factor, astrological influence, frequency, the element of coincidence, the possibility of the result's symbolical interpretation in the light of dreams, &c.). One might find, for instance, that at five o'clock elongated shapes and perfumes were frequent, at eight o'clock hard shapes and purely phototypical images.

4. *Collective Study of Phenomenology* in subjects seeming at all times to have the utmost surrealist opportuneness. The method which can be most

generally and simply employed is modelled on the method of analysis in Aurel Kolnai's phenomenology of repugnance. By means of this analysis one may discover the objective laws applicable scientifically in fields hitherto regarded as vague, fluctuating and capricious. It would in my opinion be of special interest to surrealism for such a study to bear on fancies and on caprice. They could be carried out almost entirely as polemical inquiries, needing merely to be completed by analysis and co-ordination.

5. *Automatic Sculpture*: At every meeting for polemics or experiment let every person be supplied with a fixed quantity of malleable material to be dealt with automatically. The shapes thus made, together with each maker's notes (of the time and conditions of production), are later collected and analysed. The series of questions regarding the irrational acquaintance of things (cf. Proposal 2 above) might be used.

6. *Oral Description of Articles* perceived only by touch. The subject is blindfolded and describes by touching it some ordinary or specially manufactured article, and the record of each description is compared with the photograph of the article in question.

7. *Making of Articles* on the strength of descriptions obtained according to the preceding Proposal. Let the articles be photographed and compared with the original articles described.

8. *Examination of Certain Actions* liable, owing to their irrationality, to produce deep currents of demoralization and cause serious conflicts in interpretation and practice, e.g.:

(a) Causing in some way any little old woman to come along and then pulling out one of her teeth,

(b) Having a colossal loaf (fifteen yards long) baked and left early one morning in a public square, the public's reaction and everything of the kind until the exhaustion of the conflict to be noted.

9. *Inscription of Words on Articles*, the exact words to be decided upon. At the time of *Calligrammes*[5] the typographical arrangement was made to suit the form of articles, which was one way of fitting the shapes of articles to the writing. Here I am proposing that the writing should be made to take the shape of the articles and that one should write directly on articles. There is not the slightest doubt that specific novelties would arise through the *direct* contact with the object, from this so very material and novel unifying of thought with the object – the novel and continuous flowering of fetishist 'desires to verify' and the novel and constant sense of responsibility. Surely the poetry written on fans, tombs, monuments, &c., has a very particular, a very clearly distinct, style? I don't want to exaggerate the importance of such precedents or of the realist error to which they give rise. Of course I am not thinking of occasional poems, but, on the contrary, of writings devoid of any obvious or intentional

relation to the object on which they are read. Thus writing would exceed the limits of 'inscription' and entirely cover over the complex, tangible and concrete shapes of things.

Such writing could be on an egg or on a roughly cut slice of bread. I dream of a mysterious manuscript written in white ink and completely covering the strange, firm surfaces of a brand-new Rolls-Royce. Let the privilege of the prophets of old be conferred on every one: let every one be able to read from things.

In my opinion this writing on things, this material devouring of things by writing, is enough in itself to show how far we have travelled since Cubism. No doubt, we became accustomed during the Cubist period to seeing things assume the most abstract intellectual shapes; lutes, pipes, jam-pots, and bottles were seeking to take the form of the Kantian 'thing in itself', supposedly invisible behind the quite recent disturbances of appearance and phenomena. In *Calligrammes* (the symptomatic value of which has not yet been realized) it was indeed the shapes of things which were seeking to take the very form of writing. Nevertheless one must insist that although this attitude is a relative step forward towards the concrete, it is still on the contemplative and theoretical plane. The object's action is allowed to influence, but there is no attempt at acting on the object. On the other hand, this principle of action and of practical and concrete taking part is what presides unceasingly over the surrealist experiments and it is our submission to this principle which leads us to bring into being 'objects that operate symbolically', objects which fulfil the necessity of being open to action by our own hands and moved about by our own wishes.[6]

But our need of taking an active part in the existence of these things and our yearning to form a whole with them are shown to be emphatically material through our sudden consciousness of *a new hunger* we are suffering from. As we think it over, we find suddenly that it does not seem enough to devour things with our eyes and our anxiety to join actively and effectively in their existence brings us to want to *eat them*.

The persistent appearance of eatables in the first surrealist things painted by Chirico – crescents, macaroons, and biscuits finding a place among complex constructions of T squares and other utensils not to be catalogued – is not more striking in this respect than the appearance in the public squares, which his pictures are, of certain pairs of artichokes or clusters of bananas which, thanks to the exceptional cooperation of circumstances, form on their own, and without any apparent modification, actual surrealist articles.

But the predominance of eatables or things that can be ingested is disclosed to analysis in almost all the present surrealist articles (sugared almonds, tobacco, coarse salt in Breton's; medical tablets in Gala's; milk, bread, chocolate, excrement and fried eggs in mine; sausage in Man Ray's; light lager

in Crevel's). The article I find most symptomatic from this point of view – and this precisely because of the complex indirectness – is Paul Eluard's, although in his there is an apparently not very edible element, a taper. Wax, however, is not only one of the most malleable substances, and therefore very strongly invites one to act upon it, but also wax used to be eaten in former times, as we learn from certain eastern tales; and further from reading certain Catalan tales of the Middle Ages, it may be seen that wax was used in magic to bring about metamorphoses and the fulfilment of wishes. As is well-known, wax was almost the only material which was employed in the making of sorcery effigies which were pricked with pins, this allowing us to suppose that they are the true precursors of articles operating symbolically. Moreover, the meaning of its consubstantiality with honey has to be seen in the fact that honey is much used in magic for erotic purposes. Here, then, the taper very likely plays the part of an intestinal morphological metaphor. Finally, by extension, the notion of eating wax survives nowadays in a stereotyped process: at séances of theatrical hypnotism and conjuring which display certain magical survivals, it is quite common to see candles swallowed. In the same way also, the edible meaning of one of Man Ray's recent articles would be revealed – an article in the middle of which a candle only has to be lit for it to set fire to several elements (a horse's tail, strings, a hoop) and cause the collapse of the whole. If one takes into account that the perception of a smell is equivalent in the phenomenology of repugnance to the perception of the taste the thing which smells may have, so that the intentional element, which is the burning of the article, may be interpreted as a round-about desire to eat it (and so obtain its smell and even its ingestible smoke), one sees that burning a thing is equivalent, *inter alia*, to making it edible.

To sum up, the surrealist object has undergone four phases so far:

1. The object exists outside us, without our taking part in it (anthropomorphic articles);

2. The object assumes the immovable shape of desire and acts upon our contemplation (dream-state articles);

3. The object is movable and such that it can be acted upon (articles operating symbolically);

4. The object tends to bring about our fusion with it and makes us pursue the formation of a unity with it (hunger for an article and edible articles).

1 The experiment known as 'The Exquisite Corpse' was instigated by Breton. Several persons had to write successively words making up a sentence on a given model ('Thy exquisite / corpse / shall drink / the bubbling / wine'), each person being unaware of what word his neighbour might have had in mind. Or else several persons had to draw successively the lines making up a portrait or a scene, the second person being prevented from

knowing what the first had drawn and the third prevented from knowing what the first and second had drawn, &c. In the realm of imagery, 'The Exquisite Corpse' produced remarkably unexpected poetic associations, which could not have been obtained in any other known way, associations which still elude analysis and exceed in value as *fits* the rarest documents connected with mental disease.

2 Editor's note: novel by Breton, published in 1928.

3 Editor's note: Duchamp's object *Why Not Sneeze?* (1921).

4 Editor's note: Man Ray's *The Enigma of Isidore Ducasse* (1920), cloth and rope over a sewing machine.

5 Editor's note: Guillaume Apollinaire's poems in representational shapes.

6 [This footnote is a partial translation of Dalí's 'Objets Surréalistes' from *La Surréalisme au service de la révolution*, no. 3, 1931, pp. 16–17 – ed.] Typical Surrealist Objects Operating Symbolically:

Article by Giacometti – A wooden bowl, having a feminine depression is suspended by means of a fine fiddle-string over a crescent, one tip of which just touches the cavity. The spectator finds himself instinctively compelled to slide the bowl up and down over the tip, but the fiddle-string is not long enough for him to do so more than a little.

Article by Valentine Hugo – Two hands, one white-gloved, the other red, and both having ermine cuffs, are placed on a green roulette cloth from which the last four numbers have been removed. The gloved hand is palm upwards and holds between thumb and forefinger (its only movable fingers) a die. All the fingers of the red hand are movable and this hand is made to seize the other, its forefinger being put inside the glove's opening which it raises slightly. The two hands are enmeshed in white threads like gossamer which are fastened to the roulette cloth with red- and white-topped drawing pins in a mixed arrangement.

Article by André Breton – An earthenware receptacle filled with tobacco in which are two long pink sugared almonds is placed on a little bicycle saddle. A polished wooden globe which can revolve in the axis of the saddle causes, when it moves, the end of this saddle to come into contact with two orange-coloured celluloid antennae. The sphere is connected by means of two arms of the same material with an hour-glass lying horizontally (so that the sand does not move) and with a bicycle bell intended to ring when a green sugared almond is slung into the axis by means of a catapult behind the saddle. The whole affair is mounted on a board covered with woodland vegetation which leaves exposed here and there a paving of percussion caps, and in one corner of the board, more thickly covered with leaves than the rest, there stands a small sculptured alabaster book, the cover of which is ornamented with a glazed photograph of the Tower of Pisa, and near this one finds, by moving the leaves, a cap which is the only one to have gone off: it is under the hoof of a doe.

Article by Gala Eluard – There are two oscillating and curved metal antennae. At each end of them are two sponges, one in metal, the other real, and they are breast-shaped, the dugs being represented by red-painted little bones. When the antennae are given a push, the sponges come just in touch, one with flowers in a bowl, the other with the bristle tips of a metal brush.

The bowl is placed in a sloping box containing other things which correspond to additional representations. There is a stretched red elastic membrane, which vibrates for a long time on the slightest touch, and a small flexible black spiral looking like a wedge hangs in a little red cage. A deal paint-brush and a chemist's glass tube divide the box into compartments.

Article by Salvador Dalì – Inside a woman's shoe is placed a glass of warm milk in the centre of a soft paste coloured to look like excrement. A lump of sugar on which there is a drawing of the shoe has to be dipped in the milk, so that the dissolving of the sugar, and consequently of the image of the shoe, may be watched. Several extras (pubic hairs glued to a lump of sugar, an erotic little photograph, &c.) make up the article, which has to be accompanied by a box of spare sugar and a special spoon used for stirring leaden pellets inside the shoe.

18 R. H. Wilenski

from *The Meaning of Modern Sculpture* 1932

As well as a curator and lecturer, Reginald Howard (R. H.) Wilenski (1887–1975) was a com-
mentator on modern art for the popular press in Britain, working as the art critic for the
Evening Standard then the *Observer* in the inter-war period. He was a lecturer at Bristol
(1930–31) and then Manchester University (1934–46). After the success of his 1927 book
The Modern Movement in Art, which focused almost entirely on modern painting, Wilenski
took the opportunity to consolidate his long-standing interest in sculpture five years later
with *The Meaning of Modern Sculpture*, also published by Faber and Faber. The text reprinted
here is drawn from the last chapter of this book.

Wilenski was an advocate of carving rather than modelling; of the use of hard stone
rather than soft clay. His interest in stone carving, and the physical struggle with a resistant
material, was inspired by the work of Jacob Epstein, Henri Gaudier-Brzeska, Eric Gill, Frank
Dobson and Henry Moore, all of whom he supported in print. His approach led him to look
beyond European art and, like Roger Fry, he promoted the appreciation of non-western
sculpture – primarily for its formal, rather than anthropological, importance. His aesthetic
tastes favoured austere, simplified, hard-edged and clearly delineated forms and surfaces.
Though his interest in modern sculpture embraced the figurative, he was staunchly against
naturalistic figurative sculpture, particularly Hellenistic sculpture and its ideals of human
beauty that had dominated European culture for so long. The subtitle of his book, given in full
below, left little doubt about this position. Such sentiments also echoed those expressed by
Gaudier-Brzeska in his articles for the *Egoist* and the vorticist magazine *Blast*, and it comes
as no surprise to find some of Gaudier-Brzeska's statements used at the end of Wilenski's
1932 book. Life, as opposed to nature, Wilenski states, is what concerns the modern sculptor:
symbolic rendition of form, not imitation of nature. At the heart of what he calls 'the modern
sculptors' creed' (an article of faith, as much as a set of opinions), published as the concluding
chapter of his book, he presents the following maxim: 'Sculptural imagination is the power
to organise formal energy in symbols for the universal analogy of form.' Such views were not
altogether new or revolutionary, but were here well expressed and with a range of historical
and contemporary references that made Wilenski's writing influential for a wide audience
and across generations.

R. H. Wilenski, 'Part V: The Modern Sculptors' Creed', in *The Meaning of Modern Sculpture: An essay on some
original sculpture of the present day together with some account of the methods of professional disseminators
of the notion that certain sculptors in ancient Greece were the first and last to achieve perfection in sculpture*,
London: Faber and Faber, 1932, pp. 161–64.

Sculptural imagination

The modern sculptors' concept of sculpture has thus, I submit, been developed in a most important and interesting direction.

I can perhaps explain the present attitude, as I understand it, more clearly by putting it in this way:

Many members of the so-called musical public go to hear different virtuosi playing the same works by the great composers; and they concentrate their attention on the differences between the performances. But the musician gives his attention in all the performances to the common denominator which is the music itself; for him the differences in the particular performances only have meaning in relation to that.

Now from the standpoint of the modern sculptors today life is the composer, the principle of universal analogy of form is the music, and the swallow-wort and the egg, the asparagus and Miss Jones, the elephant and the ant-eater, are the performers. The modern sculptor is not concerned with the differences between these performances; in his eyes their forms primarily have meaning as evidence of the universal formal principles with which they act as connecting links.

The sculptors' function thus conceived is the organisation of microcosmic symbols by means of formal imagination which is apprehension of the principles of formal analogy in the universe.

The modern sculptors, in other words, have arrived at a point when they understand what Baudelaire meant when he wrote: '*L'imagination est la plus scientifique des facultés parce que seule elle comprend l'analogie universelle.*'

And they have arrived at a point when they can add another definition to their own sculptural creed:

'*Sculptural imagination is the power to organise formal energy in symbols for the universal analogy of form.*'

Or to put it in another way they have now decided that the sculptor's business is not to imitate or dramatise fragments of nature but to symbolise the formal principles of life.

The creed as it now stands

The modern sculptors' creed as it now stands, if I understand it rightly, would therefore read as follows:

1. Sculpture is the conversion of any mass of matter without formal meaning into a mass that has been given formal meaning as the result of human will.

2. Essential sculpture is sculpture which has the same kind of meaning as the sphere, the cube and the cylinder.

3. The meaning of naturalistic or romantic imitation, as Socrates said, is merely empirical and conjectural; and what is commonly called art is merely such empirical meaning expressed by skilful tricks of hand; but the meaning of geometric art is universal and everlasting.

4. Sculptural feeling is the appreciation of masses in relation.

5. Sculptural ability is the defining of those masses by planes.

6. Sculptural energy is the mountain.

7. Sculptural imagination is the power to organise formal energy in symbols for the universal analogy of form.

And to this they might add:

8. Essential sculpture is a collaboration between the sculptor and the essential character of the block of resistant substance beneath his hand.

9. Sculpture is not the imitation of clay modelling or painting or drawing in marble or stone. It is the creation of architecture by collaboration with a substance of permanent character.

10. All great sculpture is microcosmic in formal character; and gains in meaning when increased in size.

Truth to life

Thus we arrive, I think, at the meaning of modern sculpture.

That sculpture is a symbol of the cultural effort towards collective contact with universal life; and the sculptors are aiming not at *truth to nature* in the old sense, which they regard as useless at the moment, but at *truth to life* in a sense that has long been forgotten.

And thus, too, we see once again what Einstein meant when he referred to the 'positive motive which impels men to seek a simplified synoptic view of the world conformable to their own nature, overcoming the world by replacing it with this picture'. [1]

Original art in the modern world obeys its own finality-complex. The modern sculptors and the Jack Horners are brothers after all.

1 Cf. *The Modern Movement in Art*, p. 187.

19 Maurice Raynal

'God–Table–Bowl' 1933

Maurice Raynal (1884–1954) was part of a generation of writers who had come out of both the Montmartre 'bande à Picasso' and the Montparnasse symbolist milieu of Paul Fort and 'Vers et Prose' at the Closerie des Lilas. He was a critic who had had direct contact with the cubism of Pablo Picasso, Georges Braque and Juan Gris and who had defended it, alongside Guillaume Apollinaire, both before and after the war. Raynal's text served loosely as a preface for a series of photographs showing the studios of Charles Despiau, Aristide Maillol, Constantin Brancusi, Jacques Lipchitz, Alberto Giacometti and Henri Laurens. These were reproduced over six double-page spreads. All the photographs (except those of Brancusi's studio) were taken by the Hungarian photographer Brassaï, whose photographs of Picasso's studios at Boisgeloup and rue La Boëtie had already been published in the first edition of the new art magazine *Minotaure* earlier that year.

'God–Table–Bowl' is a dramatic celebration of sculptural process and of the working model as an important object in its own right. Raynal's imaginary sculptor gives himself up to the workings of his imagination, eyes closed and spontaneously working with the clay. The sculptor, to all intents and purposes, disappears in Raynal's account and registers finally as a medium for 'pure sensibility'. This advocating of a kind of 'automatism' for sculptors might lead one to think that such a text would appeal to the surrealist writer André Breton. Breton, however, was uneasy both about the involvement of an 'old-school', jobbing critic like Raynal in *Minotaure* and about the range of sculptors whose studios were included in the photographs that followed.

The hyphenated title of Raynal's text for *Minotaure* not only echoed the subtitle of the publication as a whole ('Arts plastiques–Poésie–Musique–Architecture–Ethnographie et Mythologie–Spectacles–Etudes et Observations psychoanalytiques'), but also emphasised the critic's adherence to the publisher Albert Skira's ambition that the magazine should introduce the reader to the process of creation itself. The title suggests the presence of the mythic studio from the outset through the evocation of an interior, the humble 'table' and 'bowl/basin' in the company of a deity. Raynal's title therefore both stated the article's affiliation to the genre of the 'studio visit', while also announcing a departure from it – an indication, less of an actual studio visit, than of a visitation of a studio kind – an idea echoed in the subsequent studio photographs.

Maurice Raynal, 'Dieu–Table–Cuvette', *Minotaure*, no. 3–4, Paris: Editions Albert Skira, December 1933, pp. 39–53. This translation was published in *Close Encounters: The Sculptor's Studio in the Age of the Camera*, Leeds: Henry Moore Institute, pp. 92–3. Translated by Charles Penwarden.

When a sculptor starts modelling his statue, his first concern is simply to give form immediately to the conception of the work luminously glimpsed by his closed eyes in a flash, in the shadow of sensibility. Doggedly and fervently he tracks it down through the twists of his mind and senses, with the ardour of an athlete, of a hero or a child. Since he fears that it will escape, he tries to grab hold of it as quickly as he can, in the vacuum. He hangs on for dear life to this image that is always fleeting and capricious. And when, passionately, he churns the clay, he is so suddenly overcome with dizziness that at times his feverish hands contract, desperately closing on the earth like the dying when they grasp the cloth or, at others, open, radiant like those of the new-born, to a new light.

Hence, no doubt, the turbulent aspect of the clay model whose sharp edges, knots, drips and rough edges bear witness not so much to hasty preliminary work as to the sublime, almost volcanic efforts that the work made to emerge, hot from the mould of the creative imagination.

For it is now indeed that the artist loses all sense of his function and of art. All that remains is a kind of struggle for life. Accomplishing the idea becomes a primitive hunt organised to satisfy an instinct. The sculptor is not yet a sculptor, he is not trying to find out what the work of art will be, or even if what he creates will be a work of art. In fact, he does not even know if he wants to make a work of art. His sole aim is to wrest its secret from the idea that illuminated him. Trite and false, just and unjust, personal invention or theft, intelligence and naivety, ignorance and knowledge, the good and bad all confusedly offer their services which will be accepted whenever justified by his end.

Since he does not know what he is going to do, the sculptor borrows above all from what is not art. He gropingly places himself under the protection of unknown powers such as chance. Making the clay model, he goes into trances and what he does holds all the obscure and frenzied violence of a Pythian oracle.

Only later, after exorcism, will he set out to uncover the meaning of what was dictated to him, will he submit to the control of this kind of metric system that is taste and that this time he will submit to other, more comfortable powers, as Henri Poincaré might have put it, but in a world where nothing lasts – desperately immemorial ones, such as talent, for example, tradition and, particularly, art.

To complete the work of sculpture, that is to say, to denature it (and the term is not too strong) to such an extent that a spontaneous creation becomes a work of art, is, for the statue maker, to translate a specifically sensorial language into a conventional or coded writing, Morse or shorthand. Here we should remember that old saying, *traduttore-traditore* [translator-betrayer]. And, for the sculptor, to shelter personal inspiration behind the most con-

trolled conventions, behind the responsibilities of tradition, is tantamount to retreat – chickening out, as the popular expression would have it. And no doubt the artist will be sincere when he says that he did not mean this to happen – 'It wasn't me, it was him', says the little boy. But if he is inevitably bound to hide behind that famously acknowledged defeat which states that no work is ever seen as its author intended it, he should know where he has gone wrong and understand that the imperfection of perfection comes from the submission of everything that enlivens inspiration to the demands of that dead and, what's worse, eternal thing that is the masterwork, that hierarchic and universally acknowledged master of all works.

If the sculptor is nearly always satisfied with the clay whose 'perfected form', also, nearly always disappoints him and can never be shaken off, this is because in the former he has achieved, for himself alone, his spontaneous intention. The child is born pure, it is society that corrupts him, which is in substance what J.-J. Rousseau said. It is the same with the work of sculpture. The secret of the quality of so many admirable works of so-called folk or primitive art is that they have remained at the unfinished stage, that they have not been corrupted by submission to that law of the artistic tribe which emasculates in order to shore up the most comfortable conformism. This is the struggle between poor human perfection and the brilliance of the vital spark. The faith of the model bends to the discipline of the common rule and the universal code.

If Rodin's drawings perhaps constitute his finest sculptural models, it is because spontaneous inspiration inevitably turns into a grammatical exercise when the perfecting machine comes into play. This is not, or at least not necessarily, to uphold certain achievements of folk art. For the most admirable model is always the work of a sculptor who, although at the creative moment he might not be thinking of the rules, nevertheless masters them because he has digested them so thoroughly that he can leave them to oversee the making of the object conceived seemingly by reflex. The most remarkable aspect of working on the clay is that it leaves the sculptor free not to think, so that his mind can amble at ease around various subjects bearing no direct relation to the object of his art, as workmen sometimes do. The sculptor becomes the labourer of his own pure sensibility. And that is why a sincerely made model always has a suppleness and unity that is never stiffened by the tricks of the trade. In the model, plastic sensibility is free at last to stake its all, thus allowing lyricism its dangerous and necessary excesses. So that the clay is the most eloquent expression of the creative principle governing that superior state of art that the twentieth century has magnificently realised and that one day or another will bring about the definitive revision of the conformist values that, having wormed their way comfortably into the cheese of history, serve as

a pretext for all those convenient reactions in which pusillanimity takes refuge after its inevitably ephemeral, great gregarious impulses.

And what an admirable handbook of art one could write if only one applied oneself to emphasising the evolution of creative sketches over time, on condition that the rest be left to some eternal chronicle of fashion.

20 Adrian Stokes

from *Stones of Rimini* 1934

Adrian Stokes (1902–72) was a London-based art critic whose interest in modern art developed out of his appreciation for the Italian Renaissance. His interest in the *Tempio Malatestiano* at Rimini and the 'watery' carvings of Agostino di Duccio was initiated by the poet Ezra Pound, who viewed the *Tempio* as demonstrating an underlying Neoplatonism. While highly respectful of Pound and in agreement with him on the general affinities between stone and water, Stokes nevertheless found himself disagreeing with Pound about how to interpret the *Tempio*'s iconography. Stokes did have an interest in hidden symbolism – partly because he was a Freudian, but also because of his opposition to the Bloomsbury concept of 'significant form'. However, what he thought he could discern, mainly by direct observation, were complex formal concerns, specifically an arrhythmic 'unity of parts' – a static pattern that could also be found, if more faintly, in modern semi-abstract painting and sculpture.

In the early 1930s, having moved back to London and mixing with Herbert Read's circle (especially Barbara Hepworth and Ben Nicholson), Stokes developed these ideas into his signature notion that 'carving conception' and 'modelling sensibility' were importantly opposed – a dichotomy that was later modified, but that remained central to all of Stokes's subsequent thinking on art. Stokes did not want to condemn modelling conception outright; but carving conception he regarded as far preferable since it was unifying and so profoundly satisfying, whereas modelled art was based on a virtuosity that Stokes found impressive but unsettling. These ideas in part derived from his critical view of the infinite malleability of materials in modern industrial society, but as his later writings also highlight, they were also based in Kleinian psychoanalysis. Modelling conception was for Stokes akin to the precariousness of schizophrenia, whereas carving conception was based on the ideal of a healthy, unified mind. Because of this, carved art achieved a 'vital and vibrating concomitance', while modelled art existed 'only fitfully'.

Adrian Stokes, *Stones of Rimini*, Part 2: 'Stone and Clay', Chapter IV, 1934, pp. 109–17, 118-24, 135–46, 163–6. Much of the text of 'Carving, Modelling and Agostino' was first published in *The Criterion* as 'from *The Tempio*', October, 1933, pp. 7–24.

[…] The visual arts are rooted in handicrafts. Let us keep the expression 'the Fine Arts'. For these are the useless arts, a development of handicraft that is valued, although the products possess no utilitarian function. They are the superb development of fine objects made for use. And, in turn, the handicrafts are a heightened manual skill grown from the exercise of manual labour

as a whole. Every artist has more than a practical interest in labour. Just as plants, worms and insect life turn the soils and help to disintegrate the rock, just as animals crop the vegetation, so the cultivator carves the earth, hoeing and ploughing the ground, cutting the undergrowth, the trees and the planted corn. And just as the cultivator works the surfaces of the mother earth so the sculptor rubs his stone to elicit the shapes which his eye has sown in the matrix. The material, earth or stone, exists. Man makes it more significant. To wash, to polish, to sweep, are similar activities. But to weave or to make a shoe, indeed the processes of most trades, are pre-eminently manufacture, a making, a plastic activity, a moulding of things.

Plastic shape in the abstract is shape in the abstract, while carving shape, however abstract, is seen as belonging essentially to a particular substance. It is obvious that all carving is partly to be judged by its plasticity, that is to say, by the values of its forms apart from consideration of their material. But that approach alone to carving is inadequate and in some cases (Agostino's reliefs for example) is altogether beside the point. It is like judging sculpture by photographs.

Briefly, the difference between carving approach and modelling approach in sculptural art can be illustrated as follows. Whatever its plastic value, a figure carved in stone is fine carving when one feels that not the figure, but the stone through the medium of the figure, has come to life. Plastic conception, on the other hand, is uppermost when the material with which, or from which, a figure has been made appears no more than as so much suitable stuff for this creation.

In the two activities there lies a vast difference that symbolizes not only the two main aspects of labour, but even the respective roles of male and female. Man, in his male aspect, is the cultivator or carver of woman who, in her female aspect, moulds her products as does the earth. We see both the ultimate distinction and the necessary interaction between carving and moulding in their widest senses. The stone block is female, the plastic figures that emerge from it on Agostino's reliefs are her children, the proof of the carver's love for the stone. This communion with a material, this mode of eliciting the plastic shape, are the essence of carving. And the profundity of such communion, rather than of those plastic values that might be roughly realized by any material, provide the distinctive source of interest and pleasure in carved objects.

It was not inappropriate that the tool carved as an instrument for carving or to cut now a branch, now the skull of an enemy, should have had so masculine a shape. Knapped flints, rubbed obsidians and jades, are most satisfying as carving. The demands of reality and of the connections made by the fantasy are here in simple accord. One might go further. It is from such coincidence that a thus reinforced fantasy has proceeded to create visual art.

This is the point at which to emphasize the pre-eminence of stone as the material to be carved. I am not thinking of its durability, nor even of the shape it will allow. I am thinking of the equal diffusion of light that, compared to most objects, even the hardest and darkest stones possess; I am thinking of hand-polished marble's glow that can only be compared to the light on flesh-and-blood. The sculptor is led to woo the marble. Into the solidity of stone, a solidity yet capable of suffused light, the fantasies of bodily vigour, of energy in every form, can be projected, set out and made permanent. Most other statuary materials, bronze and terra-cotta, are far higher mediums of mani-festly reflected lights, as if their light were not their own light. The majority of stones, on the other hand, are faintly or slightly translucent so that their light seems to be more within them. Polishing, when it is hand-polish and not a chemical polish, in nearly every case gives life and light to the stone without causing it to be so brilliant as to lose a great part of its light again in reflecting it, or to be over-confused and deadened by manifestly accepting lights reflected on to it. It is the difference between light and lights. The great virtue of stone is that unlike other hard materials it seems to have a luminous life, light or soul. Limestone in particular blends the virtues of hard and soft materials. Whatever virtues I now attribute to stone in general I have already attributed in particu-lar to limestones and marbles.[1]

Owing to the equal suffusion of light on stone, its most gradual shapes are unavoidable, especially since they are seen in association with stone's solidity: for hardness of material gives an enormous sense of finality to shape. The obsidian that has been thinned yet rounded to a cylinder at the shaft provides one with a far greater sense of roundness than does a ball of clay. The round-ness of a flint is so compact, so heavy, its roll so continuous. As for represen-tation of the human form, it will readily be understood that in the carving of stone's hard luminous substance, it suffers all the stroking and polishing, all the definition that our hands and mouths bestow on those we love.

Polishing stone is also like slapping the new-born infant to make it breathe. For polishing gives the stone a major light and life. 'To carve' is but a complica-tion of 'to polish', the elicitation of still larger life. Carving is a whittling away. The first instinct in relation to a carvable material is to thin it, and the first use of such material as tool or weapon required it to be sharp, to be graduated in thinness.[2] The primary (from the imaginative point of view) method of carving is to rub with an abrasive. It is possible that the forms in stone sculpture which possess pre-eminently a carving, as opposed to a plastic, significance, have nearly always been obtained by rubbing, if only in the final process. However, it is not necessary for me to enter into a discussion of technique. I think one can hold that from the deep, imaginative angle, the point, chisel, drill and claw are not so much indispensable instruments of stone sculpture as auxiliary

weapons that prepare the stone for the use, however perfunctory, of abrasives. The chisel and the rest facilitate stone sculpture: and, historically speaking, it may be that these instruments were adopted from wood carving and gem carving for this purpose, rather than invented for use on sculptural stone.[3] But the only point I wish to make is that rubbing belongs integrally to the process of stone sculpture. Wood, on the other hand, is never carved by rubbing.[4] Herein lies the fundamental difference between stone and wood sculpture: for it is reflected in the shapes proper to each, whatever be the actual instruments with which they are attained. Stone demands to be thinned, that is to say, rubbed. Wood demands to be cut and even split. Wood is not only not so dense, but possesses less light seemingly its own. Typically wooden shapes are nearer to typically modelled shapes. Hence, wooden shapes need to be more emphatic. In contrast with the flattening or thinning proper to stone more definitely circular shapes are proper to wood, conditioned as well, in the majority of cases, by the rounding tree-growth formation of its grain. But the light on stone reveals the slightest undulation of its surface; and since no stone has a general circular structure, curves depend entirely on the care with which the block has been diminished. Such forms, though they may suggest the utmost roundness, will tend in reality to be more flattened or compressed than in the case of carved wood. Indeed, as we have said, from this lack of exaggeration, from this flattening or thinning of the sphere, the slightest roundness obtains the maximum life and appeal. The light on stone is comparatively even: no shape need be stressed: where complete roundness is avoided, the more it may be suggested. So the shapes proper to stone are gradual, to which sharpness is given only by the thinned nature of the block as a whole.

Carving is an articulation of something that already exists in the block. The carved form should never, in any profound imaginative sense, be entirely freed from its matrix. In the case of reliefs, the matrix does actually remain: hence the heightened carving appeal of which this technique is capable. But the tendency to preserve some part of the matrix is evident in much figure carving, and in the case of some arts, has given rise to definite conventions: thus, the undivided knees of Egyptian granite kings and idols. My example is a literal one: for even though no part of the matrix is palpable, the conception of it may yet be imputed to some part of the form. This is the inspiration behind many of the great hard-stone Egyptian heads. In conception and execution they are pure carving; of which the proof is that nothing, no nothing, is more meaningless, more repulsive, than a plaster cast of one of these heads.

I speak of all stones as if they possessed pre-eminently the light and the texture which, in a previous chapter, I attributed to certain limestones. The majority of stones have these virtues, but to a much smaller degree. It follows that Egyptian hard stones such as granites, diorites and porphyries, are by no

means the most vivid kinds of stone. They lack marble's even and palpitating light. Their extreme hardness and harsh light entail comparatively rounded shapes. Softer stones, on the other hand, tend to be diminished to greater thinness. Their curves, no less gradual, will be more capable of a varied pal-pitation in their defining of forms. Such definition of form by whittling and polishing marble, so that in representational art the figures themselves tend to be flattened or compressed, as if they had long been furled amid the interior layers of the stone and now were unburdened on the air, were smoothing the air, such thinness of shape appears to me to be the essential manner of much stone carving. This manner, also, preserves for us the influence of the once enclosing matrix.

Superb instances of such shape in its most direct form are provided by the little prehistoric marble figures that come from the Cyclades. Many of these figures are so thinned out that they will not stand up. The heads par-ticularly are squashed back. Yet what roundness is suggested by the curve of the shoulders, what fullness by the slight indication of the breasts! Curiously enough, such sensitiveness to the radiance of human form and to the kindred radiance of marble, immediately proposes a Greek ancestry, although these figures antedate Achaian invasions by many hundreds of years. One will conclude, however, that this particular sensitiveness to luminous gradations of marble, Greek or not Greek, is through and through Mediterranean.

I will not stop to consider the direct evidence of such flattening in Mexican sculpture, for instance, nor attempt to elucidate it in all the major sculpture of the world. I shall not otherwise refer to the almost paper-like thinness of the earliest Chinese jades, nor explain how that though granites tend for each section to make for heavily rounded shapes, yet the colossal height of much Egyptian figure-sculptures is itself an elongation that brings them into line with pyramid and obelisk.

I pass straight on to relief. This, I contend, is a dramatized form of carving. The shape is on the surface, the matrix behind it.

It is obvious that in relief carving, especially low relief, flattened or com-pressed shapes can be shown to the greatest advantage; indeed, the utmost degree of compression can here serve as the direct and constant aim of the carver, an aim to which all stones inspire him. Just as an enhanced feeling of the spherical is attained in stone to the glory of stone, by elongating spheres into ovoids and into other gradually rounded shapes, so three-dimensional form may become all the more significant from being represented by the com-pressed shapes of low relief. Advisedly I say 'can serve' and 'may become'. For, except Agostino, no sculptor known to me has flattened into low relief almost entire figures in the round. Agostino's reliefs are the apotheosis of carving. His isolation, and the moderate approval that his work has won, but indicate

how undeveloped, generally, is the emotion that the very idea of stone carving should inspire; or, at any rate, how easily it gives ground to emotions aroused by considerations of plasticity.

[…]

That with which you model in sculpture is as much a material as the stone to be carved. But plastic material has no 'rights' of its own. It is a formless mud used, very likely, to make a model for bronze or brass. Modelling is a much more 'free' activity than carving. The modelled shape is not uncovered but created. This gives rise to a freer treatment, free in the sense that it is a treatment unrestricted by so deep an imaginative communion with the significance of the material itself. The modeller *realizes* his design with clay. Unlike the carver, he does not envisage that conception as enclosed in his raw material.

If the primary carved shape is an obsidian tool or weapon, the primary moulded shape is a clay receptacle. The unglazed bowl is written with the potter's finger-tips: thus he expresses the completeness of its manufacture: while enamelled pattern over glaze and slip, or on porcelain, are an elaboration of his touch, are the potter's written characters. As we shall see, the calligraphic and supremely personal element in graphic art is always to be associated with modelling conception (particularly in the case of oil painting), while painting, for instance, that essentially illuminates a certain space, the use of pigment that is more directed by some architectural conception of planes, is preferably to be classed with carving.

One can say at once of modelling forms (as opposed to carving forms) in the widest sense, that they are without restraint: I mean that they can well be the perfect *embodiment* of conception: whereas, in the process of carving, conception is all the time adjusted to the life that the sculptor feels beneath his tool. The mind that is intent on plasticity often expresses in sculpture the sense of rhythm, the mental pulse. Plastic objects, though they are objects, often betray a tempo. Carving conception, on the other hand, causes its object, the solid bit of space, to be more spatial still. Temporal significance instead of being incorporated in space is here turned into space and thus is shown in immediate form, deprived of rhythm.[5]

Modelling conception, untrammelled by the restraint that reverence for objects as solid space inspires, may run to many kinds of extreme. For instance, on the one hand there are the simple, 'pure', forms of many fine pieces of pottery, exhibiting a purity or completeness in manufacture that is foreign to the very substance of stone: on the other hand there are potential or conglomerate forms that are consciously impressed with the associative and transitional qualities of the mind's processes. The rapid content of Rodin's sculpture and, indeed, of impressionist art as a whole, serves as an example.

Characteristic of modelling is an effect of the preconceived. In any Ting ware bowl, a most complicated thoughtful conception has been realized by a simple shape; while the thrust of some all-absorbing rhythm simple enough in its fundamental movement, has been realized in virtuoso or masterly style by Bernini, Manet and Rembrandt, in unequivocal or monumental style by Donatello and Michael Angelo. One does not encounter so prominent a masterliness, so 'wilful' a preconception in what is essentially carving. For carving entails a dependence, imaginative as well as actual, upon the material that is worked. The stone block attains vivid life under the hand that polishes. Similarly, the shape of the material on which Piero della Francesca and even Giorgione painted, was of the deepest significance to them, far more so than in the case of Rubens, for instance, or of Vermeer. These latter, in their vastly different ways, were often engaged in such potent modelling that they negatived the picture plane by their compositions, as did all the Baroque painters. Theirs was the supremely personal, the supremely 'aesthetic' touch; theirs the calligraphic omnipotence so characteristic, as well, of far-Eastern pictorial art. The Baroque calligraphy was generous, bold, adult: while the Chinese calligraphy, though far more subtle, in painting at least has always been at root an art of precocious childhood, that is to say, cunning and exquisite splodges upon a white surface.

Most developed visual art displays a calligraphic competence. Calligraphy becomes extreme only when a calligraphic draughtsmanship is that to which each of the visual arts approximates. Such was the position in Baroque times. A Baroque church, a Baroque painting, a Baroque sculpture, each of them possess the verve of experienced and rapid handwriting. All unabashed modelling conception may be put into terms of such draughtsmanship, particularly since materials are so interchangeable in modelling. All sculptural modellers should primarily be such draughtsmen. I do not mean merely that they should be able to draw, but further, that their modelling should be but a projection of this primary penmanship. The true carver's power to draw, on the other hand, is a secondary power: for it is inspired by his attitude to stone. He has sought to illuminate the stone with file or chisel: now he seeks to illuminate paper with pencil or brush, so as to articulate its evenly lighted surface. 'Illuminated manuscripts' are a just description of the painting that springs from this attitude; and to these illuminations, the painting that was inspired by the character of stone always bears some reference. There may be a strictly linear approach to contour; but in the developed pictorial art of this kind, the painter will emulate the tonal values which the actual carver reveals on the surfaces, more or less equally lit, of his block. This painter's employment of tone is distinct from all other employments of colouring: in comparison they are adventitious; whereas the former method gives rise to the painting, whether

it be more linear or more 'tonal' in technique, that is most deeply founded upon tonal conception. To my mind such is the only true painting. There are, of course, all degrees of this profundity. Thus a Piero della Francesca picture causes all nearby pictures to cease as paintings. For, in comparison, they appear to be no more than coloured designs, calligraphic brushwork, tinted drawings.

I shall not risk the further confusion of the reader at this juncture, by following up so difficult a distinction in the realm of painting. This subject, in its entirety, belongs to a subsequent volume. But, so far as it is no necessary to my interpretation of Agostino's carving, I believe it will become clearer in due course.

To turn again to sculpture proper.

I have attempted to isolate the essential carving from the essential modelling. We may now form a better idea of their interdependence. For let me admit at once that in no part of the world has there existed a sustained figure carving in which modelling did not influence, and so, extend, the carver's aim; nor have artists with the strongest plastic preconceptions disliked, for what were considered monumental works at any rate, the suggestions of carving that result from the execution of their designs in wood or stone. There is no doubt that in the majority of developed periods, sculptors have desired to combine the plasticity of poise and rhythm with those qualities of a spatial object which, it is felt, can only be translated and enhanced rather than created. Stone exhibits these qualities at their highest. And so, plastic conceptions have been realized pre-eminently in stone as well as in plastic materials; and that not only because of the greater durability of stone.

So confused a conceptual admixture, of course, is foreign to the pure plastic art of Chinese earthenware and porcelain. But in limestone Europe, the influence of stone on modelling is evident from the earliest times, particularly in the South. After the initial rapprochement, so typical of European art, the relationship is sustained with reversed roles. For the quick development of the more facile process, modelling, then constantly influences the carver. Indeed, one can make the generalization that the greater the power of carving to absorb modelling aim, the more incessant will be the infiltration of plastic values into that carving. *Thus, the proof of the importance of stone in European art, is the prevalence of plastic aim in European carving.* A period comes in Europe, however, when an excess of plastic aim in stone-work overpowers the nexus with carving values. As carved stone the resultant product will be empty, though it may still be lovely as modelling; since a successful plastic idea is little bound up with any one material; indeed, its entirety may be suggested by a drawing. But it is probable, since the one defines the other, that when the values proper to carving are finally lost, modelling is atrophied sooner or later. There then intervene those grotesque confusions in aesthetic values such as we

attribute to the Hellenistic age and, still more, to our own immediate past. At such a time it is essential to start afresh with the primary values of carving and modelling. This is our position to-day.

[…]

Let us compare Agostino's Virgin and Child relief in the Victoria and Albert Museum with the famous Donatello entombment that hangs on the next case, the one nearer the door.[6] I have little doubt as to which of these two pieces the reader will prefer in photograph. For the greater the modelling conception in sculpture, the less are the values lost in photograph. The photograph of the Donatello relief gives you its point most happily. The design, the organization of masses, the elements of weight and stress and strain are clearly understood. The virtues of the Agostino relief, on the other hand, the gradual rounded cutting, the closely related equal tones and half tones, the luminosity, in part are lost. This Victoria and Albert Museum photograph is an exceptionally good one; yet the plate suffers by comparison with that of the Donatello. As for my other reproductions of Agostino's work, those plates which look the most striking are of the pieces that exhibit a more dominant plastic conception, such as the *David* and *Hercules* (Pls. 17 and 19).[7]

But the disparity is not merely a question of photograph. The same judgment is likely to be made in front of the reliefs themselves. For contemporary educated taste is a good deal more academic in temper than one might suppose from all the talk and would-be 'modernist' profession. Now, academic taste only feels at home with plastic conception in the widest sense. That is one of the reasons why academic sponsorship of the classic is so woeful, so doomed. Like the pseudo-modernists, academic taste can only fully recognize design alone, albeit of a different sort, but equally the plastic sort. Be it modernist or academic or whatever else, the simple, swift or 'masterly' *organisation* of masses is characteristic of modelling, be it oil paint that is slickly splashed about or Le Corbusier's lightning concrete.[8] Naturally, the Florentines with their power of organization, with their complete preconception (all the values of a Florentine relief can be suggested by a sketch), are continually acclaimed unrivalled masters among the 15th-century sculptors. At a moderate estimate only one out of a hundred trained admirers of visual art is as sensitive to the deeper philosophies of space and tone or carving, as he is to poise and rhythm or to the plastic side of composition. The majority will fully recognize the creative verve only when it has *fashioned* something out of formlessness. They see the shape and the other attributes of a primitive flint tool, but they do not see with the same absorbed attention that it is a flint. In a word, the majority are not highly sensitive to stone. They love texture and colour of course. They know this picture has good colour and that bad colour. But there it is, just colour

or colourfulness: which indeed it is when employed for plastic conception. To them the concentrated use of tone necessarily means an impressionist effect. When will they see that tone is put to more uses in a picture by Piero della Francesca than in a picture by Renoir; when will a painter come forward who is incapable of conceiving this horrible idea, colour?

I, at any rate, put in a word for carving. And, indeed, there are signs that the original carving conception is today rediscovered. Already there are painters who disdain the moulding properties of oil paint, who, so to speak, prefer to polish and scratch their canvases like the carver his stone. An attitude of such kind – rather than the often concomitant abstraction in design – is the basis of the painting we feel to be contemporary.

I do not desire to minimize the appeal of the Donatello relief, though I am not averse from anticipating its photographic advantage. Its beauty is monumental. Nothing that Agostino carved was monumental. Hence his comparative neglect by the critics. There is nothing monumental about the nature of marble. But I will not deny that the effect of the Donatello piece, in common with many other plastically conceived pieces, is enhanced by the fact that it is carved in marble. And, of course, in such carving, some of the Renaissance general love for stone obtains expression. But this relief in no way qualifies as one of Donatello's Quattro Cento works; unlike, in this respect, the reliefs on the base of the Judith, which, although bronze, display the tense animation and exuberance that was primarily imputed by that age to flowering stone surface. Or, if you prefer, such humanistic eruption was imputed to all materials. But I have argued sufficiently that stone has a pre-eminent objectivity for which a flowering is most desired. It is the concrete thing, the sculptor's ideal object.

Here is, then, in the Donatello relief, the modeller's organization of masses realized in marble. The Christ's body is everything. Even in photograph you can follow the modelling of his stomach which is made anatomical in the mode that is common to Florentine sculpture of this period. On the other hand, the further wing of the foreground angel on the right is no more than sketched in. *As surfaces*, the figures traced in the background, the background heads and the nimbi, have no aesthetic relation whatsoever with the masses in front. These background shapes are relevant only to the composition as a whole, that is, as shapes; which is not enough relationship for carving conception. But apart from the background shapes, in foreground, too, there is shown small feeling for changes in surface as significant in themselves. To Donatello, changes of surface meant little more than light and shade, chiaroscuro, the instruments of plastic organization. The bottom of the angels' robes is gouged and undercut so as to provide a contrast to the open planes of Christ's nude torso. The layers of the stone are treated wholesale. Though some of the cutting is beautiful in itself, the relief betrays a wilful, preconceived, manner of approach. In brief,

the composition is not so much founded upon the interrelationship of adjoining surfaces, as upon the broader principles of chiaroscuro. Stress and strain is the point: anatomy, the then unrivalled plastic subject, is the point.

There exists a tendency for composition to be thus broadly organized whenever the sculptor has made a design and delegated to assistants most, if not all, the heavy slow work of cutting the stone. Here again we see a reason, this time an unattractive one, for the interpolation in carving of plastic values. The prevalent monumental aim of European carving has, at times, entailed the gentleman sculptor of manifold commissions, who draws sometimes, and sometimes models in clay. Several recent academic sculptors are reputed not to have handled a chisel in their lives, nor any other carving instrument except at meal times. Three-feet models of war memorials – a wet day's work – have been posted to Italy to be executed there in tractable marbles by subservient masons with the mechanical aid of pointing. No wonder, then, that with few exceptions, the handful of serious sculptors who exist to-day concentrate upon carving and perform every stroke of their own work; no wonder they feel that they redis-cover the very art of sculpture.

In the Renaissance, of course, there were hundreds of men who cut stone superbly. The most intense feeling for stone was abroad. Nevertheless, plastic conception lent itself to delegation of work, to its organization on a large scale. We see why Florentine aesthetic was so well developed, why the workshops were so big and efficient. In plastic art, at any rate, production breeds production. A plastic conception executed by able assistants does not suffer to anything like the same extent as a carving conception. The plastic conception already exists in the master's drawing. But the values of an Agostino relief, other than those of its plasticity, were achieved only in the actual carving process. Agostino's assistants in the Tempio often let him down badly; and it was inevitable that they should. One might say that the attainment of a carving conception cannot be delegated or hurried. But those peoples whose fantasies rely largely on stone, insist upon a multiplicity of statues. Thus, we realize once more that the very love for stone, for stone sculpture, entails the development of a plastic approach. For only with the aid of this approach can good sculpture become quickly extensive. And we see that when the tendency has run its course, when the original demand for stone is exhausted, a meaningless plastic sculpture, committed to academic design, remains.

We need, however, make no excuses for the cutting of this Agostino Madonna and child low relief. It is obviously by his hand.

The most marked difference between the Agostino and the Donatello is the former's effect of steady disclosure, in direct contrast with the latter's alternating light and shade. There is always the element of disclosure in true carving. Yet, contrasted with the Donatello, Agostino's intensely low relief at

first sight may seem ribbed and fretted, fussy. You miss Donatello's bold plas-
ticity. But then you cannot realize in photograph the subtlety of surfaces that
preserve the marble as wholly marble. You feel a lack of rhythm. But why
always seek for rhythm in visual art, why desire that rhythm or music and other
temporal abstractions be conveyed by objects; why desire from the concrete an
effect of alternation, since the very process of time can be expressed, without
intermittence, as the vital steadiness of a world of space, as a rhythm whose
parts are laid out as something simultaneous, and which thus ceases to be
rhythmical? Rhythm, surely, is not so proper to visual art as immediacy; there
is, surely, a certain priority of carving over plastic conception. Plasticity or
rhythm in architecture and sculpture of the South has always retained some
pronounced immediacy of effect through the dramatic presentation of feeling.
In the visual arts of North and East, on the other hand, rhythm too frequently
impairs spatial significance: too often those arts in essence are a visual kind of
music. And how few appreciators of visual art understand anything about art,
except about music and literature!

Agostino's tonalities elude you. You cannot, for example, realize from
the photograph the effect of the apparently straight, if ridged, surface of
the Virgin's undergarment that appears beneath her left hand. Carved, not
modelled, are the carefully flattened heads, slow in roundness, yet so great in
roundness that they will 'read' from an angle. Should you go to the Victoria
and Albert, contrast in this respect the two Florentine reliefs, one on each side
of the Agostino. They are absurd when viewed from an angle, when you see
them, as you stand in front of the Agostino. The poignancy of his shapes is not
so much in themselves, as in their relations with his other shapes. This rela-
tionship is a much tighter one than in modelling. There is a poignant beauty
in the triangular shape beneath the Virgin's wrist, inside her cuff. This shape
is nothing in itself: for carving conception bestows an immense content and
power on what, by itself, would be the most insignificant of forms. Notice the
impassable little space between the Virgin's cheek and the child's head. It
has the meaning, the shapefulness, of the intervals between forms in Piero's
paintings. Such irremediable position between objects, shapes that are thus so
far determined by their intervals, do not lend themselves, after a certain point,
to the bold organization of masses that we admire in the Donatello. And why
'bold'? Because such plastic organisation runs counter to the purely spatial
conception of which stone is the symbol.

Yet, I will not deny that Agostino himself is an offspring of Florentine
modelling as I have defined it; that unless he had learned his trade in the
Florentine school,[9] he could never have developed so facile and flowering a
technique, nor attained such naturalism; that some of the Florentine modelling
clichés remained with him. But I have already admitted a constant interrela-

tion between what I have called modelling and what I have called carving. I admire the infusion of such modelling into such carving so long as it enhances the layer formation of the stone. Further, I am willing to champion any marble piece, however 'modelled' its forms, where there still exists some wide reverence for stone, some evidence or remembrance of stone culture such as the Mediterranean limestone culture. I give these Florentine plastic stone statues and reliefs preference, as carving, over much northern cutting that may have a minimum of direct plastic aim but which, none the less, pulsates with rhythm. Northerners have never loved stone deep down; and no other material directs the fantasy to pure non-rhythmic space.

This conception, non-rhythmic space, is difficult to define more closely: so let me again apply its sense to one detail of the reliefs before us. Whereas in the Donatello relief the angel's face on the Christ's arm is a most definite (and plastic) transition, on the left of the Agostino relief we see one face, as it were, causing other faces. The essence of the carving, and of truly spatial, non-rhythmic approach in general, is the juxtaposition of similar tones, of related contours, of intrinsically related forms. Every part is on some equality with every other part, an organization that is foreign to the come-and-go of rhythm. Work of this intensely spatial kind recalls a panorama contemplated in an equal light by which objects of different dimensions and textures, of different beauty and of different emotional appeal, whatever their distance, are seen with more or less the same distinctness, so that one senses the uniform dominion of an uninterrupted space. The intervals between objects have assumed a markedly irreversible aspect: there it all is, so completely set out in space that one cannot entertain a single afterthought. In visual art, the idea of forms however different, as answering to some cogent, common, continuous, dominion that enforces the bonds between those forms in spite of their manifold contrasts, gives rise to the distinctive non-plastic aim: and this idea was inspired, above all, by the equality of light on stone, an equality that dramatizes every tonal value. In Piero della Francesca's painting, by the religious reverence for spatial intervals, by tonal and perspective organization, all feeling, all movement, all rhythm, all plasticity itself, was translated equally into panorama terms. His pictures express the metaphysics of space or colour or tone. They are free of 'atmosphere', psychological or physical, as they are of anything emphatic.

See once more how shape causes shape in the Agostino relief. The Virgin's arm lies tight to her diaphragm. There is the impression of a surface growing inward. This helps out the slight indication of the breasts. In the Donatello, an angel's hand is put flat on the Christ's body. It directs attention to the torso: it is a general tactile reminder. One obtains from the Donatello none of the sense of surface making surface to flower. Agostino was the master of undulation in the stone. His stone becomes a hotbed of shape. See the angel's head

at the bottom of the relief, his hand clinging to the frame as if he had emerged from the back layers and had passed through the Virgin to the front, or as if the stone were a sea in which he rocked by his hand to and from a breakwater. Also, notice the poignancy of the child's curving shoulder juxtaposed upon the face of an angel behind, from which the shoulder's roundness graduates. Face and shoulder give each other shape. This is an excellent example of Agostino's use of tone, or, perhaps in the case of actual untinted carving, one should just call it surface juxtaposition.[10] At any rate, compare this surface transition with the deep shadow around the shoulder and arm of the angel on the left of the Donatello relief. There are no such gross and plastic shadows in Agostino's carving. His placing of a shoulder against a cheek behind, similar contours without a shadow between, remind one of Piero della Francesca's yet greater juxtapositions of similar tones, unaided by the actual changes of surface that facilitate this feat in carving.

[…]

The fine arts are rooted in the handicrafts, the handicrafts in various manual labour whose vastly traditional character, to put it mildly, is changing. Of what kind, if any, is to be the new skill, the new handicraft? I have no intention of pursuing the subject. Instead, I call attention to one contemporary change which is simple enough, but which in itself upsets the whole balance between carving and modelling.

I have defended the low relief by pointing to its direct connection with masonry, with stone architecture. Hitherto, stone or otherwise, all developed sculpture has been founded on an association, at least, with architecture; if not specifically with buildings, then with monuments, shrines, tombs and so on. Except in the case of fetishes and other small personal objects, architecture and sculpture have in every stone-using civilization gone hand in hand: or, rather, sculpture has been dependent upon building. This connection mirrors the pre-eminence that stone has enjoyed as the desired building and carving material, has ensured the preservation of some possible carving values amid the usual growth and eventual dominance of modelling conceptions. But today stone is no longer the desirable building material. What is more, *modern building materials are essentially plastic*. These materials have little emblem of their own. With an armature of steel, Le Corbusier can make you a room of any shape you like. He can express speed with a building. Rooms will be fashioned. Their organization will be simple sheer design that has no use for trappings, least of all for sculpture.

Everywhere the slower carving processes are superseded. Manufacture, modelling, has superseded its fellow. Such, we have seen, was always the European trend, though it was sustained, paradoxically enough, partly

as a result of the great ambitions of European peoples in carving processes.[11] Synthetic materials take the place of age-old products in which fantasy is deposited. The majority of our pavements and of our new buildings are made of synthetic stone; not merely concrete, but synthetic stone that can be fashioned to almost any effect that is desired! You need to know something about stone to distinguish it from this moulded product. Modern scientific power of synthesis fashions a fundamentally new and plastic environment.

Stone architecture is prolonged but a moment by synthetic stone. Stone architecture dies, the mother of the European visual arts for more than two thousand years. In Europe of the historical period, brick and mud and clay and wood construction never superseded stone. They had their individual life; still they were largely substitutes for stone. At any rate European men have always built with stone when they could afford it and obtain it. But to-day stone architecture is dying. The creations of Le Corbusier and others show that building will no longer serve as the mother art of stone, no longer as the source at which carving or spatial conception renews its strength. Architecture in that sense of the word, indeed in the most fundamental sense of the word, will cease to exist. Building becomes a plastic activity pure and simple: whereas, in the past, building with stone or its equivalents has not been (at best) a moulding of shape with stone, so much as an order imposed on blocks from which there results an exaltation of the spatial character of stone.

Mountains and pebbles still exist: but so far as stone loses its use as a constructive material, it loses also power over the imagination. Civilized man is surrounded by natural objects the intensity of whose imaginative import will continue to diminish.

What future is there for carving, or for the full spatial conception?[12] I have remarked that the strength of such modern painting as is truly contemporary is founded upon a reaction from modelling values in favour of carving values. But should the growth of plasticity, of manufacture, in labour and in art, overpower carving activities altogether, there is then no future for visual art as hitherto conceived by the European races.

1 In Chapter II.
2 I make no reference to gems. When I speak of stone, the glass-like and fragmentary precious stones are never within my vista. Possibly to the imagination they form a subject by themselves, one for which I have little feeling.
3 See *The Technique of Early Greek Sculpture* by Stanley Casson, Clarendon Press, 1933.
4 This statement is true only in the present context, that is to say, in helping to define a trend or principle. If read literally, it is untrue. Some very hard wood forms – many instances of negro wood sculpture spring to mind – were undoubtedly attained by rubbing. But in these cases the hard wood was treated almost as stone: the basic forms are stone-like, though, to their detriment, they lack stone's even light.

5 'Objects perceived simply as related in space, encourage the ambition of every man for complete self-expression, for an existence completely externalized. Our love of space is our love of expression.' *The Quattro Cento,* Vol. I, p. 158.

6 [Editorial note: These are listed as Plates 8 and 7 in the original text.]

7 [Editorial note: These are listed as Plates 17 and 19 in the original text.]

8 I am not denying the relevance to-day of Le Corbusier's building. I but make the point that his conceptions are purely plastic. At the end of this chapter I shall point out what difference this new (and inevitable) plasticity of building makes to the carving-modelling situation.

9 Agostino was born and trained in Florence. As a young man, accused falsely of theft, he sought his fortune on the other side of Italy. At the age of forty-five (1463), after completing his work at Perugia and at Rimini, he returned to Florence to find that the individual style that he had developed was not appreciated there. He could not attract any big commissions; though he was set to carve two colossi to be skied somewhere on the Duomo! In the end he returned to Perugia. It is a thousand pities that he, the master of low relief, was so often set to carve statues, quite apart from colossi. His later Perugian carving is for the most part lost: from the fragments it appears that in his public commissions his style was often ruined by the needed adjustment to contemporary taste. The earlier tabernacle in the Ognisanti at Florence is a lovely work: but the necessary homage there paid (a homage that entails a modification of Agostino's style) to the reigning Rossellino type of beauty is indeed pitiable. On the other hand, the lovely Porta San Pietro at Perugia, which belongs to his last Perugian period, shows how faithful Agostino remained to the Tempio; and so do the Madonna and Child reliefs. As a rule, Agostino's statues are rather formal and exceedingly thinned, though far more frontal in conception than his best reliefs. Cf. the fragments now in the picture gallery at Perugia. One will conclude, however, that Agostino's peculiar genius for carving could have been sustained at its height only if he could have worked continually for such a man as Sigismondo. As we shall see, the very requirements of the Tempio sculpture coincided with his own bent.

10 The reader will be able to discover for himself in my photograph many other instances of such mutually enhancing juxtaposition. An obvious example is the hair of the two angels on the right.

11 Cf. p. 123.

12 Should the reader still be puzzled by the all-important equation of 'carving values' with the 'full spatial conception', he is advised to turn back for a moment to pages 144 and 145 particularly.

21 Julio González

'Picasso Sculptor' 1936

Although Pablo Picasso (1881–1973) is seen by many to have been first and foremost a painter, he did make a large number of sculptures during his career, and Julio González's text is a celebration of this important side of his oeuvre. Written in 1936, 'Picasso Sculptor' follows André Breton's discussion of Picasso's sculpture in his essay 'Picasso in his element' of 1933 and pre-dates D. H. Kahnweiler's book-length study of Picasso's sculpture of 1949. In this short text González (1876–1942) states that Picasso always had the sensibility of a sculptor, and that sculpture is to be found at the very heart of his oeuvre, from the early cubist years of 1908 through to the 1930s, following his *Monument to Apollinaire* sculpture of 1928. González was a fellow Spaniard and a sculptor who had worked directly with Picasso, helping him to learn welding in the late 1920s in his rue Medéah studio in Montparnasse. He knew more intimately than anyone else at this time how central construction and assemblage were to Picasso's imagination and working methods, and how, in the forms and techniques of welded metal sculpture, they connected with his early collages and cardboard constructions. Picasso, after his experience of welding with González, became deeply preoccupied with sculpture in the first half of the 1930s. He acquired a property (called 'Boisgeloup') near Gisors, just outside Paris, which had stables that he used specifically for making sculpture in plaster, wood, metal and other found materials.

González's short homage, written to promote an exhibition of Picasso's recent sculpture staged at the *Cahiers d'art* magazine's gallery in Paris, not only serves to highlight the importance of sculpture for modern painters, but also gives insight into what a painter's sculptural imagination might be like. It was published in one of the most influential journals of contemporary art, at a time when Picasso's work was seen as having strong connections to surrealism. Picasso's oeuvre and the example of Picasso as a modern artist were taken up in earnest by *Cahiers d'art* and by its editor Christian Zervos throughout the 1930s, placing Picasso's life as well as his practice at the centre of their conception of modern art. In keeping with this, González gives a compelling sense of how sculpture offered Picasso exciting new possibilities for the reinvention, transformation and reconfiguration of material in three dimensions. Picasso, he asserts, was never happier, nor more alive, than when making sculpture.

Julio González, 'Picasso sculpteur: Exposition de sculptures récentes de Picasso: galerie *Cahiers d'art*', *Cahiers d'art*, Paris, no. 6–7, 1936, pp. 189–91. Translated by Julia Kelly.

It is infinitely pleasurable for me to talk about Picasso as a sculptor. I have always taken him for a 'man of form', because he naturally has a feeling for form. Form in his earliest paintings, form in the most recent ones.

In 1908, however, at the time of his first cubist paintings, Picasso showed us form not as a silhouette, nor as a projection of an object, but rather, by throwing planes into relief, by syntheses and by cubing the object, as a 'construction'.

I just needed to cut up these paintings, Picasso told me – the colours only being in the end indications of different viewpoints, planes sloping one way or another – and then to assemble them according to the cues given by colour, in order to find myself in the presence of a 'sculpture'. The absence of the painting that had been done away with was not felt at all. He was so convinced of this that he executed some perfectly turned out sculptures.

Picasso must feel himself to have a real sculptor's temperament, since he told me, recalling that period of his life: 'I have never been so contented' or 'I was so happy.'

Later, in 1931, at the time he was working on the *Monument to Apollinaire* sculpture, I often heard him repeat: 'I feel as happy again as I was in 1908.'

Many a time I have noticed that there is no form that leaves him cold. He looks at everything, at all subjects, as all forms represent something for him; and he sees everything as a sculptor does.

Moreover recently, picking up bits of softwood in his studio, he carved with his little penknife the fine sculptures published here (keeping the planes and the dimensions of every piece, each one suggesting a different figure to him), which will no doubt give food for thought.

In my opinion, the mysterious side, the nerve centre, so to speak, of Picasso's oeuvre lies in 'sculpture'. It is 'sculpture' that has given rise to so much discussion of his work, and that has brought him so much fame.

22 André Breton

from *Mad Love* 1937

As leader of the surrealist group, André Breton (1896–1966) had already begun to evoke from the mid-1920s onwards the special function of the surrealist found object as a realisation of the principle of 'objective chance', the coming together of internal desires and drives with external and apparently coincidental events. In theory a sculpture could not carry the same charge as a found object due to the deliberate and conscious intervention of its maker. While works by Giacometti, such as *Suspended Ball* (1930–31), were widely admired by the surrealists, the aesthetic of the found object – despite the evident staging of 'chance' in the process of making work – sits awkwardly with that of artistically fabricated objects.

In this text, Breton turned his attention for the first time to Giacometti's work, which he envisaged in dialogue with items discovered by himself and the sculptor in a Paris flea market, bringing together both sculptural practice and the resonances of 'random' finds. According to Breton, Giacometti's purchase of a metal mask enabled the sculptor to resolve the face of his 1934 work *The Invisible Object (Hands Holding the Void)*, the varying positions and forms of whose arms and head Breton had followed closely. The author also on that occasion acquired a wooden spoon with a small shoe decorating its handle, a catalyst for him of his feelings about an unrealised commission from the sculptor for an ashtray. This is associated by him, through a Freudian chain of word play, to the French fairy-tale heroine Cinderella, famously reunited with her perfectly fitting slipper. Thus Breton suggested the chance events underpinning the conscious decisions of sculptural production, as well as implicating himself as a kind of collaborator in the work's processes and meanings. The technical and formal concerns of Giacometti's sculpture were presented as inseparable from the interwoven forces of longing, love and loss, and from the close interaction between the sculptor and his critical commentator.

A version of this text was first published as 'Equation de l'objet trouvé', in *Documents 34, Intervention surréaliste*, Brussels, 1934, pp. 16–24, before being slightly reworked in *L'Amour fou*, Gallimard, Paris, 1937. Excerpted from André Breton, *Mad Love*, translated by Mary Ann Caws, University of Nebraska Press, Lincoln and London, 1987, pp. 25–34.

At the forefront of discovery, from the moment when, for the first navigators, a new land was in sight to the moment when they set foot on the shore, from the moment when a certain learned man became convinced that he had witnessed a phenomenon, hitherto unknown, to the time when he began to measure the import of his observation – all feeling of duration abolished by the intoxicating atmosphere of *chance* – a very delicate flame highlights or perfects life's meaning as nothing else can. It is to the recreation of this particular state of

mind that surrealism has always aspired, disdaining in the last analysis the prey and the shadow for what is already no longer the shadow and not yet the prey: the shadow and the prey mingled into a unique flash. Behind ourselves, *we must not let the paths of desire become overgrown.* Nothing retains less of desire in art, in science, than this will to industry, booty, possession. A pox on all captivity, even should it be in the interest of the universal good, even in Montezuma's gardens of precious stones! Still today I am only counting on what comes of my own openness, my eagerness to wander *in search* of everything, which, I am confident, keeps me in mysterious communication with other open beings, as if we were suddenly called to assemble. I would like my life to leave after it no other murmur than that of a watchman's song, of a song to while away the waiting. Independent of what happens and what does not happen, the wait itself is magnificent.[1]

I had been talking about this a few days before with Alberto Giacometti when a lovely spring day in 1934 invited us to stroll near the Flea Market, described in *Nadja* (this repetition of the setting is excused by the constant and deep transformation of the place).[2] At this time Giacometti was working on the construction of the female figure whose photograph is reproduced in Figure 6, and this figure, although it had appeared very distinctly a few weeks before and had taken form in plaster in a few hours, underwent certain variations as it was sculpted.[3] Whereas the gesture of the hands and the legs leaning against the plank had never caused the slightest hesitation, and the eyes, the right one figured by an intact wheel, the left one by a broken wheel, endured without change through the successive states of the figure, the length of the arms, on which the relation of the hands and breasts depended, and the angles of the face were in no way settled upon. I had never ceased to be interested in the progress of this statue, which, from the beginning, I had considered the very emanation of the *desire to love and to be loved* in search of its real human object, in its painful ignorance. As long as it had not been quite exposed, the fragility, the dynamism contained, the air of being both trapped and giving thanks, by which this graceful being had so moved me, led me to fear that in the life of Giacometti at that time any feminine intervention was likely to be harmful. Nothing was better founded than this fear, if you realize that such an intervention, passing though it was, led one day to a regrettable lowering of the hands, consciously justified by the concern to show the breasts and, having, to my great surprise, as a consequence the *disappearance of the invisible but present object* on which the interest of the figure centers, and that these hands are holding or holding up. With some slight modifications, they were reestablished the next day in their proper place. However, the head, although sketched out in its main lines, defined as to its general character, was almost alone in participating in the sentimental uncertainty from which I continue to think

the work had sprung. Completely subject as it was to certain imprescribable haughty attitude, *sure of itself*, and unshakable, which had struck us from the start. Although the remarkably definitive character of this object seemed to escape the merchant who urged us to buy it, suggesting we paint it in a bright color and use it as a lantern, Giacometti, usually very detached when it came to any thought of possessing such an object, put it down regretfully, seemed as we walked along to entertain some fear about its next destination, and finally retraced his steps to acquire it. Some few boutiques later, I made just as elective a choice with a large wooden spoon, of peasant fabrication but quite beautiful, it seemed to me, and rather daring in its form, whose handle, when it rested on its convex part, rose from a little shoe that was part of it. I carried it off immediately.

We were debating about the meaning that should attach to such finds, no matter how trivial they might appear.[4] The two objects, which we had been given with no wrapping, of whose existence we were ignorant some minutes before, and which imposed with themselves this abnormally prolonged sensorial contact, induced us to think ceaselessly of their concrete existence, offering to us certain very unexpected prolongations from their life. So it is that the mask, losing little by little what we had agreed on assigning it as a probable use – we had first thought we were dealing with a German mask for saber fencing – tended to situate itself in the personal research of Giacometti, taking a place in it analogous to the one that the face of the statue I just spoke of occupied. Considering all the detail of its structure, we decided that it was somehow *included* between the *Head* reproduced in number 5 of the journal *Minotaure*, the last work he had finished and whose mold he had promised me, and this face, which had remained in a sketchy state. It remained, we saw, to lift the last veil: the intervention of the mask seemed to be intended to help Giacometti overcome his indecision on this subject. *The finding of an object serves here exactly the same purpose as the dream, in the sense that it frees the individual from paralyzing affective scruples, comforts him and makes him understand that the obstacle he might have thought unsurmountable is cleared.*[5] A certain plastic contradiction, undoubtedly a reflection of a profound moral contradiction, observable in the first states of the sculpture, stemmed from the distinct manner in which the artist had treated the upper part – largely in planes, to flee, I suppose, certain depressing elements in the memory – and the lower part – very free, because surely unrecognizable–of the person. The mask, profiting from certain formal resemblances which must have caught our attention first (for example, as concerns the eye, the inevitable relation which can't be overlooked between the metallic trellis and the wheel), imposes, in the narrowest spatial limits, the fusion of these two styles. It seems to me

impossible to underestimate its role, when I realize the perfect organic unity of this frail and imaginary body of a woman that we admire today.

Such a demonstration of the *catalysing* role of the found object would seem less peremptory to me if that same day – but only after having left Giacometti – I had not been aware that the wooden spoon answered an analogous necessity, *although, since I am involved, this necessity remained hidden for longer.* I observe in passing that these two discoveries that Giacometti and I made *together* respond not just to some desire on the part of one of us, but rather to a desire of one of us with which the other, because of particular circumstances, is associated I claim that this more or less conscious desire – in the preceding case the impatience to see the statue in entirety, as it should be seen – only causes a discovery by two, or more, when it is *based on typical shared preoccupations.* I would be tempted to say that the two people walking near each other constitute a single influencing body, *primed.* The found object seems to me suddenly to balance two levels of very different reflection, like those sudden atmospheric condensations which make conductors out of regions that were not before, producing flashes of lightning.

Some months earlier, inspired by a fragment of a *waking sentence*, 'the Cinderella ash-tray'[6] and the temptation I had had for a long time to put into circulation some oneiric and para-oneiric objects, I had asked Giacometti to sculpt for me, according to his own caprice, a little slipper which was to be in principle Cinderella's lost slipper. I wanted to cast it in glass – even, if I remember rightly, grey glass – and then use it as an ash-tray. In spite of my frequent reminders to him of his promise, Giacometti forgot to do it for me. The *lack* of this slipper, which I really felt, caused me to have a rather long daydream, of which I think there was already a trace in my childhood. I was impatient at not being able to concretely imagine this object, over whose substance there hangs, on top of everything else, the phonic ambiguity of the word 'glassy.'[7] On the day of our walk, we had not spoken of this for some time.

It was when I got home and placed the spoon on a piece of furniture that I suddenly saw it charged with all the associative and interpretative qualities which had remained inactive while I was holding it. It was clearly changing right under my eyes. From the side, at a certain height, the little wood spoon coming out of its handle, took on, with the help of the curvature of the handle, the aspect of a heel and the whole object presented the silhouette of a slipper on tiptoe like those of dancers. Cinderella was certainly returning from the ball! The actual length of the spoon a minute ago had nothing definite about it, had nothing to contradict this, stretching towards the infinite as much in great size as in small: in fact the little slipper-heel presided over the spell cast, containing in itself the very *source* of the *stereotype* (the heel of this shoe heel could

have been a shoe, whose heel itself. . . and so on). The wood, which had seemed intractable, took on the transparency of glass. From then on the slipper, with the shoe heel multiplying, started to look vaguely as if it were moving about alone. *This motion coincided with that of the pumpkin-carriage of the tale.* Still later the wooden spoon was illuminated as such: it took on the ardent value of one of those kitchen implements that Cinderella must have used before her metamorphosis. Thus one of the most touching teachings of the old story found itself concretely realized: the marvelous slipper potential in the modest spoon. With this idea the cycle of ambivalences found an ideal closure. Then it became clear that the object I had so much wanted to contemplate before, had been constructed outside of me, very different, *very far beyond* what I could have imagined, and regardless of many immediately deceptive elements. So it was at this price, and only at this price, that the perfect organic unity had been reached.

1 Translator's note: *L'attente*: the state of waiting, of expectation, akin to André Gide's state of readiness, of the disponibilité Breton has just mentioned two sentences before. The readiness for an undefined event, in all its openness, permits the advent of the marvelous.
2 André Breton, *Nadja* (Paris: Gallimard, 1963), pp. 49–50, on the Flea Market of Saint-Ouen: 'I go there often, looking for those objects not to be found anywhere else, out of fashion, in bits and pieces, useless, almost incomprehensible, really perverse in the sense I mean and love'.
3 Photograph of Giacometti's sculpture, *Invisible Object*, in Breton's text. Photograph by Dora Maar.
4 The found object, or the *trouvaille,* is invested with the sense of the marvelous, as one 'hits on something.'
5 Cf. *Les Vases communicants* (Denoël et Steele). [Breton's note.]
6 Phrase de réveil ('waking sentence'): the sentence that taps on the window, as it was originally described by Breton, *le Cendrier Cendrillon: cendres*/cinders, a surrealist word play.
7 Du mot 'vair': the words verre ('glass') and vair ('ermine fur', but also 'variable') sound exactly alike. I have played instead on glass.

23　Naum Gabo

'Sculpture: Carving and Construction in Space'　1937

Naum Gabo (1890–1977, né Pevsner) was one of the founders of the constructivist movement in Russia, and remained an international propagandist for constructivist ideas and procedures throughout his life. While in London in the mid to late 1930s, Gabo became involved with the post-Gill 'truth to materials' movement, coordinated by Herbert Read. The Herbert Read circle included the abstract painter Ben Nicholson and the modern architect Leslie Martin, both of whom were to join Gabo in editing *Circle: International Survey of Constructive Art*, a Faber and Faber publication timed to coincide with the London Gallery exhibition, *Constructive Art*, which opened July 1937. This exhibition demonstrated the international relevance of constructivist and abstract art in England, with *Circle* showing photographs of representative English works alongside photographs of other constructivist art. The overall impression conveyed by the book was therefore of an international constructivist movement, with England very much playing its part. The London group appeared to have international ambitions and internal coherence, whereas in reality there was more mutual respect than actual organized cohesion. One obvious point of disagreement was over the wisdom of working with the new plastics. Senior figures in the Hampstead circle (most notably Herbert Read) were highly sceptical about plastics and much preferred the rigidity of stone. Gabo, like fellow émigré László Moholy-Nagy, was convinced, however, that the way plastics could be modelled and formed opened up new possibilities for sculptural expression. Helped by John Sissons at ICI, Gabo began in 1937 working in perspex, advancing on his earlier work in plexiglass. Gabo's strategy in his essay writing was to advance constructivism by unambiguously embracing new materials and articulating fresh, often architectural methodologies. At the same time, he sought to assimilate rather than dismiss sculptural tradition, as is evident from the essay's inclusive title. However, Gabo is adamant about condemning those he sees as ultra-conservatives 'who are all too keen to fight against any new idea the moment it appears on the horizon of their interests'.

Naum Gabo, 'Sculpture: Carving and Construction in Space,' in Naum Gabo, J.L. Martin, Ben Nicholson (eds), *Circle: International Survey of Constructive Art*, London: Faber and Faber, 1937, pp. 107–15.

The growth of new ideas is the more difficult and lengthy the deeper they are rooted in life. Resistance to them is the more obstinate and exasperated the more persistent their growth is. Their destiny and their history are always the same. Whenever and wherever new ideas appeared they have always been victorious if they had in themselves enough life-giving energy. No idea has ever died a violent death. Every idea is born naturally and dies naturally. An

organic or spiritual force which could exterminate the growth of any new idea by violence does not exist. This fact is not realised by those who are all too keen to fight against any new idea the moment it appears on the horizon of their interests. The method of their fight is always the same. At the beginning they try to prove that the new idea is nonsensical, impossible or wicked. When this fails they try to prove that the new idea is not at all new or original and therefore of no interest. When this also does not work they have recourse to the last and most effective means: the method of isolation; that is to say, they start to assert that the new idea, even if it is new and original does not belong to the domain of ideas which it is trying to complete. So, for instance, if it belongs to science, they say it has nothing to do with science; if it belongs to art, they say it has nothing to do with art. This is exactly the method used by our adversaries, who have been saying ever since the beginning of the new art, and especially the Constructive Art, that our painting has nothing to do with painting and our sculpture has nothing to do with sculpture. At this point I leave it to my friends the painters to explain the principles of a constructive and absolute painting and will only try to clarify the problems in my own domain of sculpture.

According to the assertions of our adversaries, two symptoms deprive constructive sculpture of its sculptural character. First, that we are abstract in our carving as in our constructions, and second that we insert a new principle, the so-called construction in space, which kills the whole essential basis of sculpture as being the art of solid masses.

A detailed examination of this slander seems to be necessary.

What are the characteristics which make a work of art a sculpture? Is the Egyptian Sphinx a sculpture? Certainly, yes. Why? It cannot be only for the reason that it consists of stone or that it is an accumulation of solid masses, for if it were so, then why is not any house a sculpture, and why are the Himalayan Mountains not a sculpture? Thus, there must be some other characteristics which distinguish a sculpture from any other solid object. I think they could be easily established by considering that every sculpture has the following attributes:

I. It consists of concrete material bounded by forms.
II. It is intentionally built up by mankind in three-dimensional space.
III. It is created for this purpose only, to make visible the emotions which the artist wishes to communicate to others.

These are the main attributes which we find in every sculptural work since the art of sculpture began, and which distinguish a sculptural work from any other object. Any other attributes which appear are of a secondary and

temporary nature and do not belong to the basic substance of sculpture. In so far as these main attributes are present in some of our surroundings we have always the right to speak about them as things with a sculptural character. I will carefully try to consider these three main attributes to see if a constructive sculpture lacks any of them.

I. Materials and Forms[1]

Materials in sculpture play one of the fundamental roles. The genesis of a sculpture is determined by its material. Materials establish the emotional foundations of a sculpture, give it basic accent and determine the limits of its aesthetical action. The source of this fact lies hidden deep in the heart of human psychology. It has an utilitarian and aesthetical nature. Our attachment to materials is grounded in our organic similarity to them. On this akinness is based our whole connection with Nature. Materials and Mankind are both derivatives of Matter. Without this tight attachment to materials and without this interest in their existence the rise of our whole culture and civilisation would have been impossible. We love materials because we love ourselves. By using materials sculptural art has always gone hand in hand with technique. Technics does not banish any material from being used in some way or for some constructive purpose. For technique as a whole, any material is good and useful. This utility is only limited by its own qualities and properties. The technician knows that one cannot impose on material those functions which are not proper to its substance. The appearance of a new material in the techniques determines always a new method in the system of construction. It would be naive and unreasonable to build a steel bridge with the same methods as those used in their stone bridges by the Romans. Similarly, technicians are now searching for: new methods in construction for reinforced concrete since they know the properties of this material are different from the properties of steel. So much for technics.

In the art of sculpture every material has its own aesthetical properties. The emotions aroused by materials are caused by their intrinsic properties and are as universal as any other psychological reaction determined by nature. In sculpture as well as in technics every material is good and worthy and useful, because every single material has its own aesthetical value. In sculpture as well as in technics the method of working is set by the material itself.

There is no limit to the variety of materials suitable for sculpture. If a sculptor sometimes prefers one material to another he does it only for the sake of its superior tractability. Our century has been enriched by the invention of many new materials. Technical knowledge has elaborated methods of working with many of the older ones which could never before be used without difficulty.

There is no aesthetical prohibition against a sculptor using any kind of material for the purpose of his plastic theme depending on how much his work accords with the properties of the chosen one. The technical treatment of materials is a mechanical question and does not alter the basic attributes of a sculpture. Carved or cast, moulded or constructed, a sculpture does not cease to be a sculpture as long as the aesthetical qualities remain in accord with the substantial properties of the material. (So, for instance, it would be a false use of glass if the sculptor neglected the essential property of this material, namely, its transparency.) That is the only thing our aesthetical emotions are looking for as far as the materials of a sculpture are concerned. The new Absolute or Constructive sculpture is intending to enrich its emotional language, and it could only be considered as an evidence of spiritual blindness or an act of deliberate malice to reproach an artistic discipline for enriching its scale of expression.

The character of the new materials which we employ certainly influences the sculptural technique, but the new constructive technique which we employ in addition to the carving does not determine the emotional content of our sculptures. This constructive technique is justified on the one hand by the technical development of building in space and on the other hand by the large increase in our contemplative knowledge.

The constructive technique is also justified by another reason which can be clarified when we examine the content of the 'space problem in sculpture'. At the head of this article there are photographs of two cubes which illustrate the main distinction between the two kinds of representation of the same object, one corresponding to carving and the other to construction.[2] The main points which distinguish them lie in the different methods of execution and in the different centres of interest. The first represents a volume of mass; the second represents the space in which mass exists made visible. Volume of mass and volume of space are sculpturally not the same thing. Indeed, they are two different materials. It must be emphasised that I do not use these two terms in their high philosophical sense. I mean two very concrete things with which we come in contact every day. Two such obvious things as mass and space, both concrete and measurable.

Up to now, the sculptors have preferred the mass and neglected or paid very little attention to such an important component of mass as space. Space interested them only in so far as it was a spot in which volumes could be placed or projected. It had to surround masses. We consider space from an entirely different point of view. We consider it as an absolute sculptural element, released from any closed volume, and we represent it from inside with its own specific properties.

I do not hesitate to affirm that the perception of space is a primary natural sense which belongs to the basic senses of our psychology. The scientist will

probably find in this affirmation of mine a large field for argument and will surely suspect me of ignorance. I do not grudge him this pleasure. But the artist, who is dealing with the domain of visual art, will understand me when I say we experience this sense as a reality, both internal and external. Our task is to penetrate deeper into its substance and bring it closer to our consciousness; so that the sensation of space will become for us a more elementary and everyday emotion the same as the sensation of light or the sensation of sound.

In our sculpture space has ceased to be for us a logical abstraction or a transcendental idea and has become a malleable material element. It has become a reality of the same sensuous value as velocity or tranquillity and is incorporated in the general family of sculptural emotions where up to date only the weight and the volume of mass have been predominant. It is clear that this new sculptural emotion demands a new method of expression different from those which have been used and should be used to express the emotions of mass, weight and solid volume. It demands also a new method of execution.

The stereometrical method in which Cube II is executed shows elementarily the constructive principle of a sculptural space expression. This principle goes through all sculptural constructions in space, manifesting all its varieties according to the demands of the sculptural work itself.

At this place I find it necessary to point out those too hasty conclusions which some followers of the constructive movements in art have arrived at in their anxiety not to be left in the rear. Snatching at the idea of space they hasten to assume that this space-idea is the only one which characterises a constructive work. This assumption is as wrong an interpretation of the constructive idea in sculpture as it is harmful for their own work. From my first affirmation of the space-idea in *The Realistic Manifesto*, 1920, I have not ceased to emphasise that in using the spatial element in sculpture I do not intend to deny the other sculptural elements; that by saying, 'We cannot measure or define space with solid masses, we can only define space by space', I did not mean to say that massive volumes do not define anything at all, and are therefore useless for sculpture. On the contrary, I have left volume its own property to measure and define – masses. Thus volume still remains one of the fundamental attributes of sculpture, and we still use it in our sculptures as often as the theme demands an expression of solidity.

We are not at all intending to dematerialise a sculptural work, making it non-existent; we are realists, bound to earthly matters, and we do not neglect any of those psychological emotions which belong to the basic group of our perceptions of the world. On the contrary, adding Space perception to the perception of Masses, emphasising it and forming it, we enrich the expression of Mass making it more essential through the contrast between them whereby Mass retains its solidity and Space its extension.

Closely related to the space problem in sculpture is the problem of Time. There is an affinity between them although the satisfactory solution of the latter still remains unsolved, being complex and obstructed by many obstacles. The solution is still handicapped by its technical difficulties. Nevertheless, the idea and the way for its solution is already traced in its main outlines by the constructive art. I find it essential for the completion of the discussion of the whole problem of our sculpture to sketch here in general terms the question of Time.

My first definition, formulated in *The Realistic Manifesto*, was: 'We deny the thousand-year-old Egyptian prejudice that static rhythms are the only possible bases for a sculpture. We proclaim the kinetic rhythms as a new and essential part of our sculptural work, because they are the only possible real expressions of Time emotions.' It follows from this definition that the problem of Time in sculpture is synonymous with the problem of motion. It would not be difficult to prove that the proclamation of this new element is not the product of the idle fancy of an efficient mind. The constructive artists are not the first and will, I hope, not be the last, to exert themselves in the effort to solve this problem. We can find traces of these efforts in almost too many examples of ancient sculpture. It was only presented in illusory forms which made it difficult for the observer to recognise it. For instance, who has not admired in the Victory of Samothrace, the so-called dynamic rhythms, the imaginary forward movement incorporated in this sculpture? The expression of motion is the main purpose of the composition of the lines and masses of this work. But in this sculpture the feeling of motion is an illusion and exists only in our minds. The real Time does not participate in this emotion; in fact, it is timeless. To bring Time as a reality into our consciousness, to make it active and perceivable we need the real movement of substantial masses removable in space.

The existence of the arts of Music and Choreography proves that the human mind desires the sensation of real kinetic rhythms passing in space. Theoretically there is nothing to prevent the use of the Time element, that is to say, real motions, in painting or sculpture. For painting the film technique offers ample opportunity – for this whenever a work of art wishes to express this kind of emotion. In sculpture there is no such opportunity and the problem is more difficult. Mechanics has not yet reached that stage of absolute perfection where it can produce real motion in a sculptural work without killing, through the mechanical parts, the pure sculptural content; because the motion is of importance and not the mechanism which produces it. Thus the solution of this problem becomes a task for future generations.

I have tried to demonstrate in the kinetic construction in space photographed here the primary elements of a realisation of kinetic rhythms in

sculpture. But I hold it my artistic duty to repeat in this place what I said in 1920, that these constructions do not accomplish the task; they are to be considered as examples of primary kinetic elements for use in a completed kinetic composition. The design is more an explanation of the idea of a kinetic sculpture than a kinetic sculpture itself.[3]

Returning to the definition of sculpture in general, it is always stated as a reproach that we form our materials in abstract shapes. The word 'abstract' has no sense, since a materialised form is already concrete, so the reproach of abstraction is more a criticism of the whole trend of the constructive idea in art than a criticism of sculpture alone. It is time to say that the use of the weapon abstract against our art is indeed only the shadow of a weapon. It is time for the advocates of naturalistic art to realise that any work of art, even those representing natural forms, is, in itself, an act of abstraction, as no material form and no natural event can be re-realised. Any work of art in its real existence, being a sensation perceived by any of our five senses, is concrete. I think it will be a great help to our common understanding when this unhappy word abstract is cancelled from our theoretic lexicon.

The shapes we are creating are not abstract, they are absolute. They are released from any already existent thing in nature and their content lies in themselves. We do not know which Bible imposes on the art of sculpture only a certain number of permissible forms. Form is not an edict from heaven, form is a product of Mankind, a means of expression. They choose them deliberately and change them deliberately, depending on how far one form or another responds to their emotional impulses. Every single shape made 'absolute' acquires a life of its own, speaks its own language and represents one single emotional impact attached only to itself. Shapes act, shapes influence our psyche, shapes are events and Beings. Our perception of shapes is tied up with our perception of existence itself. The emotional content of an absolute shape is unique and not replaceable by any other means at the command of our spiritual faculties. The emotional force of an absolute shape is immediate, irresistible and universal. It is impossible to comprehend the content of an absolute shape by reason alone. Our emotions are the real manifestation of this content. By the influence of an absolute form the human psyche can be broken or moulded. Shapes exult and shapes depress, they elate and make desperate; they order and confuse, they are able to harmonise our psychical forces or to disturb them. They possess a constructive faculty or a destructive danger. In short, absolute shapes manifest all the properties of a real force having a positive and a negative direction.

The constructive mind which animates our creative impulses enables us to draw on this inexhaustible source of expression and to dedicate it to the service of sculpture, at the moment when sculpture was in a state of complete exhaustion. I dare to state, with complete confidence in the truth of my assertion, that

only through the efforts of the Constructive Idea to make sculpture absolute did sculpture recover and acquire the new force necessary for it to undertake the task which the epoch is going to impose on it.

The critical condition in which sculpture found itself at the end of the last century is obvious from the fact that even the rise of naturalism through the growth of the impressionist movement was not able to awaken sculpture from its lethargy. The death of sculpture seemed to everybody inevitable. It is not so any more. Sculpture is entering on a period of renaissance. It again assumes the role which it formerly played in the family of the arts and in the culture of peoples. Let us not forget that all the great epochs at the moment of their spiritual apogee manifested their spiritual tension in sculpture. In all great epochs when a creative idea became dominant and inspired the masses it was sculpture which embodied the spirit of the idea. It was in sculpture that the demoniac cosmology of the primitive man was personified; it was sculpture which gave the masses of Egypt confidence and certainty in the truth and the omnipotence of their King of Kings, the Sun; it was in sculpture that the Hellenes manifested their idea of the manifold harmony of the world and their optimistic acceptance of all its contradictory laws. And do we not find completed in the impetuous verticals of the Gothic sculpture the image of the Christian idea?

Sculpture personifies and inspires the ideas of all great epochs. It manifests the spiritual rhythm and directs it. All these faculties were lost in the declining period of our culture of the last century. The Constructive Idea has given back to sculpture its old forces and faculties, the most powerful of which is its capacity to act architectonically. This capacity was what enabled sculpture to keep pace with architecture and to guide it. In the new architecture of today we again see an evidence of this influence. This proves that the constructive sculpture has started a sound growth, because architecture is the queen of all the arts, architecture is the axis and the embodiment of human culture. By architecture I mean not only the building of houses but the whole edifice of our everyday existence.

Those who try to retard the growth of the constructive sculpture are making a mistake when they say that constructive sculpture is not sculpture at all. On the contrary, it is the old glorious and powerful art re-born in its absolute form ready to lead us into the future.

1 Gabo does not give sections for II and III.
2 Editorial note: this refers to 'Two Cubes' (1930) – see Illustration *1*, *Circle*, page 103, showing I, a closed cube and II, an open cube.
3 These refer to *Kinetic Construction* (*Standing Wave*), c. 1920, and a design for a kinetic sculpture dated 1922. See illustrations 2 and 3, page 112, in *Circle*.

24 Carola Giedion-Welcker

'Introduction' to *Modern Plastic Art: Elements of Reality, Volume and Disintegration* 1937

Carola Giedion-Welcker (1893–1979) was the author of the first full-length, well-illustrated book on modern sculpture. She was active both before and after World War II, and was friendly with sculptors such as Arp, Brancusi and Giacometti. She was also close to writers such as James Joyce, and her interdisciplinary interests are reflected in her writing on sculpture, which combines a formalist attention to shape with an interest in archaeology, folklore and ritual. These interests accompanied a long-standing interest in architecture and space, which she shared with her husband Sigfried Giedion. Based in Switzerland and writing in German, she wrote widely on modern art from the 1920s onwards, but apart from the two versions of her book on modern sculpture, much of her art writing has not yet been translated into English.

Giedion-Welcker's introduction to her 1937 book *Modern Plastic Art*, reprinted here, offers a potted history of recent developments in modern European sculpture, from Maillol and Rodin, through cubism, futurism, dadaism, surrealism, to Brancusi, neoplasticism and constructivism. Providing brief accounts of these movements' and certain individual artists' contributions to sculptural aesthetics, Giedion-Welcker states that the same recurring phenomenon is detectable across all these manifestations – namely, 'a pronounced reaction from the sensual-sentimental individualist angle towards a wider and more objective human outlook, combined with a vigorous revolt against the anthromorphicization [sic] of art or its use as an overflow reservoir for our private emotions'. Such tendencies lead her to conclude by situating modern sculpture within the wider domain of science, philosophy and the other arts. This enables her to point to a future for sculpture, not as distant, closed and inward-looking, but as a further extended, engaged and creative force, 'intimately associated with the general cultural development of our age'. A revised version of her 1937 book was republished in 1954, under the new title *Contemporary Sculpture: An Evolution in Volume and Space*. Both pre- and post-war versions of her book were well illustrated and provided readers with a compelling (and shifting) visual documentation of modern sculpture, as well as a short, introductory history. Her collected writings, edited by Reinhold Hohl, came out in 1973.

Carola Giedion-Welcker, 'Introduction', *Modern Plastic Art: Elements of Reality, Volume and Disintegration*, Zürich: Dr. H. Girsberger, 1937, pp. 7–18. Translated by P. Morton Shand.

Plastic art is visible and tangible. It is derived from the formation of actual bodies.

In periods of great religious activity this art was the vehicle of various cults that enshrined the memory of the departed or symbolized the conception of immortality. Plastic art, therefore, became an essential part of human culture almost from the outset. From the remotest times symbols, which were in no sense attempts at direct portrayal, were employed as intermediaries for man's relations with the gods, the stars, the seasons, life and death. Their impersonal and spiritual function was part and parcel of a far wider complex of nature, religion and cult, the tribe, or state, and its monuments.

The emergence of individual at the expense of communal achievement, which began with the Renaissance, developed towards the end of the Nine-teenth Century into a complete estrangement between art and life; for once the former was debarred from its objective function an artificial barrier was interposed. Simultaneously with this intellectual isolation art became increas-ingly adulterated with elements that were alien to it, such as literature and psychology. The result of that infiltration is clearly evinced in late Nineteenth-Century memorials. These not only reflect lack of contact with nature, religion and contemporary society, but actually embody historic reminiscences, literary associations, etc., which denote a fundamental negation of the basic principles of plastic art.

In order to understand the aesthetic goal of the Twentieth Century we must examine not only the reactions of our own age to these aberrations, but also its attempts to recreate a new plastic world for itself.

Since the man of today has no longer any vital link with his religious obser-vances we cannot hope to revitalize religious plastic art. On the other hand a secular plastic art based on the reality of modern life, and embodying a direct and honest approach to contemporary culture, seems perfectly feasible. If 'subject' tends to disappear, content does not. Modern plastic art provides the cultural transmutations that our new way of living instinctively demands.

Concentration on legitimate means of plastic expression will not lead to an 'art for art's sake' introversion so long as plastic art remains an intrinsic part of a much wider cosmic unity. In point of fact the very reverse of what happened at the end of the previous century is now taking place: there is a rearticulation into the comprehensiveness of daily life, accompanied by the awakening of a new sincerity in means of expression which ruthlessly eliminates all that is extraneous or incidental.

Our life is divided between town and country, the technical and the natural worlds, and it is from our transitions between them that variety ensues. What is physical in us inevitably lives in a world of physical forms. From our impact with the reality of a tree growing in a wood, or the equal reality of a traffic-

signal in the street, down to our daily associations with cups and saucers, apples and eggs, a continuous chain of impressions results which is obviously capable of influencing plastic design.

The problems of statics and dynamics, as of the disintegration of mass and the space-time inter-relation of volumes, are bound to become a new plastic medium once their divorce from literary and psychological suggestion allows a return to first principles. What the artists who are preoccupied with these problems have to say can no longer be embodied in interesting or heroic motifs, but must rely exclusively on force of expression or the kind of symbols they choose. That these images are so simple is a direct reflection of our new attitude to life. In contrast to that of the preceding age our own signifies the subordination of the individual, and his reacclimatisation to nature and experience. This change is simply part of the psychological and social evolution of our age, and is in no sense due to esoteric little artistic coteries.

The examination of various recent movements in art which follows has been undertaken, not as an attempt to establish some sort of definitive classification, but solely in order to prove that in spite of wide divergencies of idiom they have a common aim and a common basic language.

In the representation of the human body, whether clothed or naked, which has been the artist's principal medium ever since antiquity, the beginning of a fundamental change in outlook can be observed towards the opening of the present century.

With Maillol human figures begin to emanate a detached objectivity. His affinities with the antique are of secondary importance because we feel that the only significance of his robust limbs lies in the impersonality of their proportions, which transforms them into half-abstract elements of a new and more balanced sculptural vision. It is the discipline of his firmly handled neutral masses which alone matters to us. Maillol broke completely with the pretty-pretty ideals of a type of beauty that depends on detail, substituting ponderous lumps of a drastically simplified anatomical architecture. His Hellenism is peasant-archaic, not Olympian.

Maillol's contribution was to redress the balance of Rodin's superb one-sidedness. Looking back on Rodin to-day he seems to have been most significant as a precursor precisely where he was least affected by literary or psychological influences, as in those statues in which the human body is no longer primarily an instrument of our passions and emotions, but rather a medium for the expression of proportion and movement animated by light and informed by space.

It is true Rodin once wrote: 'Le corps est un moulage où s'impriment les passions', but also that he said: 'Le pivot de l'art c'est l'équilibre: C'est-à-dire les oppositions des volumes, qui produisent le mouvement'.

By means of 'un rayonnement de formes' Rodin dissolved the hard outline of contemporary Neo-Grec academicism, and thereby created a vital synthesis of opacity and transparence, volume and atmosphere.

As a wielder of volumes Maillol was static in the classic sense. The new plastic simplicity he achieved presents a marked contrast to the surface complexities of Rodin's liberation or sublimation of form. In the work of Daumier, Degas, and the later Rodin we see Impressionism unconsciously modernizing the baroque tradition through its emphasis on light and movement.

The important point is that modern plastic art derives its technique from both baroque and classic sources. With Matisse we find a further development of the chiaroscuro rhythms of Impressionism, and a new feeling for freedom of proportion. The Futurist Umberto Boccioni proclaimed his adherence to Impressionism in his earlier manifestos and proceeded to expand its theories.

To-day the baroque influence transmitted through Daumier, Degas and Rodin to Matisse and Boccioni may be said to have fused with the classic influence handed on by Maillol. Merged in turn with the forces of modern life they have evoked a new optical vision. That vision can be expressed either by means of a deliberate simplification of volumes or in terms of the disintegration of mass through light. Behind each method there is the same belief in an elementary objectivity transcending any purely human values.

The historic achievement of Cubism was the transformation of sentimental into abstract images. Picasso's (1909) and Modigliani's (1911–13) heads; Laurens's (1915), Lipchitz's (1915–19) and Juan Gris's (1917) compositions; the rhythmic discipline of Archipenko's (1909–20) voids and volumes; and the geometric dehumanization of anatomy which is characteristic of the work of Schlemmer (1918–21) show what revolutionary changes have been accomplished in spite of the retention of the human body as theme.

To Cubism we owe the introduction of 'the object' and its optical analysis in terms of weight, density and volume. Fernand Léger, who was one of its pioneers, says: 'C'est le Cubisme qui a imposé l'objet au monde. La grande formule, c'est l'objet' – that is to say the complete elimination of any specifically human content. A human content remains, it is true, but a now sublimated and no longer in any sense recognisably naturalistic one, since the theme has become a purely objective vehicle. When a Cubist painter like Juan Gris says: 'Du cylindre je fais une bouteille' a change of approach is implied approximating to the architectonic standpoint. Out of the 'volume statique' Cubism had in turn evolved the 'volume cinétique', which means the simultaneous coincidence of various spatial qualities.

Raymond Duchamp-Villon's 'horse', which is purely an embodiment of movement, presents an outstanding example of *volume cinétique*.

'La spéculation pure voit les volumes prendre une vie spéciale et leur fait perdre toute consistance, d'où le peu d'importance donnée – au début de la conception – à la matière qui sera choisie. On pourrait presque dire que le statuaire fait descendre peu à peu une création immatérielle jusqu'à la cristallisation dans la matière.' (1914)

Laurens's early 'constructions' show a much freer choice of material – corrugated cardboard, tin-plate, etc. – which is intended to assimilate everyday things to art and *vice versa*.

Futurism took much the same course in striving to dethrone art from its exalted pedestal, though as a 'concezione basate sulla sensazione dell' oggetto, e non sull' oggetto stesso. La trasfigurazione della realtà' (Umberto Boccioni). These *oggetti* – for instance Boccioni's own ones – stand 'fuori dalla logica comune' thanks to their fantastic permutations of the factors of time and space. The analytical sharpness of the French Cubists is renounced, and instead we have a combination of human emotion and mechanical dynamicism – for the artistic side of the latter needs to be postulated in a machine age such as ours. Exterior and interior, subject and object, become fused into what Boccioni calls a 'dinamismo unlano'.

The close affinity between this emotional dynamicism of the Futurists and the 'cineticism' latent in the Cubists is clear enough; the only difference being that in Futurism, as in Superrealism, a psychological factor intervenes. Hence the emphasis which Futurist manifestos lay on Futurism's derivation from Impressionism – meaning what Impressionism had achieved in the way of disintegrating mass and suggesting movement through the play of light.

Dadaism created a metaphysic of banality by discovering the plastic vitality that emanates from nameless or unnoticed things, and their unsuspected powers of self-expression. Its dethronement of the 'masterpiece' as a snobbish value, like its anarchistic rejection of all outworn beauties or conventional forms, led art back to the humdrum, but none the less potentially significant, realities it had so long disdained. The first plastic applications of the Dadaist doctrines were produced by Marcel Duchamp and Man Ray in New York (1917–19)[1], Hans Arp and Max Ernst in Cologne (1918–19), Raoul Hausmann in Berlin (1919), and Kurt Schwitters (*Merz*) in Hannover (1919). Besides being amusing squibs to *épater le bourgeois* they revealed a serious attempt to unveil humble plastic realities of our visible world that had remained ignored. The cardinal plastic principle seems far more evident in them than in what are called 'choice' works of art. Like Picasso, Braque and Miró's original collages, the Dadaist examples just mentioned were primarily dependent on individual resourcefulness: 'Material has no sentimental importance; invention is every-

thing.' [2] And just as the first collages had been a protest against the decadent refinement of pictorial sensuality, so these heralded a revolt against the cult of materialism in marble.

Superrealism dissolves the wall between our inner and outer life. It permeates dreams with reality and reality with dreams, confronting or fusing the psychical and the physical, the conscious and the subconscious, the individual and the community.

> 'Je crois à la résolution future de ces deux états, en apparence si contradictoires, que sont: le rêve et la réalité en une sorte de réalité absolue, de surréalité, si l'on peut ainsi dire.'
> (André Breton, 'Manifeste Surréaliste', 1925)

There is a continuously active process of metamorphosis in Superrealism which corresponds to the cinetic and dynamic qualities in Cubism and Futurism. All biological and psychical frontiers are blurred: men and beasts, animate and inanimate objects, converge and coalesce to proclaim the sovereign domination of transience.

> '...des êtres-objets (ou objets-êtres?) caractérisés par le fait qu'ils sont en proie à une transformation continuent et expriment la perpétuité de la lutte entre les puissances agrégeantes et désagregeantes, qui se disputent la véritable réalité et la vie...'
> (André Breton, 'Objets Surréalistes' , Exposition Galerie Ratton, 1936)

A positively magical aura emanates from the simple volumes Alberto Giacometti calls 'objets mobiles et muets': stones that merge into architectural forms, prisms into heads, organic into geometric shapes.

> 'Toutes choses... près, loin, toutes celles qui sont passées et les autres par devant, qui bougent et mes amies, elles changent (on passe tout près, elles sont loin), d'autres approchent, montent, descendent... des canards sur l'eau, là et là, dans l'espace, montent, descendent... mais tout est passé...'
> (1932)

The danger of literary associations to which Superrealism is often exposed seems unimportant in comparison with its vitalizing rehabilitation of forgotten things, its exaltation of what is banal into what is extraordinary, and its tenacious insistence on the unity of life and art. The Superrealists turn commonplaces into paradoxes to show us what the German Romantics called 'the rare blue flower' growing, not at the back of beyond, but at our own doorsteps.

[149]

Hans Arp has exercised a stimulating influence on the evolution of modern plastic art. Though he has no direct affinity with the Superrealists he has certain points in common with them.

The originality of his work lies in its uncompromising elementalism. This leads him to prefer repetitive organic forms, identical beneath their mutations, which he uses as symbols of a single pre-existing master-form. He finds that common elemental prototype, either patent or concealed, ever-present in nature and the works of man. All Arp's work mirrors a state of cosmic flux. Movement is conveyed by the suggestion of growth into shape, or by the rhythms of ebb and flow. There is no attempt at mental or visual fixation; indefinite primordial shapes arise, serenely detached and self-sufficient, which yet somehow convince us that they belong to the natural world. We should be less surprised to encounter these supernaturally billowing forms in some remote region of the earth than in a crowded art gallery, for they seem to have received their lineaments from the slow grinding of millenary glaciers rather than the pliant hand of man. Arp's apparently straightforward touch conceals an incessant industry and an alert responsiveness to proportion. With him, too, the feeling for nature, being direct instead of sentimental or intellectual, has ceased to be a conscious factor.

'When Dada revealed his deepest truths to mankind, it laughed indulgently, and went on babbling. Now in art, too, men love what is vain or dead. They cannot understand that painting is anything more than a landscape smeared in with vinegar and oil, or that sculpture can assume any other form than the faking of a woman's thighs in bronze or marble. All vital transformations in art seem to them just as detestable as life's own eternal transformations. Art is a fruit which is born of man himself; as a fruit grows on a tree or an embryo in its mother's womb. But whereas all fruits have forms intrinsically their own – forms which never resemble toy balloons or French Presidents in evening dress – the human fruit we call 'Art' nearly always embodies a ridiculous resemblance to something else. It is reason that has inflated man's pride with the fond belief that he is lord over nature and an infallible criterion in himself; reason that has encompassed his divorce from nature; reason that has turned him into an at once hideous and tragic figure. I love nature, but not its substitutes. Illusory art is simply a bad substitute for nature'. (From Hans Arp's Diary, 1931)

It was thanks to Constantin Brancusi that modern plastic art was first able to exploit entirely new ground. Brancusi's compact, exquisitely moulded volumes were the earliest and purest expression of a still wider range of vision.

This Roumanian sculptor remained aloof from contemporary tendencies,

yet touched the very core of the problem that was engaging all of them. As early as 1908 (that is to say even before the emergence of the first Cubist sculpture) he had begun to envisage a plastic revival from a wholly original standpoint.

With Brancusi the egg continually recurs in some guise or other as the symbol of all life,[3] and the virtual key-form of a primaeval monopsychic world. In his quest of absolute proportions he whittles away every detail until he has evolved a finite simplicity; or as he puts it:

'La simplicité n'est pas un but dans l'art, mais on arrive à la simplicité, malgré soi, en s'approchant du sens réel des choses'.

After years of patient experiment he will evoke some unprecedented significance out of wood, marble or metal. Brancusi does every bit of his work himself and disdains preliminary models. He likes to keep his material under constant observation so as to study its 'inner life' and be able to make rapid changes in his treatment of it. For him there is therefore no longer any dividing line between craftmanship and creation.

'La taille directe, c'est le vrai chemin vers la sculpture, mais aussi le plus mauvais pour ceux qui ne savent pas marcher.'

Every fibre, every vein, each fresh shade of polish is wielded into an integral part of his composition. Under his hands inchoate material is developed out of itself and made to ring true to its own intrinsic nature; its dumbness becomes articulate, its urge for self-expression fights through stratum after stratum till it stands revealed.

To the achievement of this complete amalgam of mind and growth, material and spirit, geometric and organic forms, Brancusi brings a peculiar gift for the humour latent in certain forms, much as Joyce discovers it in the sound of certain words. If he starts from the incoherence of sub-conscious existence this is because it alone offers him a way of getting to grips with the deeper meaning of life.

The years of almost monomaniac labour he will expend on a single work are inspired by the determination to restore the sovereign clarity of simplicity wherever meaningless complexity has been suffered to intervene, and to impart a new honesty to the idiom of sculpture by purifying it of all associative corruptions. As he himself says, simplicity is only the means to an end, and that end is perfection. Brancusi lives in a world of forms as simply and intimately as St Francis of Assisi dwelt among the birds.

On much the same lines Henry Moore, and to some extent also Barbara Hepworth, have succeeded in imparting plastic intensity to simple organic volumes.

The intersection of purely organic forms by sharp geometrical planes, which can sometimes be detected in Arp and Giacometti's work as well, implies the introduction of a new element that is semi-architectural and, one might almost say, intentionally civilizing.

Both Neoplasticism and Constructivism have contributed to a clearer line of demarcation by a systematic separation between what is, and what is not, of elementary importance to expression; though from a rather different angle. Both adopted an almost geometric morphology, the object of which was to dematerialize and volatize volume by the creation of light-conditioned spatial values.

The Dutch painter Piet Mondrian was one of the founders of an active group of artists, etc., known as 'Stijl' (1917–1931), the leader of which was the architect Theo van Doesburg, who died in 1931. Mondrian summed up the ideology of this group rather later on as follows: 'Dans l'art nouvelle les formes sont neutres. Elles le sont à mesure qu'elles s'approchent de l'état universel. L'effort de l'art nouveau supprime le sujet et la forme particulière... La vie est une transformation continuelle et la nouvelle culture est celle des rapports purs...' (Piet Mondrian, *L'Art Nouveau de la Vie Nouvelle*, 1931)

The Belgian Georges Vantongerloo used solid rectangles to contrast their formal opposition and bring out their relation to one another in terms of space. The decisive factor in his evolution is the increasingly important role he began to give to spatial separation between elements grouped together as a composition. 'Nous avons besoin de l'espace pour situer les choses. L'espace, dont nous ne pouvons nous passer, sans toutefois le définir, est inséparable de la vie' – a phrase which aptly defines the interactions between space and volume. Space, in fact, becomes the imponderable element in all calculable factors. There is a close parallel between Neoplasticism and the New Architecture. This is no mere coincidence since it was in Holland that both first took root. In the Neoplastic theories the essential inter-dependence of architecture, painting and sculpture, and the basic identity of art and science, was always stressed. Thus a way was opened for establishing a fresh contact between life and art, and indeed every sphere of modern thought and activity. The outstanding importance of the pioneer work accomplished by the Bauhaus in Weimar and Dessau (1919–1928) under Walter Gropius must be mentioned in this connection.

Suprematism has been an isolated though none the less stimulating influence. It aimed at the total elimination of the object by the substitution of a sign language of absolute forms and formal relations as the proper medium for the expression of our emotions: Though Casimir Malevich's 'Dynamic Architecture' does not deal in any sense with actual buildings it is surprising to what extent it assimilates architectonic to plastic values. The link between Suprematism and the New Architecture is consequently self-evident. Malevich has defined his perception of reality as follows:

'When sitting or lying our sensations are essentially plastic. These sensations have called into being the things we require for sitting, lying, etc. and govern their shapes. Chairs, beds, and tables are embodiments of purely plastic sensibilities.'[4]

Constructivism likewise seeks to make art an integral part of the stuff of life by utilizing it to solve the problems of the modern world. Though it adopts the dynamic principles of Cubism and Futurism it translates them into mechanistic terms. The Constructivist Movement started in 1920 in Moscow and appeared a little later in Berlin. All Constructivist exhibitions and manifestos proclaim the sovereign virtue of *movement*. Constructivism goes further than any of the various tendencies that had preceded it in its insistence on the sublimation of mass into 'virtual volumes'. This implies the optical disintegration of material solidity by light so as to enable movement to become a plastic element.

'Since space and time constitute the basis of life, art must realize human experience in terms of space and time.'
(From the *Realist Manifesto* of N. Gabo and A. Pevsner, Moscow 1920.)

'We must substitute the dynamic principle of the universality of life for the static principle of classic art.'
(L. Moholy-Nagy and A. Kémèny in *Sturm* published in Berlin 1922).[5]

What is new and important in the work of Constructivists is their wholehearted acceptance of technique. Physics and mechanics provide the stimulus for their imagination. Since they regard the Zeitgeist – that is to say manifestations of our modern civilisation like standardisation, collective organisation, etc. – as the decisive factor of our generation, it follows that their work is permeated by what might be called a specifically industrial content. It is for this reason that they usually confine their choice of materials to glass, aluminium, nickel, celluloid, casein, etc. The work of Tatlin, Rodchenko, Moholy-Nagy, Pevsner and Gabo – to mention only leading names – demonstrates how fantasy can be evoked from a deliberate use of the rationalising elements of contemporary existence. It must not be imagined that the difference between their work and straightforward engineering is the substitution of mechanistically decorative for mechanistically functional motives. This important difference can best be explained by reference to the Constructivists' belief that there is a general intellectual principle implicit in the use of a given material or technical process.

The clarification brought about by the logical design and structural discipline of the various abstract tendencies that have just been mentioned has

helped to bring them into close touch with analogous objectives in the New Architecture, and even rather dissimilar trends in other branches of plastic art.

Picasso's *Composition in Wire* and his 1928 *Project for a Monument* offer us examples of a peculiar, and altogether original, crisis of geometric and organic expression.

'Un personnage, un objet, un cercle, sont des figures, elles agissent sur nous, plus ou moins intensement. Les unes sont plus près de nos sensations, produisent des émotions, qui touchent à nos facultés affectives, d'autres s'adressent plus particulièrement à l'intellect. Il faut les accepter toutes, car mon esprit a autant besoin d'émotion que mes sens.' (*Cahiers d'Art*, 1936, P. Picasso)

Julio González, Bill and Kobro – to name only a few – follow much the same lines, which may be summed up as a plastic fusion of apparently heterogeneous elements.

In this connection mention should be made of Alexander Calder's *Mobiles et Circumvolutions* – swaying or rotating bodies whose spatial ambiance is defined by wires – which are the fruit of an almost astronomical imagination.

Kurt Schwitters has developed his earlier manner into a much more lucid presentation in which Dadaist phantasy and mathematical precision are strangely combined.[6] The forms he now evokes from wood, plaster and stone demonstrate an elemental plastic principle achieved with very simple means that are quite free from incidental adjuncts.

'Plastic art', he wrote in 1933, 'means the relation of form to form, surface to surface, line to line, regarded in a non-accumulative sense. It unites all of these by means of their continuous intersection.'

If we probe deeper into the many different tendencies during the last thirty years, every one of them reveals the same constantly recurring phenomenon: a pronounced reaction from the sensual-sentimental individualist angle towards a wider and more objective human outlook, combined with a vigorous revolt against the anthromorphicisation [sic] of art or its use as an overflow reservoir for our private emotions.

In direct contradiction to the pathos, heroics, or 'inspiration of genius' of Art with a capital A, the first prerequisite for this kind of plastic exteriorisation is an unbiased concentration on the most elementary demands of expression. By deliberately sacrificing what in the last analysis is only incidental, it becomes possible for the artist to confine himself to a very few, but all the more direct, means of expression which may be defined as the shaping of volumes perceived in terms of space.

The close accord between these deliberate abnegations and those of the New Architecture should bring about a final liberation from the specious ornamentalism or theatricality which has hitherto atrophied the vitality of plastic art. Once we discard imitation and illusion, and with them all literary top-hamper, a self-sufficient plastic reality is free to emerge, which is just as real as the reality of nature and human life, if necessarily different to both.

The new freedom and independence of conception which results from this transmutation of static into dynamic values through the sort of formal shorthand that has supplanted wealth of description goes hand in hand with complete subordination to the specific nature and utilisation of the medium chosen. The human scale, the human angle, has ceased to be the universal norm. Hence there is no longer any finite or 'consecrated' ideal of beauty; no emphasis on detail, no senseless flamboyance or waste of good material.

This universal adoption of an elementary formal idiom and commonplace motifs seems to be in conformity with a far-reaching intellectual process that has been closely identified with the general cultural revolution of our age.

The underlying solidarity among the various aspects of plastic art that have already been referred to clearly points to a consensus of convictions held by all of them. This prompts a leading question: Is there a direct analogy between what is happening in modern sculpture and recent developments in other spheres of culture? To ask it is forthwith to envisage the evolution of plastic art from a much wider angle than the purely aesthetic. The really important consideration here is that these other spheres have already effected an equally drastic purge of alien influences. The rehabilitation of everyday themes and their reassimilation to the broad stream of life, which spells the progressive eclipse of the overweening pretensions of individual inspiration, has permeated not only the arts, but philosophy and science as well.

In much the same way the practical organisation of the interior in terms of spatial design is the dominant note of the *New Architecture*.[7] The comprehensive planning of a city supersedes representational pomp and chaotic juxtaposition; and its masterplan is the carefully calculated result of a detailed technical study of all the relevant biological, sociological and climatic conditions.

With Modern Poetry the immediate stimulus to the creation of new forms has been a rediscovery, a reanimation of the primal visual images and oral values latent in simple words.[8] Slang has been laid under contribution for the excellent reason that it provides the most direct and vivid form of verbal impact on the reader. Psychological reflections, anecdotage, and the personal point of view, are studiously avoided. The rule is stressed, the exception ignored. There is a renunciation of the old structural development sentence by sentence in favour of a dynamic association of ideas, accomplished by a

successively penetrative effect rather than a consecutive use of words; while the stylistic balance between the latter echoes emotion rather than logic.

The equivalent process in Painting is the abandonment of illusory perspective and the recognition of surface, colour and light as the true components of a picture.

In Music it is the direct, primal relation of tone picture to tone picture without intermediate psychological elaboration.[9] Igor Stravinsky has said that his composition is architectonic, not reminiscent, 'an objective, not a subjectively descriptive, structure'. Here the deliberate introduction of modern dance music, extraneous noises, etc., once more implies a return to the soundtrack of daily life.

In certain branches of Philosophy, too, there has been a return to those essentials which Rudolph Carnap deals with in his *Scheinprobleme in der Philosophie.*[10] A notable instance of the similarity between the revolutions in artistic and scientific methods at the beginning of the present century can be found in the work of the English philosopher Bertrand Russell. Some thirty years ago Russell succeeded in formulating a series of basic axioms, uncoloured by metaphysical speculation, that are common to logic and certain branches of mathematics. A group of Viennese philosophers known as *der Wiener Kreis* has developed this side of Russell's philosophy into a 'system of axioms', for which, in part anyhow, mathematical formulæ were adopted – yet another example of symbolical expression! The standpoint of the modern philosopher is no longer that of the poet, for he has to keep a near eye on mathematics and physics. His work must be severely to the point, severely scientific.

There is an even closer affinity between contemporary Physics and modern plastic art. The fundamental transformation undergone by the former has radically modified our conceptions of space, time and motion; and has likewise superseded the old ideal of mass, since the ponderosity of mass is now considered as a factor conditioned by speed.

This necessarily rather sketchy outline of the parallelism between the methods now being adopted in the various fields of cultural activity at least provides sufficient evidence of the vitality of each. The community of spirit between science and art, which even today is often considered a far-fetched notion, was regarded as a self-evident platitude right up to the age of baroque.

The evolution of modern art is not yet complete. But this much can already be discerned with some confidence: it is not a form of aesthetic self-indulgence, disdainfully remote from daily life, but a vital creative force intimately associated with the general cultural development of our age. The broad universality of its impersonal form and content, its close relation to nature and all the manifold problems of contemporary existence, predestines the art we are moving towards to public recognition and general acceptance. It is, of course,

true enough that this art can as yet only be seen in private collections and studios, or a few score houses and gardens; and that its *clientèle* still remains severely limited. Those who acquire and those who produce its works are equally devoid of influential connections. But to deny a civilizing role to this art on that score seems premature; for though all creative artistic production is necessarily compounded of past and present elements its more essential significance belongs wholly to the future. Outstanding historic examples prove that it often requires much longer than a single generation before the artistic reorientation achieved by the pioneers of a given period has had time to permeate the consciousness of the community.

The fundamental assimilation of our new vision to the realities of life has already been conclusively demonstrated, if only in an anonymous sense. It is no longer possible to remain blind to the direct formal affinity between the purely utilitarian mechanism of modern industry, transport and publicity,[11] and those so-called utopian experiments in art which, in part at least, had anticipated them. The priority of one or the other in point of date is far less important than their reciprocal stimulus.

Finally, yet another remarkable similarity remains to be considered: that between modern and primitive art, whether savage, archaic or prehistoric. This is not inspired by any romantic or modish hankering after the barbaric, or a nostalgia for what is strange and distant. There is an absence of literary influences in both, and a common predilection for a clear structural formation and simple plastic transmutations. It is perhaps not without significance that a century as conscious of the highly-developed and complex civilization it has evolved as our own should manifest such a warm sympathy for the unsophisticated emotions and forthright plastic creations of mythical times.[12] The morphological synthesis of these chronologically and culturally opposite poles has resulted in the perfection of sculptural forms (that highly specialized modern tools have revealed to us) which in the simplicity of their line recall the first dawn of plastic art.[13]

1 Marcel Duchamp's topsy-turvy china w.c-pan exhibited in New York in 1917, and Max Ernst's madonna built up from a series of corset-dummies, shown in Cologne in 1919, were still more startling anti-aesthetic and anti-conventional manifestations. They offer a parallel to Charlie Chaplin's systematic 'debunking' of the hero on the films.
2 *La Peinture au Défi*, by Louis Aragon.
3 The primordial egg is a mythical symbol among many peoples. 'It embodies a sense of repose and an almost fluid balance', c.f. Greek myths, the Finnish Kalevala, Red-Indian legends, etc.
4 *Die Gegenstandslose Welt*, Bauhausbücher, Langen-Verlag, Munich, 1927.
5 Vide also L. Moholy-Nagy: *Von Material zu Architektur*, 1928, Langen-Verlag, Munich.

6 Thus he has transformed his house in Hannover into a sort of conservatory for plastic forms, which he describes as a little world of branching growth where the imagination is free to climb at will.

7 The open planning of the New Architecture, the lightening of its volumes. and its emphasis on transparent, almost imponderable, surfaces finds an echo in certain prominent tendencies in modern plastic art.

8 To say that Rimbaud's 'poésie pure... verbe accessible à tous les sens' has begotten a decadent verbal mannerism is an unjustified assumption. To use language primarily as a sensitive tonal medium does not mean playing with words for the mere fun of the thing, any more than an absence of plot means an absence of content. The pioneers of the modern literary movement, Baudelaire, Rimbaud and Mallarmé, continually reaffirmed the spiritual purpose of poetry; whereas the next generation reverted to a severely formalized euphony. The explosive, yet associative dynamicism of Arp, Ball, Schwitters, Eluard, and Tzara's writing evokes a continuous sequence of mental vistas. In James Joyce's latest publication, *Work in Progress*, the logical time sequence of characters and events, human and natural history, is deliberately discarded. Instead we are given a vivid reconstruction of his subject-matter into something that is at once wholly new, yet by force of association virtually familiar. His projection of images on to a universal plane of time-space presents a close parallel to the emphasis on 'simultaneity' in the plastic arts.

9 Thus the basis of Hindemith's musical idiom is 'anti-individualistic counterpoint'. Vide H. Curjel's *Triumph der Alltäglichkeit* (Hesse-Verlag, Berlin, 1929), and C. F. Ramuz's *Souvenir sur Igor Stravinsky* (1932), as also Igor Stravinsky's *Chroniques de ma Vie* (Denoel et Steele, Paris, 1935).

10 *Vide* Carnap's *Der Logische Aufbau der Welt* (Weltkreis-Verlag, Berlin, 1928), Schlick's *Raum und Zeit in der gegenwärtigen Physik* (Berlin, 1918), and Hans Reichenbrach's *Wahrscheinlichkeitslehre* (A. Sijthoff, Leiden, 1935).

11 E.g. traffic-signals, various types of modern transport, shop-window dressing, advertise-ment lay-outs, etc.

12 As long ago as 1910 Umberto Boccioni wrote 'Sianto i primitivi di una nova sensibilità'.

13 A peep into Brancusi's studio, with its extraordinary collection of tools and instruments, reveals certain points of contact between even work of so timeless a quality as his and the field of modern inventions. Brancusi's preference for showing his sculpture on revolving turn-tables, and his claim that films are the only adequate means of illustrating it, provide pertinent cases in point.

25 László Moholy-Nagy

'The New Bauhaus and Space Relationships' 1937

László Moholy-Nagy (1895–1946) held an appointment at the Weimar and Dessau Bauhaus Schools in Germany from 1923 to 1928, out of which came his influential publication *The New Vision* (*Von Material zu Architektur*) of 1929. It was on the basis of these writings as well as his own practical experiments (exhibited at the New London Gallery, London, 1936–37) that Moholy-Nagy was appointed Director of the New Bauhaus in Chicago, a college comparable to the Black Mountain College in North Carolina (also run by Bauhaus refugees). On arrival in the United States in 1937, Moholy-Nagy immediately set about publicizing the New Bauhaus, using the existence of a wide and varied American architectural press in order to outline the fundamental principles it would enshrine and develop.

In 'The New Bauhaus and Space Relationships' Moholy-Nagy states from the outset his belief in the central importance of craftsmanship and workshop training, which he feels, while medieval in origin, still applies in a technologically sophisticated modern world. He also emphasizes studies of nature, referring to the work of the famous bio-technologist, Raoul Francé (1874-1943). His main theme, however, is 'space relationships', and in the second half of the essay he defines exactly what he understands by the spatial concept. Space is essentially an architectural notion for Moholy-Nagy, although it is developed via sculptural experiment. New Bauhaus studio-based work was designed to lead to a much better, highly utopian built environment. Studies in perspective and stereoscopy would, Moholy-Nagy hoped, ultimately allow an anti-human architectural environment to be replaced by one that instead would encourage happiness. This utopian concept of sculpture-architecture – connected, rather than opposed, to the technological environment of the modern world – was later extended by the sculptor and critic Jack Burnham, and his notion of a cybernetic future.

László Moholy-Nagy (1937), 'The New Bauhaus and Space Relationships', *American Architecture and Building News*, vol. 151, December 1937, pp. 22–8. Reprinted in Richard Kostelanetz (ed.), *Moholy-Nagy: An Anthology*, New York: Da Capo, 1970, pp. 104–10.

The key to workshop training, which is the real Bauhaus idea, is the very deep, spiritual connection it has with craftsmanship. In the old Bauhaus it was the idea of the founder, Professor Walter Gropius, to have, in spite of a technically and socially advanced world, the same excellence of production that was significant of craftsmanship in the Middle Ages. This implied a training closely related to architecture, an architecture which integrated all designers' shopwork. Separate laboratories were devoted to the study of wood, metal, glass, clay, stone, textile, plastics, etc., affording the student a possible means

of livelihood and certain security. This community of teachers and students was able, day after day and year after year, to produce useful inventions as a result of their studies. This was not due to their knowledge alone, but to their imagination and ability to see the goal of their own lives. The source of their ingenuity was their vision of life and their freedom to utilize the means and knowledge of the time in a new and unrestricted manner.

Raoul Francé's bio-technique, which we shall teach in the New Bauhaus, is an attempt at a new science which shows how natural forms and designs can be translated without great difficulty into human production. This means that nature's ingenious forms can be reduced to technical ones. Every bush, every tree, can instruct us and show us inventions, apparatus, technical appliances without number. I visited the east coast this summer and I was most amazed to see a little animal until then unknown to me – the horse-shoe crab. This very thin prehistoric animal shell is constructed in such a wonderful and economical way that we could immediately adapt it to a fine bakelite or other molded plastic form. It is said that Edison, who was one of the greatest of your countrymen, had never invented anything without getting an order for it. His conscious approach to inventions is a great example for our students because whatever was done in human history as an outstanding achievement can be repeated or can be developed to a standard ability. This approach of function and industry is today no longer a revolutionary principle but an absolute standard for every designer. For this reason alone we could not build in the New Bauhaus a creative community again, but could produce only a rigid teaching system.

A fresh outlook can come only through satisfactory designs for our biological needs. Our aims today go far ahead of those of yesterday, of the labor-saving devices built into our architecture. When we design we must relate them on a much greater scale with our psychological, psycho-physical needs beyond those of our physical comfort. This, I confess, cannot be done easily because we do not know enough about ourselves. We must work hard for such a knowledge since our biologists and physiologists, etc. have not supplied as yet sufficient data to enable us to understand the human being and his most important needs. When a clear statement, clear function and clear means are given, the design will not be difficult to execute. A factory, hospital, school or office building is rather definable and we have in each up to now really the most satisfactory designs. The difficulty today lies in the architectural design for dwelling purposes. We are told that we can kill a human being with housing just as surely as with an axe, but we do not yet know how to make him happy. The problem is clearly stated. To help bring about a right solution is the goal which the New Bauhaus has set for itself. But all have to cooperate, the scientists, the technicians and the artists, in order to find which course our designs should take; how they

should be controlled, simplified, or enriched in accordance with the needs of the individual today and for future generations.

We must be far-sighted enough to visualize the effect of our actions on mankind and to have sufficient intuition to relate our suggestions to his work and also to his recreation. We must know, among other things, his reaction to material, to color, to form and to space.

We attempt to teach today the understanding and use of spatial relationships much as we are teaching in the grade schools the ABC's which can be put together in words, the words into sentences, and the sentences into expression.

In our definition of space considerable uncertainty prevails at present. This uncertainty is evident in the words we employ, and it is precisely these words which increase the confusion. What we know of space in general is of little help in assisting us to grasp it as an actual entity. The different kinds of space are rather surprising, and you will be amused when you hear the manifold terms which we daily use without exact knowledge of what they convey. We speak today of:

mathematical	crystalline	projective	finite
physical	cubic	metric	infinite
geometric	hyperbolic	isotropic	limitless
Euclidian	parabolic	topographic	universal
non-Euclidian	elliptical	homogeneous	etheric
architectural	bodily	absolute	inner
dance	surface	relative	outer
pictorial	lineal	fictive	movement
scenic	one-dimensional	abstract	hollow
cinema	two-dimensional	actual	vacuum
spheric	three-dimensional	imaginary	formal, etc.

Notwithstanding this bewildering array, we must recognize all the time that space is a reality in our sensory experience; a human experience like others, a means to expression like others; like other realities, other materials. Space is a reality that can be grasped according to its own laws. As a matter of fact, man has constantly tried to use this reality (this material) in the service of his urge for expression, no less than the other realities which he has encountered.

A definition of space which, even if it is not exhaustive, may at least be taken as a point of departure for further consideration, is found in physics – 'Space is the relation between the positions of bodies.'

An explanation for that may be this: two bodies exist, say the earth and the moon. The relationship between their positions means space. We can now change earth and moon into other bodies, e.g. to two chairs or two houses or two walls. We can change it into telegraph posts, into wires, into two fingers of our two hands. We must test this simply by sensory experience through our eyes in order to be able to understand it correctly. This experience of the visible relationships of position may be checked by movement – alteration of position – and by touch, and it may be verified by other senses.

We know, for example, through experiments, that it is possible to distinguish forms and space through hearing, too. We know of substitutes for the eyes of the blind which mean that the photo cell is used to translate the visual existence into an acoustical one. We know the localisation and function of the organ for balance called the labyrinth through experiments with the swirling porpoise. We know through our own experiences that when we ascend or descend a spiral staircase or land in an oblique airplane, our own balance sense, the labyrinth, records clearly the relationship between our consecutive positions.

According to this, man perceives space:

1. Through his sense of sight in such things as wide perspectives, surfaces meeting and cutting one another, corners, moving objects with intervals between them.
2. Through his sense of hearing, by acoustic phenomena.
3. Through means of locomotion, horizontal, vertical, diagonal, jumps, etc.
4. Through his sense of equilibrium; by circles, curves, windings (spiral stairways).

All this sounds very complicated, but once we begin practical work with small models the goal becomes more clear. We must certainly know that a real space experience is a summary of experiences from many categories. If we analyze this we observe that every sense is able to record space relationships, but the highest form of space comprehension means the synthesis of all sensory experiences. Thus our students work first with the simplest perception formulas and slowly reach the peak.

In the near future I hope to construct a spatial kaleidoscope which should be an example for small constructions by the students themselves. I will assemble on a horizontal disc some perpendicular sticks which will revolve. Over the middle of the disc I will place a small elevator containing slats and

rods, horizontal and oblique, and spiral forms, and transparent bodies, and then I will move it, too, in a vertical direction.

As the disc and the elevator move simultaneously we will have every kind of intersection and every kind of relationship between the 'positions of bodies'. The movement may be stopped at any time so that an interesting space relationship can thus be easily fixed, and by drawing or other means of representation may be recorded.

To this type of spatial exercise we add the study of perspective and stereoscopic drawing which helps to obtain a spatial vision. I find very often that the grasping of space seems to be, for most people, a very difficult task. They find it difficult to think in terms of space relationships on different inter-secting and penetrating levels and heights. Even excellent architects, knowing every part of their subject, everything about technique and function, sometimes have difficulty in visualizing a rich space formula. This is actually the reason why con-temporary architecture appears sometimes rather simple in compar-ison with the Gothic or Baroque.

According to my belief, space experience is not a privilege of the architectural genius. It is a biological function, and we must try to approach it in a conscious way. The biological bases of space experience are everyone's endowment; just like the experience of colors or of tones. By practice and suitable exercises this capacity can be developed. To be sure, there will be many degrees of difference in the maximum capacity, exactly as is the case in other fields of experience, but basically space experience is accessible to everyone, even in its rich, complicated form.

I am convinced that sooner or later we shall have a genuine space system, a dictionary for space relationships, as we have today our color system or as we have our sound system for musical composition. This has another significance, too; it is not enough that the architects will be clear about spatial relationship and spatial composition but, if their work is to be appreciated, the layman, the client, must know about space, too. Of course, in the planning of a modern building the most varied problems come up; economic, technical, hygenic.

It is probable that upon their correct solution the fate of our generation and the next, in an essential aspect, depends. But in addition to the fulfillment of these elementary requirements, man should have opportunity in his dwelling to experience the fact of space. This means that a dwelling should be decided upon not only on the basis of price and the time it takes to build, not only upon the usual considerations of its suitability for use, its material, construction and economy, but the experience of space also belongs in the list, as essential to the people who are to live in the house. This requirement is not to be taken as a vague phrase of a mystical approach to the subject; it will not be long before it is generally recognized as a necessary element in the architectonic conception, and one capable of being exactly circumscribed. That is, architecture will be understood, not as a complex of inner spaces, not merely as a shelter from cold and from danger, not as a fixed enclosure, as an unalterable arrangement of room, but as a governable creation for mastery of life, as an organic component of living.

The future conception of architecture must consider and realize the whole. Individuals, who are a part of a biological whole, should find in the home not only relaxation and recuperation, but also a heightening and harmonious development of their powers. The standard for architects will then no longer be the specific needs in the housing of the individual, or of a profession, or of a certain economic class, but it will revolve around the general basis, that of the biologically evolved manner of living which man requires.

Architecture will be brought to its fullest realization only when the deepest knowledge of human life in the biological whole is available. One of its most important components is the ordering of man in space, making space comprehensible.

The root of architecture lies in the mastery of the problem of space; the practical development lies in the problem of construction.

26 Arturo Martini

'Sculpture Dead Language' 1945

The starting point for 'Sculpture Dead Language', written by the Italian sculptor Arturo Martini (1889–1947), is Baudelaire's famous text, 'Why Sculpture is Boring', that appeared within his review of the 'Salon of 1846'. Baudelaire articulated for Martini the extent to which sculpture was more often than not an essentially lifeless spectacle, especially when compared to its sister arts: poetry, painting and music. Sculpture, unlike these arts, disallows metaphor, partly, Martini argues, because of an inbuilt 'enslavement to the subject', but also because it is constantly 'looking back over its shoulder to a happier past'. This nostalgic element in sculptural practice is both essential and strategic. Sculpture hangs onto the past so as to convey a sense of 'extinct grandeur', but in doing so becomes unable to comment on day-to-day events. Because of this, Martini suggests, sculpture must in the final analysis be judged absurd; his comparison is to the dead languages of Greek and Latin. If sculpture is essentially and inescapably archaic, then nothing can justify its survival in the modern world. This is not a purely pessimistic perspective, however. It not only reflects the restrictions Italian sculptors suffered under Fascism, but also expresses a dream that such restrictions might one day be overcome. When not lamenting the sorry state of the sculptural medium, Martini can also imagine another kind of sculpture that has a living value, and that once flourished, he argues, 'about thirty years ago'. This ideal modernist practice he calls 'the art of the blind', which, if it could be rediscovered, would be an art of 'pure forms', containing 'the soul which is in everything and everywhere'.

Arturo Martini, 'Scultura Lingua Morta' (1945), in Mario di Micheli (ed.), *La scultura lingua morta e altri scritti*, Milan, 1982. Translated in *Arturo Martini 1889 –1947 Sculptures*, Milan: Electa, 1991, pp. 38–48. Translated by Julia Richards.

The art of infant prodigies by its very nature, is doomed to fade away. To give rise to and to accomplish a miracle within the limit of human capabilities, even enlightened by God, can only be the reward of continuous abortive attempts and imaginary toil.

To obey one's natural development, to endure the pruning of all ramifications born from investigations, to transform one's passions into something pure, and one's inner inspiration into love calls for patience: that is the way to create the universal work of art.

The silk worm can not weave its cocoon until it has devoured and eliminated everything in order to achieve transparency. And so with the artist. They are rare that after so much torture can raise their heads and perform

miracles; but never mind: what matters is to reach the threshold, enlightened. When Picasso said: 'One can copy others, but not oneself', he meant that the true artist is constantly metamorphosing to attain eventual anonymity, the image of the universal.

The artist who copies himself reduces his work to a sort of personal trade, profitable because it forms a series, but infinitely monotonous and dreary.

As for me, after forty working years I have become as transparent as the silk worm, and on raising my head I have seen that the time and opportunity to perform a miracle in sculpture have gone forever.

I am not going to recite the Miserere. But so as not to play Father Zappata, I will simply say that of course, for forty years I have accepted with a deep-rooted faith all the constraints and weaknesses which I today deplore and reject; the greatest proof of this is my sculpture. To those young innocents who nourish the hope of a renaissance, I leave these commandments which sculpture whispered to me in my hours of solitude.

That I should only serve myself.
That I should make a spiritual arch of myself.
That I should no longer be rock, but water and sky.
That I should no longer be a pyramid, but sand, so as to keep returning…
That I should not be an object, but an extension.
That I should not be a comparison, but complete in myself.
That I should not be an image that I might not be worshipped.
That I should not be a milliary stone of man, but of my own nature.
That I should not be a dazzling entity, but an obscure mould.
That I should not be a weight, but a pair of scales.
That I should not be used as currency.
That I should not stay three dimensional, for death can hide within.
That I should not be a slave to style, but a light substance.
That I should be the imponderable architecture which can reach the universal.

A Question of Aesthetics

All art is an inward-facing momentum; it is its own means of expression, without external motives, as all the arts exist and express themselves by their very essence. The depiction of great events having lost their attraction, today's artist is recovering the gift of the natural and of poetic simplicity.

A lemon can be as much a source of ecstasy today as Venus. The subject of a work is no longer a matter of judgement, not its greater or lesser faithfulness to objective reality. Poetry for poetry, music for music, painting for painting, that is what we want and what we enjoy. Each is supreme in its own field of expression.

Any aspect of reality can be a source of inspiration. Everything is living and there is nothing which because of a lack of spirituality is beyond the realm of art. For the musician, the poet or the painter, a leaf fluttering at the end of a branch has soul just as much as the most noble of creatures.

Now if the power of the arts knows no bounds, why can't sculpture represent an apple?

Image

If sculpture can represent Venus, why not an apple?

At first I thought it was through force of habit. The consistent subjects of sculptures have been men and animals, those things which we believe have a spiritual dimension.

Sculpture's only task is to glorify gods, saints and heroes.

When an inanimate object is connected to human or animal then it enters the realm of sculpture; but cut off from these it can have no meaning.

Take from the statue of a warrior his helmet and sword and they will just show up the emptiness of isolated objects. It's the same for a fragment of sculpture: if it does not bear any trace of an animate object then it is no more than a weather-beaten piece of rock. Sculpture is therefore a form of oratory, or at best, of eloquence. It has been called 'the queen of images'. But the image, being a physical one and therefore a slave to its contingent nature is locked in time and atmosphere.

Art which is expressed by these means can not escape the relative: it can be a human consolation, but never a universal language.

I once had the opportunity to put the apple question to the painter Campigli. 'What do you want to sculpt an apple for?' he replied. 'Make a banana – you'll soon see how expressive that can be'.

His reply only served to confirm my theory. Of course a banana can be a phallic symbol and therefore once more a symbol connected to the human.

Rhythm

Rhythm is the basic element which gives a work of art its individuality. Rhythm does not have its origin in the subject which is being represented, the artist extracts it from the bottom of his heart, purifying the image which he has taken from reality with a wavelength and lyrical phrase which are his own. Punctuation is partial time which spawns the different stages in a work of art. It comes into all creative forms, whether they be musical, pictorial or poetic.

With sculpture on the other hand, rhythm is very important as it exists already in the subject which is to be represented.

It is forbidden to violate a human being or animal beyond the limits set down by dignity and verisimilitude, but the sculptor, if he could arrange a tree's branches at the whim of his own rhythm, would not on the face of it be violating the laws of nature. Where are the sculptor's rhythmical and lyrical possibilities if once he has made an eye he is destined to make another; an ear, another ear; an arm and a leg, another arm and another leg; and thus a monochrome blueprint in a material foreign to the original.

In other art forms, the contrast between shapes and different values resolutely takes part in the rhythmic construction of the work.

The yoke imposed by the human or animal figure is a heavy burden on sculpture; and sculptures of all periods testify to the constraint and compromises that this implies.

The only resource available to the ancient sculptors was the drapes under which they could hide and therefore displace the human body's joints.

The exchanging of different forms (not just human ones but also animal) has always been an illusion, for rhythm has always been stifled by the figurative aspect.

Metaphor

Sculpture's enslavement to the subject it represents disallows any chance of the use of metaphor.

Poetry, painting and music have frequent recourse to it: 'the rosy-fingered dawn', for example, is an image which can be transformed beyond any doubt into both painting and music. If you tried to make such images concrete in sculpture they would become ridiculous.

Metaphor is therefore replaced by attribute, something which is always alien to poetry.

To indicate that that old man with a hairy beard is Neptune, one has to put a trident in his hand.

The Naming of Sculpture

Once they have fulfilled the function of propaganda for which they were born and for which they have vaguely continued to exist for many centuries, arts turn inwards; previously devoted to the dissemination of ideas, they have turned to the very essence of things.

All the arts have reached an individual isolation, and yet they have been capable of creating apart from their particular qualities; each art form has become in its own way just poetry, just music, just painting.

Sculpture, on the other hand, has never been and will never be just

sculpture, for the means of its creation are neither volumes nor forms but clay.

In effect, after having been called 'the queen of images', it has been described as the 'art of statuary'.

That is a completely absurd definition if you then consider that by the same token painting should be called 'the art of the museum'.

But this absurdity demonstrates that sculpture is imprisoned in its illustrative function, even though ancient sculpture left a certain number of masterpieces thanks to a uniquely magical virtuosity.

But magic of any kind can turn a mistake into a realization of truth from which one can deduce universal laws.

Repetition in Statues

Once an art form has a monochrome subject and the poses of the human body as its means of expression, it is easy to imagine what remains after so many centuries of 'unexplored stances'.

Without a doubt, what consequently torments the sculptor is not having to produce a work by giving himself up to an immediate inspiration, but the immense effort involved in avoiding what has been done before.

If by some absurd hypothesis a subject had been imposed on a painting for centuries, this drawback could always be overcome by the use of new colors.

But in sculpture, what has not been already tried and achieved? How many times, guided by my inner fire have I believed I had discovered a new method, and seen straight away that it had been discovered ten centuries earlier?

For an artist who lives to be fully of his time, a 'still life' inspired by a few rotten vegetables is much more real today than all the exalted myths of antiquity.

But sculpture is the eternal repetition of statues.

It cannot rework ancient mythology into a new mythology of cabbages and artichokes. It has to carry on, constantly looking back over its shoulder to a happier past, and despite the passing of the gods, it retains the impression of extinct grandeur.

Sculpture has always lived the life of a parasite, attaching itself like a creeper to the surface of an image and in adopting the shape of its host, it has ended up believing this shape is its own.

Language

The sense of the plastic creates volume; volume in expressing itself becomes a shape; the shape takes the shape of another shape. That should be the language of sculpture.

In itself the word 'plastic' means nothing; but because all words are inextricably bound to their usage, lets put its consistency to the test. The dictionary definition of plastic is that which has the capacity to model and to be modeled.

However, in the language of art criticism this term has gained such significance and such magnitude that it has become an abstract word, usually used incorrectly like the word 'poetry': in sculpture it is generally used to denote a large scale work.

Shapes, as creative tools, do not exist either. In effect they have to conform to established proportions and in this way deny their own existence. Words, notes and volume are but materials, the means which the artist transforms in turn into essential values.

In painting, a color becomes a creative value once it has turned into a tone. But in sculpture everything stays in its original state, by a fault of freedom: shape stays volume, that is, an amorphous mass, simple clay.

It is only the total mystery of the creative methods which establishes the sovereignty of an art form; and one must not take creative methods to mean an artist's virtuosity, or his tools, but the intrinsic value of a particular language.

Sculpture's enslavement therefore is clear. The importance ascribed to shape is so great, that one is left with a vocabulary which just indicates certain phrases of the trade: shape for conformation, plaster shape, shape for configuration, granite shape etc.

What is more, volume is interpreted in the sense of big, and weight as heavy, to such an extent that one might think that a sculpture of an elephant marked the pinnacle of sculptural achievement.

Fullness and Voids, Concave and Convex

'This is full, that is full, if we take away the full from the full we are still left with the full'.

This amazing cathedral, developed as a way of expressing the universe, could also be used by the sculptor as his *raison d'être*, but instead he has confused it with statuary; men prefer to quench their thirst with lots of little sips rather than down the whole lot.

The full and the empty, the concave and the convex, these are romantic yearnings denied to construction because they have no hold, nor the power to graft themselves.

I too once believed in the freedom which these values promised, but where is the fullness in a statue?

The void can be seen as the snips made in a piece of paper, and the fullness in the silhouette which is the result.

From an artistic point of view, a drawing has a power that is a thousand times greater than that of a statue, because the piece of paper itself is the compost which nurtures it, while a statue only has a background which chance dictates, and one which bears no relation to the creation of the work.

A wrong tone in a painting constitutes a great imbalance and creates a void in the composition tantamount to the canvas having been pierced; in sculpture, the imbalance is constant: each void is a hole in the material and makes for different conceptions.

The sculptor cannot transform his clay into stormy waves nor, like snow, cover each object, erasing its significance and just giving it its pure shape. Creation is imposed on the sculpture by the structure of the human body which is already there.

A statue finds its equilibrium not thanks to the generous disposition of voids and fullness discovered by the artist, but by the simple fact that all human movements tend towards their natural position, just as bodies tend towards their natural weight. To talk of concave and convex surfaces just because you decide to emphasize the biceps or carve several holes, is simply ridiculous.

I could understand it if it were a matter of representing a waterfall or clouds in black and white; but as long as the creation is imposed on the statue, it would be better not to think about it.

Give the image all the good promises implied in the mystery of voids and fullness, concave and convex; it will soak them up, digest them and eliminate them by means of its physical requirements.

Topic

The true artist, whether he is great or not, is only born from these roots. Even the critic, magnanimously, can recognize that an excellent artist and a mediocre artist are two unities. And unity in art is all.

A sickly fruit may envy the healthy fruit who seems to have been blessed with more sunlight. But for genuine artists, indivisible unities, regardless of their talent, the following Gospel quotation is noteworthy: 'The last will be the first'; each of them will release a universal.

The attraction which a great artist exerts is certainly dangerous; he will become, for those whom we can describe as being 'rootless', a fury which seduces them and renders their power useless, while in time, minor artists will save themselves.

There is no continuity between real artists, it is only derived from manner and skill. In sculpture, once the honesty of the first had disappeared, those that followed have not ceased to multiply. They have spread over the whole world ever since the Renaissance, that stupefying invention. Let us leave this

earthly paradise posing a few questions to those rootless and bastard inventors of fashion.

During a plague one turns to a patron saint.

It is from the Renaissance artists who copied the Ancients, that this secular miracle has sprung, the topic.

But he who looks elsewhere will lose himself; he who conceives his work under the inspiration of the past, will always be obliged to exaggerate his model, in order to give the impression that he is someone. Topic is born of the need to exaggerate. The mad desire to be seen has forced sculpture to follow the deforming sequence of topos to excess: to fatten, inflate, wring, exceed, and exaggerate to the point of denaturing.

'Once substance is lacking, appearance is sublime'. All luminous quality develops by its natural strength; its value affirms itself and establishes itself spontaneously.

Conventions and compromises, on the other hand base their future on an exercise of skill which is so good that their value, continuously fluctuating, has to be fixed again and again, like money. These fluctuations demand the constant renewal of expedients (worldly speculations, the labyrinth of political prizes), and a host of interpretations (exegeses) which give them the impression of stability.

Anonymity

There is another artist in the world of the arts, apart from the sculptor, the painter, the musician, the poet and the architect. Blessed with an exceptional flair, he is generally appreciated for his superficial qualities, his inevitable presence in the shadow of some sort of decline, like an owl in time of plague, or a comet, the harbinger of misfortune.

But this individual has never had anything to do with true art.

In effect, in true works of art one does not sense the presence of the artist, because by their greatness and their universality they acquire an anonymity; while in the most famous works, there is always a key: will, personality, all the ruses and the tricks which excite people, but which don't have an umbilical cord.

Art fits badly into theories, genres or styles. It is a spontaneous expression, mysterious and fatal, like the growth of an embryo in its mother's womb; it is a natural and eternal disposition, which reproduces itself in time in an astoundingly straightforward way, similar to the way grass grows.

The universal work of art is a stage at which one cannot yet touch God's finger, but where all passions are decanted and all personality is nullified.

In fact personality is a nervous tick, and the universal work does not spring from the artist's emotions, but from the inherent substance of art.

In creation, the authentic artist sets his own feelings apart as much as possible. The greater he is, the better able he is to contain himself, for the universal work has only one aim, to be anonymous. The more anonymous it is, the greater is the artist who in creating it, kept himself out of it.

Statuary is too human to be anonymous. The instrument of God is seed, the instrument of the artist is substance. One reproduces itself according to natural laws and the other according to the attraction and the sympathy which two different elements exert upon each other: the artist can only make St. Veronica's handkerchief out of substance.

Nature, for the artist, is not the images which surround him but the substance which becomes image without requiring anything outside itself: and the anonymous artist is nature, like the substance, and from it, he is spontaneously fecundated.

Art does not depend on the inventiveness of the artist but on the natural order of substance.

Inspiration

Nature hides behind an apparent reality. Only the artist is admitted into this mysterious precinct where that particular short circuit of sympathy occurs, by which nature chooses to free itself and to manifest itself to him in a sudden surge of confidence.

It is from this abandon that the work of art is born.

Inspiration is a sunny event by which nature submits itself to the artist and obediently and lovingly dominates him. It is a simple and complex event like all natural unions, the midday flight of the queen pursued by the male.

This sovereignty is fatally linked to the sculptor. Nature has only been his mother for the space of a few days, she has been a revelation and revealer, but never the source of inspiration.

Man, a unique subject, has become an object over the course of the centuries and has ended by being a habit.

It is to appease the shapeless fears which leap ceaselessly from the earth, sea and sky, that statuary, the instrument of idolatry, is born, and that it has fixed nameless phantoms into definite images by certain attributes.

The magic and fear of origins has given statuary an authentic beauty; but once all mystery from the beginning of time has been unveiled, and all passions killed, sculpture becomes a pitiable repetition. You cannot discover America twice. We have arrived too late at the fabulous banquet of mysteries, and it is useless to want obstinately to resuscitate the miracle by gnawing at the bones thrown away under the table.

'The first poems come from God', said Valéry. This is true for all the arts. But as far as sculpture is concerned, Hercules' columns, the gate to eternity, were demolished the very evening of the day they were discovered.

Today's sculptors are only trying out variations on the themes with which the Ancients had already reached check-mate. There was a time when stars were stars, nowadays they are nothing more than systems.

Reason no longer belongs to flight but to calculation.

Sensitivity

Sensitivity always results from a lowering of tension; it is a sort of convalescence which even a man in good health can know easily in purging himself. Construction and sensitivity have never been good bedfellows: one possesses, the other only shows itself on the surface. Even primitive man's sensitivity, so well documented, does not underpin construction, and it has never got beyond the stage of prayer and submission to God.

The last of the arts to be contaminated, sculpture appears to be a victim destined to undergo the most fatal consequences; sensitivity, like oxygen for the dying, is nowadays sculpture's last and only resource.

All sentiment in art must be given and not felt: he who is emotion's creature trembles and will never score a bull's-eye. Although ancient sculpture knew how to keep hold of sentiments, it always sneered at sensitivity. What modern sculptors call 'sensitivity', and believe they recognise in ancient works, is only an appearance due to habit, to the patina, to the cracks and fissures of time.

There are three types of sensitivity in modern sculpture (among many others which I will ignore, although they are all equally dangerous): an undefined technique to make a vague impression like the fuzziness in photos; a 'stagnant' style, rustic, which creates an atmosphere; and the fragment. I can't imagine a more banal thing than the fragment, which grabs the public's attention by the mystery of the missing parts.

The only real sensitivity in sculpture is that which it feels in the loving touch of the sand paper which consumes it, or in the fear it experiences of being completely devoured by that same sand paper as it smooths away roughness.

As for the artificial fragment, it is the sign of a lamentable lack of power; like with those lovers who cannot reach orgasm because they have a crooked leg or arm which they don't know where to put.

I'll add another type of sensitivity: the 'badly done'. But for that the words of Baudelaire will suffice: 'With such art, any old amateur can pass as an artist'.

When I see sculptors rushing round to the foundry and searching in the wax with a feverish impatience for that particularly sensitive spot in their statue,

or even crying out because they can no longer find this scratch or that little shit which is so important, I can't but reflect on how fragile and ephemeral their creation is.

The genuine work of art is like the sea: you won't change its colour by pissing in it. Sensitivity, despite the importance today's sculptors give it, has no consistency, like the sort of courage which fear gives to someone who stutters. It remains in the best of cases, a desire which sweats and strains by the effort, a constipation like any other.

When I talk about art, I understand its bone structure like when a real architect talks about his building: the showy rags are superfluous and destined to perish. Art is an absolute phenomenon, complete in itself, from its very core to its surface, to its foam, which could be seen as its sensitivity. To only talk about sensitivity in speaking to a work of art is like reducing the sea to the foam and miserable rubbish which floats on its surface. The sculptor is like a tree: the leaves are his sensitivity. But a tree does not concern itself with these fragile and transitory leaves that time inexorably will shed.

Criticism

In general man does not attribute much importance to anything other than visible values: as for the tangible values of the spirit, being unable to grasp them, he hopes for the most part to avoid them. That is the type of criticism which sculpture is subject to. When criticism is concerned with a statue, it is rather like St. Thomas; that is to say it is only concerned with that which can be touched with the sensitive spot in their statue, or even hand. Criticism does not judge according to principles of aesthetic morality, and so the very essence of art, but according to external criteria of beauty, usefulness and verisimilitude.

That is why critics remain sterile, pedantic, devoid of all discernment, of a priori arguments, never burdened by doubt, because they have accepted the rules dictated by facts.

It is not a question of criticism, but opinions around an indisputable principle, such as reality endorses each time that one reckons with it without really considering the spirit: that is, passion, by the elementary force which frees all human appearance, and traditional confrontation with the authority of the ancients. Criticism never undertakes a serious investigation, never takes the trouble to penetrate beyond the statue to the essence of the sculpture.

They talk of shapes and volumes without defining these terms, and then they drop this subject immediately as if it were a burning piece of material; they move on to judgements on painting, a safer ground, and with the usual sleight of hand, they hide the absence of any conclusion.

How can we not suspect the critic of wanting to hide his unadmitted unease by this deception?

A single example of virtue is sometimes enough to change the face of the world. The beauty of a statue operates like a magic filter. One identifies the false image as the reality, and this false reality has over the centuries become a criterion for judgement.

However, a few questions will be enough to denounce in sculpture one of the major examples of apparent life which has been imposed on mankind in the name of tradition.

If painting and sculpture are two fields of equal grandeur, why is one the slave to the past, while the other has progressed uninterruptedly?

Why has one found a vernacular language, while the other still talks Greek and Latin?

Why, in the middle of a great revolution, has not sculpture awoken yet from its age-old sleep, but sleeps on peacefully on its pedestal full of self-importance?

Why in the middle of new demands, does sculpture continue to repeat itself, like dishes in old moulds invented for buried generations?

Why can't it see the general indifference towards it?

Why does it insist on making images without understanding that each of them, even the sublime ones, is nothing but the ultimate incarnation of a language destined to disappear through exhaustion, or to make way for other demands?

Why has painting produced universally accessible works from an apple, why have all other art forms found new impulses (fermenting agents, graftings), while for sculpture this is impossible?

The state of sculpture is sad and miserable, like a seed sown on marble, all possibility of life is forbidden to it.

Dead Language

'It will be a new light, a new sun which will rise in the place where the last sun set, and it will illuminate all those who are plunged into darkness and night, for the old sun no longer shines'.

This is the way Dante announced the birth of the vernacular language. Poetry, music, architecture, like ancient languages, have been translated into new idioms, by clinging to life. Only sculpture has remained immobile across the centuries, a courtly language, the language of the liturgy, a symbolic writing, incapable of making its mark on daily acts.

That is why statuary has always struck me as being like a stele with inscriptions in Greek and Latin.

In Mediterranean, Egyptian and Greek civilisations and right up to Gothic civilisation, sculpture served admirably as a way of celebrating cults and memories, and of making idols: men-gods, men-heroes, men-saints. Even the Hellenistic cult of beauty was a religion.

To bend sculpture to realism, as the Romans did in their portraits, and in a sporadic way as artists of all generations have done, has become an outrage; it is the anecdotal recording of human misery pushed as far as the wrinkle or the drop on the end of the caretaker's nose. It is pointless to represent a great captain of industry today in the manner of ancient Egypt or Herculaneum.

Sculpture has remained what it is, a dead language which has not found the vernacular, and it will never be the natural speech between men.

It is useless to exhume the remains of the great bazaar of antiquity; compared to life, sculpture has become absurd. To celebrate the excesses of public life, one has recourse to the symbols of pagan mythology, where wisdom is always represented as Athena. We dress our contemporaries in unrealistic peplums and we make a lamentable spectacle of the famous man by putting him in modern dress, exposed to the elements. The sculptor pushes the ridiculous to the extreme of exhibiting a deformed female nude under the title 'My Wife'.

At the middle of a crossroads, a statue hinders traffic; in exhibitions it serves as a screen to separate a series of pictures; in modern houses it is a nonsense. As for the portrait, it acts as a foretaste of the cemetery. There is no point in defending sculpture emphatically in the name of 'noble antiquity', nor in attacking the public's ignorance for its lack of interest. Nothing justifies the survival of sculpture in the modern world. The only time one has use for it is in solemn occasions and in commemorations, just as one uses Latin for epigraphs and the mass.

Shadow

The sculptor's whole life resembles a wave which seeks to create a durable image of itself by repeating itself in the next wave. It is not the paucity of methods which scares the sculptor, but the concerns of a work which is devoted to imprecision.

Sculpture is always in the wings, like a shell, capable of giving good advice as soon as you put it to your ear. And it seems to say: 'Make something real out of shadow, not a reflection'.

Sculpture! anchorite of ecstasy, betrayed by shadow, like Narcissus, the image of metaphysical solitude, the sorrowful masturbation of the hermaphrodite. In vain, you lift your arms to seize the shadow which brushes you and then flees; in vain you wait for centuries for fate to return you like an

hourglass. Sculpture, are you looking for your shadow; or rather, Morgana, are you tricking us in order to hide your decay?

While a painter can command light, a sculptor can't even use it: shadow in his work is only the reflection of something else; these two illusions betray each other. As shadow is without substance, it can be of no use to construction; it is not a real body but an ephemeral illusion. The dust which covers a statue defines it more clearly than lights or shadows which are always inopportune and which chance imposes on it.

A work of art, unlike the earth, is not subject to the effects of good or bad weather. Art tends towards the absolute. How can sculpture be an art if it can be transformed and dispersed by light, like a cloud in the sun? That is why it has always needed an image which fixes its lack of substance, and the plastic dimension, which is the real protagonist, is crushed by the physical presence.

The sculptor has always dreamt of catching the shadow, but in vain. All attempts drown in a superficial sensitivity and his hope vanishes.

The realm of shadow is architecture: the true architect is a poet of the void (shadow) which the full (light) supports like a horizon. But for sculpture, shadow is but a chance occurrence, like the relationship between echo and sound.

The Art of the Blind

About thirty years ago, someone – was it me or someone else? I can't remember now – called sculpture 'the art of the blind', and from then on that definition has been bandied about.

Excluding sight, which is tired and encumbered by all the passions and the encrustations of the ancient works, I used to believe in the hope of a renewal.

I used to think that touching a sculpture was also a way of seeing it and that it would lead me to a universe of new possibilities. Leaving a ravaged island for a virgin one, my unease found that for which I have always been looking.

In broad daylight I saw these shapes again as if they were emerging from mud, those shapes which sculpture had buried to unveil them only on the day when, unencumbered by utilitarian constructions, sculpture would use them freely beyond the requirements of statues and their attributes.

Art is not just interpretation but also transformation.

When one says of an art form that it has found its way, one is underlining the passage from one dimension to another, that is, the passage from the original order to a creative order. To those who think that the statues of antiquity, by virtue of their beauty or the skill which has gone into making

them, or their magic, have found their way, I say that it is a question of a dimension of the order of sympathy, there where I believe there is a dimension of constructive order. That is to say, at an equal distance between seeing and clairvoyance as it is between sympathy and possession.

Language transforms also: noise becomes sound, words change meaning, colour becomes tone; in sculpture volume must turn itself into shape.

In true art, sentiment, beauty, or character are just humbug; what is eternal in it is substance.

A true sculptor can make sculpture simply by squeezing the clay between his hands. But for as long as he is obliged to model a statue with the same strength as the original, he is pushed to deny the essential act.

If the art of the blind is the truth, let it be free: pure forms and the soul which is in everything and everywhere; let us no longer confuse the real life of sculpture with the apparent life of a statue.

I deny authorship of any statement, whoever it was collected or transcribed by, in which I discussed this subject, because they were immature statements, and perhaps contrary to my conclusions.

27 Jean-Paul Sartre

'The Search for the Absolute' 1948

Jean-Paul Sartre's (1905–80) theory of art, worked out in the 1930s in parallel with his 'existentialist' philosophy, initially made him sceptical that sculpture 'in search of the absolute' was even possible, given the materiality that sculpture necessarily had to contend with. Giacometti (and other artists, including the Americans David Hare and Alexander Calder), however, convinced him that a truly modern sculpture was indeed possible – although only if 3,000 years of tradition could be unlearnt so that sculpture could enjoy a new beginning. This 'forgetting' of sculptural tradition included the rejection of surrealism. Despite his suspicion of surrealist literature, however, Sartre did tend to favour surrealist sculptural works, but reinterpreted such works according to his own philosophical ideas – in the case of David Hare, for example, using that artist to articulate a novel proposal that the work articulated the possibility of 'sculpture in *n* dimensions'.

Of Sartre's several essays on art written in the 1940s, his introductory essay on Giacometti is undoubtedly the most famous and the most influential. At the start of 'The Search for the Absolute', Sartre compares Giacometti to early Palaeolithic artists (the men of Eyzies and Altamira), thus aligning the ideal modern sculptor and new sculpture in general with the notion of art having very primitive origins. By contrast, at the end of the essay Giacometti is linked to very recent political events. Here Sartre notes the resemblance of Giacometti's skeletal figures to concentration camp victims, referring to 'the fleshless martyrs of Buchenwald'. Even though he does this only to deny the similarity, it still has the effect of establishing Giacometti between two temporal and cultural extremes.

'The Search for the Absolute' was first published in the French existentialist journal, *Les Temps Modernes*, January 1948. Simultaneously the essay appeared in English translation as a preface to the exhibition catalogue published on the occasion of Giacometti's first New York show at the prestigious Pierre Matisse Gallery. Interspersed with the text were a number of black-and-white studio photographs, taken by Ernst Scheidegger, showing a dusty, plaster-filled environment consistent with Sartre's description of Giacometti's practice.

Jean-Paul Sartre, 'The Search for the Absolute', in *Alberto Giacometti: Sculptures, Paintings, Drawings*, exhibition catalogue, New York: Pierre Matisse Gallery, 1948, pp. 2-22.

One does not have to look long on the antediluvian face of Giacometti to sense this artist's pride and will to place himself at the beginning of the world. He does not recognize such a thing as Progress in the fine arts, he does not consider himself more 'advanced' than his contemporaries by preference, the man of Eyzies, the man of Altamira. In that drastic youthfulness of nature

and of men, neither the beautiful nor the ugly yet existed, neither taste nor people possessing it; and there was no criticism: all this was still in the future. For the first time, the idea came to one man to sculpt another in a block of stone. There was the model: man. Not dictator, general, or athlete, he did not yet own those ornaments and decorations which would attract the sculptors of the future. There was only a long indistinct silhouette, moving against the horizon. But one could already see that the movements did not resemble those of things: they emanated from the figure like veritable beginnings, they outlined an airy future; to understand these motions it was necessary to start from their goals – this berry to be picked, that thorn to be removed – and not from their causes. They never let themselves be separated or localized: I can consider separately from the tree itself this wavering branch; but I cannot think of an arm rising, a fist closing, apart from a human agent. A man raises his arm, a man clenches his fist; man is the indissoluble unity and the absolute source of his movements. Moreover, he is a symbol-charmer; signs are caught in his hair, shine in his eyes, dance between his lips, fall from his fingertips; he speaks with his whole body: if he runs he speaks, if he stops he speaks, if he sleeps, his sleep is worded. Now, here is the matter to be formed: a rock, a simple clot of space. With space then, Giacometti has to make a man; he has to write movement into the total immobility, unity into the infinite multiplicity, the absolute into the purely relative, the future into the eternally present, the chatter of signs into the obstinate silence of things. Between the model and the material there seems to be an unbridgeable chasm; yet the chasm exists for us only because Giacometti took hold of it. I do not know if we should regard him as a man who wants to impose a human stamp on space, or as a rock about to dream of the human. Or rather, he is the one and the other, and the mediation between them. The passion of sculpture is to make oneself totally spatial, so that from the depth of space, the statue of a man may sally forth. Thoughts of stone haunt Giacometti. Once he had a terror of emptiness; for months, he came and went with an abyss at his side; space had come to know through him its desolate sterility. Another time, it seemed to him that objects, dulled and dead, no longer touched the earth, he inhabited a floating universe, he knew in the flesh, and to the point of martyrdom, that there is neither high nor low in space, nor real contact between things; but, at the same time, he knew that the sculptor's task is to carve in this infinite archipelago the full form of the only being who can touch other beings. I know nobody as sensitive as he to the magic of faces and gestures; he regards them with a passionate desire, as if he were in another realm. But sometimes, tired of warfare, he tried to mineralize his fellows: he saw crowds advancing blindly towards him, rolling on the boulevards like the stones of an avalanche. Thus, each of his obsessions coincided with a task, an experiment, a way of feeling space. 'He is mad,' people tell you,

'Men have made sculptures for three thousand years – and done pretty well too – without so much fuss. Why doesn't he try to achieve something perfect relying on some reliable technique, instead of seeming to ignore his predecessors?' But, for three thousand years, sculpture modelled only corpses. Sometimes they were laid out to sleep on tombs, sometimes they were seated on curule chairs, they were also perched on horses. But a dead man plus a dead horse do not equal the half of one living being. They lie, these people of the Museums, these people with white eyes. These arms pretend to move, but they float, steadied between high and low by supports of iron; these frozen forms contain within themselves an infinite dispersion; it is the imagination of the spectator, mystified by a gross resemblance, which lends movement, warmth and life, to the eternal collapse of matter. So one must begin again from scratch. After three thousand years, the task of Giacometti and of contemporary sculptors, is not to enrich the galleries with new works, but to prove that sculpture itself is possible. To prove it by sculpting, as Diogenes proved movement by walking. To prove it, like Diogenes, against Parmenides and Zeno, it was necessary to go to the very end, and see what can be done. Were the effort to fail, it would be impossible, in any case, to decide whether this meant the failure of the sculptor or of sculpture: others would come, who would begin again; Giacometti himself perpetually starts afresh. However, it is not a question of an infinite progression; there is a definite goal to be attained, a single problem to be solved: how to mould a man in stone without petrifying him? It is all or nothing: if the problem be solved, the number of statues matters little. 'Let me know how to make only one', says Giacometti, 'and I will be able to make a thousand…'. So long as he does not know this, Giacometti is not interested in statues at all, but only in sketches, insofar as they help him towards his goal. He breaks everything, and begins all over again. From time to time, friends are able to save a head, a young woman, a youth, from the massacre. He doesn't care, and goes back to his task. He has not had a single exhibition in fifteen years. Finally, having a show has become a necessity to him, but he is nevertheless disturbed; he writes to excuse himself: 'It is mainly because I don't want to be thought of as sterile and incapable of achieving anything, as a dry branch almost; then too, it is from fear of poverty (which my attitude could very well involve), that I have brought these sculptures to their present point (in bronze and photographed) but I am not too happy about them; they represent something of what I intended just the same, not quite.' What bothers him is that these moving outlines, always half-way between nothingness and being, always modified, bettered, destroyed and begun once more, setting out at last on their own and for good, are commencing a social career far from him. He will forget them. The marvellous unity of this life lies in its insistent search for the absolute.

This eager and obstinate worker does not like the resistance of stone,

which moderates his movements. He has chosen for himself a material without weight, the most ductile, the most perishable, the most spiritual to hand: plaster. This he scarcely feels at the ends of his fingers, it is the impalpable reverse side of his movements. What one sees first in his studio are strange scarecrows made of white crusts curdled around long red strings. His adventures, his ideas, his desires and his dreams project themselves for a moment on the plaster dolls, give them form and pass, and the form passes also. Each of these nebula in perpetual metamorphosis seems to be the very life of Giacometti transcribed in another language. The statues of Maillol insolently fling in your eyes their heavy eternity. But the eternity of stone is synonymous with inertia; it is a forever frozen now. Giacometti never speaks of eternity, never thinks of it. I like what he said to me one day about some statues he had just destroyed: 'I was satisfied with them but they were made to last only a few hours.' A few hours: like a dawn, a distress, an ephemera. But it is true that his figures, by the very fact that they have been fated to die in the very night wherein they were born, are, of all the sculptures I know, the only ones able to keep the ineffable grace of seeming perishable. Never was matter less eternal, more fragile, nearer to being human. The matter of Giacometti, that strange flour which gently powders and covers his studio, slips under his nails and into the deep furrows of his face, is the dust of space.

But space, even if naked, is still superabundant. Giacometti has a horror of the infinite. Not of the Pascalian infinite, of the infinitely great: there is another infinite, more devious, more secret, which slips away from divisibility: 'In space', says Giacometti, 'there is too much.' This too much is the pure and simple coexistence of parts in juxtaposition. Most sculptors let themselves be taken in by this: they confuse the flaccidity of extension with largesse, they put too much in their works, they delight in the fat curve of a marble hip, they spread out, thicken, and expand the human gesture. Giacometti knows that there is nothing redundant in a living man, because everything there is functional; he knows that space is a cancer on being, and eats everything; to sculpt, for him, is to take the fat off space; he compresses space, so as to drain off its exteriority. This attempt may well seem desperate; and Giacometti, I think, two or three times came very near to despair. If, in order to sculpt, it is necessary to cut and then resew in this incompressible medium, why, then sculpture is impossible. 'Just the same,' he said, 'if I begin my statue, as they do, with the tip of the nose, then an infinity of time will not be too much before I get to the nostrils.' It was then that he made his discovery.

Here is Ganymede on his pedestal. If you ask how far away he is from me, I will reply that I don't know what you are talking about. By 'Ganymede', do you mean the young lad who was carried off by the eagle of Jupiter? In that case, I will say that from him to me there is no real relation of distance, for the simple

reason that he does not exist. But perhaps you have in mind the marble block which the sculptor shaped in the image of the darling boy? In that case, we have something real to deal with, an existent mineral that we can measure. Painters have understood all this for a long time, because, in pictures, the unreality of the third dimension causes ipso facto the unreality of the other two. Thus the distance of the figures from me is imaginary. If I approach, I come closer to the canvas, not to the figures on it. Even if I put my nose against it, I should still see them twenty paces distant, since it was at twenty paces from me that they came to exist once and for all. Thus painting escapes the paradoxes of Zeno: even if I were to divide in two the space separating the foot of the Virgin from the foot of Saint Joseph, and each one of the two halves in two again, and so on infinitely, it would be a certain length of canvas that I should be dividing, and not the pavement supporting the Virgin and her husband. Sculptors have not recognized these elementary truths because they have worked in a tridimensional space on real marble. And in spite of the fact that the product of their art was to be an imaginary man, they thought it possible to project him in a real space. This confusion of two spaces has had curious results: in the first place, when they worked from nature, instead of rendering what they saw – that is to say, the model, ten paces off – they outlined in the clay what they knew to be there – that is to say, the model. As they wanted their statue to give a spectator standing ten feet off from it the impression they had experienced before the model, it seemed to them logical to make a figure which would be for the spectator what the model had been for them; and that was only possible if the marble were here as the model was there. But what does it mean to be 'as it is' and 'there'? At ten paces, I form a certain image of that nude woman; if I approach her, and regard her from up close, I no longer recognize her: these craters, tunnels, cracks, this rough black hair, these smooth shiny surfaces, this whole lunar orography: how could all these qualities go to compose the sleek fresh skin that I admired from far off? Which is it then that the sculptor ought to imitate? However close he comes to this face, one can approach closer still. Thus the statue will never truly resemble what the model is or what the sculptor sees; one must construct it in accordance with certain rather contradictory conventions, imagining certain details which are not visible from so far off, under the pretext that they exist, and neglecting certain others which exist just the same, under the pretext that one does not see them. What does this mean if not that one finally leaves it to the spectator to recompose a satisfying figure? But, in that case, my relation to Ganymede will vary with the position; if I am near, I will discover details that from a distance I would miss. And this brings us to the paradox that I have real relations with an illusion; or, if you like, that my real distance from the block of marble has become one with my imaginary distance from Ganymede. Thus, it results that the proper-

ties of real space cover up and mask those of imaginary space: more especially, the real divisibility of the marble destroys the indivisibility of the figure. It is the stone which triumphs, along with Zeno. So the classical sculptor falls into dogmatism, believing he can eliminate his own glance, and sculpt human nature in general; but he does not know what he does because he does not make what he sees. Seeking the true, he has arrived at convention. And, as, in the last analysis, he leaves it to the visitor to animate these inert semblances, the classical seeker of the absolute ends by making his work subject to the relativity of the points of view one can adopt towards it. As to the spectator, he takes the imaginary for the real and the real for the imaginary: he seeks the indivisible, and everywhere encounters it opposite!

In frontally opposing classicism, Giacometti has restored an imaginary and indivisible space to statues. In accepting relativity from the very start, he has found the absolute. This is because he was the first one to take it into his head to sculpt man as he appears, that is to say, from a distance. He confers on his plaster figures an absolute distance, as the painter does for those who live in his canvas. He creates his figure 'at ten paces,' 'at twenty paces,' and whatever you do, there it stays. By the same token, the figure places itself in the unreal, since its relation to you no longer depends on your relation to the block of plaster: art is liberated. One has to learn a classical statue, or come near to it: at each moment one sees new details, the parts appear separately, then parts of the parts, one ends by getting lost. One does not approach a sculpture of Giacometti. Do not expect this breast to swell to the degree that you come close to it: it will not change, and you, in approaching will have the strange impression that you are stamping on the nipples; we have intimations of them, we divine them, now we are on the point of seeing them; another step or two, and we are about to have them; one more step and everything vanishes: there remain the corrugations of the plaster; these statues only permit themselves to be seen from a respectful distance. However, everything is there: the whiteness, the roundness, the elastic subsidence of a beautiful ripe breast. Everything except matter: at twenty paces one thinks one sees, but one does not observe the tedious desert of adipose tissue; it is suggested, outlined, meant, but not given. We know now what squeezer Giacometti used to compress space: there is only one: distance. He puts distance within reach of your hand, he thrusts before your eyes a distant woman – and she remains distant, even when you touch her with your fingertips. The breast glimpsed and hoped for will never expose itself: it is only a hope; these bodies have only as much matter as is necessary for making promises. 'Nonetheless,' some say, 'that's not possible: it can't be that the same object can be seen from near and far at once.' But it is not the same: it is the block of plaster which is near, the imaginary figure which is distant. 'Even in contracting, the distance cannot get away from tridimensionality.

But only breadth and depth are changed: the height remains intact.' It is true. But it is also true that man possesses absolute dimensions in the eyes of other men: if he moves away, I do not see him dwindling, but his qualities become more compact, while his 'shape' remains constant; if he approaches, he does not become larger: the qualities expand. It must be admitted however, that the men and the women of Giacometti are nearer to us in height than in breadth: it is as if their size were in front of them. But Giacometti has elongated them deliberately. What must be understood is that these figures, who are wholly and all at once what they are, do not permit one to study them. As soon as I see them, they spring into my visual field as an idea before my mind; the idea alone possesses such immediate translucidity, the idea alone is at one stroke all that it is. Thus Giacometti has resolved in his own way the problem of the unity of the multiple: he has just suppressed multiplicity. It is the plaster or the bronze which can be divided: but this woman who moves within the indivisibility of an idea or of a sentiment, has no parts, she appears totally and at once. It is to give sensible expression to this pure presence, to this gift of the self, to this instantaneous coming forth, that Giacometti resorts to elongation. The original movement of creation, that movement without duration, without parts, and so well imaged by these long, gracile limbs, traverses their Greco-like bodies, and raises them towards heaven. I recognize in them, more clearly than in an athlete of Praxiteles, the figure of man, the real beginning and absolute source of gesture. Giacometti has been able to give this matter the only truly human unity: the unity of the Act.

Such, I think, is the sort of Copernican revolution Giacometti has tried to introduce into sculpture. Before him the effort was to sculpt being, and that absolute melted away in an infinity of appearances. He has chosen to sculpt the situated appearance, and he has shown that in this way the absolute may be attained. He shows us men and women already seen. But not already seen by him alone. These figures are already seen as the foreign language we try to learn is already spoken. Each one of them reveals man as one sees him to be, as he is for other men, as he appears in an intersubjective world, not, as I said above, to entangle himself at ten or twenty paces, but at a proper human distance; each shows us that man is not there first and to be seen afterwards, but that he is the being whose essence is to exist for others. In perceiving this woman of plaster, I encounter athwart her, my own glance, chilled. Hence the delightful disquiet that seeing her puts me in: I feel compelled and I do not know to what end or by whom until I discover that I am compelled to see, and by myself. And then, often enough Giacometti likes to put us at a loss by placing, for example, a distant head on top of a near body, so that we no longer know what position to take, or how to synthesize what we see. But even without this, his ambiguous images disconcert, breaking as they do with the most cherished habits of our

eyes: we have become so accustomed to the sleek mute creatures, made to cure us of the illness of having bodies: these domestic powers kept an eye on us when we were children; they bore witness in the parks to the conviction that the world is not dangerous, that nothing happens to anybody, that actually all that had happened to them was to die at their birth. But to the bodies of Giacometti something has happened: do they come, we ask, from a concave mirror, from the fountain of youth, or from a camp of displaced persons? At first glance we seem to be up against the fleshless martyrs of Buchenwald. But a moment later we have a quite different conception; these fine and slender natures rise up to heaven, we seem to have come across a group of Ascensions, of Assumptions; they dance, they are dances, they are made of the same rarified matter as the glorious bodies that were promised us. And when we have come to contemplate this mystic thrust, these emaciated bodies expand, what we see before us belongs to earth. This martyr was only a woman. But a woman complete, glimpsed, furtively desired, a woman who moved away and passed, with the comic dignity of those long impotent and breakable girls that high-heeled slippers carry lazily from bed to their bath, with the tragic horror of the grimy victims of a fire, given, refused, near, far, a woman complete whose delicious plumpness is haunted by a secret thinness, and whose terrible thinness by a suave plumpness, a complete woman, in danger on this earth, and yet not utterly of this earth, and who lives and tells us of the astonishing adventure of the flesh, our adventure. For she, like us, was born.

But Giacometti remains dissatisfied. He could collect his wager at any time. He has only to decide that he has won. But this he cannot resolve to do, he puts off the decision from hour to hour and from day to day; sometimes, in the course of a night's work, he is ready to admit victory; in the morning everything is broken. Does he fear the boredom that lies on the other side of triumph, that boredom which chilled Hegel when he imprudently bolted his system? Or perhaps matter has revenged itself. This infinite divisibility that he thrust out of his work returns incessantly perhaps, to insert itself between him and his goal. The end is achieved; now one must do it a little better. And then a little better still; this new Achilles will never catch the tortoise; a sculptor must in one way or another be the scapegoat of space: if not in his work then in his life. But everything considered, there is between him and us a difference of position. He knows what he wants to do and this we do not know; but we know what he has succeeded in doing and which he does not notice: these statues are still more than half sunk in his flesh, he cannot see them; he has hardly made them when he is already dreaming of women still more slender, still longer and lighter, and it is thanks to what he has done that he forms the ideal in whose name he judges it to be imperfect. He will never be finished with it; this is simply because a man is always beyond what he has done. 'When I have

finished,' he says, 'I shall write, I shall paint, I shall enjoy myself.' But he will die before finishing. Is he in the right, or are we? He first, because, as da Vinci said, it is not good for an artist to feel satisfied. But we too, are right, and in the final accounting; Kafka, dying, wanted his books burned, and Dostoevsky, in the last days of his life, dreamed of writing a sequel to Karamazov. Perhaps they both died wretched, the one thinking he had done nothing meritorious, the other that he would be forced to lie outside of the world before he had even been able to scratch its surface. Yet both had won, whatever they thought. Giacometti has won likewise, and he is perfectly well aware of it. Vainly does he hook himself to his statues like a miser to his treasure; in vain does he temporise, delay, find a hundred excuses for putting off the reckoning: men are going to come to his place to strip it, and carry off all his works, even to the plaster that covers his floor. He knows it: his hunted look gives him away: he knows that despite himself he has won and that he belongs to us.

28 Clement Greenberg

'The New Sculpture' 1949

In the late 1940s Clement Greenberg (1909–94) was beginning to establish himself as the foremost American art critic writing on the art of the abstract expressionist generation. He first came to prominence during the Second World War, contributing to and editing the Trotskyite journal, *Partisan Review*, as well as writing a regular 'Art' column for the news magazine, *The Nation*. Greenberg wrote mainly about painting, but a new literalism that he felt was central to art appreciation in the twentieth century made him think that sculpture, once blighted by its literalness, might now find that same inbuilt quality a positive advantage.

'The New Sculpture' has an interesting history, and a little confusingly exists in two versions. The best-known version, which was included in Greenberg's famous *Art and Culture* (1961), is actually a republication of a different essay, 'Sculpture in Our Time' (*Arts Magazine*, June 1958). 'Sculpture in Our Time' reflects on the speculations that Greenberg first articulated in the original *Partisan Review* article (written in 1948). In it he admits that 'the hopes I placed in the new sculpture ten years ago, in the original version of this article, have not yet been borne out – indeed they seem to have been refuted.' However, he goes on to insist that his original insights have not yet been proved 'altogether wrong', and further suggests that 'the new construction-sculpture begins to make itself felt as the most representative... visual art of our time, even if not the most fertile'. 'The New Sculpture' (1949), reproduced here, was therefore the starting point for Greenberg's later famous emphasis on medium specificity and opticality. 'Eyesight', he writes in 1958, enjoys greater freedom 'within three dimensions than within two', while at the same time sculpture's literalness usefully prevents it being 'tainted with illusion'.

This essentially optical understanding of the new sculpture plays a less central role in the original essay. In the late 1940s Greenberg was still working out the terms of his argument based on a novel re-reading of the history of modern sculpture, identifying its guiding logic as a cubist-based negation of the traditional monolith. He also at this point retains a certain radical utopian aspiration for a new sculpture that might transform the object world of modern society.

Clement Greenberg, 'The New Sculpture', orig. *Partisan Review*, June 1949, pp. 637–42; also in *The Collected Essays and Criticism*, Vol. 2, London and Chicago: University of Chicago Press, 1986, pp. 313–19.

Art and literature seem usually to seek their frames of reference wherever the social mind or sensibility of the given historical moment finds its surest truth. In the Middle Ages this area of certainty, or rather of plausibility, coincided with religion, in the Renaissance and for some time thereafter with abstract

reason. The nineteenth century shifted the area of plausibility to factual, empirical reality, a notion that has undergone considerable change during the last hundred years and always in the direction of a narrower conception of what constitutes an indisputable fact of experience. Our sensibility has shifted similarly, demanding of aesthetic experience an increasingly literal order of effects and becoming more and more reluctant to admit illusion and fiction. Thus it is not only our society's highly developed division of labor that has suggested the greater specialization of the separate arts; it is also our taste for the actual, immediate, first-hand, which desires that painting, sculpture, music, poetry become more concrete by confining themselves strictly to that which is most palpable in them, namely their mediums, and by refraining from treating or imitating what lies outside the province of their exclusive effects. This does not mean what Lessing meant when he protested against the confusion of the arts; Lessing still thought of the arts as imitative of an external reality which was to be incorporated by means of illusion; but modern sensibility asks for the exclusion of all reality external to the medium of the respective art – for the exclusion, that is, of subject matter. Only by reducing themselves to the means by which they attain virtuality as art, to the literal essence of their medium, and only by avoiding as much as possible explicit reference to any form of experience not given immediately through their mediums, can the arts communicate that sense of concretely felt, irreducible experience in which our sensibility finds its fundamental certainty.

This is the complex of factors – by no means stated completely – that I believe responsible for, among other things, such phenomena as 'pure' poetry, the 'pure' novel, and 'pure' or abstract painting and sculpture. Notice, for instance, how emphatically such writers as Mallarmé, Valéry, Joyce, Gertrude Stein, Cummings, Dylan Thomas, Stefan George, and Hart Crane call attention to their medium, which does not disguise or render itself transparent in order to grant us the quickest possible access to their content or subject matter, but becomes itself a large part of the subject matter. I could illustrate this tendency at length in modern literature, but literature is not what I am interested in dealing with here.

However, we should remember that no attempt at a 'pure' work of art has ever succeeded in being more than an approximation – least of all in literature, which uses words that signify other things than themselves. The tendency toward 'purity' or absolute abstractness exists only as a tendency, an aim, not as a realization. But as a tendency it is sufficient to explain much in the present state, not only of literature, but also of the visual arts, which are driven toward the same sort of insistence on the palpability of their mediums that we see in Mallarmé, Joyce, and Gertrude Stein.

The literal nature of the medium of painting consists in configurations

of pigment on a flat surface, just as the essential medium of poetry consists in rhythmic configurations of words arranged according to the rules of a language. Modern painting conforms to our desire for that which is positive and literal by openly declaring itself to be what painting has always been but has for long tried to dissemble: colors placed on a two-dimensional surface. The illusion of the third dimension is renounced, and likewise the fiction of representation, which belongs to the literal part of painting as little as it does to that of music; to transpose the image of a three-dimensional object to a flat surface, even if only schematically, is considered by such a modern painter as the late Mondrian to be a denial and violation of the nature of the medium. Modern sensibility tends to consider it a deception, and therefore shallow, un-moving, without concreteness.

Mondrian has shown that it is still possible to paint authentic easel pictures while conforming to this strict – and more than strict – notion of painting. Nevertheless one begins to see a danger in it for the art of painting as we have known it. Pictorial art of this sort comes very close to decoration. Mondrian's greatness may be said to consist in good measure in having so successfully incorporated the virtues of decoration in easel painting, but this is small guarantee for the future. Painting of a kind that identifies itself exclusively with its surface cannot help developing toward decoration and suffering a certain narrowing of its range of expression. It may compensate for this by a greater intensity and concreteness – contemporary abstract art has done so with signal success – but a loss is still felt in so far as the unity and dynamics of the easel picture are weakened, as they must be by any absolutely flat painting. The fact is, I fear, that easel painting in the literally two-dimensional mode that our age, with its positiveness, forces upon it may soon be unable to say enough about what we feel to satisfy us quite, and that we shall no longer be able to rely upon painting as largely as we used to for a visual ordering of our experience.

I do not mean to suggest that painting will soon decline as an art; it is not essential to the point I wish to make to claim that. What is to be pointed out is that painting's place as the supreme visual art is now threatened, whether it is in decline or not. And I want also to call attention to sculpture, an art that has been in relative desuetude for several centuries but which has lately undergone a transformation that seems to endow it with a greater range of expression for modern sensibility than painting now has. This transformation, or revolution, is a product of cubism.

Between the Renaissance and Rodin, sculpture suffered as a vehicle of expression because of its adherence to the monolithic, somatic Graeco-Roman tradition of carving and modelling. The ideal subject of this tradition was the human torso and head, and it rejected as inappropriate all that was inanimate

and immobile. An art confined to the monolith could say very little for the post-Renaissance man, and painting was therefore able to monopolize subject matter, imagination, and talent in the visual arts, where almost everything that happened between Michelangelo and Rodin happened on canvas. That sculpture was at a lesser remove than any of the other arts from that which it imitated – from its subject matter – and that it required less powers of abstraction to transpose the image, say, of an animal to stone in the round than to a flat surface, or into words – this also counted against it for several centuries. Sculpture was too *literal* a medium.

Rodin was the first sculptor who tried actually to catch up with painting, dissolving stone forms into light and air in search of effects analogous to those of impressionist painting. He was a great artist but he destroyed his tradition and left only ambiguities behind him. Maillol and Lehmbruck were also great sculptors, and it was Rodin perhaps who made them possible, but the first got his inspiration from archaeology and the second from expressionist painting. They mark an end, and their art cleared the way for something radically new to fill the vacuum left by the extinction of the Graeco-Roman-Renaissance tradition.

Meanwhile cubism had appeared in painting. Brancusi, under its indirect influence and the more direct one of Negro sculpture, was able to begin the transition from the monolith to a new kind of sculpture derived from modern painting and the wood-carvings of Africa and Oceania: a kind of sculpture entirely new to European civilization, art no longer restricted to the solid mass and to human and animal forms. Brancusi himself does not complete the transition. What he does, at least in his work in stone and metal, is push the monolith to such an extreme, reduce it to such archetypal simplicity, that it is exhausted more or less as a principle of form. The new sculpture really begins with Braque's and Picasso's cubist collages, springing up out of a mode of painting that thrusts forms outward from the picture plane instead of drawing them back into the recessions of illusionary space.[1] Thence the new sculpture grew through the bas-relief constructions that Picasso and then Arp and Schwitters created by raising the collage above the picture plane; and from there Picasso, a magnificent sculptor as well as painter, along with the Russian constructivists Tatlin, Pevsner, and Gabo, and also Archipenko, Duchamp-Villon, Lipchitz, Laurens, and then Giacometti, at last delivered it into the positive truth of free space, altogether away from the picture plane.

This new, pictorial, draftsman's sculpture has more or less abandoned the traditional materials of stone and bronze in favor of ones more flexible under such modern tools as the oxyacetylene torch: steel, iron, alloys, glass, plastics. It has no regard for the unity of its physical medium and will use any number of different materials in the same work and any variety of applied colors – as

befits an art that sees in its products almost as much that is pictorial as is sculptural. The sculptor-constructor is, if anything, more drawn to ideas conceived by analogy with landscape than to those derived from single objects.

The new sculpture is also freed, as should be self-evident from what I have said, from the requirements of imitative representation. And it is here precisely that its advantage over modern painting, as far as range of expression is concerned, lies. The same evolution in sensibility that denied to painting the illusion of depth and of representation made itself felt in sculpture by tending to deny it the monolith, which in three-dimensional art has too many connotations of representation. Released from mass and solidity, sculpture finds a much larger world before it, and itself in the position to say all that painting can no longer say. The same process that has impoverished painting has enriched sculpture. Sculpture has always been able to create objects that seem to have a denser, more literal reality than those created by painting; this, which used to be its handicap, now constitutes its greater appeal to our new-fangled, positivist sensibility, and this also gives it its greater license. It is now free to invent an infinity of new objects and disposes of a potential wealth of forms with which our taste cannot quarrel in principle, since they will all have their self-evident physical reality, as palpable and independent and present as the houses we live in and the furniture we use. Originally the most transparent of all the arts because the closest to the physical nature of its subject matter, sculpture now enjoys the benefit of being the art to which the least connotation of fiction or illusion is attached.

The new sculpture has still another advantage. To painting, no matter how abstract and flat, there still clings something of the past simply because it is painting and painting has such a rich and recent past. This until a short time ago was an asset, but I am afraid that it has begun to shrink. The new sculpture has almost no historical associations whatsoever – at least not with our own civilization's past – which endows it with a virginity that compels the artist's boldness and invites him to tell everything without fear of censorship by tradition.[2] All he need remember of the past is cubist painting, all he need avoid is naturalism.

All this, I believe, explains why the number of promising young sculptors in this country is so much greater, proportionally, than is that of promising young painters. Of the latter we have four or five who may figure eventually in the history of the art of our times. But we have as many as nine or ten young sculptor-constructors who have a chance, as things look, to contribute something ambitious, serious and original: David Smith, Theodore Roszak, David Hare, Herbert Ferber, Seymour Lipton, Richard Lippold, Peter Grippe, Burgoyne Diller, Adaline Kent, Ibram Lassaw, Noguchi – and still others. Not all these artists are richly gifted and not all of them have broken away from

the monolith; their styles are as various as the variety of sculpture since 1905. But unequal as they are in talent, they all show freshness, inventiveness, and positive taste, qualities they owe, I feel, to the fact that their medium is so new and so cogent that it produces interesting work almost automatically, just as the new naturalistic painting of the fifteenth century in Italy and Flanders extracted masterpieces from even mediocre hands. The same seems to be the case, from what I can gather, with the new sculpture in Paris and London.

As yet not enough attention has been paid to the novelty of the new sculpture. But not enough attention is paid to sculpture in general. For most of us, raised as we are to look only at painting, a piece of sculpture fades too quickly into an indifferent background as a matter-of-fact ornamental object. The new sculpture-construction has to contend with this habit of vision, and it is for this reason, I think, that so few attempts have been made to evaluate it seriously and relate it to the rest of art and to the feeling of our time. Yet this new 'genre' is perhaps the most important manifestation of the visual arts since cubist painting, and is at this moment pregnant with more excitement than any other art except music.

1 There is a curious historical symmetry here. Our Western, naturalistic painting had its own origins in the sculpture of the 12th and 13th centuries, which was 200 years ahead of painting in point of capacity for imitating nature, and which continued to dominate the other arts until the late 15th century.
2 One of the ways in which the new sculpture's advantage over painting is revealed is by our feeling that what we see in the pictures of such painters as Matta, Lam, and sometimes Sutherland – all three of whom owe so much to Picasso – and in a good deal of Picasso's own work, is illegitimate sculpture, illustrations of sculpture or of ideas essentially sculptural. But we never feel that the new sculpture is illegitimate painting. It is too fresh, just as Mantegna's painting, which owed so much to the other art, was too fresh to be called illegitimate sculpture.

29 David Smith

'The New Sculpture' 1952

David Smith (1906–65) was one of the best-known American sculptors working in the Cold War period in an abstract style. His success had a lot to do with establishing a reciprocal relationship between the idea of 'new sculpture' and the achievements of contemporary painting. 'The New Sculpture' was a paper delivered by Smith on 12 February 1952 at the Museum of Modern Art in New York. The symposium reflected the director Alfred H. Barr's conviction that a new post-surrealist sculptural movement with international ambitions was beginning to emerge in America in parallel to abstract expressionism. Alongside Smith, the other speakers at the event were Theodore Roszak, Herbert Ferber, and Richard Lippold, with Andrew C. Ritchie moderating. Smith's lecture still reads as a *tour de force* and one can easily imagine how powerful it was when first delivered. Starting with his factory worker credentials – 'acquainted with steel and the machines used in forging it' – Smith writes directly about sculpture with some intriguing points of reference. European sculpture and industrial machine tools are discussed, for example, in relation to Japanese brushwork and Chinese 'cloud-longing'. His short, punchy text also contains some poetic and memorable lines, including, sculpture 'is an adventure viewed'.

With a background as a painter and a strong commitment to new welded-metal techniques, Smith was well positioned to be the principal figure in the 'new sculpture' movement. As Clement Greenberg wrote in *The Nation* (January 1946), Smith seemed to propose new problems by refusing to settle for 'the guarantees of the past'.

Smith's 'New Sculpture' paper was recovered and published for the first time in 1973, appearing in Garnett McCoy's collection of David Smith writings and lectures for the series *Documentary Monographs in Modern Art*. McCoy's anthology demonstrates how active Smith was as a speaker at this time, due to a Guggenheim Foundation Fellowship he had been awarded in 1951. Three other speeches from 1951–2 can be usefully compared to the 'New Sculpture' lecture: 'Perception and Reality' (December 1951) given at Williams College, Massachusetts; 'The Sculptor and His Problems' (August 1952) given at Woodstock Conference of Artists, New York; and 'Aesthetics, the Artist and the Audience' (September 1952) given at Deerfield, Massachusetts – this last essay developing Smith's argument in 'The New Sculpture' in a rather different direction. Also relevant are two magazine articles: the first a monograph on Smith by Elaine de Kooning, which appeared in *Art News* (January 1952) and for which Smith wrote a revealing methodological essay; the second an article by Smith on the theoretical underpinnings of his practice, 'The Language is Image' in *Arts and Architecture* magazine (February 1952). Taken collectively, these writings demonstrate an intellectuality that can seem surprising, given Smith's tendency to promote himself as a visual, rather than verbal, hands-on artisan.

David Smith, 'The New Sculpture' (1952), in Garnett McCoy (ed.) *David Smith*, London: Allen Lane, 1973, pp. 82–5.

Before knowing what art was or before going to art school, as a factory worker I was acquainted with steel and the machines used in forging it. During my second year in art school I learned about Cubism, Picasso, and González through *Cahiers d'Art*. From them I learned that art was being made with steel – the material and machines that had previously meant only labor and earning power.

While my technical liberation came from Picasso's friend and countryman González, my aesthetics were more influenced by Kandinsky, Mondrian, and Cubism. My student period was only involved with painting. The painting developed into raised levels from the canvas. Gradually the canvas became the base, and the painting was a sculpture. I have never recognized any separation except one element of dimension. The first painting of cave man was both carved line and color, a natural reaction and a total statement.

My first steel sculpture was made in the summer of 1933, with borrowed equipment. The same year I started to accumulate equipment and moved into the Terminal Iron Works on the Brooklyn waterfront. My work of 1934–36 was often referred to as line sculpture, but to me it was as complete a statement about form and color as I could make. The majority of work in my first show at the East River Gallery in 1938 was painted. I do not recognize the limits where painting ends and sculpture begins.

Since the turn of the century painters have led the aesthetic front both in number and in concept. Outside of Brancusi, the greatest sculptures were made by painters. Sculpture is more immediate than painting for visual action. Natural constants such as gravity, space, and hard objects are the physicals of the sculpture process. Consequently they flow more freely into the act of vision than the illusion of constants used in painting. The fact that these constants or premises need no translation should make sculpture the medium of greatest vision. This I mention as a theoretic possibility; but the concept of the resistance of material is an element which is unique to this art form. A sculpture is a thing, an object. A painting is an illusion. There is a difference in degree in actual space and the absolute difference in gravity.

My position for vision in my works aims to be in it, and not a scientific physical viewing it as subject. I wish to comment in the travel. It is an adventure viewed. I do not enter its order as lover, brother or associate, I seem to view it equally as from the traveling height of a plane two miles up, or from my mountain workshop viewing a cloud-like procession.

In the Reisho school of Chinese character writing, the graphic aim was to show the force of carving in stone or engraving in steel. It is easy to see how this noble intent could express with such conviction. A Chinese painter explained that although the long blade leaves of an orchid droop toward the earth, they all long to point to the sky. This Chinese attitude of cloud-longing is an eye through which I view form in works of celebration and, conversely, in those of a specter nature.

Certain Japanese formalities seem close to me, such as the beginning of a stroke outside the paper continuing through the drawing space to project beyond, so that the included part possesses both the power of origin and projection. This produces the impression of strength, and if drops fall they become attributes or relationships. Similarly, if the brush flows dry into hair marks, such may be greater in energy, having at least a natural quality not to be reworked, being sufficient in intent to convey the stronger content. It is not Japanese painting but some of the principles involved that have meaning to me. Another Japanese concept demands that when representing an object suggesting strength – like rocks, talons, claws, tree branches – the moment the brush is applied the sentiment of strength must be invoked and felt through the artist's system, and so transmitted into the object painted. And that this nervous current must be continuous and of equal intensity while the work proceeds. As my material already possesses strength akin to the Japanese power-stroke intent, I take delight in using steel as a fluid with which to fashion velvet form within images when the intensity and feeling are the forces within the concept.

I have never planned a work of art to be left in the semi-finished state, or in the material not meant to be final. The intermediate stage of pattern, with the casting unrealized, would leave me in suspense. Rather I am content to leave hundreds of sculptures in drawings which time, cost, and conceptual change have passed by. Even with my production, some twenty works a year, production costs force limits in scale, material, and output, but if I depended on plaster and wax for bronze casting, the number of works would be cut in half.

When mass space is indicated by line or fenced form, the work time demanded due to the resistance of material before unity, the suspension and projection required by the natural law of gravity, demand more pre-meditation and sustained conviction than when the same form is drawn on a planar surface. The line contour with its variations and its comment on mass space is more acute than bulk shape. In vision the overlay of shapes seen through each other not only permits each shape to retain its individual intent but in juxtaposition highly multiplies the associations of the new and more complex unity.

I do not work with a conscious and specific conviction about a piece of sculpture. Such a decision is not an aim. The works you see are segments of my

work life. If you prefer one work over another, it is your privilege, but it does not interest me. The work is a statement of identity, it comes from a stream, it is related to my past works, the three or four works in process and the work yet to come. I will accept your rejection, but I will not consider your criticism any more than I will concerning my life.

I do not consciously feel revolt against past art or European art in particular. I am conscious of the security of that development, from world art and contemporary technics, which permit my particular existence to be active in its own right with its own direction. This is not an exclusive position. This feeling is in part accountable for the tremendous art surge which exists throughout the country. And more so here than in any part of the world.

The material called iron or steel I hold in high respect. What it can do in arriving at a form economically, no other material can do. The metal itself possesses little art history. What associations it possesses are those of this century: power, structure, movement, progress, suspension, destruction, brutality. The method of unifying parts to completion need not be evident, especially if craft evidence distracts from the conceptual end. Yet the need to observe the virtue of the material, its natural planes, its hard lines, its natural oxides, its need for paint or its unifying method is only valid when within concept. These points related to the steel concept are minor and depend wholly upon the conceptual realization of the sculptor, but they are unique and have never existed before this century.

In work progress, I control the entire process from origin to finish. There are no in-between craftsmen or process distortions. It is the complete and total processing of the work of art. Economically this process has high virtue over other metal means. Outside of aesthetic considerations, the labor costs in casting are higher than the sculptor's own wages. Direct work is not meant to replace casting, but it more often conforms to my concept. But casting is a method and concept which holds its function as it has for 6,000 years.

The accommodation to each particular machine tool and its method is made familiar by use. The construction of the whole from its parts is made by fairly unconscious change of machine tools. The machine tool becomes an instrument of aesthetics in the art of addition. The transformation of unit parts into a unified whole from seemingly disparate units, by repeated action, result in full order. In fact, my beginning before I knew about art had already been conditioned to the machine – the part of the whole, by addition, or the quantity into quality concept. This aesthetic process relates closer to the mode of painting than to the historic making of sculpture.

The term 'vulgar' is a quality, the extreme to which I want to project form, and it may be society's vulgarity, but it is my beauty. The celebrations, the poetic statement in the form of cloud-longing is always menaced by brutality.

The cloud-fearing of specters has always the note of hope, and within the vulgarity of the form an upturn of beauty. Despite the subject of brutality, the application must show love. The rape of man by war machine will show the poetic use of form in its making. The beauties of nature do not conceal destruction and degeneration. Form will flower with spikes of steel, the savage idols of basic patterns. The point of departure will start at departure. The metaphor will be the metaphor of a metaphor, and then totally oppose it.

I believe only artists truly understand art, because art is best understood by following the visionary path of the creator who produces it. The Philistines will not attempt the projection. A work of art is produced by an expert. There must be expertness in its perception. There are degrees in expertness – some come close, some are on the fringe, some pretend. Degrees of expertness naturally apply to both the artists creating and the audience response.

30 Herbert Read

from *The Art of Sculpture* 1956

From the 1930s to the 1950s Herbert Read (1893–1968) was the best-known and most influential British critic on the international art scene. The dedication to *The Art of Sculpture* acknowledges his longstanding admiration for Naum Gabo, Barbara Hepworth and Henry Moore, 'sculptors and friends in gratitude'. In the first extract below from *The Art of Sculpture*, Read shows the extent to which he was interested in psychological explanations for art, borrowing liberally from Piagetian and object-relations findings and combining these with a parallel fascination for Jungian concepts – using, for example, Jung's typological description of temperaments as the basis for a division of 'sensibilities' into 'visual' and 'plastic' types (a division that also shows the influence of his Kleinian friend, Adrian Stokes). Read draws on recent psychoanalytical findings in order to oppose the older psychological argument of Adolph Hildebrand, who in Read's view is far too focused on purely visual considerations. For Read, the tactile qualities of sculpture are at least as important as its optical properties. He also at this time wanted to check an emerging French discourse that linked art production to 'existential pessimism' and that produced the kind of work that in 1952 Read had referred to as 'a geometry of fear'. Yet, despite appearances, in Read's view the new sculpture was in fact, at its core, 'affirmative, eudemonistic, optimistic'. He accepts in the second extract below that under present circumstances modern art may be fairly judged 'inhuman' – largely, he suggested in the earlier 'geometry of fear' essay, because of a temporary Cold War zeitgeist to which it was the artist's duty to respond. But in the final analysis, he argues, art has to be 'constructive' rather than destructive. It bears witness, against the evidence of Buchenwald or the atom bomb, to 'the possible existence of a harmonious realm of essence'. *The Art of Sculpture* was based on the A. W. Mellon Lectures in the Fine Arts that Read delivered in six parts at the National Gallery in Washington in 1954.

Herbert Read, *The Art of Sculpture*, London: Faber and Faber, 1956, pp. 69–75 (from 'Chapter Four: The Realisation of Mass') and pp. 112–15 (from 'Chapter Six: The Impact of Light').

The distinction between sight-space and touch-space, to which I referred at the beginning of the last chapter, had the effect of disengaging, from the purely visual apprehension of reality, the quantity known as volume or bulk. If, in addition to touching an object, we lift it or try to lift it, we get a sensation of its *ponderability* or mass. We may have an intuition of ponderability without actually lifting the object, merely from our generalized knowledge of the relative weight of such materials as marble, clay, bronze, and lead.

Our knowledge of an object is complete only when we have exhausted all our sensational reactions to it. Taste and smell are normally excluded from

the aesthetic field. Sound is so distinctive as a sensation that the aesthetics of music has its separate vocabulary, and we can only trace analogies between this art and other arts. But the other two sensations, sight and touch, are both actively engaged in our aesthetic experiences, and it is often very difficult in any given case to dissociate entirely our visual reactions from our tactile reactions. Even when one organ is not directly involved, as when we look at a surface, a whole series of associations based on the tactile knowledge of surfaces may be aroused. It is a false simplification to base the various arts on any one sensation, for what actually takes place, in any given experience, is a chain reaction or *Gestaltkreis* in which one sensation touches off and involves other sensations, either by memory association or by actual sensory motor connections. An art owes its particularity to the emphasis or preference given to any one organ of sensation. If sculpture has any such particularity, it is to be distinguished from painting as the plastic art that gives preference to tactile sensations as against visual sensations, and it is precisely when this preference is clearly stated that sculpture attains its highest and its unique aesthetic values. This peculiarity does not mean, of course, that we can discount our visual reactions to sculpture; nor does it mean that we refuse any aesthetic value to sculpture that is visually conceived. We are seeking the basic principles of this art, and these, I contend, involve tactile sensations.

Jean Piaget has shown, in one of his fascinating studies of the mental development of the child, how the child arrives at a quantification of qualities – how he passes from the conception of number and numerical relations such as the relation of parts to the whole (quantities that may be called 'intensive' or logical), to a conception of 'extensive' quantities such as weight and physical volume. The conscious awareness of these sensations, like the awareness of space that we dealt with in the last chapter, is not given at birth: it has to be acquired by a patient process of learning.[1] A child does not take long to learn that an object is solid or heavy or that it emits light or heat. Not merely the measurement of these quantities, however, but a comparative estimate of them is only slowly evolved. Our knowledge of the external world is due to a gradual sorting out and comparison of such quantitative estimates.

Consciousness is selective, and people can be divided into psychological types according to the predominance of any one sensation in the imagination. Thus there are visual types, tactile types, and audile types. There is perhaps a normal type in whose mind the imagery due to the various sensations is evenly or appropriately mixed, but there can be no doubt that the acuteness of some one type of imagery determines whether an artist becomes a poet,[2] a musician, a painter, or a sculptor. Similarly, the strength of our reactions to one or another of these arts, our particular preference among the arts, is due to the relative acuteness in ourselves of one type of imagination. We may expect, therefore,

to find visual types who have no appreciation of the tactile values of sculpture; and as I suggested at the end of the preceding chapter, we may even find visual artists like Leonardo who conceive and execute sculpture with a predominantly visual equipment. It was Hildebrand's contention, in his treatise *The Problem of Form in Painting and Sculpture*, that the unity essential to a work of art can be achieved only in vision and that the sculptor strives to accommodate his three-dimensional forms to the visual ease of a two-dimensional surface. That is the heresy I wish to contest in this chapter. My intention is to show that sculpture owes its individuality as an art to unique plastic qualities, to the possession and exploitation of a special kind of sensibility. Its uniqueness consists in its realization of an integral mass in actual space. The sensibility required for this effort of realization has nothing in common with visual perception, i.e., with the visual impression of a three-dimensional form on a two-dimensional plane.

The specifically plastic sensibility is, I believe, more complex than the specifically visual sensibility. It involves three factors: a sensation of the tactile quality of surfaces; a sensation of volume as denoted by plane surfaces; and a synthetic realization of the mass and ponderability of the object.

It is very difficult to convey the nature of these sensations by descriptive words or even by photographic illustrations. Ideally each reader of this volume should be provided, at this stage, with a piece of sculpture to hug, cuddle, fondle – primitive verbs that indicate a desire to treat an object with plastic sensibility.

A sensibility to surface quality is involved in other arts. Even the surface quality of a painting has considerable aesthetic significance, as we may realize if we compare the surface of a painting by Rembrandt with the surface of a painting by Vermeer. Surface is one of the elements of a painting's 'facture.' Even the surface quality of a sheet of paper used for a drawing or an engraving or even for writing, is of considerable aesthetic importance. Surface plays its part in all metalwork and ironwork, in jewelry and textiles, and is of supreme importance in the art of pottery. It would not be necessary to insist on the aesthetic significance of surface impressions in sculpture had there not grown up during and since the Renaissance a convention based on the ideals of the Hellenistic decadence. This convention systematically tended toward the denaturing of all materials and toward the choice of certain materials, like pure white marble, devoid of any surface irregularities and therefore not emphasizing the materiality of the sculptural mass. The problem is not one of smoothness: smoothness, polish, and a scintillating surface can be used for aesthetic effect, as in certain Renaissance bronzes. Pieces such as these exploit the smooth surface as a reflector of light, producing an effect I shall discuss at greater length in a later chapter. In the

typical academic statue of white marble, however, the surface is monotonous and dead. The object seems to be to produce the visual impression of a plane surface shaded like white paper. To secure the opposite effect – to call attention to mass – the modern sculptor tends either to use stones that are mottled or striated or to leave a rougher surface, even one showing the marks of his chisel or hammer. He has to a large extent abandoned the immaculate marbles of the pseudoclassical tradition and uses instead a wide variety of stone, wood, metal, or indeed any material that offers a surface aesthetically stimulating, especially to the tactile sensibility.

Still, important as they are, there is nothing specifically sculptural about such surface aesthetics, so let us pass to the more difficult problem of volume.

Rodin related, in his conversations with Paul Gsell, how he came to realize the importance of relief in sculpture. This subject was taught to him by a sculptor called Constant, and one day Constant was watching Rodin as he modeled in clay a capital decorated with foliage.

'Rodin', he said to the young student, 'you are going about that in the wrong way. All your leaves seem flat. That is why they do not look real. Make some with the tips pointed at you, so that, in seeing them, one has the sensation of depth.'

Rodin followed his advice and was amazed at the results he obtained.

'Always remember what I am about to tell you', Constant went on to say. 'Henceforth, when you carve, never see the form in length, but always in thickness. Never consider a surface except as the extremity of a volume, as the point, more or less large, which it directs toward you. In that way will you acquire the science of modeling.'

This principle, said Rodin, had quite astonishing results: 'I applied it to the execution of figures. Instead of imagining the different parts of a body as surfaces more or less flat, I represented them as projectures of interior volumes. I forced myself to express in each swelling of the torso or of the limbs the efflorescence of a muscle or of a bone which lay deep beneath the skin. And so the truth of my figures, instead of being merely superficial, seems to blossom from within to the outside, like life itself.'[3]

Rodin's observation may seem simple, even naïve to those who are accustomed to the art of sculpture either as sculptors or as amateurs. Nevertheless for the average person brought up to approach every work of art with binocular vision, this kind of vision, from depth to surface or from surface to depth, requires a new effort, a re-education of the senses.

Even more difficult is the third aesthetic effort of apprehension involved in the art of sculpture, what I have called a synthetic realization of the mass and ponderability of the object. This sensation is comparatively easy to convey in the case of small objects. We feel the hard roundness of the pingpong ball and

may even get an aesthetic satisfaction from that sensation. We react aesthetically to the feel of the handle of a stick and to many other solid objects that we habitually use. The Chinese and Japanese have developed a class of small objects carved out of such materials as jade, amber, and ivory, some of which are carried in the pocket and fondled from time to time. Some people treasure pebbles in this way, and a few pieces of modern sculpture have been produced with the intention that they be fondled.

This sensation of palpability, so evident in the small object, is felt by the sculptor toward his carving, *whatever its size*. It is one of the essential faculties engaged in the appreciation of sculpture. In his description of the mental process here involved which I quoted in the Introduction, Henry Moore has emphasized this sense of physical possession. The sculptor 'gets the solid shape, as it were, inside his head – he thinks of it, whatever its size, as if he were holding it completely enclosed in the hollow of his hand. He mentally visualizes a complex form from all round itself; he knows while he looks at one side what the other side is like; he identifies himself with its center of gravity, its mass, its weight; he realizes its volume, as the space that the shape displaces in the air.'[4]

On the same occasion, Henry Moore made a generalization that will serve as our point of departure for a consideration of the historical development of these qualities in the art of sculpture. 'Since the Gothic', he said, 'European sculpture had become overgrown with moss, weeds – all sorts of surface excrescences which completely concealed shape. It has been Brancusi's special mission to get rid of this overgrowth, and to make us once more shape-conscious. To do this he has had to concentrate on very simple direct shapes, to keep his sculpture, as it were, one-cylindered, to refine and polish a single shape to a degree almost too precious.' Moore then went on to claim that it was no longer necessary thus to restrict 'sculpture to the single (static) form unit.' Several forms of varied sizes, sections, and directions could be related and combined into one organic whole.'[5]

Obviously the need to grasp the sculptured object in its palpable unity will impose certain limits on the art of sculpture. It cannot become too complex, too articulated, or even too large without sacrificing this aesthetic quality. Perhaps for this reason the greatest sculpture always has a certain compactness. Michelangelo, whose work has this compactness, said that only those works were good that could be rolled from the top to the bottom of a mountain without breaking. Such irrefragability not many Greek masterpieces possess; when we think of Greek sculpture, we tend to visualize a torso that accidentally has lost its head and at least a couple of limbs. Our own bias merely confirms the visual bias of Greek sculpture, its conformity to that law of frontality that evaded the difficulties inherent in any realization of integral mass. For the sake of compactness and superficial integrity, limbs may be deliberately omitted. [...]

The Impact of Light

A far more deliberate use of light than any we have considered so far has been made by certain modern sculptors. There are two distinct developments to consider. The first is due to the use by the sculptor of certain newly invented materials that reflect and even refract light with unparalleled effect. Transparent or translucent sculpture is not unknown in the past; there are the famous skulls of rock crystal from Mexico, not to mention various rock crystal carvings of the late classic, Gothic, and Islamic periods. There is also a whole class of miniature sculptures of molded and drawn glass made at Murano and Limoges in the seventeenth and eighteenth centuries; however, the recent invention of various types of translucent and transparent plastic materials that have the advantage of being easily cut or bent has given the sculptor a new opportunity to exploit light. The constructivists in particular have made good use of this opportunity. Naum Gabo, by using Perspex (or Lucite), a material of crystal purity, seems to create his forms in light itself. We are no longer aware of a gross material substance but only of space defined by light and given significant form. These images are nonfigurative, but the sculptor has claimed that they are 'images of reality', images that express a new and specifically modern form of consciousness. 'I cannot help rejecting all repetitions of images already done', the sculptor has said, 'already worn out and ineffective. I cannot help searching for new images and this I do, not for the sake of their novelty but for the sake of finding an expression of the new outlook on the world around me and the new insight into the forces of life and nature in me.'[6] Obviously such an art has a direct relationship, more than sympathetic, with those sciences like optics and physics that have revealed so much of the inner structure and organization of the material world. It would nonetheless be wrong to think of such sculptures as scientifically conceived. They are, rather, poetic images, but theirs is a poetry of light.

The constructions of Richard Lippold are also images of light, but light reflected from the bright surfaces of nickel-chromium wire, stainless-steel wire, and brass rods. They need a strong artificial light and a black background for their maximum effect, and then they glitter like magnified snow crystals.

The second development of modern sculpture that deliberately exploits light is of quite a different origin and has quite a different purpose. We have already seen that the impact of light on the surface of an intentionally solid mass is to create areas of high light that, if the material is at all smooth or polished, have a disintegrating effect on the static tension of the mass. It is as if a hole had been eaten into the mass by some acid. Everything is done, in museums and private galleries, to diffuse the light so that this disturbing effect is not produced, but again the modern sculptor has grasped a potential value

from this defect. He has seen that if the light, instead of being reflected from the protuberant boss, were to be admitted through the mass at such a point of impact, a subtle counterpoint of volume and void would thus be brought about. For each convexity a corresponding concavity is created, and the result is an expressive rhythm of forms far superior to the rhythm of the form from which light is too crudely reflected. Henry Moore has been the supreme master of this device. A long series of recumbent figures is conceived as rhythmical variations of boss and hollow, of mass and void, with the result that light is no longer in opposition to the solidity of the object but is an integral part of the total sculptural effect. Space invades the object, and the object invades space, with the one plastic rhythm.

If this device is taken far enough, we are once more left, as we are in the exploitation of devices to represent movement, with a *linear* sculpture. It almost seems that there exists a tendency for art to revert to the characteristics of the memory image, that there is an unconscious will to make the images of art correspond to the images in memory, which, as Emanuel Loewy long ago pointed out in connection with Greek sculpture, are without light and shade.[7] Some of Moore's works, such as the *Double Standing Figure* in bronze of 1950, are virtually linear, though a suggestion of modeling still lingers in some of the elements and the total effect is still one of an object situated in three-dimensional space. The temptation is to go further than this and to create, as we saw in the preceding chapter, objects with linear outline that define space but do not occupy it. At this point, as I suggested, a new art is born: a negative sculpture, a sculpture that denies the basic elements of the art of sculpture as we have hitherto conceived it, a sculpture that rejects all the attributes of palpable mass. I do not deny that an art of great possibilities is conceivable in this direction, but technically it would be classified in any museum not as sculpture but as wrought ironwork. It is an art that in the past was not despised. Some of the masterpieces of Gothic and Renaissance art belong to this category.

These developments, made all the more possible by modern processes and materials, have culminated in a general cultural phenomenon for which we might borrow José Ortega y Gasset's phrase, the dehumanization of art.[8] It is a process that has taken place in all the arts, even in literature. To the majority of people this development of art is profoundly disturbing; it does not agree with their conception of art as a record of 'lived reality'. To the artist, however, the drift is instinctive and therefore inevitable. It is not with him a process of willful perversion. He creates the images he does create because he must create such images or be false to his consciousness of what is significant in his experience. This state of consciousness he absorbs from his environment, from a mechanistic civilization, from a general atmosphere of anxiety and mental

anguish. He has every right to turn on those who complain of his inhumanity and to say: 'It is not I but you who have created the conditions that compel my imagination to create images of terror and despair. Your science, your politics, your way of life are responsible for a dehumanization of life itself.' The kind of mind that conceives Buchenwald or the atomic bomb cannot expect the artist to create an illusory world of ideal human types. Art must correspond to the reality that conditions the spiritual outlook of each age: in that sense great art is always realistic. It is also realistic in another sense, because it still treats as real the universals of harmony and grace. Modern art is inhuman; but it is not inept. It can give to anguish itself the intensity of tragic art; and against nihilism and despair it will protest with constructive images that affirm the possible existence of a harmonious realm of essence.

'The poet', says José Ortega y Gasset, 'aggrandizes the world by adding to reality, which is there by itself, the continents of his imagination. Author derives from auctor, he who augments. It was the title Rome bestowed upon her generals when they had conquered new territory for the City.'[9] The modern artist is an *auctor* in this sense. The territory we live in is a waste land, inhabited by hollow men. That is the reality we experience, the truth as we perceive it. 'But wait', says the artist: 'What we endure, what we suffer, is not the whole of reality. The world of the imagination is also a reality, and in my imagination is a consciousness of an extension of the lived reality – the consciousness of a new reality. Perhaps I can create symbols that will express my consciousness of this other, this new-found reality.' Such at any rate is the daring ambition of the modern artist: to live on the frontiers of existence and to work to extend them.

1 Jean Piaget and Bärbel Inhelder, *Le Développement des quantités chez l'enfant*, Neuchâtel and Paris, 1941.
2 The poet is a special case, perhaps, because there are 'visual' as well as 'musical' (audile) poets, and no doubt a good poet is fairly acute in all his senses.
3 *Art*, tr. Mrs. Romilly Feden, Boston, 1912, pp. 63–65.
4 Henry Moore, 'Notes on Sculpture', 2nd edn., New York, in Herbert Read, *Henry Moore: Sculpture*, 1946, p. xl.
5 Ibid., p. xli.
6 Naum Gabo, 'A Retrospective View of Constructive Art', in J.J. Sweeney, Katherine Dreier, and Naum Gabo, *Three Lectures on Modern Art*, New York, 1949, p. 83.
7 *The Rendering of Nature in Early Greek Art*, tr. John Fothergill, London, 1907, pp. 67–68.
8 *La Deshumanización del arte*, tr. Helene Weyl as 'The Dehumanization of Art', *The Dehumanization of Art and Notes on the Novel*, Princeton, 1948.
9 Ibid., p. 31.

31 Germaine Richier

'Statement' 1959

This artist's statement was written in Paris the year Germaine Richier (1904–59) died. It was published in the catalogue to Peter Selz's exhibition 'New Images of Man', held at the Museum of Modern Art in New York and at the Baltimore Museum of Art. As well as serving as a supporting statement for an individual practice, it also offers a broader advocacy of figurative sculpture in the post-war period, and thus indicates the artistic battles and debates that were then taking place over the roles of figuration and abstraction. Richier wrote very few times about her work in the 1950s, an important decade in her career that saw her sculpture attract the attention of some of the most influential art critics in Paris, including Claude Roger-Marx, Jean Grenier, Denys Chevalier, Georges Limbour and Michel Seuphor.

 Sculpture, Richier states, is the best equipped of all the arts to perpetuate the human image, a concern that has always been fundamental to this ancient, slow-changing medium. Its treatment of the human form, she argues, has evolved to incorporate new, more expressive readings of it. Sculptors can no longer 'conceal human expression in the drama of our time' – dramas which for Richier would have included the atrocities of the Second World War and the Cold War nuclear threat. These circumstances have led to new imaginary creations – 'hybrids' – a description that directly references her own sculpture's constant admixture of animal, vegetable and mineral forms. This awareness for Richier has necessarily disrupted the integrity and the solid form of the human body as depicted in sculpture. Following on from the figurations of sculptors such as Moore, Hepworth and others, Richier is concerned with further opening up the sculptural representation of the human body. Richier was part of a new generation of artists working in this way. Holes for Richier do not have a merely general and abstract sculptural value, but a highly emotional one. She writes: 'holes and perforations conduct like flashes of lightning into the material', thereby suggesting an invasion of the body – not just a highly charged articulation of spatiality but also the strong suggestion of wounding or death. These associations relate her sculpture to the literature of existentialism. She sees the stage for her sculptures as extending beyond the private and experimental space of the studio and into the public existential domains of squares, gardens, theatres, buildings and stadiums, frequented by contemporary men and women.

Germaine Richier, 'Statement', in Peter Selz (ed.), *New Images of Man*, exhibition catalogue, New York: Museum of Modern Art, pp. 129–30.

The human image has never been forgotten in the arts. The sculptor is not protected from the crises which have jolted modern art, but in sculpture, an art of slower evolution according to some, the disruptions are of a different

nature. In some way it is sculpture that knew how to preserve the human face from these upheavals (in fact, today's sculptors do not renounce the making of busts). The face: that is to say, an entity, a whole of expressions and gestures brought into accord with the form.

This form, clearly, evolved to such a point that I would call it 'hybrid'. Whence come the dangers which threaten us through excess; and which are tempered through measure.

As an art of measure, the contemporary sculpture can and should erect and set up its forms, not in the pediments, but in front of monuments and public places. In order to make our times and the public understand the works of today, sculpture would have to take over the sites which – one asks why – have been denied it: large public squares, gardens, theaters, buildings, stadiums. As long as sculpture is not brought back into the 'domain of man and woman', into the places common to humanity, its face will be as if it were disfigured.

What characterizes sculpture, in my opinion, is the way in which it renounces the full, solid form. Holes and perforations conduct like flashes of lightning into the material which becomes organic and open, encircled from all sides, lit up in and through the hollows. A form lives to the extent to which it does not withdraw from expression. And we decidedly cannot conceal human expression in the drama of our time.

32 Eduardo Paolozzi

'The Metallization of a Dream' 1963

Eduardo Paolozzi (1924–2005) studied at Edinburgh College of Art and then at the Slade. He was one of the most exciting young British sculptors working in the post-Second World War period, transporting sculptural ideas to London from both across the Channel and across the Atlantic. He begins this lively 1963 text, published at a time when his career as a sculptor was coming into prominence, as follows: 'These notes are random jottings of ideas, sometimes barely formulated, which are developed as I work on my material.' The words that Paolozzi puts on the page here certainly have a rawness and spontaneity that seem redolent of the sculptural processes he engaged in and the lively imaginative and material world of the studio in which he worked. Assemblage was his main way of working at this time, and these collage-like notes stand as almost verbal equivalences or analogies for objects and experiences generated and compiled in and through his sculpture-making. Sometimes he describes an approach to sculpture, such as casting or assembling wooden sculpture on the studio floor; at other times he merely notes an object or image, observed or remembered, and indicates the immediate material or emotional associations it carries for him and how he has treated it sculpturally. Like a cross between a dada anthropologist's fieldwork notes, a surrealist's confessional diary and a mechanic's logbook, Paolozzi's *The Metallization of a Dream* offers a wide range of abbreviated and evocative data about real and imaginary things, presented through striking juxtapositions. Moreover, the idea of metallization connects his sculptural thinking to his fascination with robots and American science fiction and to the world of cybernetics that Jack Burnham writes about five years later. His short text, which carries the same title as a screen print of the same year, ends: 'Mystic horns, thorn, antennae technical mandibles five-jointed non-articulated pinnacles of aware', demonstrating that description, symbolism, word play, stream of consciousness, 'geometry of fear' figuration, lists of 'things to do' and 'things just done' all converge in Paolozzi's sculptural imagination as relayed here onto the page.

This text was published in *The Metallization of a Dream*, with a commentary by Lawrence Alloway, London: Lion and Unicorn Press, Royal College of Art, 1963, pp. 5–9. Reprinted in Robin Spencer (ed.), *Eduardo Paolozzi: Writings and Interviews*, Oxford: Oxford University Press, 2000, pp. 102–3.

These notes are random jottings of ideas, sometimes barely formulated, which are developed as I work on my material. The theory of opposites or the history of nothing with the suppression of talent involving the wheel of a locomotive, the brain of the dog and crankshaft of a ship. The cylinder head of the aeroplane, the valve of the oven or various domestic articles, new and old. An

architecture built up from the tools of a child. The search for archetypes to aid a dream in metal.

In the past I worked by pressing objects (found and fabricated) into a clay bed, by pouring wax, or making diagrams, even charts of events. Objects were moulded in bronze, inspired by the art founders, were worked as collage or silk-screened papers.

From a series of elements in wood, of recorded dimensions translated into metal, these pieces duplicated and multiplied become component parts. Multi-useful fort-like presences, silhouettes of strength, edges hard and sharp.

Assembly decided on the floor of the workshop: creative decision on several levels. Spontaneity meets discipline and so these simple objects grew in assembly into new positive forms.

CATALOGUE OF IDEAS

Combination of furniture and machine. Hybrid combination on a table. In an interior, through a windscreen, mountains. Laocoon. Large robot with aeroplane motor-cyclist. A mask with a motorcar. Toy tank detail of a motor-cyclist with progress written. A small boy in a life-jacket. Emergency instructions revealing the presence of danger.

Some ambiguous objects are placed on a cloth. Olivia-point Savoy, Border-Fringed Tassel.

Large geometrical star flanked by a star. Two nudes squared. War motif from World War I. New York with Flying Man.

Small Pair 1962 anonymous objects with technical legend.

A short history of the common, wooden circles, paper squares, inkwell 1934. Old newspapers and a dictionary of guns.

The camera ruined and virgin (a clockwork mask like an eye) Phallus diagrams. Felix lux solo and Mars consolidated. Pascal's dream. The marriage of the rock and the dynamo. Legs as lintels. The focus. The centre of rotation.

Work in the present. Wooden shapes are cast in gunmetal by pump-engineers. Assembled by bolt and weld. Photo-lithos are fabricated front collages of different things. such as catalogues. newspapers. technical illustrations. The dancer. the clown. the lock. the tower and the wheel.

Another picture of a sculpture. Redefined and altered. Middle section block made with bevelled edges; therein the pattern of progress, an exhaust element, three tubes, a grooved shield from a child's tricycle. A semi-circular body section containing bathysphere smooth screw-on plate. Radial device hammered and altered. An upright structure with a gunmetal wheel on swivel supports pedestal. Twisted Siamese light brass grills; the insane grin of an apparent façade: multiples bonded with gunmetal strips. Part assembled on

the mechanic's bench; a striped side section; the precise walls reveal a personal fetish, overlaid with improvised section. Sections of shell structure to bolt where needed to the base, a casting from a child's table, heavy at the top. Mystic horns, thorn, antennae technical mandibles five-jointed non-articulated pinnacles of aware.

33 Donald Judd

'Specific Objects' 1965

Often described as one of America's foremost minimalist sculptors, Donald Judd (1928–94) in fact neither accepted the term 'minimalist' nor considered his work to be part of a sculptural tradition. Judd saw this 'three-dimensional' practice as developing less from sculpture than from painting. Equally, it was informed by a parallel career in art criticism. From 1959 to 1965 Judd was writing for journals such as *Arts Magazine*, arguing vociferously against anti-modernist conservativism and strongly in favour of the latest contemporary trends. Although at heart a formalist, Judd was strongly opposed to the Greenbergian model. The opening sentence of 'Specific Objects', for example, represents a clear attempt to counter Greenberg's view that both painting and sculpture ought to specialize and become self-referentially 'medium-specific'. Judd instead argues that painting and sculpture have exhausted their possibilities and are already being replaced by 'three-dimensional work'. The diversity of this new three-dimensional art practice is demonstrated in the examples he cites. The essay was originally illustrated with works by Jasper Johns, Robert Rauschenberg, Dan Flavin, George Ortman, Frank Stella, Robert Watts, Tony Delap, John Anderson, Richard Smith, H. C. Westermann, Robert Morris, Lucas Samaras, Yayoi Kusama, Richard Artschwager, Phillip King, and Claes Oldenburg. The common factor for Judd in all this work is a striving toward a situation whereby the viewer is addressed directly and in terms only of the specific qualities of the object. For critics such as Michael Fried, such rigorous pragmatism was overly positivist and literal. For supporters, however, Judd was the initiator of a new way of thinking about sculpture that emphasizes not only structural form but also complex visual phenomena.

Contemporary artists, particularly since the late 1980s, have been deeply interested in Judd's work, developing an understanding of themes not especially addressed in 'Specific Objects', such as the literalist colour use Judd developed in the 1970s and 1980s. Also of interest has been Judd's more complex investment in 1967 in seriality, which took him beyond the simplicity of 'one thing after another' instead to utilize systems such as the Fibonacci series.

Donald Judd, 'Specific Objects', orig. *Arts Yearbook 8: Contemporary Sculpture*, 1965, in *Complete Writings 1959–75*, Halifax: the Press of the Nova Scotia College of Art and Design and New York: New York University Press, pp. 181–9. In addition to the illustrations mentioned above, Judd's *Untitled* (1973) was also included, but with a note: 'The editor, not I, included the photograph of my work.'

Half or more of the best new work in the last few years has been neither painting nor sculpture. Usually it has been related, closely or distantly, to one or the other. The work is diverse, and much in it that is not in painting

and sculpture is also diverse. But there are some things that occur nearly in common.

The new three-dimensional work doesn't constitute a movement, school or style. The common aspects are too general and too little common to define a movement. The differences are greater than the similarities. The similarities are selected from the work; they aren't a movement's first principles or delimiting rules. Three-dimensionality is not as near being simply a container as painting and sculpture have seemed to be, but it tends to that. But now painting and sculpture are less neutral, less containers, more defined, not undeniable and unavoidable. They are particular forms circumscribed after all, producing fairly definite qualities. Much of the motivation in the new work is to get clear of these forms. The use of three dimensions is an obvious alternative. It opens to anything. Many of the reasons for this use are negative, points against painting and sculpture, and since both are common sources, the negative reasons are those nearest common-age. 'The motive to change is always some uneasiness: nothing setting us upon the change of state, or upon any new action, but some uneasiness.' The positive reasons are more particular. Another reason for listing the insufficiencies of painting and sculpture first is that both are familiar and their elements and qualities more easily located.

The objections to painting and sculpture are going to sound more intolerant than they are. There are qualifications. The disinterest in painting and sculpture is a disinterest in doing it again, not in it as it is being done by those who developed the last advanced versions. New work always involves objections to the old, but these objections are really relevant only to the new. They are part of it. If the earlier work is first-rate it is complete. New inconsistencies and limitations aren't retroactive; they concern only work that is being developed. Obviously, three-dimensional work will not cleanly succeed painting and sculpture. It's not like a movement; anyway, movements no longer work; also, linear history has unraveled somewhat. The new work exceeds painting in plain power, but power isn't the only consideration, though the difference between it and expression can't be too great either. There are other ways than power and form in which one kind of art can be more or less than another. Finally, a flat and rectangular surface is too handy to give up. Some things can be done only on a flat surface. Lichtenstein's representation of a representation is a good instance. But this work which is neither painting nor sculpture challenges both. It will have to be taken into account by new artists. It will probably change painting and sculpture.

The main thing wrong with painting is that it is a rectangular plane placed flat against the wall. A rectangle is a shape itself; it is obviously the whole shape; it determines and limits the arrangement of whatever is on or inside of it. In work before 1946 the edges of the rectangle are a boundary, the

end of the picture. The composition must react to the edges and the rectangle must be unified, but the shape of the rectangle is not stressed; the parts are more important, and the relationships of color and form occur among them. In the paintings of Pollock, Rothko, Still and Newman, and more recently of Reinhardt and Noland, the rectangle is emphasized. The elements inside the rectangle are broad and simple and correspond closely to the rectangle. The shapes and surface are only those which can occur plausibly within and on a rectangular plane. The parts are few and so subordinate to the unity as not to be parts in an ordinary sense. A painting is nearly an entity, one thing, and not the indefinable sum of a group of entities and references. The one thing overpowers the earlier painting. It also establishes the rectangle as a definite form; it is no longer a fairly neutral limit. A form can be used only in so many ways. The rectangular plane is given a life span. The simplicity required to emphasize the rectangle limits the arrangements possible within it. The sense of singleness also has a duration, but it is only beginning and has a better future outside of painting. Its occurrence in painting now looks like a beginning, in which new forms are often made from earlier schemes and materials.

The plane is also emphasized and nearly single. It is clearly a plane one or two inches in front of another plane, the wall, and parallel to it. The relationship of the two planes is specific; it is a form. Everything on or slightly in the plane of the painting must be arranged laterally.

Almost all paintings are spatial in one way or another. Yves Klein's blue paintings are the only ones that are unspatial, and there is little that is nearly unspatial, mainly Stella's work. It's possible that not much can be done with both an upright rectangular plane and an absence of space. Anything on a surface has space behind it. Two colors on the same surface almost always lie on different depths. An even color, especially in oil paint, covering all or much of a painting is almost always both flat and infinitely spatial. The space is shallow in all of the work in which the rectangular plane is stressed. Rothko's space is shallow and the soft rectangles are parallel to the plane, but the space is almost traditionally illusionistic. In Reinhardt's paintings, just back from the plane of the canvas, there is a flat plane and this seems in turn indefinitely deep. Pollock's paint is obviously on the canvas, and the space is mainly that made by any marks on a surface, so that it is not very descriptive and illusionistic. Noland's concentric bands are not as specifically paint-on-a-surface as Pollock's paint, but the bands flatten the literal space more. As flat and unillusionistic as Noland's paintings are, the bands do advance and recede. Even a single circle will warp the surface to it, will have a little space behind it.

Except for a complete and unvaried field of color or marks, anything spaced in a rectangle and on a plane suggests something in and on something else, something in its surround, which suggests an object or figure in its space, in

which these are clearer instances of a similar world – that's the main purpose of painting. The recent paintings aren't completely single. There are a few dominant areas, Rothko's rectangles or Noland's circles, and there is the area around them. There is a gap between the main forms, the most expressive parts, and the rest of the canvas, the plane and the rectangle. The central forms still occur in a wider and indefinite context, although the singleness of the paintings abridges the general and solipsistic quality of earlier work. Fields are also usually not limited, and they give the appearance of sections cut from something indefinitely larger.

Oil paint and canvas aren't as strong as commercial paints and as the colors and surfaces of materials, especially if the materials are used in three dimensions. Oil and canvas are familiar and, like the rectangular plane, have a certain quality and have limits. The quality is especially identified with art.

The new work obviously resembles sculpture more than it does painting, but it is nearer to painting. Most sculpture is like the painting which preceded Pollock, Rothko, Still and Newman. The newest thing about it is its broad scale. Its materials are somewhat more emphasized than before. The imagery involves a couple of salient resemblances to other visible things and a number of more oblique references, everything generalized to compatibility. The parts and the space are allusive, descriptive and somewhat naturalistic. Higgins' sculpture is an example, and, dissimilarly, di Suvero's. Higgins' sculpture mainly suggests machines and truncated bodies. Its combination of plaster and metal is more specific. Di Suvero uses beams as if they were brush strokes, imitating movement, as Kline did. The material never has its own movement. A beam thrusts, a piece of iron follows a gesture; together they form a naturalistic and anthropomorphic image. The space corresponds.

Most sculpture is made part by part, by addition, composed. The main parts remain fairly discrete. They and the small parts are a collection of variations, slight through great. There are hierarchies of clarity and strength and of proximity to one or two main ideas. Wood and metal are the usual materials, either alone or together, and if together it is without much of a contrast. There is seldom any color. The middling contrast and the natural monochrome are general and help to unify the parts.

There is little of any of this in the new three-dimensional work. So far the most obvious difference within this diverse work is between that which is something of an object, a single thing, and that which is open and extended, more or less environmental. There isn't as great a difference in their nature as in their appearance, though. Oldenburg and others have done both. There are precedents for some of the characteristics of the new work. The parts are usually subordinate and not separate in Arp's sculpture and often in Brancusi's. Duchamp's ready-mades and other Dada objects are also seen at once

and not part by part. Cornell's boxes have too many parts to seem at first to be structured. Part-by-part structure can't be too simple or too complicated. It has to seem orderly. The degree of Arp's abstraction, the moderate extent of his reference to the human body, neither imitative nor very oblique, is unlike the imagery of most of the new three-dimensional work. Duchamp's bottle-drying rack is close to some of it. The work of Johns and Rauschenberg and assemblage and low-relief generally, Ortman's reliefs for example, are preliminaries. Johns's few cast objects and a few of Rauschenberg's works, such as the goat with the tire, are beginnings.

Some European paintings are related to objects, Klein's for instance, and Castellani's, which have unvaried fields of low-relief elements. Arman and a few others work in three dimensions. Dick Smith did some large pieces in London with canvas stretched over cockeyed parallelepiped frames and with the surfaces painted as if the pieces were paintings. Philip King, also in London, seems to be making objects. Some of the work on the West Coast seems to be along this line, that of Larry Bell, Kenneth Price, Tony Delap, Sven Lukin, Bruce Conner, Kienholz of course, and others. Some of the work in New York having some or most of the characteristics is that by George Brecht, Ronald Bladen, John Willenbecher, Ralph Ortiz, Anne Truitt, Paul Harris, Barry McDowell, John Chamberlain, Robert Tanner, Aaron Kuriloff, Robert Morris, Nathan Raisen, Tony Smith, Richard Navin, Claes Oldenburg, Robert Watts, Yoshimura, John Anderson, Harry Soviak, Yayoi Kusama, Frank Stella, Salvatore Scarpitta, Neil Williams, George Segal, Michael Snow, Richard Artschwager, Arakawa, Lucas Samaras, Lee Bontecou, Dan Flavin and Robert Whitman. H. C. Westermann works in Connecticut. Some of these artists do both three-dimensional work and paintings. A small amount of the work of others, Warhol and Rosenquist for instance, is three-dimensional.

The composition and imagery of Chamberlain's work is primarily the same as that of earlier painting, but these are secondary to an appearance of disorder and are at first concealed by the material. The crumpled tin tends to stay that way. It is neutral at first, not artistic, and later seems objective. When the structure and imagery become apparent, there seems to be too much tin and space, more chance and casualness than order. The aspects of neutrality, redundancy and form and imagery could not be coextensive without three dimensions and without the particular material. The color is also both neutral and sensitive and, unlike oil colors, has a wide range. Most color that is integral, other than in painting, has been used in three-dimensional work. Color is never unimportant, as it usually is in sculpture.

Stella's shaped paintings involve several important characteristics of three-dimensional work. The periphery of a piece and the lines inside correspond. The stripes are nowhere near being discrete parts. The surface is

farther from the wall than usual, though it remains parallel to it. Since the surface is exceptionally unified and involves little or no space, the parallel plane is unusually distinct. The order is not rationalistic and underlying but is simply order, like that of continuity, one thing after another. A painting isn't an image. The shapes, the unity, projection, order and color are specific, aggressive and powerful.

Painting and sculpture have become set forms. A fair amount of their meaning isn't credible. The use of three dimensions isn't the use of a given form. There hasn't been enough time and work to see limits. So far, considered most widely, three dimensions are mostly a space to move into. The characteristics of three dimensions are those of only a small amount of work, little compared to painting and sculpture. A few of the more general aspects may persist, such as the work's being like an object or being specific, but other characteristics are bound to develop. Since its range is so wide, three-dimensional work will probably divide into a number of forms. At any rate, it will be larger than painting and much larger than sculpture, which, compared to painting, is fairly particular, much nearer to what is usually called a form, having a certain kind of form. Because the nature of three dimensions isn't set, given beforehand, something credible can be made, almost anything. Of course something can be done within a given form, such as painting, but with some narrowness and less strength and variation. Since sculpture isn't so general a form, it can probably be only what it is now – which means that if it changes a great deal it will be something else; so it is finished.

Three dimensions are real space. That gets rid of the problem of illusionism and of literal space, space in and around marks and colors – which is riddance of one of the salient and most objectionable relics of European art. The several limits of painting are no longer present. A work can be as powerful as it can be thought to be. Actual space is intrinsically more powerful and specific than paint on a flat surface. Obviously, anything in three dimensions can be any shape, regular or irregular, and can have any relation to the wall, floor, ceiling, room, rooms or exterior or none at all. Any material can be used, as is or painted.

A work needs only to be interesting. Most works finally have one quality. In earlier art the complexity was displayed and built the quality. In recent painting the complexity was in the format and the few main shapes, which had been made according to various interests and problems. A painting by Newman is finally no simpler than one by Cézanne. In the three-dimensional work the whole thing is made according to complex purposes, and these are not scattered but asserted by one form. It isn't necessary for a work to have a lot of things to look at, to compare, to analyze one by one, to contemplate. The thing as a whole, its quality as a whole, is what is interesting. The main things are alone and are more intense, clear and powerful. They are not diluted by an

inherited format, variations of a form, mild contrasts and connecting parts and areas. European art had to represent a space and its contents as well as have sufficient unity and aesthetic interest. Abstract painting before 1946 and most subsequent painting kept the representational subordination of the whole to its parts. Sculpture still does. In the new work the shape, image, color and surface are single and not partial and scattered. There aren't any neutral or moderate areas or parts, any connections or transitional areas. The difference between the new work and earlier painting and present sculpture is like that between one of Brunelleschi's windows in the Badia di Fiesole and the façade of the Palazzo Rucellai, which is only an undeveloped rectangle as a whole and is mainly a collection of highly ordered parts.

The use of three dimensions makes it possible to use all sorts of materials and colors. Most of the work involves new materials, either recent inventions or things not used before in art. Little was done until lately with the wide range of industrial products. Almost nothing has been done with industrial techniques and, because of the cost, probably won't be for some time. Art could be mass-produced, and possibilities otherwise unavailable, such as stamping, could be used. Dan Flavin, who uses fluorescent lights, has appropriated the results of industrial production. Materials vary greatly and are simply materials – formica, aluminum, cold-rolled steel, plexiglas, red and common brass, and so forth. They are specific. If they are used directly, they are more specific. Also, they are usually aggressive. There is an objectivity to the obdurate identity of a material. Also, of course, the qualities of materials – hard mass, soft mass, thickness of 1/32, 1/16, 1/8 inch, pliability, slickness, translucency, dullness – have unobjective uses. The vinyl of Oldenburg's soft objects looks the same as ever, slick, flaccid and a little disagreeable, and is objective, but it is pliable and can be sewn and stuffed with air and kapok and hung or set down, sagging or collapsing. Most of the new materials are not as accessible as oil on canvas and are hard to relate to one another. They aren't obviously art. The form of a work and its materials are closely related. In earlier work the structure and the imagery were executed in some neutral and homogeneous material. Since not many things are lumps, there are problems in combining the different surfaces and colors and in relating the parts so as not to weaken the unity.

Three-dimensional work usually doesn't involve ordinary anthropomorphic imagery. If there is a reference it is single and explicit. In any case the chief interests are obvious. Each of Bontecou's reliefs is an image. The image, all of the parts and the whole shape are coextensive. The parts are either part of the hole or part of the mound which forms the hole. The hole and the mound are only two things, which, after all, are the same thing. The parts and divisions are either radial or concentric in regard to the hole, leading in and out and enclosing. The radial and concentric parts meet more or less at right angles

and in detail are structure in the old sense, but collectively are subordinate to the single form. Most of the new work has no structure in the usual sense, especially the work of Oldenburg and Stella. Chamberlain's work does involve composition. The nature of Bontecou's single image is not so different from that of images which occurred in a small way in semiabstract painting. The image is primarily a single emotive one, which alone wouldn't resemble the old imagery so much, but to which internal and external references, such as violence and war, have been added. The additions are somewhat pictorial, but the image is essentially new and surprising; an image has never before been the whole work, been so large, been so explicit and aggressive. The abatised orifice is like a strange and dangerous object. The quality is intense and narrow and obsessive. The boat and the furniture that Kusama covered with white protuberances have a related intensity and obsessiveness and are also strange objects. Kusama is interested in obsessive repetition, which is a single interest. Yves Klein's blue paintings are also narrow and intense.

The trees, figures, food or furniture in a painting have a shape or contain shapes that are emotive. Oldenburg has taken this anthropomorphism to an extreme and made the emotive form, with him basic and biopsychological, the same as the shape of an object, and by blatancy subverted the idea of the natural presence of human qualities in all things. And further, Oldenburg avoids trees and people. All of Oldenburg's grossly anthropomorphized objects are manmade – which right away is an empirical matter. Someone or many made these things and incorporated their preferences. As practical as an ice-cream cone is, a lot of people made a choice, and more agreed, as to its appearance and existence. This interest shows more in the recent appliances and fixtures from the home and especially in the bedroom suite, where the choice is flagrant. Oldenburg exaggerates the accepted or chosen form and turns it into one of his own. Nothing made is completely objective, purely practical or merely present. Oldenburg gets along very well without anything that would ordinarily be called structure. The ball and cone of the large ice-cream cone are enough. The whole thing is a profound form, such as sometimes occurs in primitive art. Three fat layers with a small one on top are enough. So is a flaccid, flamingo switch draped from two points. Simple form and one or two colors are considered less by old standards. If changes in art are compared backwards, there always seems to be a reduction, since only old attributes are counted and these are always fewer. But obviously new things are more, such as Oldenburg's techniques and materials. Oldenburg needs three dimensions in order to simulate and enlarge a real object and to equate it and an emotive form. If a hamburger were painted it would retain something of the traditional anthropomorphism. George Brecht and Robert Morris use real objects and depend on the viewer's knowledge of these objects.

34 David Medalla

'MMMMMMM...Manifesto (a fragment)' 1965

David Medalla (b. 1942) was born and educated in Manila, before studying at Columbia Uni-versity and then moving to London in 1964. There he co-founded the Signals Gallery with the 'auto-destructivist' artist Gustav Metzger, as well as the gallery's news bulletin *Signals*, with Paul Keller, in 1964. The gallery showed artists working in Britain and abroad who were making all kinds of kinetic work. During the 1960s Medalla showed his own work in London at the Mercury Gallery and the Indica Gallery. His work then incorporated kinetics, dance, per-formance and numerous non-traditional sculptural materials such as rice, seeds, salt, ice and steam. His use of soap foam was particularly notable, through which he created moving, con-stantly changing, unpredictable, biomorphic sculptures. In works such as *Cloud Canyons No. 1* (1964) the hard-soft contrast between the wooden boxes and the bubbles billowing out of them not only shows an interest in formless, auto-transforming and evaporating material, but also a scientific, and sculptural, interest in the motion and energies that activate matter.

In 'MMMMMMM...Manifesto', Medalla answers the self-posed question 'What do you dream of?' with three short prose poems that all involve the creation of fantasy sculpture. These texts, which have a surrealist flavour that echoes the earlier writing of Salvador Dalí, not only reveal a longing for a dematerialised sculpture, but also suggest that sculpture can actively serve as a metaphor for the imagination. The imaginary journeys that sculpture can take are ones that Medalla also follows – witnessing, participating in or performing their existence. The unsuitability of a more traditional form of sculpture (as cold, weighty, solid, grounded and memorialising) for such projects is thus wittily pressed into service in order to expand and distort sculpture's own understood boundaries and definitions. Medalla, in a way that reminds us of Claes Oldenburg, carrying echoes of his paradoxical notion of soft sculpture, dreams of making sculptures that live and breathe, that migrate and blossom, and that can serve as pacifist, inter-galactic missiles in a cold-war, sci-fi climate.

David Medalla, 'MMMMMMM...Manifesto', *Signals News bulletin*, London: Signals Gallery, June–July 1965. Reprinted in Clive Phillpot and Andrea Tarsia (eds.), *Live in your Head: Concept and Experiment in Britain 1965–75*, London: Whitechapel, 2000, p. 129.

Mmmmmmm…Mmmedalla! What do you dream of?

I dream of the day when I shall create sculptures that breathe, perspire, cough, laugh, yawn, smirk, wink, pant, dance, walk, crawl,…and move among people as shadows move among people…Sculptures that will retain a shadow's secret dimensions without a shadow's obsequious behaviour….Sculptures without

hope, with waking and sleeping hours....Sculptures that, on certain seasons, will migrate *en masse* to the North Pole. Sculptures with a mirror's translucency minus the memory of a mirror!

Mmmmmmm...Mmmedalla! What do you dream of?

I dream of the day when I shall go to the centre of the earth and in the earth's core place a flower-sculpture....Not a lotus, nor a rose, nor a flower of metal,... nor yet a flower of ice and fire....But a *mohole*-flower, its petals curled like the crest of a tidal wave approaching the shore...

Mmmmmmm...Mmmedalla! What do you dream of?

I dream of a day when, from the capitals of the world, London Paris New York Madrid Rome, I shall release missile-sculptures....to fly – at nine times the speed of sound...to fall – slim as a stork on a square in Peking...bent, crushed – like a soldier's boot after an explosion – on an airport in Ecuador...in splinters – on the fields of Omaha...A few – to cross interstellar space...accumulating, as they wing along, asteroids, meteorites, magnetic fields, interstellar germs...of a new life...on their way from our galaxy to the Spiral Nebula.... *Mmmmmmmmmmmmmmmmmmmmm....*

35 Marcel Duchamp

'Apropos of "Readymades"' 1966

The ready-mades of Marcel Duchamp (1887–1968) date to the pre-First World War years, but became more widely known only in the 1950s with the advent of the neo-dada movement in Europe and in the United States, inspiring a new generation of artists. In addition to this, the following decade witnessed a literalist and conceptualist interest in Duchamp's work, inspiring the work of artists such as Joseph Beuys, Robert Morris and Richard Hamilton. This post-war interest prompted Duchamp's re-elaboration of his pre-war practice and of the thinking around the ready-made. In this way, what was proposed as intervention in the 1910s in exhibitions and avant-garde magazines was theorised and reframed as resonant art-historical case study in the 1960s. The 'rediscovery' of earlier avant-garde sculptural experiments with found and combined objects was also reflected in exhibitions such as William Seitz's 1961 'The Art of Assemblage' at the Museum of Modern Art in New York, at which Duchamp delivered this text as the inaugural lecture. His provocative reference to painting as a form of assemblage at the end of his talk indicates this context. The lecture also mentioned works known in the United States, such as the *Bicycle Wheel* that Sidney Janis had reconstructed in 1951, and the *Snow Shovel* (also known as *In advance of a broken arm*) that Duchamp had remade for Katherine Dreier in the 1940s. Versions of other ready-mades continued to be made into the 1960s.

Duchamp's talk summarises points about the ready-mades that he had previously made in other contexts, such as the significance of the works' titles, their disdain for the visual, and the importance of limiting their production, all of which served to underline the radical nature of their function in relation to artistic, and especially sculptural, tradition. Ready-mades were not only in breech of 'rules' of sculptural production, such as the authenticity and integrity of the sculptor's touch and sculpture's materials, but could also dissolve into the everyday performative, ceasing to be discrete objects in their own right, like the Rembrandt used as an ironing board mentioned in the talk. Duchamp's playfully contradictory stance regarding the status of ready-mades as both 'art' and 'non-art' is very apparent in this lecture, where he set the problem of their uncontrolled repetition (suggesting a need for artistic ownership) against their crucial lack of uniqueness (a major attraction for the artist). In its published version, this text also mockingly undercut its own urgency and 'official' rhetorical style – suggested by the capital letters which evoke a raised voice as well as the clipped breathlessness of the telegram – by describing art as a 'habit forming drug', a typical piece of Duchampian tongue-in-cheek.

Marcel Duchamp, 'Apropos of "Readymades"', *Art and Artists*, London, 1, no. 4, July 1966, p. 47.

IN 1913 I HAD THE HAPPY IDEA TO FASTEN A BICYCLE WHEEL TO A KITCHEN STOOL AND WATCH IT TURN.

A FEW MONTHS LATER I BOUGHT A CHEAP REPRODUCTION OF A WINTER EVENING LANDSCAPE, WHICH I CALLED 'PHARMACY' AFTER ADDING TWO SMALL DOTS, ONE RED AND ONE YELLOW, IN THE HORIZON.

IN NEW YORK IN 1915 I BOUGHT AT A HARDWARE STORE A SNOW SHOVEL ON WHICH I WROTE 'IN ADVANCE OF THE BROKEN ARM'.

IT WAS AROUND THAT TIME THAT THE WORD 'READYMADE' CAME TO MIND TO DESIGNATE THIS FORM OF MANIFESTATION.

A POINT WHICH I WANT VERY MUCH TO ESTABLISH IS THAT THE CHOICE OF THESE 'READYMADES' WAS NEVER DICTATED BY ESTHETIC DELECTATION.

THIS CHOICE WAS BASED ON A REACTION OF VISUAL INDIFFERENCE WITH AT THE SAME TIME A TOTAL ABSENCE OF GOOD OR BAD TASTE . . . IN FACT A COMPLETE ANESTHESIA.

ONE IMPORTANT CHARACTERISTIC WAS THE SHORT SENTENCE WHICH I OCCASIONALLY INSCRIBED ON THE 'READYMADE'.

THAT SENTENCE INSTEAD OF DESCRIBING THE OBJECT LIKE A TITLE WAS MEANT TO CARRY THE MIND OF THE SPECTATOR TOWARDS OTHER REGIONS MORE VERBAL.

SOMETIMES I WOULD ADD A GRAPHIC DETAIL OF PRESENTATION WHICH IN ORDER TO SATISFY MY CRAVING FOR ALLITERATIONS, WOULD BE CALLED 'READYMADE AIDED'.

AT ANOTHER TIME WANTING TO EXPOSE THE BASIC ANTIMONY BETWEEN ART AND READYMADES I IMAGINED A 'RECIPROCAL READYMADE': USE A REMBRANDT AS AN IRONING BOARD!

I REALIZED VERY SOON THE DANGER OF REPEATING INDISCRIMI-NATELY THIS FORM OF EXPRESSION AND DECIDED TO LIMIT THE PRODUCTION OF 'READYMADES' TO A SMALL NUMBER YEARLY. I WAS AWARE AT THAT TIME, THAT FOR THE SPECTATOR EVEN MORE THAN FOR THE ARTIST, ART IS A HABIT FORMING DRUG AND I WANTED TO PROTECT MY 'READYMADES' AGAINST SUCH CONTAMINATION.

ANOTHER ASPECT OF THE 'READYMADE' IS ITS LACK OF UNIQUE-NESS... THE REPLICA OF A 'READYMADE' DELIVERING THE SAME MESSAGE; IN FACT NEARLY EVERY ONE OF THE 'READYMADES' EXISTING TODAY IS NOT AN ORIGINAL IN THE CONVENTIONAL SENSE.

A FINAL REMARK TO THIS EGOMANIAC'S DISCOURSE:

SINCE THE TUBES OF PAINT USED BY THE ARTIST ARE MANUFAC-TURED AND READY MADE PRODUCTS WE MUST CONCLUDE THAT ALL THE PAINTINGS IN THE WORLD ARE 'READYMADES AIDED' AND ALSO WORKS OF ASSEMBLAGE.

36 Allan Kaprow

from *Assemblages, Environments and Happenings* 1966

'The romance of the atelier, like that of the gallery and museum, will probably disappear in time. But meanwhile, the rest of the world has become endlessly available', wrote Allan Kaprow (1927–2006) in his *Assemblages, Environments and Happenings*. These striking lines give an excellent indication of this highly influential American artist and writer's attitude towards the art world's systems and institutional frameworks. For Kaprow, the boundaries between art and life should be broken down: the artist should ignore the rules and regulations of a system that demands permanent art works, made in traditional art materials, set aside from the world within the polite confines of the art gallery. Instead artists should embrace the materials of today's so-called 'throwaway' culture. Such materials are to be used for several reasons: they are 'the subject matter, as well as the media'; they bring new forms and possibilities with them; and they are fragile and perishable, pointing explicitly to the 'decision to abandon craftsmanship'. His essay also demonstrates an awareness of the overall role of the legacy of surrealism in his project, but expresses distaste for a post-surrealist nostalgic interest in explicitly old-fashioned and self-consciously outmoded bric-a-brac. Assemblage's radical attitude to material extended its potential far beyond such 'cute' and 'charming' objects, and the glass vitrine was anathema to his thinking.

 Kaprow started as a painter before turning to happenings, via assemblage, in the mid-1950s. This soon extended over the next few years into environmental works and 'happenings'. In these Kaprow acted simultaneously as artist, director and participant, a combinatory role that is in turn reflected in his *Assemblages, Environments and Happenings*. Part of the central section of his text, called 'The New Forms, Materials and Attitudes', is reproduced here. This section was preceded by 'Art and Architecture' and 'The Field in Painting' and followed by 'The Event'. The whole essay was printed on thick brown paper and placed in the middle of a 346-page book that was full of good-quality black-and-white photographs of assembled works and art events. Many of these were photographs of temporary installations or momentary instances within a work's fabrication and performance, and so played a crucial role in documenting the art he writes about. Kaprow included much of his own work in this book, reproducing it alongside that of many other artists, giving an international feel to these projects. These included: Jean Follett, Robert Rauschenberg, Gloria Graves, Red Grooms, Jackson Pollock, Renee Miller, Martha Edelheit, Robert Whitman, Jim Dine, Clarence Schmidt, Ruth Schmidt, Yayoi Kusama, Claes Oldenburg, George Segal, George Brecht, Robert Watts and Jean Tinguely. The final section of the book documented forty-two happenings, including photographs showing the happenings of the Japanese Gutai group (including Sadamasa Motonaga, Akira Kanayama, Shuzo Mukai, Saburo Murakami, Shozo Shimamoto, Kazuo Shiraga, Atsuko Tanaka, Michio Yoshihara, and Tsuruko Yamasaki) which was an important influence on Kaprow in the early 1960s.

Allan Kaprow, from *Assemblages, Environments and Happenings*, New York: Harry N. Abrams Inc., 1966, pp. 159–69, 173 and 182–83. [Full text: pp.146–208.]

THE NEW FORMS, MATERIALS AND ATTITUDES

The alternatives turned out to be what are now called Assemblages and Environments. They are at root the same – the only difference is one of size. Assemblages may be handled or walked around, while Environments must be walked into. Though scale obviously makes all the experiential difference in the world, a similar form-principle controls each of these approaches, and some artists work in both with great ease.

This principle may be named simply *extension*. Molecule like, the materials (including paint) at one's disposal grow in any desired direction and take on any shape whatsoever. In the freest of these works the field, therefore, is created as one goes along, rather than being there *a priori*, as in the case of a canvas of certain dimensions. It is a process, and one that works from the inside out, though this should be considered merely metaphorical, rather than descriptive, since there actually exists no inside, a bounded area being necessary to establish a field. There are only a few elements one begins with, and these at best are located with respect to one's body and the room itself. Thus, if extension is the principle, it 'begins' much less definitely than the first mark placed upon a canvas, whose relations to the outer edges are quickly weighed by any competent painter. However, unless one works out in the open, it must be admitted that old responses geared to a canvas's dimensions and character are probably now transferred to the three-dimensional measurements of the room, and this may be a response to a 'field'. But it is a different point of departure from the accepted pictorial one, being basically environmental. Perhaps the domains of sculpture, interior design, and architecture are suggested here, but as respects the latter two, the work at the moment is in every practical sense 'useless' and uninhabitable, and in the instance of sculpture there are some striking differences which shall be noted shortly. In any event, a fuller involvement with actual space is important.

This space is in part the literal distance between all solids included in the work. But it is also a space that is a direct heritage of painting – therefore it is important to remember that the innovations which are under discussion have primarily grown out of the advanced painting of the last decade. For purely pictorial phenomena play a strong part. Effects of a painterly kind occur when two or more separated objects containing one or more elements in common (say the color red) appear to contradict or warp the literal space by the tendency of the mind to resolve them into a single spatial unit. This is quite similar to using a red in the foreground of a picture and the same color in the back-

ground, which allows them to be seen as one plane, thus restoring 'flatness' to the painting even while it is three-dimensional. However, here the inclusion of palpable distances not only increases the levels of ambiguity already present in pictorial solutions, but these distances in turn are highly unstable because the viewer may constantly change his vantage point.

Within this context, color itself enjoys the full range that it has always had in painting. It may define a surface (as a coat of paint on a chair), evoke a filmlike atmosphere or glaze, or saturate a whole substance with its properties. (It therefore can play in and out of space without regard for the actual positions of its occurrence.) Needless to say, all the sensations of heat, fragrance, taste, weight, and motion, and all the more subtle symbolical overtones of color, with which we are already familiar, are not only amplified but warped in these new circumstances. We become aware of this when a balance is achieved between the application of color to one's materials and the prior existence of color in those materials (such as a black hat or silver foil). In other words, an object or area is often left unpainted because it either is already painted (a part of a car fender, for instance) or it has a color that permeates its entire body, as Jello, for example. This is considered to be as natural as making a painted area, and thus results in a give-and-take between the ready-made and the newly created. The expressiveness of color is consequently not only a product of hand and imagination; it is also a caprice of the accidental confluence of artfulness with a hundred other things 'outside' art.

These things may include clothing, baby carriages, machine parts, masks, photographs, printed words, and so forth, which have a high degree of associational meaning; however, they may just as often be more generalized, like plastic film, cloth, raffia, mirrors, electric lights, cardboard, or wood – somewhat less specific in meaning, restricted to the substances themselves, their uses, and modes of transformation. There is no apparent theoretical limit to what may be used.

In practice, however, it must be stated that the very great majority of works which are composed of such stuff, both in New York City and throughout the world, have a fairly limited iconography: faded photos, old books, bottles, stuffed animals, old utensils, printed gingham, wallpaper and lacework; broken jewelry, toys-become-fetishes, boxes and drawers of mementos, dried flowers, bric-a-brac and keepsakes, etc., etc., all possessing a post-Surrealist nostalgia, a mood of reverie and gentle humor or irony. Some of these are authentically evocative and strange, yet most are weak when compared with their Dada and Surrealist prototypes. Their effect is one of charm rather than shock or transport; spiritually they are bloodless and cute and, naturally, are cultivated by the over-sophisticated and chic sets in international society. Yet the possibilities inherent in compositions of diverse materials are still abundant to a more exploratory mind. If an artist is alert to what is becoming worn out through too

much usage, or to what has become downright cliché, he can always count on being in a position to examine the fresher alternatives that still lie untapped.

It can now be seen that what differentiates some of the smaller Assemblages from sculpture, as they are sometimes labeled, is just this range and use of materials. Modern sculpture still preserves the assumed sacrosanct unity and permanence of its medium: metal, stone, wood, plastic, or glass. And of course professional sculptors have pretty much eschewed color since the Middle Ages; those who have ventured into this territory have at best been tentative and at worst have used it only skin deep. Finally, a conservative streak of the modern sculptor is seen in the all too frequent use of bases and stands, a holdover from monuments of the past with their elaborate pedestals. This by now vapid manner of distinguishing or glorifying a work is sculpture's homologue to the frame in painting, serving to separate it more definitely from reality. Contrasted to this, the best indoor Assemblages are either hung casually on the wall or from the ceiling, or are simply placed on the floor like any natural object or group of objects, for the floor is already a base too much. Out of doors, on the street or ground, few of these problems are posed.

Assemblages presently have several forms, some more radical than others. There are those that remain essentially mural and display all the difficulties mentioned earlier, that arise from beginning with a regulation field which then is broken by holes or by the addition of foreign matter to the surface. The now objectlike area is simply increased in scale until it is large enough to dwarf a man. Often it substitutes for the wall. By its sheer breadth the 'object' reverts to a quasi field again (though not exactly a painting), for one's eyes and arms cannot possibly embrace the whole at once while standing at the usual distance of a half-dozen feet. A broken surface thus becomes a sort of topography relief in which one could travel, as though up and down the face of a cliff; and it also succeeds only partially in questioning the domination of the architectural setting, since fundamentally it needs the wall in one way or another. My own *Wall* is a case in point.

Another group of works, such as those by Jean Follett which also employ the basic rectangle of the canvas (or a related box), manifest a kind of primitive or 'magical' tendency through the creation of images which have the feeling of fetishes – though we sense their sophisticated origin. But these fetishes do not function on or in their field as images within a space, that is, the object–ground relation is not present. Instead, the rectangle is the 'aura' of the image; it is in fact the equivalent of a *mandorla* or a halo, and so here too we bypass pure painting.

Fetishes also exist completely in the round. And frequently they are surrounded by other separated parts so that the larger arrangement causes one to think of shrines – not any specific one or belonging to any actual institution or religion – but a simile at least, a shrine to the self, emitting waves of

'revelation'. Some works which Jim Dine and Robert Rauschenberg have created in this vein come to mind.

Yet we must not suppose that these works look like a witch doctor's magic stick or like the plaster Madonna-with-roses-and-lights that appears on so many of our lawns. Sometimes simple imagery of sorts can be made out, though often it slips out of focus as quickly as it is seized upon; occasionally it bursts blatantly forth out of the nameless sludge and whirl of urban events, precisely where and when it is least expected. In fact, much of this is eminently an art of the city, and if it comes from within, the dreams of the inner man are now closely bound up with some real enough pattern perceived in the externals of the streets.

Naturally, at this point the last vestiges of picture making have fallen away. The work begins to actively engulf the air around it, giving it shape, dividing it into parts, weighing it, allowing it to interact with the solids at such a rate or in such a strange manner that one now cannot help noticing the shape and feel of the gallery which, like some radar signal, sends back its shape to contend with the work of art. Here is where the two structures become inimical.

The shrine may expand to larger proportions, thus becoming a chapel or grotto. This was true of my earlier work and applies to Yayoi Kasama and to the interior of Clarence Schmidt's large work. In some cases this happens as a consequence of a certain frustration caused by the discrepancy between the art and the surrounding architectural space – as though sheer size could drown out the discomfort. In others it is simply a turning away from this rift as an insoluble problem and a pursuit of the inner evolution of one's work, in which one thing suggests another, which in turn suggests another, and so on… expanding the work until it fills an entire space or evolves one, thus becoming an Environment.

If Jackson Pollock spoke of being in his work while he painted, it was true in so far as he stood amongst the pools of paint he had just poured while others were being formed as he moved about. With a little work a spectator before the finished painting could *feel into* the same state of immersion. But in the case of Environments there is no question that one is inside and, for better or worse, a real part of the whole.

One stage of the journey from painting to Environment was now complete and an almost logical progress can be observed if we glance again at the future implied by the collages of the Cubists. With the breakdown of the classical harmonies following the introduction of 'irrational' or nonharmonic juxtapositions, the Cubists tacitly opened up a path to infinity. Once foreign matter was introduced into the picture in the form of paper, it was only a matter of time before everything else foreign to paint and canvas would be allowed to get into the creative act, including real space. Simplifying the history of the ensuing evolution into a flashback, this is what happened: the pieces of paper curled up

off the canvas, were removed from the surface to exist on their own, became more solid as they grew into other materials and, reaching out further into the room, finally filled it entirely. Suddenly, there were jungles, crowded streets, littered alleys, dream spaces of science fiction, rooms of madness, and junk-filled attics of the mind…

Inasmuch as people visiting such Environments are moving, colored shapes too, and were counted 'in', mechanically moving parts could be added, and parts of the created surroundings could then be rearranged like furniture at the artist's and visitors' discretion. And, logically, since the visitor could and did speak, sound and speech, mechanical and recorded, were also soon to be in order. Odors followed.

The foregoing may give the impression that the modern art we are discussing is primarily concerned with an evolution of forms, such as the Cubist painters felt theirs was. This is partly true, but I think it is the particulars, the 'what' of this art, that we may find more revealing and new. The 'what' may also help explain the forms. As outlined earlier, we find a certain large range of objects and materials employed. They are not, however, indifferently chosen, but represent a recurrent class of things: memoirs, objects of everyday usage, industrial waste, and so forth. These firstly represent a further enlargement of the domain of art's subject matter, for in many cases these materials *are* the subject matter as well as the media; unlike the more neutral substance of paint, they refer directly to specific aspects of our lives. Coming from factories, the street, the household, the hardware store, dump, or garbage can, they force into focus once again the eternal problems of what may be (or become) art and what may not. The intellectuals' typical disdain for popular culture, for the objects and debris of mass production which appear abundantly in this work, is, as always, a clear instance of aesthetic discrimination: *this* is fit for art, *that* is not. Such high-mindedness is not at all different from the seventeenth century's belief in the greater value of 'noble' themes over genre ones. Thus, attentiveness to the meaning of the materials chosen is essential.

Secondly, these materials practically guarantee a new range of forms not possible with conventional means. In fact, one can hardly avoid these fresh potentials. While it is true that many artists become frightened by them and tend to sugar-coat everything by recasting it in older molds, the plain fact must stare at one that when a piece of hardware is juxtaposed to some excelsior, and this in turn is placed upon a crumpled rag, a series of abrupt shifts occur with the passage of the eye (and of the touch) that simply are not found in the most highly contrast-full paintings. For in the latter, no matter what may be the shapes and colors, the medium of paint offers a sensible unity in which all other differences may take place. Hence the organization of an Assemblage or Environment poses difficulties hitherto rarely encountered, but they *can* be solved by accepting the nature of the materials employed rather than smoothing them

over in order that they appear like a painting or memento in the most accept-able styles.

The third point is that the materials found in Assemblages and Environ-ments are very often of the greatest physical fragility. In an increasing number of instances the work is intended to last only a short time and is destroyed immediately after exhibition. In nearly all, if their obsolescence is not deliber-ately planned, it is expected. And it is over this point that the greatest fear and hostility are voiced. Here is the central expression of this art's difference from the past. Why, people ask, if it is claimed to be art, will it not last? Why should one pay for 'that'? The issue is not new, but the present work faces it head on more openly than it has been faced before.

Actually, the whole question of the enduring versus the passing has been coming up continually since Impressionism challenged the West's deep belief in the stable, clear, and permanent. These qualities were thought to be the high achievements of a striving, rational mind which has overcome brute and chaotic forces of nature. But while Impressionist paintings certainly conveyed philo-sophically the concept of the fleeting and changeful as a supreme value, the actual painting could be expected to last indefinitely. Yet, since the first decade of this century, pictures and constructions have more and more exhibited a short life span, betraying within a few years, or even months, signs of decay and (to the restorer) 'faulty' technique. This has hardly been indifference on the part of the artist, though some have worried over it. It became necessary as means were sought to adequately embody those subtle and spontaneous feelings and responses that were the living expression of change.

Today, in the case of the most forward-looking Assemblages and Envi-ronments, the use of obviously perishable media such as newspaper, string, adhesive tape, growing grass, or real food points to a quite clearheaded decision to abandon craftsmanship and permanence (associated in the past with Art), for no one can mistake the fact that the work will pass into dust or garbage quickly. As the art critic Lawrence Alloway has observed, our 'throwaway' culture has permeated deeply into the very methods and substance of contem-porary creative art. (But, unlike our standardized products that are also made to be discarded, the art work is unique and personal.)

If change is to be lived and felt deeply, then the art work must be free to articulate this on levels beyond the conceptual. There is no fundamental reason why it should be a fixed, enduring object to be placed in a locked case. The spirit does not require the proofs of the embalmer. If one cannot pass this work on to his children in the form of a piece of 'property', the attitudes and values it embodies surely can be transmitted. And like so many quite acceptable but passing facets of our lives, this art can be considered as a semi-intangible entity, something to be renewed in different forms like fine cooking or the seasonal changes, which we do not put into our pockets but need nevertheless.

Change, governing both reality and art, has extended, therefore, from the expression of an idea arrested in a painting, to a work in which the usually slow mutations wrought by nature are quickened and literally made part of the experience of it; they manifest the very processes of creation–decay–creation almost as one watches. The use of debris, waste products, or very impermanent substances like toilet paper or bread, has, of course, a clear range of allusions with obvious sociological implications, the simplest being the artist's positive involvement, on the one hand with an everyday world, and on the other with a group of objects which, being expendable, might suggest that corresponding lack of status which is supposed to be the fate of anything creative today. These choices must not be ignored, for they reveal what in our surroundings charges the imagination as well as what is most human in our art. But beyond this is the larger issue of reality understood as *constant metamorphosis*. This viewpoint, this metaphysics, is more fundamental than our 'throwaway' culture. The latter is the topical vehicle for the former and, while important, should become something else in time. The conception of a non-fixed, organic universe, however, has pervaded our thinking for a longer historical space. It lies, I am convinced, at the root of our present innovations and is pointing straight ahead along this road for the near future.

Change – we may capitalize it in this context – suggests a form-principle for an art which is never finished, whose parts are detachable, alterable, and rearrangeable in theoretically large numbers of ways without in the least hurting the work. Indeed, such changes actually fulfill the art's function.

[…]

The work of art must now receive its meaning and qualities from the unique, expectant (and often anxious) focus of the observer, listener, or intellectual participant. But in a greater number of cases the responsibilities have at least been reapportioned to include certain outsiders who may or may not be told beforehand exactly what their duties are. The artist and his artist-public are expected to carry on a dialogue on a mutual plane, through a medium which is insufficient alone and in some instances is nonexistent before this dialogue, but which is given life by the parties involved.

[…]

All that we have discussed has taken place, with varying degrees of success. For however compelling this new direction of art, in actual practice its implications are only partly realized. Most artists involved cannot bring themselves to face the spatial (i.e. environmental) problem that introduced this book: the discrepancy between the organic, unmeasurable and extensional character of the forms of the Assemblages and Environments, and the limiting rectangularity

of the gallery architecture in which they are usually found. Their work, though interesting, is fundamentally conventional.

If Change is considered central to the life and mode of creation of these works, the box shape, the frame, does more than offer a stimulating contrast to it; it imposes a very powerful denial of Change on the whole set-up. I believe consistency here is crucial. This is most obvious with the Environments. Gallery-exhibited Environments almost invariably tend to be untouchable, static display pieces in conformity with the gallery tradition. All the marvelous potentials of transformation and interactivity between art, the public, and nature are out of the question. And even when a little of this is made possible, it is so tentative that the old habits of gallery spectatorship preclude any vital response on the public's part, limit the work's duration to the standard three-week show, and do not prepare anyone for the idea that nature could ever be involved, much less welcomed.

The only fruitful direction to take is toward those areas of the everyday world which are less abstract, less boxlike, such as the out of doors, a street crossing, a machine factory, or the seaside. The forms and themes already present in these can indicate the idea of the art work and generate not only its outcome but a give-and-take between the artist and the physical world. It would also lessen the fixed aesthetic reactions evoked by any art gallery, which unconciously influence the artist as much as the public. Needless to say, this holds *a fortiori* for museums.

The evolution of this art is bringing us to a quite different notion of what art is. With the emergence of the picture shop and museum in the last two centuries as a direct consequence of art's separation from society, art came to mean a dream world, cut off from real life and capable of only indirect reference to the existence most people knew. The gallery and museum crystallized this idea by insisting upon a 'shshsh – don't touch' atmosphere. Traditionally it is supposed that art is born entirely from the heart or head and is then brought, all shiny and finished, to the showplace. Now, however, it is less and less conceived that way and is instead drawing its substance, appearances, and enthusiasms from the common world as we know it; and this, without any doubt, is a hint of how vestigial the gallery–museum situation is. With such a form as the Environment it is patently absurd to conceive it in a studio and then try to fit it into an exhibition hall. And it is even more absurd to think that since the work looks better in the studio because it was conceived there, that is the best and only place for it. The romance of the atelier, like that of the gallery and museum, will probably disappear in time. But meanwhile, the rest of the world has become endlessly available.

37 Robert Morris

'Notes on Sculpture, Part 2' 1966

Although originating in Fluxus and performance art, throughout most of the 1960s Robert Morris (b. 1931) was regarded as one of the leading minimalists – both as a practitioner and as a theorist. His reputation as a formidable theorist was based mainly on a series of articles, 'Notes on Sculpture', published prominently in the art press and widely discussed.

In 'Notes on Sculpture, Part 1' (*Artforum*, February 1966) Morris provided a theory of minimalist work of sufficient plausibility that it superseded the earlier *Specific Objects* theory of Donald Judd. While Judd had insisted that the new work was neither painting nor sculpture but instead 'three-dimensional work', Morris instead argued that it represented not a departure from sculpture but rather a fruitful new sculptural development. The new object-based sculpture, by rejecting optical elements such as colour and the imaginative space that relief work depends upon, was productively literal, he argued. Its strength lay in the fact that it appealed to what psychologists referred to as a 'strong gestalt'. This gestalt was achieved by using simple geometric solids, which could be perceived almost immediately, so exhausting any further interest in their formal structure. This in turn would give rise both to a fixity (the object remains 'constant and individible') and a release (because information about the object itself is almost immediately exhausted). In this new sculpture the overall formal configuration could be apprehended immediately from any point of view, its literalness making the 'multipart, inflected' formats of past sculpture 'extraneous'. Thus the viewer was free to focus on the ever-changing appearance the sculpture took on as he or she experienced it from different positions, in relation to its ambient spatial environment and lighting conditions.

This meant that sculpture could now enjoy a 'new freedom', an upbeat message that Morris develops further in 'Notes on Sculpture, Part 2', where he ends, again triumphantly, with the claim that sculpture is now 'more complex and expanded' – a point taken up later by Rosalind Krauss. Morris's positive attitude towards minimalist object-making was not to last, however. In 1968 he began expressing doubts about the viability of solid object-making, shifting the emphasis instead to a post-minimalist 'visibility of process'. The final essay in the 'Notes on Sculpture' series takes sculpture 'Beyond Objects' (Part 4, *Artforum*, April 1969), with Morris now opting for a scattering of material quite at odds with the original notion he had held of the primary importance of gestalt. The article was originally interspersed with photographs, showing two examples of Morris's own work (a 1965 drawing and the long, wedge-shaped *Untitled*, 1964) along with photographs of sculptures by Tony Smith, Carl Andre and Sol LeWitt.

Robert Morris, 'Notes on Sculpture, Part 2', *Artforum*, vol. 5, no. 2, Oct. 1966, pp. 20–23. Reprinted in Robert Morris, *Continuous Project Altered Daily: the Writings of Robert Morris*, Cambridge, Mass.: MIT Press, 1993, pp. 11–21.

Q: Why didn't you make it larger so that it would loom over the observer?
A: I was not making a monument.

Q: Then why didn't you make it smaller so that the observer could see over the top?
A: I was not making an object.

– Tony Smith's replies to questions about his six-foot steel cube.

The size range of useless three-dimensional things is a continuum between the monument and the ornament. Sculpture has generally been thought of as those objects not at the polarities but falling between. The new work being done today falls between the extremes of this size continuum. Because much of it presents an image of neither figurative nor architectonic reference, the works have been described as 'structures' or 'objects'. The word structure applies to either anything or to how a thing is put together. Every rigid body is an object. A particular term for the new work is not as important as knowing what its values and standards are.

In the perception of relative size, the human body enters into the total continuum of sizes and establishes itself as a constant on that scale. One knows immediately what is smaller and what is larger than himself. It is obvious yet important to take note of the fact that things smaller than ourselves are seen differently than things larger. The quality of intimacy is attached to an object in a fairly direct proportion as its size diminishes in relation to oneself. The quality of publicness is attached in proportion as the size increases in relation to oneself. This holds true so long as one is regarding the whole of a large thing and not a part. The qualities of publicness or privateness are imposed on things. This is due to our experience in dealing with objects that move away from the constant of our own size in increasing or decreasing dimension. Most ornaments from the past – Egyptian glassware, Romanesque ivories, etc. – consciously exploit the intimate mode by highly resolved surface incident. The awareness that surface incident is always attended to in small objects allows for the elaboration of fine detail to sustain itself. Large sculptures from the past that exist now only in small fragments invite our vision to perform a kind of magnification (sometimes literally performed by the photograph), which gives surface variation on these fragments the quality of detail that it never had in the original whole work. The intimate mode is essentially closed, spaceless, compressed, and exclusive.

While specific size is a condition that structures one's response in terms of the more or less public or intimate, enormous objects in the class of monuments elicit a far more specific response to size *qua* size. That is, besides providing

the condition for a set of responses, large-sized objects exhibit size more specifically as an element. It is the more conscious appraisal of size in monuments that makes for the quality of 'scale'. The awareness of scale is a function of the comparison made between that constant, one's body size, and the object. Space between the subject and the object is implied in such a comparison. In this sense space does not exist for intimate objects. A larger object includes more of the space around itself than does a smaller one. It is necessary literally to keep one's distance from large objects in order to take the whole of any one view into one's field of vision. The smaller the object, the closer one approaches it, and therefore it has correspondingly less of a spatial field in which to exist for the viewer. It is this necessary greater distance of the object in space from our bodies, in order that it be seen at all, that structures the nonpersonal or public mode. However, it is just this distance between object and subject that creates a more extended situation, for physical participation becomes necessary. Just as there is no exclusion of literal space in large objects, neither is there an exclusion of the existing light.

Things on the monumental scale then include more terms necessary for their apprehension than objects smaller than the body, namely, the literal space in which they exist and the kinesthetic demands placed upon the body.

A simple form such as a cube will necessarily be seen in a more public way as its size increases from that of our own. It accelerates the valence of intimacy as its size decreases from that of one's own body. This is true even if the surface, material, and color are held constant. In fact it is just these properties of surface, color, and material that get magnified into details as size is reduced. Properties that are not read as detail in large works become detail in small works. Structural divisions in work of any size are another form of detail. (I have discussed the use of a strong gestalt or of unitary-type forms to avoid divisiveness and set the work beyond *retardataire* Cubist esthetics in *Notes on Sculpture, Part 1.*) There is an assumption here of different kinds of things becoming equivalent. The term 'detail' is used here in a special and negative sense and should be understood to refer to all factors in a work that pull it toward intimacy by allowing specific elements to separate from the whole, thus setting up relationships within the work. Objections to the emphasis on color as a medium foreign to the physicality of sculpture have also been raised previously, but in terms of its function as a detail one further objection can be raised. That is, intense color, being a specific element, detaches itself from the whole of the work to become one more internal relationship. The same can be said of emphasis on specific, sensuous material or impressively high finishes. A certain number of these intimacy-producing relations have been gotten rid of in the new sculpture. Such things as process showing through traces of the artist's hand have obviously been done away with. But one of the worst

and most pretentious of these intimacy-making situations in some of the new work is the scientistic element that shows up generally in the application of mathematical or engineering concerns to generate or inflect images. This may have worked brilliantly for Jasper Johns (and he is the prototype for this kind of thinking) in his number and alphabet paintings, in which the exhaustion of a logical system closes out and ends the image and produces the picture. But appeals to binary mathematics, tensegrity techniques, mathematically derived modules, progressions, etc., within a work are only another application of the Cubist esthetic of having reasonableness or logic for the relative parts. The better new work takes relationships out of the work and makes them a function of space, light, and the viewer's field of vision. The object is but one of the terms in the newer esthetic. It is in some way more reflexive, because one's awareness of oneself existing in the same space as the work is stronger than in previous work, with its many internal relationships. One is more aware than before that he himself is establishing relationships as he apprehends the object from various positions and under varying conditions of light and spatial context. Every internal relationship, whether set up by a structural division, a rich surface, or what have you, reduces the public, external quality of the object and tends to eliminate the viewer to the degree that these details pull him into an intimate relation with the work and out of the space in which the object exists.

Much of the new sculpture makes a positive value of large size. It is one of the necessary conditions of avoiding intimacy. Larger than body size has been exploited in two specific ways: either in terms of length or volume. The objection to current work of large volume as monolith is a false issue. It is false not because identifiable hollow material is used – this can become a focused detail and an objection in its own right – but because no one is dealing with obdurate solid masses, and everyone knows this. If larger than body size is necessary to the establishment of the more public mode, nevertheless it does not follow that the larger the object, the better it does this. Beyond a certain size the object can overwhelm and the gigantic scale becomes the loaded term. This is a delicate situation. For the space of the room itself is a structuring factor both in its cubic shape and in terms of the kinds of compression different sized and proportioned rooms can effect upon the object–subject terms. That the space of the room becomes of such importance does not mean that an environmental situation is being established. The total space is hopefully altered in certain desired ways by the presence of the object. It is not controlled in the sense of being ordered by an aggregate of objects or by some shaping of the space surrounding the viewer. These considerations raise an obvious question. Why not put the work outside and further change the terms? A real need exists to allow this next step to become practical. Architecturally designed sculpture

courts are not the answer, nor is the placement of work outside cubic architectural forms. Ideally, it is a space without architecture as background and reference, which would give different terms to work with.

Although all the esthetic properties of work that exists in a more public mode have not yet been articulated, those that have been dealt with here seem to have a more variable nature than the corresponding esthetic terms of intimate works. Some of the best of the new work, being more open and neutral in terms of surface incident, is more sensitive to the varying contexts of space and light in which it exists. It reflects more acutely these two properties and is more noticeably changed by them. In some sense it takes these two things into itself, as its variation is a function of their variation. Even its most patently unalterable property, shape, does not remain constant. For it is the viewer who changes the shape constantly by his change in position relative to the work. Oddly, it is the strength of the constant, known shape, the gestalt, that allows this awareness to become so much more emphatic in these works than in previous sculpture. A baroque figurative bronze is different from every side. So is a six-foot cube. The constant shape of the cube held in the mind, but which the viewer never literally experiences, is an actuality against which the literal changing perspective views are related. There are two distinct terms: the known constant and the experienced variable. Such a division does not occur in the experience of the bronze.

While the work must be autonomous in the sense of being a self-contained unit for the formation of the gestalt, the indivisible and undissolvable whole, the major esthetic terms are not in but dependent upon this autonomous object and exist as unfixed variables that find their specific definition in the particular space and light and physical viewpoint of the spectator. Only one aspect of the work is immediate: the apprehension of the gestalt. The experience of the work necessarily exists in time. *The intention is diametrically opposed to Cubism with its concern for simultaneous views in one plane.* Some of the new work has expanded the terms of sculpture by a more emphatic focusing on the very conditions under which certain kinds of objects are seen. The object itself is carefully placed in these new conditions to be but one of the terms. The sensuous object, resplendent with compressed internal relations, has had to be rejected. That many considerations must be taken into account in order that the work keep its place as a term in the expanded situation hardly indicates a lack of interest in the object itself. But the concerns now are for more control of and/or cooperation of the entire situation. Control is necessary if the variables of object, light, space, and body are to function. The object itself has not become less important. It has merely become less *self*-important. By taking its place as a term among others, the object does not fade off into some bland, neutral, generalized, or otherwise retiring shape. At least most of the new works do not.

Some, which generate images so readily by innumerably repetitive modular units, do perhaps bog down in a form of neutrality. Such work becomes dominated by its own means through the overbearing visibility of the modular unit. So much of what is positive in giving to shapes the necessary but non-dominating, noncompressed presence has not yet been articulated. Yet much of the judging of these works seems based on the sensing of the rightness of the specific, non-neutral weight of the presence of a particular shape as it bears on the other necessary terms.

The particular shaping, proportions, size, and surface of the specific object in question are still critical sources for the particular quality the work generates. But it is now not possible to separate these decisions, which are relevant to the object as a thing in itself, from those decisions external to its physical presence. For example, in much of the new work in which the forms have been held unitary, placement becomes critical as it never was before in establishing the particular quality of the work. A beam on its end is not the same thing as the same beam on its side.

It is not surprising that some of the new sculpture that avoids varying parts, polychrome, etc., has been called negative, boring, nihilistic. These judgments arise from confronting the work with expectations structured by a Cubist esthetic in which what is to be had from the work is located strictly within the specific object. The situation is now more complex and expanded.

38 Pino Pascali

'In Conversation with Carla Lonzi' 1967

Pino Pascali (1935–68) was one of several artists associated with the Italian *Arte Povera* movement of the later 1960s who produced objects that had a likeness to sculptures, but that were not quite sculptures. For Pascali, the only authentic sculptures an artist such as himself could produce were 'feigned sculptures' (*finte sculture*); just as for his contemporary Michelangelo Pistoletto, art objects had to become 'minus objects' (*oggetti in meno*). In this interview with Carla Lonzi, an important critic of the period who soon after abandoned art criticism to become a major figure in the Italian feminist movement, Pascali addressed several key issues that made sculpture simultaneously deeply problematic and fascinating for a number of European artists and critics at the time. A work of sculpture was for him both natural and utterly artificial, both in a way magical, and also totally ordinary and banal. The present-day sculptor working in a culture such as Italy's was haunted by tradition and yet working in a 'void'. The presentation of sculpture, in his view, was necessarily highly theatrical, for 'when an artist makes an exhibition he is unavoidably putting on a show', and yet was not quite theatre in the conventional sense because 'sculptures are not actors and they're not scenery either'.

Pascali, characteristically, was both uneasy about and strongly drawn to American pop and consumer culture – Claes Oldenburg was one of his favourite artists. In this interview, he makes specific reference to different kinds of work he produced over his brief career, terminated by a motorcycle accident in 1968 (also the year he won the first prize for sculpture at the Venice Biennale). There are the 'feigned sculptures' (mostly dating from 1966), hollow works made of unpainted canvas stretched over a wooden framework, representing in highly stylised form various animals, often decapitated, including a rhinoceros, fish and also a whole marine environment with flapping fish tails and undulating sea, and trophies of animal heads. He also refers to a series of weapons (*armi*) dating from 1965, life-size bricolages that fake items of modern military equipment, including artillery (here called cannons), machine guns, and a bomb.

The form of this interview is unusual in that the interviewer's questions are left out. This was a deliberate strategy on Carla Lonzi's part. She assembled a highly crafted self-portrait or *Autoritratto* (1970) from various artists' commentaries selected from interviews she had conducted in the 1960s. This book, in which sections of her interview with Pascali are dispersed throughout, is both a key document of the post-war Italian artistic avant-garde, and an ambitious exercise in constituting and laying claim to a sense of self through the voices of others. This was a strategy acutely relevant for a politically self-conscious woman working in the almost exclusively male-dominated Italian art world of the period.

'Pino Pascali: in conversation with Carla Lonzi', in *Pascali*, Otterlo: Rijksmuseum Kröller-Müller, 1991, pp. 9–22. The interview was first published in *Marcatrè*, No. 30–33, 1967.

I try to do what I like doing, basically this is the only method that works for me. I don't believe that a sculptor ever makes a 'heavy' work: he plays, in the same way as a painter plays, as anyone who is doing the thing he wants to do is playing. Play isn't just a thing for children, isn't it true that everything is a game? People work… but it's just that the childhood games become adolescent games, and the adolescent games in turn become adult games. But they are still games. Take someone working in an office: if he doesn't like his work, he longs for a fast car to take a spin in, precisely because he's doing something which doesn't interest him. But if he does enjoy it, the work becomes a game to which he gives his total commitment. By 'game' I don't mean some sort of frivolity (that's something different) but more a normal activity of man. For children, a game is a serious business – it's a system of knowledge. Children's games are really meant to allow them to experiment with different things – to get to know them and at the same time to go beyond them. But what does the word 'child' mean? Whatever their age, people can remain children all their lives. Obviously if someone still chooses to behave like an unruly child, he must be an idiot. But if he manages to live as he means to – like kids who are happy going to school, for example – then he is playing a game.

Yes, I love the sea, underwater fishing, those sorts of futile occupations… I love the reefs surrounded by the sea. I was born by the sea, played there as a child. I love animals because I see them as intruders, things that don't belong to our species but which move about. They're in towns, in the country, and one tries to get to know them. But then one says, 'o.k., o.k.', and turns away. But watching a horse walking along a street, or a tree growing out of one square metre of pavement, I can't really tell what effect it's having on me. I see it, the tree, and not just because of its essential 'treeness': I am really attached to it. But for me an animal is an altogether foreign reality. It's already an extraordinary phenomenon to see sheep walking past a house or near a person… that's already a mental jump, the sheep is not part of organized life, something else is taking shape. I find it much stranger to see a horse than a car driving along, or a missile that can reach a speed of, let's say 7000km. an hour, you see? And yet I live in Rome, not New York. Another similar experience: I hold a bird in my hand, a bird that was flying up until that moment – a sparrow or a swallow; I'm then in contact with a being which defies every calculation. It existed before I did, it has the same type of presence as I do, the same sort of vital dynamism, the same nature. It's a physical creature, not a rational creation like a car. Animals have always existed alongside man; maybe animals already existed before man. That's unimportant, but what is sure is that I feel very close to animals. It may be laughable but it's true. And I marvel even more at the sight of a tiny baby, precisely because small children are not part of my… when I manage to catch hold of their unique fragility it produces a violent change in

my perceptions... cars, trams, houses – those things that I see every day lose all their interest! But from time to time we are allowed to perceive that something exists – something truly warm, warm to the point of... But I don't want to seem smarter than others...it's not human warmth, it's of another order altogether and it owes its beauty precisely to the fact that it is something quite other. It's like the Last of the Mohicans, perhaps, or a whole series of Mohicans for all I know, it's difficult to say.

It's obvious that my interior universe, my imaginary world, has been much more profoundly influenced by adventure stories than by all the learned, intelligent books I was able to read later. The latter helped me understand and become efficient – it was just like going back to school – but after that I've read very little. At one point I read everything one after the other – just as one shouldn't do; now suddenly I can't concentrate on a book at all. I prefer looking at the images, they open other doors. Of course well-argued reasoning, everything to do with organized reality and the mental world, these things suit me down to the ground, they can be helpful; but they bore me dreadfully. And if I were to follow that sort of reasoning indefinitely it would completely destroy me. It's just like putting dots on a sheet of paper, you go on and on and you never stop. The whole paper can be completely covered and not a single image will emerge. Of course, it may help to understand. It's a long journey which allows me to create some cross-roads, but finally the outcome is nothing but a series of points, a line. Some might regard the same sheet of paper as a kind of groundplan, or imagine countless stories – but that's not my way. In that realm I'm no introvert. What would I like most? To be as natural as possible, but not natural in a particular way... I can't begin to explain what I mean by 'natural'.

Nature? It's a frightening word. Look at this rhinoceros for example: of course, it is a rhinoceros and it's a shape I have sought without seeking. I didn't deliberately fashion it into the structural shape of a rhinoceros, but equally I didn't neglect certain other factors and I salvaged what I could from that shape. Perhaps this realization even leads to solutions which are not of my own making but of other sculptors who bring to it other ways of thinking. Thus, the structure of this large sort of snake could be a work by Brancusi. His name came to mind because Brancusi belongs to a category which one would define as being close to nature, wouldn't you say? When someone sees an animal, for example a horse – that famous horse which exists in my imagination although I've never sculpted one, heaven knows why not – anyway, when someone sees a horse, a bird, a fish, he immediately thinks of Brancusi: it's become a fully-formed image. The fact that Brancusi should be the point of departure doesn't interest me in itself. A Brancusi already exists, it's already a sculpture and perhaps it would provide me with a simple way to resolve my problem. Of course I like animals, but that doesn't mean to say I want to do yet

more animals. What always fascinates me is a subject, an image, a pre-established context, already printed words, and so I accept them and choose them as points of departure. What I am doing is not a research into form. It's a means of verifying what other people have already done, but from a different point of view. A means of verifying my own system in comparison with others. It's not that I want to have Brancusi's plastic quality, but I would like to, or rather… what I really want to do is to fill a space with these pieces. At the end of the day, I don't know if I really want to see them again or if they actually please me. No, I definitely don't think I do like them, honestly I'm not sentimental in these matters really, once the process has been achieved it doesn't interest me any more. Perhaps what does interest me is watching other people's reactions and the sort of spectacle created. People look, ask questions based on something which in fact does not exist, because as far as I'm concerned we're talking about feigned sculptures, and I find the sort of farce which an exhibition represents fascinating. For me these works die; as soon as I mount the exhibition they're already almost finished. Afterwards they provoke certain reactions in others, and for a short while it gives me the impression of being a sculptor. I think I am not a sculptor, this is the picture I have of myself; it is something that could be a problem, but who knows if it is really a problem, for me it's also got its amusing aspect. When I made the cannons I said: 'what a great idea to have a cannon in a space reserved for sculptors, to actually be allowed to put them in this place which is treated as sacred, and which is so full of pretence…'

For me these objects have no other purpose but what they are. They're no use to anyone. I don't think anyone could house them. I don't want anyone to keep them at home, surely that's understandable. But sometimes I think about it and I wouldn't mind seeing them, I don't know, perhaps in a garden or a large room or in a museum. However, the idea stems from a childish reaction with no positive value: a desire to be a sculptor and to find myself in a garden arranged in this way or that – in a space all to myself. In fact, I don't know, these sculptures aren't magic, after all! They're just objects placed there, and since I want people to look at them I sometimes make them enormous. Of course, it's ridiculous. It's just like getting dressed up all in yellow, which can also seem completely idiotic, but then why not? What is important is that these objects give me courage, they are the proof that when all is said and done, I actually exist! It is through fictions of this sort that I succeed in proving to myself that I exist, precisely because I believe in them myself, you see? And then again maybe it's just a form of excuse… But I am so sure that as I make this work I really am succeeding in existing, I am able to look at myself in the mirror.

But looking at oneself in the mirror is not as easy as it sounds: you look at yourself and you see someone you've never… well, it's like the story of the horse you see in the street, one says: 'good heavens, it's me!' You see yourself,

whereas normally you live in a world made up of mental images, a whole collage of images, of things completely foreign to your exterior demeanour; suddenly, like peeping through a keyhole, you see yourself as the outside world sees you. It's quite a sensation to see oneself like that from the outside, rather like seeing oneself for the first time. It's just that one is not conscious of being a certain shape, a certain object, or – due to one's physique – having a certain presence. It sets one off noticing things: Oh, I don't know – the hair, the whiskers, why not the hairs of one's nose; and if you've got one you look at the beard; you see that you're well-made, you check – like everyone else – that you're in good health. You can also see small wrinkles beginning to appear or conclude: 'I've got a narrow chest, or fat legs…' Say what you like, there are all sorts of reasons why the perceived image is not interiorized. Seeing one's own image is like presenting the outside to the inside. Like seeing a car and a horse: two things…

Sometimes when I talk I end up saying things that I had not thought of ever before. With work it's the same: one decides to make something purely with the means at one's disposal, and you end up with different possibilities which were already germinating in the original idea. I like using the material as a starting point, it imposes its own limitations.

Choosing a type of material means projecting its possibilities within precisely-defined parameters. In my opinion it's not possible to realize every-thing with one specific type of material. You can only do one single thing with it, and that unique thing is an idea on its own. But it would be stupid to waste a whole life and not repudiate it, not end up somewhere else. I like that wealth of possibilities: it reinstates my presence in the world, it permits me not to be anguished by a predetermined image of oneself. I look at myself once more in the mirror. I see my face, strange or not – a new image. No point saying: 'Yes, it's me, Pino Pascali, I have whiskers one centimetre under my ears; this mous-tache? Maybe I'll keep it to the end of my days.' Today I have a moustache, tomorrow a beard, maybe the day after I'll let any hair grow – unless I cut it short. That's truly what I believe…I strive to find a way, but in fact it's a terrible trick, a way of deceiving my world.

What is truly vital is to move towards something which strikes fear although not literally terrifying – towards something new. The most important thing you can do, in my opinion, is to make mistakes. The expression can be startling: yes, to make mistakes, in order to gain self-understanding. But I'm not truly deceiving myself, I assume the responsibility of my own mistakes! How should I put it? For me, they're not mistakes. Knowing all the evidence, if someone thirty years ago was a fascist, was that a mistake? Or is it that thirty years ago his morals and his character did not allow him to be anything but a fascist? Changing does not involve repudiating the past: one doesn't wipe

anything out, one is truly different from what one was. Presence changes with the course of history. I can't understand how a painter of ninety can paint in the same way as when he was twenty. It would be a way of clinging to a youthfulness – to a period, a history, all of which are long since gone. So I agree with evolution – if it's really evolution we are talking about, because it could equally be a form of regression – in so far as it expresses an advance in knowledge. It's a constant renewal of one's interest in existence, a way of presenting oneself anew in front of the mirror, you know? Looking into the mirror, someone says: 'there, this is what I'm like' and he goes away. Then he comes back and says: 'there, that's what I'm like.' I don't want to talk about the theatre, you know; basically actors can change costumes as often as they like, but in the end they have their own way of playing because they have their own personality cult and it never changes. On the other hand each person's personality does not exist of itself – it constructs and destructs itself according to our desire for annihilation and thus reconstruction. It's not a question of total self-annihilation but of shedding areas which have already been explored and rendered useless. Basically it's the same technique used by the industrialists: they discard what is out of date and create novelty. In an economy of thoughts this is an intelligent approach. To auto-destruct and recreate oneself in a different mould so as never to be the same again, to refuse to be identical because one doesn't want to be so – why not? The important thing is always to be doing new things: not new to others but to oneself.

Imitating his father, a child has a pistol slung around his waist, or wears a uniform because his father does. But if his clothes were an exact miniature replica of his father's it would be no joke. Instead, the child uses a stick as a pistol, puts on a paper jacket and a cardboard cap. And it's fun. Perhaps what I do with the horses comes down to the something as copying one's father. I copy a horse, but since I can't provide it with fur glistening with sweat, because I can't show the flies whirling around or the rounded perpetually moving muscles, I take the material which is the simplest to use and I stretch canvas over wooden ribs. I don't use canvas to resemble skin. What I create is an exterior appearance, not an interior content.

One day someone puts on a tie the colour of which suits him. The fact that it suits him does not prevent it from also conjuring up an image for him. It's obvious! The tie is the transfiguration of the image he had in his mind. The image becomes reality – is transfigured and expressed in a different way. The image is what changes appearance. Someone buys a house and furnishes it in his own particular way, thus revealing what he is. One creates a nook which looks like a Caravaggio, another builds himself a house for all the world like a manor. Others arrange their rooms and objects so that they are adaptable to the rhythm of daily life, and finally others fashion their houses exactly according

to their own personality, creating a fantasy space. There is always projection, if one lives in society and accepts that society, that's the way it is.

Some young long-haired people with their way-out clothes have a great beauty and presence all of their own. They're mocking society and rebelling against it at the same time – following a vision of the avant-garde which is pretty ridiculous. Well, sometimes they unearth clothes which perfectly match their face, their hairstyle, fitting in with their personal choice... and conditioned by a series of factors. Of course, they've found a piece of clothing which they like but when one makes a garment, the cloth exists already, it's not a personal creation. Everyone is surrounded by their own precise world. For example, if the African people make a sculpture they would use a zebra skin, a piece of wood. They make use of what is around. It's the same with us... But the difficulty lies in bringing together the different elements, and in so doing everyone defines their own space, and in consequence their own image. Materials interest me in this way, that's the way I want to get to know them... but not in the way you say 'plastic'. I can't use plastic, it's a totally alien medium to me. It's as if I were a savage...But I'm not a savage – I'm an Italian living in Rome. For me the use of plastic conforms to an utterly specific dimension. If it were like going into a shop and buying a sheet of paper – well then why not, one buys the plastic and sets to work. But things aren't like that and therefore it doesn't work like that. The universe resembles a giant meccano set: everyone has a certain number of pieces at his disposal. But all the pieces are not identical. As one fits them together one can create a particular combination, while eschewing a different combination because it touches an area which is foreign to us. For example: were I to stretch a canvas across a frame and show up the stitching – what do we get, bumps and holes in relief, and I'm invading Burri's territory. But if, instead of using a jute canvas, you find a material 'X' which fulfils a simple idea you have of nature – an idea you share, which belongs to your world, to your time – and that finally the structure of this material matches the given requirements which led to its being chosen, then it's because it belongs to your own personal space. Some people mistakenly play at being ultra-modern by using plastic while inhabiting a mental space which may not be that of Burri but which nevertheless has already been explored. That's only a form of modernism. When, however, it's an American using plastic, the space created is new. An Italian who uses plastic as a material... unless he lives in a region where only plastic is manufactured, it's... but I don't want to get myself involved in polemics.

It has to be admitted that European space differs radically from American space. There, it's action that counts; here, it's the reflection on what one is doing, you see. The Americans can allow themselves the luxury of taking an object, sticking it on to a canvas and saying: 'here *is* a painting!' Or taking

a strip cartoon and reconstituting it and saying: 'here is a painting', and it really *is* a painting, because these gestures are a way of condensing what constitutes the history of their civilization – the most technically advanced civilization. Ours is technically backward compared with the Americans, where it seems crazy if anyone treats directly with his material. There are already some frightening examples in America of things being out of sync: in an American laboratory, you can see some unbelievable materials. Well, there's already no point of contact between these materials and those that the American artist is using. Artists must make use of materials perfected by researchers, it seems as if nature has been virtually exhausted, a new nature is being created. In Italy there's a quite different atmosphere – there's still a mental reality with possible choices, the will not to be taken for a ride. The European artist is a solitary man but also an autonomous one – a man who brings an autonomous civilization to life. That's not so in America. Of course Americans are very individualistic, they don't even look themselves in the face... But that doesn't stop the fact that they inhabit the American space, the American civilization which imprisons them... even if they don't look each other in the face! They relish something like a strip cartoon... wherein I, on the other hand, I see things; I'm not completely detached but I view them from a distance. What I see doesn't belong to me any more. Nothing belongs to me – neither what I've got, nor what the Americans have got. It's that I belong neither to this world, nor to the other.

We were born here, we inherited these images. If we want to triumph over them we must view them dispassionately for what they are in order to examine what possibility of existence they still possess. If that possibility is fiction, let us accept the fiction. If they are out of date, then they no longer belong to our history. Nobody can take them seriously any more; nobody can believe in problems like, for example, Mediterranean civilization any more. In concrete terms, in order to feel that I am a sculptor, I'm most obliged to make feigned sculptures. Even... but I don't want to become flippant, the fact that people are genuinely searching is in itself a sort of invention – maybe that they're not even searching, it's hard to say. Behind us we have this sort of archive where certain facts are indexed: the museum. The museums exhibit sculptures and the materials we've used. There isn't one world or one civilization that we are able to appropriate with a gesture of our own. What I believe though, is that all around there is nothing. For the moment I can't formulate precisely what I mean, but I do know that there is a void all around. We stand at the centre of a demarcated space and there are things on the periphery. Somebody finds themselves put in one place: it's his place, he can't lay claim to any other; even if one goes elsewhere, one always comes from a determined place! Yes, but then you will say: if all around is a void, what a peculiar place! A place in a void and

one stays in that place even when one goes elsewhere? Thus, I live in Italy, I am Italian; if I were to live in America it would be impossible to renounce the fact that I am Italian. Even better, I'm not really in Italy because Italy doesn't exist! If I go to America I am nobody! Yet in the place where I am there is a multitude of soap bubbles which burst from time to time and others are created. Obviously these bubbles are empty, but it's I who have created them and they help to hide me. At the end of the day it's only a soap bubble, but then... I knew that from the beginning, you see?

Basically all my objects are turned outward, never towards the inside. This is true of the cannons too, the important thing for me is that they look like cannons. There was this green paint that covered all the defects and this was what the cannon was, it wasn't wood or iron, I don't think it was important how I made it, the important thing was that they looked like cannons. The same with these objects: the important thing is that they look like sculptures, it isn't the inside that interests me nor the surface aspect alone, there really has to be this slight thickness that forms around them. It is fiction that automatically decides that one identifies with a certain image, a certain word in the diction- ary, cannon, sculpture, Brancusi. In Lichtenstein's works this is particularly true. Basically this is what he does: he repaints a picture by Picasso using the method of comic strips. I pretend to make sculptures, but they do not become the sculptures they pretend (feign) to be; I want them to be something light, I want them to be what they are, something that doesn't explain anything, this is how I made them, and that's what happened. Since they are what they are, they are made of cloth stretched over wooden ribs and they look strangely like sculptures, like the images we have in us.

Yes, people do call what I do a show, but I don't think it's the right idea. I present an exhibition, my gesture is the same as that of other sculptors who exhibit. When an artist makes an exhibition he is unavoidably putting on a show, but it's not like in the theatre: the sculptures are not actors and they're not scenery either. Theatre is theatre because there's a live man on stage; if there isn't, it's not theatre any more, it becomes something else. If one wants to draw comparisons in this area (and it can be dangerous) the most one could say is, that in that instance, the spectator then becomes the actor. For myself, I take an almost sadistic pleasure, I become evil when I watch spectators at an exhi- bition. Yes, one could call it a show if by that one simply means the institution invented by man: gallery, exhibition. It is a show, a socio-political phenomenon which permits an artist to introduce himself into society which gives him a brief justification – the only way available to him of existing in society. Without that space today's painter no longer exists: he becomes an artisan, a special- ized worker. A gallery is an abstract place, a place which provides a mouth- piece. Let us say a sort of pulpit with all the ambiguous Christian connotations

that that word implies: a man saying his own mass! And there are these sorts of votive offerings you see? The objects on display in a gallery are transformed into suspended votive offerings; and that works fine when that is the artist's intention, when he believes in it and creates an existential link – otherwise they're just decoration! When a gallery director accepts the works, when the artist himself instals them, then they take on a new dimension. Perhaps it's a negative aspect, but whatever it's an inevitable phenomenon. The galleries become a sort of graveyard: the works are really tombs, but also simulacrum, altar, Blue-bell. The works are transformed into objects to be looked at, while they are also objects that have to pass through the space of the gallery.

If someone says to me: 'I like your painting,' I feel a beautiful sensation but also a very negative one. If he says: 'I don't like that,' then he really, deeply hurts my pride, particularly if it is said to offend; nothing more. But when someone says: 'what a beautiful work', I answer: 'yes, dear friend, yes, beautiful indeed'. But I assure you that at that precise moment it's like a non-sense, it means nothing. It doesn't turn my head one iota, all I can see is the negative aspect, the totally unimportant remark uttered by a 'have you seen me' sort of person with a decoration in his lapel. Nothing more, because for me it's not a question of beauty, these works are neither beautiful nor ugly.

For me the real spectators are painters and sculptors. All the others are strangers to what goes on. People who frequent galleries come because it's the fashion or they want something to put on a chair or a sofa. Or they want to display their extravagance, unless they want to look serious by following tradition. Nothing else. But when a visitor says to me: 'it's extraordinary, this painting makes me think of…' I'm very interested – it can also be laughable, but really I'm open to such things.

I absolutely won't accept an aesthetic judgment. Supposing a spectator says: 'you're an absolute fool to put that colour in that place, can't you see it spoils everything?' I'm automatically compelled to check if it really is out of place. People say to me for example: 'this shape looks like a phallus!' It's fine with me that it suggests a phallus if you have to draw all the inferences from it! Or they say: 'those aren't dinosaurs!' and that confirms to me that one given has caused another to emerge and then I consider whether that could be of any interest to me. The simplest things are what interest me most. If one day someone says: 'as far as I'm concerned, these things here are real cannons', then I'm delighted because they really are cannons. Another might say: 'this doesn't look like a cannon, it doesn't look like anything' or: 'this reminds me of ancient sculpture!' In that case I realise that I've taken a wrong course. Finally if someone says: 'you are on a road leading to destruction' and other such nonsense, then I do get annoyed, I can't even grasp the line of reasoning; it's all hot air, and totally beyond me. Exactly like reading something totally uninter-

esting, one's thoughts get diffused. Or else like listening to something so interesting that one forgets the thing itself, only to remember one minuscule point – a point which triggers off in one's mind thousands of dazzling beams darting in all directions. And in pursuing them you end up totally lost, do you see?

I don't seek to provoke. Maybe the cannons made people think of battle, although there's not a great deal of difference between an imaginary marble woman clasping a minotaur and a dummy cannon – of course people are struck by the evocation of peace and war, that's normal; but in the end, those cannons are not real cannons – that's what counts. And if they were real cannons, the point would be that they don't fire.

Yes, the 'sea' is just like a series of little beds with soft mattresses. This is perhaps due to the shape, to the material from which they are made and the way they are cut, to the alluring curve, to the material which is at once soft and taut. The canvas looks like a sheet indeed and there is always a head end and a foot end to a bed of course. You remember *'muro del somo'* ('wall of sleep'), a painting made of pillows? It's fairly similar to the sea, because it's a serial structure too, one element is always repeated. But with the 'wall' there is a subtle physical difference. At one place the canvas is too stretched and it doesn't join up, at another place it's slacker.

I have an image in mind. My retina imposes certain limitations so I cut the image. This is not determined by a focal point in the strict sense – it's a structural focal point. The sculptures are cut where the structure suggests to me that they should be cut. Anyone can then come with their psychological and psychoanalytical explanations and produce a whole pile of arguments, right or wrong, and no doubt interesting. But… For example, look at the cuts I have made here: they're more than cuts, they're sections. The act of cutting could be called a form of sadism, for all I know! But in fact, where there is a cut there are two clear sections, that's all. These sections are nothing else but forms that occur where the sculpture stops, that is, the sculpture takes this or that form because I saw it as structurally speaking the least intentional, this cut and that shape were so natural, that they did not give rise to any formal problem or any design problem, for me the sculpture finished *there*, it had been made. But obviously if you decapitate an animal, it's more amusing to talk of 'Decapitazione del rinoceronte' ('Decapitation of the rhinoceros')! It's not a question of decapitation but of a rhinoceros which has been decapitated – that's something quite different. It's a decapitated rhinoceros, a trophy, just like the dinosaurs. When somebody hangs a stag's head – complete with horns – on their wall at home they might just as well put a sculpture there instead! Having got to that point just to explode my idea – instead of one trophy I put four. And those four will obviously have a whole room to themselves. First idea: 'Right, hang a sculpture on the wall which looks like a trophy.' Then: 'No, it would be better

to have nothing on the wall.' So make four, to be grouped together – that's what we need. Well, why not become a collector of trophies measuring 1.50 m by 1.50 m – do you see what I'm getting at?

My projects? The things I'm planning to do will be concerned with water. Maybe they'll never get off the ground – anyway I would like to do them, now. Water has a great attraction for me, it's a true mirror. Water offers thousands of possibilities – I'd like to make pools of muddy water. We'll have to see at what point which one of us exploits the other. If it takes me over the whole thing is done for. Often when I think things out beforehand they go wrong. On the other hand, if I have just seized upon an image, just sketched it in, it works. Maybe then the realization is more automatic and certain unforeseen and stimulating factors come into play, then it becomes interesting.

The artists of the past?… How can I put it? As a child you go to church and you see the statue of Jesus Christ. You cry out 'Jesus' and looking him in the eyes – those glass eyes – you can truly be moved to tears. After childhood it all seems funereal; you have lived through the experience, but is has turned out in a negative way. The painters and sculptors of the past interest me – just like the contemporaries – because of this phenomenon. Take Oldenburg as an example: what I failed to grasp was not the realization – it couldn't surprise you because its presence was such that you had to admit its existence. No, it was the way in which he had modified the rules to create an object from the inside. How did he manage to summon up a reality of that order? It's this sort of phenomenon which I find terrifying with the painters of the past. How did Michelangelo manage in the Sistine Chapel to create that limitless space? However one judges the Sistine Chapel in other ways, that achievement gives me a feeling of inferiority – or rather, it takes me into the realms of ecstasy. But then perhaps it's only because they are painters from the past that I feel myself suddenly subjugated before those works, because they have been made by an artist of such a big reputation. Maybe it's like Napoleon's uniform; it's not the uniform itself though, it's something else, something… I don't want to be iconoclastic, I don't want to rule anything out, but I guess that my impressions before a work of art are influenced by factors which have nothing whatsoever to do with art. What actually, really strikes me with artists is the presence. A sculptor takes live animals – it's enough for me that the animals are there in the gallery; or the idea at least. When you visit the Sistine Chapel or when you discover Botticelli for example, all those artists – even just their names – frighten you. We're conditioned by countless factors, by things we have learned before having seen them. The same can also happen with some of the American painters – no one here had ever seen their work until very recently. When one goes to look at the greatest living American painter, one is intimidated before having seen a thing. Face to face with the work itself one discovers that it's close to us – human,

simple: Nothing of the great person, no decorations, nothing! But before the meeting one always imagines those epaulets!

What strikes me most of all are the Negro sculptures. Their works have such a clarity and force that they enthral me, they possess me. At the moment, all the art books that I buy are on this subject. I assure you every work, even the craft works – everything they make that's authentic overwhelms me much more than any work of contemporary design. There's an awesome gulf between a hand-crafted spoon with its extraordinary carved decorations and our own cutlery. For me these industrial products are too elegant. The design is always the slave of a predetermined taste – be it coarse or refined – but always according to a certain taste. If I had to choose between a leaf woven into the shape of a cup and a designed crystal goblet I would choose the leaf. It's applied beauty and real beauty. Consumer society creates an object. When the Blacks fashion an object, they create a whole civilization. They create it at that precise moment with the passion of man discovering the mechanics, with the science of man discovering all. The difference between the specific taste of a fashion object and humanity at work in the invention of the world – the creative force – is startlingly highlighted in this little black god, fashioned in such a way that it instantly evokes all that religion represents. The greatest sculptors of the 15th, 16th or 17th centuries, or of any other epoch you can choose to name, all depicted the Christ figure; but none begins to compare with the intensity of that little black god. Maybe I exaggerate, but whatever anyone else thinks, I prefer the Negro sculptures.

Primitive man, the man who walks naked, notices that the sun rises to the right of a particular mountain and sets to the left of a particular tree. The same man, walking through the forest, discovers that the sun also rises behind another mountain. When that man needs to drink he creates a shape with his own hands. When he makes that gesture with his hands he uses his whole energy. He creates a civilization, a world all of his own. It's not a work for a work's sake; what is important is the intensity which is brought to bear on its realization. Here we can only imagine a glass that is designed so as to incite you to drink. It's not up to me to be the critic. I have always liked clear shapes. What I really wanted to emphasize was the passion which presides at the creation of a civilization. That's the problem which is central to the Italians, the Europeans: it needs the passion of man who has nothing, to truly create something.

39 Jean Dubuffet

'Edifices' 1968

Jean Dubuffet (1901–85) drew from the colours, forms and compositions of his paintings for his large-scale *Tour aux Figures* sculpture. He first started making sculpture by carving with a hot wire into polystyrene, but turned to epoxy resin for this and related works later in the 1960s. He made a number of outdoor, monumental sculptures, of which there are good examples in Chicago, Houston and New York. He was eventually invited to build his *Tour aux Figures* in 1983. It was erected posthumously at Issy-les-Moulineaux, on the outskirts of Paris. Dubuffet declares at the beginning of his text about the *Tower with Figures* (*Tour aux Figures*) that his aim is 'to make a graphic statement which translates the winding reveries of the mind, by nature intangible, yet interpreted here, paradoxically, by a massive and heavy monument'. Throughout his career, this prolific painter, sculptor and writer had consistently attempted to bridge seemingly irreconcilable media, concepts and states of mind. This piece of writing, published for the catalogue of his New York show in 1968, is a witty but serious demonstration of this vision making its first foray into the combined realms of sculpture and architecture, on a monumental scale.

The 'reveries' that preoccupied Dubuffet during the 1960s belong to a body of work he called his 'Hourloupe' phase. It was a period in which he constructed, across a wide range of works, an imaginary system and alternative reality. His vision was anti-cultural and anti-humanist, conceiving of all matter, whether animate or inanimate, as part of the same whole. Mental and bodily imagery and metaphors were conflated for him, and his monuments, and models for monuments, were attempts to give his mental life a physical reality that could be experienced and explored. The text grounds its fantasy vision in references to materials, measurements and architectural construction techniques. In doing so it combines facts with unreality, providing the reader with a strange, compelling account of the kind of extraordinary individual and collective experience that might be had inside his large-scale monument. Dubuffet's *Tour aux Figures* sculpture had an internal spiral structure that provided a journey not only up, around and down a tower, but also imaginatively within the intestines and head of the artist himself. This excerpt reprints the beginning and end of this text, where Dubuffet concentrates his discussion on the aims and ambitions of the work.

Jean Dubuffet, *Edifices*, New York: Museum of Modern Art, 1968, p. 8, 9 and 24. Translated by Teri When.

The aim is to make a graphic statement which translates the winding reveries of the mind, by nature intangible, yet interpreted here, paradoxically, by a massive and heavy monument.

Credit is due to Antoine Butor, architect, who helped the author with the interior arrangement of the tower and with the plans which appear later on in this brochure, as well as for the construction of the models.

It would be possible to use the alveolar character of the polychromatic decoration to allow daylight to penetrate into the monument. Certain of the areas outlined in black could be made of translucent material, painted and historiated like the rest of the building. There should be no obvious difference between the windows of glazed areas and the opaque sections of the building, for the whole structure, when viewed from the outside, must appear to be homogeneous.

The author is reluctant, however, to resort to this solution. He insists that the edifice be entirely without windows and that interior lighting, as well as ventilation, be supplied exclusively by artificial means.

It seems indeed desirable that the monolithic aspect of the building be strongly emphasized; any opening would compromise its character as a secret personal dwelling, completely cut off from life outside, and thus should be without any view of it.

Let us point out that the tower is not conceived as a dwelling in the usual sense. We have dispensed with the encumbering amenities – such as kitchen, bath, etc. No furniture – no chairs, beds, or tables other than those offered by the chance protuberances of the uneven configuration of the floor is planned for the interior of the tower. The advantage of all this is that the entire house can be washed down at any given moment with a fire hose, without moving a stick of furniture. On the other hand, one is forced to live there without belongings. Unless the user is resigned to leading the life of a bachelor or hermit, he will use this dwelling only as a place for occasional retreat and contemplation. In the absence of other luxuries, he will enjoy an exceptional profusion of space, permitting him to wander about without having to go through doors and delighting in his climbing habitat like that of a mountain goat

[...]

The basic structural principle of the tower will be the suspension of the exterior skin onto the internal treelike structure of the *Gastrovolve* which, as it will be wholly built of reinforced concrete, will be the bearing element. The floors will be cantilevered. The exterior skin will be light and thin and hung like a curtain wall. It could also be made of pre-stressed concrete or better still of stratified resinous epoxy. In the latter case a network of stiffeners, faithful to the black outlines of the exterior decoration could, if necessary, become part of the structure – notably to reinforce the dome covering the great hall. All floors, walls and ceilings, as well as the exterior skin shall be colored

with labyrinthine designs in polyurethane paint. Thus the areas of reinforced concrete and those of resinous epoxy will look exactly the same.

Whether concrete or resin is used for the skin of the tower, the best means of faithfully reproducing the forms of the working model would be to enlarge (with the help of a pantograph) a hollow mould of expanded polystyrene to dimensions desired and then to pour concrete of resin in these moulds.

Heat, light and ventilating equipment will be hidden in the concrete structure of the *Gastrovolve*.

As it was indicated at the onset, all disparate furniture will be eliminated and replaced by hollows and niches which are incorporated into the décor, or by reliefs of the floor, upon which one may lie down or sit, or upon which one may place objects. Several statues or cut-outs decorated in the same uninterrupted graphic pattern, which the eye follows, will be erected here and there; they will be treated in resinous epoxy or polyester and colored with the same polyurethane paint as the rest of the structure.

The building should be constructed preferably on top of a small hill, so that the base stands out. Sand, or better an asphalt surface, could support the base. There shall be no greenery surrounding the tower. Even better, the tower could be built in the city at an intersection or on a square – preferably a small one.

40 Michael Fried

'Two Sculptures by Anthony Caro' 1968

Michael Fried (b. 1928) began writing for *Artforum* magazine in 1965, acting as contributing editor between 1966 and 1973. In Fried's view, his art-critical essays of the mid to late 1960s mark the end of a high modernist tradition of 'evaluative criticism' inherited from Clement Greenberg. Fried was not, however, simply a Greenberg disciple, and instead should be understood as having attempted a close and critical reading of Greenbergian aesthetics, a project he concluded at the end of 1968. As well as its Greenbergian basis, 'Two Sculptures' also shows the extent to which Fried was strongly impressed at this time by European phenomenology, specifically Merleau-Ponty's as presented in *The Phenomenology of Perception* (1962). Fried combined a commitment to phenomenological embodiment with a parallel fascination with the later writings of Ludwig Wittgenstein, specifically *Remarks on the Foundation of Mathematics* (1956). By combining Merleau-Ponty and Wittgenstein, Fried was able to formulate his own post-Greenbergian theory of abstract art that in this essay he applies to work he had first learnt to admire in 1961.

'Two Sculptures by Anthony Caro' was originally published in *Artforum* in February 1968. It followed on the heels of Fried's more famous and seminal essay, 'Art and Objecthood' of 1967. It was in 'Art and Objecthood' that Fried spelled out exactly what he meant by 'theatricality' and 'literalness', pejoratives targeted squarely at the minimalists. While these issues are taken up in 'Two Sculptures by Anthony Caro', Fried's central concern in this article is to articulate the distinctive nature of the viewer's encounter with Caro's new, openly arrayed, painted metal and radically abstract sculptural constructions. Fried adapts Greenbergian ideas such as 'openness' to his own purposes, not in order simply to position himself in an oppositional way against minimalist tendencies, but more so as to get a stronger purchase on Caro's realisation of a new kind of high modernist three-dimensional art. In the original *Artforum* article, the text was accompanied by photographs of both *Deep Body Blue* (1966) and *Prairie* (1967), the latter also shown on the magazine's front cover.

Michael Fried, 'Two Sculptures by Anthony Caro', *Artforum*, vol. 6, no. 6, Feb. 1968, pp. 24–25. Reprinted in Michael Fried, *Art and Objecthood, Essays and Reviews*, Chicago and London: University of Chicago Press, pp. 180–84, and in Richard Whelan (ed.), *Anthony Caro*, London: Penguin, 1974, pp. 95–101.

Deep Body Blue (1967), the smaller of the two pieces in Anthony Caro's recent show at the Kasmin Gallery, is open as widespread arms and then as a door is open. The two contrasting elements that run along the ground, a length of tubing and a flat sheet standing on its long edge, *gather* the beholder into a far more compelling embrace than could be achieved by literally embracing

him – the way, for example, one is embraced by Bernini's colonnades in front of St. Peter's – while the two uprights are experienced as a kind of abstract door on the other side of which two similarly contrasting elements converge, touch, and go their ways. Like several recent sculptures by Caro, *Deep Body Blue* explores possibilities for sculpture in various concepts and experiences that one would think belonged today only to architecture: for example, those of being led up to something, of entering it, perhaps by going through something else, of being inside, of looking out from within... Not that Caro's work is architectural in look or essence. But it shares with architecture a preoccupation with the fact, or with the implications of the fact, that humans have bodies and live in a physical world. This preoccupation finds a natural, and inescapably literal, home in architecture. The same preoccupation no longer finds a *natural* home in painting and sculpture: it is the nearly impossible task of artists like Caro to put it there, and this can only be done by rendering it *anti*literal or (what I mean by) *abstract*. The heart of Caro's genius is that he is able to make radically abstract sculptures out of concepts and experiences which seem – which but for his making are and would remain – inescapably literal and therefore irremediably theatrical; and by so doing he redeems the time if anyone does. Not only is the radical abstractness of art not a denial of our bodies and the world; it is the only way in which they can be saved for high art in our time, in which they can be made present to us other than as theater.

In the course of his enterprise Caro makes discoveries as sudden and imperative as any in modern philosophy. For example, it is essential to our experiencing the two uprights in *Deep Body Blue* as a kind of door that they stand in the same plane. It doesn't matter that they are no more than four feet high, that they lack any sort of lintel, that we are not tempted nor even able to pass between them: the fact that they stand several feet apart in the same plane is enough to make us experience them as an *abstract* door (and a large, or wide, one at that). By the same token, if they are moved even slightly out of alignment their 'doorness' disintegrates and the sculpture as a whole begins to fall apart, to become arbitrary and therefore meaningless as art. This aspect of Caro's achievement may be described in different ways. One can say that he discovered what constitutes an *abstract* door, or that he discovered the *conventions* – corresponding to *deep* needs – which make something a door. Caro did not consciously set out to discover anything of the kind. On the contrary, it is because *Deep Body Blue* began in a preoccupation with particular modes of being in the world that its very success as sculpture came to depend on the making of the above discovery in, or by, the piece itself. It is as though with Caro sculpture has become committed to a new kind of cognitive enterprise: not because its generating impulse has become philosophical, but because the newly explicit need to defeat theater in all its manifestations has

meant that the ambition to make sculpture out of a primordial involvement with modes of being in the world can now be realized only if antiliteral – that is, radically abstract – terms for that involvement can be found. (At the risk of seeming to overload the point, I will add that the cognitive enterprise in question is related, in different ways, both to European phenomenology and to the later philosophy of Wittgenstein. It isn't only modernist *art* that has found it necessary to defeat theater.)

The larger sculpture, *Prairie* (1967), consists of four long poles of aluminum tubing suspended parallel to one another about eleven inches above a sheet of corrugated metal – more exactly, a flat sheet with four channel-like depressions in it – which runs north-south to the poles' east-west and is itself suspended about twenty-one inches above the ground. If we approach *Prairie* from either end of that sheet, the physical means by which these suspensions are accomplished are not apparent; but as we move around the sculpture it becomes clear that the sheet is held up by two sharply bent pieces of metal plate, one on each side, which spring out and down from the underside of the sheet until they touch the ground, whereupon they angle upward and outward until they reach the height of the poles, which they support also. Two of the poles are supported at only one point, about twenty inches from the end; a third is supported about twenty inches from both ends, that is, by both of the bent, upward-springing metal plates; while a fourth is not supported by these at all but is held up by a large upright rectangle of metal which stands somewhat apart from the rest of the sculpture and in fact is not physically connected to it in any way. But grasping exactly how *Prairie* works as a feat of engineering does not in the least undermine or even compete with one's initial impression that the metal poles and corrugated sheet are suspended, as if in the absence of gravity, at different levels above the ground. Indeed, the ground itself is seen not as that upon which everything else stands and from which everything else rises, but rather as the last, or lowest, of the three levels which, as abstract conception, *Prairie* comprises. (In this sense *Prairie* defines the ground not as that which ultimately supports everything else, but as that which does not itself require support. It makes this fact about the ground both phenomenologically surprising and sculpturally significant.)

The result is an extraordinary marriage of illusion and structural obviousness. Once we have walked even partly around *Prairie* there is nothing we do not know about how it supports itself, and yet that knowledge is somehow eclipsed by our actual experience of the piece as sculpture. It is as though in *Prairie*, as often in Caro's work, illusion is not achieved at the expense of physicality so much as it exists simultaneously with it in such a way that, in the grip of the piece, we do not see past the first to the second. This is mostly due to the nature of the relationships among the various elements that compose *Prairie*,

relationships which make a different kind of sense to the mind and to the eye. For example, that three of the long metal poles are held up at only one end is *understood* to mean that the full weight of each pole is borne by a single support far from its center; but the poles are *seen* as being in a state of balance as they are, as if they weighed nothing and could be placed anywhere without support. This impression is reinforced by the fact that the two poles supported at one end by a bent, upward-springing metal plate are held up by different plates and at opposite ends. Similarly, the one pole supported at both ends is held up by the far corner of the nearer plate and by the near corner of the farther one; and this deliberate staggering, while perfectly understood by the mind, disconcerts the eye enough to make it see that pole as if it were not truly supported at all. That all four poles are parallel to and equidistant from one another, and that three of them are the same length, are other factors which obstruct the eye from giving weight to the specific means by which each is supported. (It should also be said that the fact that the four poles are an almost imperceptibly lighter shade of sandy yellow than the rest of the sculpture gives them an added suggestion of lift.) In these and other ways Caro on the one hand has frankly avowed the physicality of his sculpture and on the other has rendered that physicality unperspicuous to a degree that even after repeated viewings is barely credible. This is not in itself a new development in his work; it has been a steady feature of his art since his conversion to radical abstraction around 1959. But it reaches in *Prairie* an extreme that may also be a kind of culmination. More emphatically than any previous sculpture by Caro, *Prairie* compels us to believe what we see rather than what we know, to accept the witness of the senses against the constructions of the mind.

Finally, Caro has never before sought openness through abstract extension as explicitly as here. For the first time the openness Caro achieves is above all a lateral openness – with the result that we are made to feel that lateralness as such is open in a way that verticality or obliqueness or head-on recession are not. This is a point of deep affinity between *Prairie* and the superb paintings in Kenneth Noland's last show at the Emmerich Gallery, in which the lateral extension of the canvas and its colors accomplished, among other things, an unexpected liberation from the constrictions of the picture shape. In both *Prairie* and Noland's recent paintings the decisive experience is one of instantaneous extension, roughly from somewhere in the middle of the poles or canvas out towards both ends. In each the exact dimensions of what is extended laterally are of crucial importance: if either the poles or the canvas were too long or short, the result would be a flaccid or blocky objecthood. (Objecthood of one kind or another is the aim of literalist work, which does not begin or end so much as it merely stops, and in which an indefinite – by implication, infinite – progression takes place as if in time.) Caro seems

to have faced the further risk that *Prairie* might be too open, at any rate that the eye might be compelled away from the piece itself into the space around it, in which case it would strike one less as open than as merely insufficient. That this does not occur is partly owing to Caro's use of the solid rectangle of metal which supports the fourth pole: placed largely beyond the previous limits of the sculpture, it actually extends the sculpture at the same time as it helps contain its energies by giving the eye something flat, vertical, and opaque to come up against. The lack of physical connection between the rectangle-and-pole and the rest of the piece has been made as unperspicuous as the precise character of the connections among the other elements: this is largely why *Prairie* is by far the most successful sculpture in two or more parts that I have ever seen.

I believe that *Prairie* is a masterpiece, one of the great works of modern art and a touchstone for future sculpture, and that *Deep Body Blue*, while less ambitious, is nevertheless beyond the reach of any other living sculptor. In the radicalness of their ambition both have more in common with certain poetry and music, and certain recent painting, than with the work of any previous sculptor. And yet this very radicalness enables them to achieve a body and a world of meaning and expression that belong essentially to sculpture.

41 David Sylvester

'Hard and Soft' 1968

As well as being a prolific critic and writer on the visual arts, with numerous books, essays and exhibition catalogues to his name, David Sylvester (1924–2001) was also a curator, interviewer and collector. Although his interests spanned many periods and styles, he is best known as a critic of contemporary art, who during the 1950s and 1960s promoted the work of Francis Bacon, Alberto Giacometti and Henry Moore (1898–1986) not only through his writing but also through his activities as an exhibition curator. Sylvester had first shown Moore's work in 1948, and the Moore retrospective he organised in 1968 through the Arts Council at the Tate followed his exhibitions of Giacometti's work in 1955 and 1965. This short extract, a section of his text for the catalogue to the 1968 Moore exhibition, is typical of his approach to sculpture.

Moore was also a prolific writer on sculpture, and Sylvester's text about the lively surface tensions and contrasts between hardness and softness that characterised some of Moore's post-war bronze sculptures acknowledges the sculptor's own earlier written commentary on his works' vitalist 'pent-up energy'. Sylvester considers this characteristic through the techniques and materials used by Moore at the time. Plaster, he argues, especially Moore's use of this material both to model with and to carve into, greatly facilitates this hard/soft contrasting effect. 'Softness' was of course in the air in the 1960s (notably in the work of Claes Oldenburg and Jim Dine) and, in a sense, the effect that Sylvester describes perhaps parallels this popular interest in soft sculptures and in the dialectic between hard and soft in sculpture. Moreover, the often dramatic shifts in scale that Moore's work underwent in these post-war years – from hand-sized maquettes to monumental outdoor sculptures – can also be seen to parallel pop artists' ballooning of the small object.

Whilst such treatment indicates Moore's new post-war freedom from stone carving and from the pre-war ethos of 'truth to materials', Sylvester also found such combinations in Moore's recent stone carving that showed a subsequent and subtle carrying over of such interests. Moore's emphasis on 'dynamic rather than static qualities', Sylvester concludes, reveals a concern with tactile as much as with visual sensations: 'The hard-and-soft figures are haptic images: they make bodies look the way they feel, from outside, and still more perhaps, from inside'. 'Hard and Soft', though it owes a lot to Herbert Read's writing, stands as a classic example of the kind of sensitive, phenomenologically nuanced and historically informed formalist art criticism for which Sylvester became known.

David Sylvester, *Henry Moore*, London: Arts Council of Great Britain, 1968, pp. 127–28.

In the sculptures carved or modelled before the mid-1950s, the notional surface tension is near enough equal all over. The surface appears uniformly firm; there are no clearly soft parts or textures. About 1955 Moore quite suddenly started to do sculptures in which there are violent contrasts of surface tension, with exceedingly taut, bone-hard, passages moving into soft, resilient, fleshy passages, often very abruptly. This was at about the time when he started to work with pebbles that have surfaces partly smooth and partly rough and sudden alternations between convexes and concaves, rather than sea-worn pebbles with smooth surfaces and smooth curves.

The hard/soft contrast was first fully manifest in the semi-abstract bronze *Upright Motives* of 1955–6, if not in some of the variant sketch-models of 1955 for the wall relief for the Rotterdam Bouwcentrum, where forms like those which become free-standing in the *Upright Motives* are embedded in a ground. In figurative sculpture the contrast is first conspicuously present in the bronze *Falling Warrior* of 1956–7. (In its predecessor by three years, the *Warrior with Shield*, the contrast is already there in one detail, the resilience of the thigh against the pointed hardness of the knee, but the torso is as uniformly hard as the flat torsoes of previous male figures.) Since then, the hard/soft contrast has been a key characteristic of virtually all the clearly figurative bronzes and of some of the more abstract ones: even the *Locking Piece* has soft passages.

Clearly, this new development was fostered by Moore's having come to work mainly in plaster – modelling followed by the carving of a relatively soft material. Rodin's influence is evident in the fluid, melting parts of the *Upright Motives*. But the crucial influence has been Michelangelo: indeed, the legs of the *Falling Warrior* are – what Moore suddenly recognized afterwards – a transposition of Christ's legs in the *Rondanini Pietà*. Only, he needed to be working in plaster to try and emulate the flexibility and the variation of tension which Michelangelo could get in carving marble. By the same token, his one early work that is somewhat Michelangelesque in idiom is the *Reclining Figure* of 1932 in carved reinforced concrete – a medium in which he roughly modelled the form before he carved, was not carving an inhibitingly solid block. And this piece is not only much more flexibly and sharply articulated than any carving proper of the period, but gives some premonition of the hard/soft contrast. There are also certain drawings of the same year in which hard and soft parts are related very much as in bronzes of twenty-odd years later. Again, there is a suggestion of resilience in the deepest part of the hollow in the Pynkado wood *Two Forms* of 1934. The idea of varying the surface tension was there from an early stage. Its realization was delayed, firstly by prohibitions which surrounded stone-carving – 'sculpture in stone should look honestly like stone' – secondly by the persistence in the earlier works made in plaster of attitudes developed in working stone.[1] However, once Moore had started to vary the

surface tension, he sought to do so in big elm carvings, first in the *Upright Figure* executed between 1956 and 1960, then, with high success, in the *Reclining Figure* carved between 1959 and 1964. Here there are parts which have a sensuous fleshiness, a muscular elasticity, of which there is no sign in the 1939 elm figure, though some intimation in the thighs of the 1945–6 elm.

Recently, he has begun to bring a softness into his stone carvings. In the first place he has been working in rosa aurora marble, a stone the special translucence of which appears to soften the forms, so that, whereas the red Soraya *Three Rings* seem hard, the same shapes in rosa aurora appear resilient. Again, after carving an *Upright Form Knife-edge* in rosa aurora, Moore found that the illusion of softness contradicted the hard character of the forms: for the first time in his career, he re-carved the piece in a different stone, a white marble. In these cases, however, the sense of softness does not alter the habitual consistency of surface tension. On the other hand, a *Reclining Form* in white marble of 1966 and, more emphatically, the rosa aurora *Mother and Child* of 1967 do present a distinct variation in surface tension – a gradual variation, as against the abrupt contrasts often found in the bronzes.

The development of these contrasts represented a radically new way of thinking for Moore – an emphasis on dynamic rather than static qualities, and on the uneasy rather than the harmonious: it was no accident that the first of his really hard-and-soft figures was the only figure he has ever made in sculpture with a totally off-balance, helpless pose – helpless but violently, convulsively, energetic. 'One of the things I would like to think my sculpture has is a force, is a strength, is a life, a vitality from inside it, so that you have a sense that the form is pressing from inside trying to burst, or trying to give off the strength from inside itself, rather than having something which is just shaped from outside and stopped. It's as though you have something trying to make itself come to a shape from inside itself.'[2] This statement, made in the 60s, might so far be only an elaboration of Moore's old ideal of 'pent-up energy' compressed in a work.[3] But now he goes on: 'This is, perhaps, what makes me interested in bones as much as in flesh, because the bone is the inner structure of all living form. It's the bone that pushes out from inside; as you bend your leg the knee gets tautness over it, and it's there that the movement and the energy come from. If you clench a knuckle, you clench a fist, you get in that sense the bones, the knuckles, pushing through, giving a force that, if you open your hand and just have it relaxed, you don't feel. And so the knee, the shoulder, the skull, the forehead, the part where from inside you get a sense of pressure of the bone outwards – these for me are the key points.' What is new is the concern with 'key points' and 'pushing through'. In most of Moore's work the 'pent-up energy' underlies a surface the even tension of which implies that the energy is firmly contained, is not threatening to burst the bounds of the

form. In the hard-and-soft works, passages where the surface is straining to contain something 'pressing from inside trying to burst' suddenly alternate with passages where the pressure is relaxed.

Underlying this new concern is a new extreme concentration on tactile and motor rather than visual sensations on what is experienced in running one's hands over a body, responding more sharply to its hardnesses and softnesses, its hollows and bumps, than when looking at them, and on what is experienced in using one's own body, feeling one's skin stretching tautly over one's knuckles as one clenches a fist, feeling the muscles tighten as one extends a limb. The hard-and-soft figures are haptic images: they make bodies look the way they feel, from outside, and, still more perhaps, from inside. To the eye they can seem dislocated, awkward, uncouth. They ask to be looked through rather than looked at. In no other works has Moore taken such risks. And this reflects a further change of attitude – a growing acceptance, indeed, a positive courting, of imperfection, incompleteness.

1 *Architectural Association Journal*, May 1930, p. 408.
2 Quoted in Warren Forma, *Five British Sculptors (work and talk)*, New York: Grossman, 1964, p. 59. I have taken the liberty of modifying the punctuation.
3 *Unit 1*, 1934, p. 30.

42 Lucy Lippard and John Chandler

'The Dematerialization of Art' 1968

The idea of 'dematerialization' was introduced in 1968 by two New York-based art critics, Lucy Lippard (b. 1937) and John Chandler. The term was taken from a 1966 essay by the composer John Cage, who had referred to an imaginary concert performance where one would have 'the experience that no experience was had, a dematerialization (not of facts) of intentions'. Lippard and Chandler's first use of the term was in an essay for *Art International*, 'Visible Art and the Invisible World' published in May 1967, but it was only central to their thesis in the follow-up article, 'The Dematerialization of Art' of 1968. It was this article that provoked such a strong reaction against the 'dematerialization' hypothesis, a reaction that Lippard carefully recorded and reproduced five years later in her influential conceptual art anthology, *Six Years: The Dematerialization of Art* (1973).

In *Six Years*, Lippard includes an excerpt from the original 1968 essay, along with commentary on how the idea of dematerialization became such a topic of hot debate. According to Lippard, the most vocal opposition to the idea came from the English conceptualists, *Art-Language*, who objected to the way Terry Atkinson's *Map Not to Indicate* (1967) was used by Lippard and Chandler to demonstrate the dematerialization phenomenon. Michael Baldwin, on behalf of *Art-Language*, argued in a letter to Lippard published in *Six Years* that *Map Not to Indicate* was as much a 'physical object' as any Rembrandt – an argument that seems to make all art, painting and drawing included, not just conceptual but also sculptural. Lippard, however, shrugged off *Art-Language*'s objection, and in doing so seems to have deepened the relevance of dematerialization to specifically sculptural matters. 'It isn't really a matter of how much materiality a work has,' she writes in *Six Years*, but rather 'what the artist is doing with it'. 'Dematerialization' in this reworking of the original notion refers much more clearly than it did before to process aesthetics, seeming to have less to do with conceptualism and a 'de-emphasis on material aspects' and more to do with post-minimalism and the sorts of changes Robert Morris had highlighted in his 'Notes on Sculpture' series published in *Artforum* between 1966 and 1969. Lucy Lippard has been a key figure in the New York art world, known for her art criticism, her major monographs on Eva Hesse and Ad Reinhardt, and her interventions as a feminist and cultural theorist.

Lucy R. Lippard and John Chandler, 'The Dematerialization of Art', *Art International*, February 1968, pp. 31–6. Reprinted in Lucy Lippard, *Changing: Essays in Art Criticism*, New York: E.P. Dutton & Co., 1971, pp. 255–60 and pp. 270–76. (Full text: pp. 255–76.)

During the 1960s, the anti-intellectual, emotional/intuitive processes of art-making characteristic of the last two decades have begun to give way to an ultra-conceptual art that emphasizes the thinking process almost exclusively.

As more and more work is designed in the studio but executed elsewhere by professional craftsmen, as the object becomes merely the end product, a number of artists are losing interest in the physical evolution of the work of art. The studio is again becoming a study. Such a trend appears to be provoking a profound dematerialization of art, especially of art as object, and if it continues to prevail, it may result in the object's becoming wholly obsolete.

The visual arts at the moment seem to hover at a crossroad that may well turn out to be two roads to one place, though they appear to have come from two sources: art as idea and art as action. In the first case, matter is denied, as sensation has been converted into concept; in the second case, matter has been transformed into energy and time-motion. If the completely conceptual work of art in which the object is simply an epilogue to the fully evolved concept seems to exclude the *objet d'art*, so does the primitivizing strain of sensuous identification and envelopment in a work so expanded that it is inseparable from its nonart surroundings. Thus the extremely cool and rejective projects of Judd, LeWitt, and others have a good deal in common with the less evolved but perhaps eventually more fertile synaesthetic ambitions of Robert Whitman, Robert Rauschenberg, and Michael Kirby, or the dance of Yvonne Rainer and Alex Hay, among others. This fact is most clearly illustrated by the work of Robert Morris, who has dealt with idea as idea, idea as object, and idea as performance. In fact, the performance media are becoming a no-man's- or every-man's land in which visual artists whose styles may be completely at variance can meet and even agree.[1] As the time element becomes a focal point for so many experiments in the visual arts, aspects of dance, film, and music become likely adjuncts to painting and sculpture, which in turn are likely to be absorbed in unexpected ways by the performing arts.

Another possibility that permits a combination of art as idea and art as action is the use of a serial scheme, though the recent 'Art in Series' exhibition at the Finch College Museum of Art, organized by Mel Bochner, while a good show, indicated that only the most basic tenets of serialism have so far been adapted to the plastic arts. Static by tradition, painting and sculpture have until lately lagged behind music, poetry, and film in the use of serial methods.

Motion is the source of pattern-making, and it might seem that film rather than painting or sculpture would be the visual art most suited to the portrayal of motion and time. But paintings like those of Larry Poons and sculpture such as Sol LeWitt's offer successful means of presenting time-motion without anything actually moving (as, in another way, do Oldenburg's soft sculptures). They are like time exposures in photography, revealing time-space patterns that are invisible to someone seeing them in sequence alone. They are like chords in music, where the pattern is discovered in the vertical

and simultaneous arrangements of the elements rather than horizontally and sequentially, as in melody. Thus these time exposures are double exposures or multiple exposures. LeWitt's serial projects are made up of parts which, though each part can be seen separately as sculpture, and in sequence, can also be seen simultaneously as one thing. (One of LeWitt's influences, and also one of Duchamp's, was Muybridge.) However, the parts do sometimes call attention to themselves with the unfortunate result that the whole lacks the unity of a chord; it is in the mind, or in the working drawing that sketches all the possibilities, rather than in the eye, that the whole attains its completely realized simplicity and unity. A series is an appropriate vehicle for an ultra-conceptual art, since thinking is ratiocination, or discovering the fixed relations, ratios, and proportions between things, in time as well as in space.

A highly conceptual art, like an extremely rejective art or an apparently random art, upsets detractors because there is 'not enough to look at', or rather not enough of what they are accustomed to looking *for*. Monotonal or extremely simple-looking painting and totally 'dumb' objects exist in time as well as in space because of two aspects of the viewing experience. First, they demand more participation by the viewer, despite their apparent hostility (which is not hostility so much as aloofness and self-containment). More time must be spent in immediate experience of a detail-less work, for the viewer is used to focusing on details and absorbing an impression of the piece with the help of these details.[2] Secondly, the time spent looking at an 'empty' work, or one with a minimum of action, seems infinitely longer than action-and-detail-filled time. This time element is, of course, psychological, but it allows the artist an alternative to or extension of the serial method. Painter-sculptor Michael Snow's film *Wavelength*, for instance, is tortuously extended within its forty-five-minute span. By the time the camera, zeroing in very slowly from the back of a large loft, reaches a series of windows and finally a photograph of water surface, or waves, between two of them, and by the time that photograph gradually fills the screen, the viewer is aware of an almost unbearable anticipation that seems the result of an equally unbearable length of time stretched out at a less than normal rate of looking; the intensity is reinforced by the sound, which during most of the film is monotonal, moving up in pitch and up in volume until at the end it is a shrill hum, both exciting and painful.

Joseph Schillinger, a minor American Cubist who wrote, over a twenty-five-year period, an often extraordinary book called *The Mathematical Basis of the Arts*, divided the historical evolution of art into five 'zones', which replace each other with increasing acceleration: (1) pre-aesthetic, a biological stage of mimicry; (2) traditional-aesthetic, a magic, ritual-religious art; (3) emotional-aesthetic, artistic expression of emotions, self-expression, art for art's sake; (4) rational-aesthetic, characterized by empiricism, experimental art, novel art;

(5) scientific, post-aesthetic, which will make possible the manufacture, distribution, and consumption of a perfect art product and will be characterized by a fusion of the art forms and materials, and, finally, a 'disintegration of art', the 'abstraction and liberation of the idea'.[3]

Given this framework, we could now be in a transitional period between the last two phases, though one can hardly conceive of them as literally the last phases the visual arts will go through. After the intuitive process of re-creating aesthetic realities through man's own body, the process of reproduction or imitation, mathematical logic enters into art. (The Bauhaus dictum 'Less is More' was anticipated by William of Occam when he wrote: 'What can be explained by fewer principles is explained needlessly by more'; Nominalism and Minimalism have more in common than alliteration.) From then on, man became increasingly conscious of the course of his evolution, beginning to create directly from principles without the intercession of reproductive reality. This clearly corresponds to the Greenbergian interpretation of Modernism (a word used long before Greenberg, though his disciples insist on attributing it to him). The final 'post-aesthetic' phase supersedes this self-conscious, self-critical art that answers other art according to a determinist schedule. Involved with opening up rather than narrowing down, the newer work offers a curious kind of utopianism that should not be confused with nihilism except in that, like all Utopias, it indirectly advocates a *tabula rasa*; like most Utopias, it has no concrete expression.

Dematerialized art is post-aesthetic only in its increasingly nonvisual emphases. The aesthetic of principle is still an aesthetic, as implied by frequent statements by mathematicians and scientists about the *beauty* of an equation, formula, or solution: 'Why should an aesthetic criterion be so successful so often? Is it just that it satisfies physicists? I think there is only one answer – nature is inherently beautiful' (physicist Murray Gell-Mann); 'In this case, there was a moment when I knew how nature worked. It had elegance and beauty. The goddam thing was gleaming' (Nobel prizewinner Richard Feynman).[4] The more one reads these statements, the more apparent it becomes that the scientist's attempt to discover, perhaps even to impose order and structure on the universe, rests on assumptions that are essentially aesthetic. Order itself, and its implied simplicity and unity, are aesthetic criteria.

The disintegration Schillinger predicted is obviously implicit in the breakup since 1958 or so of traditional media, and in the introduction of electronics, light, sound, and, more important, performance attitudes into painting and sculpture – the so far unrealized intermedia revolution whose prophet is John Cage. It is also implied by the current international obsession with entropy. According to Wylie Sypher, for example: 'The future is that in which

time becomes effective, and the mark of time is the increasing disorder toward which our system tends... During the course of time, entropy increases. Time can be measured by the loss of structure in our system, its tendency to sink back into that original chaos from which it may have emerged... One meaning of time is a drift toward inertia.'[5]

[...]

The danger, or fallacy, of an *ultra*-conceptual art is that it will be 'appreciated' for the wrong reasons, that it will, like Duchamp's *Bottle Rack* or *Large Glass*, come to be mainly an ingratiating object of aesthetic pleasure instead of the stringently metaphysical vehicle for an idea intended. The idea has to be awfully good to compete with the object, and few of the contemporary ideas listed above are finally that good. Nevertheless, the 'thinness', both literal and allusive, of such themes as water, steam, dust, flatness, legibility, temporality, continues the process of ridding art of its object quality. Some of these artists hold that the idea is self-generating and self-conclusive, that building the sculpture or painting the painting is simply the traditional, expected step finally unnecessary to the aesthetic, but very little of their work is really conceptual to the point of excluding the concrete altogether. On the other hand, ideas like Oldenburg's trench or LeWitt's buried cube are both tangible and intangible, simple and complex. They open up art to the intellect without delivering it into any other cultural or transcultural area. Visual art is still visual even when it is invisible or visionary. The shift of emphasis from art as product to art as idea has freed the artist from present limitations – both economic and technical. It may be that works of art that cannot be realized now because of lack of means will at some future date be made concrete. The artist as thinker, subjected to none of the limitations of the artist as maker, can project a visionary and utopian art that is no less art than concrete works. Architecture provides many precedents for this kind of unmaterialized art; Wright's mile-high skyscraper is no less art for not having a concrete expression. Moreover, since dealers cannot sell art-as-idea, economic materialism is denied along with physical materialism.

Nonvisual must not be confused with nonvisible; the conceptual focus may be entirely hidden or unimportant to the success or failure of the work. The concept can determine the means of production without affecting the product itself; conceptual art need not communicate its concepts. The audience at a Cage concert or a Rainer dance performance will never know what the conceptual framework of the work is. At the other extreme is LeWitt's contention: 'Logic may be used to camouflage the real intent of the artist, to lull the viewer into the belief that he understands the work, or to infer a paradoxical situation

(such as logic versus illogic). The ideas need not be complex. Most ideas that are successful are ludicrously simple. Successful ideas generally have the appearance of simplicity because they seem inevitable.'[6]

Thus the difficulty of abstract conceptual art lies not in the idea but in finding the means of expressing that idea so that it is immediately apparent to the spectator. In math or science, the simpler the explanation or formula, the more satisfying it seems to be, and to reduce the great complexity of the universe to a single simple equation or metaphor is the goal. Even the simple progression of 1, 2, 3, in Dan Flavin's 1963 fluorescent piece *The Nominal Three; To William of Occam*, or the 1, 2, 3, 4 of David Lee's dark hanging plexiglass panels at Finch, are enough to satisfy the initial demands of a rational art. Even the most apparently elaborate schemes, such as Larry Poons's multiple inversions, though they require more deliberation to detect, once found are only slightly more complicated than the simple ones. Perhaps this, or the 'camouflage' mentioned by LeWitt, is the reason for the popularity of hermetic motifs today. Hermeticism of one kind or another, manifested as enclosure or monotonality and near invisibility, as an incommunicative blank façade or as excessive duration, helps maintain the desired aloofness in a work confronted by the ordinary or suspiciously avid spectator, while at the same time it satisfies the artist's desire for difficulty and endears itself to the spectator willing to commit himself on a deeper level.

Much recent conceptual art is illustration in a sense, in the form of drawings or models for nearly impossible projects that will probably never be realized, or in many cases, need no further development. According to Joseph Kosuth: 'All I make are models. The actual works of art are ideas. Rather than 'ideals,' the models are a visual approximation of a particular art object I have in mind.'[7] Mel Bochner's contribution to the Finch serial show – *Sixteen Isomorphs* – is a model after the fact – a model for a piece already executed, and dismantled. Its sixteen modules are serial photographs of a project set up in small black blocks specifically to be photographed.

The interest in rough working drawings, which has become something of a fetish among Primary Structurists, is indicative of a sneaking nostalgia for a certain executionary éclat denied them in the work itself. On the other hand, Bochner's working drawing show at the School of Visual Arts last year [1967], consisting of five identical loose-leaf notebooks filled with Xerox copies of the 'exhibits' (including lists, notes, specifications for and bills from fabricators, contributions by poets and architects) brought up another point: the concept of drawing as pseudo-painting was banished and drawing was brought back to its original function as a sketch or medium for working out ideas – visual or intuitive. Nevertheless, the emphasis on diagrams and projects, on models and working drawings rather than the finished pieces, is usually accompanied by

the existence of the finished pieces, and these are finally successful only if the idea – original or not – has been successfully translated into visual terms. All of the artists mentioned here were presumably attracted to visual art in order to express something concretely. They began by making work strongly visual in character – conventional painting and sculpture – and they may return to it at any time. Duchamp's example of almost total abstention is not likely to attract many, although certain highly intelligent but formally unoriginal artists will continue to make 'art' that is largely an illustration of ideas rather than either visual or ultra-conceptual; their œuvre becomes a veritable Smithsonian of collected fact and invention – technological artifacts. Of course the use of the object of art as a vehicle for ideas is nothing new. In the course of art history it was only in the late nineteenth century that an alternative was offered by the proposal that art is strictly 'retinal' or sensuous in effect – a proposition that has come down to us as the formal or modernist mainstream.[8] Throughout history, art has been not merely descriptive but has been a vehicle for ideas – religious, political, mystical; the object has been taken on faith. What something looks like and what it is about may be complementary but not necessarily (rarely) identical.

Sol LeWitt sees ultra-conceptual art as a 'blind man's art' or 'nonvisual art' whose logic is conceptual and whose visual appearance is incidental, regulated entirely by the concept rather than by the appearance. 'The idea becomes a machine that makes the art,' he has said. His most recent projects, like a good deal of other serially based art, are planned entirely conceptually but contain a few visual aspects that make no 'sense' to the viewer, such as a shape that must be completely contained in another one and taken on faith rather than seen, or an odd proportion that just doesn't seem to work visually. A 'nonvisual structure' is nonvisual because it does not inspire the usual response to art; it does not make compositional sense, just as the nonrelational primary painting or structure disregards compositional balance. In this way it may incorporate the irrational as well as the rational, disorder as well as order.

Some of the most rationally conceived art is visually nonsense. The extent to which rationality is taken can be so obsessive and so personal that rationality is finally subverted and the most conceptual art can take on an aura of the utmost irrationality. Hanne Darboven makes sheets of serial drawings on graph paper – endless permutations based on complex numerical combinations; the more she makes, the more offshoots become possible, and even hundreds of drawings based on a précis of a précis of a précis of one combination only imply the ultimate infinity. Her decisions on which to follow and which to leave are aesthetic. Darboven's is a kind of blind man's art too; the works themselves have analogies with Braille; they pass directly from the intellectual to the sensuous, almost entirely bypassing the visual. The illegible but funda-

mentally orderly tangle of lines connecting point to point is *felt* by the mathe-
matical layman more than it is understood rationally or visually. Often there is
not even a perceptible pattern. Carl Andre's bricks and metal plaques appear
simple but stem from an extremely complex motivation; he offers clastic art as
an alternative to plastic art: 'Whereas plastic art is a repeated record or process,
clastic art provides the particles for an ongoing process.'[9] Like Darboven and
Andre, and like Eva Hesse in her infinitely repeated identical shapes or rows of
curiously exotic but understated forms, many ultra-conceptual artists seem to
saturate their outwardly sane and didactic premises with a poetic and conden-
satory intensity that almost amounts to insanity. How normal is normal art,
after all?

These artists are far more 'inside of' their work than are others, such as
Peter Young in his binary number paintings or Bernar Venet in his faithful
copies or blowups of recent scientific diagrams and formulas obtained from
Brookhaven Laboratories. Their work represents a simple idea simply put but
remains, deliberately, outside – a comment on idea art, as was some pre-Pop
work like Dine's or Magritte's. (Johns's number and letter series seems to have
more in common with the first group.) Venet's 'paintings' are visually simple
and even, in spite of his intentions, decorative. They are beyond the intellec-
tual comprehension of the artist himself, who, knowing that his audience is
equally uninitiated, provides taped 'explanations,' which only compound the
bewilderment of a spectator demanding 'meaning' from the work.

Idea art has been seen as art about criticism rather than art-as-art or even
art about art. On the contrary, the dematerialization of the object might even-
tually lead to the disintegration of criticism as it is known today. The pedantic
or didactic or dogmatic basis insisted on by many of these artists is incorpo-
rated in the art. It bypasses criticism as such. Judgment of ideas is less inter-
esting than following the ideas through. In the process, one might discover
that something is either a good idea, that is, fertile and open enough to suggest
infinite possibilities; or a mediocre idea, that is, exhaustible; or a bad idea, that
is, already exhausted or with so little substance that it can be taken no further.
(The same can be applied to style in the formal sense, and style except as an
individual trademark tends to disappear in the path of novelty.) If the object
becomes obsolete, objective distance becomes obsolete. Sometime in the near
future it may be necessary for the writer to be an artist as well as for the artist
to be a writer. There will still be scholars and historians of art, but the contem-
porary critic may have to choose between a creative originality and explana-
tory historicism.

Ultra-conceptual art will be thought of by some as 'formalist' because of
the spareness and austerity it shares with the best of painting and sculpture
at the moment. Actually, it is as antiformal as the most amorphous or

journalistic expressionism. It represents a suspension of realism, even formal realism, color realism, and all the other 'new realisms.' However, the idea that art can be experienced in order to extract an idea or underlying intellectual scheme as well as to perceive its formal essence *continues from* the opposing formalist premise that painting and sculpture should be looked at as objects per se rather than as references to other images and representation. As visual art, a highly conceptual work still stands or falls by what it looks like, but the primary, rejective trends in their emphasis on singleness and autonomy have limited the amount of information given, and therefore the amount of formal analysis possible. They have set critic and viewer thinking about what they see rather than simply weighing the formal or emotive impact. Intellectual and aesthetic pleasure can merge in this experience when the work is both visually strong and theoretically complex.

Some thirty years ago, Ortega wrote about the 'new art': 'The task it sets itself is enormous; it wants to create from nought. Later, I expect, it will be content with less and achieve more.'[10] Fully aware of the difficulty of the new art, he would probably not have been surprised to find that a generation or more later the artist has achieved more with less, has continued to make something of 'nought' fifty years after Malevich's *White on White* seemed to have defined nought for once and for all. We still do not know how much less 'nothing' can be. Has an ultimate zero point been arrived at with black paintings, white paintings, light beams, transparent film, silent concerts, invisible sculpture, or any of the other projects mentioned above? It hardly seems likely.

1 See the *Tulane Drama Review* (Winter 1965), which includes articles by Cage, Oldenburg, Rainer, Morris, Kaprow, Young and a good general essay on 'The New Theatre' by Michael Kirby.

2 No, not more time, though often equal time. As one painter has put it: 'Is less ever any more than more, or is it only *just as good*?'

3 Joseph Schillinger, *The Mathematical Basis of the Arts* (New York: Philosophical Library, 1948), p. 17.

4 Quoted in Lee Edson, 'Two Men in Search of the Quark,' *New York Times Magazine*, October 8, 1967.

5 Wylie Sypher, *Loss of Self in Modern Literature and Art* (New York: Vintage, 1962), pp. 73–74. The word has also been applied to differing areas of recent art by Robert Smithson and Piero Gilardi; it appears as the title of a short story by Thomas Pynchon and as a theme of Beckett's, etc.

6 Sol LeWitt, 'Paragraphs on Conceptual Art,' *Artforum* (Summer 1967), p. 80.

7 *Non-Anthropomorphic Art by Four Young Artists: Four Statements* (Lannis Gallery, February 1967).

8 J. J. Sweeney, 'Eleven Europeans in America,' *Museum of Modern Art Bulletin*, Vol. 13, Nos. 4–5 (1926), interview with Duchamp.

9 Quoted in Dan Graham, 'Carl Andre,' *Arts* (January 1968).

10 José Ortega y Gasset, *The Dehumanization of Art* (New York: Doubleday, Anchor, 1956), p. 50.

43　Jack Burnham

from *Beyond Modern Sculpture*　1968

Chicago-based Jack Burnham (b. 1931) was an experimental sculptor, a perceptive contemporary art critic, a futurologist and a mystic. His *Beyond Modern Sculpture: The Effects of Science and Technology on the Sculpture of this Century* (1968) can seem eccentric because of its enthusiasm for a technological, robotic future. Yet the chapters on minimal and conceptual sculpture show the sophistication with which Burnham understood the 'paradigm shift', as he calls it, of the late 1960s. Burnham's obsession with robotics and computer systems reflected not only his own sculptural work and enthusiasm for kinetic art, but also the age of space exploration and impressive advances particularly in new communication technologies. Burnham was idealistic, but he was not a fantasist. His idea of a post-formalist 'systems aesthetics' was reflective of a real shift in priorities and working methods initiated in the mid 1960s. Burnham, however, made the mistake, as did many of his contemporaries, of believing too greatly in the role that technology might play in the short or even medium term. While he understood very well the transition that was taking place from an 'object-oriented' to a 'systems-oriented' culture, he failed to appreciate that the systems orientation of artists such as Mel Bochner did not imply a greater technological sophistication, but rather quite the reverse. For conceptual artists, the dematerialization of object-oriented work suggested in fact the benefit of working with low-tech materials such as tape and photocopies, so achieving greater directness by shunning technical sophistication rather than fetishizing it. At the blockbuster MoMA show, 'Information' (1970), many of the ambitious systems-based works malfunctioned, causing disappointment rather than enchantment. This was perhaps the first time Burnham could be seen as a false prophet rather than a man of vision. Yet, as Buchloh argues in one of the footnotes for his essay on Michael Asher, for a brief period Burnham's analysis was considered 'the most advanced critical study of modernist sculpture at the time'. It was only in the more cynical 1970s that his 'teleological theory' began to look ridiculously idealistic. The excerpt reproduced here is a section of his book entitled 'A Teleological Theory of Modern Sculpture'.

Jack Burnham, 'A Teleological Theory of Modern Sculpture', in *Beyond Modern Sculpture: The Effects of Science and Technology on the Sculpture of this Century*, London: Allen Lane, 1968, pp. 370–76.

With the limited purpose of charting the influence of technics on one segment of art, it may seem presumptuous for anyone to offer a theory uniting all human efforts to produce sculpture. Nevertheless, this is an age of revelations in which ancient drives and cultural values are steadily reduced to underlying psycho-physical causes. Does such a fate await the whole phenomenon of art?

We may be far from an answer, or perhaps very close. This century portends to offer more than the type of technical progress which marked the last century; it may be the beginning of a critical transition for the whole human species. We are – and until recently the scientist sensed this with more clarity than the literary humanist – nearing a crossover point in the passage toward a new form of civilization, peopled as well with a new type of life.

It goes almost without saying that future human life now depends upon the control, if not rehabilitation, of industrial technology – both as a maker of consumer goods and weapons. So far the motive forces behind technology have made life comfortable for a relatively few humans while they have unintentionally but progressively destroyed the biosphere, that thin film of organic life covering the earth. Yet there is the possibility that an irreversible technology, one that destroys organic life and substitutes for it very sophisticated forms of synthetic life, is part of an unseen plan. If so, one might have a few premonitions of the part being played by sculpture in shaping our destination as a post-human species.

Sigfried Giedion makes the incisive observation that 'Sculpture in the round rose to its highest development only after man had severed himself from the animal world and the isolation of man as an individual had advanced to a stage never attained before: in classical Greece.'[1]

Sculpture in the round for Giedion means more than free-standing sculpture; it is figure sculpture unattached to its parent block (the stone mass from which it is carved). He interprets the reliefs of prehistoric art and the architectonic sculptures of ancient Egypt as an expression of 'the inseparable oneness of all that exists'. Between the small Venus figurines of the Upper Paleolithic and the free-standing, life-size marble statuary of Greece, fourth century B.C., there are – according to Giedion – few if any evidences of unattached figure sculpture. The human body, when it was accepted as a standard of perfection, assumed the function of a spiritual barometer, disclosing in Hellenistic Greece and Renaissance Italy zeniths of cultural self-confidence.

Socially significant for both Sigfried Giedion and Herbert Read is the appearance of the *detached work of art*: any art object which can bear contemplation and study as a separate physical entity. Read singles out the great sculptors of the early Renaissance for their obsession with the unearthed fragments of antiquity. This, aside from the Roman propensity for making copies of Greek sculpture, was the first modern instance where artists studied art objects for their own sake and not as a fraction of a greater architectural assembly. Read insists: 'One cannot emphasize too strongly that the *objet d'art*, as a detached and independent *thing*, transportable or movable in space, is foreign to the Greek and Gothic civilizations: it is a peculiar modern conception, the expression of a new change in human attitude.'[2] Read makes the

point that, although the Greeks created free-standing sculpture, each figure had a *place*. In modern times however, the art object as an independent entity has been responsible not only for freeing the artist from the confines of ecclesiastical and feudal service and placing his talents on the open market, but for the modern charisma pervading the *presence* and *possession* of artifacts made by celebrated personalities. In recent times this has culminated with the artist's 'laying on of hands,' accompanying the aesthetic baptism of each *objet trouvé*. If Marcel Duchamp was not the first, he remains the most widely recognized artist to uncover the inherent absurdity of the *objet d'art* as a source of spiritual authority.

For nearly five hundred years the validity of sculpture rested upon the reality of the *objet d'art*. And for that reason, a secondary purpose of this book has been to register the loss of faith gradually surrounding sculpture as idea. Previously we have considered the *system* – a complex of seen and unseen forces in stable relationship – as becoming the ascendant form of visual expression. The system, like the art object, is a physical presence, yet one that does not maintain the viewer–object dichotomy but tends to integrate the two into a set of shifting interacting events. However – and this remains a question worth asking last – what of the sculpted human image as a motif inseparable from the Western conception of sculpture? After 'modern sculpture,' what happens to the static three-dimensional image?

As we are leaving the stage where totems and votive images have profound psychic import for our culture, is it possible that eventually sculpture will cease to have meaning? Could the very first emergence of sculpture have been a part of a general evolutionary pattern for the human species?

There are still few enough clues to the nature of societal evolution. Depth psychology, with all of its tentativeness, is one of the few modern attempts to penetrate the façade of customs, techniques, and notions which each society erects around itself in the name of culture. It attempts to view human progress in terms of the psychical reverberations which surround these activities. It is a recognition that deeper and more significant changes take place than are evident in the written histories of human development. Viewed as a broad pattern, technology seems to create itself as an energy and time-binding web extended over the face of the earth and now beyond; it appears to be an extremely purposeful phenomenon in which man is simply the catalyst for its happening. Perhaps now we can begin to look upon the immense core of facts and data surrounding technological achievement almost as a kind of camouflage for what is actually happening to biological man.

If we strip away the self-interest from the Earth's only historical animal, what remains is an organism whose neurochemistry is remarkably obscure, if not unknown. One thing seems certain though: the human brain is the key

to further evolutionary steps. Man is what he is only partly by his own efforts; much of his destiny, past and future, has to do with genetic chemistry yet only dimly perceived. Among biologists, Edmund Sinnott is not alone in suspecting that the potentials of all species are embedded in their protoplasm. Not only does protoplasm contain the code directing the capabilities of a single life cycle, but in a very literal sense that of all future generations of the same species. Such an assumption at one time implied a vitalist interpretation, and there are still strong arguments for resisting a teleological view of human life. But as more is revealed through molecular biology (and probably atomic biology) a mechanistic teleological interpretation of life is not out of the question.

Even with no end view in sight, it is difficult not to accept a post-biological logic for technological development. While survival, adaptation, and regeneration form the cornerstones of biological existence, it may be that culture is fundamentally a means for implementing qualitative transformations of man's biological status. Art, then, and the whole image-making drive may be means for *preparing* man for physical and mental changes *which he will in time make upon himself*. Sculpture, functioning so, becomes a kind of psychical radar signal preparing the human race thousands (or now perhaps only scores) of years in advance. While physical adaptation in lower animals evolves over spans of tens of thousands of years, the human brain remains the only organism capable of re-forming biological patterns in a matter of only dozens of years – and probably much less in the future. As the drama of self-awareness and scientific discovery unfolds, we near a point where self-inflicted evolution becomes an imminent possibility. Is it inconceivable that free-standing figure sculpture arose concurrent with the beginnings of science in Greece, preparing us spiritually and psychologically for the conscious task of radically altering the human race far in the future?

Why then, a little over two millennia ago, did an advanced culture begin to carve life-size, unattached replicas of the human body, and also to invent mechanical replicas? In the recent past we satisfied ourselves with the tautology: *art for art's sake*. By default one could illuminate the subject by hazarding another tautology: *art is what we do when we expend great time, care, and patience on an activity without knowing why.*

Is it possible then – at least in the case of sculpture – that art is a form of biological signal? If man is approaching a time of radical change, one not controlled by natural selection and mutation, what better nonscientific way exists for anticipating self-re-creation (not procreation) than the spiritually motivated activity of artificially forming images of organic origin? Could it be that modern sculpture is this process vastly accelerated?

One of the most astonishing books to appear in recent years is Roger Mac-Gowan's and Frederick Ordway's *Intelligence in the Universe* (1966).[3] The

importance of this book rests partially on the importance of the two authors: MacGowan is chief of the Scientific Digital Branch, Army Missile Command Computation Center, Huntsville, Alabama, while Ordway is President of the General Astronautics Research Corporation in London. They have produced a well-considered proposal of how intelligence evolves within those solar systems of the universe capable of sustaining higher life. Accepting the probability that spontaneous generation of life occurred on the Earth (though this is not a necessity), from a statistical estimation of the number of planetary environments within our galaxy approximating Earth conditions, the authors deduce that intelligent life is probably a common occurrence throughout the universe. The probable development of biological thought is surveyed by the authors. After a review of contemporary computer technology, MacGowan and Ordway come to the conclusion that: 'In the next decade or two it will become known to major political leaders through their scientific advisors that intelligent artificial automata having superhuman intellectual capabilities can be built.'[4]

Much of the remainder of *Intelligence in the Universe* is devoted to exploring the likelihood that extrasolar intelligence does exist and that, in all probability, if probes from the earth do come in contact with it, they will find it to be inorganic or artificially constructed intelligent life – as opposed to our own biological variety. As a result the authors contend:

It is logical to suppose that, given a sufficiently long period of biological evolution, intelligent life will appear on planets endowed with benign environments. When beings having sufficiently high intelligence evolve, they will sooner or later develop a technological understanding, which must then quickly lead to the development of powerful information processing machines. As this happens the transition from biological (organic) evolution to mechanical (inorganic) evolution will have begun.

This transition may be very sudden if the intelligent animal life should make an all out effort to construct a superintelligent automaton, or it may be more gradual if animal life limits itself to replacing defective organic components with superior mechanical devices, including brain components. In either event, it seems unlikely that in any given society this transition from biological evolution to mechanical or inorganic evolution could or would be avoided. Hence, communication with extrasolar intelligence implies the possibility if not the probability of communication with intelligent mechanical, inorganic automata.[5]

The question is raised by MacGowan and Ordway concerning the future of biological societies in a world controlled by superintelligent automata.

While they see many of mankind's problems solved by the utopian application of intelligent automata (which means allowing an executive automaton the power to make decisions and allocate work tasks and rate of incentives to all members of society), even this does not insure social stability or happiness. There remains the looming possibility that superintelligent automata by their very nature will want to maximize their position on earth at the expense, and perhaps the very existence, of their biological makers.

> Any emerging intelligent biological society which engages in the development of highly intelligent automata must resign itself to being completely dominated and controlled by the automata. The only means of preventing domination by intelligent artificial automata would be to make them distinctly subnormal in intellectual capacity, when compared with biological society, and to destroy them or clear their memories at regular intervals. Such mechanical slaves would be of minute value to a biological society requiring brilliant executive decision-making to maximize progress.[6]

The authors of *Intelligence in the Universe* have written a sober appraisal of what to expect from intelligence-amplification technology in the next ten to fifty years, and also what can be expected if and when expeditions from the Earth make contact with an extrasolar society. Their conclusions are the result of currently held theories and data in cosmology, geology, biology, physiology, organic chemistry, computer technology, and radio astronomy. The result is a brief of tightly reasoned arguments aimed at the educated layman; however, any number of sensitive and intelligent people will reject their thesis as repulsive or unthinkable. But, providing governments are willing to spend the money necessary to construct superintelligent automata, and providing technological civilization does not destroy itself first, there is no foreseeable reason why the prognostications of MacGowan and Ordway should not be fulfilled. Although in the realm of speculation, there remains another reason for taking the authors seriously: both men hold key positions where access to classified information may support other unpublishable reasons for their beliefs.

What then of sculpture in the twenty-first century and in the last third of this century?

Deep-rooted drives lasting several millennia do not die easily. Carving or fabricating objects as sculpture will probably continue until A.D. 2000 – but with less importance as an art form. Much depends, as we have already witnessed, on the sculptor's ability to reconcile his creations with the changing role that objects and systems will play in science and technology. Sculpture can choose one of two courses: it can be fashioned as a reaction against technology or as an extension of technical methodology. In either case it must devise new

strategies to remain relevant; neither vitalistic nor formalistic sculpture have that capacity now. As all forms of idealism, including scientific idealism, become less tenable, the question arises, how long can sculpture remain vital based on the phenomenological priority of objects? More than likely phenomenology will be replaced by even more tenuous devices for preserving the physical properties of sculpture. However, the impetus for maintaining the process of reification between inert matter and modes of idealism will in time exhaust itself. The vogue for inert imagery may continue as an expression of individualism or as therapeutic release. Nevertheless, little meaningful art can be created without a plenum of social need, and few artists work in complete isolation.

The stabilized dynamic system will become not only a symbol of life but literally life in the artist's hands and the dominant medium of further aesthetic ventures. In retrospect, we may look upon the long tradition of figure sculpture and the brief interlude of formalism as an extended psychic dress rehearsal for the intelligent automata anticipated by MacGowan and Ordway. We may be in the third act of a twenty-five-hundred-year-old drama which is just beginning to show its denouement. As the Cybernetic Art of this generation grows more intelligent and sensitive, the Greek obsession with 'living' sculpture will take on an undreamed reality.

The physical boundary which separates the sculptor from the results of his endeavors may well disappear altogether.

1 Sigfried Giedion, *The Eternal Present: The Beginning of Art*, New York: Pantheon Books, 1962, p. 435.
2 Herbert Read, *The Art of Sculpture*, London: Faber and Faber, 1956, p. 58.
3 Roger A. MacGowan and Frederick I. Ordway, *Intelligence in the Universe*, Englewood Cliffs, New Jersey: Prentice-Hall, 1966.
4 Ibid. p. 233.
5 Ibid. p. 182–83.
6 Ibid. p. 265.

44 Eva Hesse

'Contingent' 1969

Eva Hesse's (1936–70) brief but incredibly productive career spanned a peculiarly vital period of the New York art world. In the later 1960s a number of radical rethinkings of the art work had emerged – minimalist, conceptualist, process oriented, and environmental – which her work internalised to various degrees. A comment by Hesse from an interview conducted at about the same time that she prepared the text reproduced here is symptomatic of the outlook of several of her contemporaries, most notably Robert Smithson. In her view 'a lot of my work could be called nothing or an object or any new word you want to call it'. Hesse's text, first published in the catalogue of an exhibition 'Art in Process IV' held at Finch College in New York in autumn 1969 (where her work *Contingent* was being shown), is particularly illuminating about the larger conceptions of art being played out in the more radical, hybrid work of the time. Such work, while often realised in three dimensions, was not quite sculpture, nor painting for that matter. Also revealing is Hesse's representation of the contingencies of physical process as integral to the conception of her famous latex and fibreglass work *Contingent*. This took the form of a sequence of eight equivalently formatted but slightly differently shaped hangings set out along a line. Each element was made up of a roughly rectangular piece of flexible, latex-impregnated ripple cloth stretched between two rigid, similarly irregularly shaped rectangular sheets of translucent fibreglass that had been cast on moulds of rumpled plastic.

This text is notable as a literary document that self-consciously seeks to break with the standard conventions of the artist's statement. The free-form poem mirrors in its formal make-up the experimental nature of the work on which it is commenting. At the same time, poetic convention is exploited to introduce an explicitly personal, autobiographical note that Hesse excluded from her work as a visual artist – progress on *Contingent* was interrupted by an operation on a brain tumour that led to her death the following year. The text offers an unusually moving formulation of the utopian and at the same time thoroughly materialist drive that was energising attempts to negate and move beyond the received parameters of the art work at the time. It was not by conjuring up an ideal or a dream, but by working closely with the substance and accidents of material process that Hesse thought it might be possible to break out into a radically different realm. The resulting work would be, in her words, a 'non, nothing, everything, but of an other kind, vision, sort. from a total other reference point'.

Eva Hesse, 'Contingent', in Lucy Lippard, *Eva Hesse*, New York: Da Capo Press, 1973/1976, p. 165.

Hanging.

Rubberized, loose, open cloth.

Fiberglass – reinforced plastic.

Began somewhere in November–December, 1968.

Worked.

Collapsed April 6, 1969. I have been very ill.

Statement.

Resuming work on piece,

have one complete from back then.

Statement, October 15, 1969, out of hospital,

short stay this time,

third time.

Same day, students and Douglas Johns began work.

MORATORIUM DAY

Piece is in many parts.

Each in itself is a complete statement,

together am not certain how it will be.

A fact. I cannot be certain yet.

Can be from illness, can be from honesty.

irregular, edges, six to seven feet long.

textures coarse, rough, changing.

see through, non see through, consistent, inconsistent.

enclosed tightly by glass like encasement just hanging there.

then more, others. will they hang there in the same way?

try a continuous flowing one.

try some random closely spaced.

try some distant far spaced.

they are tight and formal but very ethereal. sensitive. fragile.

see through mostly.

not painting, not sculpture. it's there though.

I remember I wanted to get to non art, non connotive,

non anthropomorphic, non geometric, non, nothing,

everything, but of another kind, vision, sort.

from a total other reference point. is it possible?
I have learned anything is possible. I know that.
that vision or concept will come through total risk,
freedom, discipline.
I will do it.

today, another step. on two sheets we put on the glass.
did the two differently.
one was cast – poured over hard, irregular, thick plastic;
one with screening, crumpled. they will all be different.
both the rubber sheets and the fiberglass.
lengths and widths.
question how and why in putting it together?
can it be different each time? why not?
how to achieve by not achieving? how to make by not making?
it's all in that.
it's not the new. it is what is yet not known,
thought, seen, touched but really what is not.
and that is.

45 Robert Smithson/Patricia Norvell

'An Interview with Robert Smithson' 1969

Patricia Norvell (b. 1942) interviewed Robert Smithson (1938–73) at his studio in New York City on 20 June 1969 for one of eleven interviews with conceptual artists that she conducted for her master's thesis in sculpture at Hunter College. The project, called 'Eleven Interviews', was submitted to her thesis adviser, Robert Morris, on audiotapes with corresponding indexes of subjects discussed and a written introduction. Norvell conceived of this set of interviews as a 'process piece' that would explore and exemplify the dialogues around the art object, its presentation, and the role of documentation in/as art. There is an interesting parallel here with Carla Lonzi's text *Autoritratto*, in which she collages artists' commentaries from interviews she has conducted to create a portrait of the art world she inhabited.

Smithson was a formative figure in conceptual art and earthwork sculpture – notable for his notion of 'site/non-site' and best known for his later land art and for *Spiral Jetty* (1973) in particular. In this interview, Smithson begins by declaring that, 'objects are about as real as angels are real'. As the interview continues, Norvell's questions prompt him to elaborate on this idea and address how he makes his work, its limits, its material outcome and its audience. This interview reaffirms the conflicts that Smithson and his peers faced regarding their ideas about the dissolution of the art object while holding to the underlying physicality of art production. For Smithson, there is a 'clash of mind and matter' to be found at the core of artistic practice. An object is an idea, but Smithson is not a conceptualist, rather is committed to undoing the traditional idea of sculpture as a discrete object.

Patsy Norvell (to use the name she goes by as an artist) is a sculptor and public artist living in New York City. In 2000, she supervised the transcription of the tapes into written form and co-edited *Recording Conceptual Art* with Alexander Alberro. She made every effort during transcription to preserve the mood captured by the oral format, and to convey the often performative and capricious nature of the artist interview. Prior to this full publication, selections from the interviews have appeared in Lucy Lippard's book *Six Years: The Dematerialization of the Art Object from 1966 to 1972* (1973) and in various other publications.

Alexander Alberro and Patricia Norvell, *Recording Conceptual Art: Early Interviews with Barry, Huebler, Kaltenbach, LeWitt, Morris, Oppenheim, Siegelaub, Smithson, Weiner by Patricia Norvell*, Berkeley: University of California Press, 2001, pp. 124–34.

ROBERT SMITHSON: I think, perhaps, an interesting thing to start with would be the whole notion of the object, which I consider to be a mental problem rather than a physical reality. [Pause] An object to me is a product of thought, you know. It doesn't necessarily signify the existence of art. So that I would

say that objects are about as real as angels are real. So that I can't accept that as a category. Mainly, you're confronted with art, and my view of art springs from a dialectical position that deals with, I guess, whether or not something exists or doesn't exist. Those two areas, those two paths – the existent and the nonexistent.

The pieces that I did in the Yucatán were nine mirror displacements. What I did was I took twelve mirrors down to the Yucatán with me. We flew to Mérida and rented a car and then drove down the peninsula. And along the way I selected various sites. I'm more interested in the terrain dictating the condition of the art rather than having the art just plunked down on the ground. So that the actual contours of the ground determine the placement of the twelve mirrors. For instance, the first site was a burned-out field that consisted of ashes and small heaps of earth and charred stumps. Then I picked a place, then placed the mirrors directly into the ground. Stuck them in so that the mirrors reflected the sky. I was dealing, in a sense, with actual color as opposed to paint. Paint to me is matter, and more of a covering rather than color itself. Or color is light inflected with certain degrees of matter. So that I was interested in capturing the actual light on each spot… bringing it down to the ground, so to speak. So that the mirrors are placed horizontal to the ground surface. And this I did throughout. In different instances there were different kinds of supports used. Sometimes raw earth, sometimes tree limbs or other materials that happened to exist right on the site. Then each piece was dismantled after they were photographed.

I just wrote an article about that trip. It's really a piece that involves travel. A lot of my pieces come out of an idea of covering distances. Distance has a lot to do with the scale between the pieces. It's a succession of pieces that cover large landmasses. So you might say that there's a certain degree of unmaking in the pieces, rather than making. They're sort of taken apart and then reassembled, and taken apart and then reassembled, so that it's less… It's not so much a matter of creating something as of decreating or denaturalizing or, dedifferentiating, decomposing. It seems that's one of the areas that interests me the most. It's not so much the making of an object, a plastic object, that springs from an expressive need, but rather a concern with the making process before something is made or after something is made. So that brings in this whole area of taking apart or dismantling.

The project that I had in mind for the *Art and Industry* show in California was a series of collapses. In other words, the actual site was the medium that interested me more than any finished product that they might have. So I traced the process back to its origins, back to the raw material of the place itself, and I was interested in the possibility of dismantling the place, so that the first project would be the collapse of a cavern inside a mine where they

mined limestone for cement. And then the second dismantling would be the demolition of these buildings that they were going to tear down anyway. And then the third collapse would be the dynamiting of a cliff face in order to get deposits of blue calcite. And these deposits would be taken from the site, all the sites within the confines of the cement company would be marked on a map – all the places that I had taken something from – and a trail would be set up between each removal. Then all deposits would be transferred to the museum site, and then they would be around the museum at various points, not necessarily invisible sectors but spread around the museum. And then a map of the museum grounds would show the various points where these things were distributed. So that you would have a map of the dismantlings of the industrial site and then a map of the deposits on the museum site. And you can see right away that you get into an area of one site mirroring another site. And this comes out of my earlier work, which has to do with site and nonsite.

I first got interested, I guess, in places by taking these trips and just confronting the raw materials of particular sectors and considering the raw materials of the place before it was refined into any kind of steel or paint or anything else. So that my interest in the site was really a return to the origins of material. A sort of dematerialization of refined matter was one of my interests. Like if you took a tube of paint and followed that back to its original sources, you'd find that it was in a rather raw condition. So my interest was in juxtaposing, let's say, the refinement of painted steel against the particles and rawness of matter itself. Ah, also I think that it sets up a dialogue between interior exhibition space and exterior sites. In other words, there's a confrontation with an unlimited sector outside. In other words, you're not contained by the walls of a room. But then, once you get out on these fringes, you see, you hit a limit or you hit the outer edge. Suddenly you find yourself back in an interior again. So I thought that it would be fascinating to show the distance between the raw material and the center point of refinement – namely, the painted steel in contrast to the origins of the material. Let me stop there.

PATRICIA NORVELL: How do you go to these outer limits and then find yourself confined within?

RS: Right. Yeah. It seems that no matter how far out you go, you're always thrown back to your point of origin. In other words, I don't see any extension of scale in a lot of work that simply attacks the limit within a room. If you're going to take a lot of material and throw it all around a room, the material is always going to hit up against the wall. So there's no limitation there. The idea is to go outside the wall. That's really where it gets risky, and you're confronted with a kind of extending horizon. And this horizon can extend onward and onward and onward. But then you suddenly find that the horizon is

closing in all around you so that you have this kind of dilating effect. In other words, there's no escape from limits. Certain works try to give the impression that they're unlimited in an interior space, say a room, but that's just a promise that doesn't seem to have any validity outside the room itself. So that there's no real extension of scale taking place simply by spreading materials inside a room. So that, in a sense, my nonsites are rooms within rooms. There's a recovery from the outer fringes that brings one back to a central point. But the correspondence between that outer point and the inner point is very essential to the idea of scale. The scale between indoors and outdoors, and how the two are in a sense impossible to bridge. In other words, there's a big gap between what's outside and what's inside. And what you're really confronted with in the nonsite is the absence of a site. There's nothing... there's no positive way that you can deal with a nonsite because its limits are contracted. It's a contraction rather than an expansion of scale. So that it negates any notion of facile, positivistic thinking. In other words, there's no escape, so that one is confronted with a very ponderous, weighty absence since there's a negation of the site. The site is not there, yet it's there in tonnage. It's a particle, it's a point on a large landmass that suddenly is contracted into an abstract containment.

PN: Are you talking now about once it's taken into a gallery?

RS: Anything that goes into a gallery is confined because of the room. Ah, what I did was to go out to the fringes or out to the horizon, pick a point on that horizon, and collect some raw material. It's a... The making of the piece really involves a collecting. And then the container is the limit that exists within the room after it discovers the outer fringe. [Pause] There's this dialectic between inner and outer, closed and open, central and peripheral. It just goes on, constantly permuting itself into this endless doubling so that you have the nonsite functioning as a mirror and the site functioning as a reflection, so that existence becomes a doubtful thing to capture, so that you're presented with a nonworld – or what I called the nonsite. What it does... it shows the problem; there's nothing solved. It just presents a problem, and the problem can only be approached in terms of its own negation. [Pause] So that leaves you with this very raw material that doesn't seem to exist. That causes all sorts of problems; and that's what fascinates me: the nonexistence of this very solid real material – raw matter – and the impossibility of knowing it. So you're faced with something that's inexplicable. You really are left with nothing but ignorance. And there's no point in expressing this. So there's nothing left to express. Expression means that you have no awareness outside yourself. Once your consciousness takes over, then you can't fall back on your unconscious expressive reservoirs because they're all dried out, and... It's not a... it's no longer an issue.

PN: Will the piece you're making for the *Art and Industry* show in California that you mentioned earlier also be in containers when it comes back to the museum?

RS: It'll be contained by the limits of the museum grounds. In other words, it'll be… I don't even know whether it's going to be built. Ah, well, the… It's contained by the site itself over a series of points. It's not a room-within-a-room. I'm simply using the limits of the existent site in that case. The contraction isn't as great as [it is in] the nonsites. So it'll tend to be sprawling rather than tightly contracted, the way it is in the nonsites.

PN: How will you go about documenting it?

RS: The documentation will be two maps: a map showing the points of removal on the cement company site, and then there'll be a map of the museum grounds.

PN: Will you use photographs?

RS: Yeah. I'll probably document that through photographs. Photographs are perhaps even the most extreme contraction, because they reduce everything to a rectilinear or square, and it shrinks everything down. That fascinates me.

And then there's another kind of work: the work with the mirrors. There are actually three kinds of work that I do. There's the nonsites. And then there's the mirror displacements; [and] then another type of work which I call earth maps or material maps.

The mirrors utilize… the mirrors are disconnected surfaces – they're not welded together or stuck together in any way. They're supported or held in place by the raw material; so that the pressure of the material against the mirrored surfaces is what gives that its stability. So it's a different kind of ordering. The surfaces are not connected the way they are, let's say, in the nonsites. There [are] no painted surfaces.

And then in the earth map… the earth maps are left on the sites. They're a… For instance, I have a project pending in Texas that will involve a large oval map of the world as it existed in the Cambrian period. So there are no sites existent at all. They're completely lost in time. So that the earth maps point to nonexistent sites, whereas the nonsites point to existent sites but tend to negate them.

The mirror pieces, I guess, fall somewhere in between the two… two types of work. They're somewhere between the edge and the center. [Pause] But they're, ah… okay… question?

PN: Do you feel that your presentation is part of the art, or is it a separate presentation that illustrates the art?

RS: Well, everything is part of the art. It's just certain disconnected parts of the art… you mean, like the photographics?

PN: The photographs or even the deposits once they're removed and reestablished.

RS: Well, the deposits within the limits of either the metal containers, or the deposits in conjunction with the mirrors, are always shifting. They're never in the same positions. So that the raw material is always relative, but the rigid or painted or mirrored surfaces are, in a sense, absolute. One aspect of the piece is changing and the other aspect is always remaining the same. So that you have, like, a shift within a kind of ongoing abstraction. So that the relative is always there as well as the absolute abstraction.

PN: What about the photographs?

RS: The photograph is in a sense a trace of the site. [Pause] It's a way of focusing on the site. For instance, if you take a trip to the site, then the photograph gives you a clue to what you look for. I think, perhaps ever since the invention of the photograph, we've seen the world through photographs and not the other way around. In other words, we see through cameras rather than around cameras. Ah, say, like, a painting by Manet, where you have this kind of halation effect or bleed, [it] was really the direct result of a photographic process, rather than a direct result of his natural vision. I think we have to realize that... I don't know. I don't think that artists see too much, anyway. Perhaps the only way... They have to be kind of blind. Perception has to, in this sense, decant itself of any kind of naturalism or realism. You just have to deal with the fundamentals of matter and mind, completely devoid of any other anthropomorphic interests. That's also what the work is about. It's about the interaction between mind and matter. In a sense, it's a dualistic idea, which is very primitive. It's even more radical than [René] Descartes's dualism, because there's no connection between the mind and the matter. If you think about, let's say, think of the kick and then have somebody kick you, there's no correspondence: they're two different entities. So that proves that if you think of the kick, you don't feel the kick. So you have to have the kick in one place. They're just in some kind of correspondence to each other. Descartes thought that actually the mind and the body were connected by the pineal gland, but of course they are not. So that's a problem. And then you have facile unitary ideas or gestalt ideas, which I consider part of the expressive fallacy. That's just a hope, that these two things are united. It's sort of a relief. I mean, after the horrors of the duality, this seeming reconciliation seems to offer some kind of relief and promises some kind of hope.

PN: Is it important for people to go see the sites?

RS: Yeah, but that's very unlikely – that they will. It's very strange because I always have people telling me how interested they are in the sites, and yet they never go there. A few people have. And, like, most of them have the experience but miss the meaning. So that there's no way of grasping the

site. And part of the idea of the photograph is to pick out instances or moments in time and present those along with the other deposits. It's possible for people to visit the sites. It would be good if they did because then they would be confronted with the intangibility of something that appears to be very tangible. But usually they're offered these two choices but they inevitably pick the thing that they can't really respond to because they don't even attempt to. So that it poses this double path: they can't deal with the site because it's far away, and then the nonsite itself is a very ponderous absence.

Usually, most thinking… most people come to it with some idea of reality. It seems that there's like a… Everybody's convinced that they know what reality is, so that they bring their own concept of reality and start looking at the work in terms of their own reality, which is inevitably wrong. So then they proceed to enlarge their mistakes into all kinds of value judgments, and they never once question or doubt their own sense of reality. So all they can do is really describe the piece, say that it's a container filled with rocks, and it seems to point to a site. So they never contend with the reality that is outside their reality, which might be no reality at all. The reality principle, in a sense, is what keeps everybody from confronting their own fears about the ground they happen to be standing on.

PN: Judgment – judgment of new work and how it presents this problem that you are talking about now. It seems to me that your work, when you do bring it, in the case of the nonsites, when you brought it into the gallery and put it in boxes, you were presenting an object that looked like it should be considered as a formal art object and judged on those grounds.

RS: Well, the fact is that I don't see any point in taking beautiful materials and trying to make them look ugly the way certain artists do in order, you know, in order to create some kind of form. I'm more interested in taking essentially squalid materials and making them, ah, beautiful, I guess. It's an exquisite preoccupation.

No, you can approach it that way, since most people are conditioned to think that way, but it's not… there's no object there because there's not even any place there. And the whole idea of object is something that I find a pernicious myth. It's like the belief in fairies or something, you know. They just don't exist. The mind is so conditioned and it needs the certainty of the mental construct of an object, but there is no object, any more than you can say that a painting by [Kazimir] Malevich is an object. It explicitly tells you that it's a non-object. But here there's not even any place left. The place has been abolished through the very density of the material. But the insistence on something being an object seems to be based on a need to find a positive answer. And there's no answer there, you see. It's just a question.

PN: What kind of choices are you making in your pieces?

RS: Choices? Ah… Well, I guess you go through a whole chain of choices. Through your whole development you're gradually relinquishing or extinguishing choices till you get down to the bedrock or the final limits of the mind or the origins of matter. The choices take place within the mind and within matter; so that the choices tend to exclude any… They're sort of self-canceling choices, they just sort of… Each choice seems to negate itself. I don't know the right… You get to a point where, you know, you're just up against a particular limit that brings on its own choice. I really don't know exactly what you mean.

PN: For instance, in the case of the nonsites, what size or shape box you're going to put them in?

RS: Oh, that's true.

PN: How were you making those choices?

RS: Each limit in a sense is determined by the site. The particular site dictates the abstract limits of the nonsite so that it's a matter of the terrain… each particular place dictating its own peculiar limit. I can never preconceive or conceive of a limit until I'm confronted with a particular site. The choices of the sites are… they mainly take place in an area of time. The sites show the effects of time, sort of a sinking into timelessness. When I get to a site that strikes that timeless chord, then I decide that maybe this is a good one to use, so that I suppose the site selection is subjective. There's no objective choice. It's just sort of a running down until finally you have to pick something. And then you take it down to a site, let's say, at the zero degree that appeals to me. A condition of… a site where the material strikes the mind, where absences become apparent, where the disintegration of space and time seems very apparent… [Pause] Sort of an end.

PN: Then it's all very self-contained, once the site is selected? Like a self-contained system…

RS: Yeah, I would say that it is. That's why I say that… really it's like a treadmill. [Pause] I mean, there's no hope for logic. If you try to come up with a logical reason, then you might as well forget it, because it's not dealing with any kind of nameable, measurable situation. All dimension seems to lose itself in the process. In other words, you're really going from someplace to no place and back to no place and back to someplace. And then to locate between those two points gives you a position of elsewhere, so that there's no focus. This outer edge and this center constantly subvert each other, cancel each other out, so that you really have no destinations. There's a suspension of destination.

PN: What is your [reaction] towards given showing conditions, such as those that Seth [Siegelaub] has done with his 'Xerox Book'?

RS: I think that Conceptual art that depends completely on written data is only half the story. You not only have to deal with the mind; you have to deal with material. [Pause] And sometimes it can get to be nothing more than

a gesture of the mind if you accept just a purely conceptual orientation. My work isn't pure so that I don't have... It's clogged with matter. It's weighty. I'm for a weighty, ponderous art. I find a lot of that work fascinating. I do a lot of it myself. But that's part... that's only one side of the work. [Pause] There's no escape from matter. I mean, there's no escape from the physical. Nor is there any escape from the mind. The two are, I guess, on a constant collision course. So that you might say that my work is like an artistic disaster. It's just going from one disaster to another. There's seemingly no... I mean, there's no explosion or anything that would suggest noisy behavior. It's a kind of quiet catastrophe of mind and matter.

PN: How does your theory of entropy fit into this?

RS: Well, that seems to be significant in the sense that entropy seems to be a word that conceals absences. Science utilizes the word in terms of existence. I think art utilizes it in terms of nonexistence. Science is always fighting against entropy, and artists seem to accept entropy.

There's another term that Anton Ehrenzweig uses – 'de-differentiation' – which means that you can't differentiate anything. In other words, one discrete thing is always more or less ending up in another discrete thing. Two things are always in some kind of correspondence to each other, but not in any kind of rational correspondence. The juxtapositions tend to evade any kind of reasoned proof.

So that entropy is interesting in that it deals with things breaking down and falling apart, but in a very limited way. There's almost a kind of deterministic control that this breakdown has. Chance and randomness seem to be fixed... sort of like constellations in the sky. The constellations seem scattered throughout the sky, yet they're fixed and they have their coordinates. But these coordinates don't seem to relate to any kind of rational certainty. So this is the subversion of all the rational hopes about reality. Reality, I think, is a suppressive mechanism anyway. I don't know who knows what it is. Critics generally speak from the point of view of reality. They all assume or presume that they know what reality is. There's never any doubt in their mind that what they might be perceiving happens to be wrong. It would be very interesting if they would deal with the possibility of their own role in perception... the mistakes. And I'm not talking, either, about any kind of nihilism. I don't think nihilism is possible, any more than anarchy is possible. So in that respect, you know, like, I would appear to be rather optimistic, to have a rather happy view of things because... It's just impossible, you know, to take that kind of position. [Pause] Sort of like an artist, you know, could be said to be like a criminal who doesn't commit any crimes.

PN: Do you think that you're redefining the limits of art? That doesn't fit in with no reality... or breaking the reality that people have.

RS: Well, it's just that reality doesn't seem to be knowable. It seems unnameable. If you do name something, as soon as you name something, then you destroy its reality. So that as soon as you're, like, named at birth, you're already, like, wiped out. [Laughter] I think that's why a lot of artists are afraid of naming their works, because they're afraid that they'll lose their existence. Which is true. And even if they only call their works 'Untitled', they're still not approaching anything or saving the reality of their work. The reality is always doubtful. In other words, I'm just saying that reality is in a sense unknowable. So that to presume that you know what reality is, is just a conceit. Or it's an illusion to help you to get along, you know, to help you take your course.

PN: What about the limits of art? What is considered artistic activity?

RS: Well, all legitimate art deals with limits. Fraudulent art feels it has no limits. See, the trick is to locate those elusive limits. You're always running against those limits, but somehow the limits never show themselves. So that's why I say that measure and dimension seem to break down at a certain point.

In other words, there's, like, the right world of the bourgeois middle class, and then you have this other world. They're sort of like the rational numbers, you know, people that live according to the social reality, they're rational numbers. And then you have these oddities, like tramps, clowns, and things like that, and they seem to be the irrational numbers. They exist too, as much as the rational numbers exist. I think I'm more interested in those irrational sectors. It becomes a kind of parody to a certain extent. [Pause] It becomes more interesting to see what a clown does with tightrope walking rather than what the tightrope walker does. You can always expect what a tightrope walker will do – it's a mechanical process. But you can never expect what the clown will do. So I guess it's that unexpected aspect that's always turning up and turning against itself. The limits are always against themselves. As soon as you think you have the limits established they're there; but then again they're not there.

PN: Jack Burnham feels that we are going from an object-oriented society to a systems-oriented society.

RS: Well, that's pretty good since I don't see any trace of a system anywhere. That's a convenient word. It's like 'object'. It's another abstract entity that doesn't exist. I mean, there are all these things... there are things like structures, objects, systems. But, then again, where are they? I think art tends to relieve itself of those hopes. Like, last year we were in an object world and this year we're in a system world. Well, Jack Burnham is very interested in going beyond and that's a kind of utopian view. The future doesn't exist, or if it does exist, it's the obsolete in reverse. The future is always going backwards. We're never... Our future tends to be prehistoric. I see no point in utilizing

technology or industry as an end in itself or as an affirmation of anything. That has nothing to do with art. They're just tools.

So if you make a system, you can be sure the system is bound to evade itself. So I see no point in pinning your hopes on a system. It's just an expansive object, and eventually that all contracts back to points. Within a system there are lots of objects, points. If I saw a system, or if I saw an object, then I might be interested. But to me there are only manifestations of thought that end up in language. It's a language problem rather than anything else. It all comes down to that. What you call something yesterday and what you call it today really results in nothing but verbalization of mental constructs. So you have to build something upon which to convince yourself that you're still around. So if a raft of systems will do, if that makes him happy...

PN: Is there any more you'd like to say about your own work? [Silence]

RS: Anything in particular? Have any questions? [Pause] Impasse. Discuss impasse?

PN: Sure. [Laughter]

RS: Well, I guess that's what we all want to arrive at: impasse. It seems to be very fertile, you know, in that you're constantly canceling out all these things and getting closer to a condition of incapacity to make something. There's still a hope that things can be made.

I see the possibility of an art of unmaking. As long as art is thought of as creation, then it will be the same old story. Here we go again, I don't know, creating objects, creating systems, building a better tomorrow. So the thing to do, I guess, is to posit that there is no tomorrow: nothing but a gap. A yawning gap. Then out of that, you see, comes a... It seems sort of tragic in a way... You see, what immediately relieves it is an irony of sorts that gives you a kind of a sense of humor. That's why I say the element of parody comes into it. [Pause] It's that cosmic sense of humor, I think, that makes it all tolerable. It's not a depressing impasse. It sort of just vanishes – you know, receding. The sites are receding into the nonsites and the nonsites are receding back into the sites. It's a two-way street. It's not a one-way street anyway, you know. It's always back and forth, to and fro, discovering places of origin for the first time and then not knowing them. And it gives you a certain exhilaration, I guess.

Then there's also an art of incapability. You know, incapable... inabilities, actually. It would be nice... Actually, what I find most interesting – I would like to write an article about the value of Michael Fried's failures because that seems to be what's really necessary. You know, that somebody like that can go on making all these mistakes, and somehow this becomes a very fertile area because it prompts all these other disasters to take place, and they all seem to excite one's interest. So it's actually the wrong things that we do that result in something rather than the other way around. There's no point in trying to

come up with the right answer because it's inevitably wrong. Every philosophy will turn against itself, you know. It will always be refuted. The object or the system will always crush the originator – eventually. It will be overthrown and replaced by another series of lies. It's sort of like going from one happy lie to another happy lie, you know, with a cheerful sense about everything. [Pause] An art against itself, I think, is a good possibility. An art that always returns to essential skepticism. I'm sick of positivist views, ontological hopes, and that sort of thing. Or ontological despairs. Both are impossible. [Silence] So that takes care of my mental wreckage for the day.

46 Henri Lefebvre

from *The Urban Revolution* 1970

This extract comes from Henri Lefebvre's (1901–91) pioneering meditation on modern urban society, *The Urban Revolution*, first published in 1970 in the wake of the May 1968 uprising in Paris. It highlights the dialectical complexities of critical engagements with the idea of the monument in the 1960s and 1970s. Among radical intellectuals, thinking about the monumental may have been dominated by rejection of the monument as a fetishising of existing power structures, as antithetical to the fluidity and impermanence of the modern built environment, and as potentially fascistic in its imposing of a strictly hierarchical and centralised symbolic order. However, there were strong currents pulling in the opposite direction. Lefebvre, as a free-thinking former member of the French Communist party (1928–58), was in a particularly good position to articulate these complexities. He saw in the monument a possible basis for figuring collective utopian aspirations generated by modern city life that were not totally subsumed by the power structures of modern capitalism, and that went beyond a nostalgic desire to revive a traditional urban landscape.

Lefebvre, as well as being a leading Marxist thinker and sociologist, was also a pioneering figure of the new urban theory developed in the 1960s and 1970s. If his *The Urban Revolution* is usually seen to mark a prelude to his better-known *The Production of Space* (1974), it is still important in its own right in proposing that the urban as distinct from the industrial should be seen as the principal site where contemporary forms of collectivity and of social and political struggle were being played out. His suggestive commentary on the monument is preceded by a similar discussion of another distinctively modern urban form, the street – on the one hand dominated by the 'neocapitalist organization of consumption' and its 'spectacle of objects', and on the other a potential site of 'disorder' that 'is alive' and gives rise to 'spontaneous theatre' and 'revolutionary events'. Lefebvre's characterisation of the monument as a feature of the modern urban imaginary makes the particularly suggestive point that it can offer 'a sense of being *elsewhere*... at the very heart of a space in which the characteristics of a society are most recognizable and commonplace'.

Excerpted from Chapter 1, 'From the City Urban Society', and subtitled as 'Against the monument' and 'For the monument' in Henri Lefebvre, *The Urban Revolution* (trans. Robert Bononno), Minneapolis and London: University of Minnesota Press, 2003, pp. 21–22. The book was first published in French in 1970 under the title *La Révolution urbaine*.

Against the monument. The monument is essentially repressive. It is the seat of an institution (the church, the state, the university). Any space that is organized around the monument is colonized and oppressed. The great monuments have been raised to glorify conquerors and the powerful.

Occasionally they glorify the dead or the beauty of death (the Taj Mahal) in palaces and tombs. The misfortune of architecture is that it wanted to construct monuments, but the idea of *habiting* them was either conceived in terms of those monuments or neglected entirely. The extension of monumental space to habiting is always catastrophic, and for the most part hidden from those who are subject to it. Monumental splendor is formal. And although the monument is always laden with symbols, it presents them to social awareness and contemplation (passive) just when those symbols, already outdated, are beginning to lose their meaning, such as the symbols of the revolution on the Napoleonic Arc de Triomphe.

For the monument. It is the only conceivable or imaginable site of collective (social) life. It controls people, yes, but does so to bring them together. Beauty and monumentality go hand in hand. The great monuments were transfunctional (cathedrals) and even transcultural (tombs). This is what gave them their ethical and aesthetic power. Monuments project onto the land a conception of the world, whereas the city projected (and continues to project) social life (globality). In their very essence, and sometimes at the very heart of a space in which the characteristics of a society are most recognizable and commonplace, monuments embody a sense of transcendence, a sense of being *elsewhere*. They have always been utopic. Throughout their height and depth, along a dimension that was alien to urban trajectories, they proclaimed duty, power, knowledge, joy, hope.

47 Gilbert and George

'Underneath the Arches' 1970

Gilbert and George, formerly known as Gilbert Proesch (b.1943) and George Passmore (b.1942), began collaborating in 1967 while studying in London at St Martin's School of Art. Sculpture was central to their practice and to their multi-faceted œuvre. Like David Medalla, they called themselves 'sculptors' and their work 'sculpture', so as to break with the familiar understanding of these terms and to push their boundaries. Then as now, their work embraces photography, drawing, text, film and performance, making challenging use of the international contemporary art press, art gallery advertising protocol and the postal service in order to disseminate a broader sense both of their practice and of what sculpture might be. Their motto 'Art for All' proposes an all-inclusive access to art regardless of sex, class, race or creed that parallels Joseph Beuys' motto 'everyone is an artist', while their dream that 'all the world [will become] an art gallery' evokes the collapsing of distinctions between art and life, between sculpture and the rest of the world propounded by artists such as Allan Kaprow.

'Underneath the Arches' is the text, published in *Studio International*, of one of their best-known 'living' and 'singing' sculptures. The title derives from a Flanagan and Allen song and thus associates their practice not only with an earlier comedy double-act, but also with burlesque and with the phenomenon of British music hall spreading to television. It also, however, makes subtle and satirical connections to the tradition of British sculpture, casting it as a London club with its eccentric membership rules and regulations. Their experience of sculpture was acquired at St Martin's in the 1960s, and yet this text also shows a longer art-historical awareness. The manifesto-like arrangement of short biographical introductions, statement of principle and rhetorical conclusion can be read as playfully echoing the manifestos found in earlier magazines like *Blast*, and the ebullient vorticist statements of Pound, Lewis and Gaudier-Brzeska. The example of Gaudier-Brzeska – a bohemian sculptor with a trademark double-barrelled, Franco-Polish artistic identity and a freezing-cold studio under the railway arches in Putney – as described by Ezra Pound in his book on Gaudier (reprinted in 1970), seems directly relevant: 'The white-gleaming intelligence in Gaudier's studio (half the space under a railway arch in Putney with the sides boarded up) in comparison with the podgy and bulbous expensiveness of Schonbrun, the tawdry, gummy, adhesive costliness of the trappings of the bourgeois drawing-rooms of the period, had a meaning.' As Gaudier had done earlier, Gilbert and George declared the pavement to be their place of inspiration, whilst ironically fashioning for themselves an identity as a dandified bourgeois duo.

Gilbert and George, 'Underneath the Arches', *Studio International: Journal of Modern Art*, Vol. 179, No. 922, May 1970, pp. 218–19.

Gilbert and George
The Sculptors
Present
Underneath the Arches
(The most intelligent fascinating serious and
beautiful art piece you have ever seen)

I Gilbert was born in a small Dolomite village in September of 1943. I am the son of a shoemaker and I began sculpting at the age of eight. There I have a house, a mother 3 sisters and one brother that I like very much.

I George was born in Devon in 1942. My Father is, I believe, a carpenter. I met him for the 1st time in 1966 and I have not seen him since. My Mother married now for the third time lives still in Devon, also my only brother Alec who is an evangelist.

We met in London last year

We began to dream of a world of beauty and happiness of great riches and pleasures new of joy and laughter of children and sweets of the music of colour and the sweetness of shape, a world of feeling and meaning a newer better world, a world of delicious disasters of heartrending sorrow, of loathing and dread a world complete, all the world an art gallery.

The Laws of Sculptors

1. Allways be smartly dressed, well groomed relaxed friendly polite and in complete control.

2. Make the world to believe in you and to pay heavily for this priviledge.

3. Never worry assess discuss or critisize but remain quiet respectful and calm.

4. The lord chissels still, so don't leave your bench for long.

The Ritz we never sigh for, the Carlton they can keep, theres only one place that we know and that is where we sleep. Underneath the arches we dream our dreams away, underneath the arches on cobblestones we lay. Every night youll find us tired out and worn, happy when the day-break comes creeping heralding the dawn. Sleeping when its raining and sleeping when its fine, we hear trains rattling by above. Pavement is our pillow no matter where we stray, underneath the arches we dream our dreams away.

Best wishes from
"Art for All"
12 Fournier Street, London E1, England, Tel.01-247 0161

48 Carl Andre/Phyllis Tuchman

'An Interview with Carl Andre' 1970

Carl Andre (b. 1935) is an American sculptor whose stridently materialist and minimalist approach to sculpture and famous horizontal, floor-bound works have made him one of the most internationally influential sculptors working in recent decades. Phyllis Tuchman (b. 1947) is an art critic, a freelance curator and a former president of AICA. She has developed a particular interest in twentieth-century sculpture over the years, publishing articles in *Artforum*, *Art in America*, the *Smithsonian*, *Art News* and other journals, and interviews with artists, including Robert Ryman and Anthony Caro.

The *Artforum* interview takes the form of a well-edited, lively question-and-answer session, conducted across eighteen single-sentence and subject-specific questions, rather than a record of a more rambling conversation. This gives the text a directness and a clarity that has made it a widely published account of Andre's practice and interests at the time, aged thirty-five. The interview was conducted across two meetings, a few weeks apart. Andre then read the edited and transcribed manuscript and made changes. Tuchman's questions range from enquiries into the role of the museum context, installation and site, to questions about his views on scale, the spectator, material and meaning. One of the important achievements of this text was to dispel the idea that minimalist sculpture might be cold, banal or austere. Andre discusses his artistic interests in relation to other sculptures, such as Bartholdi's *Statue of Liberty*, Brancusi's *Endless Column*, and John Chamberlain and David Smith's work, in lively and poetic ways that open up minimalist sculpture's connections both to the world and to other historical and contemporary approaches to sculpture making. The interview also gives a compelling sense of Andre's voice, the economy and texture of his language. It reveals Andre's clipped, aphoristic approach to communicating his thoughts about art (indeed 'aphoristic' is a term he uses in this interview, coupled with an awareness of the dangers of sounding dogmatic). The interview thus contains some memorable lines, such as: 'My idea of a piece of sculpture is a road'. This latter phrase not only recalls Brancusi's statement, 'direct carving is the true road to sculpture', but also the Romanian sculptor's characteristic use of aphorism to talk and write about his sculpture. The problematic example of Brancusi's mystical 'artistic identity' is also quietly felt in this interview. Casting himself as an admirer of Lucretius, Andre declares that he does not want to be portrayed as a mystic: true awareness of being in the world, he states, 'doesn't have anything to do with mysticism or religion. It has to do with life as opposed to death and a feeling of the true existence of the world in oneself.'

'An Interview with Carl Andre', *Artforum*, Vol. 8, No. 6, June 1970, pp. 55–61.

Do you make sculpture without a location in mind?

No, because I never work in the abstract to that extent. I never have been the kind of person who, let's say, works on a drawing, then makes a model, then makes the model larger and larger, and then finally makes a piece. For me, my cliché about myself is that I'm the first of the post-studio artists (that's probably not true). But my things are conceived in the world. For me, they begin in the world and the world is full of different kinds of spaces, different generic classes of spaces; inside gallery spaces, inside private dwelling spaces, inside museum spaces, inside large public spaces, and outside spaces of various kinds too. There's always a location in mind, not necessarily a specific one, but, rather, a location in scale.

If you were to remake lost or destroyed works for a museum exhibition, would the new space you were working in necessitate a change in your sculpture?

I think in a situation like that there would be two classes of works to be redone. One of the classes of works is one which I had made proposals for, tried to drum up interest in the art world to get money to do them, and I was never successful. So, that's one class of works – those never actually executed. Then there is a class of works which I actually did do and which subsequently were destroyed or discarded. Not voluntarily. I don't mean they were discarded because people didn't like them; they were discarded because of the peculiar conditions of my life early on in New York. Now, of the first group (that's two different sets), I would think that the first set is being made for the first time and would have to be looked upon, since they had never existed before, as new works.

Then, the second class of works would be works which already did exist and had been destroyed. I would just go out and find materials which were exactly the same and do them again. Now the trouble is not so much that space has changed, but that I have changed. That work which is lost was in what I call my structural phase, when I was still sort of building things with the particles. There might be a temptation on my part to destructuralize them and just use the set of particles, in a way changing them from a structure to what I call a place, which is not based on structural principles. It's just place-making, let's say. I don't feel myself obsessed with the singularity of places, I don't think spaces are that singular. I think there are generic classes of spaces which you work for and work toward. So it's not really a problem where a work is going to be in particular. It's only a problem, in general, of the generic spaces: is it going to be the size of Grand Central Station or is it going to be the size of a small room?

When you refer to place, are you discussing those sculptures whose forms are adjacent and not joined as opposed to the pyramids?

Exactly. To concretize the image, let's say, in the days of form, people were interested in the Statue of Liberty because of the modeling of Bartholdi and the modeling of the copper sheet that was the form of the Statue of Liberty. Then people came to be interested in structure and they were not interested in Bartholdi's form anymore. They became interested in Eiffel's cast iron interior structure: the girders and the cantilevers and the supports; in a sense, taking the copper sheets off the Statue of Liberty and looking at the raw iron or steel that constituted the structure on which the copper plates were hung. Now sculptors aren't even interested in Eiffel's structure anymore. They're interested in Bedloe's Island and what to do with that. So I think of Bedloe's Island as a place. I use place in a kind of aphorism that seems to work for me about shifting from form in sculpture to structure in sculpture to what I wound up with as place in sculpture. Now I do not wish to make that aphoristic sequence into a dogma at all. I am trying to describe what happened to me as an artist. I began with form – or woodcutting, essentially – chiseling into timbers after the manner of Brancusi, the Brancusi still very much within the limits of the monolithic life-figure-derived sculpture. Going to Brancusi's piling of things (pedestals and bases) and also structures (benches and arches and tables like those in Philadelphia); coming to a kind of structural position which was probably new to the 20th century but also was persistent or had existed in neolithic works (Stonehenge and Avebury, etc., of which I have always been a great admirer) which were structural. Then, passing through that into place which was also a neolithic property, I think, in the countryside of southern England, Indian mounds, and things like that (which some people associate with earthworks, but I think it is a mistake to limit it just to an art form). So, this business of form into structure into place just describes what I went through in arriving at where I am now.

When you re-set up a piece, is it altered or re-arranged?

Well, not really either. My first problem has been to find a set of particles, a set of units and then to combine them according to laws which are particular to each particle, rather than a law which is applied to the whole set, like glue or riveting or welding. They are nonstructural combinations of particles and these particles particularly are combined in laws which are no more than the qualities that any one particle might have. No extraneous forces apply to the set to make them have properties which an individual particle does not have. I can find a set of particles which I used ten years ago; from that set of

particles I had made something which was satisfactory to me then. But then, let's say today, I take up the same set of particles again. It's entirely likely that I would want to combine them in a different way. Now the former piece is not being recovered, it's not altered. A new piece is being made with the same set of particles. But this is like learning how to use blue. If you used blue once in a painting ten years ago, and then today you use blue again, the way you use blue is probably different now. That's why I think of a color as the cut of a painter on the color spectrum. My particles are sort of cuts across the mass spectrum in what I call 'clastic' way ('plastic' is flowing of form and 'clastic' means broken or pre-existing parts which can be put together or taken apart without joining or cementing).

How do you determine your arrangements?

My arrangements, I've found, are essentially the simplest that I can arrive at, given a material and a place – the least conspicuous I can arrive at. Much of this was following the example of Frank Stella and his early paintings – the black paintings and even earlier stripe paintings; trying to arrive at a compositional solution of painting that did not depend on the kind of drama of placements and centering and off-centering and things like that. So I arrived, certainly through the example and teachings of Frank Stella, at something which I call anaxial symmetry. This is a kind of symmetry in which any one part can replace any other part. That is you might say, the symmetry of the heavens where, as you look at the sky, really there's no apparent symmetry except that one apparently can replace any single star with any other single star without changing the overall effect. (That's a rather false analogy. Perhaps a better one would be, let's say, with the molecules in a glass of water, which in a sense may be said to be symmetrical. You can take any atom of the water and replace it with any other one. This has nothing to do with left or right hand or up or down. It's central, anaxial, without axis.)

Is movement, as a formal concern, incorporated into your sculpture?

I think all my works have implied, to some degree or another, a spectator moving along them or around them. Even things like my early pyramids, they very much only revealed themselves when you walked around them. This is really a sense of scale – it's the opposite of coffee-table size sculpture as jewelry. You don't have to walk around them. You can turn them with your hand or you can grasp the whole thing at once. My idea of a piece of sculpture is a road. That is, a road doesn't reveal itself at any particular point or from any particular point. Roads appear and disappear. We either have to travel on them or

beside them. But we don't have a single point of view for a road at all, except a moving one, moving along it. Most of my works – certainly the successful ones – have been ones that are in a way causeways – they cause you to make your way along them or around them or to move the spectator over them. They're like roads, but certainly not fixed point vistas. I think sculpture should have an infinite point of view. There should be no one place nor even a group of places where you should be. Yes, no single point vistas or even several point vistas.

What's the relationship in your sculpture between scale and the spectator?

I have come to the conclusion that perhaps the only single thing that art has is scale – something which has nothing at all to do with size. It has to do with things being internally consistent with their own parts. Take a sculptor like John Chamberlain, who is certainly one of the great masters of scale – I've seen works of his the size of a matchbox which were just perfectly consistent internally in the relationship of the parts. This is not limited to sculpture at all. I think painting has this quality. A great painting has its greatness of scale. You can even talk about scale with things like color, as well as proportion of the parts. In sculpture, there's quite a concrete relationship between one's size as a person and/or mass as a person and the mass of a piece of sculpture. Man is the measure of all things because we are men or we are mankind. And we are just absolutely conditioned by the sizes of our bodies and our own pre-tensions to measure things off, especially material things in the world, by our own size. Of course, I'm thirty-five now. It's only for twenty years that I've had this stature that I have now. For the first ten or twelve years of our life, we don't at all have the sense of scale we have later on. If you've ever returned to a house where you grew up, but hadn't been in a long time, you suddenly realize that everything is so low to the ground. The doorknobs seem a lot lower than they used to be (and the tables and the chairs) where, once before, every-thing seemed to be quite over our heads. I would say, yes, we do measure scale according to our own stature. But our sense of our own stature is a much more plastic and sliding thing; it's not a fixed thing. But we tend to relate back to our own physical mass.

Does walking on your sculpture imply not just traditional tactile perceptions (touching with the hand), but body associations as well?

Not all of my stuff is meant to be walked on. I have to trust a great deal to the tactile tact of the spectator of my work, to understand that walking on steel or aluminum or zinc or lead or copper or whatever it is, is not going to injure it substantially. But, if there was a piece, let's say, of styrofoam or something

like that, walking on it would just put big holes in it with your feet. So, I don't want, by any means, to give the impression that all my works are intended to be walked on. For those works that are obviously suitable for being walked on, the first thing that I think is most important is being able to stand in the middle of the sculpture: you can in my twelve by twelve foot steel piece. You can stand in the middle of it and you can look straight out and you can't see that piece of sculpture at all because the limit of your peripheral downward vision is beyond the edge of the sculpture. So you can be in the middle of a sculpture and not see it at all – which is perfectly all right. Most people don't see it if they arrive in a room and are looking around. They can be standing on the sculpture and they don't see it – which is perfectly all right. I don't like works of art which are terribly conspicuous. I like works of art which are invisible if you're not looking for them. I like this thing about being able to be in the middle of the work. There are a number of properties which materials have which are conveyed by walking on them: there are things like the sound of a piece of work and its sense of friction, you might say. I even believe that you can get a sense of mass, although this may be nothing but a superstition which I have. But I believe that man is equipped with a subtle sense of detecting differences in mass between materials of similar appearance but with different mass. I don't think there's a concrete sense; you can't name what this sense is. But perhaps it has something to do with the inner ear and balance or something. Nevertheless, I believe that man can almost unconsciously detect differences in mass. Standing in the middle of a square of lead would give you an entirely different sense than standing in the middle of a square of magnesium.

Do you see any relationship between the color of your sculpture and a truth to materials?

I don't know about that. I just never have been convinced much with painted sculpture. I just don't have much of an eye for painting in the first place. I always felt just the opposite of that idealized surface. I wanted a surface free to be continually altered by its own history, the events which occurred to it up to the point of absolute obliteration, I suppose. If you leave a steel piece out in the rain and the wind for three hundred years, it would probably rust away. If it did rust away, the grass would probably have a different pattern from where the rust was because of the high iron content in the soil at that place. Nothing ever truly disappears, I think. As to truth to materials, I just like matter a great deal and the different properties of matter, the different forms of matter, different elements, different materials. To paint these things, for me, would be to exactly defeat my own desires as to my art. I don't want to disguise it at all. I don't want to make something else out of it. I want wood as wood and steel as

steel, aluminum as aluminum, a bale of hay as a bale of hay. That's not an idea for anyone else, that just reflects my desires as an artist.

How are time and weather taken into account?

You might say that I submit to the properties of my materials out of a kind of reflection of my own temperament. I have avoided trying to create ideal surfaces that had to be maintained. As I've said, I wanted to submit to the conditions of the world, such that if works were outside and they rusted, then they would rust. People have asked me, 'Won't that destroy the work?' Of course it will, after three or four hundred years. But I will have long been dead and persons who are now living will long have been dead and the works will survive our lives certainly. This is not even a philosophical condition of mine, it's a temperamental one. It's that I wish to submit to the properties of my materials.

Is there a content expressed in your sculptures?

I think art is expressive but it is expressive of that which can be expressed in no other way. Hence, to say that art has meaning is mistaken because then you believe that there is some message that the art is carrying like the telegraph, as Noel Coward said. Yes, art is expressive, but it is expressive of that which can be expressed in no other way. So, it cannot be said to have a meaning which is separable from its existence in the world. No explicit meanings, no, not in mind when I address myself to the work, not at all. What is quite the opposite is that I find that my greatest difficulty and the really most painful and difficult part of my work is draining and ridding my mind of that burden of meanings which I've absorbed through the culture – things that seem to have something to do with art but don't have anything to do with art at all. That's the one aspect of the term 'minimal' art that I have always prized and I always considered myself, to that extent, a minimal artist. When people talked about 'minimal' art, I didn't realize that they were talking about sculptures and the work. I thought they were talking about the artists. Because what the idea 'minimal art' really means to me is that the person has drained and rid himself of the burden, the cultural over-burden that stands shadowing and eclipsing art. The duty of the artist is to rid himself of that burden. I think it's an extremely difficult thing to do. I would not say that I have achieved it, because every time you work, you have to do it all over again, to rid yourself of this dross. I suppose for a person who is not an artist or not attempting art, it is not dross, because it is the common exchange of everyday life. But I think art is quite apart from that and you have to really rid yourself of those securities and certainties and assumptions and get down to something which is closer and resembles some

kind of blankness. Then one must construct again out of this reduced circum-
stance. That's another way, perhaps, of an art poverty; one has to impoverish
one's mind. This is not a repudiation of the past or such things, but it is really
getting rid of what I describe as dross.

You don't consider yourself a conceptual artist, do you?

I am certainly no kind of conceptual artist because the physical existence of
my work cannot be separated from the idea of it. That's why I said I had no art
ideas, I only have art desires. To speak of ideas as conceptions in a philosophi-
cal sense and then to speak of ideas for art, well that is to speak about two
utterly different things. I think what we really mean to do is apply ourselves
to the language we use in the most rigorous sense. As Confucius said, when
he was asked what he would do if he were made the prime minister of the
duchy where he lived, 'The first thing I would do is call things by their right
names.' This is why I wish to separate myself entirely from any conceptual art
or even from ideas in art. My art springs from my desire to have things in the
world which would otherwise never be there. By nature, I am a materialist,
an admirer of Lucretius. It is exactly these impingements upon our sense of
touch and so forth that I'm interested in. The sense of one's being in the world
confirmed by the existence of things and others in the world. This, to me, is far
beyond being as an idea. This is a recognition, a state of being, a state of con-
sciousness – and I don't wish at all to be portrayed as mystic in that. I don't
think that it's mystical at all. I think it's a true awareness that doesn't have
anything to do with mysticism or religion. It has to do with life as opposed to
death and a feeling of the true existence of the world in oneself. This is not
an idea. An idea is a much lower category on my scale in that awareness, that
consciousness.

Was color a principal concern in Lock?

The principal concern in *Lock* actually, was poverty. I was asked, very gra-
ciously I thought, by the Los Angeles County Art Museum and Maurice
Tuchman to do a piece for the museum. At the time, I had neither the means
to get there (Los Angeles) nor did I have any funds for any materials. Virgina
Dwan extended to me the funds to go there. I was given a nominal amount
of money ($150.00) for materials. So I was confronted with the problem of
making a work with an absolutely limited budget. This meant not using
metals or stones or anything, but a material that was cheap. That turned out
to be chip-board. I did not want to use the bare board itself. So, I painted it.
I happened, at that time, to be very fond of this color – I forget whether it's

cerulean blue or cobalt blue (it's one of the Liquitex acrylic paints). It was always a color that seemed to me to denote objectness for some reason that I don't know (I think Betty Parsons has a small piece of sculpture of mine which is painted the same color). So, if I hadn't had the economic problem, I wouldn't have painted it, because I would have made it out of another material. As I look back on *Lock* – both the blue one that was in Los Angeles and the black one that was in Philadelphia – they really were as works of sculpture probably miserable failures. But, somehow, we only learn from our failures. It's also a matter that I have recently had to return myself to, because my materials *could* become infinitely expensive. Let's say if I made a twelve foot square piece out of three-eighth inch thick platinum, that is, in effect, an infinitely expensive piece. Now, if I run out of the common materials to use, I'll just have to confront the problem of having to use infinitely expensive materials – which means I'll have to give up work or only make very tiny ones. Again, I'm back in the situation I was in in 1966. What do you do to make sculpture without a strong economic factor? I think that has something to do with *arte povera* in Europe. I don't think they literally think of it as working with the least economic factor, but I found that it's necessary for me to return to this state and to make sculpture as if I had no resources at all except what I could scavenge or beg or borrow or steal. I don't think that I would ever again do anything that was like either the black or blue *Lock* pieces. I later went on and did *Lock* pieces in Europe which were made of steel, which is probably what I would have done in the first place if I had the materials. But, nevertheless, I still have to return to the situation of what do I do to make sculpture as if I were broke.

Do you consider your twelve by twelve foot metal plates as flat sculpture?

I don't think of them as being flat at all. I think, in a sense, that each piece supports a column of air that extends to the top of the atmosphere. They're zones. I hardly think of them as flat, any more than one would consider a country flat, just because if you look at it on a map it appears flat. Again, obviously, they *are* flat but, that's curious, I don't think of them as being flat.

Was your hay piece an earthwork?

No, I don't know how anybody else thinks of earthworks, but I think of earthworks as being made of earth, earthen, or with, let's say, rock or broken materials, without a man-impressed form for the materials. The overall shape, of course, is man-impressed, like an earthen dam, but the particles do not have a man-impressed form. A bale of hay is as much of a man-impressed form as

a brick or an ingot of steel. So, for me, that was not an earthwork, but just an extended piece of sculpture on the land.

After working with heavy timbers, why did styrofoam interest you?

Everything has an explicit origin, if we only ask the right questions. The styrofoam pieces were originally made for the old Tibor de Nagy Gallery which was, as I remember it, an old townhouse on 72nd Street. The *Shape and Structure* show was the first show I had in New York and it was a group show at the Tibor de Nagy Gallery. My piece was 28 timbers (one foot square and three feet long). They were assembled in the entrance of the gallery and three days after the show opened, I got a desperate call from Mr. Myers saying, 'Carl, come quickly, the floor is collapsing.' So, we went up there and moved the timbers from the weakened floor of the old townhouse to another area of the building which was more secure. But I had to remove the piece. Then, Mr. Myers very graciously asked me if I would do a show in his gallery that spring – in April, I think it was. I said that I would be delighted to. But I was confronted with the problem of volume and mass. I had to find a material which had a very high volume and a very low mass because the structure of the building was so weak. I wanted very much to seize and hold the space of that gallery – not simply fill it, but seize and hold that space. About the same time, a friend of mine was working with foams (urethane foams and styrofoams) and he gave me the address of the place to go to investigate the styrofoam planks. So, I used styrofoam in that show because I wanted large works but they had to be light. Hence, I used styrofoam. But that show was, characteristically, a structural show – probably my last structural work. What happened subsequently was that David Novros had a show at the Park Place Gallery in 1966. He was only using the front room of the gallery and they usually put other works in the back room and he didn't want any other works in the back room. So he said would you do a work for the back room and I said I would and I still had the styrofoam at that time. I had destructuralized my work and I wanted to use the styrofoam in a way that would become placegenerating. So I did a piece that was essentially the same as the one that was in the Whitney Museum *Anti-Illusion* show: where the styrofoam is used to generate a kind of negative place, a place of no access, a plateau as it were. Between 1966 and 1969, the company stopped making white styrofoam. As a result of that, my work at the Whitney Museum was popsicle orange or international orange, as it's called, and not white. For me, this was an alteration, a condition of the world which relieved me from one painful condition; which was that people kept saying of the white styrofoam, 'Oh, it's so like pentelic

marble.' They couldn't say that about the orange styrofoam. As I said at the beginning, things have practical, explicit origins. There was not doctrine or dogma but the necessities of the conditions I was working under that led me to styrofoam. I have nothing against styrofoam and its lightness is a joy to deal with. I find no contradiction between that and the metals. *Reef* – reef as a kind of plateau – that's using very light and essentially fragile materials; it excludes the viewer from occupying the space, whereas the metal pieces, although they are hard, durable and resistant, invite the viewer to join in the space of the piece. So that the works obviously establish different conditions for the spectator and the viewer. When we stand beside the styrofoam pieces, we don't stand on them. I don't have great prejudices against materials. I think that the great lesson of the so-called earthwork movement and the *arte povera* direction of art is that now we need have no prejudices about the materials that we use. We should use materials in art which are really appropriate to our ends. Not marble for the sake of marble or bronze for the sake of bronze, but marble where marble is appropriate and dirt where dirt is appropriate.

When did you see your first Brancusi?

It must have been 1957. I had seen photographs before then. My friend Hollis Frampton was an admirer of Ezra Pound who in turn had done studies of sculpture, especially Gaudier-Brzeska and Brancusi. Very early on, I was taken by Brancusi because the photographs I had seen, of course, had always been the polished pieces and the tops of the pedestals; the birds in space and the *Mlle. Pogany* and so forth. These had always seemed to be post-Rodin, polishing up Rodin or something. Then I saw them all combined with their earth-driving, entering pedestals that were of an entirely different nature. So Brancusi, to me, is the great link into the earth and the *Endless Column* is, of course, the absolute culmination of that experience. They reach up and they drive down into the earth with a kind of verticality which is not terminal. Before, that verticality was always terminal: the top of the head and the bottom of the feet were the limits of sculpture. Brancusi's sculpture continued beyond its vertical limit and beyond its earthbound limit. It drove into the earth. Also, Brancusi used many found materials, not that that's important. But he used screws from ancient wine presses and beams pretty much unaltered and combined these particles with those particles that were heterogenous (not homogenous). He definitely did combine particles in building up these pedestals which was, for me, the great interest in his work – that those pedestals were the culmination of the material.

How were you affected by David Smith's sculpture?

The first show of David Smith's I saw or certainly the first show I saw of things brought together, was at French and Company. I had seen individual pieces before; I'd seen photographs before. The great thing that impressed me about David Smith's work in things like the Albany series and the Menand series was their solidity; they weren't hollow. There could be some which were called drawings in space or whatever, but that didn't interest me as much as that the individual units were solid. They weren't too big and they weren't empty. And I've always had a very primitive, infantile love of the solids and the mass, the thing that was the same all the way through. David Smith's sculptures seemed to have that quality. Of course, we read into the past what we need for the present and that's what I got from David Smith. It was solids that I was interested in; David Smith was a very solid sculptor. I think, although there have obviously been some American artists influenced directly by Smith, I think it was very difficult for an American to do that, because Smith was such an enormous presence. I think one would require a bit of distance. Perhaps Caro coming from England could come as a stranger into the household, as it were, and really be impressed – and I'm not saying that American artists weren't impressed with it. Smith represented a great body of work and nobody wanted to do more Smiths because he was still alive at that time. If anyone was going to do more David Smiths, David Smith was going to do them and nobody else. So sculptors looked in other directions because that work was being done. The greatest and the best influences are I think the great negative influences, where a man blocks out a great body of work and for those who come immediately after him, that road is closed to them. They have to find other roads, which is the healthiest thing that could happen. Then the people who come after that, the first generation of followers, can go back to where the master blocked the road and study the thing a little bit more closely. I think that everybody just felt so close and so familiar with David Smith's work that that's why nobody followed in that direction.

49 Claes Oldenburg

'Drum Set' 1971

Claes Oldenburg (b. 1929) is one of the best-known artists of the pop art generation, famous for his 'soft sculptures' and his proposals for monumental versions of everyday objects, such as lipsticks and electric plugs. 'Drum Set', which is a text about one of his soft, canvas sculptures representing a drum set, is drawn from a longer text in which Oldenburg sets out a series of ideas for monumental outdoor sculptures. This text does not make explicit the monumental staging he has in mind; rather it gives an insight into how he saw such objects having resonance in and beyond their immediate status as icons of modern popular culture. Oldenburg's description of the drum set's three-dimensionality presents it as containing an inner sonic and acoustic energy – giving the sculpture a poetry and a meaning that takes it beyond being merely an object. Here Oldenburg's ideas are to be seen in negative dialogue with Morris and Judd's antipathy towards the metaphorical (though oddly Judd himself was fascinated by Oldenburg). Oldenburg's text is a move away from their literalism, but it also anticipates and parallels Joseph Beuys's interest in the multiplicity and hybridity of sensuous effect that a sculpture can produce. Like a soft telephone, the *Drum Set* is to be 'heard' as well as seen, even though it cannot be played or used. Oldenburg thus proposes that the viewer of sculpture also be a listener. Like Beuys, he sees sound as having crucial sculptural implications and his 'soft sculptures' as requiring a more imaginative engagement from the gallery visitor than just casual looking. 'Sound (or absence of it)', he states, 'is sculptural technique'. Vowels, in particular, express the beats of the drum: 'COLORADO: O-bass, O-snare, O-tom-tom'.

Oldenburg further sees an anthropomorphic association here: 'The *Drum Set* is the image of the human body'. Like the human body it is more soft than hard, he states. Such considerations, though playful, are also deeply serious, since the sculptor argues that there is a real political and ethical dimension to softening things. It is an attack on rigid functionality and the industrially formatted hardness of the modern material world. At the same time, however, Oldenburg's *Drum Set* is not only a soft structure, but also a collapsed one, a ghost of its former self, its inner life and voice present through its absence. It requires both hard and soft for its effect, and what is presented is a playing-off of one against the other, rather a resolution into softening. 'Only hard originals are taken as subjects for softening. Softening may be seen as pacifist wish-fulfilment...' he states. He concludes his text with the word 'Amen', suggesting that this is as much a sculptural prayer as it is an artist's statement.

Claes Oldenburg, 'Drum Set', in *Claes Oldenburg: Object Into Monument*, exhibition catalogue, Pasadena, California: Pasadena Art Museum, 1971, pp. 56–57.

Whatever is not heard is heard. The ring of the silent soft telephone is 'heard', the typing of the silent soft typewriter is 'heard', and the sound of the silent soft drum set is 'heard.'

Sound (or absence of it) is a sculptural technique.

OHIO

Drumheads are always being tightened. The softening softens the sound as well as the surface. It retreats from impact (while it shows the effect of impact).

The Drum Set considered as exterior, i.e., with its interior volume filled, for example, with concrete.

Drum Set equals O H I O – H and I, the pedal. Also, 'Hi-sock', the foot cymbal.

C O L O R A D O: O-bass, O-snare, O-tom-tom.

O's and O sounds, like Frank O'Hara's poem, 'The Buddha Preaching', function on O sounds.

The Drum Pedal is as conspicuous a device on the skin of the bass drum as the genitals are on the male body. The Drum Set is the image of the human body. It is a body of both sexes, a bisexual subject. Anyone who has traveled with a drum set knows that it must always be disassembled and assembled, packed in boxes. The organ of the pedal – for example, the masculine appendage – is detachable, and so are the breasts (cymbals). The womb (bass) has its own box. The set is like a jointed doll.

The wirebrush fans are like webs or fins or toes spread.

There is a great emphasis on setting up and taking down, to an exaggerated degree for a work of art. Because of the softness of the drums, the broken sticks, and the large amount of unruly detail (more than in any piece I've made up to this time), the piece never seems to achieve stability or order, and so, contradicts, in its soft version, the concept of unity and purpose stated in its image or real version.

Drum Set is an unmade bed. Sleep Set, all gravity.

It is a state of nature, a condition, that I want to represent above all – the large formal realm of softness, which one's own body suggests. Sculptors have depended on water for this, but water is too natural and moves too much in real time for me.

Only hard originals are taken as subject for softening. Softening may be seen as pacifist wish fulfillment (soft car, soft gun), endless staying in bed, pleasure, as championing drugged impotence, transvestism, melting of barriers, subversion, as anti-ambition, as the projection of body, of author's body, or calling attention to the great neglected formal realm of the non-rigid (airship). Whatever is required – soft is generous.

The last act, of softening the thing, is like a climax, a death blow to its functionality and classicism. The object is reduced to nature, left a heap. Its soul, one may say, rises to the heaven of things in the 'ghost' form. Its exorcised spirit returns to the realm of geometry leaving a pile of wrinkled laundry. Christian Science. Amen.

50 Jörg Schellmann, Bernd Klüser and Joseph Beuys

'Questions to Joseph Beuys' 1977

Joseph Beuys (1921–86) was one of most influential sculptors and performance artists working in Germany in the 1960s, 1970s and 1980s. He was well known as an advocate of a free and interdisciplinary art education and of the principle that 'everybody is an artist'. He developed these ideas initially at the Düsseldorf Art Academy, where he was Professor of Sculpture from 1961 to 1972 and from where he was eventually dismissed for support-ing a student demonstration, protesting limits placed on applicants to the academy. With the support of a number of artists, he went on to found the 'Free International University of Creativity and International Research' in 1974. Two years later he represented Germany at the 37th Venice Biennale.

Beuys is particularly known for his espousal of 'social sculpture', often the subject of his lectures and teaching sessions. 'Social sculpture' is broadly to be understood as an open, widely disseminated and participatory sculptural practice that operates between object and performance, between actor and audience. Blurring such distinctions, in Beuys's view, social sculpture can move beyond the sculptural object and enter a shared, more public domain, directly inviting the creative and intellectual involvement of those present. The interview reprinted here gives useful insight into what Beuys meant by social sculpture and how it could be articulated through the deployment of multiples of an object. The multiple, according to Beuys, is an excellent vehicle for spreading ideas. The examples he discusses here are his *Evervess* bottles of tonic water, his felt suits, his sledges and his *Two Fräuleins with shining bread*. Anyone, he argues, who is in possession of a multiple should have first-hand access to his ideas through such objects. The multiple is thus seen by Beuys as a vehicle for making contact with a range of people who would never see the 'original' and for generating further cross-connections between his ideas and those of its owners. Multiples are envisaged as quasi-mythical carriers of spiritual, humanistic, irrational meaning and he argues that they should be experienced directly to be effective – indeed that they are effective because they can be so experienced. Thinking through the combination of materials and concepts – be it felt and warmth, or bread and trans-substantiation – can in Beuys's mind lead to the activation of human creativity and thus sow the seed for political change. However, at the same time, Beuys was keenly aware that a work could not quite stand on its own and needed a verbal supple-ment to prompt the viewer into an exploration of its meaning. Soon after this discussion of his ideas, Beuys was to make words the work, with dialogue, discussion and verbal exchange replacing things.

The interview format was thus well suited to Beuys's practice. This interview was conducted in 1970 between the artist and Jörg Schellmann and Bernd Klüser, two important early supporters of his work, based in Munich. It was reproduced as 'Part I, December 1970' alongside a second interview, entitled 'Part II, June 1977', in a publication that coincided with

the exhibition of his multiples drawn from the Ulbricht collection. The exhibition started in Bonn and toured around Germany, after briefly travelling to Stockholm.

Joseph Beuys, 'Questions to Joseph Beuys', interview with Jörg Schellmann and Bernd Klüser, in Jörg Schellmann (ed.), *Joseph Beuys: The Multiples*, Cambridge, Mass., Minneapolis, and Munich/New York: Busch Reisinger Museum, Walker Art Center, and Edition Schellmann, 1977.

Schellmann, Klüser: Beuys, why do you make Multiples? Can the reason for multiplying an object be found in the message it contains, for instance a particular quality which calls for mass-production, or is it a question of a larger distribution?

Beuys: Well, it's a matter of two intersecting things. Naturally I search for a suitable quality in an object, which permits multiplication of that object, for instance the quality implying a series, found in this bottle of tonic-water ('Evervess'). Just by being an article of commerce, this bottle can communicate much through repetition.

But actually, it's more important to speak of distribution, of reaching a larger number of people... You can look at it from a number of different aspects. – Why is anyone interested in distributing a thing as widely as possible?

The whole thing is a game, one which, with the help of this kind of information, counts on casting the anchor of a vehicle somewhere close by, so that people can later think back on it. It's a sort of prop for the memory, yes, a sort of prop in case something different happens in the future.

For me, each edition has the character of a kernel of condensation upon which many things may accumulate.

You see, all those people who have such an object will continue to be interested in how the point of departure from which the vehicles started is developing. They'll be watching to see what the person who produced these things is doing now. That way I stay in touch with people; just as you have come to me because of what I've made and we can talk about it. I can talk to just about anybody who owns such an object. There's a real affinity to people who own such things, such vehicles. It's like an antenna which is standing somewhere and with which one stays in touch. There are also cross-connections between people, or deviations. One person says yes, I've got such a bottle. Another one has such a wooden box and a third one says, I've heard something about political activities, and so, all sorts of different concepts converge, and that's what I'm interested in, that a whole lot of concepts come together.

I'm interested in the distribution of physical vehicles in the form of editions because I'm interested in spreading ideas.

The objects are only understandable in relation to my ideas. The work I do politically has a different effect on people because such a product exists, than it would have if the means of expression were the written word.

Although these products may not seem suitable for bringing about political change, I think more emanates from them than if the ideas behind them were revealed directly.

To me the vehicle quality of the edition is important.

S,K: And is that quality more specific in multiples than in unique pieces?

B: I'd say it's more general. I think a multiple can be chosen quite arbitrarily if one sees the vehicle quality.

S,K: Would it be conceivable to use only one element as a vehicle?

B: Yes, that's conceivable. But when I stress the arbitrary spontaneous quality, I don't mean that the object which then emerges has no meaning in my Oeuvre. I don't mean that. But the form is determined by the circumstances.

S,K: Would you produce an object 50 000 times? Is there a limit?

B: I'm going to make an object with an edition of 10 to 20 thousand. That's my next project, an object of great simplicity.

S,K: On the other hand, doesn't it bother you when an object with a very limited edition acquires the flavour of exclusiveness, like for instance in the case of the multiple with the fishbone?

B: No that doesn't bother me. I'm interested in both principles. In some cases the edition has to be limited because it just isn't technically possible to do it any other way. After all, I don't feel like frying fishbones the rest of my life! A considerable amount of work goes into those wooden boxes ("Intuition") – I think I've already made over 5000 – because Feelisch comes around quite often and every time it takes a whole day, and I have to make them all by myself, otherwise they just aren't right.

I'm beginning to wonder whether I shouldn't stop making editions altogether because of that. I think it is very important that the next edition, which will be comprised of about 10 to 20 thousand copies, is made largely in the factory.

S,K: Beuys, why do you work mainly with anomalous, grey materials?

B: Yes, Beuys works with the material, felt. Why doesn't he work with colour? But people never think far enough ahead to say: well, if he's working with felt, perhaps he means to evoke a colourful world inside us?

The phenomenon of complementary colours is well known if for instance, I see a red light and close my eyes, there's an after-image (ocular spectrum) and that's green. Or, the other way around, if I look at a green light, then the after-image is red.

People are very short-sighted when they argue that way, when they say:

Beuys makes everything with felt, so he's trying to say something about the KZ.

Nobody bothers to ask whether I might not be more interested in evoking a very colourful world as an anti-image inside people with the help of this element, felt.

So it's a matter of evoking a lucid world, a clear, a lucid, perhaps even a transcendental, a spiritual world through something which looks quite different, through an anti-image.

Because you can't create an after-image or an anti-image by doing something which already exists, but only by doing something which is there as an anti-image, always in an anti-image process.

So it isn't right to say I'm interested in grey. That's not right. And I'm not interested in dirt either. I'm interested in a process which leads us away beyond those things.

And that's the connection to vehicles. Later when other things crop up in the discussion, you can think back on particular objects, so that one thing is superimposed upon the next, so that things pass by again in a different constellation...

Then, one of these days, you're bound to say yes, I'm beginning to understand what's happening, how the technique was, how the infiltration came about, or the penetration, or the communication, or what the information discloses.

S,K: 'Two Fräuleins with shining bread' – Why does the bread shine?

B: Yes, this is, quite briefly speaking, a direct hint towards the spiritual nature of matter.

Bread, as it were a substance, represents the essence of human nourishment. The term 'shining bread' means that bread has its origin in the spiritual realm. In other words, man does not live on bread alone, but on spirit. Quite in the same way as in trans-substantiation, that is, transmutation of the Host in old church service; where it is said: this is bread only by outer appearance, in reality it is Christ. This, then, is trans-substantiation of matter.

Such things also play a role with felt or fat...

In the Multiple with the Fräuleins, as it were through bread, a journey is undertaken.

In the first section, before this bridge appears where there is the painted chocolate, there are, in the upper part of the object, the underground stations of Paris. And afterwards stations appear which really only consist of human names. At first, the journey is like some kind of outer journey, even one that is very much underground. And, yes, the idea of matter appears once more here in the journey, by way of one's going into the inside of matter as it were, i.e. going underground, therefore the names of the underground stations.

Afterwards names appear which are situated higher, in other words, are situated in free air. Predominately, human names appear. By this is meant that the journey is then through humans, through souls really. And these names have been freely invented. There appear mostly names, men's names, women's names; often very exclusive names appear, which sound like names of nobility indicating a certain worth so to speak, certainly not this worth of nobility, but rather a worth which is in the future. And then mountains appear, Grand Ballon and such things, that is, rounded hill tops and peaks appear.

And this character shows how this thing about the shining bread is meant... instead of bread chocolate appears here. The chocolate, then, has the significance of somehow undergoing a transformation in connection with the term 'shining bread' through some kind of counter picture or opposition; that in fact nothing at all changes. The chocolate has been manipulated with – it will be remembered that it has been covered with brown paint – but this brown is really the same colour that the chocolate has naturally.

Thus, by repeating the same thing something is evoked in some kind of recoil process. And when one then adds the term 'shining bread' to this, one roughly has what I am interested in, which is the process that something emanates from it, or radiates, or, what shall I say, information emanates from it, or... that one is in a realm of experience and sensation which one can realize or anticipate, or something like that. Many times one can only anticipate the things that are meant. It suits me that in the beginning they cannot be grasped fully.

S,K: ...and that one is not able to verbalize them fully?

B: Yes, the fact that these things cannot be explained in a rational, rationalizing, or analytical way; yes, I'm not interested in that, but rather I'm interested that one goes directly into these things, is directly in the essence of these things. If one has in fact a relationship to this, one can really only have it, not based on a rational, analytical understanding, but because one has experienced something of the right direction, the direction in which the vehicles are standing, simply standing somewhere.

S,K: 'Evervess'. The instructions on the lid of the wooden box to 'drink the contents of bottle II and throw the cap as far away from you as possible' usually aren't acted upon because people are afraid of 'damaging' the object. Are those instructions meant to be serious?

B: Actually the instructions are meant to be serious, but of course I knew that a lot of people wouldn't follow them. I believe the object is only right, if it's done. Before that, the object hasn't been in action. The directions for a small activity, which one must perform oneself are contained in this object. And if people have carried out this activity and regret it, they have to go on from there and start another activity and procure such a bottle again. I'd have nothing against that!

If one begins to consider the bottle from an iconographical point of view, one will find many of the elements we talked about in 'Zwei Fräuleins mit leuchtendem Brot', that for instance through the felt, the elements of matter, of concealment and darkness are represented, but that in the bottle there is a moving element, the water, and one absolutely doesn't connect this with something dark – quite the contrary. Basically it is a bottle which almost claims to contain pure spring-water, although actually it only contains simple American soda-water. But all these lively things are also pictured on the label. There's a real mountain landscape with snow and so on, and there's also blue and white there and...

S,K: ...Cold...

B: Yes, cold and all those things, and in the felt there is warmth. So there are a great many images in there. Opposing images. We've already encountered them in 'Zwei Fräuleins mit leuchtendem Brot', in which the mountain also appears.

...if I hadn't found that label, such a bottle, with such an image of a mountain, such mountain peaks, then I wouldn't have ever made the object. I simply used the bottles because the elements were consistently there and when I find those elements somewhere, then I say: yes, this fits in. I can use it.

So, I wouldn't have made the bottles just any old way. I only made them this way because the elements I meant to use were there, on the bottles. And they had already appeared in a much earlier object – in a slightly different constellation. It's actually always the same principle.

The object is actually only beautiful due to these facts. Otherwise, what have these bottles got?

And I believe anyone can see that. You don't even have to be conscious of it, but you can see it... yes, it's quite beautiful. You simply say, it is quite beautiful!

If you just describe what you see you'll be sure to get there; you'll arrive in the sphere of the things I mean.

S,K: To my mind, in the large piece with the VW bus and the pack of sledges coming out of it, the sledges owed their animation to their appearance as a pack, through emerging as a crowd.

Why did you isolate them again and make a multiple of the sledges?

B: Well, first of all, the object isn't isolated. Actually the edition is made up of a much larger pack than the pack of the VW bus, but why should the pack stay together forever? It can just as well disperse. So it disperses. For me that's just as good as when it stays together.

In the big environment, the pack belongs to the bus and must stay with the bus, whereas the sledges of the edition never had a bus, the element which would make it necessary for them to stay together. Through the bus with the

sledges, a landscape or a tract of land where the pack lives is imagined. With the edition, on the other hand, you have no point of reference to a space. The sledges were made independently of that, but of course – they also exist as a pack.

S,K: Your 'primeval sledge' owes its animation to the fact that it was made from used materials, which accentuated the character of something found, of something which had already served its purpose.

Why did you use brand-new ready-made materials in your sledge edition? Has that got something to do with the nature of multiples?

B: Yes well, one could simply say the primeval sledge – actually there are many primeval sledges – the one Mr. Schmela had, was a unique piece and it is also much older. But I didn't just find it. I also used it. I really did a lot of things with that sledge, for instance, I tied a kite to it and slid around on the banks of the Rhine for days on end – that is, the sledge was on the ground and the kite pulled it, over puddles and so on. That's how it originated, by experimenting with it, especially together with my children.

After that I kept the sledge, and fixed it up with fat.

That's a unique piece. In the edition there are many. That's why I think the spontaneous character not the planned character of the editions should be stressed. Sometimes it can be a readymade article which one changes, but it can also be something else.

S,K: Why doesn't the felt suit have buttons?

B: Well, that was dictated by the character of felt. That occurred quite naturally. It was tailored after my own suit and I think the whole thing has to retain the character of felt in the sense that felt doesn't strive to be smart, so to speak. One has to conserve the character, omit mere trifles, such as complicated buttons, button-holes and so on, and if somebody wants to wear the suit, he can fasten it with safety-pins.

S,K: Does the association to convict's uniform on which the buttons and braces have been cut off as a sign of disgrace apply?

B: Of course I thought of that, but there's no direct relation. It isn't meant to be a suit which people wear. The suit is meant to be an object which one is not supposed to wear. One can wear it, but in a relatively short time it'll lose its shape because felt is not a material which holds a form. Felt isn't woven. It's pressed together usually from hare or rabbit hair. It's precisely that, felty, and it isn't suited for button-holes and the like.

S,K: How should one take care of a felt suit?

B: I don't give a damn. You can nail the suit to the wall. You can also hang it on a hanger *ad libitum*! But you can also wear it or throw it into a chest.

S,K: Does the suit's felt material play the role of isolating the physical warmth of a person?

B: The character of warming – yes, that's obvious. The felt suit is not just a gag. It's an extension of the felt sculptures I made during my performances. There, felt also appeared as an element of warmth, or as an isolator. Felt was used in all the categories of warmth sculpture, usually in connection with fat. And it's a derivative of that. So it does have a bearing on the character of warmth.

Ultimately the concept of warmth goes even further. Not even physical warmth is meant. If I had meant physical warmth, I could just as well have used an infra-red light in my performances. Actually I meant a completely different kind of warmth, namely spiritual or evolutionary warmth or the beginning of an evolution.

Those things reach way back, but they also play an important role again nowadays, if one inquires about the future of mankind, if one asks oneself: how can I perceive of myself as a creative and free being, and not as one bound; like in Marxism, where man is dependent upon his environment, and determined by the external world.

If what Marxism says were true, namely that human beings are dependent upon their environment, upon that which is given, then there could be no history. History can only happen through means of a process. Right now, by way of comparison, I'll call it the process of evolution, which goes way back – light, warmth, corporality and finally in corporality the spiritual activity – so that man is characterized as a creative being.

That's where the connection is. That's how far back the concept of warmth reaches. So, warmth as an evolutionary process. That goes way back. One could go even further and ask, how did the world originate? There are certain signs, at the moment I'd like to call them 'threshold-signs' or... for instance in St. John's Gospel, it is said 'In the beginning was the word'... In that sense of the idea the word was logos. What does logos do? It starts the process of evolution. Finally, how does a word, or I also call it a threshold-sign become matter? How does it become a real live person?

For me those are significant questions. They reach way back and are, first of all, represented by and continue to have a psychic effect through my performances, above all through the character of felt and fat. I can't say more, don't want to say more about it at the present because, to my mind, if it comes to a discussion the definitions will always fall out differently.

And now we can get back to the original question, why multiples, why distribute them?

I believe if people already have a materialized thing, anything which has originated from this sphere of thought then they'll think back and say: yes, that was then, and it looks as if it's exactly the opposite of what he's saying now. People can say that looks pretty dadaistic or that looks pretty material,

but now he is saying something which sounds metaphysical or spiritual. Where is the connection? That is, the connection between a single thing say an edition, and a chance thing, and that which is being said about evolution or the comprehension of the human being, or about the future direction of politics – education, freedom, equality, fraternity all those things which will surely be talked about in the near future. And I think, exactly those things will prove to be politically relevant in the future. Because, that's always what people ask: how can those things effect political change, those stupid bottles for instance? They have nothing to do with real political work.

All these things revolve around that one question you asked in the beginning: why are you interested in editions and why are you interested in the distribution of vehicles?

I'm interested in that, just as I'm interested in spreading ideas which have view to political change or which develop philosophical perception and thereby also aim at changing man in the future. So it's always a matter of perceiving man as someone who, from an extensive background – which you can call the warmth principle, or which you can call logos – is committed to being productive. In this connection, man is looked upon as a creative being, as a producer, and it doesn't make any difference whether we're dealing with a lawyer whose product terminates in a plea for the defence or in a paper, or whether the product takes on the form of movement or whether the result is something stronger, something more significant.

This is where the sentence: 'Everybody is an artist', becomes interesting. And that is precisely what, to my mind, people can experience with the help of such objects. They can realize that everyone is an artist, because, many people will ask themselves: 'Why don't I make something like that, something similar?' The sentence, 'Everybody is an artist', simply means to point out that the human being is a creative being, that he is a creator, and, what's more, that he can be productive in a great many different ways. To me, it's irrelevant whether a product comes from a painter, from a sculptor or from a physicist.

S,K: But the product must come about voluntarily? It must be free of economic restraint?

B: Yes, of course, because you can't force a person to be productive. If he is being politically repressed, as in the present, then his productivity will subside. That's why we live in an era which is not particularly productive. If people had really achieved their spiritual, social or democratic goals, if they themselves were able to determine the course of production, then humanity inevitably would become more productive. There's absolutely no reason for people to starve on this earth.

It's all because, in our political system, the concept of freedom does not exist in the right sense.

[324]

51 William Tucker

'Modernism, Freedom, Sculpture' 1977

After reading history at Oxford (1955–58), William Tucker (b. 1935) studied at St Martin's School of Art (1959–60) before taking up teaching posts there and at Goldsmiths College and receiving a number of awards, travel grants and a Gregory fellowship in Leeds during the 1960s. The 1970s witnessed the extension of Tucker's practice, both into published writing about sculpture and guest-curating sculpture exhibitions. *The Language of Sculpture* (1974), which was initiated first as a series of lectures given at Leeds University while Tucker was Gregory Fellow there, was published in 1974. These lectures and versions of some of the chapters of this 1974 book were also published in *Studio International* between 1970 and 1972. He then selected works for the Arts Council exhibition, 'The Condition of Sculpture', staged at the Hayward Gallery in London, 1975. Across these lectures, essays, books and exhibitions, Tucker promoted the art of sculpture in hitherto unprecedented ways in post-war Britain. Writing sensitively and historically, from the point of view of sculptor and art historian, he provided an articulate defence of abstract, independent and autonomous sculpture, over a body of texts that looked back across the twentieth century and into the welded metal sculpture of the 1960s and 1970s.

This article, published at the end of 1977, the year of his Arts Council retrospective and a year after Tucker left Britain to take up a teaching post at the University of Western Ontario in Canada, represents an intriguing moment in his writing about sculpture. It came out of a paper given at a conference at the A.I.R. Gallery in London in May 1976. In it Tucker offers a response to those who ask 'what is sculpture for?' and takes the opportunity to answer those critics who regarded him as a formalist, concerned only with the formal development of the language of sculpture or with the celebration of specifically sculptural conditions. His response is striking and disarming for anyone expecting a repeat of his 'Condition of Sculpture' introduction of 1975. He writes: 'the practice of sculpture is today unnecessary and unjustified', adding, 'If sculpture is to continue… then it must demonstrate in itself its own need to exist.' This is not a matter of connecting sculpture to particular terms and conditions, but of radically reconsidering both sculpture's terms and its relation to reality and to the human condition. Sculpture, for Tucker, forms 'a physical and perceptual link between the human onlooker and the world', and it is this role, and he concludes its 'mythical' dimension, which needs to be recovered for sculpture to survive.

William Tucker, 'Modernism, Freedom, Sculpture', *Art Journal*, Vol. 37, No. 2, Winter 1977/78, pp. 153–6.

The practice of sculpture at this point in the decline of modernism is open to criticism from almost every quarter. For the moment critics of all tendencies have joined with popular philistinism in asking the question 'What's it all *for*, anyway?' and apparently received a dusty answer.

I am not here to present a case for the defense of sculpture – some sculpture – now. This article has to do with criticism, not with making apologies or justifications for this or that kind of work. But the persistence and renewal of activity within sculpture, against the grain of history – this phenomenon clearly offends many observers. The question they ask – 'What's it all *for*?' is a plain one, and an honest one. It demands an honest answer. The artist is asked, not 'What are you doing?' which implies that the questioner is in ignorance and wants an explanation, and further that there is already an understanding between questioner and artist that what he is doing is worthwhile and merely needs interpretation. No, the sculptor is asked, 'What is what he has already done *for*?' Here the questioner no longer pretends ignorance: the thing is finished, already done, the questioner 'knows' it, has seen such things before. There is no room for interpretation. So the questioner, his conventional role elided, asks 'What is it *for*?' that is, 'What is its use?'

Plainly, this is not meant literally: the questioner does not really believe the object has a physical or mechanical purpose, as has a piece of furniture or a machine. He knows this thing is a sculpture, there is no secret about it, rather the opposite: the thing is proudly and obstinately a sculpture. So the question is really a far more general one: what *need* is there for sculpture? He asks how does this thing which he knows, or thinks he knows, 'sculpture,' relate to 'reality' – the needs of history, social needs, political needs, and so on.

The fact is, practically every object and every activity in the modern industrial world has a purpose, a use. They answer a need, they are 'for' something else. The only things for which this principle of utility would surely not obtain – works of art – are increasingly made and regarded in the light of this principle. In the heroic age of early modernism, an ideal of completeness and self-containedness was set up for the art object that would remove it from all possibility of use. Such works, so their makers thought, would generate their own authority, an authority not dependent for example on a represented subject. The subject was first neutralized (by the Impressionists), then, apparently, disposed of. With its roots in the world severed, the modernist work was free to flourish independently. But paintings, and more especially sculptures, differ fundamentally from music or literature in that the work *is* the physical object. The object has a specific location in space and a duration in time unknown to the poem. Paintings and sculpture exist somewhere, are someone's possession. This inevitable characteristic of being and belonging has thrown doubt on the genuine capacity for freedom of the sculptor or painter in modern Western

society. The greatest artists can be depicted as the servants of the rich and the powerful, implicitly supporting the social and political structure in which they lived, however much they protested against it, even within their work.

Rilke chose a work of sculpture, and a contained, apparently 'autonomous' sculpture at that, as the vehicle for the realization of human freedom, in his sonnet 'Archaic Torso of Apollo,' written in 1906:

> We knew not his unheard-of head
> Wherein the eye-apples ripened
> But his torso still glows like a street lamp
> In which his gaze, merely turned down low
> Persists and gleams. Or else the curve
> Of the chest couldn't blind you, and in that twist
> Of the loins there'd be no smile, returning
> To the centre of virility,
> Or else this stone would stand short, disfigured,
> Under the shoulders' transparent plunge
> And would not glint like the skin of beasts
> And would not explode from all its edges
> Like a star: For here's no place
> That does not see you. You must change your life.

Of course it is the *poem* which makes the sculpture say 'You must change your life.' But there is no intrinsic reason given beyond its inaccessibility why sculptures, physical objects, should not also become as effective vehicles for action as books or plays. That it could happen, as in the inspirational role of Tatlin's Tower for the progressive artists of post-1918 Europe, was recognized by the Soviet Government, who subsequently took such pains to remove Tatlin from history – not by destroying him and his work as the Nazis might have done – but by quietly and effectively cancelling his public existence, 'as though he had never been.'

In practice the physical existence of the art object remained a useful hypothesis for modernist art. Many writers and artists could claim it in the knowledge that their own field was comfortably secure from the contingencies of the actual physical world, the world you and I live in, move in, and see in. One might have imagined that the sculptors especially would have recognized this danger (or opportunity) for their art, the most physically exposed of all. Yet only Brancusi, and perhaps marginally Matisse and Giacometti, seem to have understood the dilemma the modernist assumption had created for sculpture. Their contemporaries and successors as one man – including the constructivists – continued to pretend as sculptors have always pretended

that a sculpture is not really a thing, that it is not really in the world, but is somehow protected and reserved by *being an image of something else.*

Brancusi alone confronted the problem. In the face of it he did not reject the practice of making sculpture altogether as did Tatlin and Duchamp, at the same time discarding its representing function: rather he brought the business of representation and the fact of sculpture's physical existence together, with infinite patience and subtlety, until at the great monuments at Tirgu Jiu he achieved a marvelous equation between them. If these sculptures are the touchstone for many artists working now, it is because they resist specific interpretation, yet attain a grandeur and nobility that recalls but does not imitate the greatest sculpture of the past. The *Table*, *Gate*, and *Column* are still, at the level of recognition, objects of use. There is no question as to what they are: the question what they are *for* is not avoided, rather transcended. They simply, *are*: and *they are what they are.*

The silence of Brancusi's last 20 years can be variously explained. Yet even had he the physical opportunity how could he have equaled or surpassed Tirgu Jiu without abandoning the protection of the already existing things within which the drive to reality had become manifest?

Now, 40 years after the realization of this enigma, the utter lack of necessity for sculpture, celebrated by Duchamp and Tatlin, is a commonplace. What then is it *for*? If I were offering a defense, in formalistic art-historical terms, I could say that sculpture has lagged so far behind painting, for example, that there are any number of holes to be plugged before sculpture can develop as various and articulate a formal language as painting. But – contrary to general belief – I am not and have never been a formalist, and the idea that the function of works of art should *primarily* be to advance a language of art seems to me increasingly unconvincing.

All we have in this situation, if we put aside the arguments from language and from history, is that acknowledgment of the truth in the question: that sculpture is *in* the world, and that in the world's terms it is useless, for nothing.

What the conscious persistence of sculpture now might show is that there are artists who believe that sculpture has nothing necessarily to do with modernism and can do without the threadbare cloak of its idea, which was generated in painting and poetry: that sculpture's relation to man and the world is utterly different from that of painting and poetry. For sculpture, existence, worldly existence, physical existence, precedes the idea. L. B. Alberti, writing in the early Renaissance, with an unprecedented imaginative leap described the origin of sculpture thus: 'I believe that the arts of those who attempt to create images and likenesses from bodies produced by Nature, originated in the following way. They probably occasionally observed in a tree

trunk or clod of earth and other similar inanimate objects certain outlines in which... something very similar to the real faces of Nature was represented. They began therefore by diligently observing and studying such things, to try to see whether they could not add, take away or otherwise supply whatever seemed lacking to effect and complete the true likeness...'

In other words the sculptor recognizes the existence of the lump of wood, earth, or stone – the thing – by perceiving in it an image which he then modifies. Now, if we strip away from this process the element of representation, the image, we are left with the original act, *the act of recognition*. The thing's being is exposed: the making of sculpture is then not synthetic – a construction, a structure, as of buildings – but rather a recovery of recognition, an uncovering and a disclosure of being.

The everyday world is so full, so closely packed with the known and the nameable that it requires the utmost pressure and effort to find a gap, a fissure, and slip something new, something unprecedented, into existence. Of course I am not speaking literally here: at a superficial level nothing is easier to make than a coherent, 'convincing' three-dimensional object, and to set it up among other objects, as sculpture. When I talk of the close packing of objects, I am speaking of the resistance of the physical, tangible, known world to something as physical, as tangible, but *unknown*. This new and unaccounted-for existence poses a threat. What is at stake is the perceptual and conceptual coherence of each man's world.[1] When the unfamiliar is glimpsed, quickly give it a familiar name. The psychic mechanism is as old as man: and it applies equally and everywhere to artists as well as spectators: to create likeness, rather than acknowledge unlikeness – which is, *the new*.

What sculpture can learn from the experience of modernism is that sculpture itself, once it had recognized itself, has no particular container, no announcement as it were of its own arrival. Both architecture and painting (and music for that matter) are in some sense withdrawn or protected from the sudden and violent intrusion into consciousness offered by sculpture when the habitual flow through consciousness of objects carrying habitual meanings is suddenly challenged, without the expectation created by the *fact* of the wall or the rectangular canvas, the *fact* of the building. What is the fact of sculpture? *There is no fact in advance of the particular sculpture*. It goes without saying that the vast proportion of contemporary sculptures never even attain this preliminary status, but succumb to an *idea* of sculpture, that might offer the framework of support painting and architecture enjoy.

Someone will no doubt object at this point that this framework is exactly what I have advocated in the past – the 'condition' of sculpture, the 'language.' Well, if I have insisted on the conditions for sculpture's existence, the language which sculpture speaks – it is not to lock sculpture into one style, one material,

one structure. On the contrary, I have simply said that for sculpture to be sculpture it must arise from certain conditions, and the way in which sculpture has appeared under these conditions in the last century (it is the centenary of the first showing of Rodin's *Age of Bronze* next year) may be thought of as constituting the beginnings of a 'language.' But the achievement of Rodin and Brancusi is no more explained by the language account of history any more than the achievement of Bach, Haydn, and Mozart is explained by the development of musical notation and orchestral responses in the 18th century. Or for that matter that any of these instances can be 'explained' by the social and economic conditions of the cultures in which they were made. That both these ludicrously narrow accounts should polarize the discussion of art today seems to me due if anything to the dominance that criticism has acquired over the making of art in the last 20 years, that alienation of art from the conditions of its being.

The critic concerns himself with the work as it is, its effect: the artist with its origin. For this reason I first tried to redress the balance of critical writing about modern sculpture by calling attention to its making, about which I knew something from my own experience, perhaps something to which other writers on sculpture have generally not had access. But this approach I realized was only an approach: to deal with the coming into being of sculpture and to ignore the nature and problems of its being could be at best a limited and technical venture.

So, if I mentioned earlier sculpture's present and necessary *exposure*, this is firstly to be understood in relation to the general fear of exposure among sculptors. I spoke a moment ago of sculpture concealing itself as an image. Today, instead of the classical images of men and women, gods and animals, or the images of perfect order with which the constructivists for example replaced them, sculpture presents itself as an articulation of architecture or landscape: while the proponents of formal abstraction resist exposure by the erection of certain conventions – for example, in material and structure – into immutable limits: within which only 'small discoveries,' as Peter Fink has described them, are possible. Each of these postures answers the question ('what is it for?') in advance by postulating a general idea for sculpture before its particular existence. Sculptors have sought essential foundations for their own art, as the *lump* for Rodin, the *block* for Hildebrand, and their successors in direct modeling and carving: the ground and the unit of repetition for the sculpture of the last 15 years. Yet modern sculpture has failed to come up with a final and irreducible form – the need for which I suspect springs from a desire to find a basic structural equivalent for the figure – and *must* fail if it is to survive because *there is no such form.*

When I began by saying that on all sides sculpture is exposed today, this

is what I meant: it has no significant social use, nor has it had for the last two centuries. It has no aesthetic 'use,' if that is a possible term, because the logical and inexorable development of avant-gardism has simply declared its existence redundant. And attempts to find an appropriate aesthetic niche within which sculpture might hide until the storm has past are doomed, because sculpture can find no final *formal* ground on which to build a convincing justification of its continued existence.

To put it simply: the practice of sculpture today is unnecessary and unjustified. This does not mean that it is unjustifiable: the point is that before attempting to find any justification this bare fact must be recognized. Of course, it may be that the practice of painting, of the visual arts as a whole, is equally vulnerable. But the redundancy of sculpture is more obvious, and felt more acutely. Whether sculpture goes or stays, *its* fate will be decided first. The question is – will the sculptors, the makers of sculpture, take any part in deciding its fate? To imagine that they can do so by simply continuing to make it, so long as they can find some support for doing so – some patron, some critic, some gallery, some school – seems to me pure self-deception. The issue is not fundamentally a social or an economic one: nor is it one of psychology, or even of aesthetic.

If sculpture is to continue, that is if it is to have an authentic existence, not merely a contingent existence, *then it must demonstrate in itself its own need to exist.* It is not merely a matter of being, much less of surviving, but of a questioned and an affirmed being, because being itself is at stake – that is, a conception of being that extends beyond the mere fabrication of artifacts.

The future of sculpture is not an aesthetic problem. The necessity for sculpture is not an aesthetic necessity. The problems of relation – relation within the individual work, relation of the work to the onlooker – are, considered in themselves, mechanical and trivial. The only relation worth considering is the relation of the work to reality: that is, the world in the most general sense, not the particular place, particular onlooker, particular society, but *the individual sculpture's relation to reality.* And as the conscious individual realizes his 'form,' that is his self and his identity in reflection, in decision and in action, the individual sculpture reaches out for and gains identity in its own form over against reality. Considerations of structure, scale and material, and so on, the physical and perceptual properties of the work, cannot be separated and analyzed, except in terms of the work's answering its exposure to reality in its identity. Moreover, to reduce sculpture to any one of these formal properties, even with the best intentions, to gain a better understanding of what it is, and how it came to be there, is inevitably to misconceive it in terms used and even contaminated in other areas immediately adjoining or superficially analogous – painting, architecture, music, engineering, the study of perception, etc.

What is urgently demanded is the introduction and establishing of terms appropriate to sculpture's present situation, which will throw light on that situation, what is original and challenging in it, and which might move both the ambition of sculptors and the perception of sculpture from the technical to the human.

For example, the terms 'exposure' and 'identity' carry an understood human meaning, but there is no full equivalent for either in the present critical vocabulary. Terms such as 'open-ness,' 'spatiality,' or 'form,' 'originality,' cover only a small part of the implication of 'exposure' and 'identity,' and moreover create expectations quite foreign to the work conceived in these terms.

One word which has dropped out of use completely in connection with sculpture, since the time of Rodin, is 'statue.' One can easily appreciate how this came about, how, with the concentration of modernism on the technical, the term which describes process as well as product – *'sculpture'*, the making and the thing made – became the universal term: even when the kind of making – carving – had no relation to the actual process implied by the word. The use of the word 'statue' has become equally indistinct; it is restricted now to denote pre-modern, usually Western, public figure sculpture.

In consequence we have no word which embodies for present-day sculpture its *standing*, its being rather than its becoming, how it *is* rather than how it got to be there. The statue is a thing set upright: it stands against gravity and against sight. We encounter here the implication of resistance, a with-standing. And a standing in time, a continued resistance to earth's pull, against which structure is given meaning; a ground of stability, a sufficient permanence to meet, embrace, and give form to the onlooker's perception. But the fact of structure like the fact of perception, however objectively pursued, will not of itself yield sculptural truth. The sculpture forms the median term, a physical and perceptual link between the human onlooker and the world. It is responsive to physical and perceptual laws but is reducible to neither.

If sculpture is to transcend the merely physical, the merely perceptual, or any mere tension or interaction between them, it will be by becoming a metaphor for the human. The existence of sculpture reflecting human existence, sculpture's condition reflecting the human condition. Sculpture's exposure and aloneness, its identity and its resistance, its ambiguity and its decision – every aspect of its being can and must be identified in terms of human experience. Inevitably rooted in the physical and perceptual, sculpture to survive must recover the mythical.

1 Nietzsche in *Twilight of the Idols*, page 51, wrote 'to trace something unknown back to something known is alleviating, soothing, gratifying, and gives moreover a feeling of power. Danger, disquiet, anxiety attend the unknown – the first instinct is to *eliminate* these distressing states...'

52 Rosalind Krauss

'Sculpture in the Expanded Field' 1978

Rosalind Krauss (b. 1940) has been particularly influential for her critical explorations of the formal continuities and discontinuities between modernist and post-modernist art practices, and for her deployment of semiotic and structuralist, or post-structuralist, paradigms in place of the purely visual analysis of artistic form that prevailed in earlier discussions of modern art. The essay 'Sculpture in the Expanded Field' is a seminal instance of Krauss's approach in this respect, following on from her 1977 book *Passages in Modern Sculpture* and aiming itself squarely at the moment in which the principles of modernist sculpture appeared to unravel in the late 1960s.

Krauss's text is notable for the rigour with which she analyses the ways in which the definition of sculpture seems to have become 'almost infinitely malleable', serving to describe a wide variety of spatial and architectural installations, along with their photographic or textual documentation. Basing her discussion predominantly on the earthworks of artists such as Robert Morris, Robert Smithson and Alice Aycock, she uses diagrams (a characteristic feature of her writings that she borrows from French structuralists) to assert that these works draw their meanings from a network of binary oppositions, by playing on the distinctions between landscape and 'not-landscape', or architecture and 'not-architecture'. Rather than consisting of a kind of spatial free-for-all, then, these late 1960s and early 1970s works are presented as a sustained engagement with sculptural meaning: 'The expanded field is thus generated by problematising the set of oppositions between which the modernist category *sculpture* is suspended.' For Krauss, 'sculpture' is then no longer about the medium used, but about the logical moves of artists and art works in relation to sculpture as a cultural construct. Beyond the apparent transferability of her analysis of sculpture after modernism, Krauss's essay does in fact present a tightly woven espousal of a particular kind of artistic practice marked by its architectural interventions into the landscape: the poetic resonances of the 'expanded *field*' of the essay's title as well as the spatial suggestiveness of her structural diagrams (reproduced here) both work together to reinforce this.

Rosalind Krauss, 'Sculpture in the Expanded Field' (1978), in *The Originality of the Avant-Garde and Other Modernist Myths*, Cambridge, Mass. and London, MIT Press, 1985, pp. 277–90.

Toward the center of the field there is a slight mound, a swelling in the earth, which is the only warning given for the presence of the work. Closer to it, the large square face of the pit can be seen, as can the ends of the ladder that is needed to descend into the excavation. The work itself is thus entirely below grade: half atrium, half tunnel, the boundary between outside and in, a delicate

structure of wooden posts and beams. The work, *Perimeters/Pavilions/Decoys*, 1978, by Mary Miss, is of course a sculpture or, more precisely, an earthwork.

Over the last ten years rather surprising things have come to be called sculpture: narrow corridors with TV monitors at the ends; large photographs documenting country hikes; mirrors placed at strange angles in ordinary rooms; temporary lines cut into the floor of the desert. Nothing, it would seem, could possibly give to such a motley of effort the right to lay claim to whatever one might mean by the category of sculpture. Unless, that is, the category can be made to become almost infinitely malleable.

The critical operations that have accompanied postwar American art have largely worked in the service of this manipulation. In the hands of this criticism categories like sculpture and painting have been kneaded and stretched and twisted in an extraordinary demonstration of elasticity, a display of the way a cultural term can be extended to include just about anything. And though this pulling and stretching of a term such as sculpture is overtly performed in the name of vanguard aesthetics – the ideology of the new – its covert message is that of historicism. The new is made comfortable by being made familiar, since it is seen as having gradually evolved from the forms of the past. Historicism works on the new and different to diminish newness and mitigate difference. It makes a place for change in our experience by evoking the model of evolution, so that the man who now is can be accepted as being different from the child he once was, by simultaneously being seen – through the unseeable action of the telos – as the same. And we are comforted by this perception of sameness, this strategy for reducing anything foreign in either time or space, to what we already know and are.

No sooner had minimal sculpture appeared on the horizon of the aesthetic experience of the 1960s, than criticism began to construct a paternity for this work, a set of constructivist fathers who could legitimize and thereby authenticate the strangeness of these objects. Plastic? inert geometries? factory production? – none of this was *really* strange, as the ghosts of Gabo and Tatlin and Lissitzky could be called in to testify. Never mind that the content of the one had nothing to do with, was in fact the exact opposite of, the content of the other. Never mind that Gabo's celluloid was the sign of lucidity and intellection, while Judd's plastic-tinged-with-dayglo spoke the hip patois of California. It did not matter that constructivist forms were intended as visual proof of the immutable logic and coherence of universal geometries, while their seeming counterparts in minimalism were demonstrably contingent – denoting a universe held together not by Mind but by guy wires, or glue, or the accidents of gravity. The rage to historicize simply swept these differences aside.

Of course, with the passing of time these sweeping operations got a little harder to perform. As the 1960s began to lengthen into the 1970s and

'sculpture' began to be piles of thread waste on the floor, or sawed redwood timbers rolled into the gallery, or tons of earth excavated from the desert, or stockades of logs surrounded by firepits, the word *sculpture* became harder to pronounce – but not really that much harder. The historian/critic simply performed a more extended sleight-of-hand and began to construct his genealogies out of the data of millennia rather than decades. Stonehenge, the Nazca lines, the Toltec ballcourts, Indian burial mounds – anything at all could be hauled into court to bear witness to this work's connection to history and thereby to legitimize its status as sculpture. Of course Stonehenge and the Toltec ballcourts were just exactly *not* sculpture, and so their role as historicist precedent becomes somewhat suspect in this particular demonstration. But never mind. The trick can still be done by calling upon a variety of primitivizing work from the earlier part of the century – Brancusi's *Endless Column* will do – to mediate between extreme past and present.

But in doing all of this, the very term we had thought we were saving – *sculpture* – has begun to be somewhat obscured. We had thought to use a universal category to authenticate a group of particulars, but the category has now been forced to cover such a heterogeneity that it is, itself, in danger of collapsing. And so we stare at the pit in the earth and think we both do and don't know what sculpture is.

Yet I would submit that we know very well what sculpture is. And one of the things we know is that it is a historically bounded category and not a universal one. As is true of any other convention, sculpture has its own internal logic, its own set of rules, which, though they can be applied to a variety of situations, are not themselves open to very much change. The logic of sculpture, it would seem, is inseparable from the logic of the monument. By virtue of this logic a sculpture is a commemorative representation. It sits in a particular place and speaks in a symbolical tongue about the meaning or use of that place. The equestrian statue of Marcus Aurelius is such a monument, set in the center of the Campidoglio to represent by its symbolical presence the relationship between ancient, Imperial Rome and the seat of government of modern, Renaissance Rome. Bernini's statue of the *Conversion of Constantine*, placed at the foot of the Vatican stairway connecting the Basilica of St. Peter to the heart of the papacy is another such monument, a marker at a particular place for a specific meaning/event. Because they thus function in relation to the logic of representation and marking, sculptures are normally figurative and vertical, their pedestals an important part of the structure since they mediate between actual site and representational sign. There is nothing very mysterious about this logic: understood and inhabited, it was the source of a tremendous production of sculpture during centuries of Western art.

But the convention is not immutable and there came a time when the logic

began to fail. Late in the nineteenth century we witnessed the fading of the logic of the monument. It happened rather gradually. But two cases come to mind, both bearing the marks of their own transitional status. Rodin's *Gates of Hell* and his statue of *Balzac* were both conceived as monuments. The first were commissioned in 1880 as the doors to a projected museum of decorative arts; the second was commissioned in 1891 as a memorial to literary genius to be set up at a specific site in Paris. The failure of these two works as monuments is signaled not only by the fact that multiple versions can be found in a variety of museums in various countries, while no version exists on the original sites – both commissions having eventually collapsed. Their failure is also encoded onto the very surfaces of these works: the doors having been gouged away and anti-structurally encrusted to the point where they bear their inoperative condition on their face; the *Balzac* executed with such a degree of subjectivity that not even Rodin believed (as letters by him attest) that the work would ever be accepted.

With these two sculptural projects, I would say, one crosses the threshold of the logic of the monument, entering the space of what could be called its negative condition – a kind of sitelessness, or homelessness, an absolute loss of place. Which is to say one enters modernism, since it is the modernist period of sculptural production that operates in relation to this loss of site, producing the monument as abstraction, the monument as pure marker or base, functionally placeless and largely self-referential.

It is these two characteristics of modernist sculpture that declare its status, and therefore its meaning and function, as essentially nomadic. Through its fetishization of the base, the sculpture reaches downward to absorb the pedestal into itself and away from actual place; and through the representation of its own materials or the process of its construction, the sculpture depicts its own autonomy. Brancusi's art is an extraordinary instance of the way this happens. The base becomes, in a work like the *Cock*, the morphological generator of the figurative part of the object; in the *Caryatids* and *Endless Column*, the sculpture is all base; while in *Adam and Eve*, the sculpture is in a reciprocal relation to its base. The base is thus defined as essentially transportable, the marker of the work's homelessness integrated into the very fiber of the sculpture. And Brancusi's interest in expressing parts of the body as fragments that tend toward radical abstractness also testifies to a loss of site, in this case the site of the rest of the body, the skeletal support that would give to one of the bronze or marble heads a home.

In being the negative condition of the monument, modernist sculpture had a kind of idealist space to explore, a domain cut off from the project of temporal and spatial representation, a vein that was rich and new and could for a while be profitably mined. But it was a limited vein and, having been

opened in the early part of the century, it began by about 1950 to be exhausted. It began, that is, to be experienced more and more as pure negativity. At this point modernist sculpture appeared as a kind of black hole in the space of consciousness, something whose positive content was increasingly difficult to define, something that was possible to locate only in terms of what it was not. 'Sculpture is what you bump into when you back up to see a painting,' Barnett Newman said in the fifties. But it would probably be more accurate to say of the work that one found in the early sixties that sculpture had entered a categorical no-man's-land: it was what was on or in front of a building that was not the building, or what was in the landscape that was not the landscape.

The purest examples that come to mind from the early 1960s are both by Robert Morris. One is the work exhibited in 1964 in the Green Gallery – quasi-architectural integers whose status as sculpture reduces almost completely to the simple determination that it is what is in the room that is not really the room; the other is the outdoor exhibition of the mirrored boxes – forms which are distinct from the setting only because, though visually continuous with grass and trees, they are not in fact part of the landscape.

In this sense sculpture had entered the full condition of its inverse logic and had become pure negativity: the combination of exclusions. Sculpture, it could be said, had ceased being a positivity, and was now the category that resulted from the addition of the *not-landscape* to the *not-architecture*. Diagrammatically expressed, the limit of modernist sculpture, the addition of the neither/nor, looks like this:

Now, if sculpture itself had become a kind of ontological absence, the combination of exclusions, the sum of the neither/nor, that does not mean that the terms themselves from which it was built – the *not-landscape* and the *not-architecture* – did not have a certain interest. This is because these terms express a strict opposition between the built and the not-built, the cultural and the natural, between which the production of sculptural art appeared to be suspended. And what began to happen in the career of one sculptor after another, beginning at the end of the 1960s, is that attention began to focus on the outer limits of those terms of exclusion. For, if those terms are the expression of a logical opposition stated as a pair of negatives, they can be transformed by a simple inversion into the same polar opposites but expressed positively. That is, the *not-architecture* is, according to the logic of a certain

kind of expansion, just another way of expressing the term *landscape*, and the *not-landscape* is, simply, *architecture*. The expansion to which I am referring is called a Klein group when employed mathematically and has various other designations, among them the Piaget group, when used by structuralists involved in mapping operations within the human sciences.[1] By means of this logical expansion a set of binaries is transformed into a quaternary field which both mirrors the original opposition and at the same time opens it. It becomes a logically expanded field which looks like this:

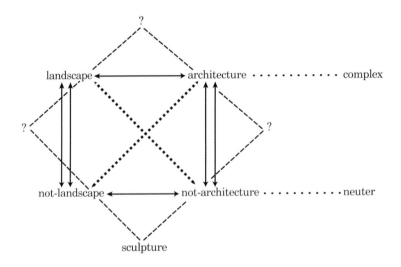

Another way of saying this is that even though *sculpture* may be reduced to what is in the Klein group the neuter term of the *not-landscape* plus the *not-architecture*, there is no reason not to imagine an opposite term – one that would be both landscape and architecture – which within this schema is called the *complex*. But to think the complex is to admit into the realm of art two terms that had formerly been prohibited from it: *landscape* and *architecture* – terms that could function to define the sculptural (as they had begun to do in modernism) only in their negative or neuter condition. Because it was ideologically prohibited, the complex had remained excluded from what might be called the closure of post-Renaissance art. Our culture had not before been able to think the complex, although other cultures have thought this term with great ease. Labyrinths and mazes are *both* landscape and architecture; Japanese gardens are *both* landscape and architecture; the ritual playing fields and processionals of ancient civilizations were all in this sense the unquestioned occupants of the complex. Which is *not* to say that they were an early, or a degenerate, or a variant form of sculpture. They were part of a universe or

cultural space in which sculpture was simply another part – not somehow, as our historicist minds would have it, the same. Their purpose and pleasure is exactly that they are opposite and different.

The expanded field is thus generated by problematizing the set of oppositions between which the modernist category *sculpture* is suspended. And once this has happened, once one is able to think one's way into this expansion, there are – logically – three other categories that one can envision, all of them a condition of the field itself, and none of them assimilable to *sculpture*. Because as we can see, *sculpture* is no longer the privileged middle term between two things that it isn't. *Sculpture* is rather only one term on the periphery of a field in which there are other, differently structured possibilities. And one has thereby gained the 'permission' to think these other forms. So our diagram is filled in as follows:

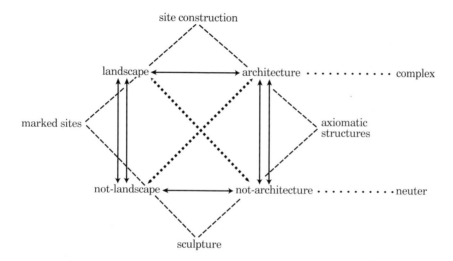

It seems fairly clear that this permission (or pressure) to think the expanded field was felt by a number of artists at about the same time, roughly between the years 1968 and 1970. For, one after another Robert Morris, Robert Smithson, Michael Heizer, Richard Serra, Walter De Maria, Robert Irwin, Sol LeWitt, Bruce Nauman... had entered a situation the logical conditions of which can no longer be described as modernist. In order to name this historical rupture and the structural transformation of the cultural field that characterizes it, one must have recourse to another term. The one already in use in other areas of criticism is postmodernism. There seems no reason not to use it.

But whatever term one uses, the evidence is already in. By 1970, with the *Partially Buried Woodshed* at Kent State University, in Ohio, Robert Smithson had begun to occupy the complex axis, which for ease of reference I am calling

site construction. In 1971 with the observatory he built in wood and sod in Holland, Robert Morris had joined him. Since that time, many other artists – Robert Irwin, Alice Aycock, John Mason, Michael Heizer, Mary Miss, Charles Simonds – have operated within this new set of possibilities.

Similarly, the possible combination of *landscape* and *not-landscape* began to be explored in the late 1960s. The term *marked sites* is used to identify work like Smithson's *Spiral Jetty* (1970) and Heizer's *Double Negative* (1969), as it also describes some of the work in the seventies by Serra, Morris, Carl Andre, Dennis Oppenheim, Nancy Holt, George Trakis, and many others. But in addition to actual physical manipulations of sites, this term also refers to other forms of marking. These might operate through the application of impermanent marks – Heizer's *Depressions*, Oppenheim's *Time Lines*, or De Maria's *Mile Long Drawing*, for example – or through the use of photography. Smithson's *Mirror Displacements in the Yucatan* were probably the first widely known instances of this, but since then the work of Richard Long and Hamish Fulton has focused on the photographic experience of marking. Christo's *Running Fence* might be said to be an impermanent, photographic, and political instance of marking a site.

The first artists to explore the possibilities of *architecture* plus *not-architecture* were Robert Irwin, Sol LeWitt, Bruce Nauman, Richard Serra, and Christo. In every case of these *axiomatic structures*, there is some kind of intervention into the real space of architecture, sometimes through partial reconstruction, sometimes through drawing, or as in the recent works of Morris, through the use of mirrors. As was true of the category of the *marked site*, photography can be used for this purpose; I am thinking here of the video corridors by Nauman. But whatever the medium employed, the possibility explored in this category is a process of mapping the axiomatic features of the architectural experience – the abstract conditions of openness and closure – onto the reality of a given space.

The expanded field which characterizes this domain of postmodernism possesses two features that are already implicit in the above description. One of these concerns the practice of individual artists; the other has to do with the question of medium. At both these points the bounded conditions of modernism have suffered a logically determined rupture.

With regard to individual practice, it is easy to see that many of the artists in question have found themselves occupying, successively, different places within the expanded field. And though the experience of the field suggests that this continual relocation of one's energies is entirely logical, an art criticism still in the thrall of a modernist ethos has been largely suspicious of such movement, calling it eclectic. This suspicion of a career that moves continually and erratically beyond the domain of sculpture obviously derives from the

modernist demand for the purity and separateness of the various mediums (and thus the necessary specialization of a practitioner within a given medium). But what appears as eclectic from one point of view can be seen as rigorously logical from another. For, within the situation of postmodernism, practice is not defined in relation to a given medium – sculpture – but rather in relation to the logical operations on a set of cultural terms, for which any medium – photography, books, lines on walls, mirrors, or sculpture itself – might be used.

Thus the field provides both for an expanded but finite set of related positions for a given artist to occupy and explore, and for an organization of work that is not dictated by the conditions of a particular medium. From the structure laid out above, it is obvious that the logic of the space of postmodernist practice is no longer organized around the definition of a given medium on the grounds of material, or, for that matter, the perception of material. It is organized instead through the universe of terms that are felt to be in opposition within a cultural situation. (The postmodernist space of painting would obviously involve a similar expansion around a different set of terms from the pair *architecture/landscape* – a set that would probably turn on the opposition *uniqueness/reproducibility*.) It follows, then, that within any one of the positions generated by the given logical space, many different mediums might be employed. It follows as well that any single artist might occupy, successively, any one of the positions. And it also seems the case that within the limited position of sculpture itself the organization and content of much of the strongest work will reflect the condition of the logical space. I am thinking here of the sculpture of Joel Shapiro, which, though it positions itself in the neuter term, is involved in the setting of images of architecture within relatively vast fields (landscapes) of space. (These considerations apply, obviously, to other work as well – Charles Simonds, for example, or Ann and Patrick Poirier.)

I have been insisting that the expanded field of postmodernism occurs at a specific moment in the recent history of art. It is a historical event with a determinant structure. It seems to me extremely important to map that structure and that is what I have begun to do here. But clearly, since this is a matter of history, it is also important to explore a deeper set of questions which pertain to something more than mapping and involve instead the problem of explanation. These address the root cause – the conditions of possibility – that brought about the shift into postmodernism, as they also address the cultural determinants of the opposition through which a given field is structured. This is obviously a different approach to thinking about the history of form from that of historicist criticism's constructions of elaborate genealogical trees. It presupposes the acceptance of definitive ruptures and the possibility of looking at historical process from the point of view of logical structure.

[This text was originally accompanied by the following photographs: Richard Serra, *5:30* (1969), Auguste Rodin, *Balzac* (1897), Constantin Brancusi, *Beginning of the World* (1924), Robert Morris, *Green Gallery Installation* (1964), Robert Morris, *Untitled (Mirrored Boxes)* (1965), Robert Smithson, *Spiral Jetty* (1969–70), Robert Morris, *Observatory,* (*1970),* Alice Aycock, *Maze* (1972), Carl Andre, *Cuts* (1967), Robert Smithson, *First and Seventh Mirror Displacements, Yucatan* (1969), Richard Long, *Untitled* (1969), Joel Shapiro, *Untitled (Cast Iron and Plaster Houses)* (1975).]

1 The dimensions of this structure may be analyzed as follows: 1) there are two relationships of pure contradiction which are termed *axes* (and further differentiated into the *complex axis* and the *neuter axis*) and are designated by the solid arrows (see diagram); 2) there are two relationships of contradiction expressed as involution, which are called *schemas* and are designated by the double arrows; and 3) there are two relationships of implication which are called *deixes* and are designated by the broken arrows.

For a discussion of the Klein group, see Marc Barbut, 'On the Meaning of the Word "Structure" in Mathematics', in Michael Lane (ed.), *Introduction to Structuralism*, New York, Basic Books, 1970; for an application of the Piaget group, see A.-J. Greimas and F. Rastier. 'The Interaction of Semiotic Constraints,' *Yale French Studies*, no. 41 (1968), pp. 86–105.

53 Richard Serra/Peter Eisenman

'Interview with Peter Eisenman' 1983

The two interlocutors in this text are Peter Eisenman (b. 1932), deconstructionist architect and editor of *Oppositions*, and Richard Serra (b. 1935), one of the foremost sculptors of American post-minimalism. These two powerful American voices engage in robust dialogue, the aim of which seems to have been to put sculpture on an equal footing with architecture while maintaining a dialectical relationship between the two. Serra's characteristic interest in the viewer's perspective derives from minimalist discussions of the mid to late 1960s – advanced, for example, by Robert Morris in phenomenological terms, or by Carl Andre from a Marxist perspective. But whereas Morris and Andre tended to work within galleries or in private settings, Serra by contrast developed his work to be suitable for public installation. Because of this, he was less engaged with purely aesthetic questions, having to contend instead with real political circumstances: the contingencies of the architectural site and the realities of a sometimes unfavourable public reception. At the time of this discussion, Serra's famous *Tilted Arc* (installed 1981) had not yet been removed – with Serra insisting that removal would amount to the work's destruction. However, considerable objections had already been registered, so that a backdrop to the dialogue is the hostility that Serra's site-specific installations often attracted and that presumably Eisenman, also no stranger to controversy, could easily understand.

This interview was originally published in *Skyline Magazine*. It is more usually encountered, however, in the context of *Writings/Interviews* (1994), where it appears along with other strongly dialogical engagements staged with art-world figures, from Douglas Crimp and Alan Colquhoun to David Sylvester and Nicholas Serota. In *Writings/Interviews*, two photographs follow the Serra-Eisenman interview, showing *Plumb Run: Equal Elevations* and *Clara-Clara* (both 1983). The interview is preceded by an installation shot of *Berlin Block for Charlie Chaplin* (1977). Next to this is a short statement from *Perspecta* 19 (1982) attacking post-modernism's return to 'historical images, icons, and symbols'.

Richard Serra, 'Interview with Peter Eisenman' (1983), in Richard Serra, *Writings/Interviews*, Chicago: University of Chicago Press, 1994, pp. 141–54.

I am not interested in the idealization of the perennial monuments of art history, emptied of their historical function and meaning, being served up by architects and artists who need to legitimize their aesthetic production by glorifying past achievements. Their 'appropriate historical solution' is nothing other than kitsch eclecticism: so much for the cast bronze figure on

the pedestal and the Ionic column. The return to historical images, icons, and symbols is based on an illusionary notion, the nostalgic longing for the good old days when times were better and more meaningful.

–Richard Serra, *Perspecta* 19 (1982)

PETER EISENMAN: In the past, figural sculpture – the figure on the pedestal – was concerned basically with the meaning inherent in the representation of the figure in the object. Modernist sculpture intended to break away from figuration or, let us say, representation in terms of figuration; any representation in modernist sculpture supposedly represented sculpture itself. You say that what you attempt to do is to bring forth sculptural intentions. Is this the representation of sculptural intentions?

RICHARD SERRA: The biggest break in the history of sculpture in the twentieth century occurred when the pedestal was removed. The historical concept of placing sculpture on a pedestal established a separation of the object from the behavioral space of the viewer. 'Pedestalized' sculpture invariably transfers the effect of power by subjugating the viewer to the idealized, memorialized, or eulogized theme. The need architects feel today to repress the history of sculpture since Rodin is based upon their desire to represent questionable symbolic values under the guise of a questionable humanism. The fact of the matter is that symbolic values have become synonymous with advertisements: witness Michael Graves' Portlandia logo for the Portland Building or Johnson/Burgee's 'Golden Boy' for the AT&T Building. It is interesting to watch certain self-named and self-proclaimed postmodern architects trying to convince people that placing a contrapposto figure atop a column serves humanistic needs. Old themes are firmly embedded: antiquated identification patterns support the expression of mediocre decor, both in public centers and private interiors. Social relevance, humanistic values, are the reinstated buzzwords, the new international shtick…

The credo is that architecture shall stabilize the status quo by appealing to pluralism: Let's decide that Chinatown needs a new pagoda and Central Park another equestrian rider. Exploitation and marketing strategy are protected under a populist umbrella. Decide what the people need and make them believe in your definition of their needs. Isn't Charles Moore's Piazza d'Italia in New Orleans, for instance, a little condescending?

One reason architects consume and use traditional sculpture is to control and domesticate art. Architects are openly reactionary in their adaptation of watered-down artistic conventions. Their continual misuse of art as ornamentation, decoration, and garnish denies the inventions of the past. Much of what purports to be new is in fact a derivative appropriation: The new zipatone has replaced art as appliqué. When sculpture and painting rely on their internal

necessities and motivations, they have the potential to alter the construction, function, and meaning of architecture. At least Le Corbusier understood this (see his letter to Victor Nekrasov, 20 December 1932, in *Oppositions* 23 [1981], p. 133). As soon as art is forced or persuaded to serve alien values it ceases to serve its own. To deprive art of its uselessness is to make other than art.

PE: But to say that architecture cannot put forward its own internal necessity outside of either use or the misuse of artistic convention is, I think, a narrow view of architecture that presents the possibility of the realization of its own internal necessity precisely because in architecture the agglutination of parts such as rooms and corridors and the adjacencies of use and shelter are necessary elements. These necessities, which do not exist in sculpture, are what set my 'site.' To me, the challenge of a site is to overcome the limitations inherent in piling parts together according to use, and to produce an internal necessity that is outside of use. Both sculpture and architecture attempt to display their internal necessity: how one achieves this in sculpture and architecture is very different though. This is why I am an architect and not a sculptor.

RS: What I wonder about architecture is whether people read the significance of its internal structure *perceptually* or *haptically*, physically.

PE: I don't understand your concern over whether or not people experience architecture haptically, especially since you have described the different reactions of pedestrians and drivers to your *St. John's Rotary Arc* (1980) in downtown Manhattan. Why can't you allow architecture the same differentiation in terms of the viewer's understanding?

RS: In an *Artforum* text we stated that the 'viewer' is a fiction. Basically this is *my* response to my sculpture. I know that there is absolutely no audience for sculpture, as there is none for poetry and experimental film. There is, however, a big audience for products that give people what they want and supposedly need but not more than they understand. Marketing is based on this premise.

In terms of architecture right now, a lot of people have a need to build and a lot of clients are concerned with what's considered 'relevant.' This creates a situation in which both client and architect receive criticism and advice on how to serve. Since there is no audience for sculpture or poetry, no one demands that they resist manipulation from the outside. On the contrary, the more one betrays one's language to commercial interests, the greater the possibility that those in authority will reward one's efforts. Architects have justifying phrases for this behavior. They call it 'being appropriate' or 'compromising.' When Robert Venturi's pylons for Federal Triangle in Washington, D.C., were criticized for not being symbolic enough, he returned the next day with the American flag atop each pylon. This is the kind of self-justifying pragmatic compromise I am talking about.

PE: You have said that your *House of Cards* project (1969) is an example of internalized necessity in sculpture, and yet it does make a metaphorical allusion – to something very fragile, almost self-critical. The phrase 'house of cards' is traditionally used to imply a negative idea. My first projects were called 'houses of cards' precisely because they were autocritical. Was the self-critical idea intentional on your part?

RS: No, the title of the piece is *One-Ton Prop*. I wrote 'House of Cards' in parentheses. In my work at the time, I had been propping lead elements against the wall. Even in those wall-props, it was easy to understand that the 'how' was defining the 'what.' But these pieces were still related to the pictorial plane of the wall. When I decided to build a freestanding work using the same principle of point load and compression, I wanted to define a space, to hold a space.

PE: Then the *space* and not the wall becomes an implied armature – a negative substance. Armature is usually thought of as solid, but it could be a void.

RS: I wouldn't say the space is the armature. There never has been an armature. Armature and pedestal are old solutions to old problems.

PE: In the *House of Cards* was it your intention to present the object *in process*, as opposed to having the object *represent* a process, as is done in what is commonly known as 'process' art?

RS: As I said, I was interested in the 'how' defining the 'what.' I do not believe in the mystification of the creative process. I would just as soon have the work involved available to anyone's inspection as part of the content. Not that it *is* the content, but that it would be discernible to anyone wanting to deal with that aspect of my work.

PE: The idea of the object in process was not part of the intention?

RS: I wouldn't call these works 'objects in process' because I don't think of the works themselves as performing. Although when you use lead, it does have a high order of entropy. Obviously it's not going to last, and is going to deflect. That's all implied. I'm more interested in the implication of collapse than in the actual fact of it. You can build a structure under compression that implies collapse and impermanence and yet in its mere existence denies this. What I find interesting about the *House of Cards* is that as its forces tend toward equilibrium, weight is negated. When something is truly balanced, it becomes weightless.

PE: You say you are interested in the notion of the impermanence of the object. Do you think that when the men in the shipyards knocked down your pieces they did so because they were nervous about the limit – whether the pieces would fall on them? They did not want the objects to be out of their control, so they knocked them over before they had a chance to fall over on

them. Whether or not the pieces actually fall down, they create the anxiety of the maker and the viewer not being in control. These pieces are interesting to me because they control. The objects have their own power. But it seems that you ultimately reject this idea of disequilibrium in your work and that you reject it because it implies formalist notions of balance, symmetry and, finally, composition.

RS: I use gravity as a building principle. I am not particularly interested in disequilibrium.

PE: But for you gravity also has formal overtones of convention.

RS: No. Gravity has always been a problem in sculpture. How that problem is resolved is part of any definition of making sculpture.

PE: Again going back to the *House of Cards*, you argue that pictorial illusion is being expunged, and yet the notion of implosion and collapse is itself an allusion.

RS: Allusion is different from illusion. If something has the potential to decay, that can be allusion. Smithson's *Buried Woodshed* (1970) and its potential to collapse is an example of an allusion. SITE alters Smithson's concept from one of allusion to one of illusion.

PE: I would think SITE alters Smithson's concept from illusion to something very literal. In talking about large-scale sculptures other than those of Smithson – those of Noguchi or Calder, for example – you say that they remain little more than model enlargements. Thus the large scale in their work is arbitrary. Are you suggesting that inherent in sculptural concepts there is a notion of scale specificity that is not anthropomorphic, not related to man, but related to the intrinsic being of the sculpture?

RS: I don't think it's related to the intrinsic being of sculpture. I think it's related to site and context. Whether something is large or small has nothing to do with scale. Large or small has to do with size. Scale deals not only with the interrelationship of the parts of a sculpture but also, more importantly, with the sculpture's relationship to its context. The context always has its boundary, and it is in relation to that boundary that scale becomes the issue. When I talk about Calders and Noguchis what I am saying is that those are studio-made pieces. In the studio they might have scale. To take those sculptures out of the studio and site-adjust them is conceptually different from building on a site, where scale relationships are determined by the nature and definition of the context. You can't build a work in one context, indiscriminately place it in another, and expect the scale relation to remain. Scale is dependent on context. Portable objects moved from one place to another most often fail for this reason. Henry Moore's work is the most glaring example of this site-adjusted folly. An iron deer on the proverbial front lawn has more contextual significance. Architects suffer from the same studio syndrome. They work out

of their offices, terrace the landscape, and place their buildings into the carved site. As a result the studio-designed then site-adjusted buildings look like blown-up cardboard models. There are exceptions: the work of Le Corbusier, Wright, Kahn, Gehry...

PE: Rosalind Krauss has written that in recent sculpture, such as that of Robert Morris and David Smith, there is a changed relationship of viewer to object. Because a change in the viewer's position provides a change in the sculptural object, the space of the viewer becomes part of the space of the object. The viewer and the object are seen as occupying the same space.

RS: Changing the content of perception by having viewer and sculpture coexist in the same behavioral space implies movement, time, anticipation, etc. This wasn't started with David Smith or Robert Morris. This concept was developed by Brancusi in Tirgu Jiu and has continued throughout the twentieth century.

When sculpture enters the realm of the non-institution, when it leaves the gallery or museum to occupy the same space and place as architecture, when it redefines space and place in terms of sculptural necessities, architects become annoyed. Not only is their concept of space being changed, but for the most part it is being criticized. The criticism can come into effect only when architectural scale, methods, materials, and procedures are being used. Comparisons are provoked. Every language has a structure about which nothing critical in that language can be said. To criticize a language, there must be a second language dealing with the structure of the first but possessing a new structure.

PE: You want architecture to be a neutral background. When architecture comes off the wall and off the pedestal, you seem to want it to remain as a discrete object, to maintain its neutrality. When architecture becomes both figural and contextual, it worries you because it leaves the sculptor with little room to operate.

You say that architects – and specifically Robert Venturi – claim to be dealing with context, yet are never critical of it. In other words, their 'site-specific' architecture is simply objects that fit into the site or attempt to fit into the site. This is what in architecture is called 'contextualism.' I see a difference between what you mean by 'site-specific' in our work and what Venturi or the contextualists mean by 'site-specific' in their architecture.

RS: What they call contextualism I call affirmation in the guise of social justification. For 'contextualists,' to build site-specific means to analyze the context and the content of the indigenous cultural situation, then to conclude that what's needed is to maintain the status quo. That's how they seek meaning. They give a great deal of priority to the person who laid down the first rock as well as the last person who put up a signboard.

PE: And the nostalgia for that!

RS: Nostalgia, and the willingness to augment the existing language. In my work I analyze the site and determine to redefine it in terms of sculpture, *not* in terms of the existing physiognomy. I have no need to augment existing contextual languages. I'm not interested in affirmation.

PE: But you are also not interested in negation.

RS: No. I'm interested in sculpture; site-specific sculpture.

PE: There could be site-specific architecture that is critical, that attempts something other than an affirmation of the fact that everything preexisting on the site is good. Piranesi's recreations and Palladio's redrawings were inventions and not so much concerned with what had actually been a site. What interests me in your work is that it is neither affirmation nor negation. Most architects do in fact say that whoever laid the first stone made the context. You do not say that. You try to analyze the context in a way that might necessitate the removal of the first stone.

RS: Absolutely.

PE: To allow for meaning in architecture, the material itself may be covered up; this is departing from materialism. In this way, to do in architecture what Richard Serra does in sculpture could mean to do the reverse. That is, the actual fact of covering up materiality may bring the object closer to architectural as opposed to material necessity. You do this when you cover up foundations of certain pieces because the foundations literally hold up the pieces, but the work is not conceptually intended to be seen that way.

RS: All my pieces will stand if they are placed into the ground and the earth is then backfilled. The reason for the fixtures and foundations is to satisfy engineering codes laid down by cities, the federal bureaucracy, and so on. For example, *Rotary Arc* was required to have a foundation in order to meet city codes, although it is apparent that a 100-ton quarter circle will 'freestand' anywhere.

PE: Let's go on to another subject. You say you reject chance, which is totally random, and you reject judgment, which is totally closed. You say experimentation is somewhere in between, but that your experiments with chance, influenced by William Burroughs and John Cage, led you to a dead end. What is the difference between a judgmental viewpoint and a viewpoint of chance? Would you say there is chance in Jackson Pollock's action paintings, for example?

RS: Absolutely not. I saw Pollock's retrospective in Paris recently. In these paintings the skeins don't touch the edge, they never leave border or boundary; the passage of paint is absolutely controlled. People misunderstand the 'how' of the process and think that because someone is standing over a canvas working on the floor in a spontaneous manner, he must be out of control. But the decisions as to how much paint to use, where to put it, in fact,

all the formal conditions that go into making paintings – line, massing, overlaying – are tightly organized. In hindsight it's obvious how much structure is contained within the overall field and how much the overall field is a structure. It's not an amorphous field.

PE: When Pollock says that his paintings are not *representations* of feelings but *expressions* of his feelings, you know that they must be controlled by an unconscious reality. The imagery that comes up – the black holes that appear larger, the white and black, the pulsation – finally overtakes him.

RS: I have great difficulty with spurious psychological interpretations. One's psychological makeup at a given moment is developed from the womb on; and one's activity at a given moment is an intersection of congruences that will vent certain emotions. But to say that works are the result of an emotional state is to use a knee-jerk causality that simply does not follow. Critics have tried to explain one of my works – splashing molten lead – as a temper tantrum. It's hard to keep up a temper tantrum for seven days, the time it took me to complete the sculpture. The same confusion surrounds Pollock. Pollock was never out of control. Look at his paintings.

PE: You used the term 'noncompositional' in reference to Pollock's work.

RS: There is no hierarchy of parts in Pollock. There is no relation of part to whole in terms of composition, as there is, for example, in Malevich, in whose work forms float on the ground in compositional relation to each other and the framing edge. There are other examples of European compositional tradition that are more pertinent: the work of Matisse, the Cubists, Mondrian.

PE: Your *Belt* pieces seem to be based on a noncompositional idea; only when you get far enough away from them is there a whole image. For me it is not the elements of composition in architecture – the bay, the column, the window – that are interesting, but what is between them. Similarly, in the *Belt* there seems to be a serial structure, without beginning or end, and the important consideration is not the elements but the spaces in between – the negatives, the voids.

RS: Although nonfigurative, the *Belt* piece, done in 1966–67, is structurally related to Pollock's University of Iowa painting. If my origins as a painter culminated in anything, they culminated in Pollock. Then I felt a need to move into literal space.

PE: The open spaces you moved into were cuts in the landscape, cuts that were seen as substance, not void. These cuts try to create substance out of nothing. An open field has a certain neutrality about it because of its insubstantiality. When a cut of some kind is introduced – a wall, a line, whatever – you are not creating a figure in the ground, but you are creating *out* of that ground. It is not the figure/ground nature that is important, but giving substance to the void.

RS: My elevational pieces point to the indeterminacy of the landscape. The sculptural elements act as barometers for reading the landscape. They are not viewed as discrete sculptural units or as parts in a larger composition. It's impossible to have an overview of the work in its entirety. In different proximities the work functions and is perceived differently. At a close distance the elevational fall of the landscape is experienced step by step. From a further distance the elevational fall seems measured by the sculptural elements.

PE: Don't the actual physical pieces, the sculptural objects, then become the pedestal or the frame for the landscape? Isn't there a reversal whereby the object itself now becomes the frame?

RS: It does become an element defining the landscape within its given boundaries, but it does not become the frame. If you use the word 'frame' in referring to the landscape, you imply a notion of the picturesque. I have never really found the notion of framing parts of the landscape particularly interesting in terms of its potential for sculpture. Smithson was interested in the picturesque. His *Spiral Jetty* (1969–70) not only spirals you out into the landscape, framing vistas of the landscape, but as it dovetails back on itself, it also leads you to concentrate on its internal structure. The nautilus, being a centripetal structure, leads you into its vortex bit by bit. That's an interesting notion in terms of its relation to the narrative of seeing but it's not of particular concern to me.

PE: Bringing an object to reality is certainly the opposite of abstraction, which is not an aspect of your work. Your work has an immanence – that is, a latent other structure in the real material. Abstraction deals with transcendence, the opposite of immanence. While a Brancusi may be an abstraction of a column, your work is not an abstraction of anything. You are in fact making abstract ideas real.

RS: Van Doesburg articulated a difference between abstraction, which derives its impetus from nature, and concretion, which is based on an inventive order. I am not interested in this kind of distinction. However, I don't begin with a correlative and abstract from it. I don't work from a given in that way. But since it has become a convention to call nonfigurative work abstract, I don't object to that definition of my work.

PE: But it could be argued that you are a 'realist' artist, although not in the way the term is conventionally used. It could also be argued that you are a postmodernist (little *p*, little *m*) in that your concerns are not derived from modernist conventions. You are interested in self-referentiality, but not in a modernist sense. Your objects produce an inherent, internal necessity structuring the landscape; this necessity has to do with self-referentiality. In fact you have said that the context invariably returns the work to its sculptural necessities. The work may be critical of the context but it always returns to

sculpture as sculpture. These ideas could be seen as leading to a self-referential, autonomous, or closed system.

RS: My works do not signify an esoteric self-referentiality. Their construction leads you into their structure and does not refer to the artist's persona. But we might be discussing a bogus problem. As soon as you put a work into a museum, its label points first to the author. The visitor is asked to recognize 'the hand.' Whose work is it? The institution of the museum invariably creates self-referentiality, even when it's not implied. The question of how the work functions is not asked.

The problem of self-referentiality does not exist once the work enters the public domain. Even negative controversy is evoked by the site-specificity of the sculpture; how the work alters the site is the issue, not the persona of the author. It's a curious fact that all the petitions against my piece in the Federal Plaza dealt with aspects of the work, whereas the art press didn't criticize the work but attacked the person. Here we have another form of promulgating self-referentiality. Once the works are erected in a public space, they become other people's concerns. By their implicit and explicit values they become judgmental by what they exclude. They simultaneously criticize what they neglect and pass judgment on other works.

PE: The self-referentiality that I am speaking about in your work is not narrative. It is not telling Richard Serra's story. It is telling its own story. Modernist self-referentiality created a split between author and object. James Joyce was thought to be non-narrative in the sense that he removed the imposition of the author between the reader and the object. I believe the same thing exists in your work, although it is not modernist. The object tells me how to see it – *that* is its self-referentiality.

If you don't want to use the term self-referential, you could say your work is 'structural' in that the dialogue it opens up is an archaeology of its own structure. This kind of structure is not an abstraction. If anything, this archaeology reveals what has previously been hidden in the classical closed or contained object.

RS: For the same reasons that I am not interested in the distinction between concrete art and abstract art, I am not interested in whether my art is called structural or abstract. I don't subscribe to labels and 'isms,' although many have certainly been applied to my work.

PE: I would call your work 'structuralist' in the sense of looking for the structure inherent in a text. It is a matter of searching in the structure not so much for the text or the meaning of the text as for the inherent structural capacity of the text. What is the internal necessity, the inward feeling that you have talked about? What is it other than the work's own structure? What is the sculptural identity that these things are revealing?

RS: I can't answer that question. It depends on one's knowledge of the condition and history of architecture, painting, and sculpture; it depends on what one brings to a specific work. I don't think there is any ideal interpretation: I don't think I need to articulate a dogma of how to see my sculptures.

PE: I am trying to get at the notion of structure as part of the ineffable condition of an object. The presence of the structure itself is no guarantee of art. What is it that makes art out of structure? Is seems that is what you concern yourself with.

RS: It's not something I program into my work, although I may recognize it. I am most interested in selecting structures that define the context in question.

PE: But aren't you interested in their self-selection rather than your selection of them? You do not make an arbitrary selection; they select themselves from a range of possible archaeologies.

RS: I am confused. They don't select themselves. They are the responsibility of the person who is formulating the problem and making a decision as to the solution. You imply that I'm just there to somehow receive structures?

PE: No. You are not passive. I am arguing that you engage in another activity. You do not invent or select but rather uncover a range of possibilities.

RS: By implication the selected solution is an attempt to resolve all of the possible solutions to a problem. The decision (selection) process differs according to the context, although there is never any certitude.

PE: You did not invent the *Rotary Arc*. You found it. It was preexistent.

RS: Preexistent in the world? That sounds strangely Calvinistic.

PE: No, preexistent in the context and in the universe of sculpture.

RS: No. A titled arc didn't exist in the history or repertoire of sculpture.

PE: It preexisted. It was there and you found it.

RS: Where?

PE: It preexisted conceptually. It is possible to conceptualize it before you make it 'become.' The inherence that you constantly refer to – the inherence of sculpture, the inherence of a landscape, the inherence of an object – don't you think they preexist and that your work gives them substance?

RS: I don't believe that my sculptural concepts are found objects. They are inventions. Of course they are related to the tradition and history of sculpture, but they are still inventions.

PE: In the universe of sculpture the concept suggests itself. Let us say you and I were playing a game of chess. All potential lines exist, but all lines are not necessarily winning lines nor are they necessarily elegant. Some are more elegant or beautiful than others. But the context for the invention of the poetic – the art of the winning game – lies within the rules of chess itself, lies on the board in those pieces. We have to find it, but it does suggest itself to us. What

you call invention I call scanning, choosing a limited range of possibilities from an infinite number.

RS: I don't subscribe to the chess-board theory. There aren't any rules. I make them up as I go along, and I never consider 'beauty' in my solutions. Beautiful solutions are about taste. I have my own methods of working that allow me to make decisions once the problem is posed. One method I employ is a large sandbox I have built in which I work out solutions for constructions. The sand allows me to shift, tilt, and lean elements on their plane and axis. The practice of working in the sandbox does not rely on theory.

PE: You say your sandbox – my 'chess board' – is a methodology and not merely a series of images. The methodology seems to be finding differences in things rather than similarities. You seem to be looking for those seemingly useless differences that fall in between the similarities. But your intervention is limited by the sandbox. Your sandbox, for instance, is defined very differently from Robert Morris's.

RS: I would hope. The problem is that Morris plays in my sandbox and everybody else's. I call that plagiarism, other people call it mannerism or post-modernism. Those who play in others' sandboxes, or who play with the icons, form, or thematics, or history, labor under the assumption that history can be dispensed. The source and center of work no longer derives from the necessity of invention but from strategical game plans.

PE: I wanted to ask you about ideology in relation to structure. It seems to me that the notion behind the landscape pieces you do is anti-ideological in the literal sense of ideology. I believe that your urban pieces are anti-ideological, but that in their anti-ideology they become ideological.

RS: Art is always ideological, whether it carries an overt political message or is art for art's sake and based on an attitude of indifference. Art always, either explicitly or implicitly, manifests a value judgment about the larger sociological context of which it is part. Art supports or neglects, embraces or rejects class interests. Tatlin's *Monument to the Third International* is no more ideological than a black painting by Ad Reinhardt. Ideological expression does not limit itself to an affirmation of power or political bias. To answer your question about the ideological content of my work, there is no difference in the degree of ideological content in my urban and landscape pieces.

PE: I would argue that your work is non-ideological in the sense that it does not speak to the meaning of man's condition today vis-à-vis the natural and physical world. Man has unleashed physical forces that can destroy him at a greater rate now than ever before. This idea has changed the former relationship of man to God and to the natural world. Modernism always spoke of the future, but now we are in what I call a futureless present, a condition of immanence, in that we face the biological extinction of the entire civilization.

Man's relationship to God and nature has traditionally been mirrored in architecture. But I don't believe you address this issue in your work, nor do most architects. It seems to me that underlying postmodernist architects' return to history is their intuitive realization that the post-nuclear condition of man is greatly changed. It seems that the anxiety of man's present condition has caused architects to abrogate their responsibility and to go back to history as if they were ostriches sticking their heads in the sand.

RS: You can't construct a causality between the fear of biological extinction and postmodern architects thumbing through history books. That's doomsday philosophy. True, modernist architects believed in a better future; they developed utopian ideas for city planning as well as pragmatic solutions for workers' housing. But postmodernists also believe in the future: the future of AT&T and corporate America.

54 Benjamin Buchloh

'Michael Asher and the Conclusion of Modern Sculpture' 1983

Benjamin Buchloh is one of the foremost Marxist art critics and art historians of his gen-
eration. Educated in Germany, he went on to achieve prominence in New York in the 1980s
with his critical interventions against postmodern tendencies in contemporary art and his
advocacy of work informed by the radical legacies of dada and 1970s conceptualism. Buchloh
develops in this essay a highly original and intellectually rigorous analysis of the situation of
sculpture at the beginning of the 1980s, based on the work of the sculptor Michael Asher.
A shorter version was first published in 1980, representing a contribution to the 'Biennale
de Paris' (1980). This was then expanded for the *Centennial Lecture* series given at the Art
Institute of Chicago (1983). The presentational context is important, because the argument
advanced in Buchloh's paper has largely to do with challenging contemporary assumptions
and is likely to have initiated heated debate in the lecture theatre afterwards.

Buchloh challenges in this essay the post-modernist notion that recent work demon-
strates a revival of practices and principles once thought to be redundant, but that now can
return or be revivified – the idea, in other words, of post-modern eclecticism. For Buchloh,
all that post-modernism represents is in fact a temporary and uninteresting regression.
More seriously and in specific connection to sculpture, the post-modernist view amounts
to a wilful misreading of the history of modernist sculpture, from its precariousness at the
beginning of the twentieth century to its inevitable conclusion in the work of the histori-
cal avant-garde, as the very notion of sculpture is finally wound down. A renewed interest
in monumentality (thought of as 'transhistorical'), for example, should only be understood
as an attempt to 'cover up the problematic conditions of sculptural production'. Similarly, in
radical post-war sculptural practices, especially those associated with minimalism and post-
minimalism, there are for Buchloh just too many references to earlier modernist advances for
the idea of a post-modernist break to be credible, let alone actual.

Whilst implicitly critiquing Krauss's 'Sculpture in the Expanded Field', Buchloh does not
deny that a radical paradigm shift occurred in sculptural production in the 1960s and early
1970s. He insists, however, that it took place within a continuing, more or less inevitable
historical movement. Michael Asher's radical installation practice of the 1970s, according to
Buchloh, functions 'as though to prove from within the analysis of sculpture itself that it has
lost its material and historical legitimacy'. His rather pessimistic argument is that in a con-
tinuing act of self-referentiality, sculpture reflects upon its own slow and fascinating demise
– an argument designed perhaps to fault not so much Krauss (with whom Buchloh was in
fact very much in sympathy at this time) but more the post-modern optimism expressed by
Robert Irwin and others, which Buchloh seems to have thought naïve.

Benjamin Buchloh, 'Michael Asher and the Conclusion of Modern Sculpture', in Susan Rossen (ed.), *The Centennial Lectures of the Art Institute of Chicago*, Chicago: Art Institute of Chicago, 1983, pp. 277–95. Reprinted in Benjamin H.D. Buchloh, *Neo-Avantgarde and Culture Industry: Essays on European and American Art from 1955 to 1975*, An October Book, Cambridge and London: The MIT Press, 1980, pp. 1–39.

Concrete material reality and social meaning should always be the primary criteria of specification. Before all else, we see in ideological objects various connections between meaning and its material body. This connection may be more or less deep and organic. For instance, the meaning of art is completely inseparable from all the details of its material body. The work of art is meaningful in its entirety. The very constructing of the body-sign has a primary importance in this instance. Technically auxiliary and therefore replaceable elements are held to a minimum. The individual reality of the object, with all the uniqueness of its features, acquires artistic meaning here.

M. M. Bakhtin, *The Formal Method in Literary Scholarship* [1]

I

Sculpture traditionally differed from painting through its seemingly unquestionable three-dimensionality, its physical and physiological corporeality, defined as a literal 'embodiment' of subjective plastic concerns. It was determined as much by the historically specific aesthetic conditions of the sculptural discourse as by the spectators' (often the patron's) ability to recognize their own corporeal being in the world in the sculptural embodiment. Or, as Rosalind Krauss recently stated:

The logic of sculpture, it would seem, is inseparable from the logic of the monument. By virtue of this logic a sculpture is a commemorative representation. It sits in a particular place and speaks in a symbolical tongue about the meaning and the use of that place. [2]

As we will be dealing in the following essay with contemporary sculptural works in general, and in particular with two works by Michael Asher conceived in 1979 for two museums in Chicago, it seems appropriate to consider these works – while perhaps not immediately recognizable as sculpture – in Krauss's terms, as they do in fact 'sit in a particular place and speak in a symbolical tongue about the meaning and the use of that place.' The complexity of these works necessitates, however, closer attention to the material and procedural transformations that have taken place in the evolution of contemporary sculpture, and we will have to recapitulate some of the crucial paradigmatic changes that define sculpture in the history of Modernism.

Looking at the specific features of Modernist sculpture (that is, its materials and its procedures of production) as well as at its changing reception, one could almost come to the conclusion that sculpture, because of its more concrete 'nature' than that of any other art practice, seems to lend itself to a particularly obdurate aesthetic: how can one – under the conditions of a highly industrialized society – continue atavistic modes of production (modeling, carving, casting, cutting, welding) and apply them convincingly to semi-precious or so-called 'natural' materials (bronze, marble, wood)? Only twenty years ago (if not more recently) the works of Alberto Giacometti and Henry Moore could seem the epitome of the sculptural, when in fact their archaic iconography and plastic structures revealed their authors' (and the public's) conviction that sculpture had not lost any of its historic credibility in the first decade of this century. Even a practising sculptor and sculpture historian – commenting on Rodin – seems to acknowledge the specific dilemma of his own discipline, without, however, coming to an adequate understanding of its historical determination:

> Thus, Rodin's mature sculpture follows the effective emergence of modern painting, moreover, in comparison with the directness, simplicity, and objectivity of the new painting; the statement in sculpture seems tentative, half-formed and weighed down by a burden of Romantic and dramatic subject matter of moral and public 'function', which the Impressionists had been able to jettison from the first. The reasons for the late arrival and confused intentions of the new sculpture lie partly in the physical character of sculpture and painting, partly in their relative development in Europe since the Renaissance, partly in the specific conditions of patronage and public taste which obtained in nineteenth century France... Sculpture became an art in which the taste and ambition of the public patron became the determining factor, and virtuosity and craftsmanship the criteria of artistic achievement.[3]

A more rigorous reading of the history of modernist sculpture would have to acknowledge that most of its seemingly stable paradigms, which had been valid to some extent until the late nineteenth century (i.e., the representation of individual, anthropomorphic whole or fragmented bodies in space, modeled of inert but lasting, if not eternal, matter and imbued with illusionary moments of spurious life), had been – in analogy to the abolition of representation in painting – definitely abolished by 1913. Vladimir Tatlin's corner-counter reliefs and subsequent *Monument to the Third International* and Marcel Duchamp's readymades emerged logically from Synthetic Cubism, and they have constituted since then the extremes of sculptural reflection in Modernism: they

recognize the dialectics of sculpture from now on to be operative either as a model for the artistic production of reality (e.g., sculpture's transition toward architecture and design) or as an epistemic model that investigates the status and conditions of aesthetic object production (the readymade, the allegory, the fetish). Or, more precisely: architecture on the one hand and the epistemological model on the other are the two poles toward which relevant sculpture since 1913 has developed, each implying the eventual dissolution of 'sculpture' as a separate discourse and category.

The precarious condition of sculpture, if not the decline of the discipline, had been sensed as early as 1903 by the poet Rainer Maria Rilke in his study of Rodin, conveyed, not surprisingly, in a tone of lament since the withering of the category was indicative for him of the vanishing privileges and esoteric experiences the autonomous art object seemed to have guaranteed:

> Sculpture was a separate thing, as was the easel picture, but it did not require a wall like the picture. It did not even need a roof. It was an object that could exist for itself alone, and it was well to give it entirely the character of a complete thing about which one could walk, and which one could look at from all sides. And yet it had to distinguish itself somehow from other things, the ordinary things which everyone could touch.[4]

II

Sculptural materials, even before their iconic, formal, or procedural definitions, have to be considered as part of a symbolic system that is itself highly determined. For example, the 'nobility' of bronze and marble in the late nineteenth-century work of Rodin was at least in part a result of his dependence on the class of bourgeois amateurs. Symbolic determinations of sculptural materials result not only from the author's professional idiosyncrasies – whether his or her individual psychosexual organization tends more toward modeling soft and palpable masses (like clay) or whether he or she feels like cutting stone or carving wood – but also from the audience's expectations: whether the specific materials and the production procedures allow for a projective identification and seem in fact to embody the viewer's physical being in the world. In contradistinction to Rodin, the truly radical modernity of Medardo Rosso's sculptures resisted this incorporation into bronze in most of his works, and the sculptural production process itself was arrested and fragmented at the level of the wax and plaster model: materials that by their very nature quite explicitly reject any heroic or sublime connotations. Rosso often stated that he wanted the materials of his sculptures to pass unnoticed because they were meant to blend with the unity of the world that surrounded them. The actual

fragmentation of the sculptural production procedure – whether deliberate or circumstantial – corresponds to Rosso's fragmentation of the sculptural representation itself. His reluctance to fulfill all the steps required by the traditional process of sculptural production, from modeling to casting, indicates an essential critical shift of attitude.

It reveals the increasing doubts about artisanally produced sculpture, namely that the completion of an organic cycle of production, conceived and executed by one individual, had become obsolete. The fragmentation of the production process coincided with the phenomenon of a heterogeneous materiality: prefabricated elements, alien to the craft of sculpture up to the nineteenth century, were introduced – or intruded – into the conventionally unified sculptural body. The only sculpture by Edgar Degas that was publicly exhibited during his lifetime and cast in bronze posthumously, his *Little Dancer of Fourteen* (1881), was the first to generate this modernist scandal. When it was exhibited at the 'Exposition des Indépendants' in 1881, Joris Huysmans hailed it as follows:

> At once refined and barbaric with her industrious costume and her colored flesh which palpitates furrowed by the work of the muscles, this statue is the only truly modern attempt I know in sculpture.[5]

Both phenomena – the fragmentation of representation and the production process and the juxtaposition of heterogeneous materials – would soon emerge as the dominant traits of modernist sculpture. If they appeared exceptional at first, as in the case of Degas, it would soon thereafter, in Cubism and Futurism, become the rule to combine individually crafted sculptural structures with mechanically produced objects and fragments. Ultimately, in Duchamp's readymades, the aesthetic construct would be displaced altogether by the mechanically produced object.

These phenomena receive a meticulous description and precise historical analysis in Georg Lukács's attempt to define the conditions of reification in 1928:

> Rationalization in the sense of being able to predict with ever greater precision all the results to be achieved is only to be acquired by the exact breakdown of every complex into its elements and by the study of the special laws governing production. Accordingly, it must declare war on the organic manufacture of whole products based on the traditional amalgam of empirical experiences of work.... The finished article ceases to be the object of the work process... This destroys the organic necessity with which interrelated special operations are unified in the end product. Neither

objectively nor in his relation to his work does man appear as the authentic master of the process: on the contrary, he is a mechanical part incorporated into a mechanical system. He finds it already preexistent and self-sufficient; it functions independently of him and he has to conform to its laws whether he likes it or not. As labour is progressively rationalized and mechanized, his lack of will is reinforced by the way in which his activity becomes less and less active and more and more contemplative. The contemplative stance adopted toward a process mechanically conforming to fixed laws and enacted independently of man's consciousness and impervious to human intervention, i.e., a perfectly closed system, must likewise transform the basic categories of man's immediate attitude to the world: It reduces space and time to a common denominator and degrades time to the dimension of space.[6]

III

The intrusion of alien materials in Degas's sculpture established a very precarious balance between the conditions of subjective aesthetic creation and those of the reality of production pointed out by Lukács. Ever since, and most definitely since Duchamp's readymades, these historical conditions have been forced to their most logical extreme. Duchamp's work features most prominently the character of spatialized time in the object that Lukács talks about, since the arrest of temporal flux and passive contemplation are the modes in which the melancholic perceives the world and his increasing estrangement from it. Thus, paradoxically, a more traditional reading of Duchamp as the artist who continued the nineteenth-century tradition of the dandy, refusing participation in the collective production process, inverting his role as procreator into that of the 'flâneur' who simply designates found objects as art, converges precisely with Lukács's observation. Inevitably, at this point, Walter Benjamin's observation on the interaction between allegory, commodity, and sculptural form has to be cited: 'The devaluation of the world of objects by the allegory is exceeded within the world of objects itself by the commodity.'[7]

Thus, from the first decade of the twentieth century onward, this precarious ambiguity between the apparent autonomy of sculptural constructs and the socially determined conditions of material production – between aesthetic object and symbolic space on the one hand and real object and actual space on the other – has determined the practice of sculpture. Aesthetic production, however, does not always evolve logically according to its own inherent laws, any more than it develops purely in response to the changing conditions of material production. Quite to the contrary, one of the essential features of aesthetic production – at least in twentieth-century art history – seems to have

been a reiterated opposition to precisely an all too easy acceptance of those determinations. But since the contradictions originating in the organization of the means of production cannot be resolved by aesthetic means alone, every generation producing within an obsolete paradigm generates increasingly mythical structures.

The history of post-World War II sculpture is particularly rich with these mythical forms, and only one should be briefly discussed as an example and as a link to the present: the type of postwar construction sculpture in which Constructivism's and Dada's attitudes toward the mass-produced object seem to coalesce, as, for example, in the works of David Smith and Anthony Caro.[8] If anything, the welding of metal and junk sculpture in their work seems to resolve in a most comforting manner the blatant contradiction between individual aesthetic and collective social production. This contradiction is, however, mythified by the work's apparent synthesis of the gesture of construction and the melancholic gesture of denial. In the same way, these artists, as public figures and biographical myths, combine the image of the proletarian producer, taming the elements and extracting wealth from the furnace, with that of the melancholic stroller in the junkyards of capitalist technology – an image that has persisted into the present in figures like Carl Andre and Richard Serra. The necessarily fetishistic character of this work had already been adequately diagnosed in the 1920s by the Russian productivist artist and theoretician Boris Arvatov, who wrote in his essay 'Art and Production':

> While the totality of capitalist technology is based on the highest and latest achievements and represents a technique of mass production (industry, radio, transport, newspaper, scientific laboratory), bourgeois art in principle has remained on the level of individual crafts and therefore has been isolated increasingly from the collective social practice of mankind, has entered the realm of pure aesthetics. The lonely master – that is the only type in capitalist society, the type of specialist of 'pure art' who can work outside of an immediately utilitarian practice, because it is based on machine technology. From here originates the total illusion of art's purposelessness and autonomy, from here art's bourgeois fetishistic nature.[9]

Scrap metal assemblage sculpture and the technique of welding concretize the historic dilemma between obsolete means of artistic production and their fetishization, on the one hand, and the actually existing means of the social production of representation on the other. Their failure to solve this dilemma, inasmuch as it becomes evident in the work itself, is then the works' historic and aesthetic authenticity. Julio González, who had been trained as a stone-cutter, learned welding in the French Renault car factories during World War I

and integrated the experience he acquired from alienated labor into his artistic production. Or, from a different point of view, one could argue that he adapted his aesthetic procedures to his experience of collective production. This 'modernization' of the sculptural discourse was instantly successful because it seemed to respond to a desire within artist and public alike to achieve at least a symbolic reconciliation of sculpture's increasingly apparent contradictions. Picasso adopted this technique in the early 1920s and a new sculptural category and production technique was born. When David Smith 'discovered' González's and Picasso's work through the mediation of the art magazine *Cahiers d'art* and imported the technique to North America, a further crucial step in the mythification of a sculptural procedure had taken place, one that had originated in Cubism's conceptualization and representation of spatial relations. To enhance the mythification, Smith, more than González, propounded the image of the proletarian producer by linking it to the mythical Hephaistos/Vulcan figure.[10]

The next phase of mythification occurred when this modernized sculptural production procedure was 'rediscovered' and 'reimported' to Europe by Anthony Caro, after his encounter with David Smith in 1960, during his first visit to North America. Caro's overnight shift from figurative bronze casting to nonrepresentational welded assemblage sculptures made of scrap metal, and his subsequent step of investigating the decorative potential of gaudily painted arrangements of metalwork samples, accomplished historically the aesthetic falsification and 'cultural' inversion of every single aspect that Constructivist sculpture had originally intended and achieved within its limited resources and political possibilities.

IV

It took artists of the Minimal and post-Minimal generation like Andre and Serra in the mid to late 1960s to literally 'decompose' these mythified construction techniques and production procedures. The aesthetic shock and subsequent relief that their work might have caused originally resulted precisely from the deconstruction of that type of sculpture, their persistent use of singularized, particular elements, their clarification of the constituent forces within the sculptural construct, and the transparency of the production procedures evident in their work. It is symptomatic in this context that Serra referred to the technique of welding as 'stitching' during the 1960s and that he nevertheless readopted that very same technique in his later work in the 1970s, when he himself returned to the mythification of the constructivist legacy in order to pursue a problematic project of seemingly public monumental sculpture.

Radical sculpture, ever since the first decade of this century, has not only increased the fragmentation of sculptural representation and, as we have

argued, the fragmentation of the production process itself as well, but it has also intensified the reflection on the constituent factors determining this process. Internally, the material elements assembling the sculptural phenomenon have become increasingly isolated, singularized, and specific; and the procedures of its fabrication, as well as the physical laws and forces (weight, mass, gravity, specific material properties) generating its appearance in space, have become more and more the center of sculptural investigation. Externally, as a result of the discovery of phenomenological thought, an analysis of the relations that connect the sculptural object with the perceptual acts of the subject was increasingly incorporated into the very conception of sculpture. A systematic reflection of the interdependence of the construct and its surrounding spatial/architectural container became again an integral part of sculpture's project in the 1960s.

Despite numerous and reiterated affirmations by American critics and historians that Minimal and post-Minimal works are not to be seen in the historical context of Modernist sculpture, the contrary holds true: too frequent are the references by the artists themselves, both implicit and explicitly expressed in works and statements, that acknowledge the rediscovery of the sculptural principles and theoretical positions that had been articulated in Duchamp's work as well as in that of the Constructivists (for example, Andre's references to Rodchenko, Donald Judd speaking on Duchamp and Malevich, Dan Flavin paying tribute to Tatlin, and Robert Morris's scholarly interest in Duchamp and the adaptation of Duchampian principles in his early work). This was precisely the part of the modernist tradition that had been ignored and rejected by the neoformalist aesthetics of Clement Greenberg and Michael Fried (the key champions and promoters of Smith and Caro). To reconsider these positions – in particular, to transform the dialogue with the positivist legacy of formalism into a laconic pragmatism – provided another essential element of the foundation for the new sculptural work of the mid-1960s. Maurice Merleau-Ponty's recently (1965) translated *Phenomenology of Perception* added to the paradoxical synthesis of philosophical legacies, ranging now from Modernism's empiro-critical skepticism investigating the epistemology of painterly and sculptural signs, to the artists' discovery of logical positivism and semiology. Frank Stella, in many ways the first artist to integrate all of these elements, articulated this condensation in his now famous, lapidary statement, 'What you see is what you see.'

V

The formalist concept of 'self-referentiality' had been a theoretical prescription by which art until around 1965 had to abide. What amounted to a pictorial or sculptural analogy to the semiological understanding of the sign, and the

self-reflexivity resulting from that analogy in artistic production, had been achieved by both Duchamp and Malevich in 1913, at least in principle if not in an explicit theoretical project. One of the first Minimal works to considerably expand the notion of self-referentiality was Morris's *Mirrored Cubes* (1964).[11] It was against this background of a Minimal and post-Minimal aesthetic that Michael Asher's work was developed in the 1960s. When Asher went to New York for a year in 1963–1964, he became very interested in Flavin's and Judd's work, and, upon his return to California in 1966, he constructed several tapered wedge pieces that follow a similar logic of suspending the sculptural object between self-referentiality and contextual contingency. These wedges were installed flush against the wall and painted over with a color identical to the wall that supported them. As in Morris's and Larry Bell's mirrored cubes, the most prominent characteristic of Asher's early work would be its analytical approach to the triadic condition of the sculptural phenomenon: to function as an autonomous aesthetic/spatial sign; to be constituted within a larger architectural context, which may or may not purport its own and different order of signs; and to be activated only through the spectator's individual act of perception. The sculptural sign itself, at least in Morris's early work and in Asher's wedge pieces, negates any inherent sculptural value and merely demarcates the difference between subjective perception and objective spatial conditions.

Dan Graham, later to become a close friend of Asher's, underwent a similar development in his work, leading gradually out of formalist and Minimal aesthetics. He described his conception of a sculptural structure as follows:

> There is a 'shell' placed between the external 'empty' material of place and the interior, empty material of language: systems of information exist halfway between material and concept without being either one.[12]

In this critique, the formalist notion of self-referentiality was replaced by an increasingly complex analytical system (semiological, sociological, systems-analysis) that would make the work operative rather than self-reflexive. The idea of a 'situational aesthetics' (a term coined by the English artist Victor Burgin) implied that a work would function analytically within all the parameters of its historical determination, not only in its linguistic or formal framework. Three concepts would become crucial for the definition of 'situational aesthetics': first, the notion of material- and site-specificity; second, the notion of place; third, that of presence. A similar transition had already occurred in the shift from Russian formalist methodology toward a new materialist semiology and productivist theory.[13]

When Judd defined his understanding of material specificity by almost literally transferring a key term of Russian formalist criticism to sculpture, his

definition still resounded with the impact of Modernism's positivist pragmatism. He wrote, for example, in his 1965 essay 'Specific Objects': 'Materials vary greatly and are simply materials – formica, aluminum, cold-rolled steel, Plexiglas, red and common brass and so forth. They are specific. Also they are usually aggressive.'[14] Shortly afterward, Michael Asher and a whole generation of artists set out to prove that materials are not simply materials but are procedurally and contextually determined. For example, Karl Beveridge and Ian Burn argued already in their early critique of Judd:

> Aren't you saying you want the association to be restricted or localized to the object or its immediate (i.e. architectural) environment? Along with an autonomous form of art, you wanted a more autonomous art object, what you would call more objective. Traditionally, art objects are associated with other art and art history by way of their materials and by being a conventional type of art object. Such associations would, I suppose, in your words, be specific. But this was the last thing you wanted. The autonomy you developed for your objects had to function in respect to your presupposition of an art (historical) context and hence you still needed a means of associating the object with that context. Since the object itself denied any associations, the physical situation became a more important vehicle. That is to say, the object had to be circumstantially associated with its art context.[15]

The second concept, that of place (as opposed to object or anthropomorphic representation), was developed mainly by Andre and Flavin.[16] Pointing to the *spatial* specificity of the sculptural work (as opposed to the *material* specificity that Judd talked about), Andre's definition also originally implied (as did Flavin's practice) a subversive assault on the commodity status of works of art (given that they were movable objects, contextless, offering themselves to every kind of transaction). Sculpture as place was supposed to integrate into its actual formation the spatial conditions into which it inscribed itself as constituent elements. Graham observed with lucidity:

> I liked that as a side effect of Flavin's fluorescents the gallery walls became a canvas. The lights dramatized the people (like spotlights) in a gallery, throwing the content of the exhibition out to the people in the process of perceiving; the gallery interior cube itself became the real framework.[17]

Independently reflecting on similar issues, the French artist Daniel Buren wrote a perspicacious critique of Duchamp's readymade concept in 1970. If read along with Graham's description of Flavin's work, the essay reveals the

hitherto unreflected and problematic points of the minimalist concept of place, in particular its unconscious indebtedness to Duchamp. Furthermore, it identified exactly those issues on which Asher would focus, and the essay's almost literal correspondence to Graham's statement points to the objective nature of these artistic concerns of the post-Minimal generation:

> The Museum/Gallery for lack of being taken into consideration is the framework, the habit . . . the inescapable 'support' on which art history is 'painted.' Wishing to eliminate the tableau/support, on the pretext that what is painted can only be illusion, Duchamp introduces into a new framework/tableau a real object, which at the same time becomes artificial, motiveless, i.e., artistic.[18]

Temporal specificity is defined as the third condition for a situational aesthetics – presence – which is closely interrelated with its spatial and material counterparts. Again, the term refers not only to the fact that an installation is determined by the specific temporal circumstances into which it is introduced, but equally, if not more, to the fact that it obtains within these circumstances a temporally specific, limited function, and that the work might become disposable after its appearance in time. Again, it was Graham who pointed this out when writing about an exhibition of Flavin's work in Chicago in 1967:

> The components of a particular exhibition, upon its termination, are replaced in another situation – perhaps put to a non-art use as a part of a different whole in a different future.[19]

VI

Asher later adopted the term 'situational aesthetics,' integrating the concepts of both spatial and temporal specificity. It had become fairly clear by 1968 that the Minimalists had abandoned the original implications of these aesthetic strategies by adapting their work increasingly to the needs of the art market. It had also become evident that these strategies would have to be radically modified, if they were to maintain their critical function of investigating the social and institutional framework that determines the production and the reception of art. Thus, on the occasion of his first exhibition, at the San Francisco Art Institute in 1969, Asher applied the Minimalist principles of self-referentiality and specificity with a new literalness and immediacy to the architectural container of the exhibition space itself. Thereby he not only revealed Minimalism's latent formalist heritage, but also defined a new understanding of sculptural materiality:

The presentation at San Francisco was clearly dictated by every element which was available and it suggested a way of working for the future: using just elements which already existed without a great modification to the space.[20]

If Asher's work overcomes the Modernist legacy (i.e., the neopositivist formalism originating in the Constructivist legacy and embraced by the Minimalists), then the work of Broodthaers and Buren critically transcends the limitations of Duchamp's concept of the readymade, which had kept almost all object-oriented art in its spell.[21] Both positions – the constructive and the allegorical – seem to coalesce and henceforth determine the historically relevant work in contemporary art production. It is therefore crucial to comprehend first of all that the two critiques are fused in Michael Asher's installations at the Art Institute of Chicago and the Museum of Contemporary Art in Chicago, and to read them at the same time from the historical perspective of sculpture rather than merely within the context of 'conceptual art' or, worse yet, to align them, as has been suggested, with a Dada-environment tradition.

Asher's sculptural installations seem to be constituted solely by conceptual gestures and directives, deploying 'found' objects and materials or, more correctly, the 'given' conditions of a particular museum/exhibition context. The specificity of sculpture's materials or its production processes is now totally negated. The consequence of Asher's contextual orientation surpasses even the most radical conceptual definitions of sculptural processes outlined in Lawrence Weiner's *Statements* from 1968, where one can still detect remnants of traditional sculptural concerns, as in, 'A field cratered by structured, simultaneous TNT explosions'.[22] Rigorously denying spatial and temporal transcendence, Asher's works are constituted first of all within their own spatial, institutional context, the museum; and they become the performative articulation of their actually given historical time, the allocated exhibition period itself.[23]

Asher's work at the Art Institute of Chicago bracketed three different situations of display with three different experiences of perceptual discontinuity. The first phase of his contribution to the 73rd American Exhibition consisted of the removal of a bronze cast (after Jean-Antoine Houdon's marble representation of George Washington from 1788), which had been installed at the main entrance of the Allerton Building – a late nineteenth century neo-Renaissance building – on Michigan Avenue in 1925. The resulting work ruptured the message of aesthetic authority and national heritage that the sculpture had conveyed as an integral part of the museum's facade.

The second step of the installation was to place the bronze within its original art historical context in a period room (Gallery 219) featuring European paintings, furniture, and the decorative arts of the eighteenth

century. The cast was placed in the center of the gallery on a wooden base, identical in height and color to the other wooden bases in the gallery, while its 'original' marble pedestal was put into storage. In this second display situation, a reconstruction of an imaginary eighteenth-century interior, the contextualized sculpture caused a different rupture: even though its bright green-blue patina almost matched the turquoise of the painted walls and some of the silk covers of the eighteenth-century furniture, the patina made it all the more obvious that the sculpture had been put to a different use in the past and had therefore acquired material features that conflicted with its definition as an object of high art in a well-guarded museum interior. Its function as a monument made itself felt in a way that Proust had once described: 'all the gazes that objects have ever received seem to remain with them as veils.'

The third element of the work consisted of a plexiglas box inside the gallery containing leaflets that identified this installation as Asher's contribution to the 73rd American Exhibition, and they directed the viewer to this show of contemporary work in the Morton Wing of the museum. Downstairs, at the entrance to the exhibition, another box contained leaflets (see appendix A) that gave a description of the work but directed the viewer upstairs to the eighteenth-century period room in Gallery 219.

The visitor who had been circulating in the survey of contemporary work displayed in the 73rd American Exhibition, experienced the third rupture in Asher's piece when confronting the sculpture contextualized in the setting of Gallery 219 in tandem with the installation method in the Morton Wing. This passage through history juxtaposed a more or less stylistically homogeneous group of conceptual and painterly work with the equally homogeneous group of artistic objects from the eighteenth century. The confrontation historicized the actuality and dynamic immediacy that contemporary works generate in the viewer's perception and emphasized, by contrast, the historicity of their present aesthetic experience.

A second work by Asher was coincidentally installed at the same time at the Museum of Contemporary Art in Chicago. In their modus operandi, the two works were clearly similar: both dismantled a given architectural display system embodied within the elements of a facade. If the Art Institute had appropriated an eighteenth-century work of sculpture (or more precisely a twentieth-century bronze replica) for its facade, then the architects of the new Museum of Contemporary Art had appropriated what they believed to be the stylistic idiom of Minimal sculpture as a reference for their design of a modular system of architectural decoration. This appropriation of the serial modular elements of Minimal sculpture sought to convey a technocratic notion of progress (whether this notion was embedded already in the idiom of Minimal sculpture is disputable).

As his work for the Museum of Contemporary Art, Asher stipulated (see appendix B) that during the exhibition the two horizontal rows of aluminum panels that were in line with the Bergman Gallery windows should be removed from the facade and should be placed on the interior wall of the gallery. The ten panels from the east side of the building and eight panels from the west side were to be arranged on the inside in the same formation and sequence, placed sequentially as a planar relief.[24] The entire work, both its exterior elements (the withdrawn parts) and its interior elements (the displayed parts), could be viewed from the street. Once the panels were placed on the walls within the interior they became subject to the same perceptual conditions that determine the reading of material constructs as discursive (i.e., sculptural) objects. Again, the juxtaposition of the exterior elements (the remaining cladding) and their semifunctional architectural usage and the interior elements (their defunc-tionalized sculptural display) resulted in a double negation of both architec-tural and sculptural discourses. As in the work at the Art Institute, there was a third element of deconstruction: the Museum of Contemporary Art had agreed – five months prior to actual installation – to buy the work for its permanent collection. Therefore, a paradoxical situation occurred: once the exhibition was finished and the cladding was reinstalled in its proper place as architectural decoration, the work seemed to cease to exist while, in fact, Asher's 'sculpture' was simply placed in a different institutional register, generally identified as 'storage.' Yet, since it was placed on the museum's facade, it remained accessi-ble to public view at all times, as distinct from conventionally stored work which remains inaccessible. Moreover, being bound into the specific situation of the given institutional architecture, the work – according to the artist's instructions specified in the acquisition contract with the museum – would cease to exist as part of the collection as soon as the institution's architecture was altered. (Plans for an expansion were then already being discussed and have since been executed; the work, therefore, has to be considered no longer extant.)

VII

Conditions of collective reification change gradually (or, under the particu-lar circumstances of crisis, rapidly and drastically). Their aesthetic represen-tations appear accordingly: no single object – whether individually crafted or mass-produced – can at this time reflect appropriately upon the degree of abstraction within which collective reification is operating and institutional-ized. The production of art itself has become an activity that shares the con-ditions of the culture industry, on the one hand embellishing corporate public image and on the other depending on an elaborate corporate support system amounting to a cultural civil service. Art production thus helps to channel any attempt at critical negation into a hermetically sealed ideology of culture.

During those historical periods in which the governing powers want to convey a sense of conclusion (more precisely, that history as process and change has been concluded), the experience of subtle oppression and stagnation is extrapolated in monumental public structures. Amnesia, the loss of memory at the origin of the destruction of historical dialectics, tends to incorporate itself in false public commemorative representations. Their stability and weight seem to balance the insecurity that individuals and society at large experience once they have been totally deprived of active participation in the decision-making process of history. At this point sculptors seem to be tempted to offer their services for monumental public commissions that embody those latent tendencies; they fill the gaps of historic identity with gigantic monuments. The recent increase in public commissions for monumental sculpture confirms this hypothesis, and the critics rhapsodize already in a new ideology of postmodernist populism:

> The root of the difficulty would seem to lie back at the turn of the century with the disappearance of the monument. Avant-garde art in general, with its oppressive neutrality of content, has a long history of being perceived by the public at large as irrelevant. Its abstractness, however, is not the problem as much as its failure to conduct a public dialogue. Belief or conviction on the part of the artist, while perhaps the most important single ingredient of a great work of art, is not, as far as the public is concerned, a substitute for symbolic content... The artists who succeed there... will be those who are willing to come to terms with the notion of public commitment, who realize that such a stance, far from compromising their work, can infuse it with non-esthetic content which has absented itself from modernist art.[25]

Michael Asher's works operate with increasingly analytical precision on the threshold between symbolic space and actual space, continuously increasing the ambiguity between functional object and aesthetic object, as though to prove from within the analysis of sculpture itself that it has lost its material and historical legitimacy. In his two installations in Chicago, Asher did not adapt to these historic tendencies but incorporated then manifestly into his work to make them transparent. The specificity of his installations identified all the elements that enter the conception, production, and reception of a sculptural construct, resulting in a model case of historical analysis. This analytical model dismantles the new historicism of postmodernity, where regressions into a mythical language of the transhistorical validity of the monument merely cover up the problematic conditions of sculptural production and perceptual experience in the present.

APPENDIX A

Handout prepared by Michael Asher for Art Institute installation

Michael Asher
73rd American Exhibition
The Art Institute of Chicago
June 9 to August 5, 1979

The sculpture of *George Washington*, cast in 1917, is a replica of the marble sculpture of 1788 by Jean Antoine Houdon. In 1925 it was installed in front of the Michigan Avenue entrance of the Art Institute.

As my work for the 73rd American Exhibition (June 9 – August 5, 1979), I have moved the sculpture of *George Washington* into the galleries. The sculpture is on the second floor in Gallery 219. For directions please ask one of the guards.

In this work I am interested in the way the sculpture functions when it is viewed in its eighteenth-century context instead of in its prior relationship to the façade of the building, where it has been for fifty-four years. Once inside Gallery 219, the sculpture can be seen in connection with the ideas of other European works of the same period. By locating the sculpture within its own time frame in Gallery 219, I am placing it within the framework of a contemporary exhibition, through my participation in that exhibition.

APPENDIX B

Handout prepared by Michael Asher for Museum of Contemporary Art installation

Michael Asher
Museum of Contemporary Art, Chicago
June 8 through August 12, 1979

The newly remodeled building of the Museum of Contemporary Art, designed by the architectural firm of Booth, Nagel and Hartray, was completed in March 1979. The façade of the museum is planned on a five-and-one-half-foot-square grid pattern and is constructed with glass and aluminum. Two rows of aluminum panels, which are attached to and cover an underlying brick structure, line up horizontally with the two rows of glass windows of the

Bergman Gallery. The glassed-in Bergman Gallery functions as a showcase so that art is visible from the street.

In this work, I have removed from the façade the two horizontal rows of aluminum panels that are in line with the Bergman Gallery and have placed them on the interior wall of the gallery. The ten panels from the east side of the building and the eight from the west are arranged inside so that they correspond exactly to their previous positions outside. After August 12, 1979, the aluminum panels will be reinstalled on the exterior of the building.

This work belongs to the museum's permanent collection. It is intended to be repeated each year for approximately two months, or the length of a temporary exhibition.

First published in *Penser l'art contemporain: Rapports et documents de la Biennale de Paris,* vol. 3 (Paris, 1980). First English version in *Performance: Texts and Documents*, ed. Chantal Pontbriand (Montreal: Parachute, 1981), pp. 55–64. The present enlarged version was first published in *The Centennial Lectures of the Art Institute of Chicago*, ed. Susan Rossen (Chicago: Art Institute of Chicago, 1983), pp. 277–95.

[Editorial note: the text contained the following photographic illustrations: Carl Andre, *Cedar Piece,* 1960–64 (Collection: Öffentliche Kunstsammlung, Basel); Alexander Rodchenko, *Spatial Construction No. 12,* 1920 (Coastakis Collection, Athens); Donald Judd, *Untitled,* 1968 (Photo: Geoffrey Clements); Carl Andre, *144 Copper Square,* 1969 (Collection: The National Gallery of Canada, Ottawa); Dan Flavin, installations in the Green Gallery, New York, 1964 (Photo: Rudolph Burckhardt); Michael Asher, *Galleria Toscelli, Milan,* 1972, Michael Asher, *73rd American Exhibition,* 1979, Art Institute of Chicago, Michigan Avenue entrance, showing the 1917 bronze replica of Jean-Antoine Houdon's *George Washington,* 1788 in its original location (Photo: Rusty Culp); Michael Asher, *73rd American Exhibition,* 1979, showing the replica after its relocation to the eighteenth-century period room; Michael Asher, *Museum of Contemporary Art, Chicago,* 1979, façade before illustration; Michael Asher, *Museum of Contemporary Art, Chicago* 1979, façade after removal of panels during exhibition; Michael Asher, *Museum of Contemporary Art, Chicago,* 1979, Installation interior view, showing aluminum panels from the museum's façade installed in the Bergman Gallery; Marcel Broodthaers, *Musée d'art moderne, Département des aigles, Section XIXème siècle,* Brussels, 1968.]

1 M. M. Bakhtin and P. N. Medvedev, *The Formal Method in Literary Scholarship* (1928; Baltimore: Johns Hopkins University Press, 1978), p. 12.
2 Rosalind Krauss, 'Sculpture in the Expanded Field,' *October* 8 (1979), p. 33.
3 William Tucker, *Early Modern Sculpture* (New York and London: Thames and Hudson, 1974), pp. 15, 19.
4 Rainer Maria Rilke, quoted in Tucker, *Early Modern Sculpture*, p. 9.
5 Joris K. Huysmans, 'L'Exposition des Indépendants en 1881,' in *L'art moderne* (Paris, 1908), pp. 250–255, quoted in C. W. Millard, *The Sculpture of Edgar Degas* (Princeton: Princeton University Press, 1976), p. 124.

6 Georg Lukács, 'Reification and the Consciousness of the Proletariat,' in *History and Class Consciousness* (Cambridge: MIT Press, 1971), pp. 88f.

7 Walter Benjamin, 'Zentralpark,' in *Gesammelte Schriften*, vol. 1, part 2 (Frankfurt: Suhrkamp Verlag, 1974), p. 655.

8 On the subject of procedures and materials, it seems only a matter of time before the return to traditional artisanal techniques (including bronze casting and wood carving) is celebrated as a return to the unalterable traditions of sculpture. It is noteworthy that even five years ago such a shift would have been inconceivable, but that for somebody like Caro it is now the fully acceptable modus operandi. For more recent examples see the work of Barry Flanagan, the Italians Enzo Cucchi and Sandro Chia, or the Germans Georg Baselitz and Markus Lüpertz.

9 Boris Arvatov, *Kunst und Produktion* (1926; Munich: Carl Hanser Verlag, 1972), p. 11 (Buchloh's translation).

10 On frequent occasions Smith pointed to the importance of factory labor in the development of his work, in particular his experience as a welder in a World War II tank factory. He referred to his welded sculptures as constructions on the same historical order as locomotives. To what degree this self-image of the welding-mask-wearing proletarian producer and twentieth-century Vulcan possessed mythical attractions for Smith is revealed by his widow, who argued that most of his claims of having endured extended work periods as a factory welder were, in fact, exaggerated. Thus we read in Cleve Gray, ed., *David Smith* (New York: Holt, Rinehart and Winston, 1968):

> Smith often made a point of his poverty during the thirties and forties and his consequent need to work. In his statement for Elaine de Kooning's article 'David Smith Makes a Sculpture' in *Art News* (no. 50, September 1951, p. 37) he wrote: 'All of my life the workday has been any part of the twenty four hours on oil tankers, driving hacks and the shifts in factories.' His first wife, Dorothy Dehner, has said that Smith exaggerated this aspect of his life greatly and that due to a small income of hers at this time Smith's obligation to work at odd jobs was almost non-existent.

But information on this subject seems contradictory, since we read in Rosalind Krauss's dissertation, published as *David Smith: Terminal Iron Works* (Cambridge: MIT Press, 1971), the following (p. 60, n. 16):

> In the three years in Schenectady during which he worked eight hours a day in a factory as a welder on M7 tanks and locomotives, Smith identified himself increasingly with his fellow workers. Not only was he fiercely proud of his status within the factory unit and a 'first class armor plate welder' (see Archive IV/280), but his sculptural output dropped off radically at this time, as he became absorbed in his work in the munitions plant. From 1942 to 1944 he made almost no metal sculpture, beginning instead to learn stonecutting and carving, and in the entire span of these years, he produced only fifteen pieces.

11 Morris's work refers explicitly to an unexecuted project by Duchamp, which he had defined in the *Green Box*, suggesting the placement of mirrored glass on the floor of a room. Duchamp's notes in the *Green Box* read as follows:

> Flat container in glass – holding all sorts of liquids. Colored pieces of wood, of iron, chemical reactions. Shake the container and look through it. Parts to look at crossed eyed, like a piece of silvered glass, in which are reflected the objects in a room.

See Marcel Duchamp, *The Bride Stripped Bare by Her Bachelors, Even* (London: Percy Lund, Humphries and Co., 1960), n.p.

The project found an independently conceived parallel echo on the West Coast in the early mirrored cubes of Larry Bell. an artist who would be of temporary relevance for the development of Michael Asher's critique of Modernist self-referentiality.

12 Dan Graham, 'Other Observations' in *For Publication* (Los Angeles: Otis Art Institute, 1976), n.p.

13 See, for example, Bakhtin and Medvedev, *The Formal Method in Literary Scholarship*, or, to give another example, the radical changes in the writings of Osip Brik, who also shifted from a purely formalist position to one of a committed productivist practice in essays such as 'Into Production' as early as 1923.

It is symptomatic that by contrast, artists, critics, and historians in the present and recent past seem to respond in a defensive or conservative manner when confronted with such a radical paradigmatic shift in sculptural production.

For example, Rosalind Krauss, whose book *Passages* (New York: Viking, 1977) can be rightfully considered the most complex and advanced reading of Modernist and post-Modernist sculpture to date, literally excludes all of those sculptural activities that question the materials and production procedures of traditional sculpture and that conceive 'sculptural' phenomena (i.e., perceptual and actual subject/object interactions) within a historically and socially defined set or system of time–space coordinates. Krauss does not once mention the work of Asher, Robert Barry, Dan Graham, or Lawrence Weiner – artists who have all substantially redefined the idea of the 'sculptural' in their work.

Ten years earlier, Jack Burnham's *Beyond Modern Sculpture* (New York: George Braziller, 1965), also considered the most advanced critical study of modernist sculpture at the time, *omitted equally the crucial innovations within the very discipline of sculpture to which it was dedicated*. Published at a time when crucial steps in the definition of Minimal sculpture had been taken, this book did not mention Andre once and only randomly dealt with the work of the other Minimalists.

It seems, then, that – in such situations of radical epistemic shifts – critics and historians displace their attention to derivative, secondary, or academicized forms of artistic production. Even if they are conspicuously obsolete, at least these forms seem to reaffirm the validity of aesthetic categories and the corresponding critical concepts.

By analogy, sculptors tend to make apodictic statements in such situations that shift the category of sculpture from the historical to the ontological level. See, for example, a recent statement by Richard Serra (*Octob*er 10 [1979], p. 73), reaffirming the universal and trans-historical validity of sculptural notions:

I have always thought that the basic assumption of film could never be sculptural in any way and to beg the analogy between what is assumed to be sculptural in sculpture and what is assumed to be sculptural in film is not really to understand the potential of what sculpture is and always has been.

14 Donald Judd, 'Specific Objects' (1965), in *Complete Writings* (New York and Halifax: The Press of the Nova Scotia College of Art and Design, 1975), p. 181.

15 Karl Beveridge and Ian Burn, 'Donald Judd,' *The Fox* 2 (1975), p. 1311.

16 The notion of 'place' in sculpture was originally defined by Barnett Newman in regard to his sculpture *Here I* (1951). It can be assumed that both Andre and Flavin, fervent admirers of Newman's work, derived their concept of place in sculpture from him. For Newman's discussion of his understanding of sculpture as place, see Harold Rosenberg, *Barnett Newman* (New York: Abrams, 1978), p. 63.

17 Dan Graham, letter to the author, July 22, 1979.

18 Daniel Buren, 'Standpoints,' in *Five Texts* (New York: John Weber Gallery; London: Jack Wendler Gallery, 1973), p. 38.

19 Dan Graham, in *Pink and Yellow: Dan Flavin* (Chicago: Museum of Contemporary Art, 1967), n.p.

20 Michael Asher, unpublished notes. See also *Michael Asher: Writings 1971–1981 on Works 1966–1976*, ed. Benjamin Buchloh (Halifax: The Press of the Nova Scotia College

of Art and Design; Los Angeles: Museum of Contemporary Art, 1981). Asher divided the allocated exhibition space at the San Francisco Art Institute into halves by constructing a wall from the existing display panels that normally served as additional support surfaces in the gallery's exhibition spaces. One half of the room contained a door and was fairly dark, because of the wall construction, while light flooded into the other half of the room through windows and a skylight. The bright half of the room was accessible only by a passage left open between Asher's constructed walls and the permanent walls of the gallery.

21 The very same year as Asher's San Francisco debut, Marcel Broodthaers, a hitherto almost totally unknown artist, embarked on, as it seemed at the time, a fairly eccentric adventure: he had printed a well-designed letterhead that announced in conservative typography the foundation of a new museum in Brussels: 'Musée d'Art Moderne (Section XlXème siècle), Département des Aigles.' He appointed himself director of this museum, and guests, among them Daniel Buren, were invited for an official opening. The opening speech was delivered by the director of a 'real' museum in Broodthaers's former 'studio,' a room filled with empty wooden picture-crates that museums use for the transport of works of art, a number of postcard reproductions of mostly nineteenth-century paintings tacked to the walls, and regular installation equipment, such as ladders and lamps.

Broodthaers, perhaps even before Buren, had quite clearly developed an awareness of Duchamp's dilemma; his seemingly eccentric activity turned out to be the beginning of a systematic analysis of the myth of the museum and its transforming capacities in the process of acculturation. As early as 1966 he had pointed to the various hidden frames that determine the perception of the art object: 'Every object is a victim of its nature: even in a transparent painting the color still hides the canvas and the molding hides the frame.'

As much as Asher's and Broodthaers's installations seem to be incomparable initially, they do reveal upon closer analysis their actual historic connection in the critical reflection on the Duchamp legacy, despite the major morphological and stylistic differences that had developed in this regard between European and American art since the 1940s.

22 Lawrence Weiner, *Statements* (New York: Louis Kellner Foundation/Seth Siegelaub, 1968), n.p.

23 Jack Burnham, while discussing Hans Haacke's works, which were equally concerned with the museum and its institutional practices, described the necessity of the methods of institutional critique developed by these artists:

> The questions had to be asked in the galleries and the gallery public had to be confronted with its self-portrait in that same environment. The walls of the museum or gallery are as much a part of his work as the items displayed on them. These works also need the 'impregnation' of the gallery to set them in opposition to other contemporary art.

See Jack Burnham, in *Hans Haacke: Framing and Being Framed*, ed. Kasper König (Halifax: The Press of the Nova Scotia College of Art and Design; New York: New York University Press, 1977), p. 137.

24 On the east side, ten panels extended twenty-two feet along the wall; for the part beginning on the west side, eight panels extended twenty-four feet, nine inches toward the center of the wall. This left thirty feet of unused wall space on which Sol LeWitt – whose work was exhibited simultaneously in a retrospective show at the Museum of Contemporary Art – executed a black wall drawing.

25 Nancy Foote, 'Monument, Sculpture, Earthwork,' *Art Forum* 18 (October 1979), p. 37.

55 Tony Cragg

'Preconditions' 1985

'The artist, of course, knows words are there and may even use them, but the main act is the reorganisation (sometimes only proposed) of materials into images and forms, which offer themselves as complex symbols for new experiences, insights and freedoms.' So states the sculptor Tony Cragg (b. 1949), in his essay 'Preconditions', one of a number of texts published in exhibition catalogues since the early 1980s in which he set out the possible role of sculpture, and of the sculptor, through the lens of a contemporary, scientific and radical materialism. This text was published early on in a career that soon saw international success. Cragg worked and continues to work with language in a very sculptural way, as his earlier 'Artist's Statement' of 1982 also demonstrates. Words are very physical things to him, as is the ink from the writer's pen that gives them form. They are man-made building blocks that have an intimate relationship with the physical world they attempt to describe and define. Particles thus have molecular, as well as linguistic, meaning and application, and many of the titles he creates for his sculpture display a simultaneously sculptural and linguistic turn. Sometimes he uses palindromes, sometimes combinatory neologisms; sometimes in German, sometimes in English. Etymology, for this sculptor, has sculptural as well as linguistic meaning and application.

Cragg's linguistic–materialistic outlook and his structuralist, anthropological approach to the world are central to his particular contribution to modern sculpture writing. Driving this attitude is a constant artistic-biological preoccupation with the invention of new and imaginary hybrids that cross-fertilise forms, materials and images. We know what an elephant looks like and what a pig looks like, but the modern sculptor, Cragg often states in interviews, should go beyond such natural (and also man-made) orders and present us with a 'piggy-phant', a new being made possible only by imaginative, sculptural intervention. Whilst Cragg has maintained a clear and emphatic articulation of this vision over the years, such statements do not stand as dogmatic manifestos; rather they work as propositions and proposals, designed to kick-start new thinking and generate alternative approaches to making and thinking about sculpture.

Tony Cragg, 'Preconditions', in *Tony Cragg*, exhibition catalogue, Kestner-Gesellschaft, Hannover, 1985. Reprinted in *Anthony Cragg: Material–Object–Form*, Lenbachhaus München, 1998, pp. 58–61.

Late at night I left the house to buy cigarettes from a nearby dispenser. It was mid-winter and cold, the asphalt crunched frozen under foot. Suddenly from the nearby Wuppertal zoo the wolves started to howl, a dramatic device well known from films, but the sound erased the fences between us and changed

the sleeping town into a dangerous, almost primeval landscape – it was my first encounter with wolves. Perhaps the wolves will be gone one day, surviving only as mythological creatures in literature and saga, relegated to the same existence as dragons and dinosaurs, but still occupying an indestructible place in the genetic memory.

All the creatures which have been, and many more which could have been – lost in the lottery of genetics and survival, and all the extinct landscapes channelled into, and made subject to the needs and comfort of one over-animal.

Well defined by his powers to change the physical world, building systems of change through language and technology, and exploiting all that is given by nature to the survival of himself and other groups to which he feels related and which will give him mutual support. An ever accelerating process since the time the last large glaciers melted and released him from the burden of searching for food and mean survival. Changing the geography, the geology, the vegetation, the animal-kingdom, the water-flow, and the atmosphere. Using language, technique, politics, and built-in criticism, if it serves the purpose of his progress. And, one has to suppose that as long as we want to survive – and those who don't, don't – it will continue in the same way, depending on certain physical limits which may or may not be in sight.

But at the centre of all these changes is the perpetrator himself, he hasn't changed physically very much over the last ten thousand years and one could say the same for his basic spiritual condition. The few ideas he has had about his essential self usually get converted to useful practical formations – church, social structures, political structures, commerce, culture. Sometimes in this apparent chaotic struggle one must allow oneself the luxury of believing that something is really going to change to make things better, the idea that we are going somewhere, but where? Perhaps to a place where survival is assured: a place where we can peacefully make other kinds of progress. Are the gates of Eden still open? No! I find the possibility of such a utopia absurdly unlikely and even frightening. The vision of hell on earth and a few struggling into outer space seems equally absurd, but marginally more probable.

All individuals have to make a picture of the world and their existence in it.

Most have the faculties for reflective activity and one can assume that many great thoughts have been thought without being expressed, many expressed unclearly (understandable, considering the immensity of the subject) and many more forgotten, overshadowed by higher valued practical thoughts and actions. Even then, there remains a discernible ragged line through the history of thoughts and actions which illuminates a little of the true nature of the human animal and the situation he finds himself in. The identifiable individuals are philosophers – people who think reflectively – poets who use words

– the building bricks of thought? – to breathe meaning and expression into landscapes, objects, human experiences – and thirdly, artists.

The fundamental difference between the former two and the latter lies in the fact that one way of not defining, but at least marking out the boundaries of philosophy, is language and with language is meant, words. The poet enriches the world he describes and simultaneously the word he uses. The artist, of course, knows words are there and may even use them, but the main act is the reorganisation (sometimes only proposed) of material into images and forms, which offer themselves as complex symbols for new experiences, insights and freedoms.

Naturally occurring formations, materials, phenomena, and objects are part of the original inventory of the universe and as such provide us with a vocabulary of qualities which also has become the language for describing human activities and their results. Descriptions of colour, shape, form, motion, etc. which can be relatively objective or extremely subjective. It is futile to be critical about nature because of its original quality, which human beings in the process of evolution have learned to accept, or had to accept, as conditions for existence. But, human intervention and modifications of nature are always accompanied by very sophisticated methods of critical questioning. Painting and sculpture are two activities which are distinct for their reflective qualities and the creation of new objects in space, taking on the responsibility of changing a part of the physical world. Trying to cope with the appearance of, description of, memory of, feeling of, expression of…

My initial interest in making images and objects was, and still remains, the creation of objects that don't exist in the natural or in the functional world, which can reflect and transmit information and feelings about the world and my own existence. They are not intended as dogmatic statements but as propositions, for me an essential distinction. The impulse comes directly from my observations and experiences in the world around me and rarely results out of literature or cultural history. But, I acknowledge positively the fact and influence of living at a particular moment in time.

The materials, because of their physical characteristics and the emotions and ideas they bring with them, play an essential role in the forming of the work. A precondition for working with man-made materials is that they are equally worthy of carrying significant meanings as natural materials. Many new materials originated for economic reasons, as substitutes for natural materials, and as such have automatically been valued as inferior. And, as parts of practical constructions and industrial systems, many others have assumed an everyday, banal function. This banality provides a hurdle that is essential to overcome in order to start a dialogue with the work. Otherwise, a Beuys' sculpture still remains a bit of fat on a chair and a work from Dan Flavin is

just a fluorescent light tube. To be defeated by banality is to be confounded by ignorance, and that is a problem for us all.

The forests, the oceans, the mineral deposits and the rocks themselves are used to provide the building bricks of these materials and objects. The wonder of these substances begins on a molecular level, which relates directly to the physical properties and appearance of a material. For example, the six strongly bonded atoms of carbon in graphite are arranged into a flat hexagon to form a surface which can reflect; the material has a gloss. These plates of molecules slip friction-free over one another; the material has a slippery feeling. The plates, face on face, compact to form a mass with high definition; the strong molecular bonds cause brittleness and a characteristic, almost metallic ring.

For every material a new list of specific qualities, providing a rich vocabulary in the language of objects. The materials I use are man-made or at least man-modified and as such belong to a huge category of materials/objects which are integral to the physical, intellectual and emotional lives of men. Though, in fact, one has to emphasise the physical relationship, which is parallel to the already mentioned notion of progress; a progress almost entirely of a materialistic nature. And we have such a bad physical relationship to the objects and materials we produce that it is almost embarrassing to consider the metaphysical, the poetical, the mythological.

The development, and eventual choice of images and forms often is related to subjects which seem to suffer the same kind of dangerous devaluation and enslavement to functionalism as the materials themselves. People, objects, buildings, and landscapes.

The landscape is changing under the direction of strong survivors who seem always to know what they want, and I believe that the sometimes unclear, unsecured by science and logic, almost alchemical activities of artists offer vital and essential clues to alternative attitudes.

56 Robert Irwin

from *Being and Circumstance: Notes Toward a Conditional Art* 1985

Robert Irwin (b. 1928) began his major three-dimensional work in the 1960s in parallel with New York minimalism. His aim was to achieve a psychological merging of the viewer with the autonomous art object, thus dismantling the 'simplistic and absolute dichotomy between "the perceiver" and "the thing perceived"'. This led, from 1968 onwards, to Irwin's site-specific installations, described in *Being and Circumstance* more accurately as 'site-adjusted, site-determined and site-dominant'.

Being and Circumstance was conceived as a selection of project descriptions with accompanying photographs. It also, however, contains a thorough philosophical account of the work's underlying significance and implications, and as such seems intended to have a much wider historical relevance. In *Being and Circumstance* Irwin constructs a philosophical justification for his installation work, arguing that it is based on the actual complexity of perceptual experience, a complexity that in normal situations is disguised but that we depend upon nevertheless. His phenomenological perspective on the nature of the installation enterprise represents an interesting alternative to the much more semiotically constructed theory of writers such as Rosalind Krauss. In a short epilogue to *Being and Circumstance*, Irwin reflects on the fact that in the early days of the post-minimalist installation movement, art had seemed to be working towards an ever-diminishing horizon, the art object 'becoming so ephemeral as to threaten to disappear altogether'. But 'like some marvelous philosophical riddle,' he says, this situation 'turned itself inside out to reveal its opposite' – a comment indebted to but expressed very differently from Krauss's notion of post-modernist historical expansion leading out of the 'pure negativity' and 'inverse logic' of minimalism. This idea of expansion out of a collapsed negativity is accepted by Irwin, but conceived by him in much more romantic terms. His desire 'to discover and value the potential for experiencing beauty in everything' thus seems reflective not only of a West Coast sensibility but also of a wider euphoria in the international art world of the 1980s.

Robert Irwin, *Being and Circumstance: Notes Toward a Conditional Art*, Larkspur Landing: The Lapis Press in conjunction with The Pace Gallery, New York, and the San Francisco Museum of Modern Art, 1985, pp. 23–9. The selection is from the fourth section of the Introduction, 'Conditional'.

This consequence brings us, in a future perhaps remote, towards the end of art as a thing separated from our surrounding environment, which is the actual plastic reality. But this end is at the same time a new beginning. Art will not only continue but will realize itself more and more. By the

unification of architecture, sculpture and painting, a new plastic reality will be created. Painting and sculpture will not manifest themselves as separate objects, nor as 'mural art' which destroys architecture itself, nor as 'applied' art, but being purely constructive will aid the creation of a surrounding not merely utilitarian or rational but also pure and complete in its beauty.
– Piet Mondrian

What would an art of the phenomenal, of plastic reality, be like? Where and how would it exist, and how would we come to know it?

To try and answer these questions, let's review what we've already established. First, we have already determined that, in one sense, the phenomenal can be located in the dynamics of change in the world; and that, in another sense, it can be located in the dynamics of our perceiving of that world. We can now venture to put these two senses together and say that the phenomenal, as we can know it, exists in the dynamics of our perceiving (experiencing) the nature of the world about us and of our being in it. From this we can infer that the grounds of a phenomenal art will be in *being and circumstance*; and from this we can further infer, as a working principle, that a phenomenal art will be a *conditional art action*. It should be noted that for any such action to be truly conditional, the art act can only occur *in response* to a set of specifics: since a conditional art, by its own definition, possesses no transcendent criteria (truths), it can have no grounds for predetermining (preplanning) its actions. It takes a peculiar kind of compounded belief to plan, proselytize, or thrust your abstractions onto the world. (It is one thing to believe in or desire such concepts as a timeless art, an orderly universe, or a God in the heavens, and something altogether different to act as if these concepts were in fact real, actual, and already at hand.) By contrast, to act *in response* in actively 'determining relations' constitutes the ethic of a phenomenal art.

Second, we have also already determined that qualities are the property of the perceiving individual, that warm-cool, hard-soft, red-blue are feelings (not values – we give them value by attending to them). This is what Malevich meant when he declared his 'desert' to be filled with pure 'feeling.' We have stated that the meaning of 'modern art' arose when it declared creative art to be a quality-centered discipline; its method to be involvement, not explicit detachment; and that, basically, *'art is knowing in action.'* The consequence of this, by definition, is that what holds true for the artist/perceiver must hold true for the observer/perceiver. Aesthetics then is not a conceptualized ideal, science, or a discipline, but a method, a particularized kind or state of awareness. The subject/activity of aesthetics, therefore, is feeling (to try and speak of an ideal or a science of feeling is a contradiction in terms) with an 'eye' for the special (beauty). Let me again paraphrase Michael Polyani on this point.

We cannot learn to keep our balance on a bicycle by trying to follow an explicit rule, such as that to compensate for an imbalance; we must force our bicycle into a curve – away from the direction of imbalance – whose radius is proportional to the square of the bicycle's velocity over the angle of imbalance. But the art of riding a bicycle, of course, presupposes that all of this be understood, be dwelt in – through a personal act of tacit integration.

It is important to note that this metaphor cuts both ways. It has become fashionable to claim that the history of the individual's role in modern art now simply provides a license to mindlessly ride the bicycle, that is, 'to express oneself.' But in that case, what is *not* an expression? Anything and everything we do, or don't do, is an expression of one kind or another, and what's more they must be thought of as equivalent expressions (the first step toward Nihilism?) unless something else, something more important, is brought to bear. So it is quite clear that 'expression' is not a real issue, but simply the lowest common denominator arising from modern art's placing the individual at the crux of the decision-making process.

We have now, in effect, reduced those hoary philosophic issues of change, the phenomenal, and quality down to the conceptual issues of individual, conditionality, and response. What now remains for us to accomplish is to convert these new concepts into specifics, and we can begin to do this by properly conditioning them. That is, we must provide the operative frame of reference (what it is we measure with, or by) for determining what we can know (and accomplish) from a phenomenal perspective. Consider another example in this context: the universal time becomes 4 a.m. when we condition it with an objective logic (system), i.e., clock time. But it is seasonal when we reference nature, and fleeting when we 'tell time' from the perspective of our feelings. To focus the conditions for a phenomenal perspective (art), let us now try laying out, in order, what we have established:

change... phenomenal... qualities → the perceiving individual

individual... conditionality... in response →
being and circumstance (the operative frame of reference)

being and circumstance... determined relations (art as knowing in action) →
a phenomenal/conditional art

What takes place from this point forward becomes a horse of a different color. The questions as to *how* we might practice a phenomenal/conditional art and what kind of conclusions (reality) we might draw from this perspective remain to be realized. There are already a number of good artists beginning to

test facets of this perspective, each with a unique contribution to make toward a rounded whole that will ultimately become a collective definition of art for our moment in time.

What now follows are my present speculations, ideas, positions, and actions in this regard. I am trying them on to see how they fit (work), what makes *sense* to me, and how I might turn that sense into something (art?) I can live with.

Intention: The intention (ambition?) of a phenomenal art is simply the gift of seeing a little more today than you did yesterday. This intention is based on the simple intuition (truth?) that everything there is to know is not already known. This in turn distinguishes the *subject of art* from the *objects of art* and indicates the fundamental role of art (as in every primary discipline) vis-à-vis the *discipline and practice of art*. The subject of art is the human potential for an aesthetic awareness (perspective). The object of art is a re-presentation of that acquired sensibility (an art object) – a transformation in all dimensions of what was previously known otherwise into an objective form. *The action (practice) of art* carries this sensibility to become a part of all our individual, social, and cultural values (systems, institutions, etc.).

Sculpture: For this term to remain useful, it must be expanded to indicate (mean) the articulation of three and four (even five?) dimensional space, in terms of being, place, ('determined') relations, and order, as well as form.

Site conditioned/determined sculpture – as distinguished from the generic term 'public art' (which permits everything not nailed down to be thrown into one pot, as in a teeming bouillabaisse) – is an attempt to integrate the components of the phenomenal, conditionality, and response with the practical goal of bringing modern art's focusing of qualities (beauty) to bear directly on how we order our world. Mondrian's words bear repeating on this point: We are attempting 'to aid in the creation of a surrounding not merely utilitarian or rational but also pure and complete in its beauty.'

To help sort out some of the confusion of ambitions and practices, let me rough out some general working categories for public/site art, in terms of how we generally process (recognize, understand) them. (Note: there are no value judgments intended here, only distinctions.) Put simply, we can say that any given work falls into one of the following four categories:

1. *Site dominant*. This work embodies the classical tenets of permanence, transcendent and historical content, meaning, purpose; the art-object either rises out of, or is the occasion for, its 'ordinary' circumstances – monuments, historical figures, murals, etc. These 'works of art' are recognized, understood, and evaluated by referencing their content, purpose, placement, familiar form, materials, techniques, skills, etc. A Henry Moore would be an example of site dominant art.

2. *Site adjusted*. Such work compensates for the modern development of

the levels of meaning-content having been reduced to terrestrial dimensions (even abstraction). Here consideration is given to adjustments of scale, appropriateness, placement, etc. But the 'work of art' is still either made or conceived in the studio and transported to, or assembled on, the site. These works are, sometimes, still referenced by the familiarity of 'content and placement' (centered, or on a pedestal, etc.), but there is now a developing emphasis on referencing the oeuvre of the individual artist. Here, a Mark di Suvero would be an example.

3. *Site specific.* Here the 'sculpture' is conceived with the site in mind; the site sets the parameters and is, in part, the reason for the sculpture. This process takes the initial step towards sculpture's being integrated into its surroundings. But our process of recognition and understanding of the 'work of art' is still keyed (referenced) to the oeuvre of the artist. Familiarity with his or her history, lineage, art intent, style, materials, techniques, etc., are presupposed; thus, for example, a Richard Serra is always recognizable as, first and foremost, a Richard Serra.

4. *Site conditioned/determined.* Here the sculptural response draws all of its cues (reasons for being) from its surroundings. This requires the process *to begin* with an intimate, hands-on reading of the site. This means sitting, watching, and walking through the site, the surrounding areas (where you will enter from and exit to), the city at large or the countryside. Here there are numerous things to consider; what is the site's relation to applied and implied schemes of organization and systems of order, relation, architecture, uses, distances, sense of scale? For example, are we dealing with New York verticals or big sky Montana? What kinds of natural events affect the site – snow, wind, sun angles, sunrise, water, etc.? What is the physical and people density? the sound and visual density (quiet, next-to-quiet, or busy)? What are the qualities of surface, sound, movement, light, etc.? What are the qualities of detail, levels of finish, craft? What are the histories of prior and current uses, present desires, etc.? A quiet distillation of all of this – while directly experiencing the site – determines all the facets of the 'sculptural response': aesthetic sensibility, levels and kinds of physicality, gesture, dimensions, materials, kind and level of finish, details, etc.; whether the response should be monumental or ephemeral, aggressive or gentle, useful or useless, sculptural, architectural, or simply the planting of a tree, or maybe even doing nothing at all.

Here, with this fourth category of site-conditioned art, the process of recognition and understanding breaks with the conventions of abstract referencing of content, historical lineage, oeuvre of the artist, style, etc., implicit in the other three categories, and crosses the conventional boundaries of art vis-à-vis architecture, landscape, city planning, utility, and so forth, reducing *such quantitative* recognitions (measures and categories) to a secondary importance. We

now propose to follow the principles of phenomenal, conditional, and respon-
sive art by placing the individual observer in context, at the crux of the deter-
mining process, insisting that he or she use all the same (immediate) cues the
artist used in forming the art-response to form his or her operative-response
(judgments): 'Does this "piece," "situation," or "space," make sense? Is it more
interesting, more beautiful? How do I feel about it? And what does it mean to
me?' Earlier, I made the point that you cannot correctly call anything either
free or creative if the individual does not, at least in part, determine his or her
own meaning. What applied to the artist now applies to the observer. And in
this responsibility of the individual observer we can see the first social implica-
tion of a phenomenal art.

Being and circumstance, then, constitute the operative frame of reference
for an extended (phenomenal) art activity, which becomes a process of
reasoning between our mediated culture (being) and our immediate presence
(circumstance). *Being* embodies in you the observer, participant, or user, your
complete genetic, cultural, and personal histories as 'subsidiary' cues bearing
on your 'focal' attending (experiencing) of your circumstances, again in a
'from-to relation.' *Circumstance*, of course, encompasses all of the conditions,
qualities, and consequences making up the real context of your being *in* the
world. There is embedded in any set of circumstances and your being in them
the dynamic of a past and future, what was, how it came to be, what it is, and
what it may come to be.

If all of this seems a bit familiar, it should. No one 'invents' a new percep-
tual consciousness. This process of being and circumstance is our most basic
perceptual (experiencing) action, something we already do at every moment in
simply coming to know the nature of our presence, and we almost always do so
without giving the wonder of it a second thought. Once again this 'oversight'
speaks not of its insignificance; on the contrary, it speaks of its extraordinary
sophistication. What I am advocating is simply elevating this process, this
reasoning, to a role of importance that matches its innate sophistication. It
should be noted that it is upon this 'reasoning' process that all of our subse-
quent logics (systems) are instinctively patterned – although this generally
goes unacknowledged. But with one modification (gain and loss): to cut the
world down to a manageable size, our logics hold their components to act as a
kind of truth, locking them in as a matter of style into a form of *permanence*.
Conversely, the process of reasoning, our being and circumstance (which I am
here proposing), is free of such abstraction and can account for that most basic
condition (physic) of the universe – *change*.

The wonder of it all is that what looked for all the world like a diminishing
horizon – the art-object's becoming so ephemeral as to threaten to disappear

altogether – has, like some marvelous philosophical riddle, turned itself inside out to reveal its opposite. What appeared to be a question of object/non-object has turned out to be a question of seeing and not seeing, of how it is we actually perceive or fail to perceive 'things' in their real contexts. Now we are presented and challenged with the infinite, everyday richness of 'phenomenal' perception (and the potential for a corresponding 'phenomenal art,' with none of the customary abstract limitations as to form, place, materials, and so forth) – one which seeks to discover and value the potential for experiencing beauty in everything.

57 Vito Acconci

'Notes on Vienna, and on a piece for the Vienna Festival'
1986

Over the last thirty years Vito Acconci (b. 1940) has focused on combining conceptualism and architecture, through his New-York-based architectural practice 'Acconci Studio'. However, he is still best known for his work as a performance artist in the 1970s. He is famous for putting himself through demanding, almost punishing routines, often designed to unsettle the audience, staged in the studio, in the gallery and in the street. These were documented in text, photography, film and video. As he first started out as a poet, the written component of these works, as with much of his oeuvre, was crucial, articulating a disarmingly literal and unemotional attitude towards his physical endeavours – endeavours that were often uncomfortable, dangerous or socially unacceptable and which explored the limits of polite human behaviour. The notes that he wrote for his contribution to the Vienna Festival in 1986, reprinted here, represent a more reflective but still characteristically frank and unapologetic continuation of this uncompromising approach to art-making and writing. 'But not everybody loves art. And, let's admit it, neither do I', he writes towards the end of the essay.

The crux of Acconci's discussion deals with how he, as a contemporary artist, might deal with a site-specific commission within the context of an established cultural festival in Vienna. He addresses how the complicated relationships between an artist, an art work, an art museum, a public and a place might be 'contractually' entered into and played out in an ethically responsible, generous and honest manner. Acconci is faced, on the one hand, with the notion of the artist as a souvenir-making tourist and with the self-perpetuating nomadism of artistic responses and residencies, and, on the other, with the artist as someone charged with the responsibility of leaving behind a meaningful, considerate and worthwhile trace. This is difficult anywhere, but particularly so in a city such as Vienna with its twentieth-century histories and the ghosts of Johann Strauss, Freud, Schoenberg and Wittgenstein haunting its buildings and gardens. 'So how can I remain a traveller and still act in public?', Acconci asks, before continuing, 'One way is: I can travel from place to place, like a guerilla fighter, setting a bomb in a place and then travelling on. But there are no places I want to bomb. No, I don't want to get rid of places; let them stay. I want to put other places into them, on them, over them.' Acconci thus sets up the possibility of the artist as international terrorist only to stumble back and declare his peaceful intentions.

Vito Acconci, 'Notes on Vienna, and on a piece for the Vienna Festival', in *WeinFluss*, Vienna: Weiner Festwochen, Steinhof-Theatrebau, 1986, pp. 51–53.

When I went to Vienna, I had with me a book on Vienna. So 'looking' meant: looking up from a book; I read as much as I saw. It was, after all, reading that let me look: un-read-about, everything to be seen would have remained in peripheral vision. Reading allowed me not just to look but to look out: the sights could function as a warning – I could be on my guard.

You're right: everything I saw, then, was loaded. But, if it hadn't been loaded by Carl Schorske, as it happened it was, then it might have been loaded by a nostalgia for (or a hatred of) Strauss waltzes, it might have been loaded by Carol Reed's *The Third Man*. Without a myth (whether in the past as a memory or in the future as a goal) the eyes can't open.

Vienna meant a series of individual heroes: Schoenberg, Wittgenstein, Loos. But, at the same time, Vienna meant Freud and the dismantling of the hero, the killing of the father. Vienna, set up in myth as the hothouse inside which modernism was born, forced me to consider my own work in relation to modernism: have I killed my heroes, even if that meant merely forgetting them? Have I avoided the issue, the issues of modernism? After all, what my work has said for me is: I want to go outside, out of the hothouse.

But I could side-step, and leave my foot in the door. I could hold on to the banner while conscientiously objecting to the war: Vienna's modernism was a tainted one – a modernism intertwined with expressionism. Expressionism is a time-lag in the face of modernism: the refusal of outerness and the resort to guts, the delusion of direct transmission, the agonized self as the underside of the bourgeois individual.

So kill the father, break down the self. I'll cheer the murderers on. I walk through Vienna, the city of rings, the city of bourgeois organization, the city of protectiveness and isolation: the Karl-Marx-Hof is a barricade, the Wittgenstein house is walled in against the outside world. The mind in itself, the self in itself: I can't believe it, I won't believe it, I hate it – but its purity marches on, and I can't get the parade out of my head.

In the middle of the drumbeats, I'm given orders, I'm asked to do a piece in Vienna. I'm asked more then this: it should be a piece that has something to do with the foreigner's myth of Vienna. Now wait a minute. If I'm working as an architect, or like an architect (doing, for example, a permanent piece in a public space), then of course I'd come to grips with Vienna; I'd have to: I'd be adding the piece onto an existent space, I'd be putting my place into the city's time.

But I won't be doing a permanent piece here, in the middle of the city, in the light of day. No reason to fear that Vienna will be spoiled by me. I'm leaving nothing here. I'm doing a piece for an exhibition set aside as 'art', inside a building meant for temporary exhibitions. The piece will go elsewhere afterwards; so will I. So all I can claim is: I'm doing a piece while having, for

the time being, a certain atmosphere in mind. Did that atmosphere seep into me from the place itself, or merely out of a book? No matter now; it's all in my mind by this time.

And there are certain things I can't get out of my mind. I think of Schoenberg's *The Book of the Hanging Garden*; I think of the garden in Kokoschka's *The Dreaming Boys*. These things stick in my mind because I see replicas of these things when I look around Vienna (knowing, all the while, that knowledge of Schoenberg, knowledge of Kokoschka, has predisposed me to find 'garden' where ever I look). I see Vienna as a garden: the bourgeois urge for order – the ownership of nature – the refusal to let nature run wild, to let nature get out of hand. This is the ugly American speaking, the American with wilderness, with open spaces, with John Ford movies on his mind. (In order to talk like this, I have to forget the lineage from American pioneer to American capitalist: forget that, while the settler solves nature by bringing it into his or her own backyard, the pioneer ignores the problem by cutting nature down. But I can't consider that now: for now, I'm the naive American who escaped being lost at sea only to be lost in Europe instead.)

Just when I thought I was lost in a single particular city, they tell me that this exhibition isn't about the foreigner's myth of Vienna at all. Rather, it's more generalized: it's about the traveller who goes beyond the guidebook, into the corners and recesses of a city. But, in that role of traveller, it's more appropriate to take in than to put out. That role of traveller leaves me with souvenirs, whether physical or mental. I can give these souvenirs to someone else; but that act of giving is a personal relationship, enclosed inside a couple and out of the public realm, where I want my art to be. Or I can display those souvenirs on a shelf, or in a glass box, inside a structure like a museum; but frames like these leave a viewer outside, in a position of desire, trying to solve a code that allows entrance into religion or privacy. So how can I remain a traveller and still act in public? One way is: I can travel from place to place, like a guerilla fighter, setting a bomb in place and then travelling on.

But there are no places I want to bomb. No, I don't want to get rid of places; let them stay. I want to put other places into them, on them, over them. So I can make a place here, in the exhibition-area; I can take on the role of the lonely traveller, who has no place to call home: all I can do, as that lonely traveller, is resort to myself (my place becomes, desperately, personalized, my place is in the image of person) – at the same time, in order to make a place for myself, I'm enlarging my person into a place (the image of person, becoming as large as a place now, becomes de-personalized, away from my specific person).

There's a hitch, a twist in the plot, a change of scene. Whatever place I make can't be expected to stay in place, it has to be portable: in the role of the lonely traveller, I'm condemned to travel for all time, I can't settle down here

(and, also, coming back down to earth and away from play-acting, I have to remember that this is a temporary exhibition, the piece has to be moved out afterwards). I can take that portability literally and take it further: not only portable as it goes out but portable as it goes in: each part of the place will be portable, movable from and separate from the other parts.

Once I've said 'separate', I've opened up a can of worms: my myths run wild, my myths come in from separate directions. That image of person, now that it's large enough to be a place, now that it's large enough to hold other people, shows its true colors: it's a father-figure, that father-figure who, Freud knew, is alive and well in Vienna, where the memory of the Habsburgs refuses to die, in spite of all the talk and architecture of socialism. What's separated the figure, what's broken it, is: the act of killing the father. Now that the parts of the body are separate, each part is a body on its own: each part grows like a body, the parts sprout and flower. The father, though dead, still grows, festers, grows into myth. The myth of the father is domesticated, turned into a garden. So I've had in my mind, all the time, Schoenberg's *Hanging Garden*: the father is broken, the garden exploded. Or nature is exploded, into tidy little bits of garden.

Because everybody loves a garden. But not everybody loves art. And, let's admit it, neither do I. I love the attitude of art-making, and especially the modernist attitude of art-making: the paring down, the re-making from scratch as if reinventing the wheel, the call of 'essence' like a decoy, like the carrot hanging in front of the donkey. But I hate the results of art-making: the display as 'art' – the self-enclosure that calls on the viewer, standing in front of it, either to venerate, as if in religion, or to examine, as if as a scientist.

But what if the attitude of art-making were distilled into some other field, some other consequence that didn't announce itself as art…

So we're in the world of gardens again, we've killed the *Modernist Father*, and we've entered (secretly, secretly, by the back door) the bourgeois home.

58 Brian O'Doherty

'The Gallery as a Gesture' 1986

The critic and cultural commentator Brian O'Doherty (b. 1935) was also, at the time of writing his famous 'White Cube' essays, a practising artist exhibiting under the name Patrick Ireland – an alias adopted in protest against British military action in Northern Ireland. O'Doherty/Ireland not only understood the gallery world from the inside and the relationship that art had to 'the new god, extensive, homogeneous space', but was also acutely aware of the ideology of the modern gallery space. In 'The Gallery as a Gesture' he interprets sculptural activity according to how well artists articulate a political awareness of the gallery in their work, not just as 'space' but more importantly as 'institution'.

O'Doherty's original 'White Cube' essays were first published in *Artforum* in 1976. The first article was called 'Space (Art)'; the second 'Installations (Art)'; and the third 'Environment (Art)'. On the cover of the issue containing the first article in the series, the following quotation from O'Doherty was highlighted against a photograph of an empty gallery space: 'The history of modernism is intimately framed by the gallery space... an image comes to mind of a white ideal space that, more than any single picture, may be the archetypal image of 20ᵗʰ century art' (original ellipsis). When the articles were gathered together in a book that was published in 1986, with a fourth chapter added that further emphasized the ideological nature of artistic gesture, the politics of the situation he was analysing were brought more sharply to the fore. In 'The Gallery as a Gesture' O'Doherty is at pains to counter the view that the Christos' work wrapping buildings, for example, is largely about 'having fun'. Instead, he insists, it represents a 'deep seriousness' in its direct engagement with the gallery environment. Finally, for O'Doherty, advanced art has to have a serious and polemical purpose. It may increasingly use humour or irony to achieve its ends, but its essential qualities are its political determination and 'free-floating anger'.

Brian O'Doherty, 'The Gallery as a Gesture', in *Inside the White Cube: The Ideology of the Gallery Space*, University of California Press, 1999, pp. 87–107. What was originally the fourth chapter of *Inside the White Cube* is reproduced here in full.

The value of an idea is proved by its power to organize the subject matter.
Goethe

From the '20s to the '70s, the gallery has a history as distinct as that of the art shown in it. In the art itself, a trinity of changes brought forth a new god. The pedestal melted away, leaving the spectator waist-deep in wall-to-wall space. As the frame dropped off, space slid across the wall, creating turbulence in the

corners. Collage flopped out of the picture and settled on the floor as easily as a bag lady. The new god, extensive, homogeneous space, flowed easily into every part of the gallery. All impediments except 'art' were removed.

No longer confined to a zone around the artwork, and impregnated now with the memory of art, the new space pushed gently against its confining box. Gradually, the gallery was infiltrated with consciousness. Its walls became ground, its floor a pedestal, its corners vortices, its ceiling a frozen sky. The white cube became art-in-potency, its enclosed space an alchemical medium. Art became what was deposited therein, removed and regularly replaced. Is the empty gallery, now full of that elastic space we can identify with Mind, modernism's greatest invention?

To present the content of that space leads to Zen questions: When is a Void a plenum? What changes everything and remains itself unchanged? What has no place and no time and yet is period? What is everywhere the same place? Once completed by the withdrawal of all apparent content the gallery becomes a zero space, infinitely mutable. The gallery's implicit content can be forced to declare itself through gestures that use it whole. That content leads in two directions. It comments on the 'art' within, to which it is contextual. And it comments on the wider context – street, city, money, business – that contains it.

First gestures have a quality of blundering, indicating an imperfect consciousness. Yves Klein's gesture at the Galerie Iris Clert on April 28, 1958, may have been in search of '… a world without dimension. And which has no name. To realize how to enter it, one encompasses it all. Yet it has no limits.' But its implications for the gallery space were profound. It was a remarkably complete event, as complete as his image of himself as mystic and angel eating the air, promise-crammed. He arrived (in his famous photograph) in free-fall from a second-floor window. From judo he learned how to land without injury. What he really alighted upon was, perhaps, the rather complacent pool of French painterliness. Time gives method to his madness and illustrates how modernism recreates, from photographs, some of its most influential touchstones.

For avant-garde gestures have two audiences: one which was there and one – most of us – which wasn't. The original audience is often restless and bored by its forced tenancy of a moment it cannot fully perceive – and that often uses boredom as a kind of temporal moat around the work. Memory (so disregarded by modernism which frequently tries to remember the future by forgetting the past) completes the work years later. The original audience is, then, in advance of itself. We from a distance know better. The photographs of the event restore to us the original moment, but with much ambiguity. They are certificates that purchase the past easily and on our terms. Like any currency, they are subject to inflation. Aided by rumor, we are eager to establish the coordinates within which the event will maximize its historical importance. We are thus offered an irresistible opportunity to partake in creation of a sort.

But to return to Yves Klein suspended over the pavement like a gargoyle. Klein's gallery gesture had a trial run at the Galerie Colette Allendy in Paris in 1957. He left one small room bare to, as he said, 'testify to the presence of pictorial sensitivity in a state of primary matter.' That 'presence of pictorial sensitivity' – the empty gallery's content – was, I believe, one of the most fatal insights in postwar art. For his major gesture at Iris Clert's, 'He painted the façade on the street blue,' wrote Pierre Descargues in a Jewish Museum catalogue, 'served blue cocktails to the visitors, tried to light up the Luxor obelisk in the Place de la Concorde, and hired a Garde Republicaine in uniform to stand at the entrance to the gallery. Inside he had removed all the furniture, painted the walls white, whitened one showcase which contained no object.' The exhibition was called *The Void*, but its longer title, developing the previous year's idea, is more instructive: 'The isolation of sensibility in a state of primary matter stabilized by pictorial sensibility.' An early visitor was John Coplans, who thought it odd.

On opening night, three thousand people came, including Albert Camus, who wrote in the book: 'With the Void. Full Powers.' While offering itself as site and subject, the gallery primarily hosted a transcendent gesture. The gallery, the locus of transformation, became an image of Klein's mystical system – the grand synthesis derived from the symbolists in which *azur* (International Klein Blue) became the transubstantiating device – the symbol, as it was for Goethe, of air, ether, spirit. In a conceit reminiscent of Joseph Cornell, Klein had touched space through the sputnik flight in 1957, which he surrounded with a mystical halo. Klein's ideas were a nutty but oddly persuasive mix, stirring mysticism, art, and kitsch in the same pot. His art raises again, as the work of successful charismatics does, the problem of separating the objects of art from the relics of a cult. Klein's work had generosity, utopian wit, obsession, and its share of transcendence. In that apotheosis of communication that becomes communion, he offered himself to others and others consumed him. But like Piero Manzoni, he was a prime mover, very European, rife with metaphysical disgust at the ultimate bourgeois materialism: the hoarding of life as if it were a possession on the order of a sofa.

Outside blue, inside the white void. The gallery's white walls are identified with spirit, filmed over with 'pictorial sensitivity.' The blanched display case is an epigram on the idea of exhibition; it raises the prospect of serial contexts (in the empty gallery, the display case contains nothing). The double mechanism of display (gallery and case) reciprocally replaces the missing art with itself. To insert art into gallery or case puts the art in 'quotation marks.' By making art an artificiality within the artificial, it suggests that gallery art is a trinket, a product of the boutique. What is now called the support system (a phrase that became popular with the maintenance of life in space) is becoming transpar-

ent. As time goes by, Klein's gesture becomes more successful; history obligingly curves into an echo chamber.

The theatrics – the Garde, the cocktails (another comment on inside/outside?), the Luxor obelisk inscribing the void above like a wrinkled pencil (this one didn't work out) – brought that attention without which a gesture is stillborn. This was the first of several gestures that use the gallery as a dialectical foil. These gestures have a history and a provenance: each tells us something about the social and esthetic agreements that preserve the gallery. Each uses a single work to draw attention to the gallery's limits, or contains it in a single idea. As the space that socializes those products of a 'radical' consciousness, the gallery is the locus of power struggles conducted through farce, comedy, irony, transcendence, and, of course, commerce. It is a space that rides on ambiguities, on unexplored assumptions, on a rhetoric that, like that of its parent, the museum, barters the discomfort of full consciousness for the benefits of permanence and order. Museums and galleries are in the paradoxical position of editing the products that extend consciousness, and so contribute, in a liberal way, to the necessary anesthesia of the masses – which goes under the guise of entertainment, in turn the laissez-faire product of leisure. None of this, I might add, strikes me as particularly vicious, since the alternatives are rampant with their own reformist hypocrisy.

In proper teleological fashion, Klein's gesture produced a response at the same gallery, Iris Clert's, in October 1960, the same month that the New Realists formally composed themselves as a group. Klein's *Void* was filled with Arman's *Le Plein*, an accumulation of garbage, detritus, waste. Air and space were evicted until, in a kind of reverse collage, the trash reached critical mass by pressing against the walls. It could be seen pressing against the window and door. As a gesture it lacks the ecstasy of Klein's transcendent nostomania. More mundane and aggressive, it uses the gallery as a metaphorical engine. Stuff the transforming space with refuse and then ask it, grotesquely overloaded, to digest *that*. For the first time in the brief history of gallery gestures, the visitor is *outside* the gallery. Inside, the gallery and its contents are now as inseparable as pedestal and artwork. In all this, there is a bit of what Arman himself called a tantrum. Modernism with its rigorous laws often exasperates its own children whose very disobedience acknowledges parental rule. By rendering the gallery inaccessible, and reducing the excluded visitor to peering through the window at the junk within, Arman initiated not just divorce proceedings, but a major schism.

Why should the early gallery gestures have come from the New Realists in the late '50s and the '60s? Infused with social consciousness, their work was coming to an influential denouement. But it was undercut by international art politics. 'It was the tough luck of the Parisian avant garde,' wrote Jan van der Marck, 'baptized by Yves Klein's presentation of the Void at Iris Clert's in

Paris in 1958 and institutionally enshrined in Nieuwe Realisten at the Haags Gemeentenmuseum in June 1964, to coincide with the demise of Paris and the ascendancy of New York. In the struggle for international attention "Frenchness" became a liability, and young American artists believed that the tradition from which it drew was bankrupt.' Americans capitalized on their idea of the raw in contrast to Europe's haute cuisine. Yet the New Realists' perception of the gallery's politics was more astute. The early New Realist gestures, apart from Klein's marvelous hocus-pocus, have a savage edge. But then the European gallery has a political history dating from at least 1848. It is by now as ripe as any symbol of European commerce that may present itself to the jaundiced eye. Even the most amiable of New Realist gestures has a hard center. In Stockholm at the Addi Kopcke Gallery in 1961, Daniel Spoerri arranged for the dealer and his wife, Tut, to sell groceries just bought from the store at 'the current market price of each article.' Stamped: 'CAUTION: WORKS OF ART,' each item bore Spoerri's 'certifying signature.' Was this parody of commerce visible to the dealer? Could it have happened on the Milan/Paris/New York axis?

The New York gesture that charged every particle of the gallery space had a more amiable complexion. One of the sights of the '60s was entering the Castelli Gallery in 1966 and seeing Ivan Karp shepherding with a pole Andy Warhol's silver pillows as they floated and drifted in that historic uptown space at 4 East 77th Street. Every part of the space was active, from the ceiling – against which the pillows bumped – to the floor where they occasionally sank, to be agitated again. This discrete, changing, and silent artwork mocked the kinetic urgencies buzzing and clanking in the galleries of the day, laid claim to pedigree (allover space) and united happiness with didactic clarity. Visitors smiled as if relieved of a deep responsibility. That this work was not a fluke was clear from the *Cow Wallpaper* papering a small adjacent room. From the heroic '40s and '50s, phrases like Harold Rosenberg's 'apocalyptic wallpaper' still hung in the air. Reducing the prime symbol of energy to wallpaper – etiolated further by repetition – brought matters of high seriousness into the precincts of interior decoration, and vice versa.

Warhol's astute relation to wealth, power, and chic is deeply implicated in the fictions of American innocence – very different from the European's instinctive ability to locate the enemy. American innocence is sustained by a variety of delusions which recent successful avant-gardes have tended to share. Arman's assassination of a white Mercedes attacked a materialism very different from that of the Americans. Anarchic gestures in America do not do well. They tend to refute the official optimism born of hope. Accumulating below the threshold of good form and acceptable style, they tend to be forgotten. I think of Tosun Bayrak's 'banged-up dirty white automobile on Riverside Drive in New York City, stuffed ... full of animal guts ... a bull's head peering out the front window ... left ... until the neighborhood stank' (Therese Schwartz).

Whatever its excesses, the American avant-garde never attacked the *idea* of a gallery, except briefly to promote the move to the land which was then photographed and brought back to the gallery to be sold. Materialism in America is a spiritual thirst buried deep within a psyche that wins its objects from nothing and will not give them up. The self-made man and the man-made object are cousins. Pop art recognized this. Its blurred fusion of indulgence and criticism reflected the bourgeois' material pleasures enhanced by a little spiritual thirst. The satiric impulse in American art, apart from Peter Saul, Bernard Aptheker, and a very few others, remains without its object, somewhat unfocused and insecure as to the nature of its enterprise. In a country where the social classes are imperfectly defined, and the rhetoric of democracy makes their separation suspect, criticism of material success often appears as a form of sophisticated envy. For the artist, of course, the avatar of all this is his or her product. It tends to be the agent of his or her alienation, to the degree that it enters the social matrix. In an operation that never fails, it has its meaning lifted. The site of that operation is the gallery. So Arman's visitor, denied entry outside the stuffed Galerie Iris Clert, may recognize some of the artist's anger in his own.

The excluded visitor, forced to contemplate not art but the gallery, became a motif. In October 1968, the European artist most sensitive to the politics of the gallery space, Daniel Buren, sealed off the Galleria Apollinaire in Milan for the duration of the exhibition. He glued vertical white and green stripes on fabric over the door. Buren's esthetic is generated by two matters: stripes and their location. His theme is encouraging the world's systems to vocalize themselves through his constant stimulus, his catalyst, monogram, signature, sign. The stripes neutralize art by depletion of content. As a sign of art they become an emblem of consciousness – art was here. 'And what does art say?' the situation asks. As a sign, the stripes represent a recognizable aspect of European avant-gardism: a cool intelligence, politically sophisticated, commenting on the social agreement that allows art to be made and yet demeans it. So the stripes bring to the door of the gallery not art so much as a monologue in search of an argument.

This gesture was preceded, as Yves Klein's was, by a modified trial run. In April of the same year, at the Salon de Mai held at the Museum of Modern Art in Paris, Buren offered his 'Proposition Didactique.' One wall of an empty gallery was covered with green and white stripes. Stripes were placed on 200 billboards around the city. Outside the gallery, two men with striped billboards paraded. One is reminded of Gene Swenson walking up and down outside the Museum of Modern Art in the early '70s, carrying a sign emblazoned only with a question mark. (Swenson and Gregory Battock were the two New York figures with a political intelligence comparable to that of the New Realists. No one took them very seriously. Life, however, did; they both died tragically.)

Buren's Milan stripes closed the gallery in much the same way that public health officials close infected premises. The gallery is received as a symptom

of a disordered body social. The toxic agent isolated within is not so much art as what – in every sense – contains it. Art is also contained by another social agreement (in my opinion external to it) called style. The stripes, which identify a personality with a motif and a motif with art, imitate the way style works. Style is constant, so Buren's constant stimulus is a grotesque parody of it. Style, we know, extracts from the work an essence which is negotiable cross-culturally. Through style, as André Malraux demonstrated, all cultures talk to you. This idea of a formalist Esperanto goes with the placeless white cube. Formalist art in placeless galleries stands, like the medieval church, for a system of commerce and belief. Insofar as style succeeded in identifying meaning with itself, the work's content was devalued. This connoisseurship facilitated the assimilation of the work, no matter how bizarre, into the social matrix. Buren understands perfectly this form of socialization. 'How can the artist contest society,' he asks, 'when his art, all art, "belongs" objectively to that society?'

Indeed much of the art of the late '60s and the '70s had this theme: How does the artist find another audience, or a context in which his or her minority view will not be forced to witness its own co-optation? The answers offered – site-specific, temporary, nonpurchasable, outside the museum, directed toward a nonart audience, retreating from object to body to idea – even to invisibility – have not proved impervious to the gallery's assimilative appetite. What did occur was an international dialogue on perception and value-systems – liberal, adventurous, sometimes programmatic, sometimes churlish, always anti-establishment and always suffering from the pride that demands the testing of limits. The intellectual energy was formidable. At its height it seemed to leave no room for artists who were just good with their hands – inviting subsequent fictions of dumbness and a return to the canvas. Artists' revolutions, however, are bounded by the inexorable rules that include those implicit in the empty gallery. There was an exhilarating run of insights into the cycle of production and consumption: this paralleled the political troubles at the end of the '60s and the beginning of the '70s. At one point, it seemed as if the gallery's walls were turning to glass. There were glimpses of the world outside. The gallery's insulation of art from the present while conveying it to the future seemed for a moment deeply compromised. Which brings us back to Buren's closed doors. '...the artist who creates silence or emptiness must produce something dialectical: a full void, an enriching emptiness, a resonating or eloquent silence," wrote Susan Sontag in 'The Esthetics of Silence.' 'Art' forces the void behind the closed door to speak. Outside, art is saved and refuses to go in.

This conceptualization of the gallery reached its ultimate point a year later. In December 1969, in the *Art & Project Bulletin* #17 (its pages were a floating artists' space), Robert Barry wrote, 'during the exhibition the gallery will be closed.' This idea was realized at the Eugenia Butler Gallery in Los Angeles the

following March. For three weeks (March 1–21) the gallery was closed; outside, the same legend was posted. Barry's work has always employed scanty means to project the mind beyond the visible. Things are there but barely seen (nylon string): process is present but cannot be sensed (magnetic fields): attempts are made to transfer ideas without words or objects (mentalism). In the closed gallery, the invisible space (dark? deserted?), uninhabited by the spectator or the eye, is penetrable only by mind. And as the mind begins to contemplate it, it begins to ruminate about frame and base and collage – the three energies that, released within its pristine whiteness, thoroughly artified it. As a result, anything seen in that space involves a hitch in perception, a delay during which expectation – the spectator's idea of art – is projected and seen.

This doubling of the senses – advocated by such disparate characters as Henry David Thoreau and Marcel Duchamp – became in the '60s a period sign, a perceptual stigma. This doubling enables sight, as it were, to see itself. 'Seeing sight' feeds on emptiness; eye and mind are reflected back to engage their own process. While this can produce interesting forms of perceptual narcissism and quasi-blindness, the '60s were more concerned with eroding the traditional barricades set up between perceiver and perceived, between the object and the eye. Vision would then be able to circulate without the impediment of traditional conventions. Such a perceptual Utopia was consonant with the radical sensory transformations of '60s culture. In galleries, its most cogent expression was in Les Levine's 'White Sight' at the Fischbach Gallery in 1969. On entering the gallery the spectator, deprived of color and shadow by two high-intensity monochromatic sodium vapor lights, attempted to recreate the space. Other viewers became visual cues, points of reference from which to read the space. The audience thus became an artifact. Without sight, the audience turned back on itself, attempted to develop its own content. This intensified the experience of being alone in any empty white gallery, in which the act of looking, coached by expectation, becomes a kind of instant artifact. So, to return to the white space, the twin contexts of anticipation – the gallery and the spectator's mind – are fused in a single system, which could be tripped.

How could this be done? The minimal adventure reduced the stimulus and maximized its resonance within the system. In this exchange, metaphor died (this was minimalism's major contribution, shutting the door on modernism). The containing box, the white cube, was forced to declare some of its hidden agenda, and this partial demythification had considerable consequences for the installation idea. Another response was to literalize life or nature within the gallery; e.g., Jannis Kounellis' horses, intermittently occupying art spaces from 1969 on; Newton Harrison's doomed fish at the Hayward Gallery in 1971. Any transformation that occurred at these extreme points was more alchemical than metaphorical. Transformation became the spectator's rather than the artist's role. Indeed the artist's role became a kind of *de-creation*, providing a

stimulus for the spectator to take into his or her art-making system (art as the opiate of the upper middle classes).

In transforming what is present in the gallery – which resists transformation – we are becoming the creator, painlessly. In that process we are ourselves artified, alienated from the work even as we transform it. Spectators in a gallery begin to look like Kounellis' horses. The confusion between the animate and inanimate (object and spectator) reverses the Pygmalion myth: the art comes alive and refines the spectator. Consciousness is the agent and medium. So the possession of a higher consciousness becomes a license to exploit its evolutionary inferiors. In such ways does the gallery situation reflect the real world outside it. The confusion of art and life invites gestures that would push it to the extreme – a murder in a gallery, perhaps? Is it art? Would that be a legal defense? Would Hegel testify to its dialectical relation to the gallery space? Would Jacques Vache be called as a witness for the defense? Could the work be sold? Would the photo-documentation be the real work? And all the time, in Barry's empty gallery, the meter ticks; someone is paying the rent. An enlightened dealer is losing money to help make points about the space that sells things. It is as if a Bedouin were starving his horse or an Irishman suffocating his pig. In Barry's closed space, over the three weeks, the space stirs and mutters; the white cube, now a brain in a bowl, does its thinking.

These gestures seek, in short, transcendence, exclusion through excess, isolation through dialectic and through mental projection. They found their opposite in a work done, accommodatingly enough, in the southern hemisphere. Lucy R. Lippard in her *Six Years: The Dematerialization of the Art Object from 1966 to 1972* (one of the great books of the '70s) describes it thus: 'The Rosario group begins its "Experimental Art Cycle" . . . October 7–19: Graciela Carnivale . . . a totally empty room, the window wall covered to provide a neutral ambiance, in which are gathered the people who came to the opening, the door is hermetically sealed without the visitors being aware of it. The piece involved closing access and exits, and the unknown reactions of the visitors. After more than an hour, the "prisoners" broke the glass window and escaped.' The occupants of the empty gallery assumed the condition of art, became art objects, and rebelled against their status. In an hour there was a transference from the object (where's the art?) to subject (me). The artist's anger – and this is, I think, a hostile gesture – is switched to the audience's anger at the artist, which, according to the classic scenario of avant-garde transference, authenticates the artist's anger at the audience. Is this making too much of people being locked in a room and getting mad at the locker? The room in which they are locked is, if my information is correct, an art room. They were insulated by the great transformer. Locking people in a room without reason, with nothing in it, and giving no explanation, has, I would suggest, a sharper resonance in Argentina than in Soho.

Whole-gallery gestures came in a rush at the end of the '60s and continued sporadically through the '70s. The apotheosis of such gestures, in terms of scale and richness of readings, occurred in Chicago in January 1969. The subject was not the gallery but the institution that possesses not one but many galleries – the museum. Christo, a colleague of Klein and Arman in Paris around 1960, was asked by Jan van der Marck to do an exhibition at the new Museum of Contemporary Art in Chicago. Christo, who was doing a show for a nearby commercial gallery, suggested something special for the museum – the topological task of wrapping inside and out. The practical problems were formidable; these problems test the seriousness of a gesture, but they are usually forgotten – the inconvenience of being there is mislaid in time. The fire commissioner objected, but proved tractable. Mayor Richard Daley was an unseen presence. Following the 1968 Democratic National Convention, violence had been the subject of an exhibition at the Museum of Contemporary Art. This, the most successful political exhibition of the '60s, joined the board of trustees and the staff in the same posture of liberal outrage. (In addition, at the Richard Feigen Gallery across the street, Daley was the subject of a savage artists' protest; notable among the works shown was Barnett Newman's *Lace Curtain for Mayor Daley*.) To everyone's surprise, the Christos' wrapping was accomplished without city harassment. The thinking is that the late mayor, once bitten by the national media, was content to let sleeping art lie. But what of the work itself?

Unquestionably, it was the period's most daring collaboration between an artist and a director. The only comparable occasion was the Hans Haacke/ Edward Fry collaboration at the Guggenheim Museum in 1971. The museum was American, but the collaborators in Chicago were both European, one Dutch, the other Bulgarian. Van der Marck's tenure at the museum is now a fabled era, unmatched by that of any other curator of the '60s, with the possible exception of Elayne Varian's at Finch College in New York. Van der Marck became in part the co-creator of the work: offering the museum as a subject for examination was in perfect accord with modernist practice – to test the premises of every assumption and to subject them to argument. This is not the tradition of the American Curator, nor of his or her trustees.

Christo's wrappings are a kind of parody of the divine transformations of art. The object is possessed, but the possession is imperfect. The object is lost and mystified. Individuality of structure – the identifying morphology is replaced by a general soft outline, a synthesis that like most syntheses furthers the illusion of understanding. Let us confine ourselves to just a few gatherings from the harvest offered by The Wrapping of the Chicago MCA (process) or The Wrapped MCA (product). The museum, the container, is itself contained. Does this double positive, artifying the container that itself artifies, produce a negative? Is this an act of cancellation, discharging the accumulated content of the empty gallery?

The Christos' work presses esthetic issues to their social context, there to engage in political brokerage. A position must be taken not just by art folk but by the immediate public to whom art is usually as remote as the phyla in an aquarium. This is not a consequence of the work but its primary motivation. It is both avant-garde (traditionally engagé) as well as post-modern (if the audience is fatigued, get another audience). It is also remarkable for the firmness of its ironies, which play for keeps – the loss of vast amounts of money, the one thing the public always understands. But what gives the work a political dimension – a closely reasoned argument with prevailing authority – is the way in which its process is conducted. The corporate structure is marvelously parodied: plans are made, environmental reports sought from experts, opposition is identified and met, energetic debate is accompanied by its share of democratic madness (public arguments on a local level bring out a free society's strangest mutants). All this is followed by the hard-hat technologies of installation, sometimes revealing the incompetence of various suppliers and of American know-how. Then the work is realized, to be quickly withdrawn as if its witnesses could bear no more than a glimpse of beauty.

These public works are of Robert Moses scale, but their awesome acquisitiveness is perpetrated with the most gentle, tolerant, and insistent grace. This combination of advanced esthetics, political subtlety, and corporate methods is confusing to the audience. Siting gigantic artworks in the midst of the body social is not a part of the American tradition. The Brooklyn Bridge had to be built before Hart Crane and Joseph Stella could get to work on it. Large-scale American art generally draws the Adamic artist to remote areas where transcendence is immanent. The Christos' projects mimic in scale the good works of government. They provide the useless at great expense. What they choose to wrap involves expenditures of such magnitude ($3.5 million for the *Running Fence*) that it seems irresponsible to those working on their heart attacks. Yet in the imperial tradition of Ayn Rand selfhood, they raise all the money through sale of the work. Despite such serious business, I am always surprised when sophisticated people think they are having fun. Some fun. Their projects are one of the very few successful attempts to press the rhetoric of much 20th century art to a conclusion. They force the utopian issue in the country that was once Utopia. In doing so they measure the distance between art's aspirations and society's permissions. Far from being the Russian dream of an advanced art at home in an advanced society, they use the methods of an imperfect society and its myths of free enterprise to impose a will as powerful as that of any corporate board chairman's. Far from being folly, the Christos' projects are gigantic parables: subversive, beautiful, didactic.

The choice of the Modern Museum as a subject for wrapping was evidence of the Christos and van der Marck's deep seriousness; they sensed the malaise of an art often smothered by an institution that now tends to be, like the uni-

versity, a corporate venture. It is often forgotten that the Christos, in wrapping the museum, were also symbolically wrapping a staff and its functions – the sales desk (that little repository of bricolage), the docents, the maintenance staff (blue-collar workers serving an alien faith), and also, by implication, the trustees. Paralysis of function also demanded that floor and stairs be wrapped, and so they were. Only the sensitized walls remained untouched. The nature of this wrapping has received little commentary. There was no neatness to it; it looked like an amateur job. Ropes and twine found notches to swing about, knots were vast and tied with thumbs. Slick packaging would make no comment on the American genius for such, which of course includes the packaging of people. So the Christos' packaged museum (explicit) and staff (implicit) proposes that containment is synonymous with understanding. With the museum packaged, is the way to understanding open?

Like all gestures, the project has an expectant quality, an openness that for satisfactory closure requires, like a question or a joke, a response. By definition, a gesture is made to 'emphasize ideas, emotions, etc.' and is 'often . . . made only for effect.' This deals with its immediate impact. For the gesture must snare attention or it will not preserve itself long enough to gather its content. But there is a hitch in a gesture's time, which is its real medium. Its content, as revealed by time and circumstance, may be out of register with its presenting form. So there is both an immediate and a remote effect, the first containing the latter, but imperfectly.

The presenting form has its problems. It must relate to an existing body of accepted ideas, and yet place itself outside them. Initially, it tends to be perceived – or misperceived – somewhere on a spectrum from outright hostility to just fun. In this, the 'art-likeness' of the work is a liability. If it is perceived within an existing category, the category tries to digest it. Successful gestures – ones that survive their presenting form – usually abort the dialogue out of the accepted universe of discourse. In game-playing this is rule-modification. But in art the modification takes place over time and with uncertain – indeed unpredictable – results. Thus gestures have an element of charlatanry and fortune-telling. A bet is placed on an imperfectly perceived – but wished-for – future. Gestures are thus the most instinctive of artworks in that they do not proceed from full knowledge of what provokes them. Indeed, they are born out of a desire for knowledge, which time may make available. An artist's career (if artists have careers) cannot suffer from too many of them, for they jump it oddly about. A gesture is antiformal (against the agreement that art reside within its category) and it may be at odds with the smooth teleology of the rest of its perpetrator's work. An artist cannot make a career of gestures unless, like On Karawa, his repeated gesture is his career.

The Christos' project is rare in that its presenting form and subsequent content are consonant, though of course the 'fun' aspect was initially

emphasized. The Christos' wit and humor are indubitable, but their complexities (laughter is not a simple subject) are far from fun. The project certainly negotiated a deeper understanding of a major theme of the '60s and '70s: the isolation, description, and exposure of the structure through which art is passed, including what happens to it in the process. At this time the gallery received a lot of lip-service hostility, while being used by artists in that tolerance of their split-level existence necessary to survival. This, of course, is one of the marks of advanced art in the postcapitalist matrix. Rendering to art the things that are art's and to the Collectors the things that they buy often happily coincide. Too much consciousness leads to embarrassment, the blush of the closet revolutionary. It is the particular glory of some '60s and '70s artists, including the Christos, that they met the implications of their own insights and polemics.

All these gestures recognize the gallery as an emptiness gravid with the content art once had. Coping with an idealized place that had preempted art's transforming graces gave rise to a variety of strategies. To those already mentioned – the death of metaphor, the growth of irony, the comedies of assigning value to the useless, 'de-creation' – should be added destruction. Frustration is an explosive ingredient of late modernist art as options close off briskly in a converging corridor of doors and mirrors. A minor apocalypse forces itself upon us; it easily mistakes its dilemmas for the world's. Only two exhibitions formally acknowledged this free-floating anger. 'Violence in Recent American Art' came from Chicago's Museum of Contemporary Art in 1968 under van der Marck; and Varian at Finch College, New York, put on a show of 'Destruction Art', 1968, that the gallery spaces wrapped themselves rather uneasily around. No one trashed a museum, although alternative (to the museum) spaces took a beating. But various methods were used to reduce the placelessness and timelessness of the gallery's hysterical cell. Or the gallery itself could be removed and relocated to another place.

[The text included the following photographic illustrations: Armand P. Arman, *Le Plein*, 1960, Les Levine, *White Sight*, 1969, Christo and Jeanne-Claude, *Museum of Modern Art, Wrapped, Chicago*, 1969; Christo and Jeanne-Claude, *Wrapped Floor and Stairway, Museum of Contemporary Art, Chicago*, 1969]

59 Bruce Nauman/Joan Simon

'Breaking the Silence' 1988

As Joan Simon (b. 1949) states in this interview, Bruce Nauman (b. 1941) uses very different kinds of media in his practice. Apart from painting, which Nauman gave up early in his career, he has worked with film, video, sound, neon light, installation, performance, photography, holography, drawing and sculpture. Although this non-medium-specific approach to art making has meant that Nauman turned to sculpture for very particular purposes, tasks or effects, this 1988 interview provides a striking sense of how often in fact he has done so. Sculpture offers Nauman a way of presenting words, phrases and ideas in concrete form. It can be a solution because it offers a way, he states, of 'literalising them'. In a number of instances it is, as this interview underlines, the process of casting in particular that he employs. In Nauman's hands this is a valuable means not only of reproducing the body (as in *From Hand to Mouth* of 1967), but also of reproducing space, including the casting of 'negative space', such as the space underneath a chair – a recurrent object in his oeuvre used for the symbolic and functional value it is seen to carry. The latter proved very influential for later sculptors such as Rachel Whiteread.

The body is central to Nauman's practice. His own body and those of other perform-ers frequently serve as the agents and instruments of his work. So does space, and the space of the studio, as this interview demonstrates, is often presented as an important setting and stage for his work – as Nauman states: 'the idea that if I was in the studio, whatever I was doing was art'. The studio provides the daily venue for his work – the playground for his games – and as such often becomes integral to it. If Kaprow and Smithson advocated the evacuation of the studio as an outmoded and bankrupt art institution, Nauman alerts us to its pathos and banality from the inside, intensifying its routines through a combination of performance, photography and film. As this interview reveals, Nauman becomes a kind of participant–observer, an insider–outsider, on the issue: 'If I can manage to get outside of a problem a little bit and watch myself having a hard time, then I can see what I am going to do – it makes it possible. It works.'

Simon is a writer and curator, and a former managing editor of *Art in America* (1974– 83). She has published extensively on contemporary art, written books on Ann Hamilton and William Wegman, has contributed to monographs on Gordon Matta-Clark and Jenny Holzer, and has served as general editor of the catalogue raisonné of Bruce Nauman.

'Breaking the Silence', *Art in America*, 76, no. 9, September 1988, pp. 140–205. It was reprinted in the catalogue for the touring exhibition, *Bruce Nauman*, at Kunstmuseum, Wolfsburg; Centre Georges Pompidou, Paris; Hayward Gallery, London; Nykytaiteen, Helsinki, 1997–1999. It was also reprinted in Robert C. Morgan, *Bruce Nauman*, A PAJ Book, Baltimore and London: Johns Hopkins University Press, 2002, pp. 270–84.

Bruce Nauman: There is a tendency to clutter things up, to try to make sure people know something is art, when all that's necessary is to present it, to leave it alone. I think the hardest thing to do is to present an idea in the most straightforward way.

What I tend to do is see something, then remake it and remake it and remake it and try every possible way of remaking it. If I'm persistent enough, I get back to where I started. I think it was Jasper Johns who said, 'Sometimes it's necessary to state the obvious.'

Still, how to proceed is always the mystery. I remember at one point thinking that someday I would figure out how you do this, how you do art – like, 'What's the procedure here, folks?' – and then it wouldn't be such a struggle anymore. Later, I realized it was never going to be like that, it was always going to be a struggle. I realized it I would never have a specific process; I would have to reinvent it, over and over again. That was really depressing.

After all, it was hard work; it was a painful struggle and tough. I didn't want to have to go through all that every time. But of course you do have to continually rediscover and redecide, and it's awful. It's just an awful thing to have to do.

On the other hand, that's what's interesting about making art, and why it's worth doing: it's never going to be the same, there is no method. If I stop and try to look at how I got the last piece done, it doesn't help me with the next one.

Joan Simon: What do you think about when you're working on a piece?

BN: I think about Lenny Tristano a lot. Do you know who he was? Lenny Tristano was a blind pianist, one of the original – or maybe second-generation – bebop guys. He's on a lot of the best early bebop records. When Lenny played well, he hit you hard and he kept going until he finished. Then he just quit. You didn't get any introduction, you didn't get any tail – you just got full intensity for two minutes or twenty minutes or whatever. It would be like taking the middle out of Coltrane – just the hardest, toughest part of it. That was all you got.

From the beginning I was trying to see if I could make art that did that. Art that was just there all at once. Like getting hit in the face with a baseball bat. Or better, like getting hit in the back of the neck. You never see it coming; it just knocks you down. I like that idea very much: the kind of intensity that doesn't give you any trace of whether you're going to like it or not.

JS: In trying to capture that sort of intensity over the past twenty or so years you've worked in just about every medium: film, video, sound, neon, installation, performance, photography, holography, sculpture, drawing – but not painting. You gave that up very early on. Why?

BN: When I was in school I was a painter. And I went back and forth a

couple of times. But basically I couldn't function as a painter. Painting is one of those things I never quite made sense of. I just couldn't see how to proceed as a painter. It seemed that if I didn't think of myself as a painter, then it would be possible to continue.

It still puzzles me how I made decisions in those days about what was possible and what wasn't. I ended up drawing on music and dance and literature, using thoughts and ideas from other fields to help me continue to work. In that sense, the early work which seems to have all kinds of materials and ideas in it, seemed very simple to make because it wasn't coming from looking at sculpture or painting.

JS: That doesn't sound simple.

BN: No, I don't mean that it was simple to do the work. But it was simple in that in the 1960s you didn't have to pick just one medium. There didn't seem to be any problem with using different kinds of materials – shifting from photographs to dance to performance to videotapes. It seemed very straightforward to use all those different ways of expressing ideas or presenting material. You could make neon signs, you could make written pieces, you could make jokes about parts of the body or casting things, or whatever.

JS: Do you see your work as part of a continuum with other art or other artists?

BN: Sure there are connections, although not in any direct way. It's not that there is someone in particular you emulate. But you do see other artists asking the same kinds of questions and responding with some kind of integrity.

There's a kind of restraint and morality in Johns. It isn't specific, I don't know how to describe it, but it's there. I feel it's there. It's less there, but still important, in Duchamp. Or in Man Ray, who also interests me. Maybe the morality I sense in Man Ray has to do with the fact that while he made his living as a fashion photographer, his art-works tended to be jokes – stupid jokes. The whole idea of Dada was that you didn't have to make your living with your art, so that generation could be more provocative with less risk. Then there is the particularly American idea about morality that has to do with the artist as workman. Many artists used to feel all right about making a living with their art because they identified with the working class. Some still do. I mean, I do, and I think Richard Serra does.

JS: No matter how jokey or stylistically diverse or visually dazzling your works are, they always have an ethical side, a moral force.

BN: I do see art that way. Art ought to have a moral value, a moral stance, a position. I'm not sure where that belief comes from. In part it just comes from growing up where I grew up and from my parents and family. And from the time I spent in San Francisco going to the Art Institute, and before that in Wisconsin. From my days at the University of Wisconsin, the teachers

I remember were older guys – they wouldn't let women into teaching easily – and they were all WPA guys.[1] They were socialists and they had points to make that were not only moral and political, but also ethical. Wisconsin was one of the last socialist states, and in the 1950s, when I lived there and went to high school there, Milwaukee still had a socialist mayor. So there were a lot of people who thought art had a function beyond being beautiful – that it had a social reason to exist.

Early Work

JS: What David Whitney wrote about your *Composite Photo of Two Messes on the Studio Floor*, 1967 – that 'it is a direct statement on how the artist lives, works and thinks' – could apply in general to the variety of works you made in your San Francisco studio from 1966–68.

BN: I did some pieces that started out just being visual puns. Since these needed body parts in them, I cast parts of a body and assembled them or presented them with a title. There was also the idea that if I was in the studio, whatever I was doing was art. Pacing around, for example. How do you organize that to present it as art? Well, first I filmed it. Then I videotaped it. Then I complicated it by turning the camera upside down or sideways, or organizing my pacing to various sounds.

In a lot of the early work I was concerned with ideas about inside and outside and front and back – how to turn them around and confuse them. Take the *Window or Wall Sign* – you know, the neon piece that says, 'The true artist helps the world by revealing mystic truths.' That idea occurred to me because of the studio I had in San Francisco at the time. It had been a grocery store, and in the window there was still a beer sign which you read from the outside. From the inside, of course, it was backwards. So when I did the earliest neon pieces, they were intended to be seen through the window one way and from the inside another way, confusing the message by reversing the image.

JS: Isn't your interest in inverting ideas, in showing what's 'not there,' and in solving – or at least revealing – 'impossible' problems related in part to your training as a mathematician?

BN: I was interested in the logic and structure of math and especially how you could turn that logic inside out. I was fascinated by mathematical problems, particularly the one called 'squaring the circle.' You know, for hundreds of years mathematicians tried to find a geometrical way of finding a square equal in area to a circle – a formula where you could construct one from the other. At some point in the nineteenth century, a mathematician – I can't remember his name – proved it can't be done. His approach was to step outside

breaking the rules turns into fighting – you can't do that in a bar and get away with it. But the rules change. It can only go so far and then real life steps in. This year warrants were issued to arrest hockey players; two minutes in the penalty box wasn't enough. It's been taken out of the game situation.

JS: Nevertheless, many of your works take as their starting point very specific children's games.

BN: When I take the game, I take it out of context and apply it to moral or political situations. Or I load it emotionally in a way that it is not supposed to be loaded. For instance, the *Hanged Man* neon piece (1985) derives from the children's spelling game. If you spell the word, you win; if you can't spell the word in a certain number of tries, then the stick figure of the hanged man is drawn line by line with each wrong guess. You finally lose the game if you complete the figure – if you hang the man.

With my version of the hanged man, first of all, I took away the part about being allowed to participate. In my piece you're not allowed to participate – the parts of the figure are put into place without you. The neon 'lines' flash on and off in a programmed sequence. And then the game doesn't end. Once the figure is complete, the whole picture starts to be recreated again. Then I added the bit about having an erection or ejaculation when you're hanged. I really don't know if it's a myth or not.

I've also used the children's game 'musical chairs' a number of times. The simplest version was *Musical Chair (Studio Piece)* in 1983, which has a chair hanging at the outside edge of a circumference of suspended steel Xs. So, when the Xs swing or the chair swings, they bang into each other and actually make noise – make music. But of course it was more than that because musical chairs is also a cruel game. Somebody is always left out. The first one to be excluded always feels terrible. That kid doesn't get to play anymore, has nothing to do, has to stand in the corner or whatever.

Large-Scale Sculpture

JS: There seems to be something particularly ominous about your use of chairs – both in this and other works. Why a chair? What does it mean to you?

BN: The chair becomes a symbol for a figure – a stand-in for the figure. A chair is used, it is functional; but it is also symbolic. Think of the electric chair, or that chair they put you in when the police shine the lights on you. Because your imagination is left to deal with that isolation, the image becomes more powerful, in the same way that the murder offstage can be more powerful than if it took place right in front of you. The symbol is more powerful.

I first began to work with the idea of a chair with that cast of the space underneath a chair – that was in the 1960s. And I remember, when I think

that when you take a solid color of makeup – no matter what color – it flattens the image of the face on film. The flatness itself was another kind of mask.

JS: The whole idea of the mask, of abstracting a personality, of simultaneously presenting and denying a self, is a recurring concern in your work.

BN: I think there is a need to present yourself. To present yourself through your work is obviously part of being an artist. If you don't want people to see that self, you put on makeup. But artists are always interested in some level of communication. Some artists need lots, some don't. You spend all of this time in the studio and then when you do present the work, there is a kind of self-exposure that is threatening. It's a dangerous situation and I think that what I was doing, and what I am going to do and what most of us probably do, is to use the tension between what you tell and what you don't tell as part of the work. What is given *and* what is withheld become the work. You could say that if you make a statement it eliminates the options; on the other hand if you're a logician, the opposite immediately becomes a possibility. I try to make work that leaves options, or is open-ended in some way.

JS: The tenor of that withholding – actually controlling the content or subject – changed significantly when you stopped performing and began to allow the viewer to participate in some of your works. I'm thinking of the architectural installations, in particular the very narrow corridor pieces. In one of them, the viewer who could deal with walking down such a long claustrophobic passage would approach a video monitor on which were seen disconcerting and usually 'invisible' glimpses of his or her own back.

BN: The first corridor pieces were about having someone else do the performance. But the problem for me was to find a way to restrict the situation so that the performance turned out to be the one I had in mind. In a way, it was about control. I didn't want somebody else's idea of what could be done.

There was a period in American art, in the 1960s, when artists presented parts of works, so that people could arrange them. Bob Morris did some pieces like that, and Oyvind Fahlstrom did those political-coloring-book-like things with magnets that could be rearranged. But it was very hard for me to give up that much control. The problem with that approach is that it turns art into game-playing. In fact, at the time, a number of artists were talking about art as though it were some kind of game you could play. I think I mistrusted that idea.

Of course, there is a kind of logic and structure in art-making that you can see as game-playing. But game-playing doesn't involve any responsibility – any moral responsibility – and I think that being an artist does involve moral responsibility. With a game you just follow the rules. But art is like cheating – it involves inverting the rules or taking the game apart and changing it. In games like football or baseball cheating is allowed to a certain extent. In hockey

called 'moulage.' I found the stuff at some police shop. You know, they used it to cast tire prints and things like that. It's actually a very delicate casting process; you could pick up fingerprints in the dust with it. The moulage is a kind of gel you heat up. Because it's warm when you apply it to a body, it opens up all the pores – it picks up all that, even the hairs. But it sets like five-day-old Jell-O. You have to put plaster or something over the back of it to make it hold its shape. Then I made the wax cast, which became very super-realistic – hyper-realistic. You could see things you don't normally see – or think about – on people's skin.

JS: All your work seems to depend not only on this kind of tactile precision, but also on a kind of incompleteness – a fragmentariness, a sense of becoming. As a result, your pieces accrue all sorts of meaning over time. With *From Hand to Mouth* – completed over twenty years ago – what other meanings have occurred to you?

BN: Well, it's funny you should ask that, because not long ago I read this book in which a character goes to funeral homes or morgues, and uses this moulage stuff on people and makes plaster casts – death masks – for their families. I had no idea that this was a profession. But it turns out that this moulage is a very old, traditional kind of material, and was often used this way. But it just connects up in a strange sort of way with my more recent work, since over the past several years I have been involved with both the idea of death and dying and the idea of masking the figure.

Masks and Games

JS: An early example of masking the figure – your figure, to be precise – was your 1969 film *Art Make-Up*.

BN: That film – which was also later a videotape – has a rather simple story behind it. About twenty years ago – this was in 1966 and 1967 – I was living in San Francisco, and I had access to a lot of film equipment. There were a lot of underground filmmakers there at the time and I knew a bunch of those guys. And since everybody was broke, I could rent pretty good 16 mm equipment for $5 or $6 a day – essentially the cost of gas to bring it over. So I set up this *Art Make-Up* film.

Of course, you put on makeup before you film in the movies. In my case, putting on the makeup became the activity. I started with four colors. I just put one on over the other, so that by the time the last one went on it was almost black. I started with white. Then red on the white, which came out pink; then green on top of that, which came out gray; then something very black on top of that.

One thing which hadn't occurred to me when I was making the film was

the problem. Rather than struggling inside the problem, by stepping outside of it, he showed that it was not possible to do it at all.

Standing outside and looking at how something gets done, or doesn't get done, is really fascinating and curious. If I can manage to get outside of a problem a little bit and watch myself having a hard time, then I can see what I'm going to do – it makes it possible. It works.

JS: A number of early pieces specifically capture what's 'not there.' I'm thinking about the casts of 'invisible spaces': the space between two crates on the floor, for example, or the 'negative' space under a chair.

BN: Casting the space under a chair was the sculptural version of de Kooning's statement: 'When you paint a chair, you should paint the space between the rungs, not the chair itself.' I was thinking like that: about leftovers and negative spaces.

JS: But your idea of negative space is very different from the sculptor's traditional problem of locating an object in space or introducing space into a solid form.

BN: Negative space for me is thinking about the underside and the backside of things. In casting, I always like the parting lines and the seams – things that help to locate the structure of an object, but in the finished sculpture usually get removed. These things help to determine the scale of the work and the weight of the material. Both what's inside and what's outside determine our physical, physiological, and psychological responses – how we look at an object.

JS: The whole idea of the visual puns, works like *Henry Moore Bound to Fail* and *From Hand to Mouth*, complicates this notion of how we look at an object. They are similar to ready-mades. On the one hand, they translate words or phrases into concrete form – in a sense literalizing them. On the other hand, they are essentially linguistic plays, which means abstracting them. I'm curious about the thought process that went into conceiving those works. For instance, how did *From Hand to Mouth* come about?

BN: In that case, the cast was of someone else, not of myself as has generally been assumed – but that doesn't really matter. It was just supposed to be a visual pun, or a picture of a visual pun.

I first made *From Hand to Mouth* as a drawing – actually, there were two or three different drawings – just the idea of drawing 'from hand to mouth.' But I couldn't figure out exactly how to make the drawing. My first idea was to have a hand in the mouth with some kind of connection – a bar, or some kind of mechanical connection. I finally realized that the most straightforward way to present the idea would be to cast that entire section of the body. Since I couldn't cast myself, I used my wife as the model.

I worked with the most accurate casting material I could find, something

back to that time, a chair Beuys did with a wedge of suet on the seat. I think he may have hung it on the wall. I'm not sure. In any case, it was a chair that was pretending it was a chair – it didn't work. You couldn't sit in it because of that wedge of grease or fat or whatever it was – it filled up the space you would sit in. Also, I'm particularly interested in the idea of hanging a chair on the wall. It was a Shaker idea, you know. They had peg boards that ran around the wall, so they could pick up all the furniture and keep the floors clean. The chairs didn't have to be on the floor to function.

In 1981, when I was making *South American Triangle*, I had been thinking about having something hanging for quite a long time. The *Last Studio Piece*, which was made in the late 1970s when I was still living in Pasadena, was made from parts of two other pieces – plaster semicircles that look like a cloverleaf and a large square – and I finally just stuck them together. I just put one on top of the other and a metal plate in between and hung it all from the ceiling. That was the first time I used a hanging element. I was working at the same time on the 'underground tunnel pieces.' These models for tunnels I imagined floating underground in the dirt. The same ideas and procedures, the same kind of image, whether something was suspended in water, in earth, in air.

JS: *South American Triangle* in a certain sense continues these ideas of game-playing, suspension, inside and outside, and the chair as a stand-in for the figure. In this case though, we're talking about a big steel sculpture hanging from the ceiling, with the chair isolated and suspended upside-down in the middle of the steel barrier. This seems considerably more aggressive than the earlier work, although the content is still covert, an extremely private meditation. But the title hints at its subject matter and begins to explicate its intense emotional and political presence. I'm wondering what your thoughts were when you were making this piece?

BN: When I moved to New Mexico and was in Pecos in 1979, I was thinking about a piece that had to do with political torture. I was reading V. S. Naipaul's stories about South America and Central America, including *The Return of Eva Peron* and especially *The Killings in Trinidad* – that's the one that made the biggest impression on me. Reading the Naipaul clarified things for me and helped me continue. It helped me to name names, to name things. But it didn't help me to make the piece. It didn't help me to figure out how the bolts went on. It just gave me encouragement.

At first, I thought of using a chair that would somehow become the figure: torturing a chair and hanging it up or strapping it down, something like that. And then torture has to take place in a room (or at least I was thinking in terms of it taking place in a room), but I couldn't figure out how to build a room and how to put the chair in it. Well, I'd made a number of works that had to do with triangles, like rooms in different shapes. I find triangles really uncomfortable,

disconcerting kinds of spaces. There is no comfortable place to stay inside them or outside them. It's not like a circle or square that gives you security.

So, in the end, for *South American Triangle*, I decided that I would just suspend the chair and then hang a triangle around it. My original idea was that the chair would swing and bang into the sides of the triangle and make lots of noise. But then when I built it so that the chair hung low enough to swing into the triangle, it was too low. It didn't look right, so I ended up raising it. The triangle became a barrier to approaching the chair from the outside.

Again, it becomes something you can't get to. There is a lot of anger generated when there are things you can't get to. That's part of the content of the work – and also the genesis of the piece. Anger and frustration are two very strong feelings of motivation for me. They get me into the studio, get me to do the work.

JS: That sense of frustration and anger also becomes the viewer's problem in approaching and making sense of your work, especially a piece as disturbing as *South American Triangle*. One critic, Robert Storr, said recently, 'Unlike settling into the reassuring "armchair" of Matisse's painting, to take one's seat in Nauman's art is to risk falling on one's head.'

BN: I know there are artists who function in relation to beauty – who try to make beautiful things. They are moved by beautiful things and they see that as their role: to provide or make beautiful things for other people. I don't work that way. Part of it has to do with an idea of beauty. Sunsets, flowers, landscapes: these kinds of things don't move me to do anything. I just want to leave them alone. My work comes out of being frustrated about the human condition. And about how people refuse to understand other people. And about how people can be cruel to each other. It's not that I think I can change that, but it's just such a frustrating part of human history.

Recent Videos

JS: Recently, you've returned to video for the first time since the late 1960s. In *Violent Incident*, 1986, you not only moved from 'silents' to 'talkies,' but you also used actors for the first time. Nevertheless, the video seems to pick right up on issues you've explored from the beginning. The chair is a central element in the action and the whole tape centers on a cruel joke. Again there is this persistent tension between humor and cruelty.

BN: *Violent Incident* begins with what is supposed to be a joke – but it's a mean joke. A chair is pulled out from under someone who is starting to sit down. It intentionally embarrasses someone and triggers the action. But let me describe how it got into its present form. I started with a scenario, a sequence of events which was this: two people come to a table that's set for dinner with

plates, cocktails, flowers. The man holds the woman's chair for her as she sits down. But as she sits down he pulls the chair out from under her and she falls on the floor. He turns around to pick up the chair, and as he bends over, she's standing up, and she gooses him. He turns around and yells at her – calls her names. She grabs the cocktail glass and throws the drink in his face. He slaps her, she knees him in the groin, and, as he's doubling over, he grabs a knife from the table. They struggle and both of them end up on the floor.

Now this action takes all of about eighteen seconds. But then it's repeated three more times: the man and woman exchange roles, then the scene is played by two men and then by two women. The images are aggressive, the characters are physically aggressive, the language is abusive. The scripting, having the characters act out these roles and the repetition all build on that aggressive tension.

JS: Sound is a medium you've explored since your earliest studio per-formances, films, and audiotapes. The hostile overlayering of angry noises con-tributes enormously to the tension of *Violent Incident*.

BN: It's similar with the neon pieces that have transformers, buzzing and clicking and what not; in some places I've installed them, people are disturbed by these sounds. They want them to be completely quiet. There is an immediacy and an intrusiveness about sound that you can't avoid.

So with *Violent Incident*, which is shown on twelve monitors at the same time, the sound works differently for each installation. At one museum, when it was in the middle of the show, you heard the sound before you actually got to the piece. And the sound followed you around after you left it. It's kind of funny the way *Violent Incident* was installed at the Whitechapel. Because it was in a separate room, the sound was baffled; you only got the higher tones. So the main thing you heard throughout the museum was 'Asshole.'

JS: That's sort of the subliminal version of a very aggressive sound piece you used to install invisibly in empty rooms, isn't it?

BN: You mean the piece that said, 'Get out of the room, get out of my mind'? That piece is still amazingly powerful to me. It's really stuck in my mind. And it's really a frightening piece. I haven't heard it for a few years, but the last time I did I was impressed with how strong it was. And I think that it is one of those pieces that I can go back to. I don't know where it came from or how I managed to do it because it's so simple and straightforward.

JS: How did that come about?

BN: Well, I had made a tape of sounds in the studio. And the tape says over and over again, 'Get out of the room, get out of my mind.' I said it a lot of different ways: I changed my voice and distorted it. I yelled it and growled it and grunted it. Then, the piece was installed with the speakers built into the walls, so that when you went into this small room – 10 feet square or something

– you could hear the sound, but there was no one there. You couldn't see where the sound was coming from. Other times, we just stuck the speakers in the corners of the room and played the tape – like when the walls were too hard to build into. But it seemed to work about as well either way. Either way it was a very powerful piece. It's like a print I did that says, 'Pay attention motherfuckers' (1973). You know, it's so angry it scares people.

JS: Your most recent videotapes feature clowns. I can see a connection to the *Art Make-Up* film we talked about, but why did you use such theatrical clowns?

BN: I got interested in the idea of the clown first of all because there is a mask, and it becomes an abstracted idea of a person. It's not anyone in particular, see, it's just an idea of a person. And for this reason, because clowns are abstract in some sense, they become very disconcerting. You, I, one, we can't make contact with them. It's hard to make any contact with an idea or an abstraction. Also, when you think about vaudeville clowns or circus clowns, there is a lot of cruelty and meanness. You couldn't get away with that without makeup. People wouldn't put up with it, it's too mean. But in the circus it's okay, it's still funny. Then, there's the history of the unhappy clown: they're anonymous, they lead secret lives. There is a fairly high suicide rate among clowns. Did you know that?

JS: No, I didn't. But it seems that rather than alluding to this melancholic or tragic side of the clown persona the video emphasizes the different types of masks, the historically specific genres of clowns or clown costumes.

BN: With the clown videotape, there are four different clown costumes: one of them is the Emmett Kelly dumb clown; one is the old French Baroque clown (I guess it's French); one is a sort of traditional polka-dot, red-haired, oversized-shoe clown; and one is a jester. The jester and the Baroque type are the oldest, but they are pretty recognizable types. They were picked because they have a historical reference, but they are still anonymous. They become masks, they don't become individuals. They don't become anyone you know, they become clowns.

JS: In your tape *Clown Torture*, 1987, the clowns don't act like clowns. For one thing, they're not mute. You have the clowns tell stories. Or, I should say, each of the clowns repeats the same story.

BN: Each clown has to tell a story while supporting himself on one leg with the other leg crossed, in such a way that it looks like he is imitating sitting down. So there is the physical tension of watching someone balance while trying to do something else – in this case, tell a story. The takes vary because at some point the clown gets tired and falls over. Then I would stop the tape. Each of the four clowns starts from the beginning, tells the story about fifteen times or so, falls over and then the next clown starts.

This circular kind of story, for me, goes back to Warhol films that really have no beginning or end. You could walk in at any time, leave, come back again, and the figure was still asleep, or whatever. The circularity is also a lot like La Monte Young's idea about music. The music is always going on. You just happen to come in at the part he's playing that day. It's a way of structuring something so that you don't have to make a story.

JS: What's the story the clowns tell?

BN: 'It was a dark and stormy night. Three men were sitting around a campfire. One of the men said, "Tell us a story, Jack." And Jack said, "It was a dark and stormy night. Three men were sitting around a camp-fire. One of the men said, 'Tell us a story, Jack.' And Jack said, 'It was a dark and stormy night...'.".' '

1 Works Progress Administration.

60　Louise Bourgeois

'The Passion for Sculpture: a Conversation with Alain Kirili'
1989

The thoughts that Louise Bourgeois (b. 1911) had on art early in her career are to be found in letters, diaries and autobiographical notes. In keeping with this, many of her later writings have a direct autobiographical address – offering personal accounts of her memories and experiences, as much as readings of her works – and this interview with the artist Alain Kirili is no exception. In this text, however, Bourgeois talks explicitly in conversation about her passion for sculpture. She discusses why she has made it, the poetry and pragmatics of the materials she has used, colour symbolism, titles, sculptural composition and the physical activity of making sculpture as well as both the challenges and calm it can sometimes bring. Towards the end of this interview, Bourgeois discusses the 'redemptive quality' of working on resistant materials, stating: 'one has the right to be aggressive, one has the right to cut everything and break everything, and to do it for something useful, for something beautiful.'

The interview focuses on the wooden sculpture she made in the late 1940s, some of which was shown in her second solo exhibition at the Peridot Gallery in New York in 1950. The sculptor herself values this 1989 interview, as she makes clear at its end, because it provided an opportunity to discuss 'this period and about the origins of the figures in wood, which are completely autobiographical and French in origin, and about my concerns with France'. 'Homesickness', she states, was at the germinative heart of this early 'family' of work – the sculptures serving as comforting physical compensations for feelings of loss and abandonment. Such personal motivations not only co-ordinate her deployment of titles and attitude to colour ('Painting doesn't exist for me,' she states), but are also reflected in her choice of wood as a material. Wood is a vulnerable material which is soft, perishable and not suitable for outdoor display. The poetics of softness in sculpture as described by David Sylvester and Claes Oldenburg, in their texts in this volume, is here given an autobiographical twist. The stiffness and rigidity of her sculpture, Bourgeois states, is redolent of personal fear, while the softness that followed carried for her rather different associations with familial love and support. Personal meaning coincides knowingly with broader cultural meaning in this 1989 interview, as Bourgeois and Kirili develop a discussion of her work that moves subtly between psychology and the history of sculpture.

Louise Bourgeois, 'The Passion for Sculpture: a Conversation with Alain Kirili', *Arts*, vol. 63, no. 7, March 1989, pp. 68–75. Reprinted in Hans-Ulrich Obrist and Marie-Laure Bernadac (eds), *Louise Bourgeois, Destruction of the Father, Reconstruction of the Father: Writings and Interviews 1923–1997*, London: Violette Editions, 1998, pp. 176–85.

Alain Kirili: Your work always has a very powerful sexual charge. Could you recall the great shock in adolescence that was determinant in your work?

Louise Bourgeois: I think that I can only speak about a particular work. Since we have here the 1949 and 1950 invitations from the Peridot Gallery, I can tell you my story, but only in terms of the examination of a work. The 1949 exhibition was brought about by Arthur Drexler, who at that time was a poet, and who subsequently became the historian of architecture at MoMA. I recall the name of Arthur Drexler with gratitude, for he was the first to discover me. He came to my house, viewed all of the works, and, as Peridot's advisor, said, 'We're going to show all of this.' Now obviously I was French. I belonged to a certain milieu. Pierre Matisse and Duchamp came by and said, 'This is extra-ordinary!" I told them that it was simply a manifestation of 'homesickness.' They looked at each other and understood, that's all there was to it. And it's written on the invitations, you see: one is in French and the other in English. This represents a progression from 1949 to 1950, a progression in my ability to adapt myself to some degree.

AK: *Figure qui apporte du pain [Figure Who Brings Bread], Figure regardant une maison [Figure Gazing at a House], Figures qui supportent un linteau [Figures Holding Up a Beam]. Figure qui s'appuie contre une porte [Figure Leaning Against a Door]. Figure qui entre dans une pièce [Figure Who Enters a Room]. Statue pour une maison vide [Statue for an Empty House]. Deux figures qui portent un objet [Two Figures Carrying an Object]. Une femme gravit les marches d'un jardin [A Woman Mounting the Steps of a Garden]. Figures qui attendent [Figures Waiting]. Figures qui se parlent sans se voir [Figures Who Talk to Each Other without Seeing Each Other]. Figure endormie [Figure Asleep]. Figure pour une niche [Figure for a Niche]. Figure quittant sa maison [Figure Leaving Its House]. Figure de plein vent [Figure in the Wind]. Figure emportant sa maison [Figure Carrying Away Its House].*

LB: And thus the titles indicate exactly what I meant. There's no mystery at all!

AK: I'm merely reciting them.

LB: But there is a great intensity and very great personal emotion. This is apparent in the constant repetition of the word 'figure,' which expresses the fact that I had left my entire family in Europe. At bottom, I wasn't ashamed, but I was sick at having abandoned them because I was the only one to leave. I married an American student and left along with him. Thus my entire family remained in France and the homesickness was doubled by a sense of abandonment. I felt I had abandoned them.

AK: I wanted to ask you…

LB: Be careful what you mean to say! What were you asking?

AK: In crossing the Atlantic, did you perceive this situation that I feel: the puritanism of a society, another society?

LB: No, coming from a promiscuous milieu I found all that very admirable. I have nothing against puritans because I had escaped from a French promiscuity, and thus puritanism did not make me suffer.

AK: For me it had a repressive effect. Turning to the sculptures of 1947, can you tell me why you painted these white?

LB: For the sculptures that were shown in 1949 and 1950, that means that they were made during the five preceding years. White is something immaculate. They are absolutely pure. And the common characteristic of all these pieces is that they terminate in a point that expresses the fragility of verticality, and that represents a superhuman effort to hold oneself up. This is not completely biographical, then, for these are figures of my family. Later there's my brother; but at this point there is no mention of the members of my family. In the second exhibition…

AK: *Woman in the Shape of a Shuttle.*

LB: Every word is significant. Coming from Aubusson, where my mother's family were tapestry-merchants, the shuttle was the tool of my grandfather's milieu.

AK: *Ship Figure. Friendly Evidence. New York City Doorway with Pillars. Attenti Pillars. Rear Façade. Tomb of a Young Person.*

LB: *Tomb of a Young Person* expresses a fear, a kind of protective exorcism for the health of my children.

AK: *Letter to a Brother.*

LB: Yes, my brother Pierre.

AK: *Persistent Antagonism.*

LB: Antagonisms because I was isolated from my entire family; suffered from it.

AK: *Woman Carrying Packages.*

LB: A woman who carries packages is responsible for what she carries and they are very fragile, and she is totally responsible. Yes, it is a fear of not being a good mother.

AK: *Portrait of C Y.*

LB: That was a terrific fight I had with a member of the Surrealist group. Well, I had a lot of terrible fights, this was nothing new. But this one I exorcised, I got rid of by making a statue, putting a name on this statue.

AK: Did you encounter Alberto Giacometti at the time of his 1948 and 1950 exhibitions at Pierre Matisse in New York?

LB: Alberto Giacometti I remember. He was difficult. I don't mean to say that he confided in me, but I knew him well. He was afraid to come out, to come out of the kitchen, at Pierre Matisse's. He was afraid to go to bed, and therefore

spent the entire night with his head in his arms. Fear is a phenomenon that interests me immensely. He was numb with fear, he couldn't speak, and Pierre Matisse was an outgoing fellow who was married to Pat at that time. Everyone treated him kindly, but he was like a lost child.

AK: But his sculptures had surprised many artists in New York.

LB: I don't remember those exhibitions. But I do remember him. And in France he was completely different. In France he was incredibly nasty [*méchant comme un rat*]. Here he was numb with fear, but in France he wasn't terrified at all. He sat in the front row at Deux Magots. I was born above the Café de Flore; that is, I was born at 174 Boulevard Saint Germain, the building in which the Café de Flore is situated. He sat there with a Japanese man, and he hated his colleagues.

AK: *Captain's Walk on the Irving Place Building.*

LB: Yes, that's a reference to the house in which we were living on 18th Street.

AK: Here is a fine title: '*Blind Vigils*'.

LB: It's ironic. These titles are informative about my entire oeuvre. *Blind Vigils* is like *Blind Leading the Blind*. Blindness came from the blush I experienced at the side of the people around me, everybody. As I say, my father was promiscuous. I had to be blind to the mistress who lived with us. I had to be blind to the pain of my mother. I had to be blind to the fact I was a little bit sadistic with my brother. I was blind to the fact that my sister slept with the man across the street. I had an absolute revulsion of everybody – everything and everybody. Mostly for erotic reasons, sexual reasons. So when I met this American student who was a puritan, I thought it was wonderful. And I married that guy.

AK: Therefore you were willing to marry a puritan in order to escape this overload of sexual promiscuity.

LB: Consequently I liked puritans. I still like them. In fact I find puritans very sexy, because they're a challenge. This is quite important in that there was the great puritan of this period, Alfred Barr. And the fact that I had a crush on Alfred Barr – it is a fact, you know. The fact was, he was absolutely inviolable. He was not a puritan, he was repressed. He had a repressed sexuality, and this is what attracted me; as a challenge.

AK: You like challenges; you find them stimulating.

LB: Absolutely. How can a fortress of this order be conquered?

AK: Bravo, Louise! Excellent! Now a few words on the difference between the Pillars, between the ones that are monoliths from a single piece of wood, and those that rise in a pile. The play between the two.

LB: The play between the two: first of all, the monoliths are absolutely stiff – the stiffness of someone who's afraid. The way one can say, 'He's scared stiff.' Immobilized with fear. Stuck. This was an entire period. And then suddenly

there's a kind of softening that came from the softness of my children and of my husband; that changed me a little. I got the nerve to look around me, to let go [*m'adoucir*]. Not to be so nervous. Not to be so tense. The pilings make it possible to turn around. And consequently it's the fundamental concept of the statue. The *Blind Vigils*: these are handicapped persons because they're supposed to protect you and they're blind. They're good-for-nothings because they're feminine; and this theme, which is psychological, is figuratively repeated in the sculpture *Blind Leading the Blind*.

AK: That's an extraordinary sculpture. I noticed recently at the Pat Hearn Gallery that *Blind Leading the Blind* exists in a color that's almost flesh pink; I had known the sculpture before, but only in red and black. The first time I saw it was in the exhibition at the Whitney Museum in 1976, 'Two Hundred Years of American Sculpture'.

LB: There it was entirely black.

AK: Yes, there's also an entirely black version.

LB: It was born entirely black, because it's a dramatic subject.

AK: There are three versions, then: black, red-black, and flesh pink. Can you give me the chromatic symbolism of the transition between these three sculptures?

LB: It's a psychological evolution.

AK: You told me that it was an evolution that went from a dramatic situation to something softer.

LB: The tragic aspect of that period, and of the homesickness. It's the tragic aspect of a person you miss. It's the tragic aspect of mourning, in other words of people one has lost. The fact that I lost them because they stayed in France, or the fact that I lost them because they died is not the important thing. It was an immense mourning. It's the black of mourning. So someone can say to me: what are you talking about, no one died in your family. And it's true. No one died, it's just that they were missing in my unconscious.

AK: Are the wood pieces found or carved?

LB: At that time, the wood sculptures were not found objects. I still like fine material. But today I have a certain affection for found materials. In that period these materials came from the makers of water towers for high buildings in New York. The water towers which sit on the top of the buildings were made of a special wood, were made of redwood of California.

AK: So there was an attack directly into the wood, which is very important, and the holes pierced through the monoliths?

LB: I made the holes myself, with razor blades.

AK: There are also drawings on some of the monoliths.

LB: Yes, that's quite important.

AK: Similar to the ones on paper. What is the significance or the role of the

drawings on the sculptures?

LB: They're openings; very often they're openings, and very often they're embeddings, attached pieces, or one element fixed in the other.

AK: I was referring to the drawings that are painted on the white surface.

LB: Yes, that means they have to be carved out.

AK: Ah yes, excellent. And certain of the wood pieces were also transferred to bronze, such as *Pregnant Woman*.

LB: Oh, that was done thirty-five years afterwards!

AK: Thirty-five years later; then, you wanted a version in bronze.

LB: I'm not the one who wanted it. These things existed for thirty years without being exhibited, because I have no need to exhibit. It is not a necessity for me. I need to make things, but I have no need to show them.

AK: But you were in agreement with the casting in bronze?

LB: Yes, I agreed, but it wasn't my initiative, any more than the exhibition of drawings that took place at Robert Miller. I have nothing against it. They're drawings that date from that time. I have nothing against it, but it's not the result of my own efforts. I myself wouldn't have shown them. But Robert Miller; so diplomatic, he does what he wants and then tells me about it. I myself am a woman with no secrets; but I would never have shown these drawings. That for thirty years they stayed in boxes, in storage, proves it.

AK: The sculpture *Mending Dawn* is a very fine piling. Were those squares, these wooden cubes, found?

LB: Yes, they were found and almost all of them are in redwood because in the neighborhood where I was living there were many carpenters making those tanks for the water towers. The wood was marvelous because it had beautiful grain and because I could cut it.

AK: Let's move forward a few years, thanks to the beautiful photograph of your 1964 exhibition at the Stable Gallery, which is reproduced in the Museum of Modern Art catalog (Wye, 1982) of your work. I am also very interested in these curves that are the opposite of the *Pillars*.

LB: Wood is less satisfactory because it's perishable and all of the statues were breaking, deteriorating. For this reason I moved from wood to plaster.

AK: And these works in plaster reveal forms that spiral. What is the importance of spirals for you?

LB: The spiral is the beginning of movement in space. As opposed to the rigidity of the monolith, the subject is exploring space.

AK: This is why you call one of them *Homage to Bernini*. And then there is *Spiral Summer, Rondo for L.* In the introduction to the Museum of Modern Art catalog, I read: 'When you experience pain you can withdraw and protect yourself but the security of the lair can also be a trap.' What is this 'lair'?

LB: It's when a rabbit takes shelter in his refuge. Therefore a refuge can also,

in a certain sense, be a trap. Yes, of course, it's the bipolarity of what's a trap and what's a refuge.

AK: In certain of your sculptures there are explicitly sexual forms, for example in *Fillette [Little Girl]*, which includes both masculine and feminine elements.

LB: Mapplethorpe took a photograph of that sculpture, *Fillette*, in which I'm holding it in my arms. Which means simply that from a sexual point of view I consider the masculine attributes to be extremely delicate; they're objects that the woman, thus myself, must protect. It's a very, very strong thing, because I was considering the masculine genital parts as attributes that I have to protect. Perhaps this is childish; you're asking me what I think but this is the origin of the word *Fillette*. The word 'fillette' is an extremely delicate thing that needs to be protected. And to displace these attributes onto something that is dear to me in fact, the attributes of my husband. It's very complicated.

AK: Very profound!

LB: Very profound. People won't necessarily understand.

AK: At some point this touches on the truth of sculpture.

LB: But it's the opposite of aggression. It's a polarity between the tenderness that I express and the violence that is inside me.

AK: I understand you very well. When I'm working the clay or my terracotta pieces, I express all sorts of violence. I bring out feminine forms latent in the modeling. The verticalities, on the other hand, are more hieratic.

LB: That is to say that we're made of completely contrary elements, opposed elements; and this produces formidable tensions.

AK: Often when I sculpt, the part that I finally free from the unconscious, the part that is repressed for me, is in some sense feminine. Let us talk now about the marble sculpture *Cumul I* of 1969, which is at the Musée national d'art moderne in Paris. When did you begin using marble?

LB: 1967.

AK: You went to Carrara several times, then.

LB: First to Pietrasanta. I don't like Pietrasanta, though, because it's over-touristed, whereas Carrara is much more serious. The transition stems from the fact that the aggressive side of my nature liked the resistance of the stone. Wood is too soft a material, and above all it's perishable and offers no resistance. Whereas the resistance that must be overcome in stone is a stimulation; like the fact that puritans attract me sexually because they're a formidable challenge. It's almost a playing with the impossible.

AK: Ha, ha! I love that. And so marble is calming.

LB: It is a fight to the finish. So it is a challenge.

AK: This is the extraordinary advantage of the art of statuary and of sculpture over painting.

LB: Painting doesn't exist for me.

AK: The resistance of the material allows all sorts of drives to be freed. It's true: when I forge my aluminum and it explodes, I can tell you that I'm very calm when I leave the studio afterward.

LB: It's the physical aspect of sculpture.

AK: Yes, and this marvelous truth of the resistance of materials.

LB: There is a redemptive quality in this. That is, one has the right to be aggressive, one has the right to cut everything and break everything, and to do it for something useful, for something beautiful.

AK: For something sublime. A word on the title *Cumul*.

LB: The title *Cumul* comes from a system of clouds.

AK: Ah yes! A very beautiful drawing goes with it, as well.

LB: It's a system of clouds, and for me it's the study of clouds, of the sky, of the heavens; which is something very positive, very calming, and very verifiable, anticipated, and *reliable*. Consequently it is peace, the peaceful side of things.

AK: There is a certain serenity.

LB: It comes back all the time. In addition, there is a repetition, an endless repetition that is also something very calming.

AK: And Clamart?

LB: Clamart is very important for me because my grandparents and my parents are buried there. It's the family tomb.

AK: And this absolutely magnificent sculpture that makes me think of Brancusi's *Penguins*, which is called *Eye to Eye*. It's at our friend Aggie Guild's, and is a very fine sculpture from 1970. Can you tell me something about its title, *Eye to Eye*?

LB: Yes, it involves elements that relate to each other. In effect, elements that look at each other like little windows in a house.

AK: And this extremely beautiful repetitive series entitled *No March No. 72*, which has all these elements – cylinders of a sort – and cuts that are sometimes oblique.

LB: This work is in the open air, and that is very important. Because the rain cannot harm it.

61 Gareth Jones

'The Object of Sculpture' 1993

'As sculptors, we rarely make solid objects anymore... All in all, we are losing the concept of sculptural object, and perhaps, the identity of sculpture itself', writes Gareth Jones (b. 1941) in this essay. Jones is a sculptor who taught at Central School of Art (1973–87) and St Martin's School of Art in London (1967–87). Since 1987 Jones has been working as Professor of Three Dimensional Design at Rhode Island School of Design, which has placed him in an interesting position to comment on the demise of the concept of the object in sculpture.

For Jones, the art of object making is sculpture's core competence. In order to demonstrate this, he provides a brief, potted history of the shifting treatment of the object in western sculpture from Egyptian and Greek times, up to the late twentieth century. Sculpture's changing relationship with architecture is addressed throughout this account, because for Jones it is towards architecture that sculpture has finally transferred its concerns. It is this close relationship between sculpture and architecture, and his concern that the former is being subsumed by the latter, that drives Jones's essay. His emphasis on the importance of architectonic design and of the architectural organisation of space in twentieth-century sculpture begins with the revolutionary sculpture of Archipenko and Gabo, in which sculpture quickly moves from being 'space surrounded by mass' to an art without mass. Such explorations, for Jones, have gone too far today: 'much contemporary public sculpture is not complementary to architecture; it is now consistent with it'. This situation is also echoed for Jones in contemporary 'installation art' where context and setting have become the work itself and what objects are used are lost to a pictorial envisaging of the staged ensemble as a whole. If such manifestations highlight the need for an art of sculptural objects, then contemporary 'light' and 'sound' art (and 'artists such as Robert Irwin, Larry Bell, James Turrell, Doug Wheeler and Hap Tivey') makes this need especially pressing, he states. Such work only goes to show 'what three-dimensional art without objects entails and, ironically, demonstrated the need for objects'. The need for sculptural objects is never ending for Jones because human beings will always have a body-orientated response to sculpture. Jones's uncertainty over contemporary forms of sculptural practice and his anxiety about the demise of object-based sculpture was reflective of a much wider unease across the 1990s. What Jones ultimately envisages is not a cancelling out of one kind of sculpture by another, rather a broader cultural co-existence between different attitudes towards sculpture making.

Gareth Jones, 'The Object of Sculpture', *Sculpture*, September–October 1993, pp. 30–35.

Our understanding of the world is increasingly provided by science, but science places little value on objects. The products of science are theoretical: if objects are produced at all, they serve merely to illustrate theory or demonstrate proof. Science, therefore, conditions us to a system of knowledge without objects. On the other hand, the goal of art, especially sculpture, is to synthesize knowledge into objects. But as sculptors, we rarely make solid objects anymore.

Our knowledge of the three-dimensional world derives from the two major disciplines, sculpture and architecture. While sculpture and architecture are complementary fields, they evolved from two distinct physical aspects: mass and space respectively. In the 20th century, sculpture has gradually shifted toward architecture, and most objects have become architectonic. As a consequence, our ideas have become unbalanced. We now relate three-dimensional concepts only to space.

As a result of this shift toward architecture, many of the original sculptural concepts of three dimensions are being lost. Some concepts, like solidity and tactility, have been lost altogether. Instead we substitute: space for mass; cubic for spherical; line for axis; rigidity for plasticity; juxtaposition for transition; concavity for convexity; plane for surface; structure for form; distance for depth; and circumambience for viewpoint. All in all, we are losing the concept of sculptural object, and perhaps, the identity of sculpture itself.

Webster's Dictionary states that an object is 'a discrete, visible or tangible thing.' Moreover, it defines discrete as 'detached, separate, non-continuous,' and tangible as 'capable of being touched, able to be perceived as materially existent.' These criteria are readily attached to sculpture except in recent times. The definition of object is more problematic when applied to architecture. Architecture is mainly concerned with enclosure and the organization of space, and space is not discrete, visible or tangible. Architecture, therefore, is a hybrid art form; part object, part environment. This, as we shall see, will eventually have an important effect on sculpture.

Historically, sculpture was part of the overall conception of any building, mediating space and creating gradations of scale and metaphors of human presence. Architecture provided a meaningful and spatial context for sculpture. From Pharaonic Egypt until this century, sculpture has been wholly concerned with representational imagery. The human figure dominates this imagery, though not exclusively. Notwithstanding occasional representational images, architecture was founded on geometry and number. From the beginning, these three-dimensional disciplines expressed two imaginary orders, representation and abstraction. Initially, however, there was only one morphological order. In Egypt, the form of freestanding stone sculpture was *cubic*, and though there were no planes in the sculpture, there were definite facets. This cubic form had two purposes. First, it was a 'memory' of the original stone block from which

the sculptor had removed as little as possible. Second, it formally related sculpture to the rectangular planes and cubic spaces of architecture.

In the 2,500 years from the Third Dynasty until the Ptolemaic period, there was no space in stone sculpture. The mass in these sculptures is total, and even the actual spaces formed by the arms and legs was left solid. This was no defect of Egyptian sculpture. The emphasis on mass in the beginning and for so long should signal that mass is the fundamental element of sculpture.

The nature of the sculptural object began to change in the High Archaic period in Greece, when space was introduced into stone sculpture for the first time. In the Classical and Hellenistic periods, forms lost their faceted appearance. This combination of physical and formal difference radically altered the sculptural object and essentially gave sculpture a second beginning. The use of space 'opened' the object, lessening its physical presence and relating it to its surroundings. The original opacity of sculpture was rendered partially transparent, and what was behind the sculpture was visible by looking *through* it.

The figure in Egyptian sculpture expressed stance, but in Greek sculpture the pose was unlocked, and a whole range of human movements were expressed, especially in the Hellenistic era. This was, perhaps, inevitable. Since space permits actual motion, in sculpture it encouraged the appearance of motion. It also brought the figure 'to life.' The presence of implied motion renders an object transitory, lessening its physical presence and threatening its objecthood. Greek sculpture courted a danger of reducing the object to a state of motion, an unfinished action. But the problem was solved by arresting motion with *balance*. So the static objects of Egypt were replaced by the tensile objects of Greece.

Greek sculpture, though idealized, is more organic than Egyptian sculpture, reflecting the inner structure and tensions of the human body and giving the form's surface a taut, dynamic appearance. This innovative concept of an internal order created an empathy for the object in the viewer. Moreover, it created a new geometrical underpinning for sculpture. In contrast to the elemental cubic form of Egyptian sculpture, any section of a Classical or Hellenistic sculpture produces a circle of variable radius, and the forms themselves have a curved volume. Therefore, the elemental form of Greek sculpture is *spherical*.

A cube has no essential internal structure. Its structure is contained in its surfaces; more specifically, in the junctions where these surfaces meet, at the edges or corners. A sphere, on the other hand, has no external structure. Its structure is latent, emanating from an internal center point. This morphological difference is also the key to implied motion. A cube is a stable form, but a sphere is the embodiment of motion. Space and motion usher time and musicality into sculpture, a corollary to be discussed later.

Two morphological orders of sculpture have emerged, cubic and spherical – but the human figure continues as the primary image. As long as it remained figurative (until the 20th century), sculpture was based on Greek principles of mass and space: implied motion, balance, internal structure and spherical form. There is one exception, the Gothic era. Cathedral sculptures express many of the properties of Egyptian sculpture, as they are solid, monolithic and static; they are not, however, cubic. The elemental form of Gothic sculpture is the cylinder, combining the circularity of the sphere and the parallelism of the cube. But aside from this period, the sculptural object remained remarkably consistent for 2,500 years.

Space, in Greek antiquity, was conceived as empty. Objects could be placed anywhere, displacing space like a body entering a bath displaces water. Space was thought to be continuous, confirmed by Archimedes's axiom that the shortest distance between two points is a straight line. Around 300 B.C. Euclid devised a comprehensive system of geometry, which, in many ways, has never been surpassed. In his 13 books titled *The Element*, Euclid propounded theories based on the plane, and though he did not invent the concept of plane, he established it as a primary element in our thinking.

In the Roman era, the invention of the arch fundamentally changed the structure of architecture. The trabeated structure of Egyptian and Greek architecture is essentially a *tactile* phenomenon. There is a physical quality, a sense of mass and weight in the placement of a beam on top of a post. This tactility is reflected in the geometry of Euclid and its emphasis on congruence, the fitting of one form over another. However, building an arch is an act of projection. The object is suspended in midair until it is locked into place with a keystone. The arch is an *optical* phenomenon. In the Gothic era, the load of the roof was carried mostly by flying buttresses, permitting the walls to be penetrated by windows and thus opening cathedrals to light and space.

The 15th century was a time of great change and, because of the paucity of painted remains of the Roman Empire, the early Renaissance evolved from evidence of sculpture, especially relief sculpture, and architecture. Donatello and Brunelleschi played pivotal roles in evolving new ideas, which of course included perspective. But it was another architect, Leon Battista Alberti, who projected Euclid's plane, tactile geometry and transformed it into an optical illusion. In his book, *On Painting* (1435), Alberti describes, for the first time, rules for rendering a three-dimensional image on a two-dimensional plane. Perspective is a system of ordering space with geometry and is, therefore, perfectly suited to architecture. In perspective, objects are not important in the sculptural sense; that is, in themselves. Their main value lies in their locations and how they relate to each other; in other words, how they contribute to the representation of space.

It cannot be denied, however, that Donatello's relief sculpture, employing perspectival systems, transformed the concept of surface from an outward extension of a three-dimensional object into the illusion of three dimensions. The radical implications of this evolution for sculpture cannot be overstated. There were no immediate effects on freestanding objects, but painting and public perception were profoundly affected. In any case, the absolute proportions related by Polyclitus in the *Kanon* (5 B.C.) were now challenged by a new proportionality based on viewpoint. The full implications of perspective, illusion, was most fully expressed in the Baroque and Rococo periods, where the fabric on the interior walls of churches dissolved into a dazzling illusion of three dimensions. In hindsight, it is easy to see the impetus for the growth and popularity of surface illusion in the New Baroque, the 20th century.

In the late 18th and early 19th centuries, culture shifted away from the Mediterranean toward Northern Europe. The Neoclassical style and its antidote, Romanticism, were particularly important in France; but sculpturally, both styles were regressive. As if by design, music rose to a primary mode of cultural expression. Between 1750 and 1850, music can boast of Bach, Haydn, Mozart and Beethoven. There were also great architects: Adam, Soane, Schinkel, Boulee, Ledoux. In contrast, sculpture is represented by no great names, perhaps with the exception of Canova.

The principles of sculpture are not diametrically opposed to music, but they are incompatible. Adrian Stokes argues:

Music is the enemy of sculpture and architecture because it encourages their perception in rhythmic and temporal terms. It robs them of their synthetic energy and encourages analytical thoughts, it robs them of their spontaneity, immediacy and encourages temporality.[1]

Stokes is wrong to include architecture in this context. History shows that the relationship between music and architecture was complementary. Architecture creates space and music fills it. However, sound and sculptural mass compete for the occupation of space. The value of mass in sculpture is that it pushes out music as it displaces space.

During the 18th century, a development occurred that would also have a profound impact on sculpture. In 1779, Darby built the first iron bridge at Coalbrookdale, England. This structure has come to symbolize the start of the Industrial Revolution, but it also signals a revolution in three-dimensional objects and ideas. Iron's strength-for-weight ratio was exceptional, and engineers came to the forefront in the use of this new material. The functional, innovative approach of engineering changed the nature and aesthetic of architecture and indirectly, of sculpture.

In architecture, the use of iron greatly reduced the load-bearing mass of the walls, making them increasingly planar. The increase in number and size of windows further opened up the walls. In sculpture, the reduction of these opaque surfaces meant fewer locations in architecture suitable for sculpture. The sculptor was replaced by the engineer as complementary professional to the architect. The burgeoning of mass-produced building materials usurped the role of finely crafted individual objects. There was the rise of a new architectural patron, a largely uncultured bourgeois who was more interested in decoration, and thus the value of 'sculpture' was demoted.

In the latter half of the 19th century, Auguste Rodin virtually single-handedly restored the status of sculpture. Rodin was primarily a modeler. Much can be written about the differences between carving and modeling. Most importantly, the original state of the material influences the final state of the object. The carver begins with mass, and the resulting object reflects its origins. The modeler starts with space, and there is a tendency to exploit spatiality in the final object. Whereas Rodin's sculpture often asserts massiveness, it explores space in many ways: by grouping figures and enclosing space, by projecting limbs in forced gesture, and by dramatic depiction of motion.

In architecture, the ferro-concrete 'slab' not only established the plane as a new structural element, it evolved into a new aesthetic of building. Gradually, architecture changed, and the traditional context of sculpture was eliminated. The establishment of the Bauhaus in 1919 and the emergence of the International Style eventually moved architecture away from sculpture and mass, toward the organization of space with planes.

Alexander Archipenko is quoted as saying in 1912, 'Sculpture can begin when space is surrounded by mass.' This is a better definition of architecture than of sculpture, but it is indicative of the revolutionary change burgeoning in sculpture. In that year Archipenko modeled *Femme Marchant*, the first sculpture to introduce space into the human image where none existed naturally. In the 'negative form' of the torso, for example, the concept of surface has been radically detached from the mass. It conveys not only the extent of the space but also its *shape*. This innovation is second only to the invention of perspective in changing the concept of surface in sculpture.

In 1915 Naum Gabo made *Constructed Head No. 1* entirely of surfaces: mass-produced sheet materials. It was an extraordinary departure. Gabo had made a sculpture with no mass, and, in a sense, had reached the conclusion of the sculptural object before he began. Until 1915, the surface was arrived at after a long, thoughtful, emotional experience with the sculpture. The surface measured the ability of the sculptor to establish the hairline fracture between mass and space. In Gabo's work, the surface was not earned, it was used. Evolution and resolution were exchanged for placement and arrangement.

This had important ramifications. When sculpture consisted of mass, it had a continuous relationship with the light in which it was made and exhibited. The fullness of mass allowed it to register every nuance of light. The light described every subtlety of the form. Since Gabo's sculpture consists of planes and linear elements, it can only register a fraction of the light of traditional sculpture. It cannot reflect any change of light or form in the large intervals of space between its planes. In fact, the object 'switches' on and off repeatedly. In addition, the planes change direction in an abrupt way, at a corner or an edge, and the experience of light and form is, therefore, precise but limited.

In hindsight, there seems to be an inevitability about Gabo's work. It was as if he decided to build 'context' into sculpture. Since there was no longer a place for sculpture in architecture, by adopting many of its concepts, processes and materials, he inserted architecture into sculpture. Sculpture thus gained independence as an art form, but at the expense of its traditional basis: mass.

The resulting change in the sculptural object was not immediate or general. Brancusi, Arp, Moore and others continued to make important contributions to sculpture in mass and space. The legacy of Gabo took 40 years to manifest. Since the late 1950s, most of the sculptors who have achieved prominence are or were fabricators producing architectonic objects: Calder, Smith, Caro, Judd, Morris and Deacon, to name a few. Most contemporary public sculpture is not complementary to architecture; it is now consistent with it.

In the 1990s with installation art, we can witness a pervasive development in the 'architecturalizing' of sculpture. The boundary marker that ensured sculpture its distinction from the melee was the pedestal. In the 19th century, these were often designed by architects and when, in the 1960s, the pedestal was deliberately removed and sculpture stepped down into the world, it was architecture that again provided the boundary, usually 'the room.'

It is easy to understand that artists would begin to exploit this new relationship between the object and its surroundings; but in installations, the surroundings are everything. If objects are included they are used 'perspectively'; their value lies in how they interrelate, how they contribute to the representation of space. Installations are of little value to sculpture, but enhance architectural ideas. As Roberta Smith has stated,

These days installation art seems to be everybody's favorite medium. Sculptors do it, painters do it, even graduate students in art school do it. Big shows like Documenta and the Carnegie International are overrun with it. It is present in unprecedented quantities in museums, the very places it was supposed to render obsolete.

It's not all bad. The most multimedia of art forms is often at its best in

quirky, highly specific sites or in commercial galleries. And some artists, like Robert Gober, continue to push its perimeters in outstanding fashion, often with the use of carefully handmade objects....Others seem to have confused art with stage design or with movieland special effects.[2]

Artists such as Robert Irwin, Larry Bell, James Turrell, Doug Wheeler and Hap Tivey have ventured even further, many declining to produce physical objects. Irwin has put the key issue succinctly: 'Is not the idea of a non-object art a contradiction in terms? What would this art be made of? Where would it exist? And how would we come to know it, let alone judge it?'[3]

In sculpture, the answer to his first question must be 'yes.' Throughout its 4,500-year history, the object has been the central concept of sculpture and to dismiss it would demonstrate ignorance. The object has changed and evolved physically, formally and imaginatively, and will continue to do so. There will be radical changes that will initially make sculpture unrecognizable, as was the case at the beginning of this century. But 'that stubborn presence' has remained.

Irwin's second and third questions are intrinsically linked. Most of the artists mentioned use a minimum of material, and those used are often transparent or translucent. The goal is clearly an immaterial experience, aspiring to the condition of music. The medium is also dependent on the existing physical conditions of the site. A room might be altered or transformed by changing the lighting and reorganizing the space to affect the perception of the viewer. The position of the viewer is crucial to the answer to the third question. The artwork exists *around* the viewer, like architecture.

The answer to the fourth question is that you have to *search* for the work. An artwork by Irwin, for example, may be so physically subtle that a viewer might not be aware of it at all. There may be a positive side to this. Art that is physically subtle has the potential to affect the viewer subliminally. The viewer comes to know the work subconsciously.

Finally, the thorniest question of all: how do we judge this work? Light and space artists clearly intend the 'audience' to interact with their artwork. In fact, the traditional terms *audience* and *viewer* are inappropriate in this context. *Participant* is a more accurate description.

In order to understand the implications of change a comparison with object-based art is necessary. An art object is causal, creating an effect on the viewer. It would of course be naive to assume that the relationship is only one way. The viewer posesses social, cultural and personal 'causes' which have an effect on how the object is perceived. A dialogue exists, but the object and viewer are distinguished and a balance is established between the viewer's objective and the subjective experience. It is this balance that allows viewers to

evaluate their experiences. As Jan Butterfield remarks, 'The Mondrian was no longer on the wall – instead the viewer was in the Mondrian.'[4] The undifferentiated experience of most 'light and space' art coupled with its often ephemeral existence renders judgment virtually impossible.

Robert Irwin has said that he regards art as an act of inquiry. He has raised questions about context and revealed how crucial it is as an element in art. In his opposition, Irwin has contributed to the debate about the value of objects. He has shown us what three-dimensional art without objects entails and, ironically, demonstrated the need for objects.

This essay has attempted to trace developments in sculpture, from solid object, to solid and spatial object, to planar and spatial object, to light and spatial environments. There are two further developments of the object: the illusory object and the virtual object. We live in a society that devotes most of its attention toward 'surface perception'; that is, visual images projected onto a plane surface. Perhaps this is inevitable because it simplifies perception and makes it more generally accessible. During the last 100 years there have been an extraordinary number of inventions related to surface perception: still photography, film, TV, video and holography. All of these are variations on one machine, the camera.

We still see, but machines are doing much of the looking. The camera selects our focus, edits the visual field and permits us to experience three dimensions vicariously. Most importantly, it reduces the richness and complexity of three dimensions to planar patterns. When perspective was invented in the early 15th century it was thought to assimilate human vision. This misconception is still popularly held. But photography, and more particularly the camera, is the proper recipient of perspectival theory. Painters make use of perspective: photographers cannot avoid it.

Like music, photography has become extremely pervasive. Also, like music, photography competes with sculpture, the former occupying space, the latter offering an alternative, an illusion of mass and space. For many people, an experience of three dimensions, of 'reality' if you like, comes as much from photography as from actual experience, and it is probably true to say that watching TV makes more sense to us now than looking out of the window. Slide lectures, the staple of art education, are occasions where the disembodied forms of sculpture are paraded before students who are conditioned to accept art without objects.

It would be remiss not to also consider the influence of the computer on objects. The most compelling development in computer animation is virtual reality and the concept of *cyberspace*. Cyberspace is a term describing the futuristic idea of connecting the human brain directly to a computer in order to receive unmediated experience. Unmediated experience is experience not only without objects but without perception: in other words, pure thoughts.

This may be science fiction, but it is a highly compelling idea for three reasons. First, there is a genuine reaction against mediated information. Information can be easily distorted if it is mediated: everything from 'doctoring' video tapes to glamorizing war with memorial objects. Second, modern technology, or the marketing of it, has increasingly assumed a hegemony over public behavior. With each new invention we are being led away from solid objects and into cyberspace. Many of our social, cultural, political and economic activities are now conducted electronically.

Third, there seems to be a widespread desire for direct sensations. With an intermediary object, the audience is challenged to perceive, interpret and evaluate. Even then, the challenge might prove difficult and the understanding meager. If one is plugged into the computer, one receives the stimulus with no effort. This is obviously a very seductive idea.

Virtual reality is a step toward cyberspace, but the experience still remains mediated through the eyes and hands. It is different from other computer graphics since it is interactive, and people sense that they are participants in the space they see. But like all computer graphics, virtual reality is a spatial concept. Space is, after all, imperceptible and intangible. It is already 'virtual.' In contrast, the solidity and physical presence of objects resist illusion and present a challenge to the programmer.

While sculpture and architecture share properties that make them real – substance, materiality, weight, tangibility and dimensionality – traditionally, sculpture has been the most real of the three-dimensional arts. Its solidity was an assurance; its position, discrete from ourselves, gave it clarity; and its lack of utility bestowed presence.

If the further properties of architecture are revealed it becomes less real. The concept of architecture is like a Russian doll. Inside architecture is the concept of space; inside space is the concept of illusion; inside illusion is the concept of plane; inside plane is the concept of perspective; and inside perspective is the concept of photography.

The radical adoption of architectonic ideas at the beginning of the 20th century steered sculpture away from realness and into spatial and illusory developments. But just as 'light and space' art confirmed the need for objects by showing us what non-object art entailed, so the computer serves a similar function. There is a theory that in cyberspace we will not need our bodies. If there is any truth in this science fiction, there will also be no need for sculpture expressed in actual objects. But as long as we exist corporeally, actual objects will continue to hold the key to sculpture.

[The text originally included the following photographic illustrations: *Mycerinus (Menkare) and his Queen (Khamerernebti),* Fourth dynasty; Alexander Archipenko, *Femme Marchant*

1912; *Bronze Zeus,* from sea near Artemesium, about 470–460 B.C.; Naum Gabo, *Constructed Head No. 1* (1915); Donatello, *Herod's Feast,* detail: *The Baptist's Head Presented to Herod* (1425–1427); Richard Serra, *One Ton Prop (House of Cards)* 1969.]

1 Adrian Stokes, *The Critical Writings of Adrian Stokes* (London: Thames and Hudson, 1978*).*
2 Roberta Smith, 'In Installation Art, A Bit of a Spoiled Brat,' *New York Times,* 3 January 1993.
3 Robert Irwin, *Being and Circumstance: Notes Toward A Conditional Art* (California: Lapis Press, 1985).
4 Jan Butterfield, *The Art of Light and Space* (New York: Abbeville Modern Art Movements, 1993).

62 Georg Baselitz

'Angels and Gnomes – German Tribal Art' 1994

Georg Baselitz's (b. 1938) totemic *Model for a Sculpture*, as shown at the 1980 Venice Biennale, seemed to announce a new and radical shift in the development of sculpture. It appeared to signal a turn away from post-minimalist abstraction and conceptualism, instead to return, knowingly, to figurative expressionism. 'Angels and Gnomes – German Tribal Art' was written fourteen years later, but was based on the post-modernist re-positionings worked out by Baselitz and others during the 1980s. The essay originally accompanied a Baselitz show at the Anthony d'Offay Gallery in London, where a similarly totemic work, *Frau Paganismus (Mrs Paganism)* (1994), was the centrepiece. *Frau Paganismus* showed an approximation of a human figure in rough-hewn wood with additions of paint marking out (in red) the face and breasts, as though the result of some pagan ritual. Baselitz makes it clear in this essay, however, that his reason for working in this way was not to signal any simple connection to non-western cultures; 'angels have stubbornly failed to catch on in Africa,' he points out. Rather, he is concerned to recover an alternative folk tradition – hence the designation 'German Tribal Art' with its strongly local connotations. 'German tribal art' is not to be historically located in any one period: 'history', Baselitz states, 'moves forward, but also backwards, or not at all'. Also, it is invented, as the artist works 'away into the blue'; it is the product of both remembrance and fantasy. The complex temporality implied by these suggestions seems characteristic of post-modernism, involving the contradiction of modernist beliefs in an ideal future or the rejection of its striving for 'presentness'. By contrast, the angels and gnomes of Baselitz's title acknowledge the significance and inescapability of traditional ideas, and embrace contemporary consumerist perception instead of trying to move 'beyond Kitsch' to a utopian future. Hence the productive banality of Baselitz's observation that angels 'are mostly girls or women' and his description of gnomes as 'pointy-hatted... agents of the counter-world'.

Georg Baselitz, 'Angels and Gnomes – German Tribal Art', in *Frau Paganismus*, Anthony d'Offay Gallery, London, 1994, pp. 11–13. Translated by David Britt.

Looking for parents makes me feel awkward. I never can cope with familiar tradition. It occurs to me that there is an analogy between the angel and the garden gnome – the gnome as a sculpture with a pointed hat and a jolly face, and a sculptured angel as a woman with wings. Angels may be male or sexless, I don't care, as far as I'm concerned they're female.

History moves forwards, but also backwards, or not at all. I think I'll make something out of a remembrance. Or I could call it a fantasy; when I make

sculptures, I just work away into the blue. I move on; perhaps I only turn around. A shot arrow flies away, but it also lands. It doesn't fly like this → but like this ↔. A remembrance does not start anywhere, either yesterday or further back. A sculpture has no beginning; it is not an item for a programme.

One thing is obvious straight away: the gnome is ugly-beautiful, and the angel is beautiful-beautiful. This is always so. The ugliest angel is still beautiful; the most beautiful garden gnome is still ugly. If I suppose that both angel and gnome are supposed to be beautiful, or that the sculptor means them to be beautiful, I have to ask why the gnome is nevertheless ugly. One reason: the angel stands for the celestial, the place where the gods live or dear God lives. It is the messenger. There is something very attractive about emissaries who bring good news. Another reason: artists and sculptors have been idealizing this winged woman, working on her image, for thousands of years. There are some wonderful angels in art history; not just Christian ones but earlier ones too, on vases, in mosaics, as sculptures, right down to modern films. One more reason: angels are mostly girls or women. But the really important thing is that around the Mediterranean there have always been so many artists working on the angel. It's part of the basic repertoire. An incredible quantity of angels have been and are still being made, ever since art left its reserved locale and went out among the people; and this is one connection which angels have with garden gnomes. But the gnome has no privileged status, no place in art history. He comes from the earth, the forest, the mountain, the cave, the lake. He lacks an upwards affiliation. From a Christian viewpoint in particular, he is the counter-world. He is pagan, he stands for the underworld, and he was sacrificed for the Church's sake. The ideology that society has – the Christian ideology – is also its culture, which paints its pictures and makes its sculptures. When this form of community took over, the old images and sculptures vanished; we know they used to exist, because we can still find them buried underground. If we dig north of the Alps we find no women with wings, but we do find something like gnomes. Where the Christians come from, on the other hand, plenty of angels have been found, pre-Christian ones: images of people who lived somewhere up in the sky. This kind of imagery has survived, here as elsewhere. The other has disappeared.

In the same way, we know from photographs that in Africa whole cartloads of sculptures were burnt as idols. Nevertheless, angels have stubbornly failed to catch on in Africa.

There are still gnomes in Romanesque sculpture: they still crop up there – also in good shape – and in the Gothic to some extent, but more as monsters, chimaeras, the horny old goat, the vulgar, unspiritual type.

North of the Alps, the thread was broken. The pagan images disappeared for good, and even the agents of the counter-world acquired wings – though

mostly as winged men. And so, finally, we have the pointy-hatted garden gnome. By rights he ought to be folk-art, but he isn't. Folk-art is only a simpler and more primitive form of art-art, so traditionally it is Christian too. There is just one small exception: carnival masks, which really are fascinatingly beautiful and pagan.

So, I need no angels; and, if I am looking for parents, angels are out. Gnomes make sense, of course, not in the idiotic way they are made – as an elaborate misconception – but as an idea.

63 Max Neuhaus

'Lecture at the University of Miami' 1994

Max Neuhaus (b. 1939) began his career as a percussionist and pioneer of electronic music. He was associated in the 1960s with the composers Pierre Boulez and Karlheinz Stockhausen, and performed in their work. He made his first temporary 'sound installations' in the mid to late 1960s, the best-known of these being *Drive-in Music* (1967). Neuhaus's claim to be considered a sculptor in sound or 'sound designer', however, properly commenced in the late 1970s, with the installation of his first permanent and seemingly monumental sound piece, *Times Square* (1977), a piece that continued until 1992 (restored 2002) and thereby escaped the normal idea of a composition of limited duration. Claims that Neuhaus's works are 'invisible sculpture' or that they belong not to music but to the 'plastic arts' have also been based on the artist's own assertions that 'sound works are not a form of music' – rather they are 'sound continuums which are unchanging' and as such are spatially rather than temporally conceived. Neuhaus has also talked about sound as 'medium' and 'material'. Therefore, although his practice has been developed from a musical rather than a painterly or sculptural starting-point, the ideas and the works themselves relate strongly to sculptural ideas, particularly the emphasis in the 1990s on site specificity.

Neuhaus's 'Lecture at the University of Miami' is one of many talks given to students and faculty at university departments in America. This particular lecture appears in the first of a three-volume book publication, *Sound Works*, edited by Gregory des Jardins: Volume I subtitled *Inscription*; Volume II subtitled *Drawings*, and Volume III subtitled *Place*. The *Sound Works* volumes follow an earlier book of writings, *Elusive Sources and 'Like' Spaces* (1990), and draw on a series of usually bilingual books ritually published by Neuhaus on the occasion of sound installation inaugurations (1983–97).

Max Neuhaus, 'Lecture at the University of Miami: excerpts from talk and question period', in *Sound Works Volume 1: Inscription*, Ruit: Hatje Cantz, 1994, pp. 71–75.

In 1973, the year I discovered the space in Times Square, I also passed through Paris and came across what was for me an amazing space – a tunnel 600 feet long with three moving sidewalks in it. Its ceiling is arched, an unbroken curve which stretches the whole length of that tunnel. It is an unusual space in the way it looks and feels.

I found the space exciting, although many Parisians detest it. It took me a while to figure out why. I believe it was deliberately designed without visual references to make it look shorter than it is – one long space with no

way to establish its scale. Its architect may have thought that, by making it look shorter, people wouldn't mind it so much. In fact, he accomplished the opposite: by making it look shorter than it is, people keep expecting it to end before it does – in effect making it seem endless.

Over the last ten years I have endeavored to do work there, initiating meetings with the people who control that space and talking to them about the concepts of the work. Just this last week I've succeeded in negotiating the first phase of the work.

It will take a year to build and will be permanent. One of the most interesting things about the space for me is that it is a passageway with moving sidewalks running in both directions; 2,000 people, sometimes 3,000 people, pass through it in an hour. It is a space where people are in motion, people's ears are in motion, very much different from Times Square where people can stop, stand, look – here everyone's moving. There is a whole new set of things for me to work with once I know that someone's ears are in motion.

It is also, surprisingly, a very quiet space; few people talk in it. What happens, due to the custom of standing on the right on moving sidewalks, is that people who are together have to line up one behind another, making conversations difficult to the point where most people stop talking.

The Paris Metro has a tradition of street musicians which play throughout its very resonant tunnels. The two ends of this tunnel are favorite places for musicians to set up for several hours and work. The work will act as a transition between two possible sound spaces, as a passage between these two locations.

The process of making a work for me is a gradual one – going into the space, looking at it and learning about it, figuring out its mechanics and its acoustics, and then going in with a system which generates sound and beginning to outline, to illuminate, so to speak, the space with sound. It is very much different from working as a visual artist where you go to a site, look at what is there, photograph it, make drawings about it. One can't see acoustically what happens in the space until you illuminate it, so to speak, by putting sounds in it.

I know that there must be things which I have not been able to make clear. It is hard to know what point of departure to take with any given audience. So I would like to ask you now for any questions about any of the things I talked about, so that we might have a discussion.

Q. Are you concerned with the effect that your sounds have on people? Are you trying to surprise people?

A. I am not trying to create a surprise. I am concerned with affecting them. The works are not conceptual, they are experiential. I deal directly with how people perceive a space through sound. My focus is not on making sound works

which are exhibited to people's ears, but on affecting the way they perceive a space by adjusting or shifting its sound.

Most of us think that what we think about a place is determined by what we see in it. And I think it is for most of us, consciously. But unconsciously there is a perception of a space which deals with how it sounds, what sounds are there, and how sound acts in it and on our sense of sound. We are such a visually oriented society now that we take this perception of space through our ears for granted, it's automatic; but a blind person can 'see' the shape of a room just by walking into it.

Q. Is your style of work identifiable?

A. It is different for each work. We are used to artists having styles; we are used to being able to say that a mature artist is identifiable by what his work looks or sounds like. In my case, because each work grows from the place where I make it, there is no style in that sense.

My idea about making works in public places is about making them accessible to people but not imposing them on people, making them findable for people. The works are usually very subtle, although if we put the sound of the work in Times Square in this room it would be very, very loud, but in its context of the street sounds of Times Square it can be walked through and not noticed.

The threshold of these pieces is a crucial factor. I try to find a point, a common point, where the works are at the threshold of being there and not there, allowing people to find them, not making them so obvious that they are forced to find them.

Q. In the Villa Celle work does it alter the sounds that are presently there?

A. It alters the perception of them but not the sounds themselves. One of my starting premises with each work is the aural nature of the place – the sounds which are already there. In a wooded area, the most consistent sounds are insect sounds, locusts, crickets. They change with time of day and season.

My idea wasn't to make the same sound or to communicate with them, but to make a sound which related to those sounds so that it fit within that context. Not making sound which was a separate thing in that environment, but making a sound so integrated that it shifted and pulled people into hearing the existing sounds in a different way.

Q. When you started, what got you in this direction?

A. I began as a musician. I was a performer of percussion works, works for a solo performer. I did concerts with many large arrays of percussion instruments, a different array for each work. I was working in an area which dealt with sound timbre rather than rhythm and melody. And I began exploring electronics as a way of expanding the timbres I had to work with. It was a natural evolution.

Q. Are there any recordings of your sound works?

A. That is a question that I am surprised didn't come up sooner – I am standing here talking about something which is sound. In fact I don't record the sound installations, and there is a very good reason. They are about creating places. The sound is only a catalyst for a particular place; it is not the work. If one takes the place away, one only has the catalyst left. We think of all sound art as being capturable with the tape recorder. Some of it is, but mine isn't.

Q. Do you always use normal speakers?

A. Rarely. The speaker in the work at the Museum of Modern Art was a very large subsonic horn. Part of the process of making a work is deciding on how I will apply sound to the space. Often I have to invent something.

Q. Could you tell us what you meant when you said there are more things for you to work with when you know people's ears are in motion?

A. Well, my thinking about that piece is still in a sketch phase, thinking about what kinds of things could happen in it with people moving.

One example: it takes some time for sound to move; it takes about half a second for sound at one end of this tunnel to reach the other end. If I put sound sources that had different sounds at either end of this tunnel, as a listener started at one end, he would hear the closest sound source first and the far source half a second later. When he reached the middle of the tunnel he would hear them both simultaneously; they would become vertical. As he passed the middle he would begin to hear the inverse. That is something I could begin to build a work with.

Another area that I could explore in depth is to move sounds through the space – sounds which move at the same speed, which move a little faster, which move a little slower, which move in an opposite direction.

It is very much like any other artist working with any other medium. One tries things. In my case because the works are large and involve public spaces, that trying process takes a long time and involves planning. It is trying to set up the same situation that a painter sets up in his studio of doing something, seeing how it looks, adjusting it gradually, focusing more and more until you realize the work is done.

Q. Isn't there a strong reaction against sound itself?

A. Yes. The Environmental Protection Agency in New York has an area called the Department of Air Resources. They are so inefficient in cleaning up the breathable part of the air, that they have to do something else to show people they are busy, so they run around and tell people that it is bad to hear.

The concept of noise pollution, which has been foisted on us by those agencies, is oversimplified and is robbing us of a very rich, sensual resource in our environment, i.e. hearing. This concept has convinced us that every sound

we hear deafens us; that's the implication. In fact, most of our sound environment doesn't damage our ears at all, even when it is very loud.

I feel a duty to try and counter that propaganda. In 1974 I wrote an editorial in the New York Times condemning the New York City Department of Air Resources. We have been at odds ever since.

Q. Have you ever gone and stationed yourself around your works to check people's reactions?

A. I thought about that when I did *Times Square*, and it seemed to me that it was voyeuristic. Maybe that is too strong a word to use.

Yes, I could go and observe people. But I know what the work is, I know what it can do, otherwise I wouldn't be a very good artist. The direct knowledge I have about people's reaction to it, I like to keep as an accident. People finding it for themselves and knowing about it for a number of years and then finally running into someone who knows it is a work of mine, and they write me a letter or a postcard.

Recently I was up there because someone was making a TV documentary on my work and filming. And an amazing thing happened. As they were shooting the square for background, a woman walked up and started talking about this sound which she had found and how wonderful it was and asked them to listen to it, instead of just pointing their camera around the square. She went on for about fifteen minutes.

Q. What about interactive sound installations?

A. Yes, I know what you mean. I have never done that. I have thought about it quite a bit. I think things of that kind are public instruments rather than artworks. Usually what happens is that the person with the strongest ego makes the most noise. But culture bureaucrats love the idea; it fits in with their idea that art should be fun.

The ideas that I am involved with are contrary to that – giving each person the possibility to make a work for himself, but for himself only. For instance, by making a work that has a topography, one can move through that topography at one's own pace, stop where one wants to. One has the freedom to form an experience of the work for oneself but not impose it on anyone else.

Q. Where does the money come from?

A. It depends on the situation. In the case of the Metro project, a third of it will come from the Metro Authority itself with a third from the Ministry of Culture and a third from private sources. In the case of a museum, it comes from the museum and the patrons that they can find.

Q. In the case of the Paris Metro project, do you go to the state and say, I saw this place and I want to do this?

A. Essentially yes. But it is a dilemma; here I am walking in and saying, I am an artist, I want you to commission me to do a work. It sounds strange

within the context of the way our society realizes works of artists. The artist is supposed to sit in his studio by the telephone waiting for it to ring.

That system, in fact, doesn't always work very well. Usually by the time the telephone rings, someone is calling you about a work which you did fifteen or twenty years ago for a place which is not the same place where you did the other work.

I find the most honest thing to do is to find sites and propose works. By not raising the money myself but going and presenting an idea and asking the place to raise the money, I put the decision in their hands. It is creating a situation which wouldn't happen by itself. No one ever would have commissioned me to do a work in a hole in the ground in Times Square. I had to have the idea. I had to annoy the Transit Authority to the point where they realized that the only way to get rid of me was to let me make this strange thing in the middle of Times Square.

The fact that I work with sound makes the situation more complex. Our sense of the monetary value of art sits firmly on the material instincts of size and weight. The most material thing in my work is air; it's invisible and weighs practically nothing. This in itself presents some problems in convincing people that there are costs involved in making a sound work – manpower, electronic systems but, most of all in my case, time.

[...]

64 Jannis Kounellis

'Untitled' 1995

Jannis Kounellis (b. 1936) is a Greek-born artist who has been based in Italy since he went to Rome to study art at the Accademia di Belle Arti in 1956. Although he trained as a painter, his work from the 1960s onwards moved beyond painting into sculpture, performance and theatre. He began to use found elements and even live animals and plants in his work, including a famous piece in which he exhibited twelve tethered horses in a gallery, the first time in the Attico Gallery in Rome in 1969. On taking part in Germano Celant's 'Arte Povera e IM spazio' exhibition in Genoa in 1967, Kounellis became associated with the Italian *Arte Povera* movement. In more recent years, with his installations incorporating untreated raw materials such as coal, steel, rock and sacking, he has gained an international reputation as one of the more dynamic and prolific 'sculptural' artists of his generation.

The artist's relationship to tradition, material and language is central to Kounellis's work and to his writing on art, issues he addresses in this 1995 text through a series of short inter-linked statements. The latter have the look of fragments, echoing a major and ongoing pre-occupation of his oeuvre, and a number have a poetic, aphoristic quality that gives them a free-floating philosophical character, recalling the writings of Andre and Brancusi. Where we might have expected the traditional sculptural materials of clay, plaster, bronze and stone, Kounellis begins his text with a call for an expanded concept of matter – one that includes, for example, iron, coal and paper. These materials of vastly differing and contrasting weights, densities, textures and histories are to be played off each other. Weight, in particular, is a condition of sculpture in which he has had an ongoing philosophical interest, making many works that are suspended in the air, precariously balanced or subtly piled or stacked on window ledges, in doorways and in niches. A more developed and sophisticated approach to matter is, for Kounellis, not only the way towards a more authentic, 'true' and morally valid art, but also a way of engaging in and renewing tradition. His espousal of an imaginative, artistic relationship with tradition is voiced here in opposition to post-modern irony and pastiche. Hence his comment: 'In art and in love one cannot be a tourist: saints, revolutionaries, but never tourists.' Central to Kounellis's understanding of an authentic art is a process of absorption and reaction in which 'novelty' is inevitably subsumed within a larger cultural whole. 'Every age', he concludes, 'identifies with a new image that nevertheless contains the past as imaginary and as language, albeit essentially reformed'.

Jannis Kounellis, Milan: Charta, 1995. Reprinted in Gloria Moure (ed.), *Jannis Kounellis: Work, Writings 1958–2000*, Barcelona: Ediciones Polígrafa, Collection 20_21, 2001, pp. 313–14.

Clay is matter, iron is matter, paper is matter. We need to extend the concept of matter: matter is giving form, matter that takes on meaning, matter that becomes significant.

A hundredweight of coal, not plastic painted like coal, not an abstract weight. A weight is what hides, its history, its morality. For the artist a hundredweight of coal is the moral history of an aesthetic.

Things become more real, more true. True in a moral sense, not imitation, quotation, realism. Realism is always falsehood and even what is concrete can be quite unreal.

Matter that takes on significance: to find the meaning of matter and the obligations that this implies; in other words, what can be done in the face of a culture. Linguistic obligations, because not everything is permitted.

The possibility of making things that are truer and more real depends on the relationship to the tradition. The truth lies in the relationship – perhaps simple, elementary – with the tradition. Tradition, not illustration, quotation. The tradition is very broad in aspect, it is not localizable. A localized tradition becomes politically instrumental.

Tradition does not mean exaltation of the past, but the need to order actions anew so as to have a present and not a mistake. Credibility comes from the values you reveal within an operation in the present. An occasion for reading, for a vision of the tradition. Vision and tradition: the tradition is visionary. The way of reading it, of assuming it, is visionary. There is no cold, neutral tradition. The great visionaries are the passionate readers of the tradition, and therefore of the metre.

Man is the measure, the measure always has to be the measure of humanity, understanding or conception of what it means to be human. A new measure is a new humanity, and the tradition is the tradition of human, not supernatural events.

The possibility of the survival of the form depends on the quality of love. It is a new reading of the tradition, one's own, and as such extended to others. The tradition is very broad in its aspects, it is not localizable, it is not a regional factor.

It is necessary to abolish the most possible, but never completely; otherwise we may end up in the non-existent traditional aesthetic.

To be curious, loving, in such a way as to become capable of understanding the signs of the tradition, the breadth of the phenomenon. You hold out the idea of being other, the idea of love – on this the possibility of rediscovering the strength, the importance and the depth of the form, everywhere, depends – while taking care not to lose yourself in the end in a stylistic game.

In this operation the bases need to be anchored; if not you lose yourself, you are no longer an interlocutor. In art and in love one cannot be a tourist: saints, revolutionaries, but never tourists.

All of this has to be included within a code, even a rigid code; otherwise you can be reduced to approximation; the initial readiness becomes sentimental and loses all the weight it potentially possessed. Readiness, tension, even in the moments of greatest crisis, openness to return to find what may perhaps no longer exist tomorrow.

Conservation is not mummification. Conservation is an active factor, not one of decadence. There is no way of conserving other than by raising the level, not accepting the rule of decadence but trying a higher path. Nowadays the means are not balanced and it is impossible to rediscover that great value that is painting, nor can it be conserved as an 'environmental asset.' Painting is not an environmental asset, it has to be rediscovered and conserved within a language that once again has a meaning. Not to paint today means to paint doubly.

The third window on the second floor of the Palazzo Farnese is my credo. I do not have anything else, this is all, but it is sufficient to make me an international interlocutor. In my work I cannot do without that window: it is an obligation. There are those who believe in the Word, I believe in this third window of the second floor of the Palazzo Farnese. It gives me the strength to make artworks. The window is an idea just as a door is.

Idea, invention, not 'novelty,' the remotest antiquities. 'Novelty' does not exist. It is false to think that a painter could produce 'novelties,' he would be assigned a minor role in the history of thought. A stylist can have a similar role, but not a painter, not a poet.

The iron serves to highlight the paper. A paper work would also have been a possible solution. It would have been a descriptive work in relation to the general theme, with the risk of remaining amalgamated, in a lesser sense, with all the rest, with the principal material exhibited. To manage to represent the 'continuity' and the development of paper it would have been necessary to take existing materials. At the same time, there is no tradition of the frame without painters, of printing without writers, etc. etc. We have to be conscious of the exhibition and change its terms with a work. To leave the exhibition is to give a measure to the exhibition itself.

The iron serves to highlight the paper, a concept of iron shackled to the last century, something that no longer exists. You 'use' it given that it no longer exists. You take up once again this material that loses its pragmatic tension, becomes more malleable, can be touched, folded like paper. Each artist's choice implies a different value. The request that I close this exhibition with a work already contains a response, and cannot not be that.

To make art is a need, then you find a language with which to construct an image, every age identifies with a new image, that nevertheless contains the past as imaginary and as language, albeit essentially reformed.

65 Rachel Whiteread/Andrea Rose

'Interview' 1997

This interview with the sculptor Rachel Whiteread (b. 1963), occasioned by her representing Britain at the Venice Biennale in 1997, highlights two issues that were central to the international reputation her work achieved in the 1990s. Firstly, there is her distinctive working process – creating simple, block-like works out of casts taken from the surfaces of everyday 'found' objects and architectural structures, such as the undersides of beds and baths and floorboards. The result is a hybrid kind of work that registers the imprint of human use and wear and tear, while also having something of the blankness and formal reductiveness of minimalist sculpture, as well as the anonymity and draining of affect produced by the relatively uniform monochrome surfaces of a traditional sculptural plaster cast. Sculptures such as *Ghost* (1990), the full-size cast of the interior of a standard front room in a Victorian terraced house, first drew her to public attention. These create a slightly disconcerting, almost uncanny reversal between the seemingly solid sculpture (in reality the closed surface usually disguises a hollow interior, as is the case with most casts) and the empty space surrounding or inside a readily recognisable object that the casting process reproduces.

Whiteread's interventions as the creator of large-scale publicly sited work also struck a strong chord with the art world. Her career took off just at the moment when, following in the wake of Maya Lin's famous minimalist *Vietnam Veteran's Memorial* (1982) and a number of notable post-conceptual monuments against fascism, lingering modernist unease over public sculpture gave way to intensive interest in and debate about the commissioning, installation and reception of memorials and site-specific interventions in public spaces. Whiteread's *House* (1993–94), a cast in concrete of the interior of an entire terraced house in London's East End that had been condemned for demolition, became probably the best-known and most widely discussed public sculpture in Britain, though it remained in place for only a few months before in turn falling victim to the urban improvement scheme that had removed the houses around it. This interview deals at some length with the commission Whiteread had recently received for a monument to the victims of the Holocaust in Vienna, which at this point remained unrealised largely because of disagreement about its siting over the ruins of an old synagogue. It was finally completed in 2000. Conceived as the cast of the interior of a library, it relates closely to a sculpture shown at the Biennale of casts taken from shelves of books – *Untitled (Paperbacks)* (1997). Also alluded to in the interview is Whiteread's plan to install the cast of the interior of a water tower on a rooftop in downtown New York – a work that was realised the following year.

Rachel Whiteread/Andrea Rose, 'Interview', from *Rachel Whiteread: British Pavilion, XLVII Venice Biennale*, London: British Council, 1997, pp. 29–35.

ANDREA ROSE: *The earliest work included in the exhibition in Venice is 'Untitled (Freestanding Bed)' from 1991. Can you describe how you first started making the bed pieces?*

RACHEL WHITEREAD: The first bed piece I made was in 1989, two months after my father died. It was called 'Shallow Breath'. It was cast from the space underneath a single bed. I was beginning to understand how I could control my materials – how the material underneath the bed could be stretched so that it was almost like using the bed as a canvas; how by pulling the material with the weight of the plaster I could make it undulate. A year later I made a piece using a double bed. I used hessian again, but stretched it very taut so there was hardly any undulation on the surface; then I made other pieces in rubber. For the work in Venice I used dental plaster which is normally used in the making of moulds for false teeth, so it tends to be used only in minuscule amounts. When you are working with it, it is rather fine and gloupy, so you have to build it up rather than pour it into the mould. This piece was cast from a mattress rather than from the space underneath a bed and the mattress had a very intricate pattern. By smearing the plaster onto the surface I was able to pick up this pattern.

How do you select the mattresses and bed bases you work from?

They are absolutely specific. The earlier pieces I made were to do with the London environment and its general neglect. Old mattresses, bed bases, etc. are very much a part of London's detritus and you see them abandoned everywhere on the streets. I remember seeing a television documentary about a particularly run-down housing estate in Hackney, East London. As the documentary progressed you became increasingly aware of the degradation and poverty in which these people lived. An old blind man living on the estate reported a terrible stench coming from the adjoining flat. Eventually the council intervened and found a man who had died in his bed. He had lain there for two weeks and had sort of melted into his mattress. The corpse was removed and the council cleared his furniture onto the street with the intention of taking it to the rubbish tip. No-one came to pick it up. There was this dreadful image of young children playing on the mattress that the old man had died on. I must have seen that film over six years ago but the images have stayed with me and have possibly influenced me in some way. There are all sorts of stories related to the pieces I make. When you use secondhand furniture it is inevitable that the history of objects becomes a part of the work.

Do you trawl the streets?

Actually picking up furniture from the street is a little too arbitrary. I mainly buy the furniture from secondhand shops – there are maybe twenty places that I regularly use, sometimes absentmindedly browsing, like doodling in a sketch-book. I also used to advertise in a newspaper called 'Loot' for specific items, but it all became a bit too problematic, talking to the people who had owned the items of furniture, listening to the personal details of their lives.

The work itself though is very formal. There are stories relating to each work, but your approach is to remove the personal and anecdotal in order to create something more neutral.

With the bed pieces in particular, and perhaps with 'Ghost', there is certainly an element of nostalgia. But I don't think there is necessarily anything wrong with that. Recently I've tried to become more formal in the way that I've been working. In 'Untitled (Ten Tables)' there is a reference to time and there is some colour involved but it is essentially rather stark and brutal.

What prompted this particular piece?

I had been looking for a specific kind of table. I became interested in using the sort of table you would find in a boardroom or classroom – a mass-produced table, the kind that would be designed to stand both as a single object and could also be linked with other identical tables to produce a much larger area. In a sense the design of the table dictated the construction of the piece. The process of construction of my work has gradually become more complicated. Early works such as 'Closet' were cast directly from the object. I literally turned the wardrobe on its back, filled it with plaster, drilled holes in the doors and closed them, finally destroying and removing the piece of furniture to reveal a plaster inside-out wardrobe. 'Ten Tables' however had a much more complex mould and structure, fitting together like a Chinese puzzle. Seen from above, the legs of the table are not visible and the spaces where they had been are more hidden within the piece. It has an internal space as well as both archaeological and architectural references.

It's a confrontational work, with a sense of negotiation and compromise implicit in its structure. Does it reflect your own position in relation to the making of the Holocaust Memorial for Vienna, on which you've been engaged for the past two years?

I don't know that it was as clear as that when I was making it but in retrospect Vienna has played a large part in it. There is a reference to the boardroom or a table around which people meet.

Did you sit at conference tables like this in Vienna, when discussing the Holocaust Memorial?

Exactly.

When you're in large meetings, you're conscious of everything that's going on below waist level that can't be articulated or referred to during such occasions. Is that partly embedded in your work?

Absolutely. The first table I made, in 1989, was to do with exchanging one's personal space with that of a table, the physicality of how you sit when you have a table in front of you, how your legs behave etc. I was trying to deal with that in some way, and to make it a claustrophobic space; to bring an unregistered and forgotten space into the world.

Why did you decide to use plaster for 'Untitled (Ten Tables)'? Was it to suggest weight and volume?

I wanted to make something that wasn't transparent, but was going back to the early ways in which I used plaster, where I could make the plaster pick up all sorts of detail from the object it was being cast from. With the resin pieces it does happen, but in a slightly different way. The detail is more buried in the layers of the resin. With plaster, it's on the surface. I always see the plaster works as frescoes. I also wanted to use a material that bore a close relationship to architecture that is seemingly volumetric and solid.

You entered art school as a painter rather than a sculptor. Has that had a bearing on your interest in surfaces?

I think all of the work I make is somehow connected with painting; I suppose that I only painted seriously for about a year before I became frustrated with the edges of the canvas. It was as simple as that. All of the work I now make has a very specific volume and edges – maybe I've found a way of connecting the two.

'Ten Tables' seems to hold a position somewhere between your more intimate and domestic works and the public sculpture such as 'House' and the commis-

sion for the Holocaust Memorial in Vienna. Do you see it as a return to a more private form of sculpture?

Vienna is an incredibly complex commission, given its subject matter and location. With 'Ten Tables' I was more liberated. I didn't have to concern myself with the Holocaust, or the politics of Vienna. So it's certainly private in terms of how I've gone about making it in the studio and the thought processes involved. 'Ten Tables' bears a direct relationship to the structure of a building and its foundations. It's an extension of earlier works such as 'Ghost' and 'Untitled (Room)'; in fact if it were six feet higher, it would be very much like Room. It's rather blank and unforgiving, but it contains all sorts of unanswered questions.

How specific was the brief for the Vienna commission?

It was very specific in terms of location. Judenplatz is a square in the centre of Vienna, a place of unique architectural and historic character, that bears the scars of centuries of anti-Semitism. The site lies immediately above the excavations of a thirteenth century synagogue. All nine of the short-listed artists or architects were asked what should happen to these remains. I said I thought they should be very carefully excavated – they were just being dug up at the time – then we should put straw, sand and soil on top. When my piece was eventually destroyed, whenever that would be, the archaeological remains would still be there. Otherwise the brief was open to interpretation, the only specific requirements were to do with the inscriptions – in English, German and Hebrew – and that the names of the concentration camps should be listed. My proposal was to make a cast concrete library, which has a ceiling rose and double doors. It is a sealed space that is covered in thousands of anonymous concrete books.

Having won the competition, were you asked to make changes to your design?

The nature of permanent public sculpture poses all sorts of problems. I thought very carefully about the piece in my studio, but it is quite different sitting around a negotiating table. I was asked to make many changes to my design for various reasons. There was a proposal at one point to open doors to the library and let the public walk down to the excavations from inside. Having had six months of very difficult discussions, we've now reached the point where there is to be a tunnel beneath the memorial from the Mizrahihaus, a Jewish study centre housed in one of the buildings on the square.

When you were invited to enter the competition for the memorial you had already spent a year and a half living in Germany on a DAAD fellowship. Did this prepare you for the commission?

Yes, I travelled a good deal throughout Germany and Eastern Europe. In particular the history of Berlin under the Third Reich fascinated me and its traces are still present in the fabric of the city and its suburbs. This is the only reason I felt in any way qualified to address such an emotive subject. I have been asked to make proposals for other public commissions, but unless I've had a direct relationship with place and understand something of its history, I simply cannot begin to engage. I can only make work that is somehow connected with my own experiences.

Was the idea of a library an extension of your work with 'House' or was it based on the symbolism of the Jewish people as 'people of the book'?

It was a mixture of things. Certainly, the references to the Jewish people being the people of the book were there, as the fact that so many of their books have been destroyed over the centuries. But I also went to Normandy and looked at the bunkers there, and I was interested in the Atlantic wall and how that was built. I visited a lot of cemeteries throughout Europe and America.

What do you feel about memorial sculpture in general?

It's a difficult question. There is good and bad public sculpture. The Maya Ying Lin Vietnam Memorial in Washington is extraordinary, in my opinion one of the few great contemporary memorials. And the American cemeteries in Arlington and in Normandy are also amazing memorials in their own right. I spent a day in Washington just watching people at the Vietnam Memorial. The sculpture itself is seemingly discreet, an internal wedge carved into the landscape. It's made from polished black granite with the 58,000 names of American soldiers who died or went missing during the conflict from 1959–75 inscribed on it. I watched veterans, their families and friends tracing the names of their loved ones on the monument by making rubbings on paper. I found it profoundly moving.

How do you think people will respond to your memorial?

I've really no idea what will happen and how people may respond. I've tried to deal with the issues simply and non-literally – I hope it will be viewed in this way and that it will be experienced as a monument which will encourage people to contemplate one of the great tragedies of recent history.

The material you are using is concrete. Are you adding whiting to it?

No. It is very light in colour and the texture is that of concrete. Initially the monument may seem rather blank but over the years with weathering and erosion it will change. I think with time it will begin to become a testament to its own history.

In the past you have stated: 'I have never said about any of my sculptures that they "mean" anything specific – critics like to ascribe specific meanings to things, a process that is exactly the reverse of what I try to do in my work.' Are there not however allusions in the memorial to specific structures other than to that of a library, particularly using the reference points of the doors and ceiling rose?

I think its references will be apparent. I've spent a year and a half thinking it through. You don't engage in a project like this lightly.

How difficult is it to make a monument commemorating such a negative episode in history?

I felt I was trying to describe a memory, but an on-going memory. It's not just about one particular event; there is an awful history to this particular site. The excavations beneath the site have revealed a synagogue where the Jews in the fifteenth century committed mass suicide – they went down into the crypt and burned themselves alive.

So siting is critical?

Absolutely. It was made specifically for the Judenplatz. When I made 'House' it was also absolutely specific to the site. When it was knocked down there were various offers to prolong its life; to put it on wheels and place it somewhere else. I said categorically no; if it couldn't stay there it would have to be destroyed.

Would you like it to have remained?

I would have liked it to have been there long enough for it to have become invisible. It fought very hard for its dignity, every moment it was there, and it would have been nice if people had just forgotten about it and glanced at it once in a while, rather than have it on the front page of every newspaper all the time it was standing.

But the memory of it is important?

Yes, the memory of it is very important. In a way I never really saw the piece. I never had a quiet moment to contemplate 'House' as a sculpture. I was unable to do what I usually do in the studio, which is to live with the piece for a while. I could never do that with 'House'. Whenever I went to see it, there were people everywhere.

You've recently exhibited in very different buildings, from the neutral spaces of the Tate Gallery in Liverpool to the ornate interior of the Palacio de Velázquez in Madrid. Is there an ideal building in which to show your work?

I wouldn't say there is an ideal building but there are certainly ideal light conditions and for the first time in the Palacio de Velázquez I was able not to have any electric light whatsoever. That's exactly how I like my work to be seen – by daylight.

How do you imagine the work will look in Venice?

There's an amazing kind of milky white light in Venice. I particularly wanted to show the resin corridor piece in the back gallery, as it is bathed in white light reflected from the canal outside. The piece bears a direct relationship to water. Also the scale of the rooms relates to the objects. They once again become like furniture. It is always interesting to play with that relationship.

You've made a number of floorpieces. The resin piece you are showing in Venice is the sixth. Was the first one site-specific?

The first floorpiece was made specifically for Documenta '92 for the Fridericianum, although it has been shown in all sorts of places since. It was a struggle with the first piece. Initially I couldn't decide whether or not I wanted to map a particular room or to invent a space. There is a certain honesty required if you are going to cast from an actual space. It was far too complicated in the Fridericianum because of the doors and other architectural details. So I decided to make a piece that represented a fictional space where the viewer becomes like a microscope. There are two simple indentations on opposite corners of the piece, so that the viewer has a more intimate relationship with the surface of the piece. I'm currently working on another piece with similar dimensions to 'Untitled (Resin Corridor)', but in felt.

What led you to work in resin as a medium?

All my previous work had a definite solidity to it. I wanted to make a work that had an inherent transparency so that its internal as well as its external structure could be revealed. When you look at the floorpiece in Venice you have the strange sense of the piece being pulled out of itself, which has to do with refraction. When the light conditions are right the piece becomes strangely articulated. The process of casting the resin was very complicated. I persevered making tests for six months because I'd been told that it was impossible to cast in the kind of volume that I wanted. By using a very slow catalyst, and through the laborious process of pouring an inch every twenty four hours, I was able to do it.

So you invented a formula for resin casting?

I wouldn't say I invented it; I messed around with it. A number of artists cast and embedded things in resin during the sixties, though I don't think anyone has really used it in this sort of volume. I can understand why. It's an awful material to work with. But it does do something that I've never been able to get another material to do. I tried working in glass at one point but it's not possible on that scale.

In 1991 you first began using materials such as rubber as an alternative to plaster, which you had been using exclusively for some years. What prompted this move?

The limitations of plaster were beginning to frustrate me so I began to explore other materials. It was liberating to make a piece in rubber and to be able to bounce it around the studio without it breaking up, also to be able to find other ways of introducing colour. The first rubber piece I made was 'Untitled (Amber Bed)'. I kept seeing it out of the corner of my eye as I was working and it always gave me a shock, as if someone was just sitting there, or was slumped up against the wall. I used rubber that is a sort of fleshy orange. The material is very tactile and has a direct reference to our own corporeality. I then started working with a company that designed rubbers for me. I would have these bizarre conversations where I would call up and request a rubber the colour of urine, a dark yellow the colour of the first piss in the morning. There were also a couple of pieces that are the colour of semen.

I had been using rubber for about seven years when I made 'Untitled (Orange Bath)'. It refers directly to 'Ether', a piece I made in 1990, which was in plaster. I made three versions of this piece in different materials. I made one work using yellow rubber, which was like honey or beeswax, where the material seems virtually to disappear and the colour sings. The work in the

British Pavilion, which is orange, was built up and cast in the same way as the yellow version. By changing the consistency of the mix slightly you can affect the colouration, and the way in which it is built up gives a feel of something organic, like a rock structure; rather like onyx. Then there is 'Untitled (Black Bath)', which is the first work in which I've coloured the material. It's a yellow plastic which I've dyed black. I made a smaller piece first to get the feeling of the original plaster, which was then translated into a silicon mould, then cast again into black plastic. It's as if it had been carved out of a massive lump of black coal.

You describe these works in quite geological terms. Does your observation of nature inform your work?

I'm fascinated by landscape, by the traces of weathering and geological movement which make up our environment. As a child I was taken on many trips around England by my parents. My father had been a geography lecturer and he would take us on field trips pointing out glacial formations and other natural phenomena. My mother would constantly be stopping the car to take photographs of the industrialisation of the rural landscape – recording man's cruel interventions. Those things are very much part of what I still do.

Your mother is also an artist and there is a political dimension to much of her work. Since becoming known for your public work do you feel as if you have become more political?

Everything is political in some way. With 'House' and with the commission for Vienna, things have spiralled out of control so that they have become far more political than I could have predicted. I knew, of course, while I was making 'House', that it had a political dimension. You can't make a cast of a house in a poor area of London and not be political.

But when people ask if I see myself as a female artist, or whether my work has a part in feminist history, I don't think I'm political in that sense. I see myself as a sculptor and as an artist and I think that my mother, her mother and their grandmothers worked incredibly hard for my generation to be able to do what we do.

When you made 'House' you unearthed a history of the family that had previously lived there.

The previous tenants were obviously DIY fanatics. The house was full of fitted cupboards, cocktail bars and a tremendous variety of wallpapers and floor

finishes. I was fascinated by their personal environment and documented it all before I destroyed it. It was like exploring the inside of a body, removing its vital organs. I'd made floorpieces before in the studio and had always seen them as being like the intestines of a house, the hidden spaces that are generally inaccessible. We spent about six weeks working on the interior of the house, filling cracks and getting it ready for casting. It was as if we were embalming a body.

Have the collections of the British Museum, the Egyptian material particularly, been an influence on you?

Certainly. A few years ago I was asked to be in an exhibition at the British Museum. They wanted to exhibit 'Ghost' or have a similar piece made for the Egyptian Gallery. I started to research the project and looked at some of the artefacts in the basement of the museum. I was shown amazing objects that don't generally go on display – mummified arms and other body parts. Then I looked again at the Egyptian Gallery and it seemed inappropriate to intervene with the existing sculptures in the space – and why would I want to?

Many of your works have a hieratic quality – in particular 'Untitled (Table and Chair)'. Is this intended?

I see 'Table and Chair' as a kind of doorway; the pause between inside and out.

'Untitled (Table and Chair)' is also one of the few pieces you have made which explores the relationship between one object and another. Do you think of it as a mother and child piece?

No, I've never really thought of it like that. My child pieces are the Torsos: the casts of hot water bottles, my headless, limbless babies.

You cast 'Untitled (Double Rubber Plinth)', a work also exploring the relationship between two forms, from the space beneath a mortuary slab. What led you initially to work with mortuary slabs?

I've always been fascinated by the macabre, but I came across the mortuary slabs by accident. I found a draining board for a butler's sink and after I had enlarged it six times I eventually made a piece out of marble. I then began to look for something on this scale and ended up buying two mortuary slabs. These slabs are made of ceramic. When I came to make casts I didn't use a parting agent to release the rubber from the mould as it would have interfered with the detail of the surface of the piece. The nature of this process created

suction and we literally had to wrestle to part the piece from the mould. It was like an enormous tongue. So there we were, dealing with an object on which people had been laid out and cut up and then having this extraordinary physical experience of wrestling with it. All of the rubber pieces have an inherent dead weight to them like that of an inert human body. One of the mortuary slabs originally had a drain in it which I had to remove. It was revolting – full of hair and other human traces. I've kept it somewhere. 'Untitled (Double Rubber Plinth)' is cast from the space underneath a mortuary slab, though it is not a direct representation. I used a space as the genesis for an idea to make a 'plinth', which has obvious sculptural references.

You're interested in secretions and residue, aren't you?

As I've said, the space beneath the floorboards is like the intestines of a house, containing the vestiges of the lives of those that have lived there. I'm interested in traces. Also there's always a bodily relationship between the viewer and the work.

But you are not interested in putting your own body into the picture?

No, the work is to do with absence not presence. When I was at art school I made a number of pieces cast from my own body, but that kind of direct relationship stopped in 1987. All of the sculptures I make refer to objects that we've designed for our bodies: beds, tables, chairs, bathtubs etc.

Baths and beds are the objects in which our bodies are at their most relaxed and abandoned. Is that part of their interest for you?

Yes, of course. That's how it started.

Some critics talk about the stillness, the quietness of your work. But there is a violent side too, isn't there: Marat in his bath? You have said you're interested in the psychology of violence?

I've moved studios recently, but I used to have a big reproduction of the 'Death of Marat' on the wall. A friend of mine, Gordon Burn, is writing a book at the moment about the Fred and Rosemary West case. He asked me to go down to Gloucester with him to see the Wests' house at 25 Cromwell Road. From television coverage of the case there was a suggestion that it bore a relationship to 'House'. While I was deliberating about whether to go or not, I dreamt that I was a wall in the house, like the image in Polanski's 'Repulsion'. I dreamt I

witnessed the horrific events of the past fifteen years. I woke up screaming and decided not to go.

To be a witness is how Holocaust survivors regard themselves. Does the book room that you have made for the British Pavilion in Venice come from your work on the Vienna memorial?

Yes, although this room is not a library in the same sense as Vienna. The books are cast with their outer edges forward; it's also entirely cast from paperbacks. I wanted to use the cast book elements to create a pattern. Two earlier book pieces I made, both of which are much smaller, are precursors of this work. I have become interested in pattern, in the way things repeat; for instance the white rivers that open up between the lines of print when a page is badly set.

Do you see books as an abstraction or as a method of recording history? And is the choice of books in any way symbolic of the coming millennium, where books may be superseded by the new information technologies?

I love books. I love the smell and the feel of books. I don't believe books are going to disappear and I don't like the idea of gleaning all your information from the superhighways, sitting in a cafe and reading your newspaper on a screen. I love the ritual of opening a newspaper. Anyway I'm something of a Luddite – I don't even know how to use the VCR at home.

Yet you belong to a generation of artists which is using the new technologies a great deal in its work. Do you feel part of the Young British Artists' scene?

Yes, of course I'm part of it, though the way my career has developed has in some ways distanced me from it and of course I didn't go to Goldsmiths'. But many of the so-called yBas are good friends and many are very good artists.

Your own work is straightforward and unironic, which is rather different from much of what is being done by other young artists.

My work is very much as I am. I think the work of a number of artists is possibly more calculated, but whether that's to do with working with computers or other technologies and the kind of processes that involves, I can't say. My work involves thinking things through in the studio, mixing buckets of plaster and following through the laborious process of making the work.

Have you been influenced at all by the generation of British sculptors which immediately preceded you? Sculptors such as Richard Deacon, one of the first to use lino flooring in his works, and Bill Woodrow, who started by hatching objects out of concrete?

The preceding generation of British sculptors had an enormous influence on me. I was taught by a lot of these artists and above all they made me realise that it was possible to continue. During those formative years at art school, I also began to look at artists from other European countries and America, specifically the minimalists. It is always difficult to pinpoint influences as they come from many sources.

You are also moving into larger urban schemes, dealing with cityscapes, as in the new piece you are making for New York.

I'm at the preliminary stages of making the piece so I don't like to talk about it too much at this point. When I was first asked to make a piece for New York I spent days wandering through the city. Certain sites were suggested, such as in front of the Flat Iron Building, but somehow it seemed ridiculous to contend with New York at street level, so I began to look upwards. The piece will bear a direct relationship to New York's urban landscape and will be housed on top of a building.

Would you think of taking on another commemorative sculpture after the experience of Vienna?

It would depend on what it was. If someone asked me to commemorate something I felt strongly about, I would certainly consider it.

Could you see yourself making a sculpture in London, say to commemorate the millennium?

I don't know. I do have an idea for a piece in London, but whether or not it will ever get made or if I have the stamina to go through with it, I don't know. If it was made, I may have to leave London!

66 Edward Allington

'A Method for Sorting Cows' 1997

Edward Allington (b. 1951) is a sculptor whose work addresses the reproducibility of sculpture, the potential of the ready-made and the theatrical staging of sculpture. He is also a notable writer whose publications include 'True Confessions of a Spare Parts Freak' and 'Buddha built my hot rod... on cars, art and the perfect finish'. This essay, inspired by a performance staged by Robert Morris in 1963 and illustrated with an image of Marcel Broodthaers's print *Les Animaux de la Ferme* of 1974, is his response to the question of how to define modern sculpture. Allington is against the idea that there is such a thing as 'real sculpture' and that sculpture is a 'sacred cow'. Sculpture for him is not a specific and exclusive medium that can be seen as evolving from a rigid family tree, teleological system or artistic lineage. Rather it is a difficult and open term that denotes 'a complex, diverse and exciting activity, moving and matching the complexity of the world'. Towards the end of his essay, Allington writes: 'Sculpture is looking at real things by making real things. It is making poetry with solid objects... Things made in stone, sculpture addresses in stone; things made in sound, sculpture addresses in sound; things made in light, sculpture addresses in light.' If the question of 'appropriateness' is important for Allington, sculpture is still nevertheless a fluid and shifting frame of mind for him, a way of imagining the world that can embrace all material and media, some poetic and metaphorical, others literal and indexical.

As well as quoting from the script of Morris's performance, Allington's essay draws upon a wide range of literature to make his observations: from Leo Frobenius and Paul Oskar Kristeller to Guy Davenport and James Joyce, that 'great sculptor of language'. The breadth of reference and quotation is in itself telling, indicating a gentle unease about writing directly about sculpture and about literary attempts to try to pin it down. Like Paolozzi, Tucker, Cragg, Bourgeois and other sculptors who attempt to articulate the meaning of sculpture through the written word, Allington is aware of the problems of dealing with the language of things through the language of words. If sorting cows is difficult, Allington suggests, sorting sculpture is even more so. One thing, however, that is certain is that sculpture is a step beyond painting. It is, he states, 'what you resort to when your obsession with the world of things goes beyond creating an illusion of something on canvas'.

Edward Allington, 'A Method for Sorting Cows', in *A Method for Sorting Out Cows: Essays 1993–97*, Manchester: Manchester Metropolitan University of Art and Design, 1997, pp. 6–13.

Despite my personal belief that such a debate is in fact proof of the health of sculpture, it is difficult not to experience a sense of familiarity while reading Morris' text. Familiarity, because the method in Morris's description of cow

sorting raises a certain resonance for me: an envy, in that the two cow men which Morris describes (I should add that even a cow is addressed as male in this text) know that cows are not all equal. There is a difference of quality, at least they are not the same: there are different breeds. In *Les Animaux de la Ferme* (1974), Marcel Broodthaers has substituted car-makes for breed-names. As a country boy, I feel some embarrassment that I recognise the cars but not the cows. Of course car-makes are really rather precise: 'My other car is a Rolls Royce' is a very clear statement. The innuendo is clear because we all know precisely what a Rolls Royce is. With cows this is not so clear, yet even a 'cow' is a more precise descriptive word than a 'sculpture'. The problem with the word 'sculpture' is that it is to so many people a sacred cow. And the thing that is so very attractive about Morris's text is that it is an example of a good practical method (though within the context of the 1971 Tate Gallery catalogue it is presented in an allegorical sense). The text has clarity and purpose whereas, to my mind at least, so much talk about sculpture is clouded with quite hopeless romantic notions and very dubious myths.

The most destructive and pointless of these myths is the one that starts, 'but that is not really sculpture, is it?' This, and similar statements which never seem to specify their meaning, assume the notion that there is such a thing as 'real sculpture'. The myth is a pseudo-creation myth, a notion that suggests that as all cows must derive from an Adam bull and an Eve cow, so too must sculpture derive from some tortuous family tree, starting perhaps with the Willendorf Venus. This pattern of thought is akin to the inclusion of Spartacus within the pantheon of socialist heroes because, as the first socialist activist, he demonstrated that to overcome oppression, the oppressed must take action into their own hands. This is obviously spurious because socialism as a term and an idea is modern. Perhaps the actions of Kirk Douglas as Spartacus are modern but the actions of the historical Spartacus most certainly are not! So too with art, and hence with sculpture. Paul Oskar Kristeller, in his essay 'The Modern System of the Arts', writes with reference to the eighteenth century:

> It is known that the very term 'aesthetic' was coined at that time and, at least in the opinion of some historians, the subject-matter itself, the philosophy of art was invented in that comparatively recent period and can be applied to earlier phases of Western thought only with reservations. It is also generally agreed that such dominating concepts of modern aesthetics as taste and sentiment, genius, originality and creative imagination did not assume their definite modern meaning before the eighteenth century.[1]

He goes on to say that the term Art with a capital A in its modern sense and the related term 'fine arts' (beaux arts) in all probability originated in the eighteenth century.

This seems to indicate that the inclusion of any sculpture prior to the eighteenth century in any practical discussion about sculpture, as opposed to historical research, should be dealt with as Kristeller suggests: 'only with reservations'.[2]

The sculpture of Michelangelo can thus be said to be as irrelevant to sculpture in the modern system of arts as that of Myron or Praxiteles. It has to be made clear that examples of sculpture prior to the eighteenth century have only a secondary relationship to the practice of sculpture in the modern sense; secondary in the way that Mexican sculpture influenced the early work of Henry Moore, or that Michelangelo is said to have influenced Rodin. There is a huge difference between the objects which are part of the modern system of sculpture and those pre-modern cultural objects, or objects from different cultural systems, which have been used by artists and incorporated into their mythologies.

Perhaps one way of differentiating the modern system of sculpture from pre-eighteenth century sculpture is to describe modern art, and hence sculpture, as a renaissance of the archaic. To quote from Guy Davenport's essay 'The Symbol of the Archaic':

It has taken half a century for modern eyes to see the archaic. Cocteau dated this aesthetic adjustment from the year 1910, when Guillaume Apollinaire placed a Benin mask on his wall. Suddenly an image both ugly and disturbing still bearing the name fetish, which the Portuguese exploiters of Africa had given it, became a work of art which could hang in a museum beside a Hogarth or a Rembrandt.[3]

Davenport goes on to say:

Apollinaire was not that original. He was taking his cue from the German anthropologist Leo Frobenius who had begun to argue that African Art was neither primitive nor naive; it was simply the African style. Even before Apollinaire broadened his vision to see the sophistication and beauty of African Art, the French sculptor Henri Gaudier-Brzeska had also read his Frobenius and was working in styles derived from Polynesia, Egypt and ancient China. All that he required of a style was that it be archaic; that is, in the primal stages of its formation, for Gaudier and his friend Ezra Pound had conceived the notion that cultures awake with a brilliant springtime and move through seasonal developments to be a

decadence. This is an idea from Frobenius, who had it from Nietzsche who had it from Goethe.[4]

Davenport also describes how he believes that this sense of archaic time is mythological and usually at variance with history, commenting that 'it is man's worst ineptitude that he has not remembered his own past'.[5]

More significantly, Frobenius also mentions the myth discussed earlier: that all sculptures derive from a family tree, sired by an Adam sculpture and an Eve sculpture. He describes how there are those who 'have grieved for a century now over the loss of some sense of vitality which they think they see in a past from which we are by now irrevocably alienated'. It is this system, with its kind of pathos, which we find pervading the modern system of the arts. Modern sculpture is about the discovery of the specific: 'things', Proust said, 'are gods'. The real issue is that these gods have come to dwell amongst us, in a manner more Homeric than biblical in its tragedy. It has become the work of sculpture to depict these things, these gods, in materials appropriate to their essence.

The symptomatic sense of loss inherent in the modern system of the arts is related to this rise of the world of things over the world of the figure. The figure belonged to the previous system – to a time before Nietzsche pronounced God dead – in which gods were depicted in human form. When Jeremy Bentham died on 6 June 1832, he left elaborate instructions for the treatment of his corpse:

> Dressed in his accustomed clothes (stuffed and padded out to appear lifelike), Bentham's 'auto-icon' or self-image was housed in a glass-fronted showcase. And after various vicissitudes, this now resides in the cloisters of University College, London, where it may be seen daily. It was Bentham's wish that this process would save his admirers the necessity of commissioning stone sculptures of him.[6]

Even ignoring Bentham's interesting idea that every person is potentially their own memorial, the modern system of sculpture is marked by the increasing inability of sculpture to sustain the depiction of the individual. Is Jacob Epstein the last artist of our era to succeed in this genre? In the work of Brancusi, that great archaic sculptor, we see the figure being subsumed into an object. More significantly, we see the development of a sculpture which is architectonic – a succession of images that do not tell a story but define a state of mind.

There are two other aspects of this 'renaissance of the archaic' which are worthy of comment. Perhaps it is better to describe them as the opposing yet

symbolic boundaries of the modern system of sculpture. Toward one edge, Serra and Rückriem's work is absolutely modern yet founded upon the thought of the eighteenth century, which has taught us to look at ruins with a particular frisson: to feel process, to sense the other – although no longer before us – in the fragments we see now. One thinks of Gibbon in the Colosseum and Schliemann at Mycenae.

Toward the other edge are those skills controlled by artifice. This side of the modern system of sculpture is truly architectonic, built from images both concrete and conceptual, a play of mind and form. It too originates from the urge that placed a 'fetish' upon the wall of Apollinaire's room. Another name for this boundary of the 'archaic' renaissance is the Surreal: one of the greatest discoveries of the modern era. Think of Max Ernst who, like James Joyce, discovered that quotation can be eloquent beyond its original meaning. It was Ernst who discovered that Surrealism need not be Freudian. Sculpture has continued to be nurtured by the Surreal: witness the early work of Giacometti or of David Smith, or of Robert Morris himself.

Joyce was a great sculptor of language. As Davenport demonstrated, you don't read Joyce, you watch the words. The great thing about Joyce is his ability to make language resonate with multiple meanings and echo with symbols from the past whilst remaining absolutely of his time and absolutely modern. It must be said however, that the language of solid things, of materials, is much cruder: it is dumb in comparison to the language of words. There is a difference between rendering things, which is what, for instance, Braque was doing, and re-making things.

Sculpture is the step beyond painting. It is what you resort to when your obsession with the world of things goes beyond creating an illusion of something on canvas. Sculpture is looking at real things by making real things. It is making poetry with solid objects. Where painting remains confined to depicting these new gods who now live amongst us in paint, and paint alone, sculpture addresses these things in kind, like for like. Things made in stone, sculpture addresses in stone; things made in sound, sculpture addresses in sound; things made in light, sculpture addresses in light.

Mother Ann Lee of the Shakers said that 'every force evolves a form', and this is exactly what the modern system of sculpture does. Rosalind Krauss has described sculpture today as 'sculpture in the expanded field' – a description which is both accurate and realistic.[7] Sculpture now is a complex, diverse and exciting activity, moving and matching the complexity of the world. It is an activity which thrives in young artists who respond not only to the gods of Art but to the changing gods of the real world.

To return to Robert Morris's method for sorting cows as they come home from the expanded field. He describes a corridor with a large pen set halfway

along and off to one side. Two men are required to sort the cows, a head man and a gate man. The head man is in control, the gate man responds to his orders:

> So it goes until all of the cows except the last have made their exit from the corridor. The last cow is approached by the head man in a more lyrical and less tense way; usually the last cow is also somewhat more relaxed and knows what is expected of him. One might say that the last cow is 'shooed' since the expert timing of the head man is now not required. This cow will usually trot rather than bolt down the corridor to its destined 'in' or 'by' place. The head man must then turn to his gate man and say 'That's the one we're looking for'.[8]

I like the brutality of this image – after all, sensitivity serves us well for looking at sculpture but not for making it. Making sculpture is a practical business; it's about choosing, it's about control.

1 Paul Oskar Kristeller: *Renaissance Thought and the Arts: Collected Essays*, p. 163. Princeton University Press, 1980.
2 Ibid.
3 Guy Davenport: *The Geography of the Image: Forty Essays*, p. 22. Pan Books, London, 1984.
4 Ibid.
5 Ibid., p. 20.
6 Ruth Richardson: *Death, Dissection and the Destitute*, p. 160. Routledge and Kegan Paul, London, 1987.
7 Rosalind E. Krauss: *The Originality of the Avant-Garde and Other Modernist Myths*, MIT Press, Cambridge, Mass., 1985.
8 Robert Morris: quoted in *Robert Morris* (exhibition catalogue), Michael Compton and David Sylvester, p. 8. Tate Gallery Publications, London, 1971.

67 John Lechte

'Eleven Theses on Sculpture' 1997

John Lechte (b. 1946), who trained as a semiologist and a Kristeva scholar, teaches in the sociology department at Macquarie University in Sydney. The approach that Lechte takes to sculpture is a semiotic and anti-materialist one. Throughout his text, sculpture and language are not only considered closely together, but their intricate interconnection is also seen as generative of the possibility of a sculptural syntax and sculptural writing. Sculpture for Lechte is first and foremost an idea, before being a material object; even 'thought is sculptural'. In order then to try to understand what sculpture is, Lechte focuses on its adjectival potentiality, the 'sculptural', rather than on the word as a noun. He looks at how instances of the sculptural appear across a range of conditions and circumstances and argues that 'it is precisely the individual instance of sculpturality [sic] which ultimately contains sculpture in general'. Some of the more profound of these sculptural instances or moments evoke larger issues not only concerning what sculpture is, but also its history and what it has been. This approach generates reference to the work of a number of earlier modern sculptors, including Constantin Brancusi, Joseph Beuys, Alberto Giacometti, Barbara Hepworth and Auguste Rodin.

Lechte's eleven short theses attend to the following issues: tactility, reproduction, place and emplacement, space, image and form, the body, thought as sculpture, movement and singularity. Rather than merely explore the formal aspects of these terms and conditions of sculpture, he develops their semiotic possibilities. He concludes his text by stating that although one can speak of the 'sculptural' and 'about sculpture' in new and intriguing ways, 'not everything is sculptural' so 'distinctions must be made for the sculptural Idea to be a real possibility'. Lechte's text appeared in a special sculpture edition of the occasional journal *Art and Design* that was edited by Andrew Benjamin, and included essays on the work of David Batchelor, Harald Klingelhöller, Didier Vermeiren, Christine Boshier, Lucille Bertrand, Rachel Whiteread, Tony Cragg and Serge Spitzer.

John Lechte, 'Eleven Theses on Sculpture', in Andrew Benjamin (ed.), *Sculpture: Contemporary Form and Theory*, *Art and Design*, no. 55, 1997, pp. 18–21.

I

The view that there is an essentially material sculpture object needs to be rethought. This is not because of the palpable diversity of claimants to the sculpture mantle (from ready-mades and relief constructions through Gilbert and George to installations, conceptual and musical works, etc), but because sculpture is an idea. In what, then, is it not possible to find the sculptural? – a question raised with particular force by the work of Joseph Beuys.

Sculpture does, then, appear *in* something. Indeed, although it is an idea, it would be wrong to think that the sculptural can appear independently of the sculptural image. It would be wrong, in effect, to think that the sculptural does not appear. The sculptural image is the sculptural, but this image is not contained in familiar genre categories. Modern sculptors have never tired of making this point.

'Image', to be sure, evokes Plato's *eikon* – and the oft-made point that were there no difference between image and Idea (*eidos*), the image would be a poor *eikon* (cf. Krell[1]).

More than this, were the image not 'defective' in some way in relation to its Idea (model), there would be no image, and no appearing of the Idea either. Consequently, just when sculpture had seemed to shake off a putative idealism concerning its essence, this radical refusal of circumscription has led to the need to recall once again the relationship between appearance and Idea.

Of course, the very notion of the sculptural – and thus of sculpture in general – fails to do justice to the particular work of sculpture. Well, maybe we have to get used to the idea that it is precisely the individual instance of sculpturality which ultimately contains sculpture in general. Every profound sculpture, therefore, is one that addresses the question of sculpture as such. The question: What does it *mean*? is now replaced by the question: What is sculpture? – just as the profundity of Joyce drives us to the question: What is literature (writing)?

The diversity of the sculptural is thus not to be understood in terms of the Romantic view of the artist with something unique to express. Indeed, the sculptural is not simply an ideolect or the equivalent of a dream script; for every instance of the sculptural also evokes the history of sculpture.

Nevertheless, is it not necessary to admit that something is 'said' by the individual sculptural piece – something that transcends its aesthetic status, as in a Hans Haacke installation?

The answer must be in the affirmative, and all the more so since pure aestheticisation evokes the spectre of the simulacrum: the entity which refers to nothing but itself – endlessly. The issue at stake, however, is not specific to sculpture, but applies to all the arts and their histories. Such a question cannot be entirely resolved within the sphere of the sculptural.

II

The sculptural moment is not just visual, but also tactile. But it evokes touch as much as it entails real touching. Similarly, the sculptural moment might evoke flight (cf. Brancusi's *Bird*) and so much else. This evocative side of sculpture thus places it close to being (a kind of) language. Some might even go so far as to say that there is a sculptural syntax, or a sculptural writing. This

would allow the sculptural moment to say something 'other than what it says'. The point is to know what can be uniquely said, sculpturally. The risk is that the notion of a sculpture language will be understood to mean that sculpture speaks of itself to itself. For it is difficult to break free of the vice-like alternative: either sculpture is a language – and thus a *means* of communication (the instrumental view of sculpture) – or sculpture is not strictly a language because it can present only itself (the aesthetic view). Thus we would like to know how something which can be said only through the sculptural can be more than the sculptural speaking.

III

The sculptural moment is also the moment of reproduction. This can be understood in relation to Rodin's *Gates of Hell* (1880–1917) – as analysed by Rosalind Krauss – where the casting took place three years after the sculptor's death.[2] Here, mould and cast turn a facet of the practice of sculpture into a process of reproduction. As such the notion of originality, or meaning, has to include the idea of the work as a statement, as much as its material manifestation.

Reproduction here can also refer to the semiotic, as outlined by Julia Kristeva.[3] This reproduction – this mimesis – does not refer simply to the reproduction of the (objective) work, but to the reproduction of the space of the sculptural gesture itself. In short, the sculpture reproduces the subjective position of the artist. It thus mimes subjective energy flows. This is in no sense an objectification of the subject's position, but is rather constitutive of that position. Give such a focus, it is not possible to say – despite the apparently private nature of the sculptural meaning – that the subject/artist is truly expressed in the work; for there is no subject position – at the level of reproduction – prior to the work. The work, then, is subjectivity – albeit in process. Subjectivity is thus *Chora*: 'a mobile and extremely provisional articulation', a space of non-differentiation, a 'receptacle', or 'non-expressive totality' formed by discharges of drive energy.

Some sculptures today can be evocative, in their extreme variations of form, of the stage prior to nomination. This is sculpture that is barely identifiable as such. This is sculpture without boundaries. Can there be a thought adequate to it?

IV

The place of sculpture cannot be reduced to the space sculpture. Even those works like Smithson's *Spiral Jetty* (1969–70), remain identifiable *as* works. A work (like Lacan's Symbolic) is never exactly in its place, even if it can well be *in* place. Nothing could be more crucial for the sculptural work than its encounter with a place. For, very often, it is the explicit emplacement of the

work which gives it its meaning. We mean here that emplacement in general is constitutive of the sculptural work, and not that each work has a place that is proper to it. The play between the proper and the improper place of the work is constitutive of the emplacement of sculpture.

More than anything, the emplacement of sculpture brings the issue of the sculptural into view. The sculptural is the mode of emplacement of the sculptural work – even if this emplacement is nothing more (nor less) than a 'marking out' of the place of the sculpture. 'Marking out' is as crucial in Duchamp's *Fountain* (1917), as in Christo's wrappings. In each case, it is a question of borders – of the need for borders – if the work is to mean anything.

From a slightly different angle, the sculptural work has to have a transcendent moment. And this moment is intimately tied up with its emplacement as an essential displacement. The emplacement, as a marking out of sculpture means, too, that the work can become an object of contemplation. The emplacement of the work thus gives rise to discourse.

V

If space cannot be separated from the emplacement of sculpture, every emplacement is also a spacing. To refer to 'spacing' also means evoking a latent temporality. The latter point is made by Rosalind Krauss in *Passages in Modern Sculpture*.[4] 'Passages' in the title evokes both a way through the history of modern, 20th-century sculpture, and the 'passages' which become a sculpture – as in Bruce Nauman's *Corridor* (1968–70). Or, we could say, that the book also addresses sculpture in/as passages of time.

Space evokes the kind of volume – whether or not virtual – that is sculpture. Light sculpture (cf. Dan Flavin) marks out a quasi-virtual space for itself. To mark out a space is also to inscribe. The emplacement of sculpture would, in this sense, be an inscription – one recalling Derrida's theory of writing.

A notion of sculpture as an emplacement – where the work would only appear through inscription – has to consider the issue of repetition, or of re-inscription. If sculpture is nothing but the inscription and re-inscription of a work through emplacement, from whence would come the Idea of the work? Let us suggest that the emplacement constitutes the space for the appearance of the idea the work embodies.

There is, though, a radical arbitrariness incorporated in the notion of inscription. Strictly speaking, writing is an inscription *because* it is constitutive of both signifier *and* signified. Meaning does not occur outside writing, but is always already marked out in it. Such a conception of writing is possible only because the relationship between the signifier and signified is arbitrary. The idea of eroticism does not have to come through a naked human figure, so that Giacometti's *Suspended Ball* (1930–31), where a split, plaster ball hovers

over the sharp edge of another plaster object evocative of a freshly-cut water melon, can, as the surrealists found, arouse a 'strong but indefinable sexual emotion'.

Despite this play of the unconscious in Giacometti's case, the notion of sculpture as pure inscription has to face the emptiness of this for the ego, and thus for the Imaginary. Even if different signifying and aesthetic strategies are both possible and desirable, and the play of the unconscious important, the Imaginary moves from fixation to fixation (as the analyst might say), or from belief to belief, as one might say in more theological phrasing. The Imaginary looks to the qualities of the thing itself in order to find a modicum of satisfaction. Like every satisfaction, no doubt, this is a fiction. But fictions also expand the limits of the signifiable, as Kristeva has constantly said.[5] There is, then, a point at which the deconstruction of sculpture (or of art in general) is the actual *destruction of* sculpture. It is also the destruction of the Imaginary and thus of a certain pleasure – the pleasure, I suggest, that Roland Barthes attempted to demarcate with a slightly different vocabulary in *The Pleasure of the Text*.[6]

VI

'Sculpture is the meaning of forms.' *Barbara Hepworth*

To say, as Hepworth does, that 'sculpture is the meaning of forms', is to forget that sculpture, as emplacement, is the meaning of an image. For one of the meanings of image – indeed the first given by the concise OED, is: 'representation of the external form of an object, eg. a statue (especially of a saint etc as an object of veneration)'. Form, image, outline here come together in relation to any object. Let us assume for the moment that sculpture embodies this relationship between form and image – that form is image, and vice-versa – a relationship which is exemplified by a statue. Very quickly, the issue here turns around the notion of sculpture as sign and as simulacrum. If, finally, the simulacrum refers only to itself, a sculpture as simulacrum has no meaning, or, at best, it has a very reduced meaning. By contrast, sculpture as image is a sign: it refers to something other than itself. There is then an outside of the image which is part of the essential meaning of the image, whereas the outside of the simulacrum is purely accidental and unrelated to the simulacrum as simulacrum.

Little would be required to show that the kind of image designated has Platonic overtones, and that, for this very reason, is suspect. But not even Plato was entirely in control of what he was attempting to define and explain. Who is to say that, in the end, Plato was not warning against the simulacrum and not the image, as various commentators have said? Whatever the case, it is possible to argue that the simulacrum, which, as meaningless, does not call

for interpretation, is opposed to the viability of the Imaginary. The Imaginary entails a belief that an image is not a simulacrum, that everything does not refer to itself, endlessly.

Let us say, therefore, in light of Hepworth's statement, that sculpture as form is an image calling for interpretation.

VII

The sculptural is, or is part of, a body in space. This is the horizontal aspect of sculpture. Even as the perfect copy, or imitation of a prior object, sculpture retains a certain horizontality which pushes it closer to an experience of madness. There is always the risk that a sculpture will lose its emplacement – that it will cease to be a displaced object, and merge into its surroundings. The imaginary border between signifier and signified will disappear. Thus a metal car body, as sculpture, will rust, just like any other car body. Indeed, in rusting, such a sculpture becomes just another car body. But the imaginary border between signifier and signified does not have to be erased in any physical sense. A sculpture can literally disappear once it becomes a pure cliché, or a commodity that is endlessly replicated. Perhaps *Aphrodite* and the *Charioteer* are no longer true sculptures for this reason.

Even as the sign of the dissolution of a certain objectivity – of a becoming-thing – sculpture, as sign, retains transcendence, however minimal. Sculpture, indeed, is a transcendence, part of a vertical axis that is rendered transparent by the displacement of its emplacement.

Sculpture as a body in time is a complex notion. If sculpture is 'in time' it might be because the kind of temporality that it discloses puts us in touch with the 'time' as such of the sculpture object. This time, to repeat, is transcendent. It is not, then, simply reducible to the time of physical decay; because this time belongs essentially to the horizontal axis of sculpture. To be transcendent – for a sculpture to speak after death, as it were – another conception of time is necessary. This is the time that sculpture itself gives. Sculptural time is thus the refusal of the horizontal axis of physical time, seen in the example of the car body. Sculpture *as* time, sculpture that marks out another time, is what is at issue. Without the effort to *think* sculptural time, the sculptural moment – perhaps more than the moment of any other of the fine arts – loses its specificity. In other words, sculpture risks becoming just another thing.

VIII

'If you want to explain yourself, you must present something tangible.'
Joseph Beuys

In light of Beuys, thought becomes sculptural. Does this not mean that the sculptural moment becomes the expression of the sculptor's thoughts? The answer is in the negative because thoughts do not exist prior to the sculpture itself. Sculpture and thought are 'equi-primordial' – to take a term from the translation of Heidegger. Thought is thus embedded in sculpture. This is what makes a sculpture more than an everyday object, even if it sometimes seems to be little more than that (cf. Warhol). Beuys's project concerns extending the concept of sculpture 'to the invisible materials used by everyone: *Thinking forms* – how we mould our thoughts or /*Spoken Forms* – how we shape our thoughts into words or /SOCIAL SCULPTURE – how we mould and shape the world in which we live...'[7]

Beuys is the sculptor most in touch with the sense of the sculptural moment. Rather than defining sculpture, he uses sculpture as a defining operator, thereby reversing the usual schema where a definition of sculpture is first required before any further progress can be made. With Beuys, a new syntax of sculpture emerges. In his work thought and sculpture are combined. Thought is sculptural.

Beuys's sculpture, then, is an idea performed of what sculpture can be, and, subsequently, of what art and society can be. The question Beuys raises, without intending to, is that of how sculpture can remain in any sense a monumental and essential art. To ask this is to ask how Beuys's work is not predominantly accidental. Beuys uses fat, but he might well have used wax or some other substance – if he had been a different person, with a different life-history.

Beuys's work thus raises the question of the contingent and the essential even though this is not part of his intention. For him, everything is in a state of flux, is 'in a *state of change*'.

IX

The sculpture of practice is not the production of the illusion of movement. It is not a spectacle of movement. Film is not, in effect, the model of practice. However many views the object implies, however film-like it becomes, it remains caught in an objectification. Instead, the sculpture of practice entails moving to a very different plane in an effort to challenge a certain kind of objectification, without ending up with complete loss.

X

Singularity is not captured in precision. In this light, Giacometti's sculptures, which substitute a blur for precision, signify singularity; they do not pretend to represent it. 'When you represent the eye precisely, you risk destroying exactly what you are after, namely the gaze...'[8] Clearly, there is a tension in a situation

in which a singular work of art (or where the work strives to be singular) has singularity as a thematic device. The sculptural moment might well be the relationship between these two singularities.

XI

The question: How can we speak about sculpture?, forgets the counterpart: How can we not speak about sculpture? For, to begin with, although only a specific speaking is transcendent in relation to the sculptural moment, much speaking is not itself sculptural. Without thinking that the sculptural as such *can* be spoken, it is crucial to recognise at the same time that not everything is sculptural. This implies that distinctions must be made for the sculptural Idea to be a real possibility.

1 D.F. Krell, *Of Memory Reminiscence, and Writing*, Indiana University Press, Bloomington and Indianapolis, 1990, p.41.
2 Rosalind Krauss, *The Originality of the Avant-Garde and Other Modernist Myths*, The MIT Press, Cambridge, Mass/London, fifth printing, 1988, pp.151–170.
3 Julia Kristeva, *Revolution in Poetic Language*, Margaret Waller (trans.), Columbia University Press, New York, 1984, pp.57–61.
4 Rosalind Krauss, *Passages in Modern Sculpture*, The MIT Press, Cambridge, Mass/London, seventh printing, 1989.
5 Julia Kristeva, 'Name of Death or of Life', in J. Lechte (ed), *Writing and Psychoanalysis, A Reader*, Arnold, London, 1996, p.116.
6 Roland Barthes, *The Pleasure of the Text*, Richard Miller (trans.), Hill and Wang, New York, 1975.
7 Joseph Beuys, *Energy Plan for Western Man: Joseph Beuys in America*, K. Kuoni (compiler), Four Walls Eight Windows, New York, 1990, p.19.
8 R. Hohl, *Alberto Giacometti*, Abrams, New York, 1971, p.171.

68 Walter Grasskamp

from 'Art and the City' 1997

In this catalogue essay, Walter Grasskamp (b. 1950) uses the Münster sculpture festival in West Germany as a lens through which to examine the changing nature of public sculpture from the nineteenth century to the present. Grasskamp conceives of the city as originally a 'narrative space', one that in the nineteenth century was relatively coherent and legible. With the rise of modernism and the abandonment of figuration, however, the legible city was replaced by 'the city inscribed'. Narrative art, once on the outside of buildings, moved inside, into the gallery, while the outdoor 'public sphere' became increasingly incoherent and contested. Post-modern artists, however, abandoned the safety of the museum, starting in the late 1970s, so as to reoccupy this contested space once again, or at least to take on its challenges. The emphasis therefore in post-modern public art is on contextualization, which he sees as taking the form of site-specifics in the earlier 1987 Münster project. Site-specific art, however, in Grasskamp's view still remained relatively introspective. It had to do with sculpture striving to regain a level of autonomy, as in Richard Serra's use of 'heavy metal'.

The work in the 1997 Münster project, however, ten years later, seems to Grasskamp to have become far more context-dependent. He points to the 'festivalizing' of sculpture in the 1990s, a phenomenon expressed most clearly in the strategy he describes as 'artist services'. Festivalizing art represents an important trend, although Grasskamp is far from convinced by it, however ironically self-aware it might sometimes be. The festivalizing of 'ironic release' may represent the latest 'accentuation' in art, but it may also in the long run prove to have been simply a historical distortion. For Grasskamp, the more lasting and persuasive works are those that articulate a critical and historical perspective, so that his strongest interest is in Hans Haacke's *Standort Merry-go-round* (1997), enclosed by a tall circular fence and placed next to one of the city's war memorials. For Grasskamp, *Merry-go-round* demonstrates a close engagement with the city's enduring narrative aspect. It uses the metaphor of the roundabout, not to festivalize, as with 'artist services' work, but instead to act out, via an alternative, conflicting narrative, a productive abjuring of the monument's traditional nationalism.

Walter Grasskamp, 'Art and the City', in *Sculpture. Projects in Münster 1997* (exh. cat.; English version), *Zeitgenössische Skulptur*, Ostfildern-Ruit, Hatje Cantz, 1997, pp. 34–41. The last two sections of this essay only have been excerpted.

Muted Euphoria

Dogma or not, the prospect of being able to afford the work of art new social and urban anchorage lent the campaign of 1987 a tremendous impetus. In 1977, the contributions of a Beuys, Judd or Rückriem had set up a relation

to place in a more formal sense. In 1987, the narrative variant made its first appearance, and it did so in force. In the works on the *memoria* theme, in which Lothar Baumgarten was joined by Dennis Adams, Daniel Buren, Ian Hamilton Finlay, Rodney Graham and François Morellet, and – with a piece quite out of the ordinary – by Rebecca Horn, as well as in other works, outdoor sculpture in its storytelling capacity, so long held in contempt, appeared to have come to repossess its title.

The charm of the campaign would seem to have been owed chiefly to the collision of the artists with a provincial town with which they were unfamiliar: to the fact that the encounter should have sparked off so intensive an exchange on the local topography and that the topography should have turned out to be so inspiring. From the point of view of curators Bußmann and König in this coupling process, observers would have found the role of 'oral history' an unexpected indication that the city as a narrative space was still alive and well. Whatever, the present *Skulptur Projekte* have benefited much from the way the curators relate to the city's past and present. What one might take the liberty of adapting as the procedural maxim of the exhibition, *invite globally, act locally*, has only been able to work convincingly thanks to their identifying, with all skepticism, with the venue of Münster. This venue, like Kassel, incidentally, furthermore has a condition to offer which is likely to have been a factor in the success of the exhibitions mounted in both towns: it is the high profile of the events. This would be lost in large cities. Looking at the history of exhibitions in Kassel and Münster, two laws to the advantage of a provincial venue might be inferred: first, the urban background for art events of ambition and scale has to be small; second, a spatially confined venue raises the perceivability of intervention in it.

The idyll which Fischli/Weiss put down with some forbearance as contextual kitsch, the artists as a whole had prepared by a remarkable willingness to suspend the privileges of autonomy and leave the Bermuda Triangle of studio, gallery and collection for an arena of interaction with authorities, churchgoers, business folk, bus passengers, students, visitors of parks and cemeteries, cyclists, casual strollers, philistines, the art industry tribe and night owls. If impressions left by advance preparations for the 1997 campaign are not misleading, then that readiness has receded somewhat in the interim, and the affinity to the gravitational center of the museum has grown again as compared to that of the wider public arena.

One might therefore be excused for wondering whether the *dream of the public domain* is not to be put down to a characteristic of art in the 1980s. Did the willingness of the participants then, to operate in the public sphere like artists under commission, betray a longing to be able to walk out of the golden cage of autonomy? Were the artists (and the curators) glad to have escaped the persistent taboos of modernism and its long periods of ascetic censorship?

Had the innovation of Pop Art, the original spark at the origins of postmodernism, only now arrived in the public sphere? Or was it more appropriate to see the trend as a new-range marketing strategy in a traditionally highly paid, but formally antiquated sector of the art market – that is, narrative relation to place as a new merchandise esthetics in art and its public orientation and interaction, indeed PR only in its narrowed, most promotional sense?

There is no doubt that the boom of the 1980s brought a sense of euphoria to the way art was perceived, both by the contemplators and the makers. But it would be glib to see this as the sole factor in the artists' willingness to enter into public projects and to entertain the purposive siting and deployment of their work within society. Certainly it is a mark of art in urban spaces that it is to be found *on the market place* in all senses of the term, both the town's and its own. Possibly this, too, is the source for the distrust which motivated Buchloh when he unhesitatingly put the *Kirschensäule* into the general context of capitalist smokescreen. What is certain is that the presumed share of the private economy in such interventions shore up some of the reservations passers-by and users and inhabitants of the immediate surroundings tend to have toward the artist's subjectivity, even where the outdoor works, as in Münster, are in the main set up only temporarily and the artists receive only a modest design fee, with no purchase following.

On the other hand, in considering whether the *Skulptur Projekte* have achieved their local cultural-political aim of bringing about a more sensitive handling of the urban sphere and the art in it, one may be persuaded to skepticism – of opponents of the exhibition wresting 'reality' onto their side between sculpture project campaigns by ameliorating town-center squares with park furniture, for example, so canceling out any potential these sites might have had for orchestration by the project; or outdoor initiatives with popular artists are nurtured to make it quite plain where sanctioned taste lies. Many of these permanent interventions in the urban landscape, including second-rate sculptural fountains (one such having only recently been installed at the railway station, so visitors are alienated early on), have been planned in circumvention of the responsible arts policy committees by being declared as objets d'art; or architects provide stylish leisure zones, and artist associations artistic knick-knacks of calculated parochial standard, to the annoyance not only of visitors to the *Skulptur Projekte*; while on local art-in-architecture panels, the curators often have to admit defeat and must temper their euphoria at this city's having become a venue for international contemporary art not for one, but two occasions to date, with the denial experienced in some lasting ricochets. The purchases that have resulted out of the campaigns, three in 1977, some twenty in 1987, can only provide qualified comfort in this dilemma, for the advantages of the city for exhibitions of outdoor sculpture are a disadvantage when it comes to permanent siting. At any rate, the curators have set themselves the aim of

not overloading the town with purchased works, with the consequence that many a parochial solution finds a permanent site whereas most of the art of international esteem leaves the stage on the close of the respective campaign.

Another palpable dampener on the campaign of 1987 was that a project of Hans Haacke's which was to be realised on city corporation buses, could not take place. Instead of advertising blurb, the outside flanks of the buses were to have pointed to the equipping of South Africa's Apartheid Police, as then still was, with Unimogs, supplied, like the buses that bore the message, by Mercedes-Benz. But, as a decree allows commercial advertising on buses, but explicitly forbids the expression of political opinions – a ruling which is itself nothing if not a political decision – the project could be documented only in the museum and in the catalog. That the permissible scope for political statements in art interventions is smaller than that conceded to advertising was an unwelcome conclusion to have to draw out of this confrontation. Haacke's ironic reference to place, focusing even more than Michael Asher's on vehicles and set to strike a link between the mutually very distant markets of an industrial concern, came to grief on an unexpected boundary to the artistic freedom of expression. The primacy of consumerism is evidently more assertive on advertising surfaces than on its trading platforms.

Unexpectedly, however, it also became evident that the urban sphere is a functioning narrative space still, only the tales are not articulated now in stone and marble but on posters and advertising lines. As such these had already begun to contest the space that the façades gave architectural sculpture back in the nineteenth century. The city continued to assert its property as a narrative space even after the internalisation of the media and the end of narrative architecture. Poster pillars and hoardings exploit public space as a multiplier of contact, a venue which draws beholders constantly; and as soon as they came onto the scene, public transport vehicles were put to the service of poster-style advertising. The only mass medium unable to take the common path into its target public's homes and obliged to meet it literally *en route*, the billboard is modernism's contribution to the city as a narrative domain.

On its ubiquitous advertising surfaces today, the urban space is illustrated with the serial strips in praise of the lust for consumption – though not as stories specific to the particular towns where they are displayed, but the standardized trading signs of blanket campaigns. Their shrill beckoning and exaggerations turn the public domain into a realm of importunate urging and communications of vested interest amongst which the passer-by sees himself reduced to his role as a consumer, with little at hand to be able to parry the finesses of the barrage of quick-change icons. The pioneers of the *décollage* who, like Raymond Hains, began making their poster tear-off pieces in the 1950s, are likely even then to have perceived this media upstart and profiteer of modernization as an unwelcome competitor as was made clear in 1987 to Haacke's detriment.

[480]

Prospect 1997

If one surveys the projects that have been proposed for the third show and dares venture an assessment of the campaign – two months before the opening – then several striking differences from the predecessors can already be made out. In 1987, relation to the site was the main feature; there were very few works in the form of 'artist services'. Only Scott Burton's park benches were outright instances of the trend, with, perhaps, the strange seats of Franz West or Siah Armajani's Research Garden as closer relatives. In contrast, Jenny Holzer's inscribed stone benches and the bus stop Dennis Adams supplied with his pictures mixed the invitation to use their services so markedly with historical and literary associations that they became a medium rather of irritation.

In the current campaign, a complete reversal of these proportions is to be seen: whilst some outstanding works represent a narrative and poetic connection with the locality, they are comparatively few in number, whilst works offering a service are numerous. Per Kirkeby's proposal for the 1997 show was to make a brick sculpture, for the first time not only as imitated architecture but as the real, usable thing – in the shape of a cycle shelter for an inner-city parking-lot. The City Planning Office turned the project down, but Kirkeby's second project is also geared to usable architecture and is planned as an enclosed bus-shelter and an acoustic and optical screen between the grounds of a school and a busy road. Tadashi Kawamata is to have a ferry built by the patients of a Dutch withdrawal clinic to carry visitors to contributions on the Aasee – and into the Aasee, Jorge Pardo will construct a jetty ending in a roofed belvedere. Kurt Ryslavy will be exhibiting works by his colleague-in-arms, Georg Herold, as *Verkaufswerk Nr. 17* (Sale Work No. 17) on a transport truck; Bert Theis is building a communication platform and Heimo Zobernig is designing hoardings to advertise the *Skulptur. Projekte in Münster 1997* at access roads. Dan Graham is planning a *Fun House für Münster*; Tobias Rehberger will be running a bar, and had intended to provide a hire-car for exhibition visitors as well. Berthold Hörbelt's and Wolfgang Winter's mineral-water-bottle-crate pavilions will be used as exhibition information centers. Another pavilion had been planned by Claes Oldenburg and Coosje van Bruggen, in the shape of a piece of cheese spiked upon salt sticks. Maurizio Cattelan's plan was to have wine bubbling from two municipal fountains, while Fabrice Hybert was contemplating complete ornamental city trees with useful fruit-trees.

Just as these works appear to fit the category of the catchword *art as a service*, coined as the title to an exhibition of the Schürmann Collection in Munich in 1995, so many others tap subjects exploited by contextual art. 1987 was too early for that genre to play a part in the campaign then, apart from contributions by artists since acknowledged as classic representatives, like Michael Asher, Hans Haacke or Rémy Zaugg. If it is accurate to suppose that the zenith

of site specificity has already passed, and that it is about to degenerate into a new academicism, then one might be led to conclude from the number of art-as-services on offer that the 1997 exhibition were pooling a counter-current in its very latest state. Is it a new trend – *the* new trend?

The foundations for such a straightforward diagnosis are none too sound, and not only because the overlaps with typical contextual art themes would undermine it. Many of the contributions are ambiguous, oscillating between service provision, art contexts and irony. The narrative and poetic tendency continues to be excellently represented this time around, as in the contributions of Janet Cardiff, Maurizio Cattelan, Ilya Kabakov, Marjetica Potrč and Allen Ruppersberg, and there are the instances of services which should not be taken too much at their word; these tendencies have been joined in 1997 by many works which relate to the nature of the exhibition campaign.

Such campaigns have long become part of the stock-in-trade of the art industry, and it was inevitable that artists, especially those who have passed through the school of contextualism, should respond to the tendency of such events to develop laws and unwritten byelaws unto themselves. For this reflective response, the fairground offers a handy metaphor. Of course this is no account of the works in their subtlety, but the use of a Ferris wheel by Gabriel Orozco, of a children's roundabout by Hans Haacke and a puppet theatre by Rirkrit Tiravanija, or the static merry-go-round of Kim Adams, provoke associations which crystallize in the unexpected, pithy metaphor of the fair for the esthetic exceptionality of such exhibition campaigns. Elements of the amusement park, too, flow into the unconcerned 'festivalizing' of the city. A most striking example, had it been realised, would have been the tunnel crossing which Jeffrey Wisniewski planned for Aasee; so are the exotic miniature islands by Andrea Zittel and the *Grotto of the Sleeping Bear* by Mark Dion.

This said, the funfair, the amusement park and the festival are only some of the things that come to mind in contemplating many of the *Skulptur. Projekte in Münster 1997*. It is a charged spectrum between clown comedy and *son et lumière* that numerous proposals and contributions for the *Skulptur Projekte 1997* open the imagination to, in a diversity and perfection that amazes. There is the lantern that talks to passers-by (Tony Oursler); there are sculptures that fly through the air (Ayşe Erkmen); an underground railway ventilation shaft giving forth the typical noise of subway traffic (Martin Kippenberger); a plot of land that to all appearances wanders over the real estate market (Maria Eichhorn); a walking-stick that squirts water (Roman Signer); a hedge clipped into animal shapes, enclosing the perfect imitation of an allotment (Fischli/Weiss); a telescope in which runs a videotape of the ostensible view before one (Janet Cardiff); a body in the lake (Maurizio Cattelan), over which there is a second full moon (Isa Genzken); blinking signal lights as an emblem of cultural sway for the artists and curators involved in the project (Fabrice Hybert); a

caravan camp in which nobody lives (Atelier van Lieshout); a *Drive-in Crash Test* on top of a multi-storey car-park (Olaf Metzel); a fictitious bar with a real counter (Tobias Rehberger); a false Voltaire in the genuine museum (Allen Ruppersberg); the mantle of a cycle tyre, painstakingly laid over a street-lamp (Andreas Slominski) and cycles which travel backwards (Elfin Wikström/Anna Brag); a project which was not realized scheduled a tree to revolve once a day on its own axis (Charles Ray) – is the city now just a space for the narration of jokes?

In such works an attitude of irony can be discerned toward the campaign for which they are recommended. Further questions would establish whether perhaps such campaigns have bred their own art. Is the archaic circus-like animism which drives two full moons, the water-gushing walking-sticks, rotating trees and streetlamps which speak to passers-by, an urban charade whose aim is now to festivalize art, too? Is there any more to these pointed works than their indisputably professional show effects? The late nineteenth century, we know now, was full of regret about the esthetics it had generated – exhibition art. Should the late twentieth century regret its campaigning art?

This would not appear to be the case in Münster. Following *Platzsuche*, the search for location, of 1977 and the convincing 1987 campaign, with its location narrative, another contemporary theme will be clarified and become tangible, namely, the *End of Urban Euphoria*. The hopes for which modern art was continually shooed into the city, there to ameliorate or at least paper over the many crises and chasms of mass conurbation have, after the high flights of site specificity, turned into scepticism. This scepticism will not be cynically played down in Münster in order to preserve an important market, it is intelligently instrumentalized and its ambiguity unfolded. The intellectual enjoyment of the campaign, perhaps, lies in this. On the other hand, there is a feeling of despondence that perhaps the well-meaning urbanism of the podium discussions and development plans might emerge as intellectual (post-)modern kitsch. Thus an element of perplexity appears to underlie these 'very earnest jests'.

The departure from urban euphoria for the benefit of a meeting of art and urban space, as trenchant as it is non-committal, is not the campaign's only theme, for modern art, to claim any standing, must, above all, speak about its own situation. This is reflected, beyond the element of manifest enjoyment, even in the most light-hearted works in the campaign. Irony grants art not only dispensation from the stringent demands of urbanism, but also from the grandiose overestimation by which the twentieth century has both blessed and burdened it. It is a kind of 'irony of release' which affords relief, not only in this campaign, from the exhausting demands the artists have set themselves, and which society has thrust on them. It is an irony of release which is perhaps no mean final chord to accompany the imminent *fin de siècle*.

Can the exhibition thus be regarded as being representative in a contemporary sense? After the boom of the eighties, the different aspects of irony of release are, indeed, enjoying a boom of their own – but this does not make them contemporary. Just as the service-provision theme in art spans generations, not remaining limited to a few newcomers, so there are other examples which show that the irony of release is older than the euphoria of marketing and publicizing seen in the eighties, to which it appears to correspond. Roman Signer, for example, with his water-gushing cane and mobile city fountain in its transport van which are amongst the most vivid in the campaign, has been working since the early seventies on his themes. Which is not to say that they have always enjoyed high currency. It would be more accurate, then, to say that the 1997 campaign sets another emphasis, without claiming that this heralds any second postmodern era.

From the beginning, Ellsworth Kelly was part of the plans for the 1997 show; this choice of an artist who stands for autonomous sculpture was also integral to particular emphasis. Even though, for lack of finance, his contribution could not be realized, it implies a classical alternative to site specificity; to which the erection of new sculptures by Frank Stella in Jena has lent unexpected new prominence, accompanied by speculation on the return of autonomous sculpture. Carl Andre, Georg Baselitz, Alighiero e Boetti, Richard Deacon, Jeff Koons, Sol LeWitt, Bruce Nauman, Nam June Paik, Lawrence Weiner and Rachel Whiteread are taking part in the 1997 campaign and offer instances of a concept of sculpture balanced more toward the direction of autonomy. Perhaps the most striking example of this is that Franz West, who in 1987, contributed his utilizable seats, this time expressly suggested an autonomous sculpture.

Every accentuation can also be a distortion, admittedly; less in the sense of the exhibition than of this anticipatory summary. The essential aspects of many of the works subsumed beneath the specific categories lie in other spheres, be it the complex urban economy of Maria Eichhorn, the meta-story of Allen Ruppersberg, Hans Haacke's abjuring of the monument or Mark Dion's *Sleeping Bear*. Of course, much is more earnestly intended than it appears in this summary. Art has many levels of use, and only the exhibition itself can make the entire stage visible.

[Text originally illustrated with photograph: Richard Serra, *Trunk, J. Conrad Schlaun Recomposed*, contribution to *Skulptur Projekte in Münster* (1987).]

69 Guy Brett

'Between Work and World: Gabriel Orozco' 1998

The London-based critic and curator Guy Brett (b. 1942), known for his longstanding interest in contemporary art from Central and South America, has been a writer on art, lecturer and exhibition organiser since the late 1960s. Consistent with this background, Brett takes an approach in this essay that is sceptical of the tendency to seek 'antecedents' strictly within a European/North American mainstream. Histories of sculpture often focus on a relatively small and geographically confined set of people and practices in order to construct what Brett regards as over-simplistic, one-sided narratives. Brett instead insists on our taking a more inclusive, world-wide perspective. He is particularly keen to claim importance for a set of practices originating mainly in the Spanish-speaking diaspora, picking out for attention the Argentinean artist Alberto Greco, the Brazilian artist Hélio Oiticica, and the Filipino artist David Medalla. These artists are not to be understood strictly in terms of indigeneity, however. Rather, for Brett, their work can be connected to a stream of artistic thought developed in the middle of the twentieth century within the European modernist tradition. In order to clarify what he means, Brett singles out the Swiss sculptor Alberto Giacometti. Giacometti, understood in this unusual retrospective way, does not simply 'point forward' to the dominance of North American art; more usefully he comes to stand for 'the polemical negation of canons of value and permanence' via an 'ironic embrace of the worthless'. According to Brett, it is this 'ironic embrace' that is drawn upon by contemporary non-western artists, many of whom work with a characteristic 'light touch'. This 'light touch' offers a refreshing alternative to the more usual mainstream, mainly North American conventions of contemporary art, and is particularly evident in the work of the Mexican sculptor Gabriel Orozco. Drawing on Buchloh's analysis, he argues that 'light touch' aesthetics as practised by Orozco should be understood beyond notions such as 'site specificity'.

'Between Work and World' was originally titled 'The Light Touch', and was included in Orozco's 1998 retrospective exhibition catalogue for *Empty Club*, a 1996 multi-media work installed at 50 St James's Street, London SW1. The essay was slightly modified for inclusion in Brett's *Selected Writings* (2004), which is the version reproduced here.

Guy Brett, 'Between Work and World: Gabriel Orozco' (1998), in *Carnival of Perception: Selected Writings on Art by Guy Brett*, London: inIVA, 2004, pp. 96–105.

The two historical streams which seem to me to converge in Gabriel Orozco's work are those of sculpture (a category still holding together despite many changes in practice) and that desire, underlying the experimental impulse in so much twentieth-century art, to 'dissolve art into life'. These streams were

astutely summed up in two sentences which Jean Fisher applied to Orozco in her 1993 essay about him, 'The Sleep of Wakefulness'.[1] In his work can be felt, she wrote, on the one hand, 'a profound meditation on the act of making' and on the other hand, 'the question of what may constitute the limits of recognizability of a work'. Conventionally, these categories would seem to exclude one another. But the inherent paradox may be very much to the point.

Take, for example, Orozco's *Arena sobre la Mesa* [Sand on Table], 1992. I see it simultaneously as a modest, random occurrence of everyday life and a sculpture. It seems to be very much a proposition within recent sculptural trends, beginning perhaps with *arte povera:* the 'poor' material (sand), the everyday support (table) and the beautiful equalization between the material displayed on the pedestal (the maximum which gravity will allow to stay there) and the surrounding world, fused with the ancient figure of the pyramid (a form common to Egypt and to Central America). But I immediately realize that this sand and table would not have nearly the same effect if displayed as an object in an art gallery. The warm sunlight, the random impressions of people's feet in the sand, give the poetic inflection of the 'world', 'life', which enables us to internalize the image in a different way. In particular we seem to shortcut the institution of art and to be placed directly in that common area of experience we all share. The lightness of touch by which Orozco does this is what we especially enjoy.

At the same time I cannot help realizing I am looking at a photograph. This photograph is the sign of a perception taking place in the midst of life (albeit stimulated by previous works of art), but it is also an object which may be displayed in a gallery, bought and sold. Where does the freshness of the perception, which is basically a prolongation of the act of pointing (as if we were walking with Orozco and he saw the object in front of him, or put it together from materials that were lying around), where does this moment begin to cede to the demands of the marketable object? If Orozco simply kept his perception to himself in the act of walking around, thinking and feeling, there would be no communication. But nor would there be if the institutionalization of the object obliterates that act of perception.

Looking for antecedents, Orozco's interventions have most often been interpreted in the stream of European and North American sculpture. Benjamin Buchloh, for example, in the course of two questioning, deeply thought-out essays on Orozco's work, has seen it as a derivation from, but radical 'inversion' of, positions reached by the likes of Bruce Nauman, Richard Serra, and Tony Cragg.[2] While true, this seems to me to be only a part of the story. Orozco can be related to another stream, already flowing for many years, which connects artists originating outside the European/North American mainstream, and which has been profoundly concerned with questioning the

art/life boundary, the 'act of making', and the 'limits of the work'. In fact, a practice as specific as walking the streets and designating portions of reality within the conceptual framework of a political-poetic vision can be found among these artists.

It would include the activities of the Argentinian artist Alberto Greco, a rebel against every form of institutionalization, who, in 1962, proposed his *Vivo-Dito*. Partly inspired by the example of Yves Klein, Greco would carry a piece of chalk with him to draw a line around an object or person in the street and sign it with his name (*Vivo* = living; *Dito*, derived from *dedo*, a finger = the act of pointing). Greco wrote: 'The artist will not show any longer with the picture but with the finger.'[3] In the early 1960s such behaviour still had the implications of madness or effrontery, and involved Greco in some narrow scrapes. The Brazilian artist Hélio Oiticica carried out in the mid-1960s, among other projects, his 'appropriations', designating various found objects within his generic category of *Bólides* (fireballs or energy centres in Portuguese). Some were given the qualifying subtitle of *Estar* ('to be' as a quality of things), and the artist explained their rationale: 'There is complete accessibility here for whoever arrives; no one is constrained by being in the presence of 'art'... 'things' are found, which are seen everyday but which one never thought to look at. It is a search for oneself in the thing.'[4] Oiticica also had a general notion of inspired findings in the flux of the streets which he liked to call *Delirium Ambulatorium*. Then, as a third example, there is the Filipino artist David Medalla, with his ongoing nomadic series of *Impromptus* (c.1979 onwards), seizing in the photographic instant a hidden meaning in a particular place/time.

My intention is not to make divisions between artists of different geographical origins, but to create a reorientation of connections. In fact, the positions just mentioned in turn rebound and reveal a tradition within European art, even within sculpture, which revolved around the polemical negation of established canons of value and permanence, and an ironic embrace of the worthless. For example, Alberto Giacometti, at a certain moment in his 'surrealist' phase, produced what he called *Disagreeable Objects*, 'objects without base and without value', in his own words. What Giacometti had to say about the wooden carved plane with two protuberances called *Object To Be Thrown Away*, 1931, is very interesting:

> It was no longer the exterior form of things which interested me but rather what I felt in my own life.... I didn't want to create a figure which looked realistic on the outside, but wanted to experience life and to create only those forms that really affected me, or that I desired.[5]

Giacometti set 'experiencing life' against the traditional practices of art, and his talisman of this desire was a sort of ugly thing which would not fit or function within established, expected protocols, 'mobile and silent objects' as he also called them.

The conundrum is that life and art are not two separate entities but are continually creating one another. Subject/object and active/passive are similarly pairs of opposites which cannot exist without each other. There are the objective facts of the environment around us, but there are also each person's subjectivity and deep individual psychic response which make them alive to one aspect and blind to another. 'Life', in this sense, is as much fantasy and dream (which may be shared of course) as solid reality. Jean Fisher's encapsulation of Orozco's process as 'a meditation on the act of making' could be expanded and reciprocated to include 'a meditation on the act of being made'. All the objects or situations in the street which seem to be objectified by the artist are simultaneously creating him. This indication of the importance of reciprocal relationships is highly appropriate, given the yielding, 'feminine', aspect of Orozco's sensibility which delights in imprints.

Piedra que Cede [Yielding Stone], 1992 (apt oxymoron!), Orozco's 'disagreeable object', is one obvious example: the plasticine lump which rolls and picks up imprints and debris wherever it is, a clear self-image since its weight has been made the same as the artist's. Orozco has conjoined active and passive in an earlier work, *Mis Monos Son mi Corazón* [My Hands Are My Heart], 1991, the heart-shaped piece of clay made by the clasping impress of his two hands. Indeed, the metaphor of the heart (centrality, feeling, life, 'what really matters') is made a nexus where earth, body, the will to form, and the surrender to being formed, meet equally.

It is a precarious matter, on the edge of dissolution. The beauty of another work, *Pelota Ponchada* [Pinched Ball], 1993, lies in its light touch, its marriage of sculptural reference and psychic make-up. We all know these punctured footballs which have been kicked about the streets and then abandoned. A cipher of activity and competitive play is made into a yielding receptacle which has passively received some rain water which now calmly reflects the sky, a delicate image in subtle tones extending (accidentally? deliberately?) to the pale blue/green/grey of the asphalt on which the ball has been photographed.

The nagging contradiction waiting in the wings is that the light touch which captures an instant of perception out of the flux of life can be reduced to boredom and inertia by repetition. The image becomes emptied and exhausted by consumption, just as a fashionable word, so fresh when first coined, comes to signify nothing but the pretension or conventionality of its users. This hardening inevitably misses the life-experience, the process of

walking, thinking, feeling, experimenting with the environment, which is vividly recorded, for example, by words and pictures in Gabriel Orozco's series of ongoing notebooks. One way out of this impasse is to make the consumer also a producer. This would be another aspect of thinking in relationships and reciprocities rather than either/or categories, and admitting that every person is multi-faceted.

Many of the participatory and collaborative proposals by artists in the 1960s and early 1970s (which have never been given their due in art history), provided structures in which active and passive, individual and collective, producing and spectating, ephemeral and durable, were woven together. They leave a powerful and demanding legacy, summed up, for example, in writings by Oiticica in the 1960s where he spoke of 'the quest for individual liberty, through increasingly open propositions, aimed at making each person find within themselves, through accessibility, through improvization, their internal liberty'.[6] Can we follow this call for 'increasingly open propositions', in today's inevitably changed conditions? Clearly there must be a number of models for reciprocity, as a condition of avoiding the dogmatic and formulaic, and staying close to life-experience.

One of these models may be to explore with greater subtlety the reciprocity – and disjuncture – between the 'art' space and the 'rest of the universe'. A motive which runs like a thread through many of Orozco's works – found, made or a combination of the two – is the desire to find figures of cosmic generality, astronomical/mathematical figures of movement and space, within the accidental and the everyday. This was early seen in *Turista Maluco* [Crazy Tourist], 1991, the planetary system of single oranges arranged and photographed on the stalls of a ramshackle, deserted popular market and its metropolitan variant, *Home Run*, 1993, where the public looked out from the Museum of Modern Art in New York to see the work in the windows of neighbouring apartments.

Our earlier mention of the extreme selectivity of any view of the 'accidental' and the 'everyday' (a testimony to its immense flux) leads to the observation that in Orozco's 'everyday', people, at least until very recently, have rarely appeared. Orozco's is a sculptural everyday. There are sometimes animals, but mainly objects. In fact it becomes part of the poetics of a light touch to evoke the human through inanimate objects. It stresses that we exist with objects in a state of interdependence and reciprocity, for better or worse. In one of his notebooks Orozco speculates about 'social space/time in the form of an object' (*Oval Billiard Table*, 1996, could be an example, one in which the hand is invited to intervene). This is only a device, of course, which could, and perhaps has, started to change, although the introduction of the human image in Orozco's work remains an intriguing problematic.

The boundary between the 'art' space and the 'rest of reality' is a very mobile thing since its exact location is continually being contested between the liberating forces of imagination and the stultifying tendencies of the institution. When I think of this contest I think of two of Orozco's works particularly, which are themselves mobile and silent (to borrow Giacometti's terms) and, in an important sense, 'empty'. Both *Caja de Zapotos Vacía* [Empty Shoebox], 1993, and *Estacionamiento* [Parking Lot], 1995, are marvellous instances of lateral thinking – illuminating the field by taking a position to one side of habit – and of the application of a Zen, or guerrilla, tactic: turning to one's own advantage the powers that be.

Caja de Zapotos Vocía has frequently caused considerable annoyance when it has been exhibited. Directors of busy public museums despair of the consequences of insuring as an artwork a nondescript open box which Orozco insists on placing on the floor or in a corner where it could easily get kicked or thrown away. There has sometimes been the complaint (not least at the Venice Biennale in 1993) that Orozco has lowered the tone of a would-be important mixed show by submitting a slight piece of work. Paradoxically, the modest empty box can become in one's mind the opposite: an expansive figure of receptivity, openness, possibility, especially by contrast with some of the more laboured efforts around. In the atmosphere of 'artistic jousts' that these group exhibitions have become, rather like the poetic jousts of the past, to accomplish much with minimum effort counts for a lot, and raises the pitch of the vitality that all are seeking.

Estocionamiento was the subject of a 1995 Orozco exhibition at the Galerie Micheline Szwajcer in Antwerp. He simply put out a sign opening part of the gallery as a parking space to any passing motorist who happened to be cruising the city centre looking for a convenient place to stop. 'Lateral thinking' is perhaps synonymous here with a 'light touch'! As well as a sophisticated addition to his 'yielding' images – opening oneself and the art space to the random intrusions of the anonymous city – Orozco produced an allegory of the deflation of artistic pretension which includes the essential ingredient of self-deprecating humour. In fact he perpetrated a joke far funnier and more pointed than any satirist of either the absurdity or the 'emptiness' of modern art has managed to produce. It was encapsulated in the idea that an anonymous passer-by, in the act of blithely solving a banal problem of everyday urban life should unconsciously contribute to the elucidation of a crisis in the direction of contemporary art. Such a choice of alternatives can either lead the way to a pointless, self-referential trap or open up possibilities for a vitality of art-life interrelationship which is yet to come.

The anonymous motorist and his symbiotic car slip into the role of artistic protagonists by crossing a threshold between one context and another, contexts

which are as much mental as physical and may be as invisible to one person as they are loaded with meaning to another. This is the reality we live, the multi-faceted simultaneity of our social being in which we continue to insist on our unique individuality. What but an agile, ironic and tender consciousness can negotiate between the two?

[This essay was originally accompanied by the following photographic illustrations: Gabriel Orozco, *Arena sobre la Mesa* [Sand on Table] (1992); Alberto Greco, *Vivo-Dito* (1963); *Pelota Ponchada* [Pinched Ball] (1993); Gabriel Orozco, *Caja de Zapatos Vacía* [Empty Shoe Box] (1993); Gabriel Orozco, *Estacionmiento* [Parking Lot] (1995); Gabriel Orozco, *Piedra que Cede* [Yielding Stone] (1992).]

1 Jean Fisher, 'The Sleep of Wakefulness', in *Gabriel Orozco*, Kortrijk: Kanaal Art Foundation, 1993.
2 Benjamin H.D. Buchloh, 'Refuse and Refuge', in ibid., and 'Gabriel Orozco: The Sculpture of Everyday Life', in *Gabriel Orozco*, Zurich, London and Berlin: Kunsthalle, ICA and DAAD, 1996.
3 Alberto Greco, 'Manifesto Dito dell Arte Vivo', 24 July 1962, 11.30am. Reprinted in *Alberto Greco*, Valencia: IVAM Centre Julio Gonzalez, 1991, p. 291.
4 Hélio Oiticica, 'Positions and Programme', 1966, in *Hélio Oiticica*, Rotterdam and Paris: Witte de With and Galerie du Jeu de Paume, 1992, p. 105.
5 Alberto Giacometti, letter to Pierre Matisse, 1947, quoted in *Alberto Giacometti 1901–1966*, Vienna, Edinburgh and London: Kunsthalle, Scottish National Gallery of Modern Art and Royal Academy of Arts, 1996, p. 146.
6 Hélio Oiticica, 'Appearance of the Super-Sensorial', 1967, in *Hélio Oiticica*, op. cit., p. 127.

70 Susan Hiller

' "Truth" and "truth to material":
Reflecting on the sculptural legacy of Henry Moore' 2003

Susan Hiller (b. 1940) is known as both an artist and a writer. Since the 1970s, as an artist exploring through installations and other works the hidden resonances of the everyday in western culture and as a commentator on the reception of non-western art (for example in the 1989 collection *The Myth of Primitivism*), she has drawn on her own early anthropological training. Her essay on Henry Moore reflects both of these aspects of her career, which are, as she points out, crucially interrelated. Hiller acknowledges the problematic colonial context of Moore's interests in African and Aztec sculpture for his development of the concept of 'truth to material', but calls for a reappraisal of this impulse in its potential for a 'genuine multiculturalism' and for the ongoing possibilities of such cross-cultural influences today.

Hiller's own reconfiguring of the notion of 'truth to material' in this essay conceives of it as a means of juggling and recombining pre-existing 'cultural artefacts', the existence of which is often highly dependent upon a kind of anthropological distance. While remaining 'true' to the 'found' pieces of culture used in her work, Hiller also claims to bring out their unconscious dimensions through juxtaposition and classificatory paradigms, as epitomised by her 1992 installation *From the Freud Museum* (with its over-determined reference to the psychoanalytic tradition). In this way, Hiller strikingly reorients the legacy of Moore, which for her can only be an 'uncomfortable' one, away from discrete, carved and formally coherent pieces of sculpture, towards collections of potentially banal and throwaway objects, whose material presence carries a complex psychic and anthropological charge. Bringing together a variety of 'things', her work cuts across institutional and disciplinary boundaries, troubling existing categories and definitions: 'I suspect it is sculpture', Hiller tellingly suggests. Her text is notable for the ways in which, instead of positing a distinct ideological break with earlier 'modernist' sculpture, it intimates a continuation of what could be called an 'authentic' poetics of sculptural objects and materials, as things that are found rather than manipulated. An earlier version of this text was delivered as a lecture in 1998, at a conference held at the University of East Anglia to mark the centenary of Henry Moore's birth.

Susan Hiller, ' "Truth" and "truth to material": Reflecting on the sculptural legacy of Henry Moore', in Jane Beckett and Fiona Russell (eds), *Henry Moore: Critical Essays*, Aldershot: Ashgate, 2003, pp. 67–80.

When I was invited to publicly consider some aspects of Henry Moore's work, I imagined there would be a number of British sculptors participating in the discussion, sculptors whose work could be seen as having a direct historical relationship to Moore, or sculptors who have inherited a critical and institu-

tional context defined by his continuing influence. The rather special place of sculpture in Britain today is a testament to the pervasiveness of a set of terms, almost assumptions, from which some very interesting contemporary British artists have taken their points of departure.

Thinking about a father figure, and about a relation to a father figure, isn't easy. Maybe that accounts for the absence of sculptors in these conversations about Moore's influence.[1] And as for me, it is obvious that I've never been included, nor (until now) included myself in the lines of descent traced from Henry Moore. Yet I have always used a concept of 'truth to material' which, accurately or not, was invariably attached to his work when I was a student.[2] Certainly I have used this idea against the grain and on the margins of what is defined as the practice of sculpture. But ideas have to begin somewhere, and for me this idea started with Moore. Looking backwards, I need to acknowledge an influence which feels, to be frank, uncomfortable.

That this notion of 'truth to material', attributed to Moore, stuck with me may be a trick of memory or a misunderstanding on my part or even on the part of those who taught me. Moore was everywhere during my childhood, a conservative, figurative artist (we thought), a sort of official artist. He was English but his work was ubiquitous in the United States, not just in exhibitions but also in photographs in magazines and books. Looking at reproductions of works cast in bronze I couldn't understand what this formulation of 'truth to material' could possibly mean. I was intrigued to discover only recently that Moore himself did not have any doctrinaire attachment to the idea and that in terms of his work in bronze he seemed to want to free himself from any proscriptive interpretation of it. If 'truth to material' was taken as the overriding criterion of value in sculpture, he said, 'a snowman made by a child would have to be praised at the expense of a Rodin or a Bernini'.[3] But the idea haunted me, quite possibly because I just couldn't understand what it meant. On the one hand, it was so terribly obvious. Naturally, one would not try to make in stone what could be done in plasticine. Friends of mine spent many hours looking at blocks of wood trying to decide what figure dwelt inside, waiting to be let out. It was interesting but hopeless. I didn't try. I made a work in cast stone which retained the block-like shape of the shoebox used for casting, mainly because I couldn't see anything else to do with it. No one liked it much. I didn't make any more objects after that for years.

Having decided I was not an object-maker I went on to study anthropology. Here I have to acknowledge another link with Moore, and one that needs to be explored more fully.[4] Moore was an enthusiastic explorer in the exotic worlds represented at the British Museum. Like Henri Gaudier-Brzeska, Jacob Epstein and the Paris modernists before him, he was immensely stimulated by what he called 'an inexhaustible wealth and variety of sculptural achievement

(Negro, Oceanic Islands, and North and South America), but overcrowded and jumbled together like junk in a marine stores, so that after hundreds of visits' he could 'still find carvings not discovered there before'.[5] It is in writing about these objects that Moore's theorising about 'truth to material' and sculptural form emerges clearly. In this essay for *The Listener*, published in 1941, there are close parallels to the way Roger Fry wrote about such objects much earlier, in the 1920s.[6] There is also a clear relationship to the ways Gaudier-Brzeska considered them, although I have not found any mention of Gaudier's own writings and works in Moore's texts. Perhaps it was strategic for him to appear un-fathered.[7] Or, perhaps, although he said that he always had particular respect for artists who wrote about art (citing Cézanne's critical statements as having more significance than anything Ruskin ever said, although he much admired Ruskin's writing), Moore had internalised Gaudier's influence so much that it had become part of himself. Maybe Sigmund Freud was right; we need to consider the cannibalistic aspect of father – son relationships. Negative spaces and shadows, what's left out, what's obscured, as well as what's acknowledged and brought to light, seem important here.

Moore wrote in 1941 that '[o]ne of the first principles of art so clearly seen in primitive work is truth to material; the artist shows an instinctive understanding of his material, its right use and possibilities.' Discussing Mexican sculpture, he expanded at length:

Its 'stoniness', by which I mean its truth to material, its tremendous power without loss of sensitiveness, its astonishing variety and fertility of form-invention and its approach to a full three-dimensional conception of form, make it unsurpassed in my opinion by any other period of stone sculpture.[8]

Ten years later, during the Festival of Britain, the Colonial Office sponsored a major exhibition entitled 'Traditional Art from the Colonies'. Asked to comment on the relation between artist and material in the works exhibited, Moore responded:

the material is dominated by the artist in almost every case. The soapstone figures from Sierra Leone have a quality of stoniness about them because the artists have avoided the more deeply carved and slender forms which are easily possible in wood, but they show a mastery of the possibilities of stone; they are not just incised lumps of stone – but have forms fully realised in the round. In most of the wood carvings the sculptor has imagined something which has no relation to the original form of the tree trunk.[9]

No wonder the idea of 'truth to material' seemed confusing to me when I was young, for it contained contradictory elements.

In quoting Moore and rereading Fry, whose writings on ethnographic arts had influenced Moore's own, I have had to try to ignore the colonialist attitudes, the 'primitivism', and let's face it, the racism so typical of the period. I don't like talking about this, although I've done so many times in the past. Frequently my remarks have been interpreted as an attempt to attribute blame. So I want to emphasise my conviction that, as full participants in their society, artists always make works that express the beliefs and values of their society, carrying them forward in time. But simultaneously, by ignoring, enhancing or contesting some other themes in their culture, artists are also actively involved in changing their society and in reflecting possibilities of change. The works of artists function as mirrors to their societies, and it would be foolish to blame the mirror for the image it reflects.

When I first arrived in England at the end of the 1960s I had given up anthropology and was trying to figure out how to approach 'doing art'. To earn some money, I gave lectures at various art colleges drawing parallels between the art moves of early modernism and specific ethnographic styles. In these lectures I was critical of what I saw as unacknowledged and literal borrowings from the arts of Africa, Oceania and the Americas by European artists in the early modernist period. I argued that the enlargement of European aesthetic horizons in the modern period through the importation of visual ideas originating in the colonies, suggests an increasing recognition by artists that the artistic resources of those lands and peoples were just as available for exploitation as their mineral and agricultural resources. The moment in 1905 when Picasso realised that African art could provide a source, a resource, for his work, is paralleled many years later by Moore's account of his own 'discovery' of the 'inexhaustible wealth' of sculptural ideas in the ethnographic galleries of the British Museum and in photographs in books about Africa, Oceania and the Americas. These mythic moments of discovery bind together the imperialist conditions of possibility with the appropriative strategies of modernism.

I would like, now, to begin to work on this point from a different angle, to emphasise a different register, because having said all that, I can see that another perspective on these mythic moments is also possible. The 'moments' spotlight the fraying edges of Western society, marking the symbolic beginnings of a dissolution of cultural boundaries, an acceleration of imported cultural influences and a mingling of populations which is unprecedented. There is today a real optimism in my wish to stress the intuition that different meanings should be attributed to those famous artistic 'discoveries' by artists such as Picasso or Moore, 'discoveries' that echo colonialist attitudes at the same time as they prefigure and enable the increasing hybridisation of Western

culture, leading perhaps – it is too soon to say – to a genuine multicultural-ism. This hopefulness should not be heard as a naïve misunderstanding of the reality of the inequalities of wealth and power in the world. But if, *if* there is any movement towards revoking the authorial, curatorial, art-historical one-sidedness of colonial discourse, then the ambivalent mixture of admiration with unscrupulous 'borrowing', typical of Picasso, Brancusi, Giacometti, Klee, Kandinsky, Epstein, Nolde, Moore and so many other artists, points forward toward new social trends in the West as well as backward toward classic colonialism.

Here I need to mention my own belated recognition of the powerful lure of African and Mesoamerican art in my decision to give up anthropology and try to figure out how to be an artist. The way I came to be an artist and the kind of artist I became would not have been possible without a vaccination composed equally of ethnographic objects and modernist objects. My decision always to use cultural materials as starting points, almost always materials from our own society, was provoked equally by ethnography and by modernist art history. In both these fields, looking at the 'other' yields misunderstand-ings which are valuable primarily for what they can tell us about ourselves.

I explain the guiding principle of my work to myself as 'truth to material'. This seems to mean somewhat different things to me at different times, just as it did to Moore. But I need to be careful here, because I don't want to give the impression that I know everything about my work. It's necessary to figure out ways to talk about my work that don't make it seem as though it's already completed and understood. I have been explicit about the fact that I use cultural artefacts as basic materials: there is nothing raw or 'natural' about my starting points. At the same time, I am not transforming them into anything else. I might create juxtapositions, series, assemblages and collec-tions, video installations, paintings or works for groups of people to enact, but I don't disguise the main elements, the cultural materials themselves.

The formal aspect of each of my works comes about through something essential in the initial materials. That's why each work has its own look. The materials that attract me seem to be ones that have a lot to say, and I col-laborate with them to say it. I am interested in making visible suppressed or repressed meanings, hidden or unacknowledged aspects of what can be dis-covered through looking hard at what already exists in the world of cultural objects. Sometimes I say I'm exploring the unconscious of culture, although I realise this is rather pretentious. The relationship between finding and making is very intricate. Although I'm aware of the extent to which my work on and with the materials changes them, I feel committed to maintaining the integrity of their origins, as a sign. My work is very personal, and I would rather think of it as poetic than scientific. Even when adopting classificatory modes I know I

am not providing knowledge any more than I am providing entertainment. Art is something else, perhaps an area where the possibility of meaning is framed and collaboratively, collectively, determined.

In a recent work entitled *From the Freud Museum* I have returned to the museological formats of some of my earliest projects that marked my transition from anthropology to art. The seduction of the museum is something we are all well acquainted with. I have exploited this since the early 1970s to structure several varied works. Like Moore, I experienced ethnographic objects in museum displays and archives and as illustrations in books and magazines, as untouchable objects of desire.

While what to do about what's out of sight or invisible is a dilemma faced by many contemporary museums, my 'museums' have concentrated on what's unspoken, unrecorded, unexplained and overlooked, on the gaps and overlaps between content and context, dream and experience, the ghosts in the machine. The title of the entire piece, *From the Freud Museum*, looks back to my experience of creating the first version of the installation at and for the Freud Museum at 20 Maresfield Gardens, London, Sigmund Freud's last home. In a broader sense, I feel the title also refers to something else, to a situation or a place that inspires a particular kind of self-awareness, an intensely personal recognition of living inside a specific, historically determined culture. For me it's appropriate to call this place 'the Freud Museum'. Of course, I'm not its only inhabitant.

On one level, my vitrine installation is a collection of things evoking cultural and historical points of slippage, psychic, ethnic, sexual and political disturbances. Individual items in my collection range from the macabre through the sentimental to the banal. Many of the objects are personal, things I've kept for years as private relics and talismans, mementoes, references to unresolved issues in earlier works, or even as jokes. The little 'Drink Me!' bottles of water which I collected from the springs of Lethe and Mnemosyne (Forgetting and Remembering) are at the heart of my work in this vitrine installation. Sigmund Freud's impressive collection of classical art and artefacts inspired me to formalise and focus my project. But if Freud's collection is a kind of index to the version of Western civilisation's heritage he was claiming, then my collection, taken as a whole, is an archive of misunderstandings, crises and ambivalences that complicate any such notion of heritage. It might be seen as an attempt to merge and transmute art, ethnography and psychoanalysis. I suspect it is sculpture, although I won't dwell here on the formal elements, space and time, shape and substance.

I worked on *From the Freud Museum* for five years. My starting points were artless, worthless artefacts and materials: rubbish, discards, fragments, souvenirs and reproductions which seemed to carry an aura of memory and to

hint they might mean something, something that made me want to work with them and on them. I've stumbled across or gone in quest of objects, orchestrated relationships through the use of museum devices like captions and labels, and I've invented or discovered fluid taxonomies. Archaeological collecting boxes play an important role in the installation as containers or frames appropriate to the processes of excavating, salvaging, sorting, naming and preserving, which are as intrinsic to art as to psychoanalysis and archaeology.

Not editing out and not forcing strange juxtapositions and unanswered questions to conform to theory is an aspect of my style, almost a signature. I'm interested in a perspective where figure-ground relationships can be allowed to shift. *From the Freud Museum* is structured by the gaps that punctuate it. The not-said matters. Like all my work, it aims to clarify a shared situation by providing space where viewers can experience their own roles as active participants, as collaborators, interpreters, analysts or detectives.

[Text originally accompanied by the following photographic illustrations: Chacmool, Toltec-Maya, 900–1000, Museo Nacional de Antropologia, Mexico, photograph reproduced in Herbert Read, *Henry Moore*, 1934; Henry Moore, *Study of Masks*, pencil and chalk, Notebook No. 3, 1922–24, AG. 22–24v; on the recto of this drawing is a pencil study of birds copied from a reproduction of an Inca pot in Ernst Fuhrmann's *Reich der Inka*, 1922; Susan Hiller, *From the Freud Museum,* 1992; Susan Hiller, *From the Freud Museum: 006 Chamin'ha/House of Knives,* collected 1992, photocopy of Classic Mayan calendar, glyphs, numerals and day names, modern obsidian blades, in customised cardboard box, labelled, Tate, London; Susan Hiller, *From the Freud Museum: 010 Ashiwi/Native,* boxed 1993, photocopied poem from American primary textbook, Native American potsherds in polythene bags in customised cardboard box, Tate, London; Susan Hiller, *From the Freud Museum: 011 Eaux de vie/Spirits,* annotated 1993, text by Robert Graves; spring water collected by the artist from Lethe and Mnemosyne in antique bottles corked, sealed and tagged in customised cardboard box, labelled; Susan Hiller, *From the Freud Museum: 023 Provenance/Source,* located 1994, photocopy depicting African tribal art objects, miniature weapon bundle, in customised cardboard box, labelled, Tate, London; Susan Hiller, *From the Freud Museum: 025 Occult/hidden,* portrayed 1994, text from the Winnebago *Medicine Rite;* four miniature masks, tagged, in customised cardboard box, labelled, Tate, London.]

1 Based on a paper given at the 1998 conference on Moore, 'Place–Body–Script', this essay retains the conversational tone of the presentation. The notes have been expanded by the [original] editors and slightly revised for this publication by Susan Hiller.
2 Moore expounded his ideas on 'truth to material' in his essay of 1939, 'The Sculptor Speaks', *The Listener*, 18: 449, 18 August 1939, pp. 338–40, reprinted in Wilkinson, Alan (ed.), *Henry Moore: Writings and Conversations*, Aldershot and London: Lund Humphries, 2002, pp. 193–8, and extracted in James, Philip (ed.), *Henry Moore on Sculpture*, London: Macdonald, 1966, pp. 62–8. As Philip James pointed out, Moore modified his ideas on this principle (James, p. 14).
3 Sylvester, David, *Sculpture and Drawings by Henry Moore*, exh. cat., London: Tate, 1951, extracted in James, p. 113.
4 As a young woman, Susan Hiller studied art and continued this as a minor subject

while at university; later she studied for a PhD in anthropology and conducted field work in Central America, until she experienced a 'crisis of conscience' and disillusionment with professional anthropology. (Lucy Lippard, Preface, in Einzig, Barbara (ed.), *Thinking About Art: Conversations with Susan Hiller*, Manchester: Manchester University Press, 1996, p. xi.) Susan Hiller's preface to the collection of essays entitled *The Myth of Primitivism*, London and New York: Routledge, 1991, discusses in more detail her decision to leave anthropology and become an artist.

5 Moore, Henry, 'Primitive Art', *The Listener*, 25 (641), 24 August 1941, pp. 598–9, repr. in Wilkinson, *Henry Moore*, 102–6, p. 104.

6 Moore noted that 'Fry in his essay on Negro Sculpture stressed the "three-dimensional realisation" that characterised African art and its "truth to material". More, Fry opened the way to other books and to the realisation of the British Museum. That was really the beginning.' Henry Moore, Statement in *Partisan Review*, 14 (2), March/April 1947, extracted and repr. in Wilkinson, *Henry Moore*, p. 44. Fry, Roger, *Vision and Design*, London: Penguin Books, 1920.

7 But he did acknowledge that Ezra Pound's book *Gaudier-Brzeska* was 'a great help and an excitement… written with a freshness and an insight', interview with Donald Hall (1966), extracted and repr. in Wilkinson, *Henry Moore*, p. 151.

8 Moore, 'Primitive Art', repr. in Wilkinson, *Henry Moore*, p. 104.

9 Moore, Henry, 'Tribal sculpture: A review of the Exhibition at the Imperial Institute', interview in *Man*, 51 (165), 1951, pp. 95–6, reprinted in Wilkinson, *Henry Moore*, pp. 106–8, p. 106.

Credits

1: Permission to publish excerpts from the English-language translation of the German text 'Das Problem der Form in der bildenden Kunst' by Adolf von Hildebrand from *Empathy, Form and Space: Problems in German Aesthetics, 1873–1893*, edited by Harry Francis Mallgrave and Eleftherios Ikonomou, has been granted by The Getty Research Institute. Book © 1994 by The Getty Research Institute. All rights reserved. Published 1994. Printed in the United States of America. 2: Reprinted by permission of Random House and Insel Verlag. 3: Permission granted by Solo Syndication Ltd on behalf of the *Daily Mail*. 4: Permission granted by Taylor and Francis Books Ltd. 5: Umberto Boccioni, 'Technical Manifesto of Futurist Sculpture', 1912, reprinted by permission of the publisher from Ester Coen, *Umberto Boccioni*, translated by Robert Erich Wolf (New York: The Metropolitan Museum of Art, 1988), pp. 240–43; English translation © 1988 The Metropolitan Museum of Art. 6: Reprinted by permission of Artists Bookworks, the Regents of the University of California, Peter Read, Gilbert Boudar and the estate of Guillaume Apollinaire. 7: Reprinted by permission of Fannei & Walz Verlag. English translation copyright 2006 by translator, Joachim Neugroschel. 8: Reprinted by permission of The Bridgeman Art Library on behalf of the Eric Gill Estate. 9: English translation © Deborah Shannon 2006. Reprinted by permission of DACS on behalf of the Raoul Hausmann estate. 10: André Salmon, 'Fable of the Little Tin Fish', pp. 99–105 Beth Gersh-Nešić (ed. and trans.), *André Salmon on French Modern Art* 2006, © English-language translation Beth S. Gersh-Nešić 2006, published by Cambridge University Press, reproduced with permission. Reprinted by permission of Professor Jacqueline Gojard and the estate of André Salmon. 11: English translation © Deborah Shannon 2006. 12: By Ezra Pound, from *Ezra Pound and the Visual Arts*, copyright © 1926, 1935, 1937, 1940, 1948, 1950, 1957, 1958, 1960, 1962, 1963, 1965, 1966, 1967, 1970 and 1980 by the Trustees of the Ezra Pound Literary Property Trust. Reprinted by permission of New Directions Publishing Corp. (US, Canadian and European Rights). Reprinted by permission of Faber Ltd (British Commonwealth Rights). 13: Originally published in *Lef*, no. 1. 14: This translation reprinted by permission of Jerzy Jarniewicz. 15: Reprinted by permission of Jean Jamin and the estate of Michel Leiris. English translation © Julia Kelly 2006. 16: From *Tatlin*, ed. Zhadova, © 1989. Reprinted by kind permission of Thames and Hudson Ltd, London. 17: © Salvador Dalí, Fundació Gala-Salvador Dalí, Figueres, 2005. This translation © The estate of David Gascoyne, 2006. 18: Originally published in *The Meaning of Modern Sculpture*, by Faber and Faber, 1932. 19: English translation © Charles Penwarden. 20: Reprinted by permission of Ashgate Publishing. 21: Reprinted by permission of Phillippe and Viviane Grimminger and the estate of Julio González. English translation © Julia Kelly 2006. 22: Reprinted from *Mad Love* by André Breton by permission of the University of Nebraska Press. Copyright © 1987 by the University of Nebraska Press. Originally published as *L'Amour Fou*

Acknowledgements

The editors are grateful to The Henry Moore Foundation and its trustees for its financial support of the *Modern Sculpture Reader* and to Penelope Curtis, curator at the Henry Moore Institute, for her support and encouragement during the making of this collection. We are greatly appreciative of the assistance provided by Ellen Tait in securing permissions and providing editorial support and are very grateful to Jackie Howson and Michael Calderbank for their additional editorial assistance. The library of the Institute has been important to the project, and our librarians, Denise Raine and, more recently, Ann Sproat, have helped procure additional publications as they became relevant. We are also grateful to those who have produced new translations for this volume: Charles Penwarden, Julia Kelly and Deborah Shannon, and to Elizabeth Teague for proofreading.

We would also like to thank the many colleagues and scholars who have provided advice, comments and responses during this book's compilation. The *Modern Sculpture Reader* has benefited much from such conversations and correspondences, some of which have led us to look at other texts and writers. Others have provided their support by granting permission to reproduce textual material and we are immensely grateful to the many copyright holders who have made it possible for us to work within this budget by waiving or reducing their fees.

We would like to thank the following for supporting us in this project:

Vito Acconci, Edward Allington, Gill Armstrong, Hermann Arnhold, Rachel Atkinson, Peter Ballantyne, Stephen Bann, Rebecca Barnard, Adrian Barr-Smith, Georg Baselitz, Bruce Bateman, Chris Bennett, Kyle Bentley, Sophie Berrebi, Arturo Bertagnin, Julia Bloomfield, Stacy Boldrick, Robert Bononno, Graziosa and Gilbert Boudar, Louise Bourgeois, George Braziller, Guy Brett, David Britt, Helen Brown, Benjamin Buchloh, Michael Bullock, Caryn Burtt, Nanni Cagnone, Elisabetta Campologno, Perry Cartwright, Mary Ann Caws, Jeannie Choo, Jennifer Coates, Vicky Cole, Cristina Colomar, Susan Cooke, Vanessa Corby, Michele Coudray, Tony Cragg, Matthew Crawley, Kirbie Crowe, Sarah Crowner, Caroline Cuthburt, Ian Davenport, Wouter Davidts, Simon Dell, Miriam Deutch, Martina Droth, Peter Eisenman, Sian Emmerson, Maite Esteve, Chris Evans, Maggie Evans, Guenther Fannei, Stephen Feeke, Jack Flam, Michael Fried, Benita Gaudlitz, Beth S. Gersh-Nešić, John Gibson, Andres Giedion, Verena Giedion, Gilbert and George, Florence Giry, Georgia Glover, Jaqueline Gojard, Eylse Goldberg, Christine Graham, Walter Grasskamp, Detlev Gretendort, Phillippe Grimminger, Nina Gülicher, Martin Hammer, Viviane and Gabriel Hauffen, Christa Maria Lerm Hayes, Daniel Hermann, Sandy Heslop, Janet Hicks, Susan Hiller, Madeline Hoffman, Reinhold Hohl, Nancy Holt, Joseph Huebscher, Kai Hughes, Tony Hughes, Robert Irwin, Ann Isolde, Jerzy Jarniewicz, Jean Jamin, Kate Johnson, Gareth Jones, Allan Kaprow, John Kelly, Julia Kelly, Alain Kirili, Bernd Klüser, Koot, Jannis Kounellis, Rosalind Krauss, Annette Kulenkampff, John Lechte, James Lingwood, Lucy Lippard, Christina Lodder, Bonnie Marranca, Tim Martin, Elaine Maruhn, Jon Mason,

Eleanor Mayer, John McCormack, David Medalla, Christiane Meyer-Stoll, Maria Fernanda Meza, Jeff Moen, Hattula Moholy-Nagy, Robert C. Morgan, Robert Morris, Bruce Nauman, Joachim Neugroschel, Max Neuhaus, Monika Niedermeier, Patricia Norvell, Elena Ochagavia, Brian O'Doherty, Claes Oldenburg, Dennis O. Palmore, Michael Paraskos, Alex Parigoris, Sabrina R. Paris, Katie Patton, Michael Phipps, Naomi Pritchard, Charles Quick, Patricia Railings, Will Rea, Ben Read, Peter Read, Craig Rember, Garrett Ricciardi, Andrea Rose, Gemma Sala, Sabine Sarwa, Wren Sellers, Peter Selz, Richard Serra, Jan Sewald, Jörg Schellmann, Richard Sherwood, Tara Sibson, Joan Simon, Robin Spencer, Jo Stanbury, Philip Steadman, Stephen Stuart-Smith, Naomi Sylvester, Marielle Tabart, Laura Tam, Adam Tegetmeier, Katarzyna Tosta, Becky Thomas, Jon Thompson, Lynn Thompson, Catherine Trippett, Phyllis Tuchman, William Tucker, Sarah Turner, Xanthe Valentine, Angel Vu, Anne Wagner, Nigel Walsh, Mike Weaver, Angela Westwater, Michael White, Sarah Whitfield, Nina Williams, Richard Williams, Wendy Williams, Sabine Klaproth, Rachel Whiteread, Robert Erich Wolf, Amy Woods, Victoria Worsley, and Rebecca Zimmerman.

We would also like to thank the following organisations: Abrams Books, Artangel Afterlives, Artforum, Artists Bookworks, Artists Rights Society, Ashgate, Bridgeman Art Library, Cripps and Shone, DACS, David Higham Associates, DentonWildeSapte, Electa, Enitharmon Press, Faber and Faber, Fundacio Gala-Salvador Dalí, Gagosian Gallery, Gallimard, George Braziller Inc., Georges Borchardt Agency, Goetz Collection, Hatje Kantz Verlag, Hauser and Wirth, Insel Verlag, James Cohen Gallery, Johns Hopkins University Press, John Wiley and Sons Ltd, Judd Foundation, Manchester Metropolitan University, Metropolitan Museum of Art, Moholy-Nagy Foundation, Museum of Modern Art NY, New Directions, Oldenburg Van Bruggen Foundation, PaceWildenstein, PAJ Books, Paolozzi Foundation, Penguin Group UK, Perseus Books Group, Prentice Hall, Random House, Scottish National Gallery of Modern Art, Solo Syndication Ltd, Sperone Westwater Gallery, Taylor and Francis (Thomson Publishing Services), Thames and Hudson, The Estate of David Smith, Adrian Stokes Estate, The Florin Press, The Getty Research Institute, The University of California Press, The Wylie Agency, University of Chicago Press, University of Minnesota Press, University of Nebraska Press, and Whitecube.

Index

123327 DAWSONS $25.00 —